GAME DESIGN WORKSHOP

GAME DESIGN WORKSHOP

A Playcentric Approach to Creating Innovative Games

Second Edition

Tracy Fullerton

with Christopher Swain and Steven S. Hoffman

ELSEVIER

AMSTERDAM • BOSTON • HEIDELBERG • LONDON
NEW YORK • OXFORD • PARIS • SAN DIEGO
SAN FRANCISCO • SINGAPORE • SYDNEY • TOKYO
Morgan Kaufmann is an imprint of Elsevier

MORGAN KAUFMANN PUBLISHERS

Senior Acquisitions Editor	Laura Lewin
Publishing Services Manager	George Morrison
Senior Production Editor	Dawnmarie Simpson
Developmental Editor	Georgia Kennedy
Assistant Editor	Chris Simpson
Production Assistant	Lianne Hong
Cover Design	Tracy Fullerton
Cover Direction	Dennis Schaefer
Content Reviewer	Frank Lantz
Composition	diacriTech
Copyeditor	Jeanne Hansen
Proofreader	Troy Lilly
Indexer	Michael Ferreira
Interior printer	Sheridan Books, Inc.
Cover printer	Phoenix Color, Inc.

Morgan Kaufmann Publishers is an imprint of Elsevier.
30 Corporate Drive, Suite 400, Burlington, MA 01803, USA

This book is printed on acid-free paper.

Library of Congress Cataloging-in-Publication Data
Fullerton, Tracy.
 Game design workshop : a playcentric approach to creating innovative games / Tracy Fullerton, with Christopher Swain, and Steven S. Hoffman. —2nd ed.
 p. cm.
 Includes bibliographical references and index.
 ISBN 978-0-240-80974-8 (pbk. : alk. paper) 1. Computer games—Programming. 2. Computer games—Design. 3. Computer graphics. I. Swain, Christopher, 1966–II. Hoffman, Steven, 1965–III. Title.

 QA76.76.C672F84 2008
 794.8'1526—dc22 2007040857

ISBN: 978-0-240-80974-8

For information on all Morgan Kaufmann publications,
visit our Web site at *www.mkp.com* or *www.books.elsevier.com*

Printed in the United States.
 11 5 4

Table of Contents

Part 2 Designing a Game147

Chapter 6 Conceptualization . 148

Chapter 7 Prototyping . 175

Chapter 8 Digital Prototyping 213

Part 3 Working As a Game Designer 347

Chapter 12 Team Structures . 348

Chapter 13 Stages of Development . 375

Chapter 14 The Design Document . 394

Foreword

Eric Zimmerman, Co-Founder & Chief Design Officer, Gamelab

There is a connection. Every point in my life is connected to every other point. The connection is there. One need only imagine in full freedom.
— Peter Handke

There is magic in games.

Not magic like a Level 19 fireball spell is magic. Not the kind of magic you get when you purchase a trick in a magic store. And not the kind of mystical experience that organized religion can go on about. No, games are magic in the way that first kisses are magic, the way that finally arriving at a perfect solution to a difficult problem is magic, the way that conversation with close friends over good food is magic.

The magic at work in games is about finding hidden connections between things, in exploring the way that the universe of a game is structured. As all game players know, this kind of discovery makes for deeply profound experiences. How is it possible that the simple rules of chess and Go continue to evolve new strategies and styles of play, even after centuries and centuries of human study? How is it that the nations of the entire world, and even countries at war with each other—at war!—can come together to celebrate in the conflict of sport? How do computer and video games, seemingly so isolating, pierce our individual lives and bring us together in play?

To play a game is to realize and reconfigure these hidden connections—between units on a game board, between players in a match, between life inside the game and life outside—and in so doing, create new meaning. And if games are spaces where meaning is made, game designers are the meta-creators of meaning, those who architect the spaces of possibility where such discovery takes place.

Which is where this book comes in. You are reading these words because you are interested in not just playing games, but in making them. Take my word for it: *Game Design Workshop* is one of the very few books that can truly help you to make the games that you want to make. Those games bursting from your heart and from your imagination. The ones that keep you up at night demanding to be designed. Games that are brimming with potential for discovery, for meaning, for magic.

Game Design Workshop presents, with sharp intelligence and an eye for the importance of the design process, tried-and-true strategies for thinking about and creating games. More than just fancy notions about how games work, *Game Design Workshop* is a treasury of methods for putting game design theories into practice. The authors of *Game Design Workshop* have real experience making games, teaching game designers, and writing about game design. And I can honestly say that they have personally taught me a great deal. In the ambition of its scope and the value of its insights, you hold in your hands a very unique text.

Why do we need a book like *Game Design Workshop*? Because despite the fact that games are so very ancient, are part of every society, and are increasingly important in people's lives, we hardly know anything about them. We are still learning. What makes games tick? How do we create them? How do they fit into culture at large? The explosion

of computer and video games in recent decades has multiplied the complexity and the stakes of such questions. For better or worse, questions like these don't have simple answers. And *Game Design Workshop* won't give them to you. But it can help you figure out how to explore them on your own, through the games you design.

We are living through the rebirth of an ancient form of human culture. Just as the nineteenth century ushered in mechanical invention, and the twentieth century was the age of information, the twenty-first will be a century of play. As game designers, we will be the architects, the storytellers, and the party hosts of this playful new world. What a wonderful and weighty responsibility we have. To bring meaning to the world. To bring magic into the world. To make great games. And to set the world on fire through play.

Are you with me?

Eric Zimmerman
New York City, October 2007

Acknowledgments

The authors wish to thank the many game designers, producers, executives, and educators who have provided invaluable ideas, information, and insights during the writing of this book and the original edition. These talented individuals include:

Steve Ackrich, Activision
Phil Adams, Interplay
Graeme Bayless, Kush Games
Ranjit Bhatnagar, Gamelab
Seamus Blackley, CAA
Jonathan Blow
Chip Blundell, Eidos
Ian Bogost, Persuasive Games
Chris Brandkamp, Cyan
Brenda Brathwaite, Savannah College of Art and Design
Jeff Chen, Activision
Jenova Chen, thatgamecompany
Stan Chow, EA Japan
Doug Church, Electronic Arts
Dino Citraro, Periscopic
Don Daglow, Stormfront Studios
Elizabeth Daley, USC School of Cinematic Arts
Rob Daviau, Hasbro Games
Bernie DeKoven
Jason Della Rocca, IGDA
Dallas Dickinson, Sony Online Entertainment
Neil Dufine
Peter Duke, Duke Media
Troy Dunniway, Brash Entertainment
Greg Ecker
Glenn Entis, Electronic Arts
James Ernest, Cheapass Games

Noah Falstein, The Inspiracy
Dan Fiden, Electronic Arts
Matt Firor, Zenimax Online Studios
Scott Fisher, USC School of Cinematic Arts
Nick Fortugno, Rebel Monkey
Tom Frisina, Electronic Arts
Bill Fulton, Microsoft Game Studios
Richard Garfield, Wizards of the Coast
John Garrett, LucasArts
Chaim Gingold, Electronic Arts
Greg Glass
Susan Gold, IGDA Education SIG
Bing Gordon, Electronic Arts
Sheri Graner Ray, Women in Games International
Bob Greenberg, R/GA Interactive
Michael Gresh
Gary Gygax
Justin Hall, GameLayers
Brian Hersch, Hersch and Company
Richard Hilleman, Electronic Arts
Kenn Hoekstra, Pi Studios
Leslie Hollingshead, Vivendi Universal Games
Josh Holmes, Propaganda Games
Robin Hunicke, Electronic Arts
Steve Jackson, Steve Jackson Games
Matt Kassan, Atari
Kevin Keeker, Microsoft Games User Research
Heather Kelley
Scott Kim
Naomi Kokubo, Rocketon
Vincent Lacava, Pop and Co.
Lorne Lanning, Oddworld Inhabitants
Frank Lantz, area/code

Nicole Lazzaro, XEODesign
Marc LeBlanc, Mind Control Software
Tim Lee, Whyville
Nick Lefevre, Konami of America
Richard Lemarchand, Naughty Dog
Ethan Levy, PlayFirst
Rich Liebowitz, Union Entertainment
Starr Long, NC Soft
Sus Lundgren, PLAY Research Group
Michael Mateas, University of California, Santa Cruz
American McGee, Spicy Horse Games
Jane McGonigal, The Institute for the Future
Jordan Mechner
Nikita Mikros, Tiny Mantis Entertainment
Scott Miller, 3D Realms
Peter Molyneaux, Lionhead Studios
Alan R. Moon
Minori Murakami, Namco
Janet Murray, Georgia Institute of Technology
Ray Muzyka, BioWare
Dan Orzulak, Electronic Arts
Trent Oster, BioWare
Rob Pardo, Blizzard Entertainment
Celia Pearce, Georgia Institute of Technology
David Perry, Gameconsultants.com
Sandy Petersen, Ensemble Studios
Chris Plummer, Electronic Arts
Rhy-Ming Poon, Activision
Kim Rees, Periscopic
Stephanie Reimann, Nintendo
Neal Robison, Vivendi Universal Games
John Rocco
Bill Roper, Flagship Studios
Kate Ross, Wizards of the Coast
Rob Roth
Jason Rubin
Chris Rubyor, Petroglyph
Susana Ruiz

Katie Salen, Gamelab Institute of Play
Kellee Santiago, thatgamecompany
Jesse Schell, Carnegie Mellon University
Carl Schnurr, Activision
Steve Seabolt, Electronic Arts
Bruce C. Shelley, Ensemble Studios
Tom Sloper, Sloperama Productions
Warren Spector, Junction Point Studios
Jen Stein, USC School of Cinematic Arts
Michael Sweet, AudioBrain
Steve Swink, Flashbang Studios
Chris Taylor, Gas Powered Games
Brian Tinsman, Wizards of the Coast
Eric Todd, Electronic Arts
Kurosh ValaNejad, USC EA Game Innovation Lab
Jim Vessella, Electronic Arts
Jesse Vigil, Psychic Bunny
Steve Weiss, Sony Online Entertainment
Jay Wilbur, Epic Games
Dennis Wixon, Microsoft Games User Research
Will Wright, Electronic Arts
Richard Wyckoff, Pandemic Studios
Eric Zimmerman, Gamelab

We would also like to thank our editors and agents at Elsevier, Morgan Kaufmann, CMP, and Waterside Productions:

Dorothy Cox, CMP Books
Danielle Jatlow, Waterside Productions
Georgia Kennedy, Elsevier
Laura Lewin, Elsevier
Carol McClendon, Waterside Productions
Jamil Moledina, CMP Books
Dawnmarie Simpson, Elsevier
Paul Temme, Elsevier

And, of course, all of our students at the University of Southern California.

Image Credits and Copyright Notices

Introduction

One of the most difficult tasks people can perform, however much others may despise it, is the invention of good games.

— *C.G. Jung*

Games are an integral part of all known human cultures. Digital games, in all their various formats and genres, are just a new expression of this ancient method of social interaction. Creating a good game, as noted in the Jung quote above, is a challenging task, one that requires a playful approach but a systematic solution. Part engineer, part entertainer, part mathematician, and part social director, the role of the game designer is to craft a set of rules within which there are means and motivation to play. Whether we are talking about folk games, board games, arcade games, or massively multiplayer online games, the art of game design has always been to create that elusive combination of challenge, competition, and interaction that players just call "fun."

The cultural impact of digital games has grown to rival television and films as the industry has matured over the past three decades. Game industry revenues have been growing at a double-digit rate for years and have recently eclipsed the domestic box office revenues of the film industry, reaching 12.5 billion dollars in 2007. According to reports in *Time Magazine* and *The LA Times*, 90% of U.S. households with children have rented or owned a video or computer game, and young people in the United States spend an average of 20 minutes per day playing video games. This makes digital games the second most popular form of entertainment after television.

As sales of games have increased, interest in game design as a career path has also escalated. Similar to the explosion of interest in screenwriting and directing that accompanied the growth of the film and television industries, creative thinkers today are turning to games as a new form of expression. Degree programs in game design are now available in major universities all over the world in response to student demand. The International Game Developers Association, in recognition of the overwhelming interest in learning to create games, has established an Education SIG to help educators create a curriculum that reflects the real-world process of professional game designers. On their website, the IGDA lists over 200 programs that offer game design courses or degrees in North America alone. Furthermore, *Game Developer* magazine puts out an annual career guide bonus issue to connect the study of game development to the practice of it.

In addition to our experience designing games for companies such as Disney, Sony, Sega, and Microsoft, the authors of this book have spent twelve years teaching the art of game design to students from a variety of different backgrounds and experience levels and have established a game design curriculum for the interactive media degrees at the USC School of Cinematic Arts. In this time, we have found that there are patterns in the way that beginning designers grasp the structural elements of games, common traps that they fall into, and certain types of exercises that can help them learn to make better games. This book encapsulates the experience we have gained by working with our students to design, prototype, and playtest hundreds of original game concepts.

XIX

Our students have gone on to jobs in all areas of the game industry, including game design, producing, programming, visual design, marketing, and quality assurance. Several of them have gone on to become prominent independent game designers, such as the team at thatgamecompany, which developed the hit downloadable title flOw from a student research project created at USC. The method we present here has proven to be successful over and over again. Whatever your background, your technical skills, your reasons for wanting to design games, our goal with this book is to enable you to design games that engage and delight your players.

Our approach is exercise driven and extremely nontechnical. This may surprise you, but we do not recommend implementing your designs digitally right away. The complexities of software development often hamper a designer's ability to see the structural elements of their system clearly. The exercises contained in this book require no programming expertise or visual art skills and so release you from the intricacies of digital game production while allowing you to learn what works and what does not work in your game system. Additionally, these exercises will teach you the most important skill in the game design: the process of prototyping, playtesting, and revising your system based on player feedback.

There are three basic steps to our approach:

Step 1

Start with an understanding of how games work. Learn about rules, procedures, objectives, etc. What is a game? What makes a game compelling to play? Part I of this book covers these game design fundamentals.

Step 2

Learn to conceptualize, prototype, and playtest your original games. Create rough physical or digital prototypes of your designs that allow you to separate the essential system elements from the complexities of full production. Put your playable prototype in the hands of players and conduct playtests that generate useful, actionable feedback. Use that feedback to revise and perfect your game's design. Part II, starting on page 147, covers these important design skills.

Step 3

Understand the industry and the place of the game designer in it. The first two steps give you the foundation of knowledge to be a literate and capable game designer. From there you can pursue the specialized skills used in the game industry. For example, you can pursue producing, programming, art, or marketing. You might become a lead game designer or perhaps one day run a whole company. Part III, starting on page 347 of this book, covers the place of the game designer on a design team and in the industry.

The book is full of exercises intended to get you working on game design problems and creating your own designs. When you reach the end, you will have prototyped and playtested many games, and you will have at least one original playable project of your own. We emphasize the importance of doing these exercises because the only way to really become a game designer is to make games, not just play them or read about them. If you think of this book as a tool to lead you through the process of design, and not just a text to read, you will find the experience much more valuable.

So if you are ready to get started, it's your turn now. Best of luck!

Part 1
Game Design Basics

Since there have been games, there have been game designers. Their names might have been lost to history, but at some point the first clay dice were thrown, and the first smooth stones were placed in the pits of a newly carved mancala board. These early inventors might not have thought of themselves as game designers—perhaps they were just amusing themselves and their friends by coming up with competitions using the everyday objects around them—but many of their games have been played for thousands of years. And although this history stretches back as far as the beginnings of human culture, when we think of games today, we tend to speak of the digital games that have so recently captured our imaginations.

These digital games have the capacity to take us to amazing new worlds with fantastic characters and fully realized interactive environments. Games are designed by teams of professional game developers who work long hours at specialized tasks. The technological and business aspects of these digital games are mind-boggling. And yet, the appeal of digital games for players has its roots in the same basic impulses and desires as the games that have come before them. We play games to learn new skills, to feel a sense of achievement, to interact with friends and family, and sometimes just to pass the time. Ask yourself, why do you play games? Understanding your own answer, and the answers of other players, is the first step to becoming a game designer.

We bring up this long history of games as a prelude to a book primarily about designing digital games because we feel that it's important for today's designers to "reclaim" that history as inspiration and for examples of what makes great gameplay. It's important to remember that what has made games such a long-lasting form of human entertainment is not intrinsic to any technology or medium but to the experience of the players.

The focus of this book will be on understanding and designing for that player experience, no matter what platform you are working with. It is what we call a "playcentric" approach to game design, and it is the key to designing innovative, emotionally engaging game experiences. In the first chapter of this section, we'll look at the special role played by the game designer throughout the process, the designer's relationship to the production team, the skills and vision a designer must possess, and the method by which a designer brings players into the process. Then we will look at the essential structure of games—the formal, dramatic, and dynamic elements that a designer must work with to create that all-important player experience. These are the fundamental building blocks of game design, and they provide an understanding of what it takes to create great games.

Chapter 1

The Role of the Game Designer

The game designer envisions how a game will work during play. She create the objectives, rules, and procedures, thinks up the dramatic premise and gives it life, and is responsible for planning everything necessary to create a compelling player experience. In the same way that an architect drafts a blueprint for a building or a screenwriter produces the script for a movie, the game designer plans the structural elements of a system that, when set in motion by the players, creates the interactive experience.

As the impact of digital games has increased, there has been an explosion of interest in game design as a career. Now, instead of looking to Hollywood and dreaming of writing the next blockbuster, many creative people are turning to games as a new form of expression.

But what does it take to be a game designer? What kinds of talents and skills do you need? What will be expected of you during the process? And what is the best method of designing for a game? In this chapter, we'll look at the answers to these questions and outline a method of iterative design that designers can use to judge the success of gameplay against their goals for the player experience throughout the design and development process. This iterative method, which we call the "playcentric" approach, relies on inviting feedback from players early on and is the key to designing games that delight and engage the audience because the game mechanics are developed from the ground up with the player experience at the center of the process.

An Advocate for the Player

The role of the game designer is, first and foremost, to be an advocate for the player. The game designer must look at the world of games through the player's eyes. This sounds simple, but you'd be surprised how often this concept is ignored. It's far too easy to get caught up in a game's graphics, story line, or new features and forget that what makes a game great is solid gameplay. That's what excites players. Even if they tell you that they love the special effects, art direction, or plot, they won't play for long unless the gameplay hooks them.

As a game designer, a large part of your role is to keep your concentration focused on the player experience and not allow yourself to be distracted by the other concerns of production. Let the art director worry about the imagery, the producer stress over the budget, and the technical director futz with the engine. Your main job is to make sure that when the game is delivered, it provides superior gameplay.

When you first sit down to design a game, everything is fresh, and, most likely, you have a vision for what it is that you want to create. At this point in

the process, your view of the game and that of the eventual new player are similar. However, as the process unfolds and the game develops, it becomes increasingly difficult to see your creation objectively. After months of testing and tweaking every conceivable aspect, your once clear view can become muddled. At times like this, it's easy to get too close to your own work and lose perspective.

Playtesters

Situations like these are when it becomes critical to have playtesters. Playtesters are people who play your game and provide feedback on the experience so that you can move forward with a fresh perspective. By watching other people play the game, you can learn a great deal.

Observe their experience and try to see the game through their eyes. Pay attention to what objects they are focused on, where they click or move the cursor when they get stuck or frustrated or bored, and write down everything they tell you. They are your guide, and it's your mission to have them lead you inside the game and illuminate any issues lurking below the surface of the design. If you train yourself to do this, you will regain your objectivity and be able to see both the beauty and the flaws in what you've created.

Many game designers don't involve playtesters in their process, or, if they do bring in playtesters, it's at the end of production when it's really too late to change the essential elements of the design. Perhaps they are on a tight schedule and feel they don't have time for feedback. Or perhaps they are afraid that feedback will force them to change things they love about their design. Maybe they think that getting a playtest group together will cost too much money. Or they might be under the impression that testing is something only done by marketing people.

What these designers don't realize is that by divorcing their process from this essential feedback opportunity, they probably cost themselves considerable time, money, and creative heartache. This is because games are not a form of one-way

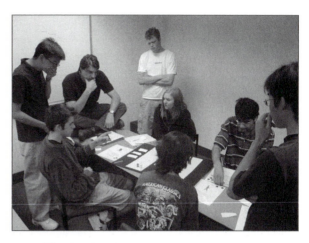

1.1 Playtest group

communication. Being a superior game designer isn't about controlling every aspect of the game design or dictating exactly how the game should function. It's about building a potential experience, setting all the pieces in place so that everything's ready to unfold when the players begin to participate.

In some ways, designing a game is like being the host of a party. As the host, it's your job to get everything ready—food, drinks, decorations, music to set the mood—and then you open the doors to your guests and see what happens. The results are not always predictable or what you envisioned. A game, like a party, is an interactive experience that is only fully realized after your guests arrive. What type of party will your game be like? Will your players sit like wallflowers in your living room? Will they stumble around trying to find the coatroom closet? Or will they laugh and talk and meet new people, hoping the night will never end?

Inviting players "over to play" and listening to what they say as they experience your game is the best way to understand how your game is working. Gauging reactions, interpreting silent moments, studying feedback, and matching those with specific game elements are the keys to becoming a professional designer. When you learn to listen to your players, you can help your game to grow.

1.2 More playtest groups

In Chapter 9 on page 248, when we examine the playtesting process in detail, you'll learn methods and procedures that will help you hold professional quality playtests and make the most of these tests by asking good questions and listening openly to criticism. For now though, it's just important to know that playtesting is the heart of the design process explored in this book and that the feedback you receive during these sessions can help you transform your game into a truly enjoyable experience for your players.

Like any living system, games transform throughout their development cycle. No rule is set in stone. No technique is absolute. No scheme is the right one. If you understand how fluid the structures are, you can help mold them into shape through repeated testing and careful observation. As a game designer, it's up to you to evolve your game into more than you originally envisioned. That's the art of game design. It's not locking things in place; it's giving birth and parenting. No one, no matter how smart they are, can conceive and produce a sophisticated game from a blank sheet of paper and perfect it without going through this process. And learning how to work creatively within this process is what this book is all about.

Throughout this book, we've included exercises that challenge you to practice the skills that are essential to game design. We've tried to break them down so that you can master them one by one, but by the end of the book, you will have learned a tremendous amount about games, players, and the design process. And you will have designed, prototyped, and playtested at least one original idea of your own. We recommend creating a folder or notebook of your completed exercises so that you can refer to them as you work your way through the book.

Exercise 1.1: Become a Tester

Take on the role of a tester. Go play a game and observe yourself as you play. Write down what you're doing and feeling. Try to create one page of detailed notes on your behaviors and actions. Then repeat this experience while watching a friend play the same game. Compare the two sets of notes and analyze what you've learned from the process.

PASSIONS AND SKILLS

What does it take to become a game designer? There is no one simple answer, no one path to success. There are some basic traits and skills we can mention, however. First, a great game designer is someone who loves to create playful situations. A passion for games and play is the one thread all great designers have in common. If you don't love what you're doing, you'll never be able to put in the long hours necessary to craft truly innovative games.

To someone on the outside, making games might seem like a trivial task—something that's akin to playing around. But it's not. As any experienced designer can tell you, testing their own game for the thousandth time can become work, not play. As the designer, you have to remain dedicated to that ongoing process. You can't just go through the motions. You have to keep that passion alive in yourself and in the rest of the team to make sure that the great gameplay you envisioned in those early days of design is still there in the exhausting, pressure-filled final days before you lock production. To do that, you'll need to develop some other important skills in addition to your love of games and your understanding of the playcentric process.

Communication

The most important skill that you, as a game designer, can develop is the ability to communicate clearly and effectively with all the other people who will be working on your game. You'll have to "sell" your game many times over before it ever hits the store shelves: to your teammates, management, investors, and perhaps even your friends and family. To accomplish this, you'll

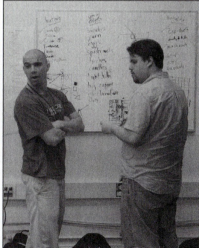

1.3 Communicating with team members

need good language skills, a crystal-clear vision, and a well-conceived presentation. This is the only way to rally everyone involved to your cause and secure the support that you'll need to move forward.

But good communication doesn't just mean writing and speaking—it also means becoming a good listener and a great compromiser. Listening to your playtesters and to the other people on your team affords fresh ideas and new directions. Listening also involves your teammates in the creative process, giving them a sense of authorship in the final design that will reinvest them in their own responsibilities on the project. If you don't agree with an idea, you haven't lost anything, and the idea you don't use might spark one that you do.

What happens when you hear something that you don't want to hear? Perhaps one of the hardest things to do in life is compromise. In fact, many game designers think that compromise is a bad word. But compromise is sometimes necessary, and if done well, it can be an important source of creative collaboration.

For example, your vision of the game might include a technical feature that is simply impossible with the time and resources you have available. What if your programmers come up with an alternate implementation for the feature, but it doesn't capture the essence of the original design? How can you adapt your idea to the practical necessities in such a way as to keep the gameplay intact? You'll have to compromise. As the designer, it's your job to find a way to do it elegantly and successfully so that the game doesn't suffer.

Teamwork

Game production can be one of the most intense, collaborative processes you'll ever experience. The interesting and challenging thing about game development teams is the sheer breadth of types of people who work on them. From the hardcore computer scientists, who might be designing the AI or graphic displays, to the talented illustrators and animators who bring the characters to life, to the money-minded executives and business managers who deliver the

1.4 Team meeting

game to its players, the range of personalities is incredible.

As the designer, you will interact with almost all of them, and you will find that they all speak different languages and have different points of view. Computer-ese doesn't often communicate well to artists or the producer, while the subtle shadings of a character sketch might not be instantly obvious to a programmer. A big part of your job, and one of the reasons for your documents and specifications, is to serve as a sort of universal translator, making sure that all of these different groups are, in fact, working on the same game.

Throughout this book, we often refer to the game designer as a single team member, but in many cases the task of game design is a team effort. Whether there is a team of designers on a single game or a collaborative environment where the visual designers, programmers, or producer all have input to the design, the game designer rarely works alone. In Chapter 12 on page 348 we will discuss team structures and how the game designer fits into the complicated puzzle that is a development team.

Process

Being a game designer often requires working under great pressure. You'll have to make critical changes to your game without causing new issues in the process. All too often, a game becomes unbalanced while trying to correct an issue because the designer gets

too close to the work, and in the hopes of solving one problem, introduces a host of new problems. But, unable to see this mistake, the designer keeps making changes, while the problems grow worse, until the game becomes such a mess that it loses whatever magic it once had.

Games are fragile systems, and each element is inextricably linked to the others, so a change in one variable can send disruptive ripples throughout. This is particularly catastrophic in the final phases of development, where you run out of time, mistakes are left unfixed, and portions of the game are amputated in hopes of saving what's left. It's gruesome, but it might help you understand why some games with so much potential seem D.O.A.

The one thing that can rescue a game from this terrible fate is instilling good processes in your team from the beginning. Production is a messy business, when ideas can get convoluted and objectives can disappear in the chaos of daily crises. But good process, using the playcentric approach of playtesting, and controlled, iterative changes, which we'll discuss throughout this book, can help you stay focused on your goals, prioritize what's truly important, and avoid the pitfalls of an unstructured approach.

Exercise 1.2: D.O.A.

Take one game that you've played that was D.O.A. By D.O.A., we mean "dead on arrival" (i.e., a game that's no fun to play). Write down what you don't like about it. What did the designers miss out on? How could the game be improved?

Inspiration

A game designer often looks at the world differently from most people. This is in part because of the profession and in part because the art of game design requires someone who is able to see and analyze the underlying relationships and rules of complex systems and to find inspiration for play in common interactions.

When a game designer looks at the world, he often sees things in terms of challenges, structures, and play. Games are everywhere, from how we manage our money to how we form relationships. Everyone has goals in life and must overcome obstacles to achieve those goals. And of course, there are rules. If you want to win in the financial markets, you have to understand the rules of trading stocks and

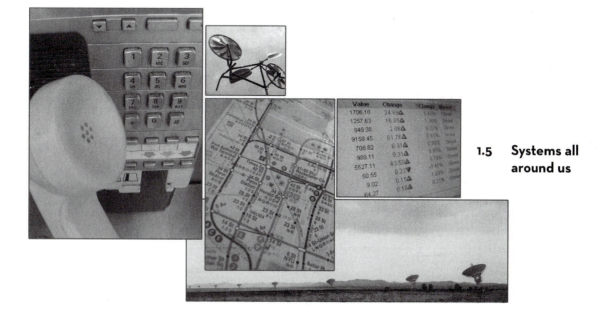

**1.5 Systems all
around us**

bonds, profit forecasts, IPOs, etc. When you play the markets, the act of investing becomes very similar to a game. The same holds true for winning someone's heart. In courtship, there are social rules that you must follow, and it's in understanding these rules and how you fit into society that helps you to succeed.

If you want to be a game designer, try looking at the world in terms of its underlying systems. Try to analyze how things in your life function. What are the underlying rules? How do the mechanics operate? Are there opportunities for challenge or playfulness? Write down your observations and analyze the relationships. You'll find there is potential for play all around you that can form the inspiration for a game. You can use these observations and inspirations as foundations for building new types of gameplay.

Why not look at other games for inspiration? Well, of course, you can and you should. We'll talk about that in just a minute. But if you want to come up with truly original ideas, then don't fall back on existing games for all your ideas. Instead, look at the world around you. Some of the things that have inspired other game designers and could inspire you are obvious: personal relationships, buying and selling, competition in the workplace, etc. Take ant colonies, for example. They're organized around a sophisticated set of rules, and there's competition both within the colonies and between competing insect groups. Well-known game designer Will Wright made a game about ant colonies in 1991, SimAnt. "I was always fascinated by social insects," he says. "Ants are one of the few real examples of intelligence we have that we can study and deconstruct. We're still struggling with the way the human brain works. But if you look at ant colonies, they sometimes exhibit a remarkable degree of intelligence."[1] The game itself was something of a disappointment commercially, but the innate curiosity about how the world works that led Wright to ant colonies has also led him to look at ecological systems such as the Gaia hypothesis as inspiration for SimEarth or psychological theories such as Maslow's hierarchy of needs as inspiration for artificial intelligence in The Sims. Having a strong sense of curiosity and a passion for learning about the world is clearly an important part of Wright's inspiration as a game designer.

What inspires you? Examine things that you are passionate about as systems; break them down in terms of objects, behaviors, relationships, etc. Try to understand exactly how each element of the system interacts. This can be the foundation for an interesting game. By practicing the art of extracting and defining the games in all aspects of your life, you will not only hone your skills as a designer, but you'll open up new vistas in what you imagine a game can be.

Exercise 1.3: Your Life as a Game

List five areas of your life that could be games. Then briefly describe a possible underlying game structure for each.

Becoming a Better Player

One way to become an advocate for the player is by being a better player yourself. By "better" we don't just mean more skilled or someone who wins all the time—although by studying game systems in depth, you will undoubtedly become a more skilled player. What we mean is using yourself and your experiences with games to develop an unerring sense for good gameplay.

The first step to practicing any art form is to develop a deep understanding of what makes that art form work. For example, if you've ever studied a musical instrument, you've probably learned to hear the relationship between the various musical tones. You've developed an ear for music. If you've studied drawing or painting, it's likely that your instructor has urged you to practice looking carefully at light and texture. You've developed an eye for visual composition. If you are a writer, you've learned to read critically. And if you want to be a game designer, you need to learn to play with the same conscious sensitivity to your own experience and critical analysis of the underlying system that these other arts demand.

The following chapters in this section look at the formal, dramatic, and dynamic aspects of games. Together, the concepts in these chapters form a set of tools that you can use to analyze your gameplay experiences and become a better, or more articulate,

player and creative thinker. By practicing these skills, you will develop a game literacy that will make you a better designer. Literacy is the ability to read and write a language, but the concept can also be applied to media or technology. Being game literate means understanding how game systems work, analyzing how they make meaning, and using your understanding to create your own game systems.

We recommend writing your analysis in a game journal. Like a dream journal or a diary, a game journal can help you think through experiences you've had and also to remember details of your gameplay long afterwards. As a game designer, these are valuable insights that you might otherwise forget. It is important when writing in your game journal to try and think deeply about your game experience—don't just review the game and talk about its features. Discuss a meaningful moment of gameplay. Try to remember it in detail—why did it strike you? What did you think, feel, do, etc.? What are the underlying mechanics that made the moment work? The dramatic aspects? Perhaps your insights will form the basis for a future design, perhaps not. But, like sketching or practicing scales on a musical instrument, the act of writing and thinking about design will help you to develop your own way of thinking about games, which is critical to becoming a game designer.

Exercise 1.4: Game Journal

Start a game journal. Try to describe not just the features of the game, but dig deeply into the choices you made, what you thought and felt about those choices, and the underlying game mechanics that support those choices. Go into detail; look for the reasons *why* various mechanics of the game exist. Analyze why one moment of gameplay stands out and not another. Commit to writing in your game journal every day.

Creativity

Creativity is hard to quantify, but you'll definitely need to access your creativity to design great games. Everyone is creative in different ways. Some people come up with lots of ideas without even trying. Others

focus on one idea and explore all of its possible facets. Some sit quietly in their rooms thinking to themselves, while others like to bounce ideas around with a group and find the interaction to be stimulating. Some seek out stimulation or new experiences to spark their imaginations. Great game designers like Will Wright tend to be people who can tap into their dreams and fantasies and bring those to life as interactive experiences.

Another great game designer, Nintendo's Shigeru Miyamoto, says that he often looks to his childhood and to hobbies that he enjoys for inspiration. "When I was a child, I went hiking and found a lake," he says. "It was quite a surprise for me to stumble upon it. When I traveled around the country without a map, trying to find my way, stumbling on amazing things as I went, I realized how it felt to go on an adventure like this."[2] Many of Miyamoto's games draw from this sense of exploration and wonder that he remembers from childhood.

Think about your own life experiences. Do you have memories that might spark the idea for a game? One reason that childhood can be such a powerful inspiration for game designers is that when we are children, we are particularly engrossed in playing games. If you watch how kids interact on a playground, it's usually through game playing. They make games and learn social order and group dynamics from their play. Games permeate all aspects of kids' lives and are a vital part of their developmental process. So if you go back to your childhood and look at things that you enjoyed, you'll find the raw material for games right there.

Exercise 1.5: Your Childhood

List ten games you played as a child; for example, hide and seek, four square, tag, etc. Briefly describe what was compelling about each of those games.

Creativity might also mean putting two things together that don't seem to be related—like Shakespeare and the Brady Bunch. What can you make of such a strange combination? Well, the designers of You Don't Know Jack used silly combinations of

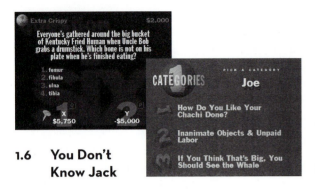

1.6 You Don't Know Jack

1.7 Beautiful Katamari and tamakorogashi

high- and low-brow knowledge like this to create a trivia game that challenged players to be equally proficient in both. The result was a hit game with such creative spark that it crossed the usual boundaries of gaming, appealing to players old and young, male and female.

Sometimes creative ideas just come to you, and the trick is to know when to stand by a game idea that seems far-fetched. Keita Takahashi, designer of the quirky and innovative hit game Katamari Damacy, was given an assignment while working at Namco to come up with an idea for a racing game. The young artist and sculptor wanted to do something more original than a racing game, however, and says he just "came up with" the idea for the game mechanic of a sticky ball, or katamari, that players could roll around, picking up objects that range from paper clips and sushi to palm trees and policemen. Takahashi has said inspiration for the game came from sources as wildly different as the paintings of Pablo Picasso, the novels of John Irving, and Playmobil brand toys, but it is also clear that

Takahashi has been influenced by Japanese children's games and sports such as tamakorogashi (ballroller) as a designer and is thinking beyond digital games for his future creations. "I would like to create a playground for children," he said. "A normal playground is flat but I want an undulating one, with bumps."[3]

Our past experiences, our other interests, our relationships, and our identity all come into play when trying to reach our creativity. Great game designers find a way to tap into their creative souls and bring forth the best parts in their games. However you do it, whether you work alone or in a team, whether you read books or climb mountains, whether you look to other games for inspiration or to life experiences, the bottom line is that there's no single right way to go about it. Everyone has a different style for coming up with ideas and being creative. What matters is not the spark of an idea but what you do with that idea once it emerges, and this is where the playcentric process becomes critical.

A PLAYCENTRIC DESIGN PROCESS

Having a good solid process for developing an idea from the initial concept into a playable and satisfying game experience is another key to thinking like a game designer. The playcentric approach we will illustrate in this book focuses on involving the player in your design process from conception through completion. By that we mean continually keeping the player experience in mind and testing the gameplay with target players through every phase of development.

Setting Player Experience Goals

The sooner you can bring the player into the equation, the better, and the first way to do this is to set "player experience goals." Player experience goals are just

what they sound like: goals that the game designer sets for the type of experience that players will have during the game. These are not features of the game but rather descriptions of the interesting and unique situations in which you hope players will find themselves. For example, "players will have to cooperate to win, but the game will be structured so they can never trust each other," "players will feel a sense of happiness and playfulness rather than competitiveness," or "players will have the freedom to pursue the goals of the game in any order they choose."

Setting player experience goals up front, as a part of your brainstorming process, can also focus your creative process. Notice that these descriptions do not talk about how these experience goals will be implemented in the game. Features will be brainstormed later to meet these goals, and then they will be playtested to see if the player experience goals are being met. At first, though, we advise thinking at a very high level about what is interesting and engaging about your game to players while they are playing and what experiences they will describe to their friends later to communicate the high points of the game.

Learning how to set interesting and engaging player experience goals means getting inside the heads of the players, not focusing on the features of the game as you intend to design it. When you're just beginning to design games, one of the hardest things to do is to see beyond features to the actual game experience the players are having. What are they thinking as they make choices in your game? How are they feeling? Are the choices you've offered as rich and interesting as they can be?

Prototyping and Playtesting

Another key component to playcentric design is that ideas should be prototyped and playtested early. Immediately after brainstorming ideas, we encourage designers to construct a playable version of their idea. By this we mean a physical prototype of the core game mechanics. A physical prototype can use paper and pen, index cards, or even be acted

out. It is meant to be played by the designer and her friends. The goal is to play and perfect this simplistic model before a single programmer, producer, or graphic artist is ever brought onto the project. This way, the game designer receives instant feedback on what players think of the game and can see immediately if they are achieving their player experience goals.

This might sound like common sense, but in the industry today, much of the testing of the core game mechanics comes later in the production cycle, which can result in disappointment. Because many games are not thoroughly prototyped or tested early, flaws in the design aren't found until late in the process—in some cases, too late to fix. People in the industry are realizing that this lack of player feedback means that many games don't reach their full potential, and the process of developing games needs to change if that problem is to be solved. The work of professional usability experts like Nicole Lazzaro of XEODesign and Bill Fulton and Kevin Keeker of Microsoft (see sidebars in Chapters 9 and 6) is becoming more and more important to game designers and publishers in their attempts to improve game experiences, especially with the new, sometimes inexperienced, game players that are being attracted to platforms like the Nintendo Wii and the DS. You don't need to have access to a professional test lab to use the playcentric approach. In Chapter 9 we describe a number of methods you can use on your own to produce useful improvements to your game design.

We suggest that you do not begin production without a deep understanding of your player experience goals and your core mechanic—the central activity of your game. This is critical because when the production process commences, it becomes increasingly difficult to alter the software design. Therefore, the further along the design and prototyping is before the production begins, the greater the likelihood of avoiding costly mistakes. You can assure that your core design concept is sound before production begins by taking a playcentric approach to the design and development process.

DESIGNERS YOU SHOULD KNOW

The following is a list of designers who have had a monumental impact on digital games. The list was hard to finalize because so many great individuals have contributed to the craft in so many important ways. The goal was not to be comprehensive but rather to give a taste of some designers who have created foundational works and who it would be good for you, as an aspiring designer yourself, to be familiar with. We're pleased that many designers on the list contributed interviews and sidebars to this book.

Shigeru Miyamoto

Miyamoto was hired out of industrial design school by Nintendo in 1977. He was the first staff artist at the company. Early in his career he was assigned to a submarine game called Radarscope. This game was like most of the games of the day—simple twitch-game play mechanic, no story, and no characters. He wondered why digital games couldn't be more like the epic stories and fairy tales that he knew and loved from childhood. He wanted to make adventure stories, and he wanted to add emotion to games. Instead of focusing on Radarscope, he made up his own beauty and the beast-like story where an ape steals his keeper's girlfriend and runs away. The result was Donkey Kong, and the character that you played was Mario (originally named Jumpman). Mario is perhaps the most enduring character in games and one of the most recognized characters in the world. Each time a new console is introduced by Nintendo—starting with the original NES machine—Miyamoto designs a Mario game as its flagship title. He is famous for the wild creativity and imagination in his games. Aside from all the Mario and Luigi games, Miyamoto's list of credits is long. It includes the Zelda, Starfox, and Pikmin games.

Will Wright

Early in his career, in 1987, Wright created a game called Raid on Bungling Bay. It was a helicopter game where you attacked islands. He had so much fun programming the little cities on the islands that he decided that making cities was the premise for a fun game. This was the inspiration for SimCity. When he first developed SimCity, publishers were not interested because they didn't believe anyone would buy it. But Wright persisted, and the game became an instant hit. SimCity was a breakout in terms of design in that it was based on creating rather than destroying. Also it didn't have set goals. These things added some new facets to games. Wright was always interested in simulated reality and has done more than anyone in bringing simulation to the masses. SimCity spawned a whole series of titles including SimEarth, SimAnt, SimCopter, and many others. His game, The Sims, is currently the best-selling game of all time, and Spore, his most ambitious project yet, explores new design territory in terms of user-created content. See "A Conversation with Will Wright by Celia Pearce" on page 136.

Sid Meier

Legend has it that Sid Meier bet his buddy, Bill Stealey, that within two weeks he could program a better flying combat game than the one they were playing. Stealey took him up on the offer, and together they founded the company Micro Prose. It took more than two weeks, but the company released the title

Solo Flight in 1984. Considered by many to be the father of PC gaming, Meier went on to create groundbreaking title after groundbreaking title. His Civilization series has had fundamental influence on the genre of PC strategy games. His game Sid Meier's Pirates! was an innovative mix of genres—action, adventure, and roleplaying—that also blended real time and turn-based gaming. His gameplay ideas have been adopted in countless PC games. Meier's other titles include Colonization, Sid Meier's Gettysburg!, Alpha Centauri, and Silent Serv.

Warren Spector

Warren Spector started his career working for board game maker Steve Jackson Games in Austin, Texas. He went from there to the paper-based role-playing game company TSR, where he developed board games and wrote RPG supplements and several novels. In 1989 he was ready to add digital games to his portfolio and moved to the developer Origin Systems. There he worked on the Ultima series with Richard Garriott. Spector had an intense interest in integrating characters and stories into games. He pioneered "free-form" gameplay with a series of innovative titles including Underworld, System Shock, and Thief. His title Deus Ex took the concepts of flexible play and drama in games to new heights and is considered one of the finest PC games of all time. See his "Designer Perspective" interview on page 23.

Richard Garfield

In 1990 Richard Garfield was an unknown mathematician and part-time game designer. He had been trying unsuccessfully to sell a board game prototype called RoboRally to publishers for seven years. When yet another publisher rejected his concept, he was not surprised. However, this time the publisher, a man named Peter Adkison doing business as Wizards of the Coast, asked for a portable card game that was playable in under an hour. Garfield took the challenge and developed a dueling game system where each card in the system could affect the rules in different ways. It was a breakthrough in game design because the system was infinitely expandable. The game was Magic: The Gathering, and it single handedly spawned the industry of collectible card games. Magic has been released in digital format in multiple titles. When Hasbro bought Wizards of the Coast in 1995 for $325 million, Garfield owned a significant portion of the company. See his article, "The Design Evolution of Magic: The Gathering," on page 191.

Peter Molyneux

The story goes that it all started with an anthill. Peter Molyneux as a child toyed with one—tearing it down in parts and watching the ants fight to rebuild, dropping food into the world and watching the ants appropriate it, etc. He was fascinated by the power he had over the tiny, unpredictable creatures. Molyneux went on to become a programmer and game designer and eventually the pioneer of digital "god games." In his breakout title *Populous* you act as a deity lording over tiny settlers. The game was revolutionary in that it was a strategy game that took place in real time, as opposed to in turns, and you had indirect control over your units. The units had minds of their own. This game and other Molyneux hits had profound influence on the real-time strategy (RTS) games to come. Other titles he has created include *Syndicate*, *Theme Park*, *Dungeon Keeper*, and *Black & White*. See Molyneux's "Designer Perspective" interview on page 22.

Gary Gygax

In the early 1970s Gary Gygax was an insurance underwriter in Lake Geneva, Wisconsin. He loved all kinds of games, including tabletop war games. In these games players controlled large armies of miniatures, acting like generals. Gygax and his friends had fun acting out the personas of different pieces on the battlefield such as commanders, heroes, etc. He followed his inclination of what was fun and created a system for battling small parties of miniatures in a game he called Chainmail. From there players wanted even more control of and more character information about the individual units. They wanted to play the role of single characters. Gygax, in conjunction with game designer Dave Arneson, developed an elaborate system for role-playing characters that was eventually named Dungeons & Dragons. The D&D game system is the direct ancestor of every paper-based and digital role-playing game since then. The system is directly evident in all of today's RPGs including Diablo, Baldur's Gate, and World of Warcraft.

Richard Garriott

Richard Garriott—aka "Lord British"—programmed his first game right out of high school in 1979. It was an RPG called Akalabeth. He sold it on his own through a local computer store in Austin, Texas. The packaging for this first version was a Ziploc bag. Akalabeth later got picked up by a publisher and sold well. Garriott used what he learned to create Ultima, and thus one of the most famous game series of all time began. The Ultima titles evolved over the years—each successive one pushing the envelope in terms of both technology and gameplay—eventually bringing the world of the game online. Ultima Online, released in 1997, was a pioneering title in massively multiplayer online worlds. Garriott continues to push the boundaries of online gaming with work on the science fiction MMO Tabula Rasa.

Iteration

By "iteration" we simply mean that you design, test, and evaluate the results over and over again throughout the development of your game, each time improving upon the gameplay or features, until the player experience meets your criteria. Iteration is deeply important to the playcentric process. Figure 1.8 shows a detailed flow of the iterative process that you should go through when designing a game:

- Player experience goals are set.
- An idea or system is conceived.
- An idea or system is formalized (i.e., written down or prototyped).
- An idea or system is tested against player experience goals (i.e., playtested or exhibited for feedback).
- Results are evaluated and prioritized.

- If results are negative and the idea or system appears to be fundamentally flawed, go back to the first step.
- If results point to improvements, modify and test again.
- If results are positive and the idea or system appears to be successful, the iterative process has been completed.

As you will see, we will apply this process during almost every aspect of game design, from the initial conception through the final quality assurance testing.

Step 1: Brainstorming

- Set player experience goals.
- Come up with game concepts or mechanics that you think might achieve your player experience goals.

Generate
Ideas

No
Problems

Problems
with Design

Evaluate
Results

Formalize
Ideas

Test
Ideas

1.8 Iterative process diagram

- Narrow down the list to the top three.
- Write up a short, one-page description each of these ideas, sometimes called a treatment or concept document.
- Test your written concepts with potential players (you might also want to create rough visual mockups of your ideas at this stage to help communicate the ideas).

Step 2: Physical Prototype

- Create a playable prototype using pen and paper or other craft materials.
- Playtest the physical prototype using the process described in Chapters 7 and 9.
- When the physical prototype demonstrates working gameplay that achieves your player experience goals, write a three- to six-page gameplay treatment describing how the game functions.

Step 3: Presentation (Optional)

- A presentation is often made to secure funds to hire the prototyping team. Even if you do not require funding, going through the exercise of creating a full presentation is a good way to think through your game and introduce it to the team members and upper management for feedback.
- Your presentation should include demo artwork and a solid gameplay treatment.
- If you do not secure funding, you can either return to Step 1 and start over again on a new concept

or gain feedback from your funding sources and work on modifying the game to fit their needs. Because you have not yet invested in extensive artwork or programming, your costs so far should be pretty reasonable, and you should have a great deal of flexibility to make any changes.

Step 4: Software Prototype(s)

- When you have your prototyping team in place, you can begin creating rough computer models of the core gameplay. Often there are several software prototypes made, each focusing on different aspects of the system. Digital prototyping is discussed in Chapter 8 beginning on page 213. (If possible, try to do this entirely with temporary graphics that cost very little to make. This will save time and money and make the process go faster.)
- Playtest the software prototype(s) using the process described in Chapter 9.
- When the software prototype(s) demonstrate working gameplay that achieves your player experience goals, move on to the documentation step.

Step 5: Design Documentation

- While you have been prototyping and working on your gameplay, you have probably been compiling notes and ideas for the "real" game. Use the knowledge you've gained during this prototyping stage to write the first draft of a document that outlines every aspect of the game and how it functions.
- This document is usually called the design document, but recently, many designers have moved away from static documents toward online design wikis because of their flexible, collaborative nature. A design wiki is a great collaboration tool and living document that changes and grows with the production.

Step 6: Production

- Work with all of the team members to make sure each aspect of the design is achievable and correctly described in the design document.

THE ITERATIVE DESIGN PROCESS

by Eric Zimmerman, Cofounder and CEO, Gamelab

The following is adapted from a longer essay entitled "Play as Research," which appears in the book Design Research, *edited by Brenda Laurel (MIT Press, 2004). It appears here with permission from the author. Iterative design is a design methodology based on a cyclic process of prototyping, testing, analyzing, and refining a work in progress. In iterative design, interaction with the designed system is the basis of the design process, informing and evolving a project as successive versions, or iterations, of a design are implemented. This sidebar outlines the iterative process as it occurred in one game with which Eric was involved—the online multiplayer game SiSSYFiGHT 2000.*

What is the process of iterative design? Test, analyze, refine. And repeat. Because the experience of a player cannot ever be completely predicted, in an iterative process design decisions are based on the experience of the prototype in progress. The prototype is tested, revisions are made, and the project is tested once more. In this way, the project develops through an ongoing dialogue between the designers, the design, and the testing audience.

In the case of games, iterative design means playtesting. Throughout the entire process of design and development, your game is played. You play it. The rest of the development team plays it. Other people in the office play it. People visiting your office play it. You organize groups of testers who match your target audience. You have as many people as possible play the game. In each case, you observe them, ask them questions, then adjust your design and playtest again.

This iterative process of design is radically different than typical retail game development. More often than not, at the start of the design process for a computer or console title, a game designer will think up a finished concept and then write an exhaustive design document that outlines every possible aspect of the game in minute detail. Invariably, the final game never resembles the carefully conceived original. A more iterative design process, on the other hand, will not only streamline development resources, but it will also result in a more robust and successful final product.

Case Study: SiSSYFiGHT 2000

SiSSYFiGHT 2000 is a multiplayer online game in which players create a schoolgirl avatar and then vie with three to six players for dominance of the playground. Each turn a player selects one of six actions to take, ranging from teasing and tattling to cowering and licking a lolly. The outcome of an action is dependent on other players' decisions, making for highly social gameplay. SiSSYFiGHT 2000 is also a robust online community. You can play the game at www.sissyfight.com. In the summer of 1999, I was hired by Word.com to help them create their first game. We initially worked to identify the project's play values: the abstract principles that the game design would embody. The list of play values we created included designing for a broad audience of nongamers, a low technology barrier, a game that was easy to learn and play but deep and complex, gameplay that was intrinsically social, and finally, something that was in line with the smart and ironic Word.com sensibility.

These play values were the parameters for a series of brainstorming sessions interspersed with group play of computer and noncomputer games. Eventually, a game concept emerged: little girls in social conflict on a

playground. While every game embodies some kind of conflict, we were drawn toward modeling a conflict that we hadn't seen depicted previously in a game. Technology and production limitations meant that the game would be turn based, although it could involve real-time chat.

When these basic formal and conceptual questions had begun to be mapped out, the shape of the initial prototype became clear. The very first version of SiSSYFiGHT was played with Post-it Notes around a conference table. I designed a handful of basic actions each player could take, and acting as the program, I "processed" the actions each turn and reported the results back to the players, keeping score on a piece of paper.

Designing a first prototype requires strategic thinking about how to most quickly implement a playable version that can begin to address the project's chief uncertainties in a meaningful way. Can you create a paper version of your digital game? Can you design a short version of a game that will last much longer in its final form? Can you test the interaction pattern of a massively multiplayer game with just a handful of players?

In the iterative design process, the most detailed thinking you need at any moment is that which will get you to your next prototype. It is, of course, important to understand the big picture as well: the larger conceptual, technical, and design questions that drive the project as a whole. Just be sure not to let your design get ahead of your iterative research. Keep your eye on the prize, but leave room for play in your design, for the potential to change as you learn from your playtesting, accepting the fact that some of your assumptions will undoubtedly be wrong.

The project team continued to develop the paper prototype, seeking the balance between cooperation and competition that would become the heart of the final gameplay. We refined the base rule set—the actions a player can take each turn and the outcomes that result. These rules were turned into a specification for the first digital prototype: a text only version on IRC, which we played hot-seat style, taking turns sitting at the same computer. Constructing that early, text-only prototype allowed us to focus on the complexities of the game logic without worrying about implementing interactivity, visual and audio aesthetics, and other aspects of the game.

While we tested gameplay via the text-only iteration, programming for the final version began in Director, and the core game logic we had developed for the IRC prototype was recycled into the Director code with little alteration. Parallel to the game design, the project's visual designers had begun to develop the graphic language of the game and chart out possible screen layouts. These early drafts of the visuals (revised many times over the course of the entire development) were dropped into the Director version of the

game, and the first rough-hewn iteration of SiSSYFiGHT as a multiplayer online game took shape, inspired by Henry Darger's outsider art and retro game graphics.

As soon as the Web version was playable, the development team played it. And as our ugly duckling grew more refined, the rest of the Word.com staff was roped into testing as well. As the game grew more stable, we descended on our friends' dot-com companies after the workday had ended, sitting them down cold in front of the game and letting them play.

SiSSYFiGHT 2000 Interface

All of this testing and feedback helped us refine the game logic, visual aesthetics, and interface. The biggest challenge turned out to be clearly articulating the relationship between player action and game outcome: Because the results of every turn are interdependent on each player's actions, early versions of the game felt frustratingly arbitrary. Only through many design revisions and dialogue with our testers did we manage to structure the results of each turn to unambiguously communicate what had happened that round and why.

When the server infrastructure was completed, we launched the game to an invitation-only beta tester community that slowly grew in the weeks leading up to public release. Certain time slots were scheduled as official testing events, but our beta users could come online anytime and play. We made it very easy for the beta testers to contact us and e-mail in bug reports.

Even with this small sample of a few dozen participants, larger play patterns emerged. For example, as with many multiplayer games, it was highly advantageous to play defensively, leading to standstill matches. In response, we tweaked the game logic to discourage this play style: Any player that "cowered" twice in a row was penalized for acting like a chicken. When the game did launch, our loyal beta testers became the core of the game community, easing new players into the game's social space.

In the case of SiSSYFiGHT 2000, the testing and prototyping cycle of iterative design was successful because at each stage we clarified exactly what we wanted to test and how. We used written and online questionnaires. We debriefed after each testing session. And we strategized about how each version of the game would incorporate the visual, audio, game

SiSSYFiGHT 2000 Game Interfaces

- When an initial draft of the design document is completed, move on to production.
- Production is the time to staff up and begin the creation of the real artwork and programming.
- Don't lose sight of the playcentric process during production—test your artwork, gameplay, characters, etc., as you move along. As you continue to perform iterative cycles throughout the production phase, the problems you find and the changes you make should get smaller and smaller. This is because you solved your major issues during the prototyping phases.

- Unfortunately, this is the time when most game designers actually wind up designing their games, and this can lead to numerous problems of time, money, and frustration.

Step 7: Quality Assurance

- By the time the project is ready for quality assurance testing, you should be very sure that your gameplay is solid. There can still be some issues, so continue playtesting with an eye to usability. Now is the time to make sure your game is accessible to your entire target audience.

design, and technical elements of the previous versions, while also laying a foundation for the final form of the experience.

To design a game is to construct a set of rules. But the point of game design is not to have players experience rules—it is to have players experience play. Game design is therefore a second-order design problem in which designers craft play, but only indirectly, through the systems of rules that game designers create. Play arises out of the rules as they are inhabited and enacted by players, creating emergent patterns of behavior, sensation, social exchange, and meaning. This shows the necessity of the iterative design process. The delicate interaction of rule and play is something too subtle and too complex to script out in advance, requiring the improvisational balancing that only testing and prototyping can provide.

In iterative design, there is a blending of designer and user, of creator and player. It is a process of design through the reinvention of play. Through iterative design, designers create systems and play with them. They become participants, but they do so in order to critique their creations, bend them, break them, and refashion them into something new. And in these procedures of investigation and experimentation, a special form of discovery takes place. The process of iteration, of design through play, is a way of discovering the answers to questions you didn't even know were there. And that makes it a powerful and important method of design. SiSSYFiGHT 2000 was developed by Marisa Bowe, Ranjit Bhatnagar, Tomas Clarke, Michelle Golden, Lucas Gonze, Lem Jay Ignacio, Jason Mohr, Daron Murphy, Yoshi Sodeka, Wade Tinney, and Eric Zimmerman.

About the Author

Eric Zimmerman is a game designer exploring the practice and theory of gaming. Eric has been making games in the game industry for more than 13 years and presently runs Gamelab, a company he cofounded with Peter Lee in 2000. Gamelab creates experimental online single player and multiplayer games. Before Gamelab, Eric collaborated with Word.com on the underground online hit, SiSSYFiGHT 2000 (www.sissyfight.com). Other titles include the PC CD-ROM games Gearheads (Philips Media, 1996) and The Robot Club (Southpeak Interactive, 1998). Eric has taught game design at MIT, NYU, Parsons School of Design, and School of Visual Arts. He is the coauthor with Katie Salen of Rules of Play (MIT Press, 2004) and The Game Design Reader (MIT Press, 2006) as well as the coeditor with Amy Schoulder of RE:PLAY (Peter Lang Press, 2004). Also see his article on page 330.

As you can see, the playcentric approach involves player feedback throughout the production process, which means you'll be doing lots of prototyping and playtesting at every stage of your game's development. You can't be the advocate for the player if you don't know what the player is thinking, and playtesting is the best mechanism by which you can elicit feedback and gain insight into your game. We cannot emphasize this fact enough, and we encourage any designer to rigorously build into any production schedule the means to continually isolate and playtest all aspects of their game as thoroughly as possible.

Prototypes and Playtesting in the Industry

In the game industry today, designers often skip the creation of a physical prototype altogether and jump straight from the concept stage to writing up the design and then to implementation. The problem with this method is that the software coding has commenced before anyone has a true sense for the game mechanics. The reason this is possible is because many games are simply variations on standard game mechanics, so the designers have a good idea of how

the game will work because they've played it, or a variation of it, as another game.

It's important to remember that the game industry is just that: an industry. Taking risks and spending a lot of time and money creating new gameplay mechanics are difficult to reconcile with a bottom line. However, the game industry has come to a point where it needs to reach new markets if it is going to continue to grow. This means designing for different types of players outside the traditional gaming audience. New platforms like the Nintendo Wii and DS, and breakout hit titles like Guitar Hero, have proven that there is demand from such new audiences if the right new kind of gameplay is offered.

While the industry as a whole is extremely skilled at maintaining steady technological innovation and cultivating core audience demand for those innovations, the same isn't true when it comes to developing original ideas in player experience. To reach new types of players, there are going to have to be breakthroughs in player experience just as surely as there had to be breakthroughs in technology for the industry to come this far. But it is difficult to design an original game if you skip the physical prototyping process. What happens is that you are forced to reference existing games in the design description. This means your game is bound from the outset to be derivative. Breaking away from your references becomes even more difficult as the production takes off. When your team is in place,

with programmers coding and artists cranking out graphics, the idea of going back and changing the core gameplay becomes very difficult.

That is why a number of prominent game designers have begun to adopt a playcentric approach. In fact, Electronic Arts has created an in-house training workshop on preproduction (see sidebar in Chapter 6, page 157) that is run by Chief Visual Officer Glenn Entis. This workshop includes physical prototyping and playtesting as part of the initial development stage. Entis runs development teams through a series of exercises, one of which is coming up with a quick physical prototype. His advice is to make it "fast, cheap, public, and physical. If you don't see people on the team arguing," he says, "you can't know if they are sharing ideas. A physical prototype gets the team talking, interacting."[4]

Chris Plummer, an executive producer at Electronic Arts Los Angeles says, "Paper prototypes can be a great tool for low-cost ideation and playtesting of game features or systems that would otherwise cost a lot more to develop in software. It's much easier to justify spending the resources to realize a game in software after the game framework is developed and refined through more cost-effective means, such as analog prototypes."[5]

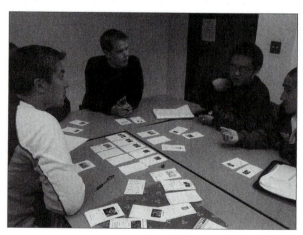

1.10 Dan Orzulak, a game designer at Electronic Arts Los Angeles, playtesting a paper prototype of a nondisclosed game with USC students

1.9 Playing the Wii—Unconventional players

DESIGNING FOR INNOVATION

As we mentioned above, it's clear that the next generation of game designers is going to have to be able to produce breakthroughs in player experience just as certainly as the next generation of programmers is going to have to produce breakthroughs in technology. They will have to do this without taking too many risks in terms of time and money. By innovation we mean:

- Designing games with unique play mechanics—thinking beyond existing genres of play

- Appealing to new players—people who have different tastes and skills than hard-core gamers

- Trying to solve difficult problems in game design such as:

 ◊ The integration of story and gameplay

 ◊ Deeper empathy for characters in games

 ◊ Creating emotionally rich gameplay

 ◊ Discovering the relationships between games and learning

- Asking difficult questions about what games are, what they can be, and what their impact is on us individually and culturally

The playcentric approach can help foster innovation and give you a solid process within which to explore these provocative, unusual questions about gameplay possibilities, to try ideas that might seem fundamentally unsound but could have within them the seed of a breakthrough game and to craft them until they are playable. Real innovation seldom comes from the first spark of an idea—it tends to come from long-term development and experimentation. By interacting with players throughout the design process, experimental ideas have time to develop and mature.

CONCLUSION

Our goal in this book is to help you become a game designer. We want to give you the skills and tools you'll need to take your ideas and craft them into games that aren't mere extensions of the games already on the market. We want to enable you to push the envelope on game design, and the key to doing this is process. The approach you will learn here is about internalizing a playcentric method of design that will make you more creative and productive, while helping you to avoid many of the pitfalls that plague game designers.

The following chapters in this first section will lay out a vocabulary of design and help you to think critically about the games you play and the games you want to design. Understanding how games work and why players play them is the next step to becoming a game designer.

Designer Perspective: Peter Molyneux

Managing Director, Lionhead Studios

Peter Molyneux is a twenty-year veteran of the game industry. He has been a game designer on many influential game titles, including: Populous (1989), Powermonger (1990), Syndicate (1993), Theme Park (1994), Dungeon Keeper (1997), Black & White (2001), Fable (2004), The Movies (2005), and Fable 2 (2008).

On inspiration:

My inspiration from games started from the earliest games, in particular Wizardry on the Apple IIe which, in terms of game design, for me was the equivalent of the invention of the wheel. The ability to explore dungeons, create your own characters, and take part in heroic quests had never been seen in a game before.

On design process:

The design process starts with an idea. These ideas just appear in my mind fully formed as opposed to being formed gradually by logic. I then roll this idea out to a small team of people who flesh the idea out and then talk through the areas of design. After the idea has been expanded, we go into prototyping. Art, animation, gameplay, and technology all get their own prototypes. We use these prototypes to prove things we don't know rather than to prove subjective concepts like "Is this game fun?"

On Fable 2:

In Fable 2 we hit a design problem whereby the player was required to experience the same snippet of the story multiple times because every time they "died" they were sent back 20 minutes in the game story. This is the standard in all computer games and usually results in people feeling frustrated and bored with the story—our design answer was to think of dying in a different way. So, rather than sending players back to an earlier level, we dealt with death by having it cost the player something they care about.

Advice to designers:

Designing a game is not about thinking up a storyline but about what the player does and sees while playing your idea. If you can crack that, then that game's design stands a much higher chance of being a hit.

Designer Perspective: Warren Spector

President and Creative Director, Junction Point Studios

Warren Spector is a veteran game designer and producer whose credits include Ultima VI (1990), Wing Commander (1990), Martian Dreams (1991), Underworld (1991), Ultima VII (1993), Wings of Glory (1994), System Shock (1994), Deus Ex (2000), Deus Ex: Invisible War (2003), and Thief: Deadly Shadows (2004).

On getting into the game industry:

I started out, like most folks, as a gamer, back in the days. Back in 1983, I made my hobby my profession, starting out as an editor at Steve Jackson Games, a small board game company in Austin, Texas. There, I worked on TOON: The Cartoon Roleplaying Game, GURPS, several Car Wars, Ogre, and Illuminati games and learned a ton about game design from people like Steve Jackson, Allen Varney, Scott Haring, and others. In 1987, I was lured away by TSR, makers of Dungeons & Dragons and other fine RPGs and board games. 1989 saw me homesick for Austin, Texas, and feeling like paper gaming was a business/art form that had pretty much plateaued. I was playing a lot of early computer and video games at the time, and when the opportunity to work for Origin came up, I jumped at it. I started out there as an associate producer, working with Richard Garriott and Chris Roberts before moving up to full producer. I spent seven years with Origin, shipping about a dozen titles and moving up from AP to producer to executive producer.

On game influences:

There have probably been dozens of games that have influenced me, but here are a few of the biggies:

- *Ultima IV:* This is Richard Garriott's masterpiece. It proved to me (and a lot of other people) that giving players power to make choices enhanced the gameplay experience. And attaching consequences to those choices made the experience even *more* powerful. This was the game that showed me that games could be about more than killing things or solving goofy puzzles. It was also the first game I ever played that made me feel like I was engaged in a dialogue with the game's creator. And that's something I've striven to achieve ever since.

- *Super Mario 64:* I was stunned at how much gameplay Miyamoto and all managed to squeeze into this game. And it's all done through a control/interface scheme that's so simple it shames me. Mario can do about ten things, I think, and yet you never feel constrained—you feel empowered and liberated, encouraged to explore, plan, experiment, fail, and try again, without feeling frustrated. You have to be inspired by the combination of simplicity and depth.

- *Star Raiders:* This was the first game that made me believe games were more than just a fad or passing fancy, for me and for, well, humanity at large. "Oh, man," I thought, "we can send people places they'll never be able to go in real life." That's not just kid stuff. That's change the world stuff. There's an old saying about not judging someone until you've walked a mile in their shoes, you know? Well, games are like an experiential shoe store for all mankind. We can allow you to walk in the shoes of anyone we can imagine. How powerful is that?

- *Ico*: Ico impressed me because it proved to me how powerfully we can affect players on an emotional level. And I'm not just talking about excitement or fear, the stuff we usually traffic in. Ico, through some stellar animation, graphics, sound, and story elements, explores questions of friendship, loyalty, dread, tension, and exhilaration. The power of a virtual touch—of the player holding the hand of a character he's charged to protect, even though she seems weak and moves with almost maddening slowness. The power of that touch blew me away. I have to find a way to get at some of that power in my own work.

- *Suikoden*: This little PlayStation role-playing game showed me new ways of dealing with conversation. I had never before experienced Suikoden's brand of simple, straightforward, no player choice options unless they're really significant, binary choices—little things like "Do you fight your father or not? Y/N" or "Do you leave your best friend to almost certain death so you can escape and complete your critically important quest? Y/N" will blow you away! In addition, the game featured two other critical systems: a castle building mechanic and a related player-controlled ally system. The castle building bit showed me the power of allowing players to leave a personal mark on the world—the narcissistic aspect of game playing. The ally system, which affected what information you got before embarking on quests, as well as the forces/abilities available to you in mass battles, revealed some of the power of allowing each player to author his or her own unique experience. It is a terrific game that has a lot to teach even the most experienced RPG designers in the business.

On free-form gameplay:

I guess I'm pretty proud of the fact that free-form gameplay, player-authored experiences, and the like are finally becoming not just common but almost expected these days. From the "middle" Ultimas (IV–VI), to Underworld, to System Shock, to Thief, to Deus Ex, there's been this small cadre of us arguing, through our work, in favor of less linear, designer-centric games and, thanks to the efforts of folks at Origin, Looking Glass Studios, Ion Storm, Rockstar/DMA and so on, people are finally beginning to take notice. And it isn't just the hard-core gamers—the mass market is waking up, too. That's pretty cool.

I'm hugely proud of having had the privilege of working alongside some amazingly talented people. It's standard practice in all media to give one person credit for the creation of a game, but that's nonsense. Game development is the most intensely collaborative endeavor I can imagine. It's been an honor to work with Richard Garriott, Paul Neurath, Doug Church, Harvey Smith, and so many others who will now be offended that I didn't single them out here! I know I've learned a lot from all of them and hope I've taught a little bit in return.

Advice to designers:

Learn to program. You don't have to be an ace, but you should know the basics. In addition to a solid technical foundation, get as broadly based an education as you can. As a designer, you never know what you're going to need to know—behavioral psychology will help you immensely, as will architecture, economics, and history. Get some art/graphics experience, if you can, so you can speak intelligently with artists even if you lack the skills to become one yourself. Do whatever it takes to become an effective communicator in written and verbal modes. And most importantly, make games. Get yourself on a mods team and build some maps, some missions, anything you can. Oh, and make sure you really, really, really want to make games for a living. It's gruelingly hard work, with long hours and wrecked relationships to prove it. There are a lot of people who want the same job you want. Don't go into it unless you're absolutely certain it's the career for you. There's no room here for dilettantes!

FURTHER READING

Kelley, Tom. *The Art of Innovation: Lessons in Creativity from IDEO, America's Leading Design Firm.* New York: Random House, 2001.

Laramée, François Dominic, ed. *Game Design Perspectives.* Hingham, MA: Charles River Media, 2002.

Moggridge, Bill. *Designing Interactions.* Cambridge, MA: The MIT Press, 2007.

The Imagineers. *The Imagineering Way.* New York: Disney Editions, 2003.

Tinsman, Brian. *The Game Inventor's Guidebook.* Iola, WI: KP Books, 2003.

END NOTES

1. Phipps, Keith. "Will Wright Interview by Keith Phipps." A.V. Club. February 2, 2005. http://www.avclub.com/content/node/24900/1/1. February 2, 2005.

2. David Sheff. Game Over: How Nintendo Conquered the World (New York: Vintage Books, 1994), p. 51.

3. Hermida, Alfred. "Katamari Creator Dreams of Playground." BBC News.com. November 2005. http://news.bbc.co.uk/2/hi/technology/4392964.stm.

4. Entis, Glenn. "Pre-Production Workshop." EA@USC Lecure Series. March 23, 2005.

5. Plummer, Chris. E-mail interview. May 2007.

Chapter 2
The Structure of Games

Exercise 2.1: Think of a Game

1. Think of a game, any game. Now write down a description of the game. Be detailed. Describe it as if to someone who has never played a game like it before.

2. Now think of another game—a completely different type of game. The more different this game is from the first one, the better. Describe it.

3. Compare your descriptions. Which elements were different and which were similar? Dig deep and really think about the underlying mechanics of each game.

There is no wrong answer to this exercise. The goal is simply to get you to begin thinking about the nature of games and to realize that games, no matter how dissimilar they might seem, do share some common elements. Those common elements are why we recognize certain experiences, and not others, as games, and throughout this book they will form the basis for our study of games and game design.

Go Fish versus Quake

Do all games share the same exact structure? Of course not. A card game has a very different format than a board game; a 3D action game is not at all the same as a trivia game. There is something, however, that they must share because we clearly recognize them all as games. Take Go Fish and Quake. They must have some similarities because if we asked you if each was a game, you'd say, "Yes!" In other words, if these games don't share the same structure, then what do they share that makes them games and not two different forms of entertainment?

Before venturing to say what the similarities between them might be, it would help to look more closely at each of the two example games.

Go Fish

This is a game for three to six players using a standard 52-card deck. The dealer deals five cards to each player. The rest of the cards are placed face down in a draw pile. The player to the dealer's left starts.

A turn consists of asking a player for a specific rank. For example, if it's your turn, you might say, "Chris, please give me your jacks." You must already hold at least one card of the requested rank, so you must hold at least one jack to say this. If Chris has cards of the named rank (jacks in this case), he has to give you all his cards of this rank. You then get another turn and can again ask any player for any rank that you hold.

If Chris does not have any cards of the named rank, he says, "Go fish!" You must then draw the top card from the draw pile. If the drawn card is the rank you asked for, you show it and get another turn. If the drawn card is not the rank you asked for, you keep it, but the turn now passes to the player who said, "Go fish!"

As soon as a player collects a book of four cards of the same rank, this must be shown and discarded face down. The game continues until either someone has no cards left in their hand or the draw pile runs out. The winner is the player who then has the most books.

Quake

In single player Quake,[1] the player controls a character within a 3D environment. Your character can walk, run, jump, swim, shoot, and pick up stuff, but you have a limited amount of armor, health, and ammo.

In the game there are eight types of weapons: axe, shotgun, double-barreled shotgun, nail gun, perforator, grenade launcher, rocket launcher, and thunderbolt. Each weapon uses a specific type of ammo: Shells are for both types of shotguns, nails are for nail guns

and perforators, grenades are for grenade launchers and rocket launchers, and cells are for thunderbolts. There are also power-ups within the game that will boost your power, protect you, heal you, or render you invisible, invulnerable, or able to breathe underwater.

Your enemies include Rottweilers, grunts, enforcers, death knights, rotfish, zombies, scrags, ogres, spawn, fiends, vores, and shamblers. Hazards you might find in the environment are explosions, water, slime, lava, traps, and teleporters. Your main enemy, codenamed Quake, is using "slip-gates" (transporter devices) to insert death squads inside your bases to kill, steal, and kidnap. There are four episodes in the game; the first level of each episode ends in a slip-gate—these signify that you've entered another dimension. When you complete an entire dimension (five to eight levels), you encounter another slip-gate that returns you to the start. The goal of Quake is to stay alive while you work your way through each level, killing all enemies in your way.

Comparison

At first glance, the descriptions of these two experiences could not be more dissimilar: One is a turn-based card game; the other is a real time 3D action shooter. One requires a piece of commercial software and a personal computer capable of running it; the other can be played with a common deck of cards. One is a copyrighted product; the other has a public domain set of rules that can be transferred verbally

2.1 Quake and Go Fish

from person to person, generation to generation. And yet we call them both games and agree, even if we cannot at first verbalize it, that they are similar experiences at some deep level.

If we look closely, though, and try not to ignore ideas that seem self-obvious, there are enough similarities between the experience of Quake and the experience of Go Fish for us to begin to understand what underlying requirements we are looking for when we judge whether or not something is a game.

Players

The most obvious similarity in these two descriptions is that both describe experiences designed for players. This sounds like a simple distinction, but what other forms of entertainment are designed to demand active participation by their consumers? Music is one example; musicians participate in creating the experience of music, but the primary consumers are the audience, not the players. Similarly, dramatic actors participate in the experience of a play, but again, the experience is primarily created for the audience.

In single player Quake, the design calls for a lone player working against the game system, while Go Fish requires a group of at least three players challenging each other. These are very different scenarios, but what the term "player" implies in each situation is the notion of a voluntary participant who both

partakes in and consumes the entertainment. Players are active, they make decisions, they are invested, they are potential winners—they are a very distinct subset of people. To become a player, one must voluntarily accept the rules and constraints of a game. This acceptance of a game's rules is part of what author Bernard Suits has called the "lusory attitude" ("lusory" derives from the Latin word for game).

The lusory attitude of the players is the "curious state of affairs wherein one adopts rules which require one to employ worse rather than better means for reaching an end."[2] For example, Suits describes the game of golf: "Suppose I make it my purpose to get a small round object into a hole in the ground as efficiently as possible. Placing it in the hole with my hand would be a natural means to adopt. But surely I would not take a stick with a piece of metal on one end of it, walk three or four hundred yards away from the hole, and then attempt to propel the ball into the hole with the stick."[3] But, of course, players do just this when they play golf because they have accepted the rules of golf as constraints on their attempts to achieve the objective of the game.

This attitude, this voluntary acceptance of the rules of a game, is part of the psychological and emotional state of players that we need to consider as part of the playcentric process of game design.

2.2 Players

Exercise 2.2: Players

Describe how players might join or start a game of Go Fish versus single player Quake. What steps do they need to take in each case—social, procedural, or technical? There will clearly be differences in beginning of a multiplayer card game versus a single player digital game, but are there also similarities? If so, describe them.

Objectives

The next clear distinction is that both descriptions lay out specific goals for the players. In Go Fish, the goal is to be the player who makes the most books. In Quake, it's to stay alive and complete the level of the complex you are in.

2.3 Objectives

This is very different from other experiences in which we can participate in general. When you watch a film or read a book there is no clear-cut objective presented for you to accomplish during the experience—of course, there is one for the characters, but we're talking about the players here. In life, we set our own objectives and work as hard as we feel necessary to achieve them. We don't need to accomplish all of our objectives to have a successful life. In games, however, the objective is a key element without which the experience loses much of its structure, and our need to work toward the objective is a measure of our involvement in the game.

Exercise 2.3: Objectives

List five games, and in one sentence per game, describe the objective in each game.

Procedures

Both descriptions also give detailed instructions on what players can do to achieve the game objectives. For example, in Go Fish, some of these instructions include: "The dealer deals five cards to each player," or "A turn consists of asking a specific player for a

specific rank." In Quake, the description states that "Your character can walk, run, jump, swim, shoot, and pick up stuff." The directions also provide a set of controls for doing so. These controls are the method by which the player accesses the basic procedures of the game. If we played Go Fish on a computer, we'd have to create controls for dealing or asking a player for a card of a certain rank.

Procedures, the actions or methods of play allowed by the rules, are an important distinction of the experiences we call games. They guide player behavior, creating interactions that would probably never take place outside the authority of the game.

For example, if you wanted to create a set of four cards of like rank, you wouldn't necessarily ask one player at a time for these cards. You might use a more efficient means, like asking all of the players at once, or simply looking through the draw deck for the cards you need. Because games, by their nature, have procedures that must be followed, you don't take these more efficient actions. Instead, you follow the procedures, and in doing so, you confirm that these required actions are indeed an important distinction that sets games apart from other behaviors and experiences.

2.4 Procedures

Rules

Both descriptions spend a great deal of time explaining exactly what objects the game consists of and what the players can and cannot do. They also clarify what happens in various situations that might arise. In Go Fish, "The cards are placed face down in a draw pile," or "If Chris has cards of the named rank, he must give me all his cards of this rank." And from Quake, "There are eight types of weapons," and "Shells are for both types of shotguns, nails are for nail guns and perforators, etc."

Some of these rule statements define game objects and concepts. Objects, like the deck of cards, draw pile, and weapons, are the building blocks of each of these systems upon which the rest of the design depends. Other rules limit player behavior and proscribe reactive events. For example, if nails are for nail guns, you can't use nails in the thunderbolt. If you have a Jack when you're asked for one, you have to give it up; you can't keep it, or you're breaking the rules of the game. Who will stop you from breaking the rules? Your own sense of fair play? The other players? The underlying code of a digital game?

The concepts of both rules and procedures imply authority, and yet there is no person or body named in either description with whom to associate that authority. The authority of the rules stems from an implicit agreement by the players to submit themselves to the experience. If you don't follow the rules, in a very real way, you are no longer playing the game.

So our next distinctive quality of games is that they are experiences that have rules that define game objects, proscribe principles, and limit behavior within the game. These rules are respected because the players understand that they are a key structural element of the game, and without them, the game would not function.

Exercise 2.4: Rules

Can you think of a game that has no rules? If so, describe it. How about one rule? Why is this exercise difficult?

Resources

In the discussion of each of these games, we have mentioned certain objects that seem to hold a rather high value for the players in reaching their objectives. In Go Fish, the cards of each rank are valued, and in Quake, the weapons, their ammunition, and the power-ups mentioned in the rule set are valued. These objects, made valuable because they can help the players achieve their goal, but which are made scarce in the system by the designer, are what we call resources.

2.5 Rules

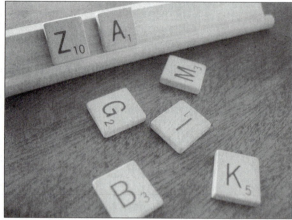

2.6 Resources

Finding and managing resources is a key part of many games, whether those resources are cards, weapons, time, units, turns, or terrain. In the two examples we see here, one depends on a direct exchange of resources (Go Fish), while the other offers resources fixed in place by the game designer (Quake).

Resources are, by definition, items made valuable by their scarcity and utility. In the real world, and in game worlds, resources can be used to further our aims; they can be combined to make new products or items; and they can be bought and sold in various types of markets.

Conflict

As noted previously, both experiences we described lay out specific objectives for their players. And, as we've also noted, they dictate procedures and rules that guide and limit player behavior. The problem for the players is that the procedures and rules of games tend to deter them from accomplishing goals directly; and, in the case of multiplayer games like Go Fish, can also make players work against each other to accomplish these goals. For example, as mentioned earlier, you cannot simply ask everyone at the table to give you the other three Jacks all at once when you're playing Go Fish. You have to ask each player one at a time, risking that you might not get a card and lose your turn, while revealing to the other players that you have a card of the rank you asked for.

Similarly, in Quake, if you could just leave the level of the complex you're on, that would solve the objective, but it's not that easy. To find the exit, you're forced to make it through a mazelike obstacle course of enemies and hazards. In both cases, the relationship between the objectives of the players and the rules and procedures limiting and guiding behavior creates another distinctive element of games: conflict, which the players work to resolve in their own favor.

Exercise 2.5: Conflict

Compare and contrast the conflict in football to the conflict in poker. Describe how each game creates conflict for the players.

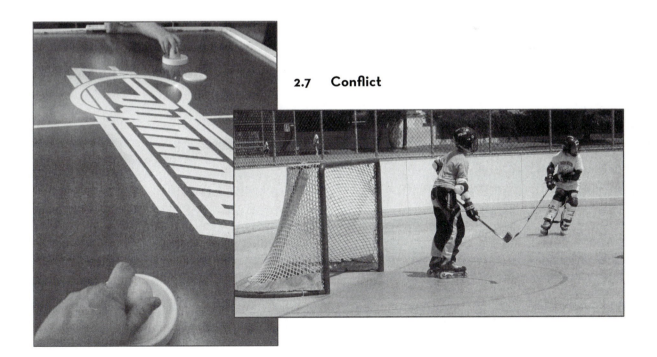

2.7 Conflict

Boundaries

Another similarity between these two experiences, one that is not referred to directly in either description but is, however, implied, is that the rules and goals that are driving the players apply only within the game and not in "real life." In the case of Quake, the architecture of the 3D space forms a virtual boundary. Players are precluded from moving their characters out of these boundaries by the underlying code.

In the case of Go Fish, the boundaries are more conceptual than physical. Players are not precisely bound in a physical sense by any of the rules, except that they need to be able to speak to one another and trade cards back and forth. They are, however, conceptually bound by the social agreement that they are playing the game and that they will not leave the game with some of the cards or add extra cards to the deck.

In his foundational book *Homo Ludens*, theorist Johan Huizinga (see Further Reading) describes the physical and/or conceptual space in which a game takes place as the "magic circle," a temporary world where the rules of the game apply, rather than the rules of the ordinary world. He writes: "All play moves and has its beginning within a playground marked off beforehand either materially or ideally . . . the arena, the card-table, the magic circle, the temple, the stage, the screen, the court of justice, etc. are all in form and function playgrounds, i.e. forbidden spots, isolated, hedged round, within which special rules obtain. All are temporary worlds within the ordinary world, dedicated to the performance of an act apart."[4]

The idea that these experiences are somehow set apart from other experiences by boundaries is yet another distinction we can make about the structure of games.

Outcome

One last similarity between both of these experiences is that for all their rules and constraints, the outcome of both experiences is uncertain, though there is the certainty of a measurable and unequal outcome of some kind—a winner, a loser, etc. For example, in Go Fish, the player who achieves the objective of making the most books by the end of the game wins. In Quake, a player can either win (stay alive) or lose (be killed).

The outcome of a game differs from the objective in that all players can achieve the objective, but other factors within the system can determine which of them actually win the game. For example, in Go Fish, a number of players can accomplish the objective of creating books, but only one player will create the most books, unless there's a tie, and that type of special case is usually addressed in the rules of a game.

The aspect of uncertainty in outcome is an important one for our playcentric process because it is a key motivator for the players. If players can anticipate the outcome of a game, they will stop playing. You have probably been in this situation before—when one player is so far ahead that no one will be able to catch up. At this point, everyone generally agrees to end the game. In chess, a player who has calculated that she cannot win will often concede the game without playing it to the conclusion.

Unlike favorite movies or books, which can remain entertaining even if we already know the ending, games depend on uncertainty of outcome in every play for their dramatic tension. And players invest their emotions in that uncertainty, making it the job of the game designer to craft a satisfying resolution to the game, usually in the form of a measurable and unequal outcome.

2.8 Boundaries

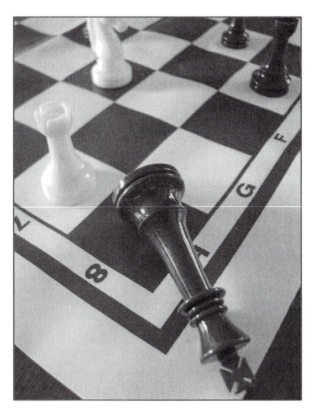

2.9 Outcome

Formal Elements

The games you described in Exercise 2.1 might also have other elements we have not mentioned here: perhaps special equipment, digital environments, complex resources structures, or character definitions. And of course Go Fish and Quake each have their own unique elements that we haven't touched upon, such as the turn structure in Go Fish or the real-time element of Quake. But what we're interested in

right now are elements that all games share—elements that make up the essence of games.

A number of scholars from different fields have examined this same question from other perspectives. Some of the most influential have been those looking at games in terms of studying conflict, economics, behavioral psychology, sociology, and anthropology. Katie Salen and Eric Zimmerman do an excellent job of synthesizing these various points of view about the nature of games in their book *Rules of Play* (see Further Reading). But our perspective here is not strictly scholarly, and our purpose here is not to provide a definitive taxonomy. Rather, it is to provide a useful context, a set of conceptual tools, and a vocabulary for us to discuss the playcentric process of designing games.

The distinctive elements of games that are described above are important concepts for the game designer to understand because they provide structure (and form), which can help a beginning designer make choices in their design process and understand problems that arise in their playtesting process.

As with any art form, one of the reasons to understand and master the traditional structures is so that you can experiment with alternatives. (See sidebar on page 228 on the development of the experimental game Cloud.) The innovation we seek for the game industry very well might require going beyond these basic elements and exploring new forms of interactivity that lie at the edge of what we call "games." Because they play an essential structural function in traditional game systems, however, we call these the "formal elements" of games. We will look at each of these formal elements in more detail in Chapter 3 and discuss how you can use them in various combinations to achieve your player experience goals.

ENGAGING THE PLAYER

If the formal elements mentioned provide structure to the experience of games, then what gives these elements meaning for the players? What makes one game capture the imagination of players and another fall flat? Certainly, some players are attracted to pure abstract challenges, but for most players, there needs to be something else that draws them in and allows

them to connect emotionally with the experience. Games are, after all, a form of entertainment, and good entertainment moves us both intellectually and emotionally.

This sense of engagement comes from different things for different players, and not all games require elaborate means to create it. Next we list some

elements that allow a player to make an emotional connection with a game.

Challenge

We said that experiences created conflict that the players had to work to resolve in their own favor. This conflict challenges the players, creating tension as they work to resolve problems, as well as creating varying levels of achievement or frustration. Increasing the challenge as the game goes on can cause a rising sense of tension, or if the challenge is too great, it can cause frustration. Alternately, if the challenge level remains flat or goes down, players might feel that they have mastered the game and move on. Balancing these emotional responses to the amount of challenge in a game is a key consideration for keeping the player engaged with the game.

Exercise 2.6: Challenge

Name three games that you find particularly challenging and describe why.

Play

The relationship between games and play is a deep and important one. To engage with a game system is to play it, but play itself is not a game. Salen and Zimmerman define play as "free movement within a more rigid structure," using the example of "free play" of a car's steering wheel. "The 'play' is the amount of movement that the steering wheel can move on its own within the system, the amount the steering wheel can turn before it begins to turn the tires of the car. The play itself exists only because of the more utilitarian structures of the driving-system."[5] While this is a somewhat abstract definition, it is useful because it points out the way in which the more rigid systems of games can provide opportunities for players to use imagination, fantasy, inspiration, social skills, or other more free-form types of interaction to achieve objectives within the game space, to play within the game, as well as to engage the challenges it offers.

Play can be serious, like the pomp and circumstance surrounding a Grand Master match in chess, or it might be charged and aggressive, like the marathon play environment of a multiplayer Quake tournament. It might also be an outlet for fantasy, like the rich online environments of World of Warcraft and City of Heroes. Designing for the type of play that will appeal to your players, and also designing the freedom for a bit of free play within the more rigid game structures, are other key considerations for engaging players in your game.

2.10 Chess tournament and multiplayer Quake tournament

WHAT IS A PUZZLE?

by Scott Kim

Scott Kim has been a full-time puzzle designer since 1990 with his company, Shufflebrain. His work includes puzzles for Tetris, Bejeweled, and Collapse!, as well as game design for computer games Heaven & Earth and Obsidian. He also writes a monthly puzzle column for Discover magazine, and he has designed many games, including Sudoku 5x5, for the toy company ThinkFun. He has degrees in music and computers and graphic design from Stanford University, and he lectures widely on puzzle design and math education.

An earlier version of this article originally appeared in The Games Cafe, a now defunct Web site devoted to lovers of board games and puzzles.

From casual games to 3D action games, puzzles are an important part of many electronic games. Whether you are designing or producing games for the Web, mobile phones, computers, arcades, or console games, you need to know how to create good puzzles. In this article I define what a puzzle is, explain how it differs from other types of games, and offer suggestions for how to design good puzzles.

What Is a Puzzle?

The Random House Dictionary defines a puzzle as "a toy or other contrivance designed to amuse by presenting difficulties to be solved by ingenuity or patient effort." A humorous but insightful definition is "a simple task with a bad user interface." For example, twisting the faces of a Rubik's Cube is a deliberately bad user interface for the simple task of turning all the faces solid colors.

My favorite definition of "puzzle" came out of a conversation with puzzle collector and longtime friend Stan Isaacs:

1. A puzzle is fun,
2. and it has a right answer.

Part 1 of the definition says that puzzles are a form of play. Part 2 distinguishes puzzles from other forms of plays, such as games and toys. This deceptively simple definition has some interesting consequences. For example, here's the first puzzle I invented. (Martin Gardner first wrote about it in *Games* magazine.) The figure below is a letter of the alphabet that has been cut out of paper and folded just once. It is not the letter L. What letter is it?

Figure 1 What letter has been folded once to make this shape?

Take a moment to solve this puzzle if you like. The answer is given at the end of this article. Now let's see how well our definition applies.

Is It Fun?

There are several things that help make this puzzle fun.

- *Novel*: Puzzles are a form of play. And play starts by suspending the rules of everyday life, giving us permission to do things that are not practical. Folded letters certainly don't have any practical value. They take something familiar and give it a novel twist—a good way of inviting you to be playful.

- *Not too easy, not too hard*: Puzzles that are too easy are disappointing; puzzles that are too hard are discouraging. You know there are only 26 letters in the alphabet, so it seems that this puzzle can't be too difficult. In fact this puzzle is hard enough that many people never get the answer. Nonetheless, the perceived lack of difficulty helps keeps you interested.

- *Tricky*: To solve this puzzle, you must change how you interpret the picture. Personally, I enjoy puzzles that involve such perceptual shifts.

But, like beauty, fun is in the eye of the beholder. What may be fun for one person may be torture for another. For example, some people prefer word puzzles and won't touch visual or logical puzzles. Puzzles that are too easy for one person might be too hard for another. Chess puzzles are fun only if you know how to play chess. Consequently, my first job as a puzzle designer is to tailor puzzles to the interests and abilities of my audience. For example, my monthly puzzles for *Discover* magazine all revolve around science and math themes. To reach both scientific lay people and experts, I break each puzzle into several questions, ranging from very easy to very hard. Finally, I include three puzzles in each column—usually a word puzzle, a visual puzzle, and a mathematical puzzle—to reach readers who prefer various types of puzzles.

Another consequence of the subjective nature of fun is that what might seem like an everyday problem to you can seem like a delightful puzzle to someone else. Is washing the dishes a chore or a game? That depends on whom you ask. It tickles me to think that for every problem in the world, no matter how tedious, there is someone who would leap at the chance to figure it out. If fun is a state of mind, then you can make your life more enjoyable by finding ways to turn work into play. When I was in school, I used to hate to take notes. Then I learned about mind mapping, a technique of capturing ideas in diagrams and cartoons instead of transcribing every word the teacher says. Not only were my notes more useful, taking notes became an enjoyable game of translating words into pictures. On the flip side, even the best game can be ruined if the players do not play it with a spirit of fun. Game designer and philosopher Bernie Dekoven recommends in his book *The Well Played Game* that players be willing to alter the rules to keep the game fun for everyone. For example, an expert chess player playing with a beginner can level the playing field by starting with fewer pieces or letting the other player take back moves.

Does It Have a Right Answer?

So does my letter puzzle have a right answer? It does in the sense that when shown the answer, most people will agree that this is the best answer. But there are several loopholes.

First, exactly what shape constitutes a letter is a subjective matter. For example, in a squarish typeface, the following shapes could be interpreted as a lowercase R or a capital J:

Figure 2 These shapes could be the letters R or J

I could plug this leak in my puzzle by showing the particular alphabet of letters I have in mind:

ABCDEFGHIJKLM
NOPQRSTUVWXYZ

Figure 3 The answer comes from this typeface

Another subtlety is that my definition doesn't insist that there be only one right answer. If you interpret the diagram differently, there are many other possible answers. For example, the following shapes, which could be interpreted as the letters J and G, can all be unfolded from Figure 1 if we interpret the edges a bit differently:

Figure 4 Other ways to unfold Figure 1

Puzzles versus Games

The purpose of "has a right answer" is to distinguish puzzles from games and other play activities. Some game designers categorize puzzles as a subspecies of games. I prefer a finer-grained definition from Chris Crawford, veteran game designer and author of *Chris Crawford on Game Design*.

Chris distinguishes four types of play activities, ranging from most to least interactive:

- Games are rule-based systems in which the goal is for one player to win. They involve "opposing players who acknowledge and respond to one another's actions. The difference between games and puzzles has little to do with mechanics; we can easily turn many puzzles and athletic challenges into games and vice versa."
- Puzzles are rule-based systems, like games, but the goal is to find a solution, not to beat an opponent. Unlike games, puzzles have little replay value.
- Toys are manipulable, like puzzles, but there is no fixed goal.
- Stories involve fantasy play, like toys, but they cannot be changed or manipulated by the player.

Figure 5 Four types of play, each built on the previous

For example, in the realm of computer entertainment software:

- Quake is a game that includes some puzzles.
- The Incredible Machine is a series of puzzles that includes a toylike construction set for building puzzles.
- SimCity is a toy that players make more puzzle-like by setting their own goals.
- Myst is a story that happens to be told partly through puzzles.

This hierarchy leads me to a useful rule of thumb for puzzle designers: To design a good puzzle, first build a good toy. The player should have fun just manipulating the puzzle, even before reaching a solution.

For example, players can enjoy rotating and manipulating blocks in the action puzzle game Tetris even if they don't understand the goal. The card game Solitaire is an interesting borderline case between game and puzzle. We normally call Solitaire a single player game, but in fact it is a kind of puzzle because any given deck has a definite solution (or sometimes no solution). Shuffling the cards is a way to randomly generate a new puzzle. Other types of puzzles that walk the line on the issue of right answers include trivia questions (which require knowledge of the world), dexterity puzzles (which could be classified with sports), puzzles involving chance (in which the player does not completely control their own fate), and poll-based questions (in which the rightness of an answer depends on what everyone else answers).

Designing Puzzles

Here are some tips for designing good puzzles.

First, there are two aspects of puzzle design. Level design, as it applies to puzzles, is crafting a particular puzzle configuration within a fixed set of rules. For example, composing a crossword puzzle is a form of level design. The level designer's challenge is to craft a puzzle with a distinct sense of drama and coherence that is tailored to a particular difficulty level.

The other type of puzzle design is rule design: inventing the overall rules, goal, and format of a puzzle. For example, Ernö Rubik was a rule designer when he invented Rubik's Cube. Note that some rule sets, like Sudoku, are reusable forms that yield thousands of puzzles, while other rule sets yield only a single unique puzzle. Generally speaking, rule design is harder than level design.

Second, puzzle design has the same goal as game design in general: to keep the player in a pleasurably challenging state of flow. That means capturing the player's interest with an attractive goal, teaching the player the rules in a seamless and interesting way, giving feedback during gameplay that keeps the player engaged, and rewarding the player appropriately at the end.

Finally, be creative. Don't limit yourself to imitating the puzzles you have seen. There is an infinite supply of puzzles waiting to be invented. Puzzles can be as varied and expressive as songs, movies, or stories. For inspiration, look beyond other computer games to puzzle books, mystery stories, physical puzzles, science, mathematics, and anything else that captures your imagination.

Exercise: Invent a Puzzle

Your challenge is to invent a computer-based puzzle inspired by a headline from today's newspaper. After you have invented the rules, craft at least two levels for your game: one easy and one hard. Remember that you are designing a puzzle, not an action game, so the puzzle must have a precisely defined solution.

Make a paper prototype of your puzzle and test it on other people. Be sure to explain what the goal of the puzzle is, what the rules are, and how the player controls the action. What do your testers enjoy? Where do they get stuck or confused? How can you change the puzzle or the rules to make the game better?

Answer to the Letter Puzzle

Just to make things more exciting, the answer to the quiz above is the only letter that does not appear in this sentence.

Premise

A basic way that games create engagement is with their overarching premise, which gives context to the formal elements. For example, the premise in Monopoly is that the players are each landlords, buying, selling, and developing valuable pieces of real estate in an effort to become the richest player in the game. This premise was quite appealing to down-and-out players during the Great Depression when the game was invented. It remains a favorite to this day, and one reason for that continued appeal is its premise—players enjoy the fantasy of being powerful, land-grabbing landlords with plenty of money to wheel and deal.

Many digital games have even more elaborate premises. Our earlier example of Quake, for instance, places the game play in an immersive environment, filled with violent, militaristic imagery. The premise of World of Warcraft is that players are characters in a rich fantasy world filled with archetypal quests and adventures. The base-level effect of the premise is to make it easier for players to contextualize their choices, but it's also a powerful tool for involving players emotionally in the interaction of the formal elements.

Exercise 2.7: Premise

What are the premises for the games Risk, Clue, Pit, and Guitar Hero? If you don't know these games, pick games that you are more familiar with.

Character

Within the last 25 years, games have begun to address another potential tool for engagement, and that is the notion of character. In traditional storytelling, characters are the agents through which dramatic stories are told, and they can function this way in games as well, providing a way for us to empathize with the situation and live vicariously through their efforts. But characters in games can also be vessels for our own participation, entry points for us to experience situations and conflicts through the guise of a mask we create and direct. Character is a useful tool for dramatic engagement in games, and many games, especially digital games, have explored this area of potential.

2.11 Monopoly

2.12 The Evolution of Mario

Story

Lastly, some games engage players emotionally by using the power of story within or surrounding their formal elements. Story differs from premise in its narrative qualities. A premise need not go anywhere from where it begins, while stories unfold with the game. How story can be integrated into gameplay is an ongoing and fairly contentious debate. How much story is too much? How little is too little? Should gameplay change the story? Should story dictate the gameplay? There is no one answer to these questions, but it's clear from the interest of both players and designers that story integrated with play can create powerful emotional results.

Exercise 2.8: Story

Have any stories within a game ever gripped you, moved you emotionally, or sparked your imagination? If so, why? If not, why not?

Dramatic Elements

The games you picked in Exercise 2.1 on page 26 almost certainly have one or more of the elements described previously as a part of their design. We call these the "dramatic elements" of games because they engage the players emotionally by creating a dramatic context for the formal elements. In Chapter 4 on page 86 we'll look at each of these more closely and discuss how you can use dramatic elements to create meaningful game play experiences for your players.

2.13 Final Fantasy VIII—dramatic story elements

The Sum of the Parts

One thing that might not be immediately apparent from your game descriptions or from our examples of Go Fish and single player Quake is the depth to which each of the elements we've discussed relies on the others. This is because games are systems, and systems, by definition, are groups of interrelated elements that work together to form a complex whole.

An important idea to consider when thinking about games as systems is the old saying that the whole is greater than the sum of its parts. What we mean by this is that a system, because of the interrelationship of its elements, takes on new dimensions when it is set in motion. As an example, think of a system you are familiar with, such as the engine in your car. You can examine and understand the physical makeup of each element in the engine. You can understand their functions and even predict how they will respond in interaction with other elements. But unless you set the system in motion, you cannot observe certain important qualities of the engine as a whole—namely, its primary function of producing motive power. When the system is started, however, these qualities emerge as a consequence of the interaction of all the elements.

Game systems are much the same. All of the elements we have laid out previously form a potential that remains nascent until the game is played. What emerges in play is something that cannot be predicted from examining each of the elements separately. The game designer needs to be able to look at a game system not only as separate elements but also as a whole in play. Chapter 5 will look at games as dynamic systems and describe a number of key concepts for working with the system elements in your own games.

Defining Games

Now that we've thought about some of the various aspects of games, it seems natural to try to pull it all together and answer the question we posed at the beginning of this chapter: What is a game? What makes Go Fish, or Quake, or any other game that you can play, a game and not some other type of experience?

We have said that games are given structure by their formal elements, that they also have dramatic elements that make them emotionally engaging experiences. We have also said that games are dynamic systems and that their elements work together to produce a complex whole. We can go even further in our definition by pulling out some of the most important elements from the earlier discussion.

When we talked about boundaries, we mentioned the physical and the conceptual because this is what most games deal with in their rules. What we did not mention is the emotional boundary between the rest of life and a game. When you play a game, you set the rules of life aside and take up the rules of the game instead. Conversely, when you finish playing a game, you set aside the incidents and outcome of that game and return to the trappings of the outside world. Within the game, you might have slaughtered your best friend, or she might have slaughtered you. But that was within the game. Outside the game, these actions have no real consequences. What we are describing is the fact that game systems are separate from the rest of the world; they are closed.

We said that games are formal systems—that they are defined as games, and not some other type of interaction, by their formal elements. Also, we know that it is key to our definition of games to show that these elements are interrelated, and we should include the concept that a game is a system. So the first statement we can make confidently about games is that they are closed, formal systems.

We have talked at length about the fact that games are for players, that the entire purpose of games is to engage players. Without players, games have no reason to exist. How do games engage players? By involving them in a conflict that is structured by their formal and dramatic elements. Games challenge players to accomplish their objectives while following rules and procedures that make it difficult to do so. In single player games, this challenge can come from the system

itself, while in multiplayer games it can come from the system, from other players, or from both. So the second statement we can add to our definition of games is that they engage players in structured conflicts.

Lastly, games resolve their uncertainty in unequal outcomes. A fundamental part of gameplay is that it is uncertain. However, it promises to end that uncertainty by producing a winner or winners. Games are not experiences designed to prove we are all equal. In fairness to the great breadth of game systems, some games are not exacting in their sense of closure or in the measure of their outcome. However, even

if you are playing a game like World of Warcraft that goes on and on ad infinitum, or a game like The Sims, which has no specified objective, these games find ways to provide both moments of resolution and measurable achievement to their players.

Drawing these concepts together, we can come to this working conclusion about the nature of games. A game is:

- A closed, formal system that
- Engages players in structured conflict and
- Resolves its uncertainty in an unequal outcome.

BEYOND DEFINITIONS

Now that we have created a definition, the first thing we want to do is look beyond it. There is a realm of possibilities for game designers that exists on the edges of what we consider to be games. We have already mentioned online environments such as World of Warcraft and simulations such as The Sims, but there are also "serious games," such as Darfur is Dying, a game about the genocide in Darfur, or September 12th, a simulation about the futility of direct militaristic response to terrorism, that take on serious themes and use some of the formal and dramatic elements of games to engage players with those themes. Some people would not call these games, but it is possible that these, and other experimental game designs, will point the way to new forms of play and interactivity.

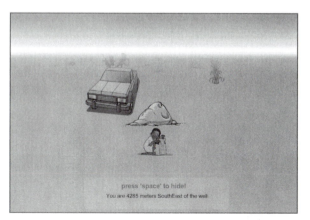

2.14 Darfur is Dying

Exercise 2.9: Applying What You Have Learned

For this exercise, you will need a piece of paper, two pens, and two players. First, take a moment to play this simple game:[6]

1. Draw three dots randomly on the paper. Choose a player to go first.

2. The first player draws a line from one dot to another dot.

3. Then that player draws a new dot anywhere on that line.

4. The second player also draws a line and a dot:
 - The new line must go from one dot to another, but no dot can have more than three lines coming out of it.
 - Also, the new line cannot cross any other line.
 - The new dot must be placed on the new line.
 - A line can go from a dot back to the same dot as long as it doesn't break the "no more than three lines" rule.

5. The players take turns until one player cannot make a move. The last player to move is the winner.

Identify the formal elements of this game:

- *Players:* How many? Any requirements? Special knowledge, roles, etc.?
- *Objective:* What is the objective of the game?

- *Procedures:* What are the required actions for play?
- *Rules:* Any limits on player actions? Rules regarding behavior? What are they?
- *Conflict:* What causes conflict in this game?
- *Boundaries:* What are the boundaries of the game? Are they physical? Conceptual?
- *Outcome:* What are the potential outcomes of the game?

Does the game have dramatic elements? Identify them:

- *Challenge:* What creates challenge in the game?
- *Play:* Is there a sense of play within the rules of the game?
- *Premise/Character/Story:* Are these present?

What types of dramatic elements do you think might add to the game experience?

CONCLUSION

Notice that although we have arrived at a working definition, we have come to no grand conclusion on the absolute nature of games. In fact, we have said that part of our hope is that the next generation of game designers will look beyond the traditional definition of games and explore new territories. The areas of structure we have mapped out are important to the process of design, and as such they need to be clear. The areas left in shadow are just as interesting, and we encourage you to think about aspects of games that interest and inspire you.

Our goal in this taxonomy exercise is to provide a starting point. It is not meant to constrict you as a designer. Having said that, terminology is key. The lack of a single vocabulary is one of the largest problems facing the game industry today. The terms we have suggested here are just that—suggestions. We use them consistently throughout this book so that we can have a common language with you with which to discuss the design process and to help you evaluate and critique your designs.

After you have gained experience with this process, it is up to you as a designer to move beyond any limitations you find with it. Consider everything you read here a starting point from which you can jump off—a launch pad for your expedition into the world of designing games that will hopefully push the envelope and transport players to places they didn't imagine possible.

DESIGNER PERSPECTIVE: AMERICAN MCGEE

Creative Director, Spicy Horse Games

American McGee is a game designer and entrepreneur who began his career at id Software creating levels for such games as DOOM II (1994), Quake (1996), and Quake II (1997). He has since designed his own games, including American McGee's Alice (2000), American McGee presents Scrapland (2004), American McGee presents Bad Day LA (2006), and Grimm (2008).

On getting into the game industry:

I was working as an auto mechanic and living in Mesquite, Texas. It just so happened that one of my neighbors was John Carmack, owner of id Software. He and I became friends, and after several months of hanging out and beta testing at id, John offered me a job doing tech support. While answering phones I trained myself on the in-house design tools and quickly found myself creating content for DOOM II. The rest, as they say, is history.

On favorite games:

Games that deliver a sense of an endless world, living environments, and open-endedness always get my stamp of approval. I'm looking forward to the day when emergent gameplay takes us away from the idea of "video games" and into alternate realities where we decide what the gameplay is.

On inspiration:

Every game I play inspires me in some way. It could be an elegant solution to a third person auto camera or the worst driving physics ever created—even the mistakes have something to teach us.

On the design process:

Game design is a collaborative and iterative process for me. Early on I focus on narrative while my art director sketches visuals. Together we flesh out characters, environments, and simple game concepts. We build on things we know, game ideas that we admire, and pieces collected from other mediums. Our first rough concepts are often very jumbled, even confused. From these we distill down until we're left with a concept, game mechanic, story, art style, and other creative elements that all click. From start to finish this can take us months, but it is a very enjoyable and exciting process.

On simple design solutions:

There have never been difficult problems, just difficult solutions that need to be made simple. Like the idea of making "jump puzzles" accessible to people who were new to third person action games on the PC. We struggled with this on Alice, trying ways to automate the jump, for example, which was difficult. Finally,

I hit on the idea of projecting a 2D image of Alice's feet into the world where she'd land after a jump. It helped novice players with jump puzzles and was elegantly simple.

Advice to designers:

Think entertainment, not games. The creative people within our industry need to start thinking about the big picture, not just the boxed game product. When you design, design with toys, books, films, soundtracks, clothing lines, and any other franchise extensions you can think of. In addition to that, design these things for your audience, not for yourself or your team. Games are not about designer versus player any more, they're about your ideas versus the marketplace. I'll add to this by saying, "think small, different, and online." Thankfully the market is now more accepting of new ideas than ever before.

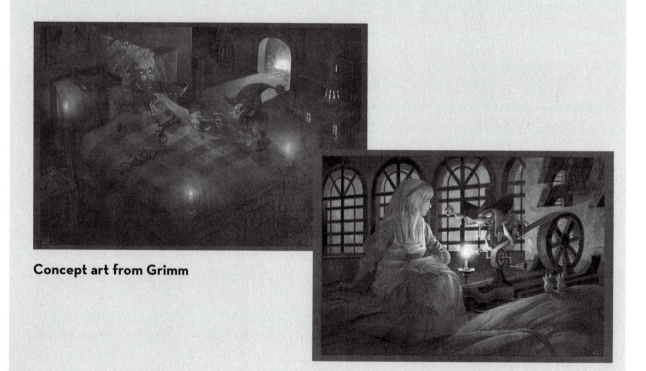

Concept art from Grimm

DESIGNER PERSPECTIVE: SANDY PETERSEN

Designer, Ensemble Studios

Sandy Petersen is a prolific game designer whose career includes games such as DOOM (1993), DOOM II (1994), Quake (1996), Age of Empires (1997), AOE: Rise of Rome (1998), AOE: Ages of Kings (1999), AOE: The Conquerors (2000), Age of Mythology (2002), AOM: The Titans (2003), Age of Empires III (2005), and Call of Cthulhu (1981), a paper role-playing game based on the work of H.P. Lovecraft.

On getting into the game industry:

I backed into it by accident. I took up a job typesetting for a game company to fund my college years and ended up turning an avocation into a vocation.

On favorite games:

- *Contract Bridge*: Best card game ever, bar none. It features many different ways to excel, which means not all good players are good in the same way, so games become clashes of different styles.
- *Cosmic Encounter*: This was the first game to instigate the concept of different players having different abilities. This has become a mainstay of computer games (such as Civilization), but Cosmic Encounter's simple auto balancing system still rules supreme as the finest use of this concept.
- *World in Flames 5th Edition*: Something deep within my soul forces me to replay all of World War II every year or two by using this huge retro-style war game. There's no excuse for it, really.
- *Civilization (the board game)*: Civilization brings the economy to the forefront in a way that few games have done successfully. Every decision you make in Civilization affects your economy for better or worse, and the card trading is a blast.
- *Runequest*: Runequest is my favorite role-playing game.

An astute reader will notice that none of my five favorites are computer games. I didn't realize this until after I'd written them down, but it's probably not a coincidence.

Advice to designers:

Be familiar with all types of games, not just computer games.

Further Reading

DeKoven, Bernie. *The Well-Played Game: A Playful Path to Wholeness.* Lincoln, NE: Writers Club Press, 2002.

Huizinga, Johan. *Homo Ludens: A Study of the Play Element in Culture.* Boston: The Beacon Press, 1955.

Salen, Katie and Zimmerman, Eric. *Rules of Play: Game Design Fundamentals.* Cambridge, MA: The MIT Press, 2004.

Suits, Bernard. *The Grasshopper: Games, Life and, Utopia.* Boston: Godine, 1990.

Sutton-Smith, Brian. *The Ambiguity of Play.* Cambridge, MA: Harvard University Press, 1997.

End Notes

1. It can be argued that single and multiplayer Quake are completely different games, or at least they provide very different player experiences. For the sake of this discussion, we have chosen to look at the single player version to establish a greater contrast between it and the multiplayer card game Go Fish.

2. Suits, Bernard. *The Grasshopper: Games, Life and Utopia.* Boston: Godine, 1990. p. 23.

3. Ibid, p. 38.

4. Huizinga, Johan. *Homo Ludens: A Study of the Play Element in Culture.* Boston: The Beacon Press, 1955. p. 10.

5. Salen, Katie and Zimmerman, Eric. *Rules of Play: Game Design Fundamentals.* Cambridge, MA: The MIT Press, 2004. p. 304.

6. Conway, John and Patterson, Mike. Sprouts, 1967.

Chapter 3
Working with Formal Elements

Exercise 3.1: Gin Rummy

Let's take the classic card game gin rummy. (If you don't know the game, you can look up the rules online.) There are two basic procedures to a turn in gin rummy: drawing and discarding. Take away the discard procedure and try to play the game. What happens?

Now take away both the discard procedure and the draw procedure, and then play the game. What's missing from the game?

Put the drawing and discarding procedures back, but take out the rule that says that an opponent can "lay off" unmatched cards to extend the knocker's sets. Is the game still playable with this change?

Now put back the original rules, but take away the objective and play the game again. What happens this time?

What does this exercise tell us about the formal elements of games?

Formal elements, as we've said, are those elements that form the structure of a game. Without them, games cease to be games. As you saw in the opening exercise of this chapter, a game without an objective, without rules or procedures, is not a game at all. Players, objective, procedures, rules, resources, conflict, boundaries, and outcome: These are the essence of games, and a strong understanding of their potential interrelationships is the foundation of game design.

After you grasp these basic principles, you can use the knowledge to create innovative combinations and new types of gameplay for your own games. This chapter will delve more deeply into each of the formal elements discussed in Chapter 2 and break them down into conceptual tools that you can use to analyze existing games or help make design decisions in your own games.

PLAYERS

We've said that games are experiences designed for players and that players must voluntarily accept the rules and constraints of the game in order to play. When players have accepted the invitation to play, they are within Huizinga's "magic circle," as discussed in Chapter 2. Within the magic circle, the rules of games take on a certain power and a certain potential. Bound by the rules of play, we perform actions that we would never otherwise consider—shooting, killing, and betrayal are some. But we also perform actions we would like to think ourselves capable of and have never had the chance to face—courage in the face of untenable odds, sacrifice, and difficult decision making. Somehow, through a strange and wonderful paradox, those restrictive and binding statements that are game rules, when put into motion within the safety of the magic circle, mysteriously create the opportunity for play.

Invitation to Play

Other arts also create their own temporary worlds: the frame of a painting, the proscenium of a stage, a motion picture screen. The moments of entry into these worlds are ritualized in recognizable moments: the dimming of the lights, the drawing back of the curtains, and, for games, the invitation to play. One of the most important moments in a game is this invitation. In a board or card game, the invitation is part of the social makeup of the game—players invite each other to play. The offer is accepted and the game is begun. In a digital game, the process is much more technical. Usually there is a start button or an entry screen. But some games make an extra effort to extend a more visceral invitation. One of the best examples of this is the Guitar Hero controller. A small plastic mock-up of a guitar, when strapped on by a player, suddenly becomes an excuse to *act* like a guitar player, not just play the game, but play the fantasy of the game. Crafting this invitation to play, making it visceral and compelling to your target audience, is an important part of playcentric design.

It might seem obvious that you need to create an engaging invitation to get players interested in playing your game. But there are other decisions you'll need to make about players in your game. For example, how to structure their participation: How many players does the game require? How many total players can the game support? Do various players have different roles? Will they compete, cooperate, or both? The way you answer these questions will change the overall player experience. To answer them, you'll need to look back to your player experience goals and think about what structure will support your goals.

Number of Players

A game designed for one player is essentially different from a game designed for two, four, or 10,000 players. And a game designed for a specific number of players has different considerations than a game designed for a variable number of players.

Solitaire and tic-tac-toe are games that require an exact number of players. Solitaire, obviously, supports only one player. Tic-tac-toe requires two players—no more, no less—the system will not function without the exact number of players. Many single player digital games support only one player. This is because, like solitaire, their structure supports one player competing against the game system.

On the other hand, there are games that are designed to be played with a range of players. Parcheesi is a game designed for two to four players, while Monopoly is designed for two to eight players. Massively multiplayer games like EverQuest or World of Warcraft are designed to function for a variable number of players, ranging into the tens of thousands; however, a single player can be alone in the world of EverQuest, and many of the formal elements of the system will still function.

Exercise 3.2: Three Player Tic-tac-toe

Create a version of tic-tac-toe that works for three players. You might need to change the size of the board or other elements of the game to do this.

Roles of Players

Most games have uniform roles for all players. In chess and Monopoly, there is only one role for all players. But some games have more than one role for players to choose between. In Mastermind, one player chooses to be the code-maker, while the other chooses to be the code-breaker. The system requires both roles to be filled, or it will not work. Also, many

3.1 Costumed players at an EverQuest convention

3.2 Create character screens: World of Warcraft and City of Heroes

team games, like football, have different player roles that make up the full team. Role-playing games, as the name implies, have a variety of roles for players to choose between. Players can take on the role of healers or fighters or magic wielders. These roles define many of the player's basic abilities, and often players will create more than one character in an online world so that they will have the opportunity to play several different roles.

In addition to roles that are defined within the game rules, however, you might also want to consider potential play styles as a type of role when you are designing your game. Richard Bartle, creator of the first multiuser dungeon (MUD), wrote a widely-referenced article describing the four basic player types he found in his MUD. These were: achievers, explorers, socializers, and killers.[1] Bartle posits that players often have a primary play style and will only switch if it suits their purposes. Online worlds such as Second Life offer players a completely open-ended play environment where roles are player defined. This design decision tends to encourage creativity and self-expression rather than competition. So if you are designing a game with different roles for your players, or if you provide the opportunity for players to define their own roles, the nature and balance of these roles will be a critical consideration.

Player Interaction Patterns

Another choice to consider when designing your game is the structure of interaction between a player, the game system, and any other players. The following breakdown of interaction patterns is adapted from the work of E. M. Avedon in his article, "The Structural Elements of Games."[2] You'll see that many digital games fall into the pattern "single player versus game," and, more recently, "multilateral competition." There's a lot of potential in the other patterns that is rarely taken advantage of, and we offer these ideas to you in the hopes that they can inspire you to look at new combinations and possibilities of player interactions to use in your designs.

1. Single player versus game

This is a game structure in which a single player competes against a game system. Examples include solitaire, Pac-Man, and other single player digital games. This is the most common pattern for digital gaming. You'll find this pattern in arcade games, console games, and PC games. Because there are no other human players in this pattern, games that use it tend to include puzzles or other play structures to create conflict. It is perhaps because of the success of this pattern that we now refer to digital games that have more than one player as "multiplayer" games when, in fact, games have been multiplayer by definition for thousands of years.

Single Player vs. Game

Multiple Individual Players vs. Game

Player vs. Player

Unilateral Competition

Multilateral Competition

Cooperative Play

Team Competition

3.3 **Player interaction patterns**

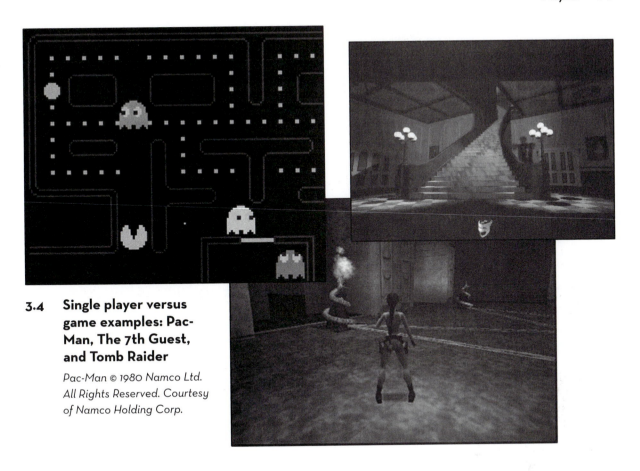

3.4 Single player versus game examples: Pac-Man, The 7th Guest, and Tomb Raider

Pac-Man © 1980 Namco Ltd. All Rights Reserved. Courtesy of Namco Holding Corp.

2. Multiple individual players versus game

This is a game structure in which multiple players compete against a game system in the company of each other. Action is not directed toward each other, and no interaction between participants is required or necessary. Examples include bingo, roulette, and Slingo. This is a rarely used pattern in digital gaming, although AOL had a lot of success with their online Slingo game. Essentially, this pattern is a single player game that is played in the company of other players who are also playing the same game. This pattern works well for noncompetitive players who enjoy the activity and the social arena (a large percentage of Slingo players are women). This pattern also works well for gambling games.

3.5 Multiple individual players versus game: Slingo

3.6 Player vs. Player: Boxing for Atari 2600 and Soul Calibur II for Xbox

Soul Calibur II © 2003 Namco Ltd. All Rights Reserved. Courtesy of Namco Holding Corp.

3. Player versus player

This is a game structure in which two players directly compete. Examples include checkers, chess, and tennis. This is a classic structure for strategy games and works well for competitive players. The one-on-one nature of the competition makes it a personal contest. Two player fighting games such as Soul Calibur II, Mortal Kombat, and others have employed this structure successfully. Again, the intense competition marks this pattern for focused, head-to-head play.

4. Unilateral competition

This is a game structure in which two or more players compete against one player. Examples include tag, dodge ball, and the Scotland Yard board game. A highly undervalued structure, this pattern works as well with "free for all" games like tag, as it does with intensely strategic games like

3.7 Unilateral competition: Scotland Yard

Scotland Yard. As does tag, Scotland Yard pits one player, Mr. X, against all the other players. However, unlike tag, Scotland Yard has the larger

3.8 Multilateral competition: Super Bomberman and Mario Party

group (the detectives) trying to catch the singled out player (the criminal). This game balances between the two forces because the criminal has full information about the state of the game, while the detectives have to work together to deduce the state from clues left by the criminal. It's a very interesting model for combining cooperative and competitive gameplay that is wide open for digital game development.

5. Multilateral competition

This is a game structure in which three or more players directly compete. Examples include poker, Monopoly, multiplayer games like Quake, WarCraft III, Age of Mythology, etc. This is the pattern that most players think of when they refer to "multiplayer" gaming. Nowadays, the trend is to think of multiplayer in terms of massive numbers of players, but as the thousands of years of pre-digital multiplayer game history supports, there's still plenty of room for innovative thinking in terms of smaller, directly competitive groups. Board games with this pattern of player interaction have been "tuned" for generations for groups ranging between three to six players; clearly there's a social force at work that makes this an ideal group size for

direct competition. Want to do something fresh in digital gaming? Try tuning your multiplayer game to encourage the same high level of social interaction that occurs with a three to six person board game.

6. Cooperative play

This is a game structure in which two or more players cooperate against the game system. Examples include Harvest Time, the Lord of the Rings board game, and cooperative quests in World of Warcraft. This pattern has received a lot of attention in terms of children's board games, like Harvest Time, but not much in games for adults. Reiner Knizia, the prolific German game designer, tackled this pattern in his Lord of the Rings board game, in which a group of players cooperate to save Middle-earth. Also, role-playing games often feature cooperative quests within a competitive game structure. It could also be argued that Second Life's noncompetitive, creative environment is a form of cooperative play. It would be interesting to see more designers experiment with this approach.

7. Team competition

This is a game structure in which two or more groups compete. Examples include soccer, basketball,

3.9 Cooperative play: Lord of the Rings board game

charades, Battlefield 1942, and Tribes. Team sports have proved the power of this pattern of player interaction over and over, not only for the players but for a whole other group of participants—the fans. As if responding to the need for this particular multiplayer pattern, teams (called clans or guilds) sprang up almost immediately upon the introduction of multiplayer and massively multiplayer digital games. The multiplayer features introduced in Halo 2 include custom games in which players can define their own rules and teams. Think about your own experiences with team play—what makes team play fun? What makes it different from individual competition? Is there an idea for a team game that comes from your answers to those questions?

Exercise 3.3: Interaction Patterns

For each of the interaction patterns, create a list of your favorite games in each pattern. If you can't think of any games in a particular pattern, research games in that area and play several of them.

3.10 Team competition: Halo 3

PERSUASIVE GAMES

by Ian Bogost

Ian Bogost is a professor of digital media at the Georgia Institute of Technology and founding partner at Persuasive Games LLC. He is the author of Unit Operations: An Approach to Videogame Criticism *and* Persuasive Games: The Expressive Power of Videogames.

How do video games express ideas? Without understanding how games can be expressive in a general sense, it is hard to understand how they might be persuasive. And how do video games make arguments? Video games are different from oral, textual, visual, or filmic media, and thus when they try to persuade, they do so in a different fashion from speech, writing, images, or moving images.

How Video Games Express Ideas

Video games are good at representing the behavior of systems. When we create video games, we start with some system in the world—traffic, football, whatever. Let's call this the "source system." To create the game, we build a model of that source system. Video games are software, so we build the model by author-ing code that *simulates* the behavior we want to focus on. Writing code is different from writing prose or taking photographs or shooting video; code models a set of potential outcomes, all of which conform to the same general rules. One name for this type of representation is *procedurality* (Murray, 1997); procedurality is a name for a computer's ability to execute rule-based behaviors. Video games are a kind of procedural representation.

Consider some examples: Madden Football is a procedural model of the sport of American football. It models the physical mechanics of human movement, the strategy of different sets of plays, and even the performance properties of specific professional athletes. SimCity is a procedural model of urban dynamics. It models the social behavior of residents and workers, as well as the economy, crime rate, pollution level, and other environmental dynamics.

So in a video game we have a source system and a procedural model of that source system. A player needs to interact with the model to make it work—video games are interactive software; they require the player to provide input to make the procedural model work. When players play, they form some idea about the modeled system and about the source system it models. They form these ideas based on the way the source system is simulated; that is to say, there might be many different ways of proceduralizing a system. One designer might build a football game about the strategy of coaching, while another might build one about the duties of a particular field position, such as a defensive lineman. Likewise, one designer might build a city simulator that focuses on public services and new urbanism (Duany et al., 2003), while another might focus on Robert Moses-style suburban planning. This is not just a speculative observation: It highlights the fact that the source system never really exists as such. One person's idea of football or a city or any other subject for a representation of any kind is always *subjective*.

The inherent subjectivity of video games creates dissonances, gaps between the designer's procedural model of a source system and the players' subjectivity, their preconceptions and existing understanding of that simulation. This is where video games become expressive: They encourage players to interrogate and reconcile their own models of the world with the models presented in a game.

How Video Games Persuade

Most of the time, video games create procedural models of fantasy lives, like that of the pro ballplayer (Madden), or a blood elf (World of Warcraft), or a space marine (DOOM). But we can also use this facility to invite the player to see the ordinary world in new or different ways. One way to use video games in this fashion is for persuasion, to make arguments about the way the world works.

Consider a game we created at my company, Persuasive Games. Airport Insecurity (Persuasive Games 2005) is a mobile game about the Transportation Security Administration (TSA). In the game, the player takes the role of a passenger at any of the 138 most trafficked airports in the United States. The gameplay is simple: The player must progress through the security line in an orderly and dignified fashion, taking care not to lag behind when space opens in front of him, as well as to avoid direct contact with other passengers. When he reaches the X-ray check, the player must place his luggage and personal items on the belt. The game randomly assigns luggage and personal items to the player, including "questionable" items like lighters and scissors, as well as legitimately dangerous items like knives and guns.

Airport Insecurity

For each airport, we gathered traffic and wait time data to model the flow of the queues, and we also gathered as much as we could find in the public record on TSA performance. Government Accountability Office (GAO) analysis of TSA performance used to be reported publicly, but the agency reportedly started classifying the information after it became clear that it might pose a national security risk. The upshot of such tactics is that the average citizen has no concept of what level of security they receive in exchange for the rights they forego. While the U.S. government wants its citizens to believe that increased protection and reduced rights are necessary to protect us from terrorism, the effectiveness of airport security practices is ultimately uncertain. The game made claims about this uncertainty by modeling it procedurally: The player got to choose if they would dispose of their dangerous items in a trash can near the X-ray belt or if they would test the limits of the screening process by carrying them through.

Consider another example, this one a live action game played via text messaging on mobile phones in a real world environment. Cruel 2 B Kind, which ubiquitous game researcher and designer Jane McGonigal and I created, is a modification of games like Assassin where players attempt to surreptitiously eliminate

each other with predetermined weapons like water pistols. But in Cruel 2 B Kind, players "kill with kindness." Each player is assigned a "weapon" and "weakness" that corresponds with a common, even ordinary pleasantry. For example, players might compliment someone's shoes or serenade them. While Assassin is usually played in closed environments like college dorms, Cruel 2 B Kind is played in public on the streets of New York City or San Francisco or anywhere in the world.

Cruel 2B Kind

Players not only don't know who their target is, they also don't know who is playing. In these situations, players are forced to use guesswork or deduction to figure out who they might target. As a result, players often "attack" the wrong groups of people or people who are not playing at all. The reactions to such encounters are startling for all concerned; after all, exchanging anonymous pleasantries is not something commonly done on the streets of New York. Cruel 2 B Kind asks the player to layer an alternative set of social practices atop the world they normally occupy. Instead of ignoring their fellow citizens, the game demands that players interact with them. This juxtaposition of game rules and social rules draws attention to the way people do (or more properly, don't) interact with one another in everyday life.

Disruptive and Strange

Persuasive games model ideas about the world and how it works in the subjective opinion of the game's designer. As players, we come to a video game with an idea of the world and how it works. A game presents a model of that same world, but that model has its own properties that likely differ from the player's. When we put the two models together, we can see where they converge and diverge—this is what we do when we play games critically. Procedural arguments can do just this: produce player deliberation, not by making those arguments seamless and comfortable, but rather by making them disruptive and strange.

REFERENCES

Bogost, I. *Persuasive Games: The Expressive Power of Videogames.* Cambridge, MA: MIT Press, 2007.

Bogost, I. *Unit Operations: An Approach to Videogame Criticism.* Cambridge, MA: MIT Press, 2006.

Duany, A., Plater-Zyberk, E., and Alminana, R. *The New Civic Art: Elements of Town Planning.* New York: Rizzoli Publications, 2003.

Murray, J. *Hamlet on the Holodeck: The Future of Narrative in Cyberspace.* New York: Free Press, 1997.

OBJECTIVES

Objectives give your players something to strive for. They define what players are trying to accomplish within the rules of the game. In the best-case scenario, these objectives seem challenging—but achievable—to the players. In addition to providing challenge, the objective of a game can set its tone. A game in which the objective is to capture or kill the opponent's forces will have a very different tone from a game in which the objective is to spell more or longer words.

Some games are constructed so that different players have different objectives, while other games allow the player to choose one of several possible objectives, and still others allow players to form their own objectives as they play. Additionally, there might be partial objectives, or miniobjectives, in a game that help the players to accomplish the main objective. In any case, the objective should be considered carefully because it affects not only the formal system of the game but also the dramatic aspects. If the objective is well integrated into the premise or story, the game can take on strong dramatic aspects.

Some questions to ask yourself about objectives as you design your own games are:

- What are some objectives of games you have played?
- What impact do these objectives have on the tone of the game?
- Do certain genres of play lend themselves to certain objectives?
- What about multiple objectives?
- Do objectives have to be explicit?
- What about player-determined objectives?

Here are some examples of objectives from games you might have played:

- *Connect Four:* Be the first player to place four units in a contiguous line on the playing grid.
- *Battleship:* Be the first player to sink all five of your opponent's ships.
- *Mastermind:* Deduce the secret code of four colored pegs in as few steps as possible.

- *Chess:* Checkmate your opponent's king.
- *Clue:* Be the first player to deduce who, where, and how a murder was committed.
- *Super Mario Bros.:* Rescue Princess Toadstool from the evil Bowser by completing all eight worlds (32 levels) of the game, each of which have their own miniobjectives.
- *Spyro the Dragon:* Rescue your fellow dragons who have been turned to stone, and defeat the evil Gnasty Gnorc by completing all six worlds of the game, each of which have their own miniobjectives.
- *Civilization:* Option 1: conquer all other civilizations on the board, or Option 2: colonize the star Alpha Centauri.
- *The Sims:* Manage the lives of a virtual household; as long as you can keep your household alive, you can set your own goals for the game.

Are there any generalizations we can make about the types of objectives that might help us in our design process? A number of game scholars have made attempts to categorize games by their objectives. Here are some of the categories they defined.[3]

1. Capture

The objective in a capture game is to take or destroy something of the opponent's (terrain, units, or both), while avoiding being captured or killed. Examples of this type of game are strategy board games like chess and checkers, as well as action games like Quake, SOCOM II, and their brethren. Also in this category are real-time strategy games like the WarCraft series and Command & Conquer. There are, in fact, so many examples of games with this type of objective that it is difficult to make any generalizations. Suffice to say that the concept of capture or killing the opponent's forces is one that is deeply ingrained in games today and has been since antiquity.

3.11 Capture or kill: SOCOM II and DOOM

2. Chase

The objective in a chase game is to catch an opponent or elude one, if you are the player being chased. Examples of chase games include tag, Fox & Geese, Assassin, and Maximum Chase. Chase games can be structured as single player versus game, player versus player, or unilateral competition. For example, tag and Fox & Geese are unilateral competitions, or one player versus many. Assassin is player versus player with each player chasing and being chased simultaneously. And Maximum Chase, an Xbox game, is player versus game, with the player in pursuit of computer-controlled enemy cars. Chase games can be determined by speed or physical dexterity, as in tag and Maximum Chase, or by stealth and strategy, as in Assassin. Also, a game like Scotland Yard, discussed on page 54, is a chase game that is determined by logic and deduction. There is clearly a wealth of possibilities for games using this type of objective.

3. Race

The objective in a race game is to reach a goal— physical or conceptual—before the other players. Examples could be a footrace, a board game like Uncle Wiggly or Parcheesi, or a simulation game like Virtua Racing. Race games can be determined by physical dexterity (such as with the footrace and, to some extent, Virtua Racing) or chance (such as with Uncle Wiggly and Parcheesi). They can also be determined by a mix of strategy and chance, such as in backgammon.

4. Alignment

The objective in an alignment game is to arrange your game pieces in a certain spatial configuration or create conceptual alignment between categories of pieces. Examples include tic-tac-toe, solitaire, Connect Four, Othello, Tetris, and Bejeweled. Alignment games are often somewhat puzzle-like in that they involve solving spatial or organizational problems to achieve the goal. They can be determined by logic and calculation, as in Othello and Pente, or by chance opportunity combined with calculation, as in Tetris and Bejeweled. Conceptual alignment is used in many games that require the players to make matches or sets of game pieces.

5. Rescue or escape

The objective in a rescue or escape game is to get a defined unit or units to safety. Examples are Super Mario Bros., Prince of Persia 3D, Emergency Rescue: Firefighters, and Ico. This objective is often combined with other partial objectives. For example, in Super Mario Bros., the overall objective, as mentioned previously, is to rescue the Princess. But each of the game levels also has their own objectives that are more puzzle-like (see Solution on page 64).

3.12 Chase games: Maximum Chase

Maximum Chase trademark Microsoft Corporation

3.13 Race games: Pole Position and Gran Turismo 4

Pole Position © 1982 Namco Ltd. All Rights Reserved. Courtesy of Namco Holding Corp.

6. Forbidden Act

The objective in a forbidden act game is to get the competition to break the rules by laughing, talking, letting go, making the wrong move, or otherwise doing something they shouldn't. Examples include Twister, Operation, Ker-Plunk!, and Don't Break the Ice. This is an interesting game type that isn't often found in digital games, perhaps because of its lack of direct competition or the difficulty in monitoring fair play. From the examples it is clear to see that there is often a physical component to games with this objective, sometimes involving stamina or flexibility, and sometimes just plain chance.

Not included in the work of the scholars mentioned previously, but interesting nonetheless, are objectives such as the following items.

7. Construction

The object in a construction game is to build, maintain, or manage objects; this might be within a directly competitive or indirectly competitive environment. This, in many instances, is a more sophisticated version of the alignment category. Examples of this type of game are simulation games like Animal Crossing, Gazillionaire, SimCity, or The Sims, or board games like Settlers of Catan. Games with a

3.14 Alignment: Bejeweled

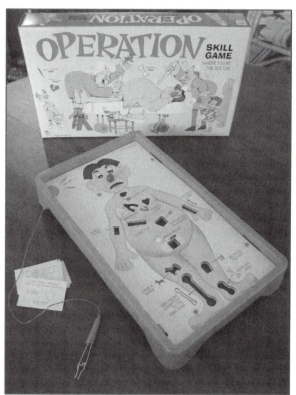

3.16 Forbidden act: Milton Bradley's Operation

3.15 Rescue or escape: Prince of Persia 3D

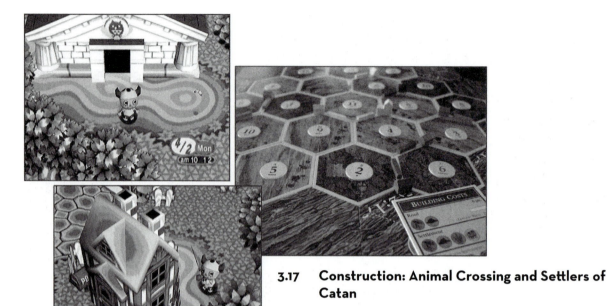

3.17 **Construction: Animal Crossing and Settlers of Catan**

construction objective often make use of resource management or trading as a core gameplay element. They are usually determined by strategic choice making rather than chance or physical dexterity. Also, construction games can often be left open to player interpretation as to what ultimate success is within the game; for example, players choose what type of city to build in SimCity or what household to encourage in The Sims.

8. Exploration

The object in an exploration game is to explore game areas. This is almost always combined with a more competitive objective. In the classic game of exploration, Colossal Cave Adventure, the objective is not only to explore Colossal Cave but also to find treasure along the way. In games like the Zelda series, the objectives of exploration, puzzle solving, and sometimes combat intertwine to form multifaceted gameplay. Online worlds like Ultima and EverQuest have also used exploration as one of several objectives in their game structures.

9. Solution

The object in a solution game is to solve a problem or puzzle before (or more accurately) than the competition. Examples include graphic adventures like the Myst series, text adventures like the classic Infocom titles, and many games that fall into other categories but have puzzle qualities. These include some we have mentioned already: the Mario and Zelda games, Tetris, and The Sims. Some games of pure strategy fall into this puzzle-like category as well: Connect Four and tic-tac-toe.

10. Outwit

The object in a game of wits is to gain and use knowledge in a way that defeats the other players. Some games of this type focus on having extra-game knowledge, like in Trivial Pursuit or Jeopardy! Others focus on gaining or using in-game knowledge, such as Survivor and Diplomacy. This second type of game provokes interesting social dynamics, which have yet to be truly explored in digital games.

3.18 Exploration: Stationfall and The Legend of Zelda: The Wind Waker

3.19 Solution: Day of the Tentacle

3.20 Outwit: Diplomacy

Summary

This list is by no means exhaustive, and one of the most interesting things about objectives in games is when they are mixed in interesting ways. For example, the genre of real-time strategies mixes war with construction, forming a split focus that appeals to gamers who might not be attracted to either pure war games or pure construction games. What you can do with a list like this is use it as a tool to look at the types of objectives you like in games, as well as those you do not like, and see how you might use these objectives in your own game ideas.

Exercise 3.4: Objectives

List ten of your favorite games and name the objective for each. Do you see any similarities in these games? Try to define the type or types of games that appeal to you.

PROCEDURES

As discussed in Chapter 2, procedures are the methods of play and the actions that players can take to achieve the game objectives. One way to think about procedures is: Who does what, where, when, and how?

- Who can use the procedure? One player? Some players? All the players?
- What exactly does the player do?
- Where does the procedure occur? Is the availability of the procedure limited by location?
- When does it take place? Is it limited by turn, time, or game state?
- How do players access the procedure? Directly by physical interaction? Indirectly through a controller or input device? By verbal command?

There are several types of procedures that most games tend to have:

- *Starting action:* How to put a game into play.
- *Progression of action:* Ongoing procedures after the starting action.
- *Special actions:* Available conditional to other elements or game state.
- *Resolving actions:* Bring gameplay to a close.

In board games, procedures are usually described in the rule sheet and put into action by the players. In digital games, however, they are generally integrated into the control section of the manual because they are accessed by the player via the controls. This is an important way in which procedures differ from rules because rules might actually be hidden from the player in a digital game, as we'll discuss on page 68. Here are some examples of procedures from both a board/tabletop game and a digital game.

Connect Four

1. Choose a player to go first. Each player chooses a color: red or black.
2. On each turn, a player drops one colored checker down any of the slots in the top of the grid.
3. The play alternates until one of the players gets four checkers of one color in a row. The row can be horizontal, vertical, or diagonal.

Super Mario Bros.[4]

Select button: Use this button to select the type of game you wish to play.

Start button: Press this button to start the game. If you press it during play, it will pause/unpause the game.

Left arrow: Walk to the left. Push button B at the same time to run.

Right arrow: Walk to the right. Push button B at the same time to run.

Down: Crouch (Super Mario only).

A Button

Jump: Mario jumps higher if you hold the button down longer.

Swim: When in water, press this button to bob up.

B Button

Accelerate: Press this button to run. While holding B, if you press A to jump, you can jump higher.

Fireballs: If you pick up a fire flower, you can use this button to throw fireballs.

Comparison

Notice that both Connect Four and Super Mario Bros. specify a starting action. The progression of action in Connect Four is clearly shown in steps 2 and 3, while in Super Mario Bros., real time game, the progression is implied by the left and right walk commands, which move the player through the game. Connect Four doesn't have any special actions, but Super Mario Bros. has commands that are only appli-

3.21 Super Mario Bros. and Connect Four

cable in certain situations; that is, "when in water press this button to bob up," and "if you pick up a fire flower, you can use this button to throw fireballs." Connect Four also states the resolving action: when one player gets four checkers in a row. Super Mario Bros. does not state the resolving action; this is because the resolution is adjudicated by the system, not the players.

Exercise 3.5: Procedures for Blackjack

List the procedures for blackjack. (If you don't know this game, choose another game you are familiar with.) Be specific. What is the starting action? The progression of action? Any special actions? The resolving action?

System Procedures

Digital games can have much more complex game states than nondigital games. They can also have multifaceted system procedures that work behind the scenes, responding to situations and player actions. In a role-playing combat system, character and weapon attributes can be used as part of a system calculation determining whether a particular player action succeeds, and if so, how much damage it causes. If the game were to be played on paper, as many role-playing games are, these system procedures need to be calculated by the players, using dice to generate random numbers. If the game is played digitally, the same system procedures are calculated by the program rather than the players.

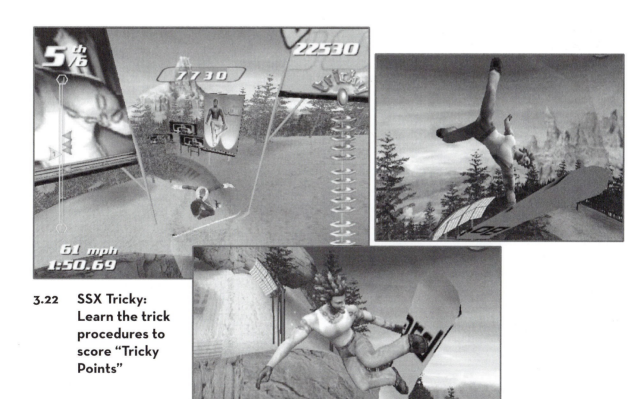

3.22 **SSX Tricky: Learn the trick procedures to score "Tricky Points"**

Because of this, digital games can involve more sophisticated system procedures and process them more quickly than nondigital games. This does not mean that digital games are more complex than nondigital games. When we discuss system structures in Chapter 5 on page 115, we'll look at systems that have simple procedures that lead to extremely complex results. For example, games like chess or Go are nondigital systems that have intrigued players for centuries with their innate complexity, all of which stems from the relationship of very simple game objects and the procedures for manipulating them.

Defining Procedures

When you are defining the procedures for your game, it's important to keep in mind the limitations of the environment in which your game will be played. Will your game be played in a nondigital setting? If so, you will want to make sure the procedures are easy for players to remember. If your game will be played in a digital setting, what type of input/output devices will that setting have? Will players have a keyboard and mouse, or will they have a proprietary controller? Will they sit close to a high-resolution screen or several feet from a low-resolution screen?

Procedures are, by nature, affected by these physical constraints. As a designer, you need to be sensitive to constraints and find creative and elegant solutions so that the procedures are intuitive to access and easy to remember. These types of questions will be addressed in more detail in Chapter 8, when we discuss the prototyping of interfaces and controls for digital games.

RULES

We said in the last chapter that rules define game objects and allowable actions by the players. Some of the questions we might ask ourselves about rules are: How do players learn the rules? How are the rules enforced? What kinds of rules work best in certain situations? Are there patterns to rule sets? What can we learn from those patterns?

Like procedures, rules are generally laid out in the rules document of board games. In digital games, they can be explained in the manual or they can be implicit in the program itself. For example, a digital game might not allow certain actions without explicitly stating that fact; the interface might simply not provide controls for such an action, or the program might stop a player from performing that action if it is attempted.

Rules can also close up loopholes in the game system. One classic example of this is the famous rule from Monopoly: "Do not pass Go, do not collect $200." This rule is applied when a player is sent to jail from any spot on the board. It is important because if it was not stated, a player could make the argument that moving past "Go" all the way to jail entitled him to collect $200, transforming the intended punishment into a reward.

When you are designing rules, as when you are designing procedures, it's important to think of them in relation to your players. Too many rules might make it difficult for the players to manage their understanding of the game. Leaving rules unstated or poorly communicating them might confuse or alienate players. Even if the game system (in the case of a digital game) is tracking the proper application of rules, the players need to clearly understand them so that they do not feel cheated by the consequences of certain rules.

Here are some sample rules from several different types of games that we can use as reference for the following discussion:

- *Poker:* A straight is five consecutively ranked cards; a straight flush is five consecutively ranked cards of the same suit.
- *Chess:* A player cannot move her king into check.
- *Go:* A player cannot make a move that recreates a previous state of the board—this means an exact replication of the whole board situation.
- *WarCraft II:* To create knight units, a player must have upgraded to a keep and built a stable.
- *You Don't Know Jack:* If a player answers a question incorrectly, the other players get a chance to answer.

- *Jak and Daxter:* If a player runs out of green mana, they are "knocked out" and return to the last checkpoint of the level.

Even from this short list, there are some generalities that start to emerge concerning the nature of rules, which are discussed below.

Rules Defining Objects and Concepts

Objects in games have a unique status and meaning that is different from objects in the real world. These game objects, defined as part of the game's rule set, can be completely fabricated, or they can be based on real world objects. But even if they are based on familiar objects, they are only abstractions of those objects and still need to be defined in the rules as to their nature in the game.

Think about the poker rule regarding the concept of a straight or a straight flush. This is a concept unique to the game. There is no straight outside of the realm of poker. When you learn the rules of poker, one of the key concepts to learn is the makeup and values of certain hands—a straight being one of these hands.

Then again, there is chess. We know that chess has objects in its system called kings, queens, bishops, etc., all of which have counterparts in the real world. But this is misleading; the king in a chess game is an abstract object with explicit rules defining its nature. A king outside of the game bears no resemblance to this abstract game object. The rules of chess have simply used the notion of a king to give context to the behavior and value of this important piece.

Board games and other nondigital games generally define their objects explicitly as a part of their rules sets. Players must read and understand these rules, and then they have to be able to adjudicate the game themselves. Because of this, most nondigital games limit themselves to fairly simple objects, with only one or two possible variables or states for each, usually denoted by some physical aspect of the equipment, board, or other interface elements. In a board game like chess, the variables for each piece are rank, color, and position, each of which the player can visibly track.

Digital games, on the other hand, can have objects, such as characters or fighting units that are made up of a fairly complex set of variables that define their overall state. Players might not be aware of this entire state because, unlike a board game, the program can track the variables behind the scenes. For example, here are the default variables underlying both knights and ogres in WarCraft II:

- Cost: 800 gold, 100 lumber
- Hit Points: 90
- Damage: 2–12
- Armor: 4
- Sight: 5
- Speed: 13
- Range: 1

While these variables are important to how the play proceeds, and they are in fact available to players via the interface, they are not something that players must directly manage and update. Even the most advanced player probably does not consistently calculate their strategy using these mathematical variables. Rather, they gain an intuitive knowledge of the knight's cost, strength, power, range, etc., versus the other units on the board through their play experience.

When defining your game objects and concepts, an essential thing to keep in mind is how players will learn the nature of these objects. If the objects are complex, will the players have to deal with that complexity directly? If the objects are simple, will players feel they are differentiated enough from each other to make an impact on the gameplay? Do the objects evolve? Are they only available under certain circumstances? How will players learn the nature of each object in the game? One interesting point to note is the way in which the laws of the physical world allow many nondigital games to compress a lot of complexity in their description of game objects. For example, the effect of gravity in Connect Four is used to create an implicit rule about how players can place pieces on the board.

Rules Restricting Actions

The next general rule concept we can see reflected in our list of sample rules is the idea of rules restricting actions. In chess, the rule that "a player cannot move

Unit Properties ☒

☑ <u>U</u>se Default Data

<u>O</u>K

<u>C</u>ancel

<u>D</u>efault

<u>H</u>elp

	Knight	Ogre	Elven Archer	Troll Axethrower	Mage
Visible Range:	4	4	5	5	9
Hit Points:	90	90	40	40	60
Magic Points:	0	0	0	0	1
Build Time:	90	90	70	70	120
Gold Cost:	800	800	500	500	1200
Lumber Cost:	100	100	50	50	0
Oil Cost:	0	0	0	0	0
Attack Range:	1	1	4	4	2
Armor:	4	4	0	0	0
Basic Damage:	8	8	3	3	0
Piercing Damage:	4	4	6	6	9

3.23 WarCraft II—Unit properties

their king into check" keeps players from losing the game by accident. The example from Go where "a player cannot make a move that recreates a previous state of the board" keeps the players from becoming locked in a never ending loop of play. Both of these address potential loopholes in the game systems.

Additionally, rules restricting actions can take the form of basic delimitations: "the play takes place on a field of 360 × 160 feet" (football) or "a team shall be composed of not more than 11 players, one of whom shall be the goalkeeper" (soccer). In both of these cases, we can see that the rules overlap with other formal aspects—namely the number of players and the boundaries of the game. This is actually true of all formal aspects, which will be represented in either the procedures or the rules in some way.

Another example of rules that restrict actions is in the type of rules that keep gameplay from becoming imbalanced in one or more players' favor. Think about the effects of the rule from WarCraft II where "in order

3.24 Dimensions of a football field

to create knight units, a player must have upgraded to a keep and built a stable." What this means is that one player cannot simply choose to use their resources early in the game to create knights, while other players are still creating lower-level fighting units. All players must progress along a fairly similar path of resource management to gain more powerful units.

Exercise 3.6: Rules Restricting Actions

There are many types of rules that restrict action. Here is a list of games: Twister, Pictionary, Scrabble, Operation, and Pong. What rules within these games restrict player actions?

Rules Determining Effects

Rules also can trigger effects based on certain circumstances. For example, "if" something happens, there is a rule that "xyz" results. In our list of sample rules, the condition from You Don't Know Jack falls into this type of rule: "If a player answers a question incorrectly, the other players get a chance to answer." Also, this rule from Jak and Daxter is of the same quality: "If a player runs out of green mana, they are 'knocked out' and return to the last checkpoint."

Rules that trigger effects are useful for a number of reasons. First, they create variation in gameplay. The circumstances that trigger them are not always

applicable, so it can create excitement and difference when they come into play. The example from You Don't Know Jack shows this quality. In this case, the second player gets a chance to answer the question, already having seen the results of the first player's guess. Because of this, they have an advantage, a higher percentage chance of answering correctly.

Additionally, this type of rule can be used to get the gameplay back on track. The rule from Jak and Daxter shows this. Because the game is not competitive in the sense that it is a single player adventure, there is no reason for the player to "die" when they lose all their mana. However, the designers want the player to be penalized in some way so that they will take care with their actions and try to keep from losing mana. Their solution is the previous rule: Players are penalized, but not badly, for losing all their mana. This gets the game back on track, incentivizing the players to work harder to keep their mana loss in check.

Defining Rules

As with procedures, the way in which you define your rules will be affected by your play environment. Rules need to be clear to players, or, in the case of digital games that adjudicate for players, they need to be intuitively grasped so that the game seems fair and responsive to given situations. In general, it is important to keep in mind that the more complex your rules are, the more demands you will place on the players to comprehend them. The less well that players understand your rules, whether rationally or intuitively, the less likely they will be able to make meaningful choices within the system and the less sense they will have of being in control of the gameplay.

Exercise 3.7: Rules for Blackjack

In the same way that you wrote down the procedures for blackjack in Exercise 3.5, now write down the rules. It is harder than you think. Did you remember all the rules? Try playing the game as you have written it. You might realize that you have forgotten something. What rules did you forget? How did those missing rules affect the play of the game?

3.25 Jak II—Almost out of mana

RESOURCES

What exactly is a resource? In the real world, resources are assets (i.e., natural resources, economic resources, human resources) that can be used to accomplish certain goals. In a game, resources play much the same role. Most games use some form of resources in their systems, such as chips in poker, properties in Monopoly, and gold in WarCraft. Managing resources and determining how and when to control player access to them is a key part of the game designer's job.

How does a designer decide what resources to offer to players? And how does a player control access to those resources to maintain challenge in the game? This is a hard question to answer in the abstract. It is easier if we take an example that you are probably familiar with.

Think of a role-playing game like Diablo II. What are some of the resources you might find in such a system: money, weapons, armor, potions, magic items? Why don't you find things like paper clips or pieces of sushi? While it might be fun to find such random items, the truth is, a piece of sushi won't help you to achieve the goals of the game. The very same items might actually have useful value in another game. For example, in Katamari Damacy, which was discussed in Chapter 1 on page 10, paper clips and sushi are just two of the quirky types of game resources you need to deal with. In this game, the main value of these resources lies in their size relative to your katamari, or "sticky ball." In each of these examples, the designers have carefully planned how you can find or earn the very resources that you need to accomplish the goals they have put before you. You might not find or earn as much money as you would like, but if you meet the challenges the game presents, you will gain resources that will allow you to move forward. If you did not gain these resources, the game system would be unbalanced.

By definition, resources must have both utility and scarcity in the game system. If they do not have utility, they are like our example of sushi in Diablo II: a funny and strange thing to find, but essentially useless. On the same note, if the resources are overly abundant, they will lose their value in the system.

Exercise 3.8: Utility and Scarcity

What are the resources in the games Scrabble and DOOM? How are they useful to players? How are they made scarce by the game system?

Many designers fall into the trap of copying existing games when it comes to resource management. One way to break your game away from the tried and true is to think about resources in a more abstract sense. Look at the basic functions of resource types and try to apply them in new and creative ways. To illustrate what we mean, let's review some example resource types that you should consider when designing your game.

Lives

The classic resource in action games are lives. Arcade games are built on the management of this primary resource. Examples of this are games like Space

3.26 Galaxian: Two lives left

Galaxian (©) 1979 Namco Ltd., All Rights Reserved. Courtesy of Namco Holding Corp.

Invaders or Super Mario Bros., where you have a certain number of lives to accomplish the goals of the game. Lose your lives, and you have to start over. Do well, and you earn more lives to work with. Lives as a resource type are usually implemented as part of a fairly simplistic pattern: More is always better, and there's no downside to earning lives.

Units

In games in which the player is represented in the game by more than one object at a time, they generally have unit resources to manage rather than lives. Units can be all of one kind, as in checkers, or a number of different types, as in chess. Units can keep the same values throughout the game, or they can upgrade or evolve, as in real time strategy games. Units can be finite (i.e., when they are lost, they are

lost for good), or they can be renewable, as in games that allow players to build new units over time. When units are renewable, they often have an associated cost per unit. Determining this cost per unit and how it balances with the rest of the resource structure can be tricky. Playtesting is the one good way to determine if your cost per unit is balanced.

Health

Health can be a separate resource type, or it can be an attribute of an individual life in a game. No matter how it is thought of, when health is used as a resource, it helps to dramatize the loss or near loss of lives and units. Using a resource like health usually means that there is some way to increase health, even as it is lost as part of gameplay.

How might players raise health levels in a game? Many action games place medical kits around their levels—picking one up raises a player's health. Some role-playing games force players to eat or rest to heal their characters. Each of these methods has its uses in a particular genre. The action game uses a method that is very fast, while being somewhat unrealistic. The role-playing example is more realistic within the story aspect of the game, but it is slow and potentially frustrating to players.

3.27 Checkers: Simple units

3.28 Diablo—Low health meter on lower left of screen

Currency

One of the most powerful resource types in any game is the use of currency to facilitate trade. As we'll see in Chapter 5 on page 122, currency is one of the key elements of an in-game economy. It is not the only way to create an economy—many games also use barter systems to accomplish the same goals. Currency in games plays the same role it does in real life: It greases the wheels of trade, making it easier for players to trade for what they need without having to barter using only the goods they have on hand. Currency need not be limited to a standard bank note system, however.

Actions

In some games, actions, such as moves or turns, can be considered resources. An example of this is the game of 20 Questions. Your questions have utility and scarcity in this system, and you have to ration them carefully to guess the answer within your limit. Another example is the phase structure of the turns in Magic: The Gathering. Each turn is made up of phases; some specific actions can be performed in each phase. Players must plan their turns carefully to not waste any potential actions.

Even real time games can restrict actions that are too powerful, and by doing so, these actions

3.29 Ultima Online—Player knapsack with sack of gold

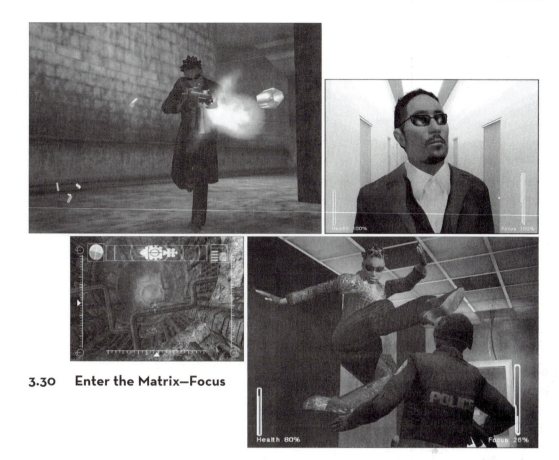

3.30 **Enter the Matrix—Focus**

become resources that need to be managed by the players. An example of this can be seen in Enter the Matrix, where the "focus" feature allows the player to enter "bullet time," a mode that slows down the action so the player's avatar can move more quickly relative to the opponent. You have only so much time to focus, however, before you return to normal time. Managing the use of your focus time is a key part of gameplay.

Power-ups

One classic type of resource is the power-up. Whether it is magic mushrooms in Super Mario Bros. or blue eco in Jak and Daxter, power-ups, as their name implies, are generally objects that give a boost of some sort to the player. This boost can increase

3.31 **Super Mario Bros.—Magic mushroom**

size, power, speed, wealth, or any number of game variables. Power-up objects are generally made scarce, so that finding them doesn't make the game too easy. Power-ups are also generally temporary, limited in number, available for only a short time, or useful only in certain game states.

Inventory

Some game systems allow players to collect and manage game objects that are not power-ups or units. As a generic term, we are calling these game objects "inventory" after the way in which they are usually managed. We've already mentioned the armor, weapons, and other objects found in role-playing games such as Diablo II. These objects help players to accomplish game objectives, and they are made scarce by their high price at purchase or by the opportunity cost of finding them in dungeons guarded by more and greater monsters. The concept of an inventory of game objects is not limited to role-playing games: trading card games like Magic: The Gathering ask players to manage their inventory of cards, limiting the number of cards they can have in their playing deck. Additionally, objects like ammunition or weapons can also be thought of as inventory. Like all of the other types of resources mentioned above, inventory objects must have utility and scarcity so that players are making meaningful choices when managing these objects.

Special Terrain

Special terrain is used as a resource in an important part of some game systems, especially those that are map-based systems, such as strategy games. In games like WarCraft III, the currency of the game (wood, gold) is extracted from special areas of the terrain, so these areas become important primary resources. Other types of games can also use terrain as a resource in ways you might not have thought of. The triple letter squares in Scrabble are important resources found on the terrain of the game board, as are the bases on the diamond of a baseball field.

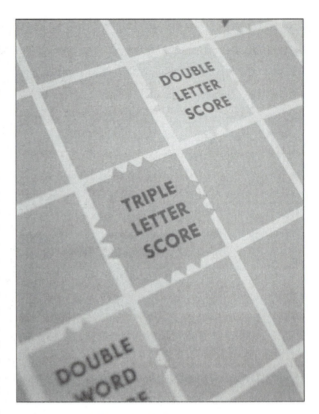

3.32 Scrabble—Triple letter score

Time

Some games use time as a resource—restricting player actions by time or phases of the game in periods of time. A good example of time used as a resource can be seen in speed chess, where players have a total amount of time (for example, 10 minutes) to use over the course of a game. Players alternate turns as normal, but a game clock keeps track of each player's total used time. Another example of time as a resource are the children's games hot potato and musical chairs. In each of these cases, players struggle not to be "it," whether that means holding the hot potato or being the only one without a chair, when the time is up. Time is an inherently dramatic force when used as a resource. We are all familiar with the tension of a countdown deadline or the anticipation caused by a ticking bomb in an action movie. When used as a resource that players must ration or work against, time can add an emotional aspect to a game design.

3.33 Chess clock

Exercise 3.9: Resource Types

For each of the resource types just described, create a list of your favorite games that use resources of that type. If you can't think of any games that use a particular type of resource, research games that do and play several of them.

These are just some of the resource types that you should think about using when designing your own games. We challenge you to both create your own original types of resources and take resource models from one genre and adapt them to games where they're seldom, if ever, used. You might be surprised with the results.

CONFLICT

Conflict emerges from the players trying to accomplish the goals of the game within its rules and boundaries. As we have already mentioned, conflict is designed into the game by creating rules, procedures, and situations (such as multiplayer competition) that do not allow players to accomplish their goals directly. Instead, the procedures offer fairly inefficient means toward accomplishing the game objective. While inefficient, these means challenge the players by forcing them to employ a particular skill or range of skills. The procedures also create a sense of competition or play, which is enjoyable in some way, so that players will submit themselves to this inefficient system to gain the ultimate sense of achievement that comes from participating.

Here are some examples of things that cause game conflicts to emerge:

- *Pinball:* Keep the ball from escaping the field of play using only the flippers or other devices provided.
- *Golf:* Get the ball from the tee to the hole, past any obstacles on the course, in as few strokes as possible.
- *Monopoly:* Manage your money and your properties to become the richest player in the game.
- *Quake:* Stay alive while player or nonplayer opponents try to kill you.

- *WarCraft III:* Maintain your forces and resources while using them to command and control the map objectives.
- *Poker:* Outbid opponents based on your hand or your ability to bluff.

These examples point to three classic sources of conflict in games: obstacles, opponents, and dilemmas. Let's look at each of these more closely to see what they offer in terms of various types of gameplay.

Obstacles

Obstacles are a common source of conflict in both single and multiplayer games, though they play a more important role in single player games. Obstacles can take a physical form, such as the sack in a sack race, the water on a golf course, or the bumpers on a pinball table. Obstacles can also involve mental skills, such as the puzzles in an adventure game.

Opponents

In multiplayer games, other players are typically the primary source of conflict. In the previous examples, Quake uses other players in addition to nonplayer opponents and physical obstacles to create conflict

3.34 Pong and Quake III opponents

in the game. Also, Monopoly's conflict comes from interactions with other players.

Dilemmas

As opposed to physical or mental obstacles and conflict from direct competition with other players, another type of game conflict can come from dilemma-based choices that players have to make. An example of a dilemma in Monopoly is the choice of whether to spend money to buy a property or use that money to upgrade a property that is already owned. Another dilemma would be whether to stay in or fold in poker. In both cases, players have to make choices that have good or bad potential consequences. A dilemma can be a powerful source of conflict in both single and multiplayer games.

Exercise 3.10: Conflict

Explain how conflict is created in the following games: Tetris, Frogger, Bomberman, Minesweeper, and solitaire. Does the conflict in these games come from obstacles, opponents, dilemmas, or a combination of these?

BOUNDARIES

Boundaries are what separate the game from everything that is not the game. As discussed on page 32, the act of agreeing to play, to accept the rules of the game, to enter what Huizinga calls the "magic circle," is a critical part of feeling safe that the game is temporary, that it will end, or that you can leave or quit if you don't want to play anymore. As a designer, you must define the boundaries of the game and how players will enter and exit the magic circle. These boundaries can be physical—like the edges of an arena, playing field, or game board—or they can be conceptual, such as a social agreement to play. For example, ten people can be physically sitting in a room where Truth or Dare is being played, but two of them might not have agreed to play and are therefore outside the boundaries of the system.

Why are boundaries an important aspect of game design to consider? Think about what might happen if there were no boundaries in a familiar game system. Imagine a game like football. What if you tried to play football (either in a physical setting or on a computer) without boundaries? Players could run anywhere they wanted to; they could run as far as they could physically get without being tackled by

the other team or blocked by random objects like buildings or cars. What does this do to the strategy of football? What about the abilities necessary for play? Apply this line of thinking to other games you know. Can you see how they would be intrinsically different if their boundaries were not closed? What if you could add real money to the bank in Monopoly? Or if you could add cards to the deck in poker? What if the edges of a chess board were infinitely expanding? It is clear without even playing these games that without their boundaries they would become totally

3.35 Boundaries of a tennis court

different games. This is not necessarily a bad thing—an interesting design exercise would be to take a familiar game and change its boundaries to see how it affects the play experience.

In addition to the purely formal aspect for game boundaries, however, there's also an emotional one. The boundaries of the game serve as a way to separate everything that goes on in the game from daily life. So while you might act the part of a cutthroat opponent facing off against your friends within the boundaries of a game (taking over their civilizations or destroying their forces), you can shake hands at the end of the game and walk away without any real damage to your relationships. In fact, you might feel closer to them, having met in this game-world competition.

As a designer, boundaries are another tool we have in crafting the player experience. Some games are very free form and do not require strictly defined boundaries to work. For example, tag is usually played with loosely defined boundaries, but with no detriment to the overall experience. Some modern game designers have begun playing with the idea that interaction with outside elements is an interesting design choice for their systems. An emerging genre of games called alternate reality games (ARGs) use a combination of real-world and online interaction to create their game play.

3.36 Big Urban Game and PacManhattan— Turning cities into game boards

A good example of this was I Love Bees, an ARG created to promote the release of Halo 2. The game, which was accessed at the Web site www.ilovebees.com, sent players to real world locations to find ringing pay phones where they would receive further information and instructions. Other games that break physical and conceptual boundaries are sometimes called "big games," which are large-scale games that take over public spaces for playful interactions. Games like the Big Urban Game by Frank Lantz, Katie Salen, and Nick Fortugno, or Cruel 2 B Kind by Ian Bogost and Jane McGonigal (see Ian Bogost's sidebar on page 57), are examples of this type of boundary-breaking play.

The ways that these experimental games treat the boundaries of their systems are something of an exception. Most games are typically closed systems. Typically, games clearly define that which is within the game versus that which is outside the game, and they purposefully keep the in-game elements from interacting with outside forces. But it is up to you as the game designer to determine just where and how these boundaries are defined and when, or if, to ever breach them.

Exercise 3.11: Boundaries

What are the boundaries in the tabletop role-playing game Dungeons & Dragons? Can you think of physical and conceptual boundaries?

OUTCOME

As described previously, the outcome of a game must be uncertain to hold the attention of the players. That uncertainty is generally resolved in a measurable and unequal outcome, though this is not always necessary: Many massively multiplayer online worlds do not have the concept of a winner or even an end state. Also, simulation games might not have a predetermined win condition. These games are built to go on indefinitely and reward players in other fashions than by winning or finishing the game. Though some people might not call these games because they differ from the basic definition, we don't find it useful to remove these powerful experiences from our consideration of games. Rather, we believe that expanding our definition or exploring the border cases makes for a more interesting and useful stance.

For most game systems, however, producing a winner or winners is the end state of a game. At defined intervals either the players (in the case of a nondigital game) or the system check to see if a winning state has been achieved. If it has, the system resolves and the game is over.

There are a number of ways to determine outcome, but the structure of the final outcome will always be related to both the player interaction patterns discussed earlier and the objective. For example, in pattern one, single player versus game, the player might either win or lose, or the player might score a certain amount of points before ultimately losing. Examples of this outcome structure are solitaire, pinball machines, or a number of different arcade games.

In addition to the player interaction patterns described on page 50, the outcome is determined by the nature of the game objective. A game that defines its objective based on points will most certainly use those points in the measure of the outcome. A game that defines its objective as capture, like chess, might not have a scoring system—rather, chess games are won or lost based solely on meeting the primary objective, checkmating the king.

Chess is what we call a "zero-sum" game. By this we mean that if we count a win as +1 and a loss as a −1, then the sum for any outcome is zero. In chess one player wins (+1) and one player loses (−1). No matter which player wins, the sum is always zero.

But many games are not zero-sum games; a non-zero-sum game is one in which the overall gains and losses for the players can be more than or less than zero. Games such as World of Warcraft are not zero-sum because the overall outcome of this complex, ongoing game world is never equal to zero. Cooperative games, such as the Lord of the Rings board game by Reiner Knizia, are also non-zero-sum because a gain by one player does not mean a loss

by the others. Non-zero-sum games often have more subtle gradations of reward and loss than zero-sum games; for example, ranking systems, player statistics, or multiple objectives, all of which can create measurable outcomes without the finite judgment of a zero-sum game.

On page 322 we discuss the way in which non-zero-sum games can create interesting player dilemmas and complex, interdependent risk/reward scenarios that can make for interesting gameplay. Look at the games you play: What types of outcomes are most satisfying? Does that answer change in different situations; for example, social games versus sporting events? When you determine the outcome for a game that you are designing, be sure to keep these types of considerations in mind.

Exercise 3.12: Outcome

Name two zero-sum games and two non-zero-sum games. What is the main difference in the outcomes of these games? How does this affect gameplay?

CONCLUSION

These formal elements, when set in motion, create what we recognize as a game. As we have seen throughout this chapter, there are many possible combinations of these elements that work to create a wide variety of experiences. By understanding how these elements work together and thinking about new ways of combining these elements, you can invent new types of gameplay for your games. A good practice for a beginning game designer is to use these formal elements to analyze games that you play. Use the game journal you began in Chapter 1 to start a record of your analysis of the games you play. This will increase both your understanding of gameplay and your ability to articulate complex game concepts.

Exercise 3.13: Revise Rules and Procedures

The rules and procedures of backgammon are fairly simple. Change them so that they are not dependent on chance. How does this affect the gameplay?

Designer Perspective: Lorne Lanning

President, Creative Director, and Cofounder, Oddworld Inhabitants

Lorne Lanning is a game designer, writer, and animated film director whose game credits include Oddworld: Abe's Oddysee (1997), Oddworld: Abe's Exoddus (1998), Oddworld: Munch's Oddysee (2001), and Oddworld: Stranger's Wrath (2005). Current projects include Citizen Siege: The Animated Motion Picture and Citizen Siege: Wage Wars, an online game.

On the design process:

It's a very abstract process for me that stems from those issues in life that I care passionately about. I also do a lot of research on unrelated topics. Usually the best ideas come from way out of left field, so I spend a lot of time in left field in ways that others might consider off target, but the creative process is one where we marry ideas that didn't previously go together . . . so as a designer I believe it's critical to research beyond the field of your medium. Those that don't and only inherit ideas from their medium tend to have a harder time coming up with something unique and fresh.

On prototypes:

Prototypes are critical. Focus on the most critical components that are going test your project's feasibility and fun factor by investing in prototypes up front. The last thing you want is a team working on something that they don't believe can be done, so this prototype stage not only benefits the learning curve, but also a team's morale.

On game influences:

- *Flashback/Out of This World/Prince of Persia:* I felt that all of these platform games brought a new degree of drama and life to game design. Realistic animations combined with an interesting story, continued cut scenes, and story-oriented puzzle mechanics inspired the first Oddworld games on the PlayStation. These games were gleaming light posts, indicating that one day films and games would have more in common than previously imagined.

- *Terminator 2 (arcade):* I saw this arcade game at a theme park convention before it was released to the public (it was also before I was in the game design business). When I saw this game, it became quite evident how the future of content would be in amortized digital databases across various delivery mediums. This was the first game that successfully used actual film production assets in the game. It was a signpost for me that read, "This way lies the future of universe oriented digital multimedia properties."

- *WarCraft II*: This game really brought home the joy that could be experienced when managing a large group of agents that you have birthed and nurtured over time. This also revealed a huge psychological component to me that emerged via absolute control over their fate. Certainly, other games had touched upon this, but WarCraft II enabled a smooth, simple control/management interface that allowed the positive emotional reaction to the experience to unfold without frustrating tedium. It also installed a sweet, simple blend of sim and strategy that was previously lacking in real time war games.

- *Super Mario 64*: Though it is very challenging to stay interested in the content (admittedly, it is for kids), the analog controls mixed with analog animations brought the interactive 3D character to new levels of life and fluidity. It always amazes me how people will tolerate stiff and digital controls, sometimes even preferring them. For me, I can't play games that suggest they are dealing with living life forms yet have stiff or digital feeling controls that result in robotic looking/feeling characters. It's always a huge turnoff that keeps me from enjoying what might be a good game. On this front, Mario set the stage for what constitutes great 3D analog character controls.

- *The Sims*: This game is a record holder when it comes to innovation as well as an amazing example of a developer's ability to nurture and support a mod community that will, in return, nurture and support the shelf life of a product. This is a product that is beyond the norm of traditional genres. This is a game that, if focus tested with the usual suspects in the community, could likely have faced being cut while still in development. However, this series stands tall when it comes to proving that games are not always what we (in the biz) think they should be, while also proving that there is a tremendous market of potential players that are just plain uninterested in what the rest of the industry has to offer them. In many ways, this series is a great white hope for the future of innovation in game design, not necessarily in terms of the game design structure and chemistry, but more importantly in how different this game is from the rest of the herd.

- *Tamagotchi*: Much like The Sims, I know there is an entire breed of games that have yet to be created that will take the concept of nurturing virtual life forms to entirely new levels. When games' sociological effects can force a major corporation, like Japan Airlines, to change a policy in response to screaming children that are delaying takeoff (because they were told they needed to turn off all their electrical devices), then you're witnessing something much deeper than people just being addicted to challenging games. We're now watching humans experience new levels of emotional attachment and codependency on virtual life forms.

Advice to designers:

Beyond having an extremely strong work ethic, beyond looking at and studying all the games that you can learn from, beyond being educated and brilliant in programming, design, computer animation, writing, whichever is your skill set, you need to look at and study the life outside of games that is all around you. The best ideas will not come from other games. The best ideas will come from areas that have nothing to do with games. They will come from other areas, art forms and sciences like sociology, agriculture, philosophy, zoology, or psychology. The more you find inspirational sources that come from areas beyond the spectrum of your intended medium, the more unique your creations will feel to others.

DESIGNER PERSPECTIVE: MARC LEBLANC

Technical Director, Senior Designer, Mind Control Software

Marc LeBlanc is a game designer, programmer, and project leader with 14 years of experience in the game industry. His game credits include Ultima Underword II (1993), System Shock (1994), Thief: The Dark Project (1998), System Shock 2 (1999), Thief 2: The Metal Age (2000), Oasis (2004), and Arrrrr! (2007).

On getting into the game industry:

When I went to school at MIT, I lived on 41st West, a dormitory hall that was home to a number of quirky individuals. Around 1990, several of my 41st West friends (including Dan Schmidt, Jon Maiara, James Fleming, Tim Stellmach, and the ubiquitous Doug Church) joined with Paul Neurath to form Blue Sky Productions. They were working on a game called Underworld. The game later became Ultima Underworld, and the company later became Looking Glass Studios. I joined in 1992, and the rest is history.

On favorite games:

- *X-Com: UFO Defense*: Now a classic, this game took two smaller games—strategic resource management and tactical combat—and married them perfectly. X-Com is a textbook example of emergent narrative. Through the simplest tricks, it gets the player's imagination to connect the narrative dots between the characters and events of the game. Suit up, son! You're going to Mars!
- *Pikmin*: Real time strategy games have always had the wrong user interface for the job. Skilled players have to master complicated finger acrobatics until they become keyboard virtuosos. Pikmin does away with all that, creating the first real time strategy game to truly embrace its "twitchiness." Brilliant!
- *Star Control II*: This game had mixed authored storylines with some simple real time tricks to create a narrative that was both well written and compellingly organic in a way that has yet to be duplicated. Combine that with twitchy combat that is the worthy heir to Space War, and you have a classic.

On game influences:

- *Sid Meier's SimGolf*: This game should be mandatory for all game designers. Don't be fooled by the golf theme; this game is a tutorial in level design.
- The board games of Reiner Knizia, particularly Modern Art and Tigris & Euphrates. If you ever find yourself wishing you had faster hardware or more RAM, remember what this guy can do with ten pages of rules and a few slabs of cardboard.
- *Grand Theft Auto III*: While I'm not necessarily a fan of the subject matter, it was heartening to see this kind of open-ended gameplay capture the mainstream console audience.

Advice to designers:

- Have a critical eye for games. If you can't say one critical thing about any game, even your *favorite* game, then you're an amateur.
- Learn to program. Designing a game without know how to program is like painting without a brush.
- *Play lots of games. Play games in every medium:* PC, console, board games, party games, and sports. Play the classics. Play Go.
- Remember that if you're lucky, your game will get played by millions of people. Design the game for them, not for you.

FURTHER READING

Callois, Roger. *Man, Play and Games.* Urbana, IL: University of Chicago Press, 2001.

Church, Doug. "Formal Abstract Design Tools." *Game Developer.* August, 1999.

Hunicke, Robin, LeBlanc, Marc, and Zubek, Robert. "MDA: A Formal Approach to Game Design and Game Research." AAAI Game AI Workshop Proceedings. July 25–26, 2004. Available online at http://www.cs.northwestern.edu/~hunicke/pubs/MDA.pdf.

Salen, Katie, and Zimmerman, Eric. *The Game Design Reader: A Rules of Play Anthology.* Cambridge, MA: The MIT Press, 2006.

END NOTES

1. Bartle, Richard. "Hearts, Clubs, Diamonds, Spades: Players who Suit MUDS." April 1996. http://www.mud.co.uk/richard/hcds.htm.

2. Avedon, E. M. "The Structural Elements of Games," *The Study of Games.* New York: Robert E. Krieger Publishing, Inc. 1979. pp. 424–425.

3. Adapted from the work of Fritz Redl, Paul Gump, and Brian Sutton-Smith. "The Dimensions of Games," *The Study of Games.* New York: Robert E. Krieger Publishing, Inc. 1979. pp. 417–418; David Parlett, *The Oxford History of Boardgames.* New York: Oxford University Press, 1999.

4. Nintendo, *Super Mario Bros.* Manual, 1986.

Chapter 4
Working with Dramatic Elements

Exercise 4.1: Making Checkers Dramatic

The game of checkers is very abstract: There is no story, no characters, and no compelling reason why you would want to capture all of your opponent's pieces, except for the fact that it's the objective of the game. For this exercise, devise a set of dramatic elements for checkers that make the game more emotionally engaging. For example, you might create a backstory, give each piece its own name and distinctive look, define special areas on the board, or whatever creative ideas you can think of to connect the players to this simple, abstract system. Now play your new game with friends or family and note their reactions. How do the dramatic elements improve or detract from the experience?

We have seen how formal elements work together to create the experience we recognize as a game, but now let's turn to those elements that engage the players emotionally with the game experience and invest them in its outcome—the dramatic elements of games. Dramatic elements give context to gameplay, overlaying and integrating the formal elements of the system into a meaningful experience. Basic dramatic elements, like challenge and play, are found in all games. More complicated dramatic techniques, like premise, character, and story, are used in many games to explain and enhance the more abstract elements of the formal system, creating a deeper sense of connection for the players and enriching their overall experiences.

One way to create more engaging games is to study how these elements work to create engagement and how they've been used in other games—as well as other media. Your exploration of these dramatic elements and traditional tools can help you think of new ideas and new situations for your own designs.

Exercise 4.2: Dramatic Games

Name five games that you find dramatically interesting. What is it about those games that you find compelling?

CHALLENGE

Most people would agree that one thing that engages them in a game is challenge. What do they really mean by challenge, though? They don't simply mean that they want to be faced with a task that is hard to accomplish. If that were true, the challenge of games would hold little difference from the challenges of everyday life. When players talk of challenge in games, they're speaking of tasks that are satisfying to complete, that require just the right amount of work to create a sense of accomplishment and enjoyment.

Because of this, challenge is very individualized and is determined by the abilities of the specific player in relationship to the game. A young player

who is just learning to count might find a game of Chutes and Ladders particularly challenging, while an adult who mastered that skill long ago would probably find it boring.

In addition to being individualized, challenge is also dynamic. A player might find one task challenging at the beginning of a game, but after becoming accomplished in the task, they'll no longer find it challenging. So the game must adapt to remain challenging and hold the interest of the more accomplished player.

Is there a way to look at challenge that is not defined by individual experience? One that can give us some general ideas to keep in mind when designing a game? When you set out to create the basic challenge in your game, you might start by thinking how people really enjoy themselves and which types of activities make them happy. As it turns out, the answer to this question is directly related to the concept of challenge and the level of challenge presented by an experience.

The psychologist Mihaly Csikszentmihalyi set out to identify the elements of enjoyment by studying similarities of experience across many different tasks and types of people. What he found was surprising: Regardless of age, social class, or gender, the people he talked to described enjoyable activities in much the same way. The activities themselves spanned many different disciplines, including performing music, climbing rocks, painting, and playing games, but the words and concepts people used to describe their enjoyment of them were similar. In all these tasks, people mentioned certain conditions that made the activities pleasurable for them:

First, the experience (of enjoyment) usually occurs when we confront tasks we have a chance of completing. Second, we must be able to concentrate on what we are doing. Third and fourth, the concentration is usually possible because the task undertaken has clear goals and provides immediate feedback. Fifth, one acts with a deep but effortless involvement that removes from awareness the worries and frustrations of everyday life. Sixth, enjoyable

experiences allow people to exercise a sense of control over their actions. Seventh, concern for the self disappears, yet paradoxically the sense of self emerges stronger after the flow experience is over. Finally, the sense of the duration of time is altered; hours pass by in minutes, and minutes can stretch out to seem like hours. The combination of all these elements causes a sense of deep enjoyment that is so rewarding people feel like expending a great deal of energy is worthwhile simply to be able to feel it.[1]

Based on his findings, Csikszentmihalyi created a theory called "flow" that is illustrated in Figure 4.1. When a person begins performing an activity, they usually have a low level of ability. If the challenge of the activity is too high, they will become frustrated. As they continue on, their ability rises, however, and if the challenge level stays the same, they will become bored. Figure 4.1 shows a path of rising challenge and ability balanced carefully between frustration and boredom, which would result in an optimal experience for a user.

If the level of challenge remains appropriate to the level of ability, and if this challenge rises as the ability level rises, the person will stay in the center region and experience a state that Csikszentmihalyi calls "flow." In flow, an activity balances a person

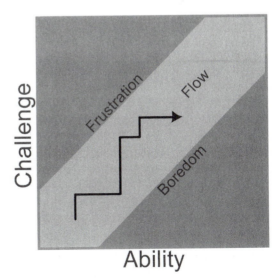

4.1 Flow diagram

between challenge and ability, frustration and boredom, to produce an experience of achievement and happiness. This concept is very interesting for game designers because this balance between challenge and ability is exactly what we are trying to achieve with gameplay. Let's look more closely at the elements that help to achieve flow.

A Challenging Activity That Requires Skill

According to Csikszentmihalyi, flow occurs most often within activities that are "goal-directed and bounded by rules . . . that could not be done without the proper skills."[2] Skills might be physical, mental, social, etc. For a person who does not have any of the skills a task requires, it is frustrating and meaningless. For a person who has the skills but is not completely assured of the outcome, a task is challenging. This is particularly important to game design.

Exercise 4.3: Skills

List the types of skills required by the games you enjoy. What other types of skills do people enjoy that you could incorporate into the games you design?

The Merging of Action and Awareness

"When all of a person's relevant skills are needed to cope with the challenges of a situation, that person's attention is completely absorbed by the activity," Csikszentmihalyi goes on to say. "People become so involved in what they're doing that the activity becomes spontaneous, almost automatic; they stop being aware of themselves as separate from the actions they are performing."[3]

Clear Goals and Feedback

In everyday life, there are often contradictory demands on us; our goals are not always clearly defined. But in flow experiences, we know what needs to be done, and we get immediate feedback on how well we're achieving our goals. For example, musicians know what notes to play next and can hear when they make mistakes; the same is true whether it's playing tennis or rock climbing. When a game has clearly defined goals, the players know what needs to be done to win, to move to the next level, to achieve the next step in their strategy, etc., and they receive direct feedback for their actions toward those goals.

4.2 **An activity that requires skill: Tony Hawk's Pro Skater**

4.3 **Merging action and awareness: Metal Gear Solid 3**

4.4 Clear goals and feedback: Incredible Machine: Even More Contraptions

Exercise 4.4: Goals and Feedback

Pick three games and list the types of feedback generated in each. Then describe how the feedback relates to the ultimate goal of each game.

Concentration on the Task at Hand

Another typical element of flow is that we are aware only of what's relevant here and now. If a musician thinks of his health or tax problems when playing, he is likely to hit a wrong note. If a surgeon's mind wanders during an operation, the patient's life is in danger. In game flow, the players are not thinking of what is on television or how much laundry they have to do; they are focused entirely on the challenges presented in the game. Many game interfaces take over the entire screen of the PC or build impressive audiovisual worlds to focus our attention. Here is a quote from a mountaineer describing a flow experience (but these might as well be the words of an EverQuest player): "You're not aware of other problematic life situations. It becomes a world unto its own, significant only to itself. It's a concentration thing. Once you're in the situation, it's incredibly real, and you're very much in charge of it. It becomes your total world."[4]

4.5 Concentration on the task: Asteroids

4.6 Paradox of control: Civilization III

The Paradox of Control

People enjoy the sense of exercising control in difficult situations; however, it is not possible to experience a feeling of control unless the outcome is unsure, meaning that the person is not actually in complete control. As Csikszentmihalyi says, "Only when a doubtful outcome is at stake, and one is able to influence that outcome, can a person really know she is in control."[5] This "paradox of control" is a key element of the enjoyment of game systems. How to offer meaningful choices to players, without offering complete control or an assured outcome, is a subject we will return to many times throughout this book.

The Loss of Self-Consciousness

In everyday life, we are always monitoring how we appear to other people and protecting our self-esteem. In flow we are too involved in what we're doing to care about protecting the ego. "There is no room for self-scrutiny. Because enjoyable activities have clear goals, stable rules, and challenges well matched to skills, there is little opportunity for the self to be threatened."[6] Although the flow experience is so engrossing that we forget our self-consciousness while we are engaged in it, after a flow activity is over, we generally emerge with a stronger self-concept. We know that we have succeeded in meeting a difficult challenge. So, for example, the musician feels at one with the harmony of the cosmos; the athlete moves at one with the team; the game player feels empowered by the efficacy of her strategies. Paradoxically, the self expands through acts of self-forgetfulness.

4.7 Loss of self-consciousness: Dance Dance Revolution

The Transformation of Time

"One of the most common descriptions of optimal experience is that time no longer seems to pass the way it ordinarily does," says Csikszentmihalyi. "Often hours seem to pass by in minutes; in general, most people report that time seems to pass much faster. But occasionally the reverse occurs: Ballet dancers describe how a difficult turn that takes less than a second in real time stretches out for what seems like minutes."[7] Digital games are notorious for sucking players in for hours on end because they involve players in flow experiences that distort the passage of time.

Experience Becomes an End in Itself

When most of these conditions are present, we begin to enjoy whatever it is that produces such an experience, and the activity becomes autotelic, which is Greek for something that is an end in itself. Most things in life are exotelic. We do them not because we enjoy them but to achieve some goal. Some activities such as art, music, sports, and games are usually autotelic: There is no reason for doing them except to enjoy the experience they provide.

These elements of enjoyment are not a step-by-step guide to creating enjoyable, challenging game experiences; you need to work out for yourself what these ideas mean in the context of your own games. But the focus that Csikszentmihalyi places on goal-oriented, rule-driven activities with clear focus and feedback are clues that might point you in a beneficial direction.

Think about questions like these as you design your game:

- What skills does your target audience have? What skill level are they at? Within that knowledge, how can you best balance your game for your players' abilities?

- How can you give your players clear, focused goals, meaningful choices, and discernible feedback?

- How can you merge what a player is doing physically with what they need to be thinking about in the game?

- How can you eliminate distractions and fear of failure; that is, how can you create a safe

**4.8 Transformation of time: Dark Age
of Camelot**

environment where players lose their sense of
self-consciousness and focus only on the tasks at
hand?

- How can you make the game activity enjoyable as
an end in itself?

Answering these questions is a good first step
toward creating an environment where challenge
becomes a central attraction rather than a feature
that is too off-putting, or too simplistic, to engage
players' emotions.

PLAY

The potential for play is another key dramatic ele-
ment that engages players emotionally in games. As
discussed in Chapter 2, play can be thought of as
freedom of movement within a more rigid structure.
In the case of games, the constraints of the rules and
procedures are the rigid structure, and the play within
that structure is the freedom of players to act within
those rules—the opportunity for emergent experi-
ence and personal expression.

The Nature of Play

The Promise of Play, a documentary film investigating
the subject, queried a number of people about the
nature of play. Here are some of their responses: "Play
is boisterous." "It's non-directed." "It's spontaneous."
"It's not scripted." "Play is loud." "Not work." "It's
physical." "It's fun." "An emotional state when you're

having a good time." "Play actually is meaningless
behavior. You do it for its intrinsic value to you, but
play can have utility. That is, you end up developing
skills, and those skills can then be used in other are-
nas." "I think play is one of the ways that we get a feel
for the shape of the world." "Play is the central item
in children's lives. It's like work is to grown-ups. They
play to learn." "Play is child's work. It's all that young
children do to learn about the world that they're in."[8]

It's clear from these responses that play has many
faces: It helps us learn skills and acquire knowledge,
it lets us socialize, it assists us in problem solving, it
allows us to relax, and it makes us see things differently.
Play is not too serious; it induces laughter and fun, which
is good for our health. On the other hand, play can be
somewhat serious: Play as a process of experimenta-
tion—pushing boundaries and trying new things—is an
area of common ground for artists and scientists, as

	Free-form play (paida)	Rule-based play (ludus)
Competitive play (agôn)	Unregulated athletics (foot racing, wrestling)	Boxing, billiards, fencing, checkers, football, chess
Chance-based play (alea)	Counting-out rhymes	Betting, roulette, lotteries
Make-believe play (mimicry)	Children's initiations, masks, disguises	Theater, spectacles in general
Vertigo play (ilinx)	Children "whirling," horseback riding, waltzing	Skiing, mountain climbing, tightrope walking

4.9 **Examples taken from *Man, Play and Games* (diagram based on Rules of Play by Salen and Zimmerman)**

well as children. In fact it is one of the few areas where children are seen as experts with something to teach adults. Play is recognized as a way of achieving innovation and creativity because it helps us see things differently or achieve unexpected results. The one thing that stands out from these meditations on play is that play is not any one thing but rather a type of approach to an activity. A playful approach can be applied to even the most serious or difficult subjects because playfulness is a state of mind rather than an action.

Play theorist Brian Sutton-Smith, in his book *The Ambiguity of Play*, describes a number of activities that could be considered play, including: mind play like daydreaming; solitary play such as collection or handicrafts; social play such as joking around or dancing; performance play such as playing music or acting; contest play such as board games or video games; and risky play such as hang gliding or extreme sports.[9] Playful activities such as these were categorized by sociologist Roger Callois in his 1958 book *Man, Play and Games* into four fundamental types of play:

- Competitive play, or *agôn*
- Chance-based play, or *alea*
- Make-believe play, or *mimicry*
- Vertigo play, or *ilinx*

Callois modifies these categories further with the concepts of *ludus*, or rule-based play, and *paida*, or free-form, improvisational play. Figure 4.9 shows examples of types of play within each of these categories. What is interesting for game designers about this classification system is that it allows us to talk specifically about some of the key pleasures of the types of play associated with different types of game systems. For example, strategy games like chess or Warcraft III

are clearly competitive, rule-based play, while role-playing games involve both mimicry and competition in a rule-based environment. Examining the pleasures of each of these types of play can help you determine player experience goals for your game system.

Types of Players

After categorizing play itself, we can also identify the various types of players, each of whom comes to a game with different needs and agendas. Similar to the basic player types described by Richard Bartle in Chapter 3 on page 51, these categories address the pleasures of play from the point of view of the player.[10]

- *The Competitor:* Plays to best other players, regardless of the game
- *The Explorer:* Curious about the world, loves to go adventuring; seeks outside boundaries—physical or mental
- *The Collector:* Acquires items, trophies, or knowledge; likes to create sets, organize history, etc.
- *The Achiever:* Plays for varying levels of achievement; ladders and levels incentivize the achiever
- *The Joker:* Doesn't take the game seriously—plays for the fun of playing; there's a potential for jokers to annoy serious players, but on the other hand, jokers can make the game more social than competitive
- *The Artist:* Driven by creativity, creation, design
- *The Director:* Loves to be in charge, direct the play
- *The Storyteller:* Loves to create or live in worlds of fantasy and imagination
- *The Performer:* Loves to put on a show for others
- *The Craftsman:* Wants to build, craft, engineer, or puzzle things out

This list is not exhaustive, and not all of these types of players have been equally addressed by today's digital games, meaning that they offer an interesting area of study for the game designer looking for new areas of play with which to emotionally engage players.

Exercise 4.5: Player Types

For each player type described above, list a game you know that appeals to that variety of player. What type of player do you tend to be?

Levels of Engagement

In addition to thinking about categories of play and types of players, the level of engagement can also vary; not all players need to participate at the same level to find the same enjoyment. For example, spectators might find watching sports, games, or other events more satisfying than playing them. We don't tend to think of designing games for spectators, but the truth is, many people enjoy games in this way. How many times have you sat and watched a friend make their way through the level of a console game, waiting for your turn at the controls? Is there a way as a designer to take this spectator mode into account when designing the play?

Participant play is, of course, the most common way to think about play. As opposed to spectator play, where risk is minimal, participant play is active and involved. It is also the most directly rewarding for all the reasons we've already talked about. Sometimes participants experience transformational play: This is a deep level of play that actually shapes and alters the

4.10 Peacemaker

player's life. Children experience this level when they learn life lessons through play; in fact, it is one of the reasons they engage in play naturally.

Some games in the emerging genre of serious games attempt to access this level of transformational play as a key goal of their player experience. For example, the game Peacemaker, in which players take on the role of a leader trying to bring peace to the Middle East, is an example of a game that attempts to educate players through direct experience with the intricate problems involved in that real-world situation.

It is an interesting area to think about if games are to advance as an art form. Certainly other forms of art inspire transformation and deep learning through their experience. Perhaps finding ways to create this level of play can raise the bar for games as an art form as well.

PREMISE

In addition to challenge and play, games also use several traditional elements of drama to create player engagement with their formal systems. One of the most basic is the concept of premise, which establishes the action of the game within a setting or metaphor. Without a dramatic premise, many games would be too abstract for players to become emotionally invested in their outcome.

Imagine playing a game in which you are a set of data. Your objective is to change your data to increase its values. To do this, you engage other sets of data according to complex interaction algorithms. If your data wins the analysis, you win. This all sounds pretty intangible and rather boring, but it is a description of how a typical combat system might work from a formal perspective. To connect players to the game

emotionally, the game designer creates a dramatic premise for the interaction that overlays the formal system. In the previous example, let's imagine you play a dwarf named Gregor rather than a set of data. You engage an evil wizard, rather than an opposing set of data, and you attack him with your broadsword, rather than initiating that complex interaction algorithm. Suddenly, the interaction between these two sets of data takes on a dramatic context over and above its formal aspects.

In traditional drama, premise is established in the exposition of a story. Exposition sets up the time and place, characters and relationships, the prevailing status quo, etc. Other important elements of story that can be addressed in the exposition are the problem, which is the event that upsets the status quo and creates the conflict; and the point of attack, which is the point at which the problem is introduced and the plot begins. While there is not a direct one-to-one relationship, these last two elements of exposition are mirrored in our definition of formal game elements by the concepts of objective and starting action discussed in the previous chapter.

To better understand premise, let's look at some examples from well-known stories from films and books rather than games:

In *Star Wars: Episode IV*, the story is set in a far away galaxy. The protagonist, Luke Skywalker, is a young man who wants to get away from his uncle's remote farm and join the interstellar rebellion, but responsibility and loyalty hold him back. The story begins when his uncle buys two droids carrying secret information that is critical to the rebellion.

In *The Fellowship of the Ring*, the story is set in Middle-earth, a fantasy world of strange races and characters. The protagonist, Frodo Baggins, is a young hobbit who is happy right where he is—at home. The story begins when Frodo inherits a ring from his uncle, which turns out to be a powerful artifact, the existence of which threatens the safety of all of Middle-earth.

In *Die Hard*, the story is set in a modern office tower in downtown Los Angeles. The protagonist, John McClane, is an off-duty New York City police officer who is in the building trying to make amends with his estranged wife. The story begins when the building is taken over by terrorists and McClane's wife is taken hostage.

These are each examples of how premise is defined in traditional stories. As can be seen, the premise sets the time and place, the main character(s) and the objective, as well as the action that propels the story forward.

Now let's look at examples of premise from games that you might have played. In a game, the premise might be as complex as those previously mentioned, involving characters with dramatic motivations, or a game's premise can simply be a metaphor overlaying what would otherwise be an abstract system.

First, here is a very simple game premise: in Space Invaders, the game is set on a planet, presumably Earth, which is attacked by aliens. You play an anonymous protagonist responsible for defending the planet from the invaders. The story begins when the first shot is fired. Clearly this premise

4.11 Space Invaders

has none of the richness that we see in the earlier stories. It does, however, have a simplicity and effectiveness that made it very powerful as a game premise. No player needed to read the backstory of Space Invaders to feel the tension of the steadily approaching aliens.

Now, let's look at some games that have attempted to create somewhat more developed premises. In Pitfall, the game is set in the "deep recesses of a forbidden jungle."[11] You play Pitfall Harry, a "world famous jungle explorer and fortune hunter extraordinaire." Your goal is to explore the jungle and find hidden treasures while surviving various hazards like holes, logs, crocodiles, quicksand, etc. The story begins when you enter the jungle.

In Diablo, you play a wandering warrior who arrives in the town of Tristram, which has been ravaged by Diablo. The townspeople ask for your help in defeating Diablo and his undead army, which is ensconced in the dungeon beneath the church. The story begins when you accept the quest.

In Myst, the game is set on a strangely deserted island filled with arcane mechanical artifacts and puzzles. You play an anonymous protagonist with no knowledge of Myst Island or its inhabitants. The story begins when you meet Sirrus and Achenar, two brothers trapped in magical books in the island's library. The brothers, who accuse each other of betrayal,

each need you to find some missing pages of their books to help them escape, but both warn you not to help the other brother.

Exercise 4.6: Premise

Write out the premise for five games that you've played and describe how this premise enhances the game.

The first task of a premise is to make a game's formal system playable for the user. Rather than shooting at abstract blocks on a screen, players shoot at aliens in Space Invaders. Rather than searching for a generic resource worth 5000 points, players look for diamond rings in Pitfall. Beyond simply concretizing abstract system concepts and making the game playable, a well thought-out premise can also create a game that appeals to players emotionally.

For example, the premise of Myst not only sends the player on a quest to find the missing pages of one or both of the brothers' magical books, but it also implies that the brothers are not to be trusted and one or both of them might be duping the player. This makes the experience richer for the player, who must determine, by clues found in each age, which, if either, brother to help.

Creating a premise that unifies the formal and dramatic elements is another opportunity for the game

4.12 **Pitfall and Diablo**

4.13 Myst

designer to heighten the experience of players. As digital games have evolved, more and more designers have begun to make use of elaborate premises in their designs, which, as we'll see, have evolved to the point where they can be considered to be fully realized stories.

CHARACTER

Characters are the agents through whose actions a drama is told. By identifying with a character and the outcome of their goals, the audience internalizes the story's events and empathizes with its movement toward resolution.

There are several ways to understand fictional characters in stories. The first, and probably most common, is psychological—the character as a mirror for the audience's fears and desires. However, characters can also be symbolic, standing for larger ideas such as Christianity, the American dream, democratic ideals, etc. Or they can be representative: standing for a segment of people, such as socioeconomic or ethnic groups, a group with a specific gender, etc. Characters can also be historic, depicting real-world figures. How characters are used in a story depends greatly on the type of story being told. An action adventure story might deal only with stereotypical characters who represent certain cultural clichés. Or perhaps it is an action story told as a metaphor or allegory. Perhaps the main character of this action story is symbolic of a larger idea, like truth, justice, and the American way.

The main character of a story is also called the protagonist. The protagonist's engagement with the problem creates the conflict that drives the story. Working against the main character is the antagonist,

4.14 Digital game characters (clockwise from top left): Duke Nukem, Guybrush Threepwood, Abe, Link, Sonic the Hedgehog, Lara Croft, and Mario

Guybrush Threepwood image courtesy of LucasArts, a division of Lucasfilm Entertainment Company Ltd.

who opposes the main character's attempts to solve the problem. The antagonist can be a person or some other force that works against the main character. Characters can be major or minor—major characters have a significant impact on the story's outcome, while minor characters have a small impact.

Characters are defined within the story by what they say, what they do, what they look like, or what others say about them. These are called methods of characterization. In addition to function and impact on the story, characters can vary in the complexity of their characterization. If a character has well-defined traits and a realistic personality or undergoes a significant change in personality during the story, they can be thought of as a "round" character. Examples of round characters would be Humphrey Bogart's Rick Blaine from *Casablanca*, Hamlet, or Scarlet O'Hara from *Gone with the Wind*. Characters who have few (if any) defined traits and a shallow personality are considered to be "flat." Flat characters show little or no

change in personality, and they are often used as foils to show off the elements of another character. They are also usually recognizable as stereotypes: the lazy guard, the evil stepmother, the jolly doorman, etc.

No matter what level of complexity a character is written with, the there are four key questions to ask when writing to make sure you have really thought through the character's presence in your story:

- What does the character want?
- What does the character need?
- What does the audience/player hope?
- What does the audience/player fear?

These questions are applicable to game characters as well as characters in traditional media. In fact, game characters have many of the same characteristics and functions as traditional characters, and they are often created using the same techniques of characterization.

Game characters also have some unique considerations. The most important of these is the balance between "agency" and "empathy." Agency is the practical function of a character to serve as a representation of the player in the game. Agency can be completely utilitarian, or it can include aspects of creativity, role-playing and identification. Empathy is the potential for players to develop an emotional attachment to the character, to identify with their goals and, consequentially, the game objectives.

Agency and empathy must be considered at every level of the game design that involves characters. For example, are characters predesigned? Do they have an existing backstory and motivations? Or are they player-created characters? Do they allow customization and growth? Early game characters were completely defined by how they looked, with little or no attempt at characterization. Mario, in his first appearance in Donkey Kong, was defined by his funny nose and signature cap and overalls. While his motivation, rescuing Pauline, was integrated into both the formal and dramatic aspects of the game, he was ultimately a flat, static character who did not change or grow over the course of the game. More importantly, Mario would not do anything to accomplish his goal without the player's control.

Today many game characters have deep backstories and rich characterizations that affect the player's experience of the game. For example, Kratos, the main character of God of War, is a Spartan general who is sent to kill the god Ares. His duty is intertwined with

fate, and as the game progresses, we discover his motivation to be much deeper than a simple order; he blames Ares for the death of his family, and this mission is one of revenge. Another example is Wander, the protagonist of Shadow of the Colossus. Wander is motivated by his desire to resurrect Mono, a girl who has been sacrificed. We don't know much about the relationship between Wander and Mono or much about Wander himself. But his character is rounded by his actions and demeanor, and the changes that take place in him over the course of the game as he gradually transforms into the form of his own enemy, the Colossi he has been ordered to destroy.

Avatars, however, in games like World of Warcraft or City of Heroes, are player created, often with great investment of time and money. Player-created characters have as great a potential for empathy (if not more) as story-driven characters. The question is not which method is better but which is best for your game's design and player experience goals.

Another question for the designer in the creation of game characters is in regards to "free will" versus player control. Game characters that are controlled by the player do not always have the opportunity to act on their own. The player is assuming agency for the character's actions, which limits the degree to which characters can demonstrate their own personality and inner thought process. But sometimes game characters are not entirely in the control of the player. Sometimes the character is controlled by artificial intelligence (AI). AI-controlled characters

Characters vs. Avatars

Predesigned characters;
backstories, motivations

Player-created characters;
role-playing, growth, customization

4.15 Characters versus avatars

4.16 God of War II and Shadow of the Colossus

Free Will vs. Player Control

| "Free will" AI-controlled character | Mixture: Player-controlled characters w/elements of simulation that provide "character" | "Automaton" Player-controlled character |

4.17 Free will versus player control

exhibit a sense of autonomy that creates an interesting potential tension between what the player wants and what the character wants.

An early, primitive version of this autonomy is the character of Sonic the Hedgehog—Sega's answer to Mario. If the player stopped interacting with Sonic, the little hedgehog let the player know of his dissatisfaction by crossing his arms and tapping his feet impatiently. Impatience was central to Sonic's character: He did everything fast and had no time to spare. Unlike the blazingly fast actions controlled

by the player, however, the toe-tapping routine was Sonic's own, and it established him as a unique character.

Of course, Sonic's toe tapping had no impact on gameplay, but the tension between player-controlled action and character-controlled action is an interesting area that has been explored to great effect more recently in games like The Sims, Oddworld: Munch's Oddysee, and Black & White. If the free will feature is turned on in The Sims, characters will decide on their own course of action (assuming the player

hasn't given them anything specific to do). Players can stop a character from performing an action at any time, but with this feature on, the game usually unfolds as a complicated dance between what the player desires and what the character "wishes." This sophisticated model produces dramatic results that the player feels both responsible for and yet surprised by.

Believable AI for characters like The Sims is a holy grail of game design these days both for player-controlled characters and nonplayer characters. Believable enemy and nonplayer characters in action games can make for more exciting, replayable game levels. For example, both the enemies and the nonplayer allies in the Halo series have a sophisticated AI that tracks their knowledge of the area (how many enemies are around, etc.) and their fear. If they are outnumbered and afraid, they might run away. Experimental games like Michael Mateas and Andrew Stern's Façade are breaking new ground not only in terms of believable character AI, but also believable story AI. In Façade, the main characters, Grace and Trip, invite you (the player) over for dinner. What happens at this fated dinner party is generated procedurally based on a unique "story beat" AI, the character AI, and the player input.

In general, game characters are evolving to become more rounded, dynamic individuals that play an

4.18 Façade

increasingly important part of many games' dramatic structures. A good understanding of how to create engaging characters using both traditional dramatic tools and developing AI concepts can add to the effectiveness and believability of characters in your games.

Exercise 4.7: Game Characters

Name three game characters that you find to be compelling. How are these characters brought to life within the game? What allows you to identify with them? Are they rounded or flat, dynamic or static?

Story

We've said that the outcome of a game must be uncertain—that this is part of the formal structure of the game. This is true of a story as well. The outcome of a story is also uncertain (at least the first time we experience it). Plays, movies, television, and games are all media that involve storytelling and narratives that begin in uncertainty and that are resolved over the course of time. However, the uncertainty in a film or a play is resolved by the author, while the uncertainty of a game is resolved by the players. Because of this, it is very difficult to integrate traditional storytelling methods into games.

In many games, story is actually limited to backstory, sort of an elaborate version of premise. The backstory gives a setting and context for the game's conflict, and it can create motivation for the characters, but its progression from one point to the next is not affected by gameplay. An example of this is the trend of inserting story chapters into the beginning of each game level, creating a linear progression that follows a traditional narrative arc interspersed with gameplay that does not affect how the story plays out. Games like the WarCraft or StarCraft series follow this model in their single player modes. In these games, the story points are

laid out at the beginning of a level, and the player must succeed to move on to the next level and the next story point. Like a gameplay version of the Bill Murray film *Groundhog Day*, failure means playing the level again and again until you succeed; only then will the story progress.

There are some game designers who are interested in allowing the game action to change the structure of the story so that choices the player makes affect the eventual outcome. There are several ways of accomplishing this. The first, and simplest, is to create a branching story line. Player choices feed into several possibilities at each juncture of a structure like this, causing predetermined changes to the story. The diagram in Figure 4.19 shows an example of this type of story structure using a simple fairy-tale story we are all familiar with.

One of the key problems with branching story lines is their limited scope. Player choices might be severely restricted in such a structure, causing the game to feel simplistic and unchallenging. In addition, some paths can create uninteresting outcomes. Many game designers believe that there is better potential for use of story in games if the story emerges from gameplay rather than from a predetermined structure. For example, in The Sims, players have used the basic elements provided by the formal system to create innumerable stories involving their game characters. The system provides features that support this emergent storytelling, including tools for taking snapshots of the gameplay, arranging the snapshots in a captioned scrapbook, and uploading the scrapbook to the Web to share with other users.

In addition to simulation games, other genres are also addressing the possibility of designing for emergent storytelling. This includes games like Black & White, which combine elements of simulation with strategy and role playing, as well as action games like Half-Life, which triggers story sequences depending on player actions, and Halo 2, which uses AI techniques in nonplayer characters to create unique and often dramatic responses to player actions.

While it remains to be seen if these attempts to allow emergent storytelling to arise out of formal game structures will have a significant impact on games, it is certain that game designers are still searching for better ways to integrate story into their systems without diminishing gameplay.

Exercise 4.8: Story

Pick a game that you feel successfully melds its story line with the gameplay. Why does this game succeed? How does the plot unfold as the game progresses?

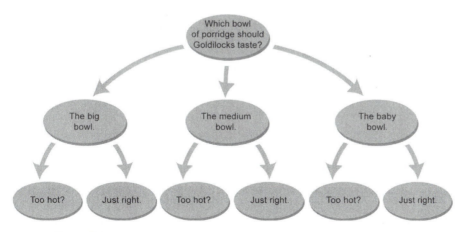

4.19 Branching story structure

THE TWO GREAT MYTHS OF INTERACTIVE STORYTELLING

by Jesse Schell

Myth #1: Interactive Storytelling Has Little to Do with Traditional Storytelling

I would have thought that by this day and age, with story-based games taking in billions of dollars each year, this antiquated misconception would be obsolete and long forgotten. Sadly, it seems to spring up, weedlike, in the minds of each new generation of novice game designers. The argument generally goes like this:

> "Interactive stories are fundamentally different from noninteractive stories because in noninteractive stories, you are completely passive, just sitting there, as the story plods on, with or without you."

At this point, the speaker usually rolls back his or her eyes, lolls his or her tongue, and drools to underline the point.

> "In interactive stories, on the other hand, you are active and involved, continually making decisions. You are doing things, not just passively observing them. Really, interactive storytelling is a fundamentally new art form, and as a result, interactive designers have little to learn from traditional storytellers."

The idea that the mechanics of traditional storytelling, which are innate to the human ability to communicate, are somehow nullified by interactivity is absurd. It is a poorly told story that does not compel the listener to think and make decisions during the telling. When one is engaged in any kind of story line, interactive or not, one is continually making decisions: "What will happen next?" "What should the hero do?" "Where did that rabbit go?" "Don't open that door!" The difference only comes in the participant's ability to *take* action. The *desire* to act, and all the thought and emotion that go with that, are present in both. A masterful storyteller knows how to create this desire within a listener's mind, and then knows exactly how and when (and when not) to fulfill it. This skill translates well into interactive media, although it is made more difficult because the storyteller must predict, account for, respond to, and smoothly integrate the actions of the participant into the experience.

WORLD BUILDING

While story structure itself is a difficult problem for games and interactive media, there is an aspect of story creation that is a natural complement to game design, and that is world building. World building is the deep and intricate design of a fictional world, often beginning with maps and histories, but potentially including complete cultural studies of inhabitants, languages, governments, politics, economies, etc. The most famous fictional world, and perhaps the most complete, is J.R.R. Tolkien's Middle-earth.

The way that skilled interactive storytellers manage this complexity, while still using traditional techniques, is through the means of *indirect control*, using subtle means to covertly limit the choices that a participant is likely to make. This way, masterful storytelling can be upheld while the participant still retains a feeling of freedom. For it is this feeling of freedom, not freedom itself, which must be preserved to tell a compelling interactive story.

Myth #2: Interactive Storytelling Has Little to Do with Traditional Game Design

I am amazed by the vast number of would-be game designers who whine that while they are brimming with great game design ideas, they lack the large team required to implement these ideas, and therefore they are unable to practice their craft.

This is nonsense of the highest order. A game is a game is a game. The design process for a board game, a card game, a dice game, a party game, or an athletic game is no different from the process of designing a video game. Further, a solo designer can fully develop working versions of these nonelectronic games in a relatively short time. Making and analyzing traditional games can often be far more instructive than trying to develop a fully functioning video game. You can learn much more about game design in a much shorter time, and you won't have to concern yourself with the technical headaches and limitations involved with interactive digital media. If you really want to understand how to create good interactive entertainment, first study the classics, and then try to improve on them. Riddles, crossword puzzles, chess, poker, tag, soccer, and thousands of other beautifully designed interactive entertainment experiences existed long before the world even knew what a computer was.

To sum up: New technologies allow us to mix together stories and games in interesting ways, but there are very few elements that are fundamentally new—most designs are simply new mixtures of well-known elements. If you want to master the new world of interactive storytelling, you would be wise to first understand the games and stories of old.

About the Author

Jesse Schell was formerly the creative director of the Walt Disney Imagineering VR Studio, where his job was to invent the future of interactive entertainment for the Walt Disney Company. Now he is professor of entertainment technology at Carnegie Mellon University, specializing in game design. He also is the CEO and chief designer at Schell Games, a studio that specializes in the design and development of unusual video games.

Tolkien began by creating languages, then the creatures who spoke them, and later the stories that took place in the world. Many games and films are created using world building techniques, which, though not as detailed as Middle-earth, give them a sense of depth and story potential that keeps players interested over long periods of times. The World of Warcraft universe is a good game-based example, as the Star Wars universe is an example that spans both films and games.

The Dramatic Arc

We have looked at a number of key elements that can help to create player engagement with the game system. But the most important of these elements is actually one that we have talked about already, and that is conflict.

Conflict is at the heart of any good drama, and, as we have seen in our discussion of formal elements, it is also at the heart of game systems. Meaningful conflict is not only designed to keep players from accomplishing their goals too easily, as we pointed out in the discussion of formal elements, but it also draws players into the game emotionally by creating a sense of tension as to the outcome. This dramatic tension is as important to the success of a game as it is to a great film or novel.

In traditional drama, conflict occurs when the protagonist faces a problem or obstacle that keeps her from accomplishing her goal. In the case of a story, the protagonist is usually the main character. In the case of a game, the protagonist can be the player or a character that represents the player. The conflict that the player encounters can be against another player, a number of other players, obstacles within the game system, or other forces or dilemmas.

Traditional dramatic conflict can be broken down into categories such as character versus character, character versus nature, character versus machine, character versus self, character versus society, or character versus fate. As game designers, we might overlay another group of categories, which are player versus player, player versus game system, player versus multiple players, team versus team, etc. Thinking about game conflict in this way helps us to integrate a game's dramatic premise and its formal system, deepening the players' relationships to both.

When the conflict is set in motion, it must escalate for the drama to be effective. Escalating conflict creates tension, and in most stories, the tension in a story gets worse before it gets better, resulting in a classic dramatic arc. This arc describes the amount of dramatic tension in the story as it progresses in time. Figure 4.20 shows how tension rises and falls during various stages of a typical story. This

arc is the backbone of all dramatic media, including games.

As the figure shows, stories begin with exposition, which introduces the settings, characters, and concepts that will be important to the rest of the action. Conflict is introduced when the protagonist has a goal that is opposed by their environment, an antagonist, or both. The conflict, and the protagonist's attempt to resolve it, causes a series of events that lead to a rising action. This rising action leads to a climax, in which some sort of deciding factor or event is introduced. What happens in the climax determines the outcome of the drama. The climax is followed by a period of falling action in which the conflict begins to resolve, and the resolution, or dénouement, in which it is finally resolved.

To better understand the classic arc, let's look at in terms of a simple story you are probably familiar with. In the movie *Jaws*, Sheriff Brody is the protagonist. His goal is to keep the people of Amity safe. The antagonist is the shark, who opposes Brody's goal by attacking the people of Amity. This creates a conflict between Brody and the shark. Brody, who is afraid of the water, attempts to keep the people safe by keeping them out of the water, but this plan fails. The tension rises as the shark attacks more people, even threatening Brody's own children. Finally, Brody must face his fear and go out on the water to hunt down the shark. In the climax of

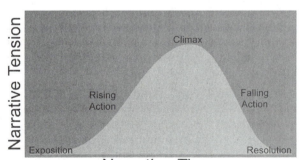

4.20 Classic dramatic arc

the story, the shark attacks Brody. The story resolves when Brody kills the shark and returns the story to the status quo. Simple, right? You can look at any story you know and you will see the dramatic arc reflected in its structure.

Now, let's look at the arc again, this time in terms of a game. In a game, the rising action is linked to both the formal and dramatic systems. This is because games are usually designed to provide more challenge as they progress. Games that also have well-integrated dramatic elements will intertwine those elements with the formal system so that as the challenge rises, the story develops. Here is an example from a classic game: In Donkey Kong, Mario is the protagonist. Mario's girlfriend, Pauline, has been kidnapped by the giant ape, Donkey Kong, and taken to the top of a building under construction. Mario's goal is to save Pauline before time runs out. To do so, he must climb the levels of the building, traversing girders, elevators, and conveyer belts, while avoiding flames, barrels, and bouncing rivets thrown at him by Donkey Kong. Each time Mario reaches Pauline, Donkey Kong grabs her and carries her off to the next higher level. Each level builds in difficulty, creating rising tension for the player. Finally, in the climax of the game, Mario must not only avoid Donkey Kong's attacks but also fight him directly by removing all the rivets on every floor of the level. After the rivets are removed, Donkey Kong falls

head first onto a stack of girders and is knocked out, allowing Mario to rescue Pauline and resolve both the formal and dramatic tension.

It is clear from even these simple descriptions that the story in *Jaws* is more developed as to character and story—Brody has a fear that he must overcome to solve the problem, and his character changes in motivation as he goes from protecting all the people of Amity, to saving his own family, to defending himself from the shark. While Mario has a goal, and he is certainly vulnerable to attacks from Donkey Kong, he does not have any internal conflict that keeps him from completing his goal, and his goal never wavers. The jeopardy that Pauline is in never increases either, a touch that would have made the formal and dramatic systems of the game better integrated.

What Mario has that Brody does not, however, is that his success or failure is in the hands of the player. It is the player who must learn how to avoid the attacks, moving closer and closer to the goal. And in the climax of the game, it is the player who must figure out how to topple Donkey Kong from his perch and knock him out. So while our response to the climactic moment in *Jaws*, when Brody figures out how to finally kill the shark, is a release of tension built up by our empathy for his character and the character's struggles over the course of the story, our response to the climatic moment in *Donkey Kong* is quite different.

4.21 **Donkey Kong**

In the case of *Donkey Kong*, we are the ones who have figured out the crucial action needed to resolve the tension, and that tension has built up over a number of levels of play. When we finally resolve that tension, there's a sense of personal accomplishment on top of any sympathetic response that we might have to the resolution of Mario and Pauline's story. This integration of conflict in the formal and dramatic systems can clearly provide a powerful combination for the players in a game experience.

Exercise 4.9: Plotting a Story, Part 1

Choose a game that you've played all the way through. Make certain it is a game with a story involved. For example Halo 2, Deus Ex, Gears of War, or Star Wars: Knights of the Old Republic, might be a good choice. Now, plot the story against the dramatic arc.

- How is the exposition handled? Who is the protagonist? What is the main conflict, and when is it introduced?

- What does the protagonist do to resolve the conflict?

- What causes the tension in the story to rise? What deciding factor brings the story to a climax?

- What happens in the resolution?

Exercise 4.10: Plotting a Story, Part 2

Now take the same game and plot the gameplay against the dramatic arc.

- What elements of gameplay, if any, support each of these points?

- How is the exposition of gameplay handled? Are controls and mechanics clearly explained? Are they integrated with the dramatic premise? Is the goal clearly stated and integrated with the main conflict of the story?

- How does the gameplay cause the dramatic tension to rise?

- What deciding factor in the gameplay brings the game to a climax?

- What happens in the resolution? Do the dramatic elements and gameplay elements help or hinder each other?

- How might they be better integrated to make the game work from an emotional standpoint?

Exercise 4.11: Plotting a Story, Part 3

Take the same game and come up with three changes to the story or gameplay that you believe would make the two better integrated.

CONCLUSION

The elements of drama that we have looked at form the basis of a tool set that the game designer can use to elicit powerful emotional reactions from players. From integral game concepts like challenge and play, to complex integration of premise, characters, and story, these tools are only as powerful as the inspiration behind their use. Although the media palette of game design has grown to rival film and television, it is clear that the emotional impact of games still has not achieved the depths it is capable of and that will make it recognized as an important dramatic art form.

What new areas of dramatic possibility do you see? What new ground will your designs break? To answer these questions, you must have a strong grasp of the tools of traditional drama and understanding of good gameplay and the process by which it can be achieved. Before going on to read about system dynamics in games, spend some time with the exercises in this chapter if you have not already done so, because they are designed to help you practice with some of these traditional tools.

Designer Perspective:
Dr. Ray Muzyka

CEO and Coexecutive Producer, BioWare Corp.

Dr. Ray Muzyka is a game designer, producer, and entrepreneur whose credits include Baldur's Gate (1998), Baldur's Gate: Tales of the Sword Coast (1999), MDK 2 (2000), Baldur's Gate II (2000), Baldur's Gate II: Throne of Bhaal (2001), Neverwinter Nights (2002), Neverwinter Nights: Shadows of the Undrentide (2003), Neverwinter Nights: Hordes of Underdark (2003), Star Wars: Knights of the Old Republic (2003), Jade Empire (2005,) and Mass Effect (2007).

How did you get into the game industry?

My original background was training and practice as a medical doctor. Dr. Greg Zeschuk and I cofounded BioWare back in 1995 after working on the programming and art for a couple of medical education projects for our university. We met some talented programmers and artists who worked on what became BioWare's first game, Shattered Steel. We never looked back, and now we have over 160 talented, smart, creative, hard-working employees at BioWare, working on three to six projects at any one time.

On favorite games:

My favorite games cover a lot of platforms and a long time period. Back in the early 1980s I was a big fan of some of the great role-playing franchises, such as Wizardry and Ultima on the Apple II. Later on, I was a big fan of games like System Shock and Ultima Underworld on the IBM PC. These too were role-playing games, revolutionary for their time in their interface, graphics, and storylines, and still worth playing. More recently I've enjoyed a number of console RPGs including Final Fantasy VII, Chrono Cross, and the Zelda series. I also enjoy a bunch of other types of games such as real-time strategy (WarCraft II, StarCraft, Age of Empires) and first person action games like Halo, Battlefield: 1942, and Half-Life. All of these games share the common traits of being very good at what they set out to do. This is what we try to do in our games at BioWare; we try to make each game better than our last.

Advice to designers:

Be passionate but self-critical. Never compromise on quality, but do realize that there is a point of diminishing returns on effort and a point where every game is "as good as you can make it." Most games never reach this point, but if they do, you'll increase the chances of it succeeding by a lot. And for those entrepreneurial types out there, hire smart, talented, creative, and hard-working staff to work with and make sure you treat them extremely well—video games are not a solo endeavor, and the team sizes required to keep the production values high enough for the increasingly sophisticated video game audiences seem to grow larger every year.

DESIGNER PERSPECTIVE: DON DAGLOW

President, Stormfront Studios

Don Daglow is a pioneer of the game design industry whose credits include the preindustry PDP games Baseball (1971–1974), Star Trek (1972–1973), and Dungeon (1976–1978); as well as commercial titles ranging from Utopia (1982), World Series Baseball (1983), Adventure Construction Set (1985), Racing Destruction Set (1985), Earl Weaver Baseball (1987), NASCAR 99 (1998), NASCAR 2000 (1999), Tony La Russa's Ultimate Baseball (1991), Neverwinter Nights (1991), and The Lord of the Rings: The Two Towers (2002).

On getting into the game industry:

I had been writing games as a hobby on the university mainframe through my college and grad school years, and then while I was a grad school instructor, teacher, and writer.

When Mattel started their in-house Intellivision game design team, they advertised on the radio for programmers who wanted to learn how to create video games. I'd never have thought of looking in the paper for a games job, but I heard the radio ad and called them. When I said, "I don't have a computer science degree, but I've been programming games for the last nine years," I think they thought I was making up stories because Pong had only been out for about five years at the time. Fortunately, it all worked out, and I was selected as one of the original five members of the Intellivision game design team at Mattel. As the team grew, I ended up being director of Intellivision game development.

On favorite games:

- *Seven Cities of Gold, design by Dan Bunten and Ozark Softscape, published by EA, 1984*: The game has only a handful of resources to manage and a gigantic map to explore for treasure. It is proof that a simple concept with few moving parts on a primitive machine with basic graphics can be compelling if the tuning of challenge, suspense, and reward is elegant and subtle.
- *The original Super Mario Bros. for Nintendo, design by Shigeru Miyamoto, 1985*: The game style has been the subject of endless variations, but this game to me is the foundation on which all the others are built. Just the right balance of eye-hand coordination, environmental and enemy challenges, hidden goodies, and ongoing positive reinforcement made this a game that adults and kids could both play and love.

- *Sim City, design by Will Wright, published by Maxis, 1989:* This game redefined what a computer game could be and was fun despite breaking many of the commonly accepted design commandments: It had no true opponents (apart from an occasional visit by Godzilla), a score with no clear methodology as to how you earned it, and no clear final goal so you could play for as long as you wanted. Will Wright persevered through repeated rejections before finding a publisher for one of the biggest hits in the history of the industry.
- *John Madden Football for Sega Genesis, design by Scott Orr and Rich Hilleman, published by EA, 1992:* The first console version of Madden Football created a monster franchise in the industry, but what made it shine initially was a beautifully tuned head-to-head gameplay mechanic that made playing your buddies an incredibly fun way to pass an afternoon.
- *Metal Gear Solid 2 for PS2, published by Konami, 2001:* The cinematic coverage of both stealth and combat advanced the use of cameras in our craft. Where Final Fantasy featured episodic tours de force, Metal Gear Solid started to blur the line between film and game.
- *Lord of the Rings: The Two Towers, design by LotR design team, developed by Stormfront Studios, published by EA, 2002 (conflict of interest note: our team created this game):* We started out talking about making the transition from a movie to a game seamless so you reached a moment of interactivity thinking you were still watching a theatrical film. This is a dream many of us had discussed for years. Unlike many dreams, this time we actually pulled it off. Having now done it once, the result has inspired us about a much wider range of effects we can create in future games.

Advice to designers:

Enjoy the journey, not just the wrap party. I see many people enter our industry who are anxious to be the next Shigeru Miyamoto or Will Wright. Most well-known designers are the product of the special cases of their era, and rarely are they well known in later phases of industry history. For every Miyamoto and Wright there are many designers who were once trumpeted in the industry press but who have now faded from the scene and are forgotten.

If I look at the people who have had the most success in the industry over the last 10, 15, or 20 years, a simple truth emerges. You have to do what you love, and you have to keep growing as you do it, in all areas of your personal and professional skills.

If you love games and love the process of creating them, it will rub off on everyone around you. If you keep looking for how to do a task better than the last time you did it, you'll grow. Your career will still have ups and downs, but it will advance.

If you embark on a master plan to become a video game celebrity by age 30, you stop thinking about building great games and start thinking about your personal pride. At that moment the energy that should be going into the craft of game design and execution instead goes into career planning. Which, of course, is the fastest way to sabotage your career. The person who is unhappy until they achieve their goal spends most of their time unhappy. The person who enjoys the journey toward the goal—and is resolute about reaching it—is happy most of the time.

Further Reading

Csikszentmihalyi, Mihaly. *Flow: The Psychology of Optimal Experience*. New York: Harper & Row Publishers, Inc., 1990. p. 49.

Hench, John. *Designing Disney: Imagineering and the Art of the Show*. New York: Disney Editions, 2003.

Howard, David. *How to Build a Great Screenplay*. New York: St. Martin's Press, 2004.

Isbister, Katherine. *Better Game Characters by Design: A Psychological Approach*. San Francisco: Morgan Kaufmann, 2006.

McCloud, Scott. *Understanding Comics: The Invisible Art*. New York: HarperCollins Publishers, 1994.

Murray, Janet. *Hamlet on the Holodeck: The Future of Narrative in Cyberspace*. Cambridge, MA: The MIT Press, 1997.

End Notes

1. Csikszentmihalyi, Mihaly. *Flow: The Psychology of Optimal Experience*. New York: Harper & Row Publishers, Inc., 1990. p. 49.

2. Ibid.

3. Ibid, p. 53.

4. Ibid, pp. 58–59.

5. Ibid, p. 61.

6. Ibid, p. 63.

7. Ibid, p. 66.

8. Brown, Stuart, and Kennard, David. Executive Producers. *The Promise of Play*. Institute for Play and InCA Productions, 2000.

9. Sutton-Smith, Brian. *The Ambiguity of Play*. Cambridge, MA: Harvard University Press, 1997. pp. 4–5.

10. *The Promise of Play*.

11. Activision, Pitfall instruction manual, 1982.

Chapter 5

Working with System Dynamics

In the previous two chapters, we looked at games in terms of their formal and dramatic elements. Now we will look at how the elements of games fit together to form playable systems and how designers can work with system properties to balance the dynamic nature of their games.

A system is defined as a set of interacting elements that form an integrated whole with a common goal or purpose. General system theory, the idea that the interaction among elements of systems can be studied across a wide variety of disciplines, was first proposed by the biologist Ludwig von Bertalanffy in the 1940s. Variations of system theory have evolved over time, each focusing on different types of systems. Our goal here is not to investigate all the various disciplines of system theory but rather to discover how we can use an understanding of basic system principles to control the quality of interactions within our game systems as well as the growth and change of those systems over time.

GAMES AS SYSTEMS

Systems exist throughout the natural and human-made world wherever we see complex behavior emerging from the interaction between discrete elements. Systems can be found in many different forms. They can be mechanical, biological, or social in nature, among other possibilities. A system can be as simple as a stapler or as complex as a government. In each case, when the system is put in motion, its elements interact to produce the desired goal, for example, stapling papers or governing society.

Games are also systems. At the heart of every game is a set of formal elements that, as we have seen, when set in motion, create a dynamic experience in which the players engage. Unlike most systems, however, it is not the goal of a game to create a product, perform a task, or simplify a process. The goal of a game is to entertain its participants. When we talked about formal and dramatic elements, we determined that games do this by creating a structured conflict and providing an entertaining process for players to resolve that conflict. How the interaction of the formal and dramatic elements is structured forms the game's underlying system and determines a great deal about the nature of the game and the experience of the players.

As we mentioned earlier, systems can be simple or complex. Systems can produce precise, predictable results, or they can produce widely varied, unpredictable effects. What type of system is best for your game? Only you can determine this. You might want to create a game in which there is a certain amount of predictability, in which case you might design a system with only one or two possible outcomes. On the other hand, you might want to create a very unpredictable system, in which there are countless possible outcomes determined by the

choices of the players and the interactions of the game elements.

To understand why it is that systems act in such different ways and be able to control the type of system elements that impact the outcome of your own games, we need to first identify the basic elements of systems and look at what factors within these elements determine how a system acts in motion.

The basic elements of systems are objects, properties, behaviors, and relationships. Objects within the system interact with each other according to their properties, behaviors, and relationships, causing changes to the system state. How those changes are manifested depend on the nature of the objects and interactions.

Objects

Objects are the basic building blocks of a system. Systems can be thought of as a group of interrelated pieces called objects, which can be physical, abstract, or both, depending on the nature of the system. Examples of objects in games might be individual game pieces (such as the king or queen in chess), in-game concepts (such as the bank in Monopoly), the players themselves, or representations of the players (such as the avatars in an online environment). Areas or terrain can also be thought of as objects: the squares on a grid board or the yard lines on a playing field. These objects interact with other game objects in the same way that playing pieces do, and they need to be defined with the same amount of consideration.

Objects are defined by their properties and behaviors. They are also defined by their relationships with other objects.

Properties

Properties are qualities or attributes that define physical or conceptual aspects of objects. Generally these are a set of values that describe an object. For example, the attributes of a chess piece include its rank (king, queen, bishop, knight, rook, pawn), its color (white or black), and its location. The properties of a

character in a role-playing game can be much more complex, including variables such as health, strength, dexterity, experience, level, as well as its location in the online environment, and even the artwork or other media associated with that object.

The properties of objects form a block of descriptive data that can be essential to determining interactions of objects in a game system. The simplest types of game objects have very few properties, and those properties do not change based on gameplay. An example of this type of object would be the checkers in a checker game. Checkers have only three properties: color, location, and type. While the location of checkers changes, their color never does. The type of checker can change from "normal" to "king" if it reaches the other side of the board. These three properties completely define the state of each checker within a game.

What would be an example of a game object with more complex properties? How about a character in a role-playing game? Figure 5.1 shows the main properties of a character from Diablo. As you can see, this list defines an object of much greater complexity than our first example. Also, the properties of this object change over the course of the game, and not in a simple binary way, like the checker. Because of its greater complexity, the object in this case will probably have less predictable relationships with other objects in the system than would a simple object like a checker.

5.1 Diablo: Character properties

Exercise 5.1: Objects and Properties

Choose a board game you have at home in which you are able to clearly identify the objects and their properties. Strategy board games often have objects with properties that are easy to identify. Make a list of all of the objects and their properties in the game you have chosen.

Behaviors

The next defining characteristics of objects in a system are their behaviors. Behaviors are the potential actions that an object might perform in a given state. The behaviors of the bishop in chess include moving along any of the diagonals radiating from its current position until it is blocked by or captures another piece. The behaviors of the role-playing character described previously might include walking, running, fighting, talking, using items, etc.

As with the sheer number of properties, the more potential behaviors an object has, the less predictable its actions within the system. For example, let's take the checkers example again. A "normal" checker has two potential behaviors: It can move diagonally one space or jump diagonally to capture another piece. Its behavior is restricted by the following rules: It can only move toward the opponent; if it can jump an opponent's piece it must do so; and if possible, it can make multiple jumps in a turn. A "king" has the same behaviors, but it does not have the rule regarding moving toward the opponent; instead, it can move forward or backward on the board. This comprises all the potential behaviors of the checker objects in the game (obviously, a very limited set of behaviors that result in a fairly predictable game pattern).

Now, let's look at the Diablo character again. What are the behaviors of this character? It can move: running or walking. It can attack using weapons in its inventory or skills like magic spells. It can pick up objects, converse with other characters, learn new skills, buy or trade objects, open doors or boxes, etc. Because of the range of behaviors available, the progression of this object through the game is much less predictable than the poor checker.

Does this make the game inherently more fun, however? We discuss this in the sidebar "Deconstructing Set" on page 116 when we analyze the system of Set, a simple, yet compelling, card game; the fact is, a greater complexity of gameplay does not always equate to a more enjoyable experience for the player. For now, it is simply important to note that the addition of more potential behaviors tends to add choice and lessen the predictability of outcome in a game.

Exercise 5.2: Behaviors

Take the list of objects and properties you created in Exercise 5.1 and add a description of the behaviors for each object. Consider all behaviors in different game states.

Relationships

As we mentioned earlier, systems also have relationships among their objects. This is a key concept in design. If there are no relationships between the objects in question, then you have a collection, not a system. For example, a stack of blank index cards is a collection. If you write numbers on the cards or mark them in several suits, then you have created relationships among the cards. Removing the "3" card from a sequence of 12 will change the dynamics of a system that uses those cards.

Relationships can be expressed in a number of ways. A game played on a board might express relationships between objects based on location. Alternately, relationships between objects might be defined hierarchically, as in the numerical sequence of cards described previously. How relationships between objects in a system are defined plays a large part in how the system develops when it is put in motion.

The hierarchy of cards is an example of a fixed relationship: The numerical values fix a logical relationship between each of the cards in the set. An example of a relationship that changes during gameplay is the movement of the checkers on our

checkerboard: Pieces move toward the other side of the board, jumping and capturing the opponent's pieces along the way. As they do so, their relationship to the board and to the other pieces on it continually changes.

Another example of a relationship is the progression of spaces on a board game like Monopoly. This is a fixed, linear relationship that constrains gameplay within a range of possibilities. On the other side of the spectrum, objects might have only loose relationships with other objects, interacting with them based on proximity or other variables. An example of this would be The Sims, where the relationships of the characters to other objects are based on their current needs and the ability of the objects in the environment to fulfill those needs. These relationships change as the characters' needs change; for example, the refrigerator is more interesting to a character who is hungry than a character who has just eaten a huge meal.

Change in relationships can also be introduced based on choices made by the players. The checkers game exhibits such change: Players choose where to move their pieces on the board. There are other ways to introduce change into game relationships. Many games use an element of chance to change game relationships. A good example of this is seen in most combat algorithms. Here is an explanation of how the combat algorithm works in WarCraft II.[1]

Each unit in the game has four properties that determine how effective it is in combat.

- *Hit Points:* These indicate how much damage the unit can take before dying.
- *Armor:* This number reflects not only armor worn by the unit, but also its innate resistance to damage.
- *Basic Damage:* This is how much normal damage the unit can inflict every time it attacks. Basic damage is lowered by the target's armor rating.
- *Piercing Damage:* This reflects how effective the unit is at bypassing armor. (Magical attacks, like dragon's breath and lightning, ignore armor.)

When one unit attacks another, the formula used to determine damage is: (Basic Damage − Target's Armor) + Piercing Damage = Maximum Damage Inflicted. The attacker does a random amount of damage from 50–100% of this total each attack. To see how this algorithm tends to introduce chance into the relationship between objects, or units as we have been calling them, let's look at an example from the strategy guide on Battle.net:

> *An ogre and a footman are engaged in combat. The ogre has a Basic Damage rating of 8 and a Piercing Damage rating of 4. The footman has an Armor value of 2. Every time the ogre attacks the footman, it has the potential to inflict up to (8 − 2) + 4 = 10 points of damage, or it could inflict as little as 50% damage, or 5 points. On average, the ogre will kill the 60-Hit-Point footman in about 8 swings.*
>
> *The poor footman, on the other hand, with a Basic Damage of 6 and a Piercing Damage of 3, will only inflict 3 to 5 points of damage each time he attacks the ogre, which has an Armor value of 4 (that's (6 − 4) + 3 = 5). Even if the footman is extremely lucky and does the maximum amount of damage with every attack, it will take 18 swings to kill that 90-Hit-Point ogre. By that time, the ogre will have pounded him into mincemeat and moved on.*

This example actually shows two ways of determining relationships: chance and rule sets. As can be seen by the calculation, there is a basic rule set determining the range within which damage can fall.

5.2 WarCraft II: Going up against an ogre

When that range is set, however, chance determines the final outcome. Some games tend more toward chance in their calculations, while others tend more toward rule-based calculations. Which method is best for your game depends on the experience you want to achieve.

Exercise 5.3: Relationships

Take the list of objects, properties, and behaviors you created in Exercises 5.1 and 5.2 and describe the relationships between each object. How are these relationships defined? By position? By power? By value?

SYSTEM DYNAMICS

As we have noted, the elements of systems do not work in isolation from each other. If you can take components away from a system without affecting its functioning and relationships, then you have a collection, not a system. A system, by definition, requires that all elements be present for it to accomplish its goal. Also, a system's components must typically be arranged in a specific way for it to carry out its purpose; that is, to provide the intended challenge to the players. If that arrangement is changed, the results of the interaction will change. Depending on the nature of the relationships in the system, the change in results might be unnoticeable or it might be catastrophic, but there will be a change to some degree.

Let's say that our example on page 114 of the ogre and the footman from WarCraft II was changed; instead of using the properties of basic damage, piercing damage, and target's armor to determine the range of potential damage from an attack, let's assume the damage dealt by each unit was just a random number between 1 and 20. How would this change the outcome of each individual battle? How would it change the overall outcome of the game? What about the value of resources and upgrades?

If you said that the element of chance in the game would increase in both individual combat encounters and overall outcome, you are right. Also, the value of resources and the upgrades available via those resources would disappear because upgrades to units and armor would mean nothing in terms of determining outcome. The only strategy open to players in this game would be to build as many units as possible because sheer numbers would still overwhelm in battle. So by changing the relationship between units in combat, we have changed the overall nature of the WarCraft II system.

On the other hand, if we changed the original damage calculation by removing the random element at the end and assuming that all units would deal maximum damage, how would that change the outcome of each battle? In this case, a player would be able to predict exactly how many attacks would be necessary for any one unit to destroy another. This sense of predictability would affect not only strategy but also player engagement. While in the first example of a completely random damage system, player decisions lose much of their strategic value, the example of a completely nonrandom damage system would diminish the unpredictability of individual encounters and the overall game as well.

Another important feature to understand about the interaction of systems is that systems are greater than the sum of their parts. By this we mean that studying all of the individual qualities of each system element in isolation does not equal studying these elements in relationship to each other. This is important for game designers to realize because games can only be understood during play when their dynamics become evident. Katie Salen and Eric Zimmerman call game design a "second order" problem because of this,[2] meaning that when we design a game, we cannot directly determine the player experience—we cannot determine exactly how the rules will play out. We have to craft a "possibility space" as best as we can, and playtest it as rigorously as possible, but in the end, we just do not know how each and every play of the game will go.

Exactly how the dynamics of any given game system are affected by the properties, attributes, and relationships of its objects is difficult to generalize. A good way to understand how these elements can affect each other is to look at some example systems—ranging

DECONSTRUCTING SET

Set is a card game designed by Marsha Falco in 1988. At the time, Falco was studying as a population geneticist in Cambridge, England, trying to understand if German shepherds that get epilepsy actually inherit it. To help her understand the variables, she wrote information about each dog on file cards; she drew a symbol to represent a block of data, indicating different gene combinations. One day she found her kids playing with her research cards—they had made a game out of them. The game was so fun that they went on to publish it as a family business. The game became an instant classic, winning a number of awards, including the Mensa award.

The Rules of Set

The system of Set is quite elegant. The game is played with a special card deck made of 81 unique cards. The cards are the basic objects in the game, and each has a group of symbols with four properties: shape, number, pattern, and color; there are three options for each property. The diagram below shows how the number of properties and the options for each add complexity to the deck, which is measured by the number of unique cards.

The procedures of Set are also quite simple. The deck is shuffled; twelve cards are then dealt out as shown in the next diagram. (You will have to imagine color based on the shades of gray in the diagram, but in the original game, there are three colors.) The players all look at the cards, searching for "sets." A set consists of three cards in which each property is either all the same *or* all different. For example, in this layout, A1, A2, and A3 are a set because (1) shape = all the same, (2) number = all different, (3) pattern = all different, and (4) color = all different. A1, A4, and C1 are also a set because (1) shape = all different, (2) number = all the same, (3) pattern = all different, and (4) color = all different.

	1	2	3	Unique Cards
Shape	Oval	Diamond	Squiggle	3
Number	1	2	3	9
Pattern	Solid	Clear	Striped	27
Color	Green	Red	Purple	81

Elements of Set and how they contribute to complexity

When a player sees a set, she calls out, "Set!" and point out which cards she believes make a set. If she is correct, she takes the cards; three more cards are dealt and play begins again. If she is incorrect, she must give back one of her sets to the discard pile. When there are no more cards, the player with the most sets wins.

Analyzing Set

As we have said, the design of Set is quite elegant. If you look closely at the cards in this figure, you will see that for any two cards you choose, you can describe the third card you would need to create a set. For example, look at B2 and C4. What card would need to create a set including these two cards? First, these cards have different shapes, so you would need another card with a different shape: an oval. Second, these cards have different numbers, one and three, so you need a card with two ovals. Third, these cards have different

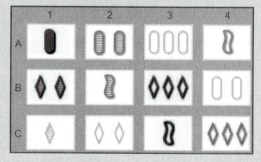

Set playing cards

patterns, so you need a card with a different pattern: solid. Fourth, these cards have the same color, red (in this figure it is medium gray), so you need another red. To make a set with B2 and C4, you need a card with two solid red ovals—there is only one such card in the deck, and it is not shown, so we cannot make a set with these two cards.

Now, how did Marsha Falco decide on this system configuration for the game of Set? Why not more properties? Or less? Why not more options for each property? As we will discuss in our analysis of Mastermind and Clue on page 120, the complexity of a system is greatly affected by the underlying mathematical structures. In Set, a deck of 81 cards provides a challenging, yet playable, number of possibilities. When learning to play Set, players often will remove the property of color to make the experience simpler. Without the property of color, the deck consists of only 27 cards, and it is much easier to find a set. After new players get the hang of it, they add back the remaining cards and the additional complexity that comes with a deck of 81 cards.

	1	2	3	Unique Cards
Shape	Oval	Diamond	Squiggle	3
Number	1	2	3	9
Pattern	Solid	Clear	Striped	27
Color	Green	Red	Purple	81
Background	White	Black	Grey	243
Border	Silver	Gold	Onyx	729
Animation	Still	Blinking	Rotating	2187

Elements of Set with added properties

Imagine adding one more property—a background color, for example. As shown in the previous figure, this would create a deck of 243 cards. If we add a background border, our deck has 729 cards. Let's say we are making a digital version of Set. Now we can add animation! Should we? Well, that would mean there are 2187 cards in our digital game of Set. For a player trying to apply the rules of the game, there are now seven properties to consider and about 30 times less probability that the card you need to make a set will be dealt to the current display. You can see that adding this level of complexity has probably *not* improved your player experience. In fact, it is likely that this version of Set is unplayable.

	1	2	3	4	Unique Cards
Shape	Oval	Diamond	Squiggle	Square	4
Number	1	2	3	4	16
Pattern	Solid	Clear	Striped	Hatched	64
Color	Green	Red	Purple	Yellow	256

Elements of Set with added option to original properties

The next figure shows another possibility—adding another option to each of the original properties. This does not change things quite as much; at least the deck is only 256 cards, only 3 times more complex than the original game system. But the game is already quite difficult. If you want to see what this change does to the player experience, build your own Set deck with the new option and playtest it.

Conclusion

This analysis deals with a game that is, compared to many digital games, quite simple. However, as you can see, changing just a few of the system elements can exponentially change the complexity of that simple system and the player experience. It is critical to understand the mathematical structures of your own game design and to test differing levels of complexity by adding or deleting from your properties. One way to do this is they way we have done here with Set: build a matrix and calculate the level of complexity mathematically. And always keep in mind: A more complex mathematical solution might not offer the most satisfying gameplay result. The goal is always to build a system that is complex enough to delight and surprise your players but not to confound or frustrate them.

from very simple to fairly complex—that exhibit various types of dynamic behavior.

Tic-tac-toe

The objects in tic-tac-toe are the spaces on the board. There are nine of them, and they are defined by their properties, behaviors, and relationships. For example, their properties, are "null," "x," or "o." Their relationships are defined by location. There is one center space, four corners, and four sides. When the game begins, the relationship between the spaces is such that there are only three meaningful choices for the first player: center, corner, or side.

The second player has between two and five meaningful choices, depending on where the first player puts an "x." You can see by the diagram of potential moves that playing the first "x" in the center reduces the amount of significant next moves to two. Playing the first "x" in a corner or on a side creates up to five next moves.

If we continued this diagram of tic-tac-toe out to its conclusion, we would see that the tree of possibilities is not very large. In fact, when you learn the best possible moves to make, you can always win or tie at this game because of its ultimate simplicity. What is it about tic-tac-toe that makes its system so easy to learn?

First, we can see that the game objects themselves are simple: They have only three properties and one behavior. Also, their relationships to each other are fixed: The locations of the spaces on the board do not change. Because of both the number of objects (i.e., the size of the board) and their relationships, the system has only a few possible outcomes, and these are all completely predictable. And as a result of its limited possibilities for play, tic-tac-toe tends to lose the interest of players after they learn the optimal moves for any given situation.

Chess

An example of a system that has more than one type of object, and more complex behaviors and relationships between objects, is chess. First, let's look at the

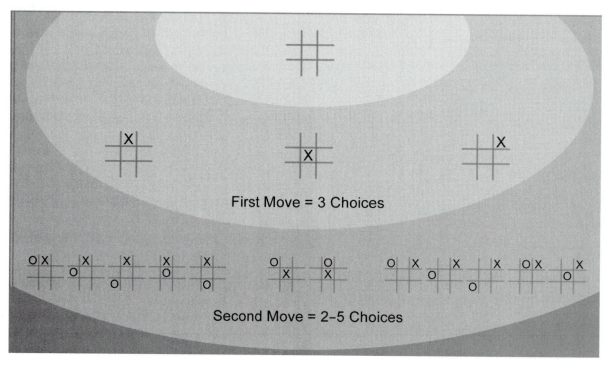

First Move = 3 Choices

Second Move = 2–5 Choices

5.3 Partial tic-tac-toe game tree

objects in chess: There are six types of units plus 64 unique spaces on the board.

Each unit has several properties: color, rank, and location, as well as a set of behaviors. For example, the white queen has a beginning location of D1 (the space at the intersection of the fourth rank of the first file). The movement behavior of the queen is that it may move in any straight line horizontally, vertically, or diagonally, as long as it is not blocked by another piece. Alone, these properties and behaviors do not make the objects in chess more complex than the spaces on the tic-tac-toe board. However, the varied behaviors of the objects and relationships between them do make the emergent gameplay more complex. Because each unit has specific behaviors in terms of movement and capture, and because those abilities create changes to their locations on the board, the relationships between each unit are effectively changed as a result of every move.

While it is theoretically possible to create a tree similar to the one we drew for the opening moves of tic-tac-toe, it quickly becomes clear that the complexity of potential outcomes beyond the first few moves makes this a useless and physically impossible process. This is not the way players tend to approach the game, and it is not even the way that computer chess applications have been programmed to decide the best move. Instead, both players and successful programs tend to use pattern recognition to solve problems, calling up solutions from memories of previously played games (or a database in the case of the computer) rather than plotting out an optimal solution for each move. This is because the elements of the game system, when set in motion, create such a large range of possible situations that the tree becomes too complex to be useful.

Why does chess have such a vast number of possible outcomes as opposed to tic-tac-toe? The answer lies in the combination of the simple, but varied, behaviors of the game objects and their changing relationships to each other on the board. Because of the extremely varied possibility set, chess remains challenging and interesting to players long after they have mastered its basic rule set.

One of the most important aspects of a game is the sense of possibility that is presented to the players at any given time. As we discussed in the previous chapter when talking about challenge, the goal of the designer is to present a situation that is equal to the abilities of the players and yet grows in challenge over time with their abilities. It is clear from our two examples, tic-tac-toe and chess, that how a system is constructed dramatically changes the dynamics of that system over time and the range of possibilities that face the player at any given point.

The range and type of possibilities within the system is not a situation where more is better in all situations. Many successful games have a somewhat constrained set of possibilities, and yet they still offer interesting gameplay. For example, a linear board game like Trivial Pursuit has a very small possibility space in terms of outcome, but the overall challenge of the game is not affected by this. Some console games, like side-scrollers, have a similarly small range of possibilities: Either you successfully navigate the challenge or you are stuck. But this range of action works for these types of games. Story-based adventure games often have branching structures with a limited number of outcomes. For players of these games, navigating that defined set of possibilities is part of the challenge.

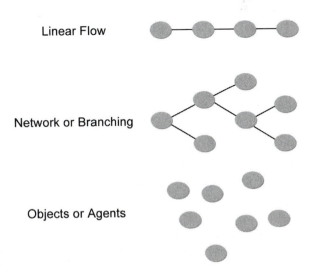

5.4 Various game structures

On the other hand, some games have attempted to create larger spaces of possibility for their systems. The way in which they do this is to introduce more objects into the system with defined relationships to each other. Simulation games (like The Sims), real time strategy games, and massively multiplayer worlds all use such an approach to creating increased possibilities. The desired effects of a larger possibility space are a greater scope of choice for the player, opportunities for creative solutions to game problems, and enhanced replayability, all of which are an advantage to capturing a certain type of game player.

The following example shows how two games with very similar objectives and related system designs can provide extremely different ranges of possibilities, and they therefore create completely different player experiences.

Mastermind versus Clue

The game of Mastermind is quite simple. In case you are not familiar with the game, Mastermind is a two player puzzle game in which one player is the puzzle-maker and the other is the puzzle-breaker. The puzzle is made up of four colored pegs (from a possibility of six colors), and the object of the puzzle-breaker is to solve the puzzle in as few guesses as possible. The procedures are also simple: On each turn, the puzzle-breaker makes a guess, and the puzzle-maker gives him feedback by showing how many pegs are: (1) the correct color and (2) the correct placement in the sequence. The puzzle-breaker uses a process of elimination and logic attempts to narrow the possibilities and solve the puzzle in as few guesses as possible.

Now let's look at the system structure. The objects in the game are the pegs, the properties are the colors, and the relationships are set by the puzzle-maker when they create the puzzle sequence. In the common version of Mastermind, the puzzle uses four pegs and six colors of pegs; repeated colors are allowed, so there are 6^4, or 1296, unique codes that can be made. If you added one more peg to the length of the code, you would have 6^5, or 7776, possibilities. If you added another color, you would have 7^4, or 2401.

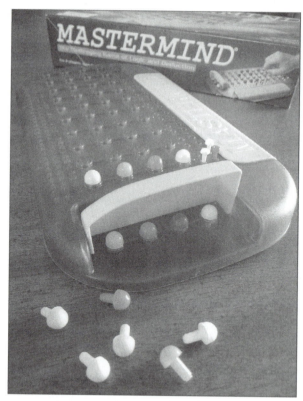

5.5 Mastermind

These choices are part of the game's system structure and define the possibility set for the players.

Even if you aren't a mathematician, you can see that adding another peg to the code would add such an exponentially greater number of possibilities that it would make the game potentially unplayable—or at least a lot harder. Adding another color would not be as great a change, but it would still double the number of potential puzzles and make the game significantly harder. The designers of Mastermind undoubtedly playtested these various combinations of the system before settling on four pegs and six colors.

Now let's look at Clue, or Cluedo as it is called in Europe. Clue has a similar puzzle-breaking objective, but that objective has a slightly different mathematical structure, and it is couched in a different set of procedural elements, resulting in an entirely different player experience.

5.6 Clue board, circa 1947

Clue is also a game of logic and deduction in which the objective is to solve a puzzle. But Clue is a game is for three to six players, and there are no special roles—all players are trying to deduce the answer to the puzzle. The game maps the premise of solving a murder onto the puzzle system and adds an element of chance into the procedures via the board and movement system.

In terms of its mathematical structure, the puzzles in Clue have a much smaller possibility set. There are six possible suspects, six possible weapons, and nine possible rooms, or $6 \times 6 \times 9 = 324$ possible combinations. The puzzle is mathematically simpler to solve, but players are hindered in their ability to guess the answer by the fact that they must roll the die and move around the board to gain information and make accusations. This addition of chance evens the playing field for those who might not have the best deduction skills (i.e., children) and makes Clue more accessible to a wider range of players. Also, the addition of the mystery premise and colorful characters provides a more compelling experience for some types of players; ergo, a "family game."

If we compare Mastermind and Clue, we see that both have similar objectives (i.e., solve a puzzle). Both

puzzles are combinatorial (i.e., they use combinations of existing sets to create a "random" puzzle for each play). Mastermind has many more possible puzzle combinations, so the puzzle is harder to deduce. Clue has more ways of finding information: a social structure of asking for information, reading other players' faces, etc. Mastermind uses logic and deduction. Clue also uses logic and deduction, but it adds more chance to the system (dice and movement), as well as story (characters and setting).

This comparison is not meant to suggest that there is any one correct way to design a game system, just as there is no one type of game player. But you might find, upon analyzing some of your favorite games, that they share successful system designs in terms of the properties, behaviors, and relationships of their objects. Studying how the dynamics of these systems work can help focus your own thoughts and explorations and help you meet your own player experience goals.

Exercise 5.4: System Dynamics

Now let's take the game you have been working with in Exercises 5.1, 5.2, and 5.3 and see how we can change the system dynamics by experimenting with the properties, behaviors, or relationships of its core objects.

1. For example, if you chose a game like Monopoly, change the prices, placement, and rent of every property on the board or change the rules for movement. How you change these things is up to you, but make significant changes.

2. Now play the game. What happens? Did your changes affect the balance of the game? Is the game still playable?

3. If the system is still playable, make another change. For example, take out all the "positive" Chance cards in Monopoly and leave in only "negative or neutral" cards. Play the game again. What happens?

4. Continue doing this exercise until the game is no longer playable.

What was the crucial change you made? Why do you think that change finally broke the game?

One important type of system structure often found in games is an economy. We are going to look more closely at this structure because it involves dynamics surrounding the resources in a game, one of the fundamental formal elements of games.

Economies

What is an economy? As we touched on briefly in our discussion of the utility and scarcity of resources in Chapter 3, some games also allow for the exchange of resources—either with the system (i.e., the bank in Monopoly) or among players. When a game allows exchanges of this kind, the system of trade forms a simple economy. In more complex systems, the rules of real-world economies might apply, but more often, games have severely controlled economies that only vaguely resemble real-world markets. Even so, there are some basic concepts of economic theory that we can use as a barometer for the feasibility of our game economies.

First of all, to have an economy, a game must have items of exchange, such as resources or other barterable items; agents of exchange, such as players or the system bank; and methods of exchange, such as markets or other trading opportunities. Also, an economy may or may not have currency, which helps to facilitate trade. As in the real world, the methods by which prices are set in an economy depend on what type of market controls are in place. Prices of market items in games can be free, fixed, or subject to a mixture of controls, depending on the design of the system. Also, the opportunities players have for trade can range from complete freedom to controls on prices, timing, partners, amount, etc. Here are some basic questions a designer should ask before building a game economy:

- Does the size of the economy grow over the course of the game? For example, are resources produced, and if so, is the growth controlled by the system?
- If there is a currency, how is the supply of that currency controlled?
- How are prices set in the economy? Are they controlled by market forces or set by the game system?

- Are there any restrictions on opportunities for trade among participants; for example, by turn, time, cost, or other constraints?

To get a sense for how games handle these economic variables, let's look at some examples ranging from classic board games to massively multiplayer online worlds.

Simple Bartering

Pit is a simple card game in which players barter for various commodities to "corner the market." There are eight suits of commodities, nine cards in each suit. The commodities are worth a varying number of points from 50–100. For example, oranges are worth 50 points, oats are worth 60 points, corn is 75, wheat is 100, etc. You start with the same number of suits in the deck as there are players—from three to eight.

The cards are shuffled and dealt out evenly to all the players. During each round, players trade by calling out the number of cards they want to trade but not the name of the commodity on the cards offered. Trade continues until one person holds all nine cards of a single commodity—a "corner" on that market.

There are several features to note in this simple barter system. First, the amount of product (i.e., cards) in the system is stable at all times—cards are not created or consumed during play. Additionally, the value of each card never changes relative to the other cards

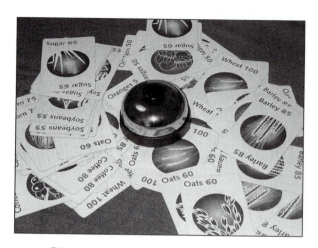

5.7 Pit

in the deck. The value is fixed by the printed point value set before the game begins. Also, the opportunity to trade is only restricted by number—all trades must be for an equal number of cards. Other than this, trade is open to all players at all times.

In this simple barter system, the in-game economy is so restricted by the rules of the game that there is no opportunity for economic growth, no fluctuation of prices based on supply and demand, no chance for market competition, etc. However, the trading system serves its purpose as an excuse for creating a frenetic, social trading atmosphere without any of the complexities of a real-world economy. To recap the features of this system:

- Amount of product = fixed
- Money supply = n/a
- Prices = fixed
- Trading opportunities = not restricted

Complex Bartering

Settlers of Catan is a German board game by designer Klaus Teuber in which players compete as pioneers developing a new land. During the course of the game, players build roads and settlements that produce resources such as brick, lumber, wool, ore, and wheat. These resources can be traded with other players and used to build more settlements and upgrade settlements to cities, which in turn produce more resources.

As in Pit, the bartering of resources is a central part of the gameplay, and the trade in this game is also fairly unrestricted, with the following exceptions:

- You may only trade with a player on their turn.
- Players can only trade resources, not settlements or other game objects.
- A trade must involve at least one resource on each side (i.e., a player cannot simply give a resource away). However, trades can be made for unequal amounts of resources.

Other than these constraints, players can wheel and deal as they like for the resources they need. For example, if there is a scarcity of brick in the economy,

players can trade two or three of another resource, such as wheat, for one brick.

As you can probably judge already, the economy of Settlers of Catan is much more complex than the simple barter system of Pit. One of the key differences is the fact that the relative values of the resources fluctuate depending on market conditions, an interesting and unpredictable feature that changes the experience of the game from play to play. If there is a glut of wheat in the game, the value of wheat falls immediately. On the other hand, if there is a scarcity of ore, players will trade aggressively for it. This simple example of the laws of supply and demand adds a fascinating aspect to gameplay that we did not see in the Pit example.

Another key difference from the simple bartering in Pit is that in Settlers of Catan, the total amount of product in the economy changes over the course of the game. Each player's turn has a production phase, the results of which are determined by a roll of the dice and the placement of player settlements. Product enters the system during this phase. Product is then traded and "consumed" (used to purchase roads, settlements, etc.) during the second phase of the player's turn.

To control the total amount of product in the system at any time, the system includes a punishment for holding too many resources in your hand. If a player rolls a seven during the production phase of their turn, any player holding more than seven cards has to give half of their hand to the bank. In this way, players are discouraged from hoarding and are encouraged to spend their resources as they earn them.

Another aspect of the economy that is interesting to note is the fact that while the barter system is fairly open, there is a control on price inflation. The bank will always trade 4:1 for any resource; this effectively caps the value of all resources. And, as we also noted, while the trading system itself is quite open, the opportunity to trade is restricted by player turn.

The last difference between these two barter systems is their information structures. In Settlers of Catan, players hide their hands, but the production phase is an open process, so by simply paying attention to which players are getting certain resources on

5.8 Barterable resources from Settlers of Catan

each turn, an attentive player can remember some, if not all, of the game state.

- Amount of product = controlled growth
- Money supply = n/a
- Prices = market value with cap
- Trading opportunities = restricted by turn

Exercise 5.5: Bartering Systems

For this exercise, take the simple barter game of Pit and add a new level of complexity to its trading system. One way to do this might be to create the concept of dynamically changing values for each of the commodities.

Simple Market

The first two examples we have looked at have both been barter systems (i.e., they did not employ currency). The next type of system we will look at is the simple market system of Monopoly. In Monopoly, players buy, sell, rent, and improve real estate in an attempt to become the richest player in the game.

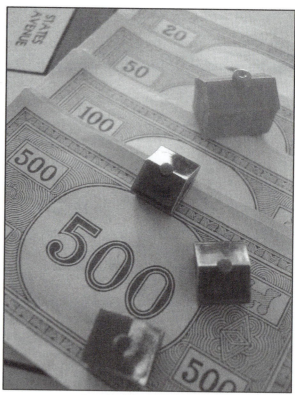

5.9 Monopoly money and property

The real estate market in the game is finite—there are 28 properties in the market (including railroads and utilities) at all times. Although properties are not sold until a player lands on their board space, they are still active in the sense that they are available for purchase.

Each player begins the game with $1500 from the bank that they can use to purchase properties or pay rent and other fees. The growth of the economy is controlled by the rate at which players can circle the board, passing "Go" to collect $200. According to the official rules, the bank never goes broke; if it runs out of money, the player acting as banker can create new notes out of slips of paper.

In terms of trading opportunities, the rules state that buying and trading of properties between players can occur at any time, although "etiquette suggests that such transactions occur only between the turns of other players."[3]

Values of properties in the game are set in two basic ways. First, there is the face value on the title deed; if a player lands on a property, she may purchase it for this amount. If she fails to purchase the property, it goes up to auction and sells to the highest bidder. The auction is not limited by the face value, and the player who passed up purchasing it may bid in the auction. After a property is purchased, it can be traded between players at any price they agree upon. So the second and more important value of properties in the game is a true market value set by the competition of the players.

- Amount of product = fixed
- Money supply = controlled growth
- Prices = market value
- Trading opportunities = not restricted

Complex Market

For examples of complex market economies, we'll look at two games: Ultima Online and EverQuest. The two economies have much in common overall, but different emphases in their designs have created unique situations for each system. The key similarity in these and other online worlds is the fact that they have persistent economies that surpass a single game session by any one player. This immediately puts them in a category of complexity far beyond all the other examples we have looked at so far. The assumption often is that real world economies apply directly to their systems because of the persistence of economy in these games and because they strive to create a sense of an alternate world.

In both games, players create characters, or avatars, that begin the game with a small number of resources—a little gold in Ultima or platinum in EverQuest, some minimal armor, and a weapon. Now players must enter the "labor market" to gain more resources. In both games, players begin at the lowest level of the labor market—killing small animals or doing other menial work to earn money. They can sell the results of their labor to system agents (in the form of shopkeepers) or to other players, if they can find interested buyers. In addition to the labor market, players can find, make, buy, or sell more complex items than those gained by labor. Items like weapons, armor, and magic items are part of a complex "goods" market.

In both games, goods and labor are traded in two ways: player to player and player to system. In both games, player to system trade, controlled by the game designers, exists to keep low-level "employment" steady while encouraging the player to trade in scarce items. For example, shopkeepers will generally buy anything a player wants to sell, even if there is a glut of the object in the market. This keeps newbies steadily "employed." On the other hand, the shopkeepers' offers to buy on higher-level items will not be as competitive as the player to player market, encouraging players to seek out higher prices from one another.

In this way, the games create markets that mimic real-world situations in important ways and contradict real-world expectations in others. Supply and demand is a factor for players dealing at higher levels of commerce, with scarce or unique items, but it is not a factor for a newbie just trying to get ahead.

The amount of product in the system is controlled by the game designers, although Ultima at first tried to create a self-regulating flow in which resources were recycled through the system, available to respawn as new creatures and other materials as they were "spent" by the players. This was quickly changed to a system in which the flow of resources into the economy could be directly controlled by the designers. There were several reasons for this, one of which was a tendency for players to hoard game objects, restricting the total amount of products circulating in the game.

In both games, a metaeconomy has emerged separate from official gameplay in which characters and game objects are sold between players in real-world markets. Characters have been offered on sites such as eBay and Yahoo! Auctions sometimes sell for hundreds of dollars, depending on the level and inventory offered. While this metaeconomy was not a planned feature of these role-playing games, there are games that have included the concept of a metaeconomy in their designs.

The Jolly Roger Catskills, Felucca Facet, 85 15' N, 141 11'E

The Jolly Roger Tavern, a dirty but legendary tavern, is the heart of the town of Red Skull Bay and home to fighting contests and some of the best ale in all Britannia. Landlubbers and sailors alike are invited to have a look at this unique bay, and raise a bottle of ale or two with the residents of Red Skull Bay.

5.10 Player-run establishment in Ultima Online

- Amount of product = controlled growth
- Money supply = controlled growth
- Prices = market value with base
- Trading opportunities = not restricted

Metaeconomy

Magic: The Gathering is somewhat different from the other example games we have looked at, in that the game itself does not include a trading or exchange component. The main system of Magic is a dueling

game in which players use custom-designed decks of cards to battle each other. These cards, purchased by individual players, form the central resource in a metaeconomy surrounding the game itself.

Magic: The Gathering was designed by Richard Garfield and released by Wizards of the Coast, a Seattle-based game company, in 1993. At the time, Garfield was a mathematics professor at Whitman College as well as a part-time game designer. Wizards asked him to design a card game that was quick, fun, and playable in under an hour. But Garfield imagined

a game that had the collectible nature of trading cards or marbles, combined with the qualities of Strat-O-Matic Baseball, in which players draft and compete their own teams. The result was a collectible card game that has been likened to "gaming crack."

As mentioned, the game Garfield designed is a two player dueling game with a fantasy theme. Each player has a deck of cards that consists of various spells, monsters, and lands. Land provides mana, which powers spells. These spells summon monsters that you use to attack your opponent. This would seem pretty straightforward except for the fact that a basic deck of game cards does not include all the cards in the system. In fact, it contains a mere fraction of the cards available. Players are encouraged to buy booster sets and to upgrade their deck as new revisions are released. And, important to our discussion of game economies, players can also buy and trade cards from each other, which they do aggressively. The market for Magic cards, and other similar trading game cards, is worldwide, now greatly facilitated by the Internet.

The publisher of the game has control of the overall shape of this economy, in that they gauge how many cards to release—some cards are very rare, some are just uncommon, and others are not valuable at all because there are simply far too many of them available. But the publisher has no control over where and how these cards are traded after they have been purchased; and, other than rarity, they have no control over the prices set for these game objects.

In addition to the collectible nature of Magic and the metaeconomy formed by the trade of its game objects, there is an in-game aspect to this metaeconomy. Players choose cards from their collection to build decks, adjusting the amount of land and the types of creatures and spells to strike a winning balance.

This process of building and testing decks for effectiveness is similar to the process a game designer would go through when testing the balance of their system, and, of course, the designers of Magic work hard to make sure that any single cards or combinations of cards are not so overpowered as to imbalance the game. But the final decisions regarding resource

balance are left in the hands of the player and are highly affected by the metaeconomy surrounding the game.

The openness of the Magic system, and its success as a business as well as a game, has spawned a whole genre of trading games. As with the current interest in online worlds, it is clear that much of the success of these future games will depend on how their in-game and metagame economies are managed over time.

- Amount of product = controlled growth
- Money supply = n/a
- Prices = market value
- Trading opportunities = not restricted

As you can see, there are a wide variety of economies, ranging from simple bartering to complex markets. The task of the designer is to wed the economic system with the game's overall structure.

5.11 Magic: The Gathering cards

The economy must tie directly into the player's objective in the game and be balanced against the comparative utility and scarcity of the resources it involves. Every action the player performs in relation to the economic system should either advance or hinder their progress in the game.

Economies have the potential to transform rudimentary games into complex systems, and if you are creative, you can use them as a way to get players to interact with one another. There is nothing better for community building than an underlying economy, which makes socializing into a game.

Developing new types of in-game economies is one of the areas in which modern game design has just begun to explore the potential. Even with the success of EverQuest, and more recently Word of Warcraft, we are just beginning to understand the power of these systems. The fusing of economic models and social interaction is one of the most promising areas for future game experimentation, and in the next decade, we will see new types of Internet-based games emerge that challenge our conception of what a game can be.

Emergent Systems

We have talked about how game systems can display complex and unpredictable results when set in motion. But this does not mean that their underlying systems must be complex in design. In fact, in many cases, very simple rule sets, when set in motion, can beget unpredictable results. Nature is full of examples of this phenomenon, which is called "emergence." For example, an individual ant is a simple creature that is capable of very little by itself and lives its life according to a simple set of rules. However, when many ants interact together in a colony, each following these simple rules, a spontaneous intelligence emerges. Collectively the drone ants become capable of sophisticated engineering, defense, food storage, etc. Similarly, some researchers believe that human consciousness might be a product of emergence. In this case millions of simple "agents" in the mind interact to create rational thought. The topic of emergence has spawned dozens of books that explore links between previously unconnected natural phenomena.

One experiment in emergence that is interesting for game designers is called the Game of Life. (No, it is not related to Milton Bradley's board game The Game of Life.) This experiment was conducted in the 1960s by a mathematician at Cambridge University named John Conway. He was fascinated with the idea that rudimentary elements working together according to simple rules could produce complex and unpredictable results. He wanted to create an example of this phenomenon so simple that it could be observed in a two-dimensional space like a checkerboard.

Building on the work of mathematicians before him, Conway toyed with rules that would make squares on the board turn "on" or "off" based on their adjacency to the other squares around them. Acting very much like a game creator, he designed, tested, and revised different sets of rules for these cells for several years with several associates in his department at Cambridge.

Finally he arrived at this set of rules:

- *Birth:* If an unpopulated cell is surrounded by exactly three populated cells, it becomes populated in the next generation.
- *Death by loneliness:* If a populated cell is surrounded by fewer than two other populated cells, it becomes unpopulated in the next generation.
- *Death by overpopulation:* If a populated cell is surrounded by at least four other populated cells, it becomes unpopulated in the next generation.

Conway and his associates set Go pieces on a checkerboard to mark populated cells, and they administered the rules by hand. They found that different starting conditions evolved in vastly different ways. Some simple starting conditions could blossom into beautiful patterns that would fill the board, and some elaborate starting conditions could fizzle into nothing. An interesting discovery was made with a configuration called R Pentomino. Figure 5.12 shows the starting position for the R Pentomino, followed by several generations.

One of Conway's associates, Richard Guy, kept experimenting with this configuration. He administered the rules for a hundred generations or so and watched a mishmash of shapes appear. Then suddenly

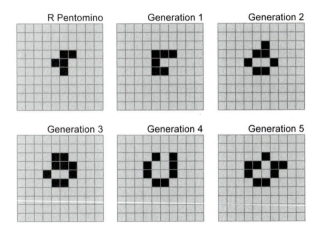

5.12 R Pentomino over several generations

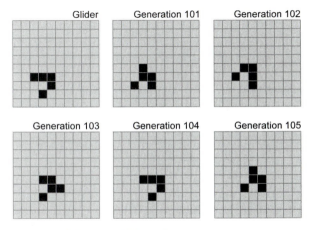

5.13 Glider "walk" cycle

a set of cells emerged from the group and appeared to "walk" on its own across the board. Guy pointed out to the group, "Look, my bit's walking!"[4] Guy worked on the configuration until it walked across the room and out the door. He had discovered what the group would call a "glider." A glider is a configuration that cycles through a set of shapes and moves along the board as it goes. Figure 5.13 shows what several generations of Guy's glider look like.

Conway's system was dubbed the Game of Life because it showed that from simple beginnings, life-form-like patterns could develop. There are a number of emulators online that you can download and experiment with. You will see that some use different

5.14 The Sims

rules and allow you to create your own starting conditions.

These types of systems are interesting to game designers because games can employ emergent techniques to make more believable and unpredictable scenarios. Games as different as The Sims, Grand Theft Auto 3, Halo, Black & White, Pikmin, Munch's Oddysee, and Metal Gear Solid 2 have all experimented with emergent properties in their designs.

One recent example, as mentioned in Chapter 4, is the character AI in the Halo series. Nonplayer characters have three simple impulses that drive them: (1) perception of the world around them (aural, visual, and tactile), (2) state of the world (memories of enemy sightings and weapon locations), and (3) emotion (growing scared when under attack, etc.).[5] These three sets of rules interact—each consulting the other—as a decision-making system in a character. The result is semirealistic behavior within the game. The nonplayer characters do not follow a script written by a designer but rather make their own decisions based on the situation they are in. For example, if all of their friends have been killed and they are facing overwhelming firepower from the enemy, they tend to run away; otherwise, they stay and fight.

Different games utilize different methods for creating emergent behavior. The Sims embeds simple rules in both the characters and in items in the environment. Will Wright, creator of The Sims, built the

household items in the game to have values. When a character gets near an item—such as a bed, refrigerator, or pinball machine—the rules in the character interact with the rules in the item. So if a character's rules say he is sleepy, then an item that provides comfort, such as a bed, might attract his attention.

All of the previous examples share the same basic concept that simple rules beget complex behavior when interacting within a system. This concept is an exciting and fast-moving aspect of games today, and it is wide open to experimentation and innovation.

INTERACTING WITH SYSTEMS

Games are designed for player interaction, and the structures of their systems are integrally related to the nature of that interaction. Some of the things that need to be considered when designing for interaction are:

- How much information do players have about the state of the system?
- What aspects of the system do players control?
- How is that control structured?
- What type of feedback does the system give the players?
- How does this affect the gameplay?

Information Structure

For players to make choices about how to proceed in a game, they need information about the state of the game objects and their current relationships to each other. The less information players have, the less informed their choices will be. This affects the sense of control they have over their progress. It can also add to the amount of chance in the system and allow space for misinformation or deception as a part of the gameplay.

To understand the importance of information in a game system, think about what types of information you are given in some of the games that you like to play. Do you know the effect of every move you make? What about the other players? Is there information that you only have access to some of the time?

How information is structured in a game has a large influence on how players come to their decisions. In classic strategy games like chess and Go, the players have complete information about the game state. This is an example of an open information structure.

An open structure emphasizes player knowledge and gives full disclosure on the game state. It will generally allow for more calculation-based strategy in the system. If this is the type of play you want to encourage in your system, you need to make sure that important information is available to your users.

On the other hand, if you want to create play situations built around guessing, bluffing, or deceiving, you might want to consider hiding information from players. In a hidden information structure, players do not receive certain data about their opponent's game state. A good example of this is the 5-card stud variation of poker in which all cards are dealt facing down. In this game, the only information players have about their opponents' hands is how many cards they are dealt and the way in which they bet. This hidden information structure allows for a different type of strategy to develop—one based on social cues and deception rather than calculation. It tends to appeal to an entirely different type of player.

Exercise 5.6: Hidden Information

Many strategy games have open information structures that allow the players access to perfect information about the game state. Examples are chess, checkers, Go, mancala, etc. Take a game with an open information structure and change the system so that there is an element of hidden information. You might need to add new concepts to the game to accomplish this. Test your new design. How does adding hidden information change the nature of the strategy? Why do you think this is so?

Many games use a mixture of open and hidden information so that players are given some data

about the state of their opponent's game, but not all. An example of such a mixed information structure might be the 7-card stud variation of poker where several cards are dealt down and several up over the course of the betting cycle, giving players only partial information about their opponents' hands. Another example of a mixed information structure is black-jack, for the same reasons.

The amount of information that players receive about their opponents' states often changes during the course of the game. This might be because they have learned information by interacting with their opponents, or it might be because the concept of a dynamic information structure is built into the game. For example, real-time strategy games like the WarCraft series use the concept of "fog of war" to provide dynamically changing information to players about their opponents' status. In this game, players can see the state of their opponents' territory if they move a unit into that territory. When they move the unit out of the territory, the information freezes until another unit ventures back to the territory.

A dynamically changing information structure provides an ever-shifting balance between strategy based on knowledge and strategy based on cunning and deceit. For the most part, this type of advanced information structure has only been possible since the advent of digital games and the computer's ability to orchestrate the complex interactions between players.

Exercise 5.7: Information Structures

What type of information structures are present in Unreal Tournament, Age of Empires, Jak II, Madden 2008, Lemmings, Scrabble, Mastermind, and Clue? Do they have open, hidden, mixed, or dynamic information structures? If you do not know one of the games, pick a game that we have not mentioned and substitute it.

Control

The basic controls of a game system are directly related to its physical design. Board games or card games offer control by direct manipulations of their equipment. Computer games might use a keyboard, mouse, joystick, or alternate types of control devices. Console games usually provide a proprietary controller. Arcade games often use game-specific controls. Each of these types of controls is best suited to certain types of input. Because of this, games that require specific input types have been more successful in some game platforms than others. For example, games that require text entry have not been as popular on consoles as they have been on PCs.

The range of control types for games is extreme, everything from pencil and paper to flight simulations with mock cockpits. The arcade simulation games of Yu Suzuki, for example, offer realistic controls shaped like full-scale motorcycles and racing cars. The goal of some games is to make control of game systems as realistic and responsive as possible. Others provide a more abstract, less realistic control system.

One type of control system is not inherently better than another. What matters is whether or not the control system is well suited for the game experience, and it is the job of the designer to determine this. We encourage you to think about the games you like to play. What type of controls do you enjoy? Do you prefer to have direct control over the game elements, such as you might have when moving your character through a 3D shooter? Or indirect control, as in a game like SimCity? Do you prefer real time control, like in WarCraft, or turn-based control, as in Warlords II? These decisions will have a huge impact on what type of game you design and how you go about structuring it.

Direct control of movement is a clear-cut way for players to influence the state of the game. Players can also have direct control over other types of input, like selection of items, directly presented choices, etc. Some games do not offer direct control, however. For example, in a simulation game like Rollercoaster Tycoon, players do not have direct control over the guests at their theme park. Instead, players can change ride variables, trying to make certain rides more attractive by lowering price, increasing throughput, or improving the ride design. This indirect control offers ways for players to influence the state of the game that is one step removed from the desired changes and provides an interesting type of challenge within certain game systems.

5.15 Indirect control: Rollercoaster Tycoon

When the designer chooses what type of control to offer to players, he is deciding a very important part of the game. This decision forms the top-level experience that players will have with the system. Control often involves a repetitive process or action performed throughout a game, referred to as the "core mechanic." If this basic action is hard to perform, unintuitive, or just not enjoyable, the player might stop playing the game altogether.

In addition to deciding the level of control, the designer also needs to consider restricting control of some elements completely. As we discussed when we talked about designing conflict, games are made challenging by the fact that the players cannot simply take the simplest route to a solution. This is true in terms of designing controls as well. Some games allow a high degree of freedom in terms of player control. For example, a 3D shooter allows for spontaneous, real time movement throughout the environment. Other games restrain player control tightly, using this structure to provide part of the challenge. An example of this would be a turn-based strategy game, like Go or chess.

How do you decide what controls to allow players and what not to allow? This is a central part of the design process. You can see the impact that different levels of input have on games if you look at a familiar game and imagine how it would work if you took away some of the player input.

For example, let's look at a real time strategy game like WarCraft III. In this game, the player selects certain units to mine gold, others to chop trees, etc. How many units are doing these tasks at any given time is a function of availability, but it is basically under the player's control. What if this opportunity for control was taken away? Imagine how the system would work if the designer determined that system would always assign 50% of the available units to mine gold and 50% to chop trees. How would taking this input away from the player affect the system? Would it create too much balance between various players' resources? Would it take away some tedious parts of gameplay? Or would it take away critical resource management? These are questions a designer faces when thinking about how much and what type of control to give players in the system.

Exercise 5.8: Control

For the same games mentioned in Exercise 5.6, describe the methods of control they use: direct or indirect, real time or turn based. Are there any cases in which these distinctions are mixed?

Feedback

Another aspect of interaction with the system is feedback. When we use the word "feedback" in general conversation, we often are just referring to the information we get back during an interaction, not what we do with it. But in system terms, feedback implies a direct relationship between the output of an interaction and a change to another system element. Feedback can be positive or negative, and it can promote divergence or balance in the system.

Figure 5.16 shows example feedback loops for two different types of game scoring systems. In the first example, if a player scores a point, they get a free turn. This reinforces the positive effects of the scored point, creating an advantage for that player. A negative feedback loop, on the other hand, like that on the right, works against the effect of the point. In this example, every time a player scores a point, they

5.16 Positive and negative feedback loops

5.17 Reinforcing and balancing relationships over time

must pass the turn to the other player. This has the effect of balancing the system between the two players rather than allowing one player to get a larger advantage over the other.

"Positive" and "negative" are somewhat loaded terms, and some systems theories use the terms "reinforcing" and "balancing" instead. Generally, reinforcing relationships are ones in which a change to one element directly causes a change to another element in the same direction. This might force the system toward one or the other extreme. By contrast, in balancing relationships, a change to one element causes a change to another in the opposite direction, forcing the system toward equilibrium.

For example, in the game Jeopardy!, when a player answers a question correctly, she retains control of the board. This presumably gives the leading player an advantage in answering the next question, reinforcing her lead in the game and moving the system toward resolution in their favor. This is a reinforcing relationship, or loop. An example of the same type of relationship, but in the opposite extreme, would be if a Jeopardy! player who answered incorrectly was forced to sit out the next question. This is not a rule in

A Conversation with Will Wright

by Celia Pearce

Will Wright is cofounder of game developer Maxis Inc. He is famous for thinking outside the box with his game creations and is the mind behind SimCity, The Sims, and many other hit titles. When Will started work on The Sims, publishers tried to dissuade him from the project on the grounds that no one would play such a game. The Sims is the current best-selling title of all time. This is an excerpt of a conversation between Will and game designer/researcher, Celia Pearce. The full discussion appears in the online journal "Game Studies" at http://www.gamestudies.org/0102/pearce/. It is reprinted here with permission.

On why he designs games:

Celia Pearce: *I wanted to start out by talking about why you design games. What is it about the format of an interactive experience that is so compelling to you? And what do you want to create in that space?*

Will Wright: Well, one thing I've always really enjoyed is making things. Out of whatever. It started with modeling as a kid, building models. When computers came along, I started learning programming and realizing the computer was this great tool for making things, making models, dynamic models, and behaviors, not just static models. I think when I started doing games I really wanted to carry that to the next step, to the player, so that you give the player a tool so that they can create things. And then you give them some context for that creation. You know, what is it, what kind of kind of world does it live in, what's its purpose? What are you trying to do with this thing that you're creating? To really put the player in the design role. And the actual world is reactive to their design. So they design something that the little world inside the computer reacts to. And then they have to revisit the design and redesign it, or tear it down and build another one, whatever it is. So I guess what really draws me to interactive entertainment and the thing that I try to keep focused on is enabling the creativity of the player. Giving them a pretty large solution space to solve the problem within the game. So the game represents this problem landscape. Most games have small solution landscapes, so there's one possible solution and one way to solve it. Other games, the games that tend to be more creative, have a much larger solution space, so you can potentially solve this problem in a way that nobody else has. If you're building a solution, how large that solution space is gives the player a much stronger feeling of empathy. If they know that what they've done is unique to them, they tend to care for it a lot more. I think that's the direction I tend to come from.

On the influences of SimCity:

CP: *When you were first working on SimCity, what was going on in the game world at that time? Were you responding to games that were out there, were you wanting something different? Were there things that influenced you at all in the game world or were you just totally in a different mindset?*

WW: There were things that influenced me—not many though. There was a very old game called Pinball Construction Set by Bill Budge, which was great. He was kind of playing around with the first pre-Mac Lisa interface, which was icon-based. He actually put this in the game, even though it was an Apple II game. He kind of emulated what would later become the Mac interface. But it was very easy to use, and you would create pinball sets with it, which you could then play with. I thought that was very cool.

Also early modeling things, like the very first flight simulator by Bruce Artwick which had this little microworld in the computer with its own rules, kind of near reality to some degree, but at a very low resolution. But yet it was this little self-consistent world that you could go fly around in and interact with, in sort of limited ways.

So those are some of the influences. But then mostly, stuff I read. I started getting interested in the idea of simulation. I started reading the early work of people like Jay Forrester, starting with that, going forward. When I did SimCity, the games at the time really were much more about arcade style action, graphics, very intense kinds of experiences. There were very few games that were laid back, more complex.

CP: *They were more twitch-type games at that time?*

WW: Yeah, the games that were more complex were these detailed war games. I had played those as a kid, these board games. With 40-page rule sets.

CP: *Like what?*

WW: Oh, like Panzer Blitz was a big one, Global War, Sniper.

CP: *Were those ones with the hex-grid boards?*

WW: Yeah, they had a 40-page rule book, and you'd play with your friend. And it ended up being . . . I mean, I think it would be excellent training for a lawyer. Because you're sitting there, most of the time, arguing over interpretations of these very elaborate rules. And you could actually combine the rules and say, "Well, this was in panic mode so he couldn't go that far." "Well, my indirect fire has a three-hex radius of destruction." So you'd sit there and argue over this little minutia of the rules. And that was kind of half the fun of it—both of you trying to find the legal loopholes for why your guy didn't get killed. So I was familiar with that stuff, but I knew at the same time that most people couldn't relate to that at all. But yet the strategy of those games was actually quite interesting. It was interesting to have a game where you'd sit back and you'd think about it, and the model was far more elaborate than you could really run in your head. So you had to approach it kind of in a different way.

On experimentation as a play mechanic:

CP: *I wanted to ask you about this idea of experimentation as a play mechanic. That seems like a big aspect of your games, that play and experimentation are working together.*

WW: The types of games we do are simulation based and so there is this really elaborate simulation of some aspect of reality. As a player, a lot of what you're trying to do is reverse engineer the simulation. You're trying to solve problems within the system, you're trying to solve traffic in SimCity, or get somebody in The Sims to get married or whatever. The more accurately you can model that simulation in your head, the better your strategies are going to be going forward. So what we're trying to do as designers is build up these mental models in the player. The computer is just an incremental step, an intermediate model to the model in the player's head. The player has to be able to bootstrap themselves into understanding that model. You've got this elaborate system with thousands of variables, and you can't just dump it on the user or else they're totally lost. So we usually try to think in terms of, what's a simpler metaphor that somebody can approach this with? What's the simplest mental model that you can walk up to one of these games and start playing it, and at least understand the basics? Now it might be the wrong model, but it still has to bootstrap into your learning process. So for most of our games, there's some overt metaphor that allows you approach the simulation.

CP: *Like?*

WW: Like for SimCity, most people see it as kind of a train set. You look at the box and you say, "Oh, yeah, it's like a train set come to life." Or The Sims, "It's like a dollhouse come to life." But at the same time, when you start playing the game, and the dynamics become more apparent to you, a lot of time there's an underlying metaphor that's not so apparent. Like in SimCity, if you really think about playing the game, it's more like gardening. So you're kind of tilling the soil, and fertilizing it, and then things pop up and they surprise you, and occasionally you have to go in and weed the garden, and then you maybe think about expanding it, and so on. So the actual process of playing SimCity is really closer to gardening. In either case, your mental model of the simulation is constantly evolving. And in fact you can look at somebody's city that they designed at any point and see that it's kind of a snapshot of their current understanding of the model. You can tell by what they've done in the game—"Oh, I see they think this freeway is going to help them because they put it over here." So it gives you some insight into their mental model of the game.

CP: *What's the underlying metaphor of The Sims? The less obvious one, the garden-level one?*

WW: That depends on how you play the game. For a lot of people, the mainstream game is more like juggling, or balancing plates. You start realizing that you basically don't have enough time in the day to do everything that you want to do. And you're rushing from this to that to this, and then you're able to make these time decisions. So it feels very much like juggling and if you drop a ball, then all of a sudden, the whole pile comes crashing down. But other people play it differently. So it's kind of hard. With The Sims I've thought about that, and it's not as clear to me what The Sims is. I think that SimCity has a more monolithic play style, once people get into it, than The Sims does. In The Sims people tend to veer off in a different direction. Some people go off into the storytelling thing. So eventually the metaphor becomes that of a director on a set. You're trying to coerce these actors into doing what you want them to do, but they're busy leading their own lives. And so you get this weird conflict going on between you and The Sims where you're trying to tell a story with the game but they want to go off and eat, and watch TV, and do whatever.

CP: *Like real actors.*

WW: Yes, exactly. Kind of like little actors who just won't do what you want them to do.

On his favorite game:

CP: *Let's shift gears a little here and talk about your favorite games. And not just limiting it to computer games, but any games you like. What's your favorite game?*

WW: My favorite game by far probably is Go. The board game.

CP: *That's no surprise to me.*

WW: (Laughs.) That game is just so elegant in that it's got two rules really, one of which is almost never used. But yet from those two rules flow this incredible complexity. It's kind of the board game version of John Conway's Game of Life, the cellular automata game. It's not dissimilar.

On the emergent properties of games:

CP: *When you were talking about Go, I was thinking that when you create a mental model of the environment as it is now, you're also creating a model of how you want it to be. So in Go the mental models have to do with imagining where the players want the game to go, right?*

WW: Right.

CP: *And then as the game fills itself out, as the emergent properties come forth . . .*

WW: . . . and of course part of that model is modeling what the other player is likely to do. "Oh, I think they're going to play very aggressively; therefore, my model of them says that this would be the optimum strategy."

CP: *So that's interesting, because there's also this aspect of imagination, which you alluded to earlier.*

 And that sort of brings me back to a question about SimCity and The Sims. Each of those games has a different level of abstraction from the other. You can really see the different choices that are made in terms of design. But in terms of this modeling idea, you briefly alluded to the use of The Sims from a directorial standpoint as a storytelling tool, and that in a way, there's a little bit of a dynamic that goes on because the game doesn't want to be, the characters don't want to be used that way necessarily.

 So I'm just curious how you grapple with that. I mean you're obviously taking that into account. Are you making a way to use the game as a storyboarding tool, or continuing to play around with the tension that the characters are kind of resisting that kind of control?

WW: It's actually very interesting in The Sims how the pronouns change all the time. I'm sitting there playing the game and I'm talking about, "Oh, first I'm going to get a job, then I'm going to do this, then I'm going to do that." And then you know when the character starts disobeying me, all of a sudden I shift and say, "Oh, why won't he do that?" or, "What's he doing now?" And so at some point it's me kind of

inhabiting this little person, and I'm thinking, "It's me; I'm going to get a job and I'm going to do x, y, and z." But then when he starts rebelling, it's he. And so then I kind of jump out of him, and now it's me versus him. You know what I'm saying?

CP: *Yes, I do. But one of things that interests me about the game is that you have these semiautonomous characters. They're not totally autonomous, and they're not totally avatars either. They're somewhere in between. Do think that's disorienting to the player, or do you think it's what makes the game fun?*

WW: I don't think so. I mean it's interesting. I'm just surprised that people can do it that fluidly, they can so fluidly say, "Oh, I'm this guy, and then I'm going to do x, y, and z." And then they can pop out and, "Now I'm that person. I'm doing this that and the other. What's he doing?" And so now he's a third person to me, even though he was me a moment ago. I think that's something we use a lot in our imaginations when we're modeling things. We'll put ourselves in somebody else's point of view very specifically for a very short period of time. "Well, let's see, if I were that person, I would probably do x, y, and z." And then I kind of jump out of their head and then I'm me, talking to them, relating to them.

At some level I want people to have a deep appreciation for how connected things are at all these different scales, not just through space, but through time. And in doing so I had to build kind of a simple little toy universe and say, here, play with this toy for a while. My expectations when I hand somebody that toy are that they are going to make their own mental model, which isn't exactly what I'm presenting them with. But whatever it is, their mental model of the world around them, and above them and below them, will expand. Hopefully, probably in some unpredictable way, and for me that's fine. And I don't want to stamp the same mental model on every player. I'd rather think of this as a catalyst. You know, it's a catalytic tool for growing your mental model, and I have no idea which direction it's going to grow it, but I think just kind of sparking that change is worthwhile unto itself.

CP: *But you're more interested in setting up the rule space and letting the outcome evolve with the player's experimentation.*

WW: Right, I mean what I really want to do is I want to create just the largest possibility space I can. I don't want to create a specific possibility that everybody's going to experience the same way. I'd much rather have a huge possibility space where every player has as unique an experience as possible.

CP: *One of the things that I think is interesting about what you do as a role model for interactive designers it that you enjoy the unpredictable outcome. When people do things that you didn't plan on, that seems to be something that you embrace.*

WW: To me, that feels like success.

About the Author

Celia Pearce is a game designer, artist, teacher, and writer. She is the designer of the award-winning virtual reality attraction Virtual Adventures: The Loch Ness Expedition, and the author of The Interactive Book: A Guide to the Interactive Revolution (Macmillan, 1997), as well as numerous essays on game design and interactivity. She is currently an assistant professor in the School of Literature, Communication and Culture at Georgia Tech, where she directs the Experimental Game Lab and the Emergent Game Group.

the game, but if it were, it would reinforce the repercussions of answering a question wrong.

Reinforcing loops cause output that either steadily grows or declines. Many games use reinforcing loops to create satisfying risk/reward scenarios for players that drive the game toward an unequal outcome based on player choices. To keep the game from resolving too quickly, however, balancing relationships are also used.

Balancing relationships, on the other hand, try to counteract the effects of change. In a balancing relationship, a change to one element results to a change in another element in the opposite direction. The classic example of a balancing relationship is in football. When one team scores, the ball is turned over to the other team. This gives a boost to the non-scoring team, attempting to balance the effects of the points won. If the advantage was given to the scoring team instead, it would be an example of a reinforcing relationship.

Some balancing relationships are not as easy to distinguish. For example, the board game Settlers of Catan has a procedure that attempts to create balance in the number of resources each player can hold at any one time. In this game, every time a seven is rolled with 2 six-sided dice, any players holding more than seven cards in their hand must give up half of them. This has the effect of keeping prosperous players from becoming too powerful and resolving the game too quickly.

To improve gameplay, a good designer must be able to evaluate how quickly or slowly the game is progressing, understand if there are patterns to growth or contraction in the system caused by reinforcing loops, and know when and how to apply a balancing factor.

TUNING GAME SYSTEMS

As mentioned earlier, the only way to fully understand a system is to study it as a whole, and that means putting it in motion. Because of this, after a game designer has defined the elements of her system, she needs to playtest and tune that system. The designer does this first by playing the game themselves, possibly with other designers, and then by playing with other players who are not part of the design process. In Chapters 10 and 11 we will discuss the tuning process in detail and a number of specific issues that your game system can exhibit, but in general, there are several key things that a designer is looking for when balancing a game system.

First, the designer needs to test to make sure that the system is internally complete. This means that the rules address any loopholes that could possibly arise during play. A system that is not internally complete creates situations that either block players from resolving the conflict or allow players to circumvent the intended conflict. This can result in "dead ends" of gameplay and, sometimes, in player conflict over the rules. If players argue over how the rules should deal with a particular situation, it is probably because the system is not internally complete.

When the system is judged to be internally complete, the designer will next test for fairness and balance. A game is fair if it gives all players an equal opportunity to achieve the game goals. If one player has an unfair advantage over another, and that advantage is built into the system, the others will feel cheated and lose interest in the system. In addition, a system can be unbalanced by the availability of dominant strategies or overpowered objects such as those described on pages 288–290. In these cases, the fact that one strategy or object is better than the others effectively reduces the meaningful choices for the player.

When a system is internally complete and fair for all players, the designer must test to make sure the game is fun and challenging to play. This is an elusive goal that means different things to every individual game player. When testing for fun and challenge, it is important to have clear player experience goals in mind and to test the game with its intended audience

of players. Generally, this is not the designer or the designer's friends.

For example, when a designer is testing a game for children, he might not be able to accurately judge the difficulty level, making the game too hard for its young audience. Determining the needs and skills of the target players and balancing a system for them requires a clear idea of who the target players are and a process for involving players from that target in the playtesting. Chapter 9, on playtesting, will talk more about how to identify those players and bring them into the design process. Testing for fun and challenge brings up a number of issues regarding player experience and improving the opportunity for meaningful choice that will be addressed in detail in Chapter 11.

CONCLUSION

We have looked at the basic elements of a game system and seen how the nature of the objects, properties, behaviors, and relationships create different dynamics of interaction, change, and growth. We have looked at how player interaction with these elements can be affected by the structures of information, control, and feedback.

One of the challenges in designing and tuning game systems is to isolate what objects or relationships are causing problems in gameplay and to make changes that fix the issue without creating new problems. When the elements are all working together, what emerges is great gameplay. It is the job of the game designer to create that perfect blend of elements that, when set in motion, produce the varieties of gameplay that bring players back time and again.

DESIGNER PERSPECTIVE: ALAN R. MOON

Game Designer

Alan R. Moon is an award-winning and prolific designer of board and card games, including Reibach & Co (1996), Elfenland (1998), Union Pacific (1999), Das Amulett (2001), Capitol (2001), San Marco (2001), Canal Grande (2002), and Ticket to Ride (2004).

On getting into the game industry:

I was hired by the Avalon Hill Game Co. in Baltimore to take over as editor of their house magazine called *The General*. But I never really assumed that job because when I got to Avalon Hill I started working on developing games. I loved working on games, hated editing. After working as a developer, I also started designing games. Four years later, I left Avalon Hill to go to Parker Brothers in Beverly, Massachusetts, as a designer in their video division.

On favorite games:

- *Spades*: Best partnership card game ever invented. Endlessly fascinating. Even if you are dealt the worst hand possible, you must still play it well and use it to score as many points as possible.

- *Hunters & Gatherers (second Carcassonne game by Hans im Glueck)*: On your turn, you draw a tile and play it, and then you can place one of your Meeples or not. That's all you do. But the game is constantly tense and exciting. Every game is different and you always feel like you can win right up until the end.

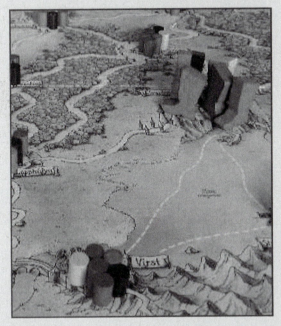

- *Adel Verpflichtet (originally F.X. Schmid and Avalon Hill, now ALEA and Rio Grande)*: Sort of advanced "rock, paper, scissors." Each turn, the five players initially choose one of two locations, dividing themselves into two groups. Then the players in each group compete against each other. The ultimate game about player tendencies and psychology. You have to learn to play against your natural inclinations or you'll become too predictable. Gets better and better the more you play with the same people.

- *Liars Dice/Bluff (originally Milton Bradley & F.X. Schmid, now Ravensburger and Endless Games)*: A dice version of the game gamblers play with dollar bills. The dice just provide the mechanics though, as there is little or no luck involved.

Elfenland

- *Crokinole (Generic):* Never thought I'd like an action game or a flicking game. But this one is totally addictive. Most people get better with practice too, which makes the game rewarding as well as fun.

Ticket to Ride

On game influences:

When I was a kid, my family played games every Sunday. I can still remember games of hearts, Risk, and Facts in Five. Hearts and bridge were the foundation for my love of card games, which has grown ever since. My friend Richard Borg described the fascination of cards the best when he said, "Every five or ten minutes you get a new hand, a new chance to get that all-time best hand." Risk led to more complex historical simulations, most published by Avalon Hill. European games retain the strategy and decision making of these more complex games, but add the social element of multiplayer, more interactive games, and that is what really keeps me playing and designing games. But if I had to pick one game that inspired me the most, it would be Acquire by Sid Sackson. Sadly Sid died in 2002, but he will always be the dean of game designers. My first big board game, Airlines (Abacus, 1990), was inspired by Acquire.

Advice to designers:

Play as many games as you can. It's research. It's the only way you learn. You can't design games in a vacuum, without knowing what has already been done, what's worked, and what hasn't worked. The idea for almost all games comes from other games. Sometimes you play a bad game with one good idea. Sometimes you play a good game and find a new twist to a good idea. Keep playing. Keep designing. Be confident, but remember that there is always more to learn. Like everything, you'll get better with practice. It took me 14 years to have any real success as a designer. Those 14 years were tough, but they were worth it.

Playtest your designs as much as possible. Develop a core group of playtesters. You also need to learn when it's time to let something go and work on something else, and when you should keep plugging even though it doesn't seem like the game is ever going to work. Being a game designer is much more than just being creative. You need to be organized, thorough, and flexible. You'll also need to be a good salesman because designing a game is just half the battle. You still have to sell it to someone after that.

Designer Perspective: Frank Lantz

Creative Director and Cofounder, area/code

Frank Lantz has worked in the field of game development for the past 20 years. Before starting area/code, Frank was the director of game design at Gamelab, a developer of online and download- able games. Frank has also worked as a game designer for the developer Pop&co., where he created games for Cartoon Network, Lifetime TV, and VH1. Between 1988 and 1998, he was creative director at R/GA Interactive, a New York digital design company.

On getting into the game industry:

I studied theater and painting in school, then did computer graphics for several years at R/GA, a New York digi- tal design studio. I helped to transition that company from a focus on graphics and special effects for film and TV into a focus on designing interactive media, including games. Eventually, I left R/GA to work on games full time, first as a freelance game designer and then as the lead designer at the indie game developer Gamelab.

Five favorite games:

- Go because of the whole simplicity and depth thing, and the whole global and local thing, and the whole black and white thing, and the whole life and death thing.
- Poker because, like Go, it can be approached as a martial art and a spiritual discipline. Not the way I play it, though.
- Shadow of the Colossus because it's so sad and beautiful, and it breaks so many game design rules and still works brilliantly.
- Fungus, a little-known multiplayer Mac game by an unsung genius game designer named Ryan Koopmans. Fungus was probably the first game I played seriously and for a long enough time to start understanding how deep a game can go.
- Wipeout because of the music and the graphics, and then more importantly, because of the way it encouraged and rewarded a deep, zen-like level of precise skill mastery.
- Half-Life because I can't count. Also Crackdown, Rhythm Tengoku, Starcraft, Nethack, and Bushido Blade for the same reason.

On game influences:

The first one that comes into my head is Magic: The Gathering. It's hard to overstate the degree of influence that game has had on me. First of all, just the idea that you can invent not just mechanics, but an entirely new genre, a totally new way to think about how games are played and their social context, it's mind-blowing. And then, just the combinatory richness of it. The idea of engines, the way that the game is about players exploring this possibility space constructing these combinatory engines, it's so beautiful!

Also, the board games of Reiner Knizia, and modern German board games in general, are very inspiring because of their constant inventiveness in regards to mechanics and their light touch with themes accompanied by a serious attention to surfaces and materials.

On the design process:

Start with a fun game, put some stuff in it, then take some stuff out.

On prototypes:

I'm a huge believer in the prototype > playtest > redesign loop as the ultimate method for making great games. Sometimes, in reality, you don't have the time and resources you need to really prototype an idea properly, but that's OK. As long as you're continually making games you can think of each game as a prototype for a better, more finished game that you will make later.

On solving a difficult design problem:

We did a game for A&E about the *Sopranos*, and the main idea was that players had a collection of pieces representing the characters, places, and objects from the show, and these pieces would score points whenever the show was aired, based on what was happening on-screen.

We started with a set of really weird and interesting constraints. First, the game had a prize element, so because of antigambling laws it had to have no randomness, it had to be totally deterministic. At the same time, it had to produce, out of potentially hundreds of thousands of players, a single clear winner, it couldn't result in a tie, it had to have a lot of room at the top, a lot of differentiation between the scores of high-level players. And this was for reruns of Season One, a bunch of episodes that were available on DVD. So we could assume that any serious player had complete access to every episode and a complete knowledge of whatever scoring system we were going to use, so no hidden information. Added to this was the idea that the game had to be, you know, actually fun for a broad audience of nongamers, which meant it had to make intuitive sense.

So the game had to be simple and obvious for casual players and "unsolvable" for a very large community of expert players with a lot of time and cash-money motivation to find optimal solutions and complete access to every event that was going to occur during the entire game. In all honesty, however, this isn't as hard as it looks, because this is exactly what games do well!

I'm not a big math guy, but I recognized that what I needed was a game system that was NP-complete. NP-complete is a math term describing a class of problems that become very, very, hard as they scale up—the kind of math problems that are used to encrypt billion dollar bank accounts. Seems complicated, but plenty of games are NP-complete, including Tetris, Minesweeper, and Freecell Solitaire.

Basically I ended up designing a system in which players scored for groups of touching pieces that lit up at the same time; the larger the group, the more points. Seems pretty obvious in retrospect, it's a system that is totally familiar from puzzle games, but it allowed for an almost infinite variety of arrangements, and a lot of different viable strategies.

Advice to designers:

Play a lot. Play deeply. Pay attention. Don't be lazy. Simplificate. Learn how to think like a programmer, and learn how to think like an artist. Be an advocate for the player, but don't treat the player like a child. Fail often. Take something in a game you like and combine it with something new that seems like it might be cool. Don't make games you wouldn't want to play. Persist.

FURTHER READING

Casti, John. *Complexification: Explaining a Paradoxical World Through the Science of Surprise.* New York: HarperCollins Publishers, 1995.

Castronova, Edward. *Synthetic Worlds: The Business and Culture of Online Games.* Chicago: The University of Chicago Press, 2005.

Flynt, John. *Beginning Math Concepts for Game Developers.* Boston: Thomson Course Technology, 2007.

Johnson, Steven. *Emergence: The Connected Lives of Ants, Brains, Cities and Software.* New York: Touchstone, 2002.

END NOTES

1. Blizzard Web site, accessed August 2003. http://www.battle.net/war2/basic/combat.shtml

2. Salen, Katie, and Zimmerman, Eric. *Rules of Play: Game Design Fundamentals.* Cambridge, MA: The MIT Press, 2004. p. 161.

3. Parker Brothers, Monopoly Deluxe Edition rules sheet, 1995.

4. Poundstone, William. *Prisoner's Dilemma.* New York: Doubleday, 1992.

5. Johnson, Steven. "Wild Things." *Wired* issue 10.03.

Part 2
Designing a Game

Now that we have looked at the basic elements of games, it is time to walk through the process of designing a game of your own. This might seem overwhelming at first, especially if your goal is to create a game like the ones you see on the shelves of your local game store—filled with complex animations and elaborate programming. So before we even think of discussing these aspects, let's back away from the ultimate goal and take the process of design step-by-step from the beginning.

First, we will discuss conceptualization—coming up with ideas for your games. This might be easy for you. You might already have an idea of the game you want to make. But what if you cannot get support for your one idea? What will you do then? We will show you how you can train yourself to become an "idea person," someone for whom ideas come easily throughout the design process.

After you have an idea, you will need to execute it. Many designers jump right to writing up their design documentation at this point, but we will show you how to prototype your idea and get playtesters involved very early in the process. The playcentric design process that we outlined in Chapter 1 on page 10 is detailed in Chapters 7 (Prototyping), 8 (Digital Prototyping), and 9 (Playtesting). By prototyping and playtesting early, you can grasp which aspects of your system are working and which are not. It is only after you have seen players interact with your idea that you have enough knowledge to even think about drafting detailed design documentation.

What will you test for? Chapters 10 and 11 discuss strategies for making sure that your game is complete, that it is fair, that it offers meaningful choices, and that it is fun and accessible for your players.

Our goal here is to give you an accurate picture of the design process. If you follow along with the exercises in this section, you will have designed at least one full game prototype of your own. Going through this process yourself will teach you important methods for conceptualizing, building, and examining your work. By the time you are done, you will understand how to design a game, playtest it, and use your knowledge of the formal, dramatic, and dynamic aspects of games to perfect its gameplay.

Chapter 6

Conceptualization

Coming up with ideas is difficult for many people; coming up with excellent ideas is even more difficult. But coming up with an idea is just the beginning of the creative process. Crafting your ideas, fleshing them out, and bringing them to life is all part of the ongoing work of game design that in the end means generating not just one grand idea but rather layers and iterations of ideas that all help to refine and evolve your original concept. This process will be different for every game designer and for every game on which a designer works, beginning with different sources of inspiration and yielding a variety of results.

We cannot tell you exactly what your own personal process should be, but we can offer some insight and best practices into the ideation process that will help you learn which methods work best for you and your design team. Not only will you want to try the range of methods we suggest here, but you will also want to come up with methods of your own and vary them from project to project. As prolific board game designer Reiner Knizia says, "I don't have a fixed design process. Quite the contrary, I believe that starting from the same beginning will frequently lead to the same end. Finding new ways of working often leads to innovative designs."[1]

COMING UP WITH IDEAS

The first thing to understand about ideas is that they do not come out of thin air—even if they seem to at some times. Great ideas come from great input into your mind and senses. Living a full life—full of curiosity, interesting people, places, thoughts, and events— is the starting point to being a person full of ideas. In Chapter 1, we discussed the way in which designers like Will Wright and Shigeru Miyamoto have been influenced by personal interests and hobbies such as ant farms and exploration. We suggest making sure that you spend a significant part of every day doing something other than playing games: Read a book or a newspaper, watch a film, listen to music, take a photo, exercise, draw or sketch, volunteer at a neighborhood organization, go see a play, study a new

language, etc. Whatever it is, do it with passion and curiosity. Use your interest in something other than games to fill your mind with potential ideas.

Psychologist Mihaly Csikszentmihalyi, whose work on flow we discussed in Chapter 4, has also done a study of creativity, trying to understand how creative people work and how they develop. In his book on the topic, Csikszentmihalyi describes the classic stages of creativity as follows:

- *Preparation:* Preparation is becoming immersed in a topic or domain of interest, a set of problematic issues.
- *Incubation:* Incubation is a period of time in which ideas "churn around" below the threshold of consciousness.

- *Insight:* Insight is sometimes called the "aha!" moment, when the pieces of puzzle, or an idea, fall together.
- *Evaluation:* Evaluation is when the person decides whether the insight is valuable and worth pursuing. Is the idea really original?
- *Elaboration:* Elaboration is the longest part of the creative process; it takes the most time and is the hardest. This is what Edison meant when he said invention is 99% perspiration and 1% inspiration.[2]

Csikszentmihalyi warns, however, that we should not expect creativity to proceed regularly along a path from one stage to another. "The creative process," he says, "is less linear than recursive. How many iterations it goes through, how many loops are involved, how many insights are needed, depends on the depth and breadth of the issues dealt with. Sometimes incubation lasts for years; sometimes it takes a few hours. Sometimes the creative idea includes one deep insight and innumerable small ones."[3]

By encouraging you to become involved and interested in activities outside of games, what we are really saying is that you need to work on the preparation and incubation stages of creativity all the time. No one can say when the aha! moment will come. Perhaps it will be when you sit down to think of ideas, or perhaps it will come when you are taking a shower or driving on the freeway. It is a good habit to always carry a notebook or PDA in which you can write down your ideas so that they do not fade away after that initial moment of inspiration.

The other stages of creativity—evaluation and elaboration—are just as important as the initial insight, however. Having an idea for a game does not simply mean saying, "I want to make a game about studying Chinese!" As we discussed in Chapter 3, games are formal systems, and an idea for a game usually includes some aspect of that system. Perhaps your study of the Chinese language leads you to an interesting insight about using symbolic characters to represent hidden ideas in a game system. Your game might not have anything to do with Chinese at all. As you work through your idea, elaborating on its unique elements, it might turn out that no one would

recognize the influence of your language interests in the final experience, even though you know that is where the initial spark of the idea began. When you train yourself to begin thinking like a game designer, to begin looking below the surface of your daily activities and interests to the intrinsic systems at their core, you will begin to find a wealth of ideas for game systems in their structures.

Exercise 6.1: Below the Surface

Take the subject of the last book or newspaper article you read and think of its systematic aspects. Are there objectives? Rules? Procedures? Resources? Conflict? Skills to be learned? Make a list of the systematic elements of the subject or activity. Do this several times per week with different types of activities or hobbies.

Ideas can also come from analyzing existing games and activities. We talked about developing your critical skills in Chapter 1, Exercise 1.4, when we suggested that you begin a game journal. After you have been keeping your game journal for some time, you will notice that your ability to discuss games critically will improve. Also, you will naturally begin to have ideas related to this criticism of existing game systems. It is important that you use this journal to analyze the games you play in detail, not just to review their features and determine their "coolness." Magazine articles on games often focus on the new, top-level features of a game; don't get caught in this style of writing. Dig deeply into the formal, dramatic, and dynamic elements of the games you play. Also, pay close attention to your emotional responses to gameplay: your cycles of frustration, exhilaration, confidence, uncertainty, pride, tension, curiosity, etc. Record them; they will be difficult to remember later on, and when you are searching for inspiration someday, you will want to have a record of how a particular game affected you the first time you played it.

In addition to writing your analysis of games in your game journal, another way to improve your critical skills is to present and debate your game analyses with friends or other people who are also studying game design. At the USC School of Cinematic Arts,

in the Game Innovation Lab, the students hold regular "game deconstruction salons" in which one or two students prepare a formal presentation of their analysis of a selected game. This analysis breaks down the game into its formal, dramatic, and dynamic elements. They present this analysis, along with a detailed walkthrough of several game sections to back up their analysis, to industry professionals and then lead a discussion about the game. This type of public debate and analysis helps to hone their critical skills as well as generate new ideas that arise from the discussion.

Exercise 6.2: Game Deconstruction

Take one of the games you have analyzed in your game journal and create a "game deconstruction" presentation. Analyze the formal, dramatic, and dynamic elements of the game. If you can, create a PowerPoint presentation from your analysis and organize an opportunity to present this to an appropriate audience. Lead a discussion of your ideas following the presentation.

A very good source of understanding and inspiration for video game designs are the unique and interesting board games that can be found at specialty game and hobby stores or online at sites such as www.funagain.com or www.boardgames.com. Excellent games that can be found at these sites include:

- Settlers of Catan, by Klaus Teuber
- Carcassonne, by Klaus-Jurgen Wrede

- Scotland Yard, by Ravensburger
- El Grande, by Wolfgang Kramer and Richard Ulrich
- Modern Art, by Reiner Knizia
- Illuminati, by Steve Jackson
- Puerto Rico, by Andreas Seyfarth
- Acquire, by Sid Sackson
- Cosmic Encounter, by Bill Eberle, Jack Kittredge, and Bill Norton
- I'm the Boss, by Sid Sackson

There are many more; these are only a sampling of the titles you can find. One of the reasons that we suggest that aspiring digital game designers play and analyze these games is that they have very innovative and complex mechanics. And, because of the nature of board games, these mechanics are not hidden from you in the code, the way they might be in digital games. They are right on the surface, easy to see, and possible to deconstruct and analyze.

Exercise 6.3: Board Game Analysis

Choose one of the games listed above and play it with a group of friends. Write your analysis of the formal, dramatic, and dynamic elements of the game in your game journal. Now find another group of players who have not played the game before. Have them play the game while you watch and take notes. Do not help them learn the rules. Note the steps of their group learning process as well as their impressions of the game in your analysis.

BRAINSTORMING SKILLS

What we have talked about so far are ongoing training exercises you should do to fill your life and mind with interesting thoughts that might, or might not, lead to an "aha!" moment. Sometimes, however, it is necessary to solve a specific problem or come up with an idea on demand. Often, when you are working as a creative professional, there is no time to wait for that moment of inspiration to hit; you need a more formalized system of idea generation—what is called "brainstorming."

Brainstorming is a powerful skill. And, like any skill, it takes practice to become good at it. There

are brainstorming beginners and brainstorming experts, and the difference between their abilities is akin to the difference between an average golfer and Tiger Woods. Expert brainstormers train themselves in the craft of generating workable ideas and solutions to problems, building on the contributions of their fellow team members. You can brainstorm alone, of course, but ultimately, game development is a collaborative art, and you will want to develop good team brainstorming skills as well. Working with others to generate interesting, innovative ideas is

both stimulating and highly productive. Also, it is often a business necessity and a good way to give everyone on the team a sense of authorship in the design process.

The Imagineers at Disney are expert brainstormers; it is a part of their company culture. One of the key skills they have developed is asking the right questions. Bruce Vaughn, Executive Director of Research and Development, says, "Whether you're soliciting help from others or tackling the challenge yourself, you must first be able to articulate what the challenge is . . . articulating a challenge requires you to let go of all the possible solutions you are considering and pare the challenge back to its core. What is the bare essence of the challenge in front of you?"4 Articulating a challenge is just one brainstorming rule that can improve your creativity flow, whether you are working alone or with a team. The following is a list of best practices collected from techniques used by the Imagineers, the design consultancy IDEO, and other successful creative thinkers.

Brainstorming Best Practices

1. State a challenge

When you sit down to brainstorm, articulate the challenge for the session. Here are some examples:

- Design a game in which players must make strong alliances and then betray them.
- Design a game with a special role for parents to play together with their children.
- Come up with a game that makes interesting use of only one button for control.

As you can see, each of these is a very different type of challenge. The first is what we described in Chapter 1 as a player experience goal. The challenge here is to create a specific type of gameplay potential. The second challenge is also audience focused, but it does not address the specific player experience. The third challenge is completely driven by technology. Each of these can drive a good brainstorming session, but the second two will ultimately need to be refined to specify their player experience goals.

2. No criticism

If you are brainstorming alone, do not self-censor or edit your ideas. Write down all of your ideas and worry about their quality later. If you are brainstorming with a team, do not criticize or ignore your colleagues' ideas during the brainstorming process. The process should be about free thinking, about building on each other's thoughts, and if you begin to criticize or edit their ideas before they are fully developed, it will disrupt the flow. Also, certain members of your team, feeling wounded by harsh comments, might limit their contributions, which is the death of creativity. A good trick for this is to practice the "yes, and" rule of brainstorming: Whenever you want to jump into the conversation, start your sentence with the words "yes, and . . ." You will find that your contribution will naturally begin to build on that of others, and suddenly you are all part of a single, exhilarating idea-building process.

3. Vary the method

Don't rely on just one method for brainstorming. Mix it up. Some structures might work fine for the group leaders but less well for other members. Beginning on page 150, we have created a list of potential structures for generating ideas. If you are a leader, make sure to experiment with structures that you are not comfortable with. Also, ask team members to suggest alternative ways of conducting the brainstorming sessions. You might give them a shot at leading the group. Do not be afraid of losing control—if you are, you have already lost it.

4. Playful environment

Sometimes it is hard to cut loose and be creative in your normal working area, where you are used to sitting at a desk, facing a computer screen. Get up, go someplace else; seek neutral territory, like a conference room, or in the best case scenario, a special brainstorming room. Bring some toys with you to a brainstorming session. Sometimes it helps to just have a Nerf ball to toss around or a stack of blocks to play with while you are thinking. Of course, you do not want to get too caught up in playing, but you would be surprised how having some playful distractions in

the brainstorming room can help your team to relax and think creatively.

5. Put it on the wall

It is important to get visual with your ideas. A favorite technique is writing on a whiteboard or on large pieces of paper taped to the walls. This can help get people out of their chairs and up on their feet talking and thinking. Writing on a whiteboard lends itself to big ideas, sketches, and side notes. When your ideas are on the wall, they can be seen and absorbed by the whole group. This helps spark even more ideas and facilitates collaboration.

6. Go for lots of ideas

Go for quantity when developing ideas. Try to generate 100 ideas an hour. Be free and do not worry if the ideas are outrageous. A good practice during brainstorming is to number your ideas. It is helpful to be able to refer back and forth between several ideas quickly using shorthand when you are developing a big concept. The numbers allow you to do this without losing your larger train of thought. Aside from that, it is satisfying to generate lots of ideas in a brainstorming session. The numbers will measure your output, serving a function similar to tracking distance when jogging or reps when lifting weights.

7. Don't go too long

Brainstorming is a high-energy activity. A good session will naturally die down after 60 minutes or so. The mind and body need a break after that much focused time. Do not push yourself beyond what is reasonable. Whatever ideas you have after an hour or so can continue to be worked on in the coming days.

6.1 Working at the whiteboard

Exercise 6.4: Blue Sky Brainstorm

In this exercise, use the techniques previously described to do a brainstorm for a "blue sky" project. By blue sky, we mean that we know this project could not technically be made today, but we are going to pretend it could. The challenge is to come up with ideas for a "remote control" for a stereotypical character. Choose a character from this list:

- Door to door salesman
- Busy mother
- God
- Superhero
- Politician

First, brainstorm about the character: What does the character do? What makes the character interesting? What aspect of the character would it be engaging to control? How does the character react? Does the character have free will? Next, brainstorm features for your imaginary controller. What will it look like? What could each button do? Remember, this is "blue sky," so the buttons can do crazy things. Have fun with this! Come up with as many ideas as you can.

ALTERNATE METHODS

Sometimes you need a little help in your brainstorming. Or perhaps you just want to vary your process, as previously suggested. The next sections outline several creativity methods you can experiment with. There is no single best solution. You might find that some methods work better for you than others. We encourage you to try all the methods and vary your approach. The key to productive brainstorming is finding the right balance of stimulation and structure. If you can do this, you will improve both the quantity and quality of your output.

List Creation

One simple form of brainstorming is making lists. List out everything you can think of on a certain topic. Then create other lists on variations of that topic. You will be amazed at how many great ideas come out in simple lists. The process of writing them down helps you to freely associate and organize at the same time.

Idea Cards

Take a deck of index cards and write a single idea on each one. Then mix them up in a bowl. Now take out the cards and pair them. For example, "nectar" might appear with "giants." Perhaps, your next game will include "nectar giants," whose bodies are fluid and smell like persimmons. You can concatenate sets of

two, three, or four cards. It does not matter. And the more wild ideas you throw into the bowl, the richer the combinations become.

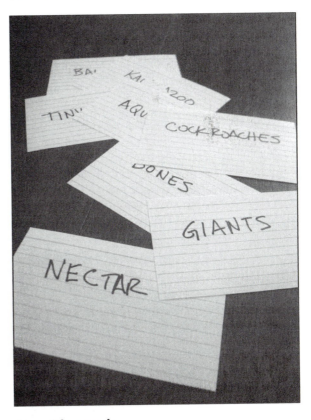

6.2 Idea cards

Mind Map

Mind mapping is a way of expressing ideas visually. You start with a core idea in the center and let related ideas radiate outward. You can use lines and different colored markers to connect ideas. Mind mapping provides a structure for thinking in a nonlinear manner. There are software tools to help generate mind maps, but we find that working on a whiteboard can give the best results when working with a team. One good mind map exercise is to begin with the core concept for your game at the center and then map verbs or actions and the feelings associated with those actions around that central concept. Figure 6.3 shows the results of a 15-minute exercise done at the EA preproduction workshop described in Glenn Entis' sidebar on page 157. This mind map exercise was done by the team that went on to produce the hit game Need for Speed: Most Wanted. As Glenn Entis

comments, the idea of creating a mind map of game words "seems basic, but it came after seeing multiple examples where teams did not share simple key vocabulary to describe their game, or where different team members used the same words to mean very different things."

Stream of Consciousness

Sit down at your computer or with a pen and paper and start writing anything that comes to mind when you think of your game. Do not worry about being coherent. Do not think about punctuation or spelling. Just write as quickly as humanly possible. Whatever comes out is fine. After 10 minutes of spewing words on a particular topic, stop and read over what you have done. Sometimes it turns out better than work you have spent days perfecting because you are not self-editing your thoughts.

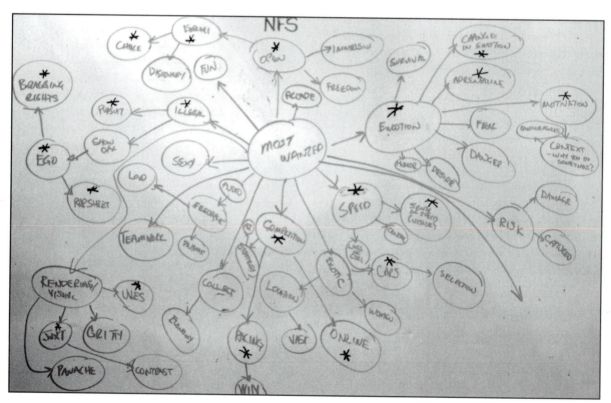

6.3　Mind map of game words

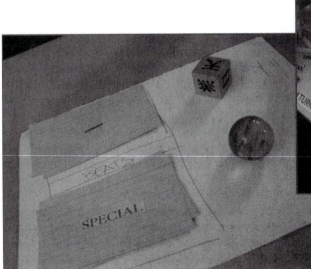

6.4 Cut up games

Shout It Out

This is similar to stream of consciousness, but rather than writing, you shout out whatever comes into your head while a voice recorder is running. After five minutes of auditory abuse, go back and transcribe your mad ramblings. There is often a prized nugget hiding in your verbal blitzkrieg.

Cut It Up

Take a newspaper or magazine, open it up to any page, and cut random words and images out of it. It does not matter what they are. Anything that attracts your eye is fine. When you have a pile of pieces, start playing with them, matching them up, and trying to come up with a game concept using this random collection. You can do the same with random Web page searches or using a dictionary or the phone book.

Surrealist Games

Many of the techniques we have described are variations on techniques used by surrealist and dadaist artists to generate unexpected ideas from the collision of chance and the unconscious mind. There are many other games of this type that can be used as brainstorming methods, from the cut up and stream of consciousness methods previously mentioned to more formal games, like the Exquisite Corpse, which can be played either with words or images.

Exercise 6.5: Exquisite Corpse

This version of the game is played with words. Everyone writes an article and an adjective on a piece of paper, then folds it to conceal the words and passes it to their neighbor. Now everyone writes a noun on the paper they are holding, folds it again to conceal their word, and passes it to their neighbor. Repeat with a verb; repeat with another article and adjective; finally, repeat with a noun. Everyone unfolds their papers and reads the poems they are holding aloud. One of the first poems written this way was, "The exquisite corpse shall drink the new wine," which is how the game gets its name.

Research

All the previous techniques try to spark your creativity through a certain amount of randomness. On the other side of the spectrum, you might try doing research into a subject that interests you. Were you always fascinated by giant squid? Find out as much as you can about them. Research how they live and interact with their environment. Is there an idea or concept in this research that you can use in a game?

Research can also mean getting physical experience and understanding of systems you are trying to model in your game. If your game is about fishing, then go! If it is about collecting butterflies, you should try it, or go talk to expert collectors and find out how they go about it. Doing research means immersing yourself in a subject, and while your game system might not need to be precisely true to life, understanding how the real activity works can help you decide what to focus on and what to leave out for the best possible gameplay.

If your game is geared to a particular audience, you should do some target player research by watching their interactions with other games and each other. This is not the same as a focus group; it is closer to market research but a bit more fun. For example, if you want to make a game for 'tween girls, then you should find out what they are already playing and try to watch a group engaged with existing products. Ask them what they are missing, what they wish was there. This might give you some insight that will lead to an idea.

Exercise 6.6: Do It

Now it is time to brainstorm your own idea. Get a potential team together—either in class or a group of friends who are interested on working on a game with you. If you cannot get a group together, do it on your own. As we did in Exercise 6.4 in the blue sky brainstorm, state an interesting challenge for your game, set up a whiteboard or a sheet of butcher paper, and use the techniques previously discussed to generate 100 ideas related to your challenge in 60 minutes. This might sound like a lot, but if you can keep the energy level up, you can do it!

EDITING AND REFINING

What do you do after you have had a successful brainstorming session? Now you have a lot of ideas but no game. Next you will need to edit and refine your pool of ideas. This is the stage of the creative process previously described that Csikszentmihalyi called "evaluation," where you decide whether an idea is valuable and worth pursuing. There are a number of reasons for editing an idea out of your final list. Most of them fall into the following categories.

Technical Feasibility

Sometimes you come up with an idea, like our blue sky character remote controls from Exercise 6.4, which just is not technically possible yet. You can try to brainstorm ways to make it technically feasible, but often there is just no way. Also, sometimes an idea that would be feasible for a more experienced, or larger, production team has to be cut by a team that has limited resources or expertise. This does not mean it is a bad idea, just that you cannot do it right now. Keep a list of these ideas for later—you never know when a technology advance will make them feasible.

Market Opportunity

Sometimes there is no market opportunity for a particular idea. Again, this does not mean it is a bad idea; it just might not be advisable to do it right now. Market trends are affected by world events, by the success (or failure) of other products, by the overall economy, by technology cycles, and any number of other outside influences. It is a good idea as a designer to follow market trends, not so that you can follow the decisions of others, but so that you can make smart creative business decisions regarding your own ideas.

Electronic Arts Preproduction Workshop

by Glenn Entis

Glenn Entis is Senior Vice President and Chief Visual and Technical Officer of Electronic Arts, where he is responsible for leading EA's worldwide community of over 3000 talented artists and engineers. Prior to EA, Glenn was CEO of DreamWorks Interactive and cofounded the pioneering animation studio Pacific Data Images.

The EA Preproduction Workshop was a company-wide program we launched in 2004 to improve our pre-pro skills and create a vocabulary of preproduction that was understood at EA studios around the world.

The workshop was developed in response to a growing awareness that the complexity of games, teams, and platforms had grown faster than our preproduction skills. There was broad consensus about the warning signs—lack of clarity in game design, key roles, and essential processes; a need for more urgency and focus during preproduction; and panic at the end of preproduction as the reality of the remaining schedule sunk in.

We realized that teams did not need or want traditional training. They understood the problem, and in many cases they knew what they should do about it. However, in watching teams struggle to improve their preproduction performance, we realized that teams needed practice in new techniques and enough success in those techniques to form new long-standing preproduction habits. Practice and habits do not come from traditional handouts and lectures; it comes from highly engaging, hands-on working sessions that incorporate each studio's local culture and concerns.

The result was the EA Preproduction Workshop, a two-day hands-on workshop delivered to every team in each of our then twelve studios around the world. Each team brought six to ten people—leads from each of the major disciplines on the team (producer, technical director, art director, game designer, various leads, and development director/project manager). At each workshop, we invited three to ten teams—it was important for teams to see other teams at work—that were struggling with the same problems, breaking through barriers, and loosening up to try new things.

Some of the guiding principles that made the workshop effective are discussed in the following sections.

Do Real Work

- *Each team brings its current game:* The team works on real current issues, not classroom exercises.
- *Learn by doing:* Presentations were usually 15 minutes at most; the majority of the workshop time was spent working as a team on a particular technique or phase of preproduction.
- *Keep a fast pace:* Most of the exercises were 15 to 20 minutes and demanded speed and concentration from the team. This intense time pressure filtered out a lot of mental blocks. Fifteen minutes for a tough task just doesn't give a team enough time to think about all the reasons they couldn't or shouldn't do a task, or shouldn't include, for example, an engineer on a design task. Everyone had to immediately pitch in and work together as one team.
- *Leave with a pre-pro plan:* Over the two days, each team put together (on a whiteboard with Post-it Notes) a pre-pro plan and schedule. It was rough, but that's why Post-it Notes can be moved. For as rough as it was, it was the first time many teams had a detailed pre-pro schedule. More importantly, for many teams it was the first time they had developed such a plan as an interdisciplinary group so that multiple points of view could be represented and conflicts and issues identified and handled on the spot.

The images in this sidebar portray some of the techniques, teams, and collaborative processes found in the workshops.

Medal of Honor sandbox: Medal of Honor Frontline and at least two sequels were designed in the sandbox—a cheap, fast, physical way to block out and play test levels. It is as simple as it looks, but when the kids in the sandbox are the lead game designer, producer, art director, and lead environment artist, there is a rapid-fire generation of ideas and on-the-spot multidisciplinary solutions of problems. And it's fun!

Lord of the Rings paper and dice prototype: Paper, card, and dice prototypes are fast, cheap ways to work out the metagame and overall scoring systems. This prototype is from the Lord of the Rings team at EA Redwood Shores

EA Los Angeles team in 15 minute prototype exercise: The pre-pro workshop asks teams to produce results very quickly. In one exercise, we ask each team to build a physical prototype of a key game feature in 20 minutes. Because game teams rarely build physical prototypes, this exercise often yields surprising results and gives the team a new and more visceral experience of their design ideas

Matt Birch in flames: In this exercise at one of the EAUK workshops in Chertsey, England, we asked each team to perform one of the key features of their game. Game designer Matt Birch, who was working with the Burnout team at the time, is shown here erupting in flames as he flies through the air, heading for a catastrophic collision with the lorry (aka the black chair) in front of him

EA Redwood Shores Maxis pre-pro workshop: Each team works together on preproduction for its own game. In this exercise on physical prototyping, Will Wright is interacting with a creature from Spore

Burnout team after a brainstorming session: The exercises in the pre-pro workshop are 15–20 minutes each, but they are meant to give the teams practice in new tools that they can adopt and expand outside the workshop. Mindmap-based brainstorming was a new tool for the Burnout team, and after the workshop they continued to develop their skills in this method. This is the aftermath of one such session, roughly one hour of intense brainstorming. Also notable is the interdisciplinary mix of the group; this ten-person brainstorm team includes a producer, game designer, concept artist, art director, sound designer, front-end designer, and lead engineer

Make It Fun

- People are more creative, more receptive, and more productive when they're having fun.
- Was the fun in the workshop a cause or a symptom of the productivity? Probably both.
- A fast way to create leaders is to ask people to teach. At each studio, we asked local studio leaders to colead the workshop. Those local leaders helped customize the workshop for the games and issues in their studio. They presented, and they committed to follow-up projects as well as additional local workshops. This approach not only made the workshops more locally relevant but also left each studio with local leaders who could passionately drive further progress on pre-production.

Some of the key ideas delivered in the workshop are as follows:

1. Studiowide shared pre-pro concepts and vocabulary
 - Same terms mean the same things—create a common language of pre-pro
 - Enable communication horizontally (within teams, across teams and studios) and vertically (through layers of management)
2. Rapid, early iteration
 - Make mistakes as quickly and cheaply as possible
3. Rapid prototyping
 - *Types*: We covered all types of prototypes—paper games (cards and dice), 3D physical models, and simple software prototypes.
 - *Description*: We described the early prototypes as fast, cheap, public, physical, etc.

Artistic Considerations

Sometimes you just do not like an idea enough to do it. This is a perfectly valid reason to edit an idea. If you and your team do not feel passionately about the idea when you are beginning the project, think of how you will feel down the line when you have been working on it for months or years. Also, as a game designer, you want to stretch yourself artistically, and if an idea just does not do that, then cut it. Do not rest on the laurels of game genres or ideas that have already been proven. Think about how this idea might break new ground. If you do not think this idea is artistically challenging, then cutting it might be the right decision.

Business/Cost Restrictions

Sometimes an idea is just too expensive, or too ambitious for your team, time frame, or budget you have available. If the idea cannot be scaled down, then cutting it from your list might be the best answer. As with the other cuts you have made, it is always a good idea to keep a list of these ideas for later, just in case you have an opportunity to do a larger, more ambitious game.

Whether you are working alone or as a team, we recommend that you schedule your editing sessions on different days than your brainstorming meetings. Letting some time go by between the two phases is a good idea. You do not want to blur the line between the two because you might combine editing and brainstorming, which will decrease the productivity of your brainstorming sessions.

Most of the time, people will think about the ideas between the time of the brainstorm and the editing session and will have a list of favorites. The top five to ten ideas should be thoroughly discussed, going over the merits of each idea. Try to keep the discussion positive. Do not bash any ideas. Instead talk about

- *Fast:* We developed prototypes and iterations quickly
- *Cheap:* Cheap prototypes can be thrown or radically changed, and if something is cheap enough, no one has to ask permission to build. (It is surprising how often we got questions about "will we be allowed to do this.")
- *Public:* In this context, "public" means that the team can see and experience the prototype together in some meaningful way. For many design problems, shared play and design are better than sitting isolated in a cube hunched over a big document.
- *Physical:* Physical prototypes are underrated and underused. Creating opportunities to experience any aspect of the game in an immediate and visceral way is fun, engages every part of the brain, and helps the team to literally feel their way through their blind spots.

4. Preproduction process and discipline
 - The discipline of creative productivity is as important as the discipline of software development. There are few off-the-rack solutions, but by understanding a few general principles and pooling their collective experience in the creative process, each team can develop their own habits and incredibly high standards for creative productivity.

Outcome

The original preproduction workshop was put together for EA Canada by Pauline Moller, Gaivan Chang, and me. I then further developed the workshop and took it global, personally leading the workshop 14 times in 2004 at EA studios around the world. Scores of other EA members from around the world contributed to the workshop's development and improvement.

the relative strengths of each idea in terms of the four qualities listed above to make sure it is technically feasible, marketable, artistically interesting, and within the scope of your team to produce.

Narrow down the list to three ideas. Then schedule new brainstorming sessions to flesh out these three ideas. In these second-level brainstorming sessions, focus on features and clearly define what producers at Electronic Arts often call the "X" of the game. The X is the creative center of the game. It is also an alignment tool—aligning the development team, marketing, advertising, and customers so that you can communicate the value of the game to each party in terms they understand.

Electronic Arts' Chief Visual Officer, Glenn Entis, describes the two parts of an X as "the razor" and "the slogan." The razor cuts—it allows the team to determine which features belong and which do not. The slogan is catchy—it allows marketing and play-

ers to determine whether or not this sounds like something they want to do. For example, the razor for the original Medal of Honor was "GoldenEye set in WWII on a PlayStation." Entis felt this was a great razor because it allowed the team to decide what features the game absolutely needed. It was not a great slogan, however. The slogan that went on the box was, "Prepare for your finest hour." While this was a great slogan, it would not have helped drive the creative process at all.[5]

When you have a clear idea of key features and your X, write your ideas up as short one-page descriptions. Hold an informal feedback group (the process for which will be described in Chapter 9, Playtesting) and find out how your game concepts appeal to your target players. At this stage, it is very easy to make changes to your concepts. The goal is to keep the process fluid so you do not get locked into a single idea too early or spend too much time perfecting

your writing. Your original concept can be refined with early player input, or you might discover a better idea by talking with potential players. You can iterate on these ideas, holding more feedback groups until one clearly stands out as the idea that you and your team should pursue at this time.

Exercise 6.7: Describe Your Game

In one or two paragraphs, describe the essence of your game idea. Try to capture what makes it interesting to you and how the basic gameplay will work. State your "X"—both razor and slogan—as a part of your game description.

TURNING IDEAS INTO A GAME

Now you have a single idea that you like; you have a list of potential features and an "X" that you think will make a great game. But you cannot be certain until you have done some prototyping and playtesting of the concept. After all, the only way to know if a game works is to actually play it.

At this point, many game designers try to take a shortcut. They believe that the best way to develop a game concept is to begin with an existing set of mechanics, a "genre" of play. After all, genres produce proven gameplay. That is what publishers want and even what players say they want. That is fine, to a certain extent. Many designers actually do very well by modifying existing mechanics, what we might call "feature innovation." By relying on feature innovation, a designer is sure to attract the core players of the main genre, and they are apt to appeal to their sense of novelty with the new features they have added.

But what if your idea does not fit nicely into an existing genre of gameplay? Should you try and force it to more closely resemble a first person shooter or a real time strategy game? We encourage you to try and experiment with your game mechanics, to explore new directions of play. This is not because we do not enjoy the existing genres of play. Rather, it is because we see those areas as being "solved problems" of gameplay. What we mean by this is that a lot of designers have spent a number of years working out the specifics of the first person shooter game as we know it today. They have solved many of the gameplay issues surrounding this genre. Unless you feel that you can ask new questions about this genre (and perhaps you can), we suggest staking out some brand new territory for your gameplay. As we described in Chapter 1, you should develop a vision of the type of player experience you would like to create. The

formal structure will follow from that vision. Perhaps it will have elements of existing games, but overall it will feel like something entirely new.

As you continue to brainstorm, edit, and refine your game idea, ask yourself how you would like your players to act and feel. Come up with a list of game verbs as described in the mind mapping method. What is the role of the player? Does the player have a clearly defined goal? And what are the obstacles in getting to that goal? What kind of resources do they have to accomplish that goal? The game mechanics should stem from the core idea. They are an outgrowth of your overall vision.

During this process you will want to refer to the formal, dramatic, and dynamic elements of game design presented in Chapters 2 through 5 of this book. Think about each aspect of your game idea in terms of these elements. If you have forgotten any of them, please go back and review them before proceeding. If you have been playing and analyzing a lot of games in your game journal, you will see that combinations of certain formal elements will begin to emerge that can elicit the type of emotions or player experience you are looking for in your own game. We encourage you not to copy these mechanics but rather to learn from them. As you analyze more and more games, you will train yourself to recognize familiar structures and how they are adding to the gameplay. Your growing experience will eventually help you construct new, groundbreaking systems of your own.

One stumbling block many beginning designers run into is allowing themselves to be distracted by the dramatic elements. Story and characters are important for all the reasons we have already discussed, but do not let them obscure your view of the gameplay. They should remain in your mind, but secondary until you pin down the formal elements.

Focus on the Formal Elements

The formal elements, as we have discussed, are the underlying system and mechanics of the game. Your initial concept might already include some of the formal elements of your game. As you move forward, you will need to fill in that system more and more. Here are some questions to ask yourself:

- What is the conflict in my game?
- What are the rules and procedures?
- What actions do the players take and when?
- Are there turns? How do they work?
- How many players can play?
- How long does a game take to resolve?
- What is the working title?
- Who is the target audience?
- What platform will this game run on?
- What restrictions or opportunities does that environment have?

The more questions you ask yourself the better. And it is okay if you do not know all the answers at this point in the process. In the beginning, you can only guess, and you won't know if you are on the right track until you actually play the game and see how it works. But do not let this stop you from conceptualizing the game. You might be working blind at first, but soon the game will begin to take form.

To flesh out the game structure, consider the following:

- Define each player's goal.
- What does a player need to do to win?
- Write down the single most important type of player action in the game.
- Describe how this functions.
- Write down the procedures and rules in outline format.
- Only focus on the most critical rules.
- Leave all other rules until later.
- Map out how a typical turn works. Using a flowchart is the most effective way to visualize this.
- Define how many players can play.
- How do these players interact with one another?

You might have noticed that this is the very beginning of a prototyping process. We won't go into detail here because Chapters 7 and 8 will take you through the process of prototyping a game. Suffice it to say that the conceptualization and discovery process, as it evolves, naturally segues into prototyping and then playtesting.

For now, the goal is to have an outline of where your game is headed, both in terms of a written treatment and a rough sense of the game mechanics. Whenever you get stuck or feel you can improve upon a particular feature idea, remember to go back and utilize the brainstorming techniques described previously.

Practice, Practice, Practice

The first time you go through this process will be the hardest. Each time you do it, however, you will become more capable of generating workable ideas. Every accomplished game designer has developed many more concepts than he will ever produce. The key is to be persistent and keep practicing.

Exercise 6.8: Write a Treatment

Take the description you wrote in Exercise 6.7 and expand it into a three- to five-page treatment for your game idea. Ask yourself questions about the formal and dramatic elements as you write. Remember that this is just a draft. When we go on to the prototyping stage, we will address these questions again in more detail.

Feature Design

Another good way to get practice in coming up with game ideas is to design new features for existing games. Rather than trying to come up with an idea for an entire original game, you can do a focused brainstorm on improving a specific area of an existing game. The following are examples of new feature ideas for games you might be familiar with.

Battle for Middle-earth II

New feature: "Self Made Man." Units in Battle for Middle-earth II build veterancy until they transform into Hero units. After they are transformed, they build

WHERE DO GAME IDEAS COME FROM?

by Noah Falstein, The Inspiracy

Game design is my favorite part of game development, and brainstorming is my favorite part of game design. Brainstorming meetings are capricious, at one moment puttering along like an old jalopy on a bumpy road, and at the next zooming like a Ferrari on a racetrack, with the ideas coming so fast there's no time to write them down. Ideas can come from anywhere—books, movies, television, and of course other games are frequent sources, but I've had ideas spawned from personal relationships, from dreams, from scientific principles, from art, from music theory, and from children's toys. Ultimately I think most good ideas come from the subconscious and involve combining dissimilar things in novel ways. When a design client of mine is stuck on a point, I often find it useful as an exercise to pick something apparently totally unrelated to the concept to spark new thought. For example, if a real time strategy game about rapidly evolving alien creatures needs a new creature type and attack, I might turn for inspiration to frothy romantic comedy films. There's a scene in *When Harry Met Sally* where Meg Ryan's character fakes an orgasm in a crowded diner. For the game, that might suggest a siren creature that generates a fake mating cry that causes all enemies of the opposite sex to drop what they're doing and head toward that creature for a few seconds. Ideas are everywhere.

One example of the evolution of one of my favorite ideas was in the original Secret of Monkey Island game from LucasArts. Ron Gilbert, the project leader, had worked with me previously on the game Indiana Jones and the Last Crusade. For that game we needed a boxing interface so Indy could box with an opponent, and I'd recently been playing Sid Meier's Pirates!, which had a simple, fun sword fighting interface. By changing swords to fists, it worked great for us. The problem is, I neglected to tell Ron where the idea came from, so when Ron was talking to me about Monkey Island he casually remarked that he'd realized that the boxing interface would make a great sword fighting interface for his new game. I confessed to the history of the concept, and for a while we were stumped. Then I suggested that some of the best classic swordplay in movies involved more talking than fighting—thinking of old Errol Flynn movies or the then-recent film *The Princess Bride*. That seemed more appropriate anyway for the comic tone of his game. What if sword fighting in Monkey Island was about insult and rejoinder, not thrust and parry? And so out of movies, a classic game mechanism was born that proved to be one of the more popular parts of Monkey Island.

When I've told this story, some people have asked me if I felt embarrassed adapting an idea from Sid Meier. I might—if Sid hadn't admitted publicly that several of the concepts in his Pirates! game were based on what he'd seen in Dani Bunten's Seven Cities of Gold game, which Dani said was in turn based heavily on a board game. Sometimes I think no idea can ever be truly original.

About the Author

Noah Falstein has been developing games professionally since 1980. Currently he runs www.theinspiracy.com as a freelance designer and producer. He is also the design columnist for Game Developer magazine.

Hero abilities just like the heroes Aragorn, Gandalf, Gimli, etc. in the game. Self Made Men, however, are not immortal. If they die they cannot be revived. The Self Made Man feature get players more emotionally engaged with their units.

Battlefield 2

New feature: "Stealth Pack." This is a new kind of gameplay for Battlefield 2. Players can choose a stealth agent kit, which is a very fast, camouflaged unit that is deadly at close range. Agents' armor is accordingly light, and their weapons are tuned for close combat. Stealth Agents are available only on special stealth maps that include special missions such as "rescue the diplomat," "disable the radio tower," etc. Completing these missions depletes tickets from the opposing team just like other objectives in Battlefield 2.

Karaoke Revolution

New feature: "World Party." Think Karaoke Revolution meets *American Idol* meets YouTube. It is an extension feature to the game Karaoke Revolution that lets players record performances using an EyeToy camera and then upload them to the Internet straight from

the PlayStation 3. Performances are judged online by masses of viewers. Performers with the highest ratings move through tournaments and win prizes.

All of these feature ideas were generated by students in our beginning game design classes at USC School of Cinematic Arts. We give this assignment because it is good practice for designers at any level, and the final concepts make an excellent portfolio piece for potential job interviews. Designing a game from scratch is not something that beginning designers get to do at established game companies until later in their careers. Designing features for existing games, however, is a task that is often assigned to entry level designers. We want our students to have experience with the process.

Exercise 6.9: Feature Design Exercise, Part 1

Think of a feature you would like to see added to one of your favorite games. We are sure you have plenty of ideas on this one. It does not matter how far-fetched or technically difficult the idea is at first because you are not going to actually build it. Rather, you are going to illustrate how it works using storyboards and words.

6.5 Feature design proposals

GETTING THE MOST OUT OF FOCUS GROUPS

by Kevin Keeker, User Research Lead, Microsoft Game Studios

Kevin Keeker has spent the better part of his career working on game projects as a user researcher and game designer. Here he shares some insight into the psychology of focus groups and how to get the most out of them.

Many people believe that focus groups are a good way to evaluate their games. I've learned that focus groups aren't the best way to gauge the quality or popularity of your ideas. Instead, focus groups should be used to generate ideas for your game. A well-run focus group is one where the participants are encouraged to speak freely and disagree with one another if necessary. This environment can generate ideas that will fuel your own creativity and provide a glimpse into the common points of wisdom and key disagreements in your gaming audience. This sidebar describes why focus groups are better for generating ideas than evaluating them. Then it provides a few pointers to help you achieve either objective.

Let's say that you're designing a snowboarding game and you're feeling pretty good about it. You know that you're making the game for teens and young adults. You know that you need a great sense of speed, big air, tons of attitude, and crazy tricks. You've been tuning the basic play of the game with usability feedback from teens and young adults. They're able to pull off the tricks and find the challenges that you've positioned around the course. Meanwhile, you've got to refine the attitude part.

Music is a huge part of snowboarding culture. You know that. You know that the kids like punk rock. After all, you make video games. You're just a 30-year-old man-child. So, you talk to some labels, pick some tunes, and plan a focus group to validate your musical choices.

This is all a lot of fun until the dozen boarders in your focus group room go into heavy posturing. "What are your favorite bands?" Some start eagerly throwing out names. Others snipe at these suggestions. A third set of participants sinks sullenly back in their seats, and a couple of boarders drift off into the powder.

To reel everyone back in, you remind the group that this is a brainstorm by eagerly accepting all suggestions and going around the room one-by-one. This generates a pretty sizable list of bands with most of the overlap in tastes centering on expensive bands with some widespread popularity.

Thankfully, lots of the bands mentioned could be labeled punk if you're just a little generous in your categorization. At least you can be confident that you've validated punk as an enjoyable musical style for most of the snowboarding crowd.

Now you move on to the music you've picked. You play a song. Ask people to give it a thumbs-up or thumbs-down and please explain their opinions. You notice the participants noticing each other. They look

around the room as they make their decision. You probe and encourage people to be open. But, in the end, the bands that are familiar names receive the clearest enthusiasm. At least a few people have heard of them. Most of the songs receive halfhearted enthusiasm. No one likes a few of them. During the wrap-up, you ask for an overall consensus on the musical selection. A few people passionately argue for something other than punk music. The group as a whole agrees that variety is the key.

You're left with a very uneasy consensus. What do you do now? You could go with your gut. But then the focus group has been a waste of time and a truckload of money. You try to sum thumbs and go with the songs that evoked the least ire. But that skews you toward the bands that you already knew to be the most radio friendly—not necessarily the cutting edge.

This scenario points out a fundamental issue in choosing your method. Focus groups are very good for generating ideas and very poor at validating them.

Why are focus groups better than individual responses for generating ideas? Group interaction seeds individual creativity by encouraging us to examine differences between our opinions and those of others. The thoughts of others remind us of the way we feel ourselves. The differences between our ideas and others spur us to distinguish our ideas. They also encourage us to try out alternate perspectives and potentially incorporate elements of those perspectives into our own ideas. Creativity is this process of incorporating new elements into our ideas and putting together disparate ideas to create new ideas.

However, a similar process can lead people to avoid stating differences with others. It takes precious mental effort to withstand social pressure, to disagree with others, and to generate a plausible reason why you differ from others. Disagreeing becomes significantly harder if you perceive that you're the only person with an opinion. This perception comes quickly in group settings where one person might state an opinion and others might quickly agree. The onus is then on the dissenters to come forward. But the dissenters may take time to reevaluate their positions. Pauses and delays further support the appearance that there is consensus.

On the other hand, some participants will thrive on countering the crowd. This can lead to satisfying or at least interesting discussions. But it's hard to say whether the nonconformists are expressing attitudes about the songs or about the social setting. In psychology literature, the tendency for group discussions to result in more extreme attitudes—both more positive or more negative—is called group polarization (though you might be more amused by the military's term: incestuous amplification). Group polarization can disrupt accurate measurement of the attitudes of your participants.

So, what do you do? You pick the right method for the question that you're trying to answer.

When you want to generate ideas, you use a focus group. As moderator of a focus group, your job is to facilitate the generation of ideas. Bring dissidents into the conversation ("I'd like to hear from someone who feels differently..."). Clarify ideas ("So, you're saying..."). Encourage healthy consensus ("Some of you seem to be in agreement..."). Draw parallels between ideas ("What if Kelly's chocolate and your peanut butter..."). All of these techniques can simultaneously be used to avoid getting stuck in one area too long and move the conversation forward. In short, encourage people to clearly explain their ideas in a safe and constructive fashion, then encourage the group to combine and build upon each others' ideas.

Alternatively, if you want to evaluate ideas, you survey people individually. Give each person a concrete list of alternatives and ask them to choose or rank those alternatives. The clearest answers will

come when you present people with realistic trade-offs. Do you want this song or that song? Or rank the songs in terms of which songs you'd most like to see in the game. Make your acceptance criteria explicit. Rather than asking people which songs they like, ask them which songs they want to include in the snow-board game.

About the Author

Kevin Keeker trained as a social and personality psychologist at the University of Illinois and at the University of Washington before stumbling into usability engineering. Since 1994 he has worked on a variety of enter-tainment and media-related products at Microsoft. After managing Microsoft Game Studios' usability group, he shifted focus to apply his user-centered design experience as a game designer on Xbox sports titles. He's currently a user research lead at Microsoft Game Studios.

Feature Storyboards

The most powerful way to explain your ideas for new features is to visualize them. You can use Photoshop or any other image editing program you have access to. A good way to begin is to use screenshots from the existing game and edit them to explain what the player sees when they use your new feature ideas.

For example, show how the feature starts (e.g., exactly what the player sees on the screen when the feature is activated) and how the interface changes as the player manipulates the controls to use the feature. Show a series of still images—each with a slightly different on-screen condition—to simulate a player moving through the game using the feature. Storyboards like this can include dozens of still images—each just incrementally different than its predecessor—to show exactly how the feature works. Do not worry if you have poor art skills. The goal is not for the graphics to look perfect but rather to communicate your ideas with simple imagery.

Assemble the storyboard and add some light explanatory text. You can assemble the storyboard using presentation programs such as PowerPoint or Keynote. These programs make it easy for you to put together a long series of images and add light text. Do not put much text on the images because you want your ideas to be communicated visually.

Practice presenting the feature design to others to make sure it flows nicely. Ultimately this is an exercise in effective communication (i.e., transferring the idea that is in your mind to another person's mind), so treat it accordingly.

Exercise 6.10: Feature Design Exercise, Part 2

Create a visual storyboard stepping through the use of the feature idea you came up with for Exercise 6.9. Assemble the storyboard so that it tells a visual story of a player successfully playing the game. For example, the storyboard for Karaoke Revolution World Party could show all of the interfaces as if a player starts as a beginner and moves all the way to winning a prize. Present your idea to an appropriate group of people for critique, such as classmates or a game design club.

Visualizing new game features in the manner described above forces you to think through the hard problems of feature design. There is a big difference between an idea and a design. An idea is a loose concept that you present verbally or via a short written description. A design, on the other hand, is a detailed execution of an idea. Translating ideas into designs is an invaluable skill for a professional game designer.

CONCLUSION

Most beginning game designers simply borrow elements from successful games and adapt them to their own purposes. This is fine, and many experienced game designers make a career out of doing the same. Our goal, however, is to enable you to go beyond borrowing and begin innovating.

The game designers we admire are the ones who break conventions and go where other designers dare not tread. The advantage of computers is that improvements in technology often allow us to do things that were previously impossible. This gives the designer a unique chance to experiment with novel types of gameplay.

But do not rely solely on technical advancements to open up new avenues of design. Many of the greatest designs come about through tireless experimentation.

For example, take board games. Technically, they have not advanced much in the past 200 years—they still use cardboard, dice, and tokens—but conceptually, they keep advancing all the time. The top designers come up with games that break all the old rules or push the envelope in terms of creativity and gameplay. Play the games suggested in Exercise 6.3 for inspiration.

The same is true in the computer world. You will find that some of the most inventive games were designed on so-called "primitive" systems. Sometimes limiting yourself to the basics helps you focus your ideas more clearly. With that in mind, it is time to see if the ideas you have generated actually work. This is called prototyping and playtesting—the subjects of our next three chapters.

DESIGNER PERSPECTIVE: BILL ROPER

CEO, Flagship Studios

Bill Roper is a game designer and producer whose credits include games such as Warcraft: Orcs and Humans (1994), Warcraft II: Tides of Darkness (1995), Diablo (1996), Starcraft (1998), Starcraft: Brood War (1998), Diablo II (2000), Diablo II: Lord of Destruction (2001), Warcraft III: Reign of Chaos (2002), and Warcraft III: The Frozen Throne (2003).

On getting into the game industry:

I have always been an avid gamer, ever since my mom and dad introduced me to cribbage and blackjack (respectively) to teach me quick addition skills at the age of five. I was doing desktop publishing on the 4:00 p.m.–1:00 a.m. shift for a company called Lasertype when a good friend of mine told me about an opportunity at the small game company where he worked. They needed someone to do the music for a port of one of their games onto the PC because the regular music guy was busy working on their first self-published title. The company was Blizzard, and after doing music for the PC version of Blackthorne, I was fortunate enough to stay on to do voice-over work, world design, and the manual for WarCraft: Orcs and Humans. The day I started in the game industry and turned in my resignation to the desktop publishing company was one of the best in my life.

On favorite games:

This list changes slightly every time I think about it, due in great part to the sheer number of games I play. Also, these are from an all-time list, and not necessarily the ones I am playing right now—some of which might be on this list if I wrote it out again in few months.

- *Wizardry:* One of the great early gaming experiences on the Apple II, I can still remember marveling at the fact that it looked like you were actually walking down a hallway to fight the monsters. The dungeon designs, the puzzles, the interface, the items (Cuisinart the Vorpal Blade) and the story were all fun and exciting. Wizardry was definitely a defining title in my high school gaming days on the computer.
- *Carcassonne:* This is a fantastic board game out of Germany that centers on the construction of cities and roadways. It changes every time you play it, thanks to the system of people playing

a randomly drawn tile on their turn. The game has a lot of social aspects as well because each piece is flipped up and the entire table is supposed to give their advice on how best to play it. I can, and have, played game after game after game of this for hours on end.

- *Diablo II:* Although I worked on this game, it (along with the expansion set) still holds my interest. It is a wonderfully fun romp where just about everything is random, so it simply never gets old. A great community of gamers has grown around the game, and hooking up to play over Battle.net is so easy, it all makes a terrific package for single or multiplayer fun, whether I have 15 minutes or an entire weekend to spend on it.
- *Grand Theft Auto III:* Whether you agree with the edgy premise of the game world, the mechanics and thoughtfulness that went into this game are undeniable. I have played this since it came out, and I am still finding new, fun things to do. The openness of the design and the sheer fun of driving around at breakneck speeds keeps this high on my list.
- *Poker:* I honestly think this is perhaps the perfect game. It has simple rules with a limited and easy to understand number of pieces, has innumerable game variations that don't require an expansion set, is played by both core and mass market gamers, is portable, has a scalable risk to reward ratio, and is equal parts skill and luck. Throw in the fact that it is a multiplayer game, and you can hopefully see why it has all the pieces of the puzzle for being an amazingly good game.

On inspiration:

I think that everything we do in life can act as inspiration for making games, whether reading books, watching movies, listening to music, traveling to different places, playing sports, or just simply living your life. I have always believed that you have to play games to make games, just like a chef eats at a lot of different restaurants to better understand and refine his own craft. I can look to games from Civilization to Monopoly to EverQuest to Super Mario Bros. to StarCraft to Bard's Tale to Half-Life to Madden NFL and find elements that either really make that game work or could have been done better. The real challenge comes in being able to just sit down and play without completely analyzing every minute element, but I suppose that comes with the territory.

Advice to designers:

To quote a popular ad campaign: "Just Do It." You can't get good at making games unless you make games. Use the level design tools that are a part of many of the best-selling titles to work out game ideas. Tear apart board games to prototype your ideas. Play around with existing games by changing rules or goals or the strengths and weaknesses of the individual components and see how the balance works. Most importantly, never stop playing.

DESIGNER PERSPECTIVE: JOSH HOLMES

Vice President and Studio Manager, Propaganda Games

Josh Holmes is an experienced game producer and designer whose credits include NBA Live '98 (1997), NBA Live '99 (1998), NBA Live 2000 (1999), NBA Street (2001), Def Jam Vendetta (2003), and Turok (2008).

On getting into the game industry:

I was a struggling film actor with a series of dead-end jobs on the side to help pay my bills. I started looking for something I could do that might interest me as much as acting. I had always been a gamer and dreamed of creating my own games, so I applied with EA. In the interview I told them my goal was to be a game designer within five years. I started as a game tester, and after a year and a half in the QA department, I moved into production and started making games.

On favorite games:

- *Sid Meier's Pirates!:* This is my all-time favorite. It was (and still is) the most successful example of a hybrid game, combining several different game styles to create a cohesive overall experience. While the game experience was predominantly nonlinear, it gave the impression of creating a rich narrative each time you played, based on the actions of the user. It also featured multilayered goals and rewards, so the replay value was extremely high.

- *SimCity:* This was the ultimate sandbox game. By providing a simple, yet rich simulation, it gave the user the tools with which to create his own fun. There are just so many ways you can play SimCity. That's what makes Will Wright's games so amazing; he helps you unlock your inner creativity while playing his games.

- *Tetris:* If there was only one game I could play for the rest of my life, I would choose Tetris. Simple, abstract, and devilishly addictive, I never seem to grow bored of playing. There is a lesson on the value of simplicity here.

- *Grand Theft Auto III:* It successfully combined a compelling action experience with the sandbox concept of building your own fun and then threw in a dark humorous fiction borrowed from many of my favorite films. It came the closest to realizing my vision of what games will one day be: a complementary part of mainstream entertainment and culture.

- *Virtua Fighter 2:* This is my favorite fighting game. I love the characters, the variety of fighting styles, and most of all the immersive control system. When you learned the controls, it had a

feeling of connection with your fighter that all other fighting games seemed to lack. It wasn't just a matter of memorizing long strings of button presses to initiate scripted combos; fights were back-and-forth dances of action and reaction. It really captured the essence of what fighting is all about.

On Creating NBA Street:

Everyone's expectations for the game were basically just that we deliver an arcade-like basketball experience. We took the game much further, introducing bold new gameplay concepts and representing streetball culture. The gameplay engine was created from scratch, and it became a step forward for basketball games in a lot of ways.

What words of advice would you give to an aspiring designer today?

1. Think of the consumer

You aren't designing for yourself. It doesn't matter what game you personally want to play, you have a responsibility to create the experience that the audience wants. That doesn't mean you should be predictable. Give them what they want, just not how they expect it.

2. Fun first

Whenever you have a choice between realism and fun, go with fun. Anybody who chooses realism at the expense of fun needs a smack upside the head.

3. Always strive for balance

As a designer, game balance should be foremost in your mind whenever you introduce a new feature or concept. For every reward, there must be risk. For every attack, there must be a defense. Balance is the key to a great game experience.

4. Think big

Any time you have an idea, take it as far as you possibly can. Subtleties rarely play.

5. Remember pacing

Design your game experience to be a series of emotional peaks and valleys. If the experience remains at one level, it becomes flat and boring, even if it's "action-packed." (See State of Emergency for a one-note action-packed experience.) Always remember: you can't have highs without lows.

6. Play bad games

Learn from the mistakes of others. Compare successful games against their hurting counterparts and analyze what went wrong. Then make sure you don't fall into the same traps.

7. Look outside of games

The best and most innovative designers create new experiences that seem different from anything we've played before, though the core mechanics are often familiar. Look outside of games for new ideas and then marry them to proven gameplay mechanics. A perfect example of this is The Sims. Life is filled with new experiences just waiting to be expressed as games. Don't be content to photocopy existing games. The world does not need another sassy female adventurer with big boobs.

FURTHER READING

Brotchie, Alastair and Gooding, Mel. *A Book of Surrealist Games*. Boston: Shambhala, 1995.

Csikszentmihalyi, Mihaly. *Creativity: Flow and the Psychology of Discovery and Invention*. New York: HarperCollins Publishers, 1996.

Edwards, Betty. *The New Drawing on the Right Side of the Brain: A course in enhancing creativity and artistic confidence*. New York: Putnam, 1999.

Gladwell, Malcolm. *Blink: The Power of Thinking Without Thinking*. New York: Little, Brown and Company, 2005.

Michalko, Michael. *Thinkpak: A Brainstorming Card Deck*. Berkeley, CA: Ten Speed Press, 2006.

END NOTES

1. Salen, Katie, and Zimmerman, Eric. *Rules of Play: Game Design Fundamentals*. Cambridge, MA: The MIT Press, 2004. p. 22.

2. Csikszentmihalyi, Mihaly. *Creativity: Flow and the Psychology of Discovery and Invention*. New York: Harper Perennial, 1996. pp. 79–80.

3. Ibid, pp. 80–81.

4. The Imagineers. *The Imagineering Way*. New York: Disney Editions, 2003. p. 53.

5. Glenn Entis at EA@USC Lecture Series, January 2005.

Chapter 7

Prototyping

Prototyping lies at the heart of good game design. Prototyping is the creation of a working model of your idea that allows you to test its feasibility and make improvements to it. Game prototypes, while playable, usually include only a rough approximation of the artwork, sound, and features. They are very much like sketches whose purpose is to allow you to focus on a small set of the game's mechanics or features and see how they function.

Many first-time designers would rather jump in and start making the "real" game rather than starting with a prototype. But if you invest the time, you will discover that there is nothing more valuable for improving gameplay than a good prototyping process. When you are making a prototype, you do not need to be concerned with perfecting how it looks or whether the technology is optimized. All you need to worry about are the fundamental mechanics, and if these mechanics can sustain the interest of playtesters, then you know that your design is solid.

METHODS OF PROTOTYPING

There are many types of prototypes, including physical prototypes, visual prototypes, video prototypes, software prototypes, etc. A single project might require a number of different prototypes, each addressing a unique question or feature. The important thing to remember when prototyping is that you are not creating the final design, you are simply trying to formalize your ideas or isolate issues so that you can discover what works before going on to create the final design. This chapter will deal mainly with physical prototypes, those made using pen and paper, cards, dice, etc. to test the core game mechanics. Such paper designs are one of the most powerful tools a designer has to work with, but they are only one method of prototyping. Chapter 8 will discuss digital prototyping and how to successfully use software prototypes in your design process.

Physical Prototypes

Physical prototypes are the easiest type of prototype for most game designers to construct on their own. These are typically created using slips of paper, cardboard, and household objects with hand-drawn markings. You are free to use anything you like, from lead figures to plastic army men to pieces borrowed from other games. Whatever you can cobble together is fine.

The benefits of physical prototyping are many. First, it allows you to focus on gameplay rather than technology. Over the years, in the many game design classes and workshops we have taught, we have found that when a team starts programming, they become very attached to their code. Making changes to the gameplay becomes a challenge right away. But if the design is on paper, iterations do not seem as difficult.

Don't like the way a turn structure works? Just change it and try it again. Games can go through more iterations in a shorter period of time and with little wasted effort. Another benefit of physical prototyping is that you can respond in real time to player feedback. If players come up with an issue or idea, you can incorporate it on the fly and see how it works.

Physical prototyping also allows for nontechnical team members to participate at a very high level in the design process. No one needs specialized knowledge or expertise in a programming language to give their input, which will allow for a wider variety of perspectives in the design process. Physical prototyping will also allow for a broader and deeper experimentation process simply because it can be done without major cost or use of resources.

In early drafts of your physical prototype, we recommend that you pay no attention to the quality of the artwork. Stick figure drawings are the norm. The goal is to rough out system components so that you can see how the game operates on a mechanical level. Spending time on the artwork only slows down the process. Also, if you invest too much time crafting the look and feel of the prototype, you might become attached to your work and be reluctant to make changes. Because the prototyping process is all about iteration and change, this becomes counterproductive.

Battleship Prototype

We are going to walk through the process of developing several physical prototypes so that you can get a sense of how they are made and used. We will start with a classic game with a simple system you have probably played before. If you are not familiar with Battleship, it is a popular two-player board game in which the object is to be the first player to sink your opponent's fleet.

Let's construct a physical prototype of this game. When starting with a prototype, it is best to identify the key elements of a game and then handcraft each element. In this case, take four sheets of paper and draw a 10 × 10 grid on each. Label the rows on each grid with the letters A through J. Label the columns on each grid 1 through 10. Put the following titles on the four grids: Player 1 Ocean Grid, Player 1 Target Grid, Player 2 Ocean Grid, and Player 2 Target Grid. The final set will look like Figure 7.2.

Next find two players and give each an Ocean Grid, a Target Grid, and a pen. Players should shield their grids from their opponent's view. Each player distributes the following five ships by drawing on his Ocean Grid. The numbers in parentheses are the ships' sizes on the grid:

- Carrier (1 × 5 cells)
- Battleship (1 × 4 cells)
- Destroyer (1 × 3 cells)

7.1 Prototyping materials

7.2 Battleship grids

- Submarine (1 × 3 cells)
- Patrol Boat (1 × 2 cells)

All segments of the ships should be drawn on the ocean grid. Ships may not be placed diagonally. Figure 7.3 shows an example of ships placed on the grid.

Now that you have the prototype assembled, it is time to play. On a player's turn, that player calls out grid coordinates, such as "B5." If the opponent has a ship on that cell, then she answers "hit." If not, she answers "miss." When all segments of a ship have been hit, the opponent says, "You sank my battleship!" Simple enough?

Players track hits and misses on their target grids. If B5 is a hit, the player marks an H on his target grid. Players take turns calling coordinates like this until one player sinks all five of the opposing ships. Figure 7.4 shows an example of what grids will look like during play.

Play this game yourself. Think about it in terms of how it functions as a prototype. Does it accurately represent the game mechanics? Although the artwork is crude and the rules are rough, do they provide enough of an experience for someone to grasp the game and give feedback? If this is the case, then the prototype is a success.

As you can see, making a playable game prototype does not require programming skills or art skills. The experience generated by the paper version of Battleship is almost identical to the experience generated by the fully produced Milton Bradley version.

The advantage of prototyping is that as you assemble the game, you gain a tactile sense for how the mechanics fit together. Abstract rules suddenly become concrete. You can look at the grid and ask yourself, "What if I made that bigger? How would that affect the gameplay?" Enlarging the grid is simple; it is just a matter of getting out a piece of graph paper and drawing a bigger box. Then you can replay the game and see if the experience is better or worse.

Exercise 7.1: Modifying Your Prototype

Take your Battleship prototype and modify three aspects of the game. You can change the grids, the ships, the object of the game, the procedures for playing, etc. Get creative with the changes you make. After each change, play the game with a friend and describe how that particular change affects the gameplay.

As you manipulate elements of the game structure, it will invariably spark more ideas, and it is not uncommon for entirely new systems to materialize during this process. You can then spin some of these systems off into their own games. After you become experienced at prototyping, you will find that this is

7.3 Battleship grids with ships

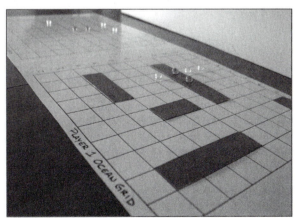

7.4 Battleship grids during play

probably the most effective way to create gameplay because it takes you right down into the mechanics and permits you to experiment in a way no other process can.

More Examples

Physical prototypes are critical for designing both board games and sophisticated electronic games. Many famous electronic games are based on paper games. The system for digital role-playing games such as Diablo II, Baldur's Gate, EverQuest, Asheron's Call, and World of Warcraft are derived from the paper-based system of Dungeons & Dragons. Likewise, the system for the famous computer game Civilization is based on a Civilization board game published by Avalon Hill.

The designers and programmers of these games used the paper-based originals to figure out what would work electronically. Many video game designers actually started out as board game designers, including Warren Spector and Sandy Petersen, whose Designer Perspectives you can find on pages 23 and 47. Building and revising paper prototypes instills a deep understanding of gaming principles, and it does so in a setting that is not bogged down by the complexities of software development.

One good way to train yourself in the design of game mechanics is to challenge yourself with controlled design exercises in which you take an existing game system, set a new player experience goal, and make changes to the system to meet that goal. While not as difficult as designing a game from scratch, this is good practice in thinking through design problems and designing to meet a goal.

Our example will use another simple system, a children's game by the company Ravensberger called Up the River. You might not have played this game, but we will walk through the original rules and the creation of an initial prototype in the same way we did with Battleship. We have done this particular exercise with hundreds of game design students all over the world, and the system, while simple, has lent itself to a wide range of resulting game concepts.

Up the River Prototype

Up the River has an unusual board design. The board is made up of ten equally-sized pieces, as can be seen in Figure 7.5. These pieces are lined up to form the river. To make your own board pieces, just cut up regular white paper as shown in Figure 7.6. When the game begins, the piece at the bottom of the river is the sandbar, and the fifth piece from the bottom is the high tide. These are special terrains that will be explained later; be sure to mark them on your prototype board pieces. At the top of the river sits the harbor or goal card, which you will need to create as well. This card has twelve numbered docks, or spaces across its top. In addition to the board, you will need some player pieces and a six-sided die. You can use beads or buttons of four different colors for the player pieces, or boats, and you will need three of each color. To begin, players line all their pieces up on the fourth piece from the bottom of the board, as seen in Figure 7.5.

The objective of the game is to move all three of your boats to the harbor card and earn the most points. Your score is the total of all docks your boats are placed at, and the player with the most points wins.

7.5 **Up the River**

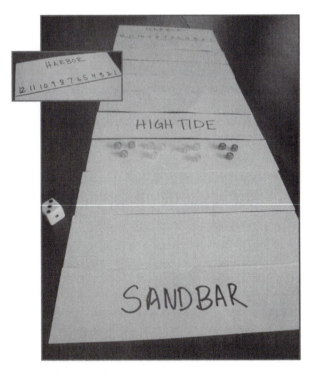

7.6 Up the River prototype

The procedures of the game are simple: The youngest player goes first. On her turn, a player rolls the die and chooses one of her boats to move forward that many spaces. A player can only move one boat per turn. If a boat lands on the sandbar, it must stop there until the player's next turn, even if the roll was higher. If a boat lands on the high tide card with a direct throw, it advances three extra spaces, even if this means it advances into the harbor. A player does not need an exact throw to enter the harbor.

So far the game seems fairly mundane—a dice race. But there are two special rules that give the system just enough of a twist to make it interesting. The first is called the waterfall. After each player has had a turn, the bottom piece of the board is moved to the top. This simulates the current of the river pushing the boats back downstream. Any boats that are on that bottom piece are lost and taken out of the game. Suddenly our simple dice race has a more dramatic twist! Each time you choose a boat to move, you must consider the placement of your other boats as well.

Are they at risk? Will they be at risk the next time the waterfall occurs? As we have discussed, this simple dilemma adds conflict to the system.

The next special rule is called good wind/ill wind. This occurs when a player rolls a six. Instead of moving six spaces, the player must now make a choice: whether to move any one of her boats *up* to join her next boat farther up the river—good wind—or whether to move one of her opponent's boats *down* to join the nearest boat of the same color—ill wind. When choosing good wind, if a boat moves past the sandbank, it must stop there. When choosing ill wind, if a boat moves past the sandbank, it need not stop. If the player who rolled the six has only one boat, or if all her boats are on the same card, the good wind option is not available. If her opponents have only one boat or all their boats are on the same card, the ill wind option is not available. If neither option is available, the player who rolled loses her turn, and the turn moves to the next player. The good wind option may not be used to move into the harbor.

The good wind/ill wind option adds an interesting choice to this simple system. Players can, in effect, choose to act for themselves or against their opponents. This moment of choice is an example of player to player interaction that creates an interesting moment of gameplay. When players move their boats into the harbor, they place them on the next available dock and score the number of points on that dock. The game ends when all the boats have either gone over the waterfall or entered the harbor. All the points are added up, and the player with the highest score wins.

Play your Up the River prototype and analyze how each element in this simple system adds to the game. Ask yourself these questions about the formal system:

- What is the relationship between the size of the board and the number of points on the die? What happens if you change the size of the board?

- What is the relationship between the number of boats each player has and the starting position? What happens if you change the starting location?

- Why is the starting position of the sandbar important? What about the high tide card?
- What skills are necessary to play this game? Is the game ultimately decided more by skill or by chance?
- What does the good wind/ill wind option add to the game?
- Why does play begin with the youngest player? Who is the market for this game?

Thinking about these and other questions should lead you to see some potential changes you might make in the game system, but change for the sake of change is not the goal here. Before you begin modifying this system, brainstorm several possible player experience goals for your new version of the game. Here are some examples:

- The game is resolved by strategy rather than chance.
- The game has teams on which each player has a special role to play.
- The game has more player to player interaction, including negotiation.

In addition to your player experience goal, you will want to come up with a dramatic metaphor for your new game that reflects your player experience goal. Figure 7.7 shows a number of variations on Up the River, including a pirate game that added trade and theft to the system; a mountain climbing game that required teamwork; and a race game set in a traffic jam surrounding the USC campus.

Exercise 7.2: Up the River Variation

Create your own variation of Up the River. Set a player experience goal first and brainstorm ideas to change the system to meet that goal. Then modify your Up the River prototype, or build a new one, to reflect your changes to the system. Play your variation with friends and see if you have met your experience goal.

You can create your own controlled design exercises and continue practicing your design process. Just start with an existing game system and analyze it to clearly understand its formal, dramatic, and dynamic elements. Then come up with a new

7.7 Variations on Up the River

player experience goal and make changes to the system to meet your design goal. We advise starting with very simple games. And remember, even small changes to a tightly balanced system can have a great impact on the gameplay. By practicing this process, you will become a stronger designer and gain a deeper understanding of many different types of mechanics.

Prototyping a First Person Shooter

It's one thing to prototype a simple board game, but you are probably wondering if it possible to create a physical prototype of an action-packed video game. The answer is yes. While a paper prototype of a digital system has limitations, it is still quite valuable to the design process. For example, you can create a paper prototype of a game in the first person shooter (FPS) genre. Classic examples of first person shooters include Quake, Castle Wolfenstein, Battlefield 1942, Half-Life, Unreal Tournament, and Medal of Honor. The core game mechanics of these games involve player units running around shooting other units. That is simple to understand, but how do you model one of these games on paper, and what can that teach us?

A physical prototype of a first person shooter can help you understand the larger tactical and strategic issues of weapon balance, territorial control, etc., but it won't help you to understand the fluid process of running, aiming, and shooting in a 3D environment. In this way, it is possible, in fact probable, that an accurate paper prototype of a first person shooter will fail to capture the essence of the game's player experience while still providing a valuable design process. As we will see in the following chapter on digital prototyping, one game can have many different prototypes, each addressing different questions about the design. A paper prototype is well suited to some questions about the design of a first person shooter (for example, those regarding level design and weapon balance), while not being suited to others. The distinction should become clear to you as we construct our physical prototype for a first person shooter.

Arena Map

Take a large sheet of hexagonal graph paper. Hexagons are nice for prototypes because they allow units to move diagonally. You can purchase this graph paper at most board game stores or print it out using one of several freeware and shareware programs available online, such as HexPaper 2. The grid will serve as the arena for your game.

Cut out a small paper chit and color it red to mark spawning points. A spawning point is the cell on the grid where units materialize after they are killed.

Put lines on the grid to represent walls. Units cannot move or shoot through walls. It is helpful to make walls out of objects that can be repositioned on the grid. Matchsticks are perfect for this. Having moveable walls makes it easier to tweak the system.

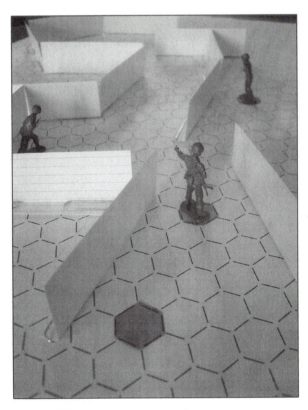

7.8 FPS prototype example

CATASTROPHIC PROTOTYPING AND OTHER STORIES

by Chaim Gingold

Chaim Gingold was part of Spore's original concept team and is the design lead of Spore's creature creator and other in-game creativity tools. Prior to working with Will Wright, Chaim studied with Janet Murray at Georgia Tech, where he earned an MS in digital media. He has spoken around the world on game design, prototyping, and player creativity. His current obsessions include improv, trains, and Japanese aesthetics.

My hard drive was full of failures. Twelve years after learning to program, I looked back on all my software: Almost none of it was finished, and what was, wasn't ambitious enough. The projects that started out ambitiously always seemed to fall back to Earth, like failed rockets lacking the power to propel their own weight into orbit. Sure, there were interesting ideas in there, lots of wacky toys, and I had even attempted a few large projects, but none of them ever came together like the cool games and software I had always admired.

Sure, I had become a pretty good programmer and learned to make cool stuff, but clearly none of it would ever amount to anything. I just didn't have what it took.

I went to graduate school at Georgia Tech and read some Chris Crawford. I learned that he had the same problem. But he didn't think of it as failure. For him, this was an organic part of the development process. The failures filling his head were actually prototypes that helped him decide which ideas were worth pursuing. For each good idea, there were a large number of stupid ones that didn't work out. Failing, for this successful designer, was a way to find the good ideas. The revelation hit me like a ton of bricks. Maybe I had a chance after all.

Ken Perlin came to Georgia Tech and gave a talk on his work with emotional software actors. His work blew my mind. He had an infinite series of cool little toys, which he considered to be sketches or studies. Master artists like Escher or van Gogh don't just sit down and crank out a finished piece. Artists create numerous sketches and studies before they undertake finished paintings, let alone masterpieces. Ken's larger demos clearly built on top of what he had learned in previous ones. It all formed one long line of inquiry and research. In Ken's world, my failures, which I was now calling *prototypes*, were like an artist's studies, a necessary part of any major undertaking.

All of my software failures, which I was now thinking about as prototypes, sketches, and studies, had taught me a thing or two about design and programming. If you want to learn to draw, you have to make a ton of bad drawings first. The difference between practice and failure is simply a matter of attitude. One thing led to another, and my experience, plus being in the right place at the right time, led to an internship with Will Wright. He was working on a new game at the time, code named Spore, and had a small team working on prototypes.

I went to Walnut Creek for the summer, joined the impossibly small Spore team, and it all finally started to click into place. Maxis was in the thick of The Sims Online, and the other intern and I were placed in the hallway outside of Will's office, next to the Elvis shrine, on folding tables. Under my "desk" was one of Will's old Macs, a fancy machine from the mid-1990s, which, to my delight, we hooked up. Spending the summer at Maxis was like going to Santa's workshop at the North Pole and finding out how the elves made the toys.

Prototypes from Spore

The old Mac was like a treasure cave, a historical archive of blueprints, prototypes, projects, and concepts. I could study the source code to some of my favorite games, like SimAnt, SimCity, and SimCity 2000. But that wasn't even the best part. I found an ambitious Maxis project about tribal civilization from the early 1990s that was never completed. It was like a murder mystery. Why had this project died? The hard drive was full of prototypes for a secret project, which turned out to be The Sims. Apparently, Maxis had been working on the game for a long time, and many aspects of it had been prototyped in isolation, including a 2.5d character animation system and editor, the motive- and decision-making AI, and a house editor. The code to the last prototype was clearly a hacked version of the SimCity 2000 engine. I found a program that used genetic algorithms to procedurally generate SimCity-style buildings with a blind watchmaker style interface. That program had clearly been written as efficiently as possible, not from a run time point of view, but from an implementation standpoint. It was using the SimCity 2000 code base as a host organism for some rapid experimentation. Will's imagination had clearly been running faster than proper software engineering practice allowed. All of this, plus the awesome array of prototypes the Spore concept team had been cranking out, made a big impression on me. I joined in and contributed some of my own wacky prototypes to Spore.

What was going on here? What did all of this mean? Thinking back, I realized I had made two classic mistakes. First, my eyes were bigger than my stomach. The ambitious projects I had undertaken in the past "failed" because I made the mistake of not proving out the core ideas in prototypes. You can't send a rocket to the moon if you haven't first experimented with launching simple toy rockets. My sense is that the tribal civilization game died for similar reasons: Its author had launched into an ambitious finished project without doing the proper research, sketches, and prototypes.

Secondly, my success/failure evaluation function had been wrong. While the code to the The Sims prototypes wasn't in the final game, they had clearly informed the final product. All of my small "failures" were actually a series of small successes that had improved my design skills, and they were in fact studies I could incorporate into larger projects. I had it backward the whole time. My "successful," but incomplete, large projects were the real failures. I had invested too much energy into large projects that would fail because I hadn't done my homework. It's a hard lesson to take and one that most people probably have to learn the hard way.

So I dusted off my ACM programming competition skills, which taught me to make tightly focused programs in minimal time and with minimal frills. I became a better designer, really fast. I gained tons of design experience points by slaying so many gremlins.

I finished at Georgia Tech and joined Spore. My vast collection of tiny student projects, bite-sized personal projects, and work prototypes I had made added up to a huge amount of experience and intuition. Compared to my peers, I had a tremendous amount of design experience, simply from writing, evaluating, and throwing away so many ideas. I witnessed good prototypes move mountains. I like to think of good prototypers as powerful ninjas who can drop into hard design challenges, or tedious design debates, and cut them to shreds with one swift movement of their prototyping blade.

Here are a few prototyping rules of thumb. Even with years of experience, I often find a prototype going nowhere and can usually trace the problem to not following one of these rules:

- **Always Ask a Question.** Always ask a question, which will give you purpose, and have a hypothesis, which is a specific idea you are testing out. For example, you might be thinking about mouse-based control schemes for a school of fish. Your question is: How do I control these fish with a mouse? A hypothesis might be: Flocking will make the fish move together, and every mouse click will drop an invisible "bomb" that will act as a repulser upon every fish's steering AI, and it will take a few seconds to complete exploding. A good way to make sure you aren't going to waste time implementing ideas you don't actually have, which happens to me more often than I'd like, is to diagram the idea on paper first and work out as many details with a pen as possible. This also speeds up writing the prototype.

- **Stay Falsifiable.** Just like good science, you must validate the results of your experiment. Did your hypothesis work? Does your fish flock control scheme feel good to you? Do your friends find that it feels good? Does it work in the context of your game idea? You can never user test and playtest an idea too early. I have seen many cool ideas go down in flames because its owner was overprotective, didn't think it was ready, didn't believe the feedback they were getting, explained away people's responses, or thought that only their opinion mattered. Eventually users will play with your work, and by then it will be much harder to fix the design. Incorporate the user into the design process as early as possible. Be honest with yourself and your players, and you will be richly rewarded. This one is easy for me because as a designer, my main intent is to entertain and transform other people, so I'm always interested in what effect my work has on others. Watching people use what you make will also make you a smarter designer.

- **Persuade and Inspire.** We're making entertainment and art—your prototype should be cool, fun, and excite people. If you and your peers are compelled, your players will be too. On the flip side,

You probably already have questions like: How many hexes should be on the grid? How big should each hex be? How many spawning points do I need? and Do I need lots of walls or only a few? The answer to all of these questions is: Take your best guess. There is no way to know what will work until you play the game. No matter what you decide, you will probably wind up changing it later on. Pick whatever parameters you deem reasonable and proceed with the process.

Units

Units are "your guys" in this game. You can represent them with coins or plastic army men or other household objects. Whatever you use should fit within one cell on the grid. In addition, a unit should clearly show which direction it is aiming. For example, if you use coins as units, draw an arrow on them to indicate their direction.

This prototype is designed so multiple units can play at the same time. To determine starting cells for the different unit on the grid, roll a die. The player

if something isn't resonating with other people, perhaps your idea or approach should be reconsidered. Prototypes can be powerful persuasive devices. Keita Takahashi, the designer of Katamari Damacy, couldn't convince anyone that rolling around a giant sticky ball would be fun. Until they played the prototype.

- **Work Fast.** Try to minimize time to your first "failure" (rejecting a hypothesis), and don't be afraid to push the eject button. A classic error is to spend months working on an engine, architecture, or something else that has nothing to do with proving out your core design idea. Prototypes don't need engines. Prototypes are slipshod machines held together by bubble gum and leftover bits of wire that test and prove simple ideas as quickly as possible. If you find yourself weeks or months into a project with only an engine, you've failed. Perhaps you need to articulate a specific gameplay idea to validate. For me, the ideal window of time to start and finish a prototype (including design, implementation, testing, and iteration) is two days to two weeks. Anything longer than that sets off alarm bells.

- **Work Economically.** You're making something small and beautiful, so invest development effort wisely. To work fast, you must stay small: Don't do too much at once or you'll never make progress. Be realistic. Here are some questions to ask yourself when you are considering how much effort to spend on proper engineering, art, interface design, or any aspect of your prototype. What's the purpose of this prototype? Who will use it? What's important? Look? Kinesthetics? Load time? Run time? Usability? Persuading your peers? Be a cheap, lazy, slothful programming bum. Just make it work so you can test your idea. Don't go above and beyond the call of duty in programming, art, or any other aspect of your prototype.

- **Carefully decompose problems.** Don't bite off more than you have to at once. If you prototype all systems simultaneously you will fail because you can't work fast or reach any kind of conclusion. To build it all at once is to build the actual game, which is hard. The prototype designer's job, like a good Go player, is to cut and separate the enemy stones (your design problem) into small, weak groups that can be killed or manipulated at will. Wisely divide your problem into manageable pieces. You must be careful because problems are sometimes connected in nonobvious ways and bite you later. Through practice, your designer's intuition and experience will help you see the connected nature of the problem you are trying to subdivide and make the most judicious cuts.

with the lowest number places her unit on the grid first. Go in clockwise order from there and have each player choose a starting cell. An example of what your prototype might look like is presented in Figure 7.8.

Exercise 7.3: Movement and Shooting

If you want a challenge, stop reading now and come up with your own movement and shooting rules. Explain your reasoning behind this set of rules.

Movement and Shooting Rules

Here is one possible solution for movement and shooting. There are endless other creative possibilities, and we encourage you to experiment with them.

Each player gets the following nine cards:

- Move 1 space (1)
- Move 2 spaces (1)
- Move 3 spaces (1)

- Move four spaces (1)
- Turn any direction (2)
- Shoot (3)

Play is executed in rounds.

1. Build stack: Each player chooses three cards and places them face down on the table in a stack.

2. Reveal: Each player turns over his top card.

3. Resolve shoot cards: Players with a shoot card fire in the direction their unit is pointed. They follow an imaginary line across the grid. If this line intersects with a cell containing another unit, the shot hits. If this line comes to a wall or otherwise does not intersect with a unit, it misses. Shots happen simultaneously so that two or more players can hit at the same time.

4. Resolve turn cards: Players with turn cards turn their unit to whatever direction they please. If two or more players have turn cards, roll a die to determine who turns first.

5. Resolve move cards: Players with move cards move their units the number of spaces specified on the card. If two or more players have move cards, roll a die to determine who moves first. Players cannot occupy the same cell.

6. Repeat steps 2–5 for the second card in the stack.

7. Repeat steps 2–5 for the third card in the stack.

If a unit is shot, it is removed from the grid, and the player chooses one of the spawning points on the grid and reappears there at the beginning of the next round.

Exercise 7.4: Build It Yourself

Build the physical prototype described just previously and test it out. Describe any problems that you encounter. Also, list out any questions you have while building it.

This process of prototyping an action-based game might seem to be complex, but if you think about what we have done, it is pretty amazing. In a few pages, we have completely described how to build a first person shooter using only pen and paper. When you play with this model, you will see that it is both flexible and simple to use.

Some suggested additions to your first person shooter prototype are as follows:

- Add a scoring system: Make players track the number of kills they get. The first player to get ten kills wins the game.

- Include a hit percentage: Suppose the chance that a shot hits is 100% when two units are standing on adjacent hexes on the grid. This percentage decreases by 10% for each hex of distance added. Calculate hits and misses using a ten-sided die.

- Provide hit points: Have each unit start with five hit points. One shot suffered removes one hit point.

- Drop in first aid: If a unit stands on a first aid hex on the board for a full round, then his hit points return to their original amount.

- Add in ammo: Units start with ten rounds each. Every time they shoot, one bullet is removed. If a unit stands on an ammo hex for a full round, he will reload his clip.

- Introduce other weapons: New weapons can be placed on the grid. If a unit stands on the weapon, he can use it in the next round. Enhancements to weapons include more damage per shot, higher accuracy, more bullets, etc.

Exercise 7.5: Features

Add some or all of the features mentioned previously plus a few that you dream up yourself and incorporate them into the physical prototype. Write down how these features affect the gameplay.

New rules and features can continue to be added, altered, and removed. You can use the system to create capture the flag games, cooperative play missions, and death matches. You can continue

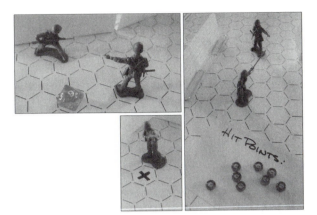

7.9 FPS prototype example with additions; clockwise from top left: hit percentage, hit points, and first aid

adding, testing, and tweaking until you come up with the right combination. Each time you add a rule or feature, it might spark new ideas and lead you down a path you did not expect to go. This is the heart of the creative process, and you should encourage yourself to try things that might seem ridiculous or absurd and just see what happens when you play the game. Completing these exercises will give you insight into how first person shooters and 3D adventure games are structured.

Exercise 7.6: Working Backward

Now let's apply what you have learned to a different type of game.

1. Take two different real time strategy (RTS) games, such as WarCraft and Age of Empires, and work backward. Strip away the external feature set and show what both games have in common. These are the core game mechanics.

2. Translate the core game mechanics for one of the RTS games to paper in a playable format.

 Remember, all we care about are the rules that correlate between the two games. These rules represent

the core gaming system and will form the basis for your RTS physical prototype.

Perspective on Physical Prototyping

People who are not used to physical prototyping might argue that this method does not accurately represent the player experience on a computer. They might think a pen and paper prototype might work for a turn-based game, but not for an action-based shooter because gameplay is integrally tied to the 3D environment and the ability of the players to act in real time. We are not arguing that physical prototyping replaces those things. What we are saying is the overall gaming system can benefit tremendously in its early stages by building a physical prototype.

Physically prototyping allows you to build a structure for the game, think through how the various elements interact, and formulate a systemic approach to how the game will function. The sensory experience created by a digital game—that is, the feeling of moving through a 3D space—is only one component of an engaging game experience. Although it is a critical component, it can be isolated and left until later in the process. At a minimum, physical prototyping forces you to think through the design elements and define them. You can always change them down the road, but this gives you a framework to build upon, and that in itself can save you from stumbling around blindly when it comes to preparing and launching a production team.

Imagine getting in a room with programmers who know nothing about the project and to describe to them the game you have in your head. It is not easy. If you want to create gameplay that people have never seen before, it might be impossible. A physical prototype that they can sit down and play ensures that they will be able to grasp your vision of the game. They also have something solid to work from. A written treatment or design specification is good, but when it comes to communicating a complex system, these do not compare to a prototype that someone can actually play.

PROTOTYPING YOUR ORIGINAL GAME IDEA

Now that you have some experience creating and modifying prototypes, it is time to take one of your game concepts and create your own original prototype. The first step is to pick one of the ideas that you brainstormed in Chapter 6, Conceptualization. When your idea and concept treatment are done, you will be ready to make your first prototype. But before we dive into the mechanics of constructing the prototype, make sure you have clearly articulated the core gameplay that will be created.

Visualizing Core Gameplay

If you try to design the entire game at once, you might become confused and overwhelmed. There are so many elements in a typical game that it is difficult to know where and how to start. What we recommend is that you isolate the core gameplay mechanisms and build out from there.

The core gameplay mechanism, or "core mechanic," can be defined as the actions that a player repeats most often while striving to achieve the game's overall goal. Games are repetitive by nature. While the meaning and consequences of

what a player does can change over the course of game, the core actions tend to remain the same from beginning to end. Figure 7.10 is a visualized analysis comparing the core actions of Spider-Man 2 with True Crime that was done by Jeff Chen, Game Analyst, and Carl Schnurr, Senior Director of Game Design, both at Activision. As you can see, player actions in these diagrams are interrelated with meters and rewards. In the case of Spider-Man 2, challenges, exploration, and rewards all translate into points that can be spent in the Spidey Store to buy upgrades, combos, health, etc. This is a very simple reward system that will motivate players to look out for opportunities to gain points. If you look at the diagram for True Crime, you can see it is a much more complex design. The player activities pay off in multiple forms of rewards, and these rewards and meters in turn have an affect on the overall world system. It should be noted that more complex designs do not always make for a better player experience.

As we discussed in Chapter 5, sometimes you will find your mechanics are creating a positive or negative feedback loop that throws the play out of

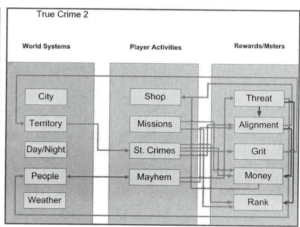

Diagrams courtesy of Activision Central Design (Jeff Chen and Carl Schnurr)

7.10 Visualization of gameplay mechanics for Spider-Man 2 and True Crime 2

balance. By diagramming your core game actions, you are more likely to spot such a problem early on. Your visualization does not have to be done in a formal presentation style like the examples from Activision. You can just sketch it on a piece of paper or on a whiteboard as in Figure 7.11, which is a very rough visualization of the core actions in a student game prototype. Even a rough sketch such as this can expose features that are not integrated into the main mechanics and allow you to go back and redesign to better integrate these features.

Here are some examples of popular games and brief descriptions of their core gameplay mechanisms:

- *WarCraft:* Players build and move units on a map in real time with the intent of opposing units in combat and destroying them.
- *Monopoly:* Players buy and improve properties with the goal of charging rent to other players who land on them in the course of play.
- *Diablo:* Players battle monsters, seek treasure, and explore dungeons in an attempt to amass wealth and become more powerful.
- *Super Mario Bros.:* A player controls Mario (or Luigi), making him walk, run, and jump, while avoiding traps, overcoming obstacles, and gathering treasure.

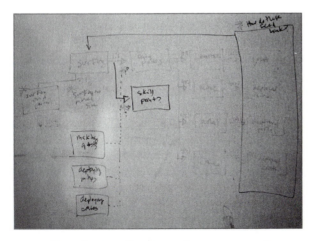

7.11 Rough visualization of core gameplay

- *Atomic Bomberman:* Players move their Bombermen around a maze and drop bombs next to their opponents in an attempt to blow them up.

Exercise 7.7: Diagramming Core Gameplay 1

If you are familiar with these games, you can probably sketch out a visualization of their core gameplay mechanisms fairly quickly. If you are not familiar with them, choose two or three games that you know, write a short description of their core gameplay, and then sketch a visualization of it like the ones previously shown.

Exercise 7.8: Diagramming Core Gameplay 2

Now try diagramming the core gameplay of your own game idea. Your treatment from Exercise 6.8 on page 164 should give you a head start with this. If you find you do not know how some of the activities should interrelate, just take your best guess. The answers are going to evolve as you prototype and revise your game, so do not let them slow you down here at the beginning.

Building the Physical Prototype

Now that you have practiced by making and changing prototypes of existing games, you are ready to begin prototyping your original game concept. Here are four steps that will help you build a physical prototype efficiently.

1. Foundation

Build a representation of your core gameplay. Get some arts and crafts materials, such as cardboard, construction paper, glue, pens, and scissors. Draw a board layout or rough map if necessary, and cut pieces out of the cardboard and paper.

As you do this, questions will come to your mind. How many squares should a player be allowed to move? How will the players interact with one another? How is the conflict resolved? Do not try to

answer all these questions at once. In fact, place the questions on the back burner and focus on the core gameplay.

Designing the basic game objects (physical setting, units, resources, etc.) and the key procedures for the game (those repetitive action cycles that keep the game in motion) are the heart of the foundation stage.

Try playing your core gameplay on your own—it might not be much of a game, but you will be able to see if the basic concept is worth pursuing. After you have your foundation in place, questions that you will want to answer become evident. But watch out. Try to test the game without expanding the rules at this point. If you have to add a rule to make the mechanic playable, then add it, but only do this if it

is absolutely necessary. Your goal should be to keep the core gameplay mechanism down to as few rules as possible.

In the FPS prototype, the first element that we fleshed out was simultaneous movement because this is the core mechanic of the game. The idea that all players should reveal an action card at the same time to simulate real time movement was conceived. This was a foothold to build upon. From there, the next logical question was: What are options on the action cards? The answer was: move, turn, or shoot. Other ideas for action cards popped up as well, such as stand, crouch, go prone, etc. However, we decided to keep the options as simple as possible at first. These options lead us to the next stage of our prototype: structure.

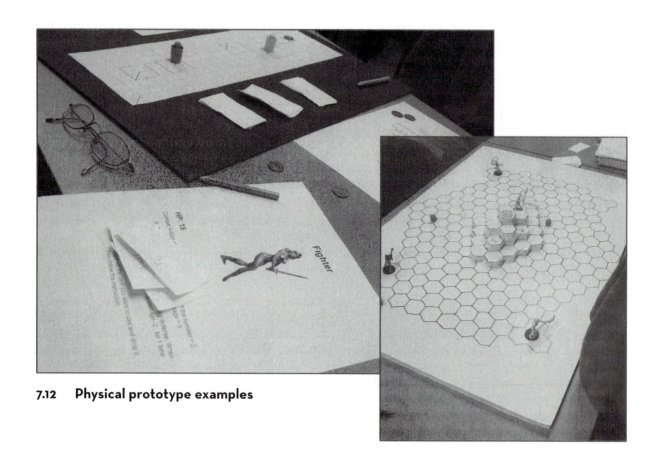

7.12 Physical prototype examples

The Design Evolution of Magic: The Gathering

Magic: The Gathering is one of the most important and influential games of our time. It was an instant hit when it first appeared at the Gen Con game convention in 1993 and has grown steadily in popularity since. This is a special two-part look at the creation and development of the game as written by the designer, Richard Garfield. Richard wrote the first part, "The Creation of Magic: The Gathering," nearly 10 years ago when the game was first released. In it he muses about the design challenges of a collectable trading card game, and he recounts the game's fascinating playtest history.

The second part, "Magic Design: A Decade Later," is a retrospective on the original design notes. In it Richard provides insight about how and why the game has evolved the way it has, including thoughts on today's Magic Pro Tour, Magic Online, and the next 10 years for the game.

The Creation of Magic: The Gathering

by Richard Garfield (written in 1993)

The Ancestry of Magic

Games evolve. New ones take the most loved features of earlier games and add original characteristics. The creation of Magic: The Gathering is a case in point.

Though there are about a dozen games that have directly influenced Magic in one way or another, the game's most influential ancestor is a game for which I have no end of respect: Cosmic Encounter, originally published by Eon Products and rereleased by Mayfair Games. In this game, participants play alien races striving to conquer a piece of the universe. Players can attempt their conquest alone or forge alliances with other aliens. There are nearly 50 alien races that can be played, each of which has a unique ability: The Amoeba, for example, has the power to Ooze, giving it unlimited token movement; the Sniveler has the power to Whine, allowing it to automatically catch up when behind. The best thing about Cosmic Encounter is precisely this limitless variety. I have played hundreds of times and still can be surprised at the interactions different combinations of aliens produce. Cosmic Encounter remains enjoyable because it is constantly new.

Cosmic Encounter proved to be an interesting complement to my own design ideas. I had been mulling over a longtime idea of mine: a game that used a deck of cards whose composition changed between rounds. During the course of the game, the players would add cards to and remove cards from the deck so that when you played a new game it would have an entirely different card mix. I remembered playing marbles in elementary school, where each player had his own collection from which he would trade and compete. I was also curious about Strat-o-matic Baseball, in which participants draft, field, and compete their own teams of baseball players whose abilities are based on real players' previous year statistics. Intrigued by the structure of the game, I was irritated that the subject was one for which I had no patience.

These thoughts were the essence of what eventually became Magic. My experiences with Cosmic Encounter and other games inspired me to create a card game in 1982 called Five Magics. Five Magics was an attempt to distill the modularity of Cosmic Encounter down to just a card game. The nature of Cosmic Encounter seemed entirely appropriate for a magical card game—wild and not entirely predictable, but not

completely unknown, like a set of forces you almost, but don't quite, understand. Over the next few years, Five Magics went on to inspire entirely new magical card games among my friends.

Ten years later, I was still designing games, and Mike Davis and I had come up with a board game called RoboRally. Mike was acting as our agent, and among the companies he approached was a brand new gaming company called Wizards of the Coast. Things seemed to be going well, so that August, Mike and I made our way to Portland, Oregon, to meet over a pizza with Peter Adkison and James Hays of Wizards of the Coast.

Both Peter and James were very receptive to RoboRally, but they informed me that they weren't really in a position to come out with a board game right away. This wasn't what I had come out to hear, of course, but I didn't want the trip to be a total waste. I asked Peter what he would be interested in. Peter replied that he really saw a need for a game that could be played quickly with minimal equipment, a game that would go over well at conventions. Could I do it?

Within a few days, the initial concept for a trading card game was born, based on another card game I had developed in 1985 called Safecracker. It hadn't been one of my best games. But then I remembered Five Magics.

The First Designs

I went back to graduate school at the University of Pennsylvania and worked on the card game in whatever spare time I had. It wasn't easy; there were three months of false starts on the project, there are so many aspects of card game design that have to be reconsidered when designing trading card games. First of all, you can't have any bad cards—people wouldn't play with them. In fact, you want to prevent too much range in the utility of cards because players will only play with the best—why make cards people won't play with? Besides, homogeneity of card power is the only way to combat the "rich kid syndrome" that threatened the game concept from the start. What was to keep someone from going out and getting ten decks and becoming unbeatable?

It was a major design concern. I had numerous theories on how to prevent purchasing power from unbalancing the game, none of which were entirely valid but all of which had a grain of truth. The most compelling counter to this "buy out the store" strategy was the ante. If we were playing for ante, the argument ran, and your deck was the distilled fruit of ten decks, when I did win, I would win a more valuable card. Also, if the game had enough skill, then the player purchasing their power would surely be easy prey for the players dueling and trading their way to a good deck. And of course there was the sentiment that buying a lot of poker chips doesn't make you a winner. In the end, however, the "rich kid syndrome" became less of a concern. Magic is a fun game, and it doesn't really matter how you get your deck. Playtesting showed that a deck that is too powerful defeats itself. On the one hand, people stopped playing against it for ante unless a handicap was invoked; on the other, it inspired them to assemble more effective decks in response.

The first Magic release was affectionately named Alpha. It consisted of 120 cards split randomly between two players. The two players would ante a card, fight a duel over the ante, and repeat until they got bored. They often took a long time to get bored; even then, Magic was a surprisingly addictive game. About ten o'clock one evening, Barry "Bit" Reich and I started a game in the University of Pennsylvania Astronomy lounge, a windowless, air-conditioned room. We played continuously until about 3:00 a.m.—at least that's what we thought until we left the building and found that the sun had risen.

I knew then that I had a game structure that could support the concept of individually owned and tailored decks. The game was quick, and while it had bluffing and strategy, it didn't seem to get bogged down

with too much calculation. The various combinations that came up were enjoyable and often surprising. At the same time, the variety of card combinations didn't unbalance the game: When a person started to win, it didn't turn into a landslide.

From Alpha to Gamma

Except for the card mix, little has changed about Magic since alpha. In alpha, walls could attack, and losing all your lands of a particular color destroyed the associated spells in play, but otherwise, the rules are much the same now as they were in the early stages of playtesting.

Moving from alpha to the beta version was like releasing a wild animal. The enjoyable game that was alpha now burst the confines of the duel to invade the lives of the participants. Players were free to trade cards between games and hunt down weaker players to challenge them to duels while gamely facing or cravenly avoiding those who were more powerful. Reputations were forged—reputations built on anything from consistently strong play to a few lucky wins to good bluffing. The players didn't know the card mix, so they learned to stay on their toes during duels. Even the most alert players would occasionally meet with nasty surprises. This constant discovery of unknown realms in an uncharted world gave the game a feeling of infinite size and possibility.

For the gamma version, new cards were added and many of the creature costs were increased. We also doubled the pool of playtesters, adding in a group with Strat-o-matic Baseball experience. We were particularly anxious to find out if Magic could be adapted for league play. Gamma was also the first version that was fully illustrated. Skaff Elias was my art director: He and others spent days poring over old graphic magazines, comic books, and game books searching for art for the cards. These playtest decks were pretty attractive for crummy black-and-white cardstock photocopies. For the most part, the cards were illustrated with serious pictures, but there were a lot of humorous ones as well. Heal was illustrated by Skaff's foot. Power Sink showed Calvin (of *Calvin and Hobbes*) in a toilet; after all, what is a toilet but a power sink? Berserk was John Travolta dancing in *Saturday Night Fever*. Righteousness pictured Captain Kirk, and Blessing showed Spock doing his "live long and prosper" gesture. An old comic book provided a Charles Atlas picture for Holy Strength, and a 98-pound weakling getting sand kicked in his face for Weakness. Instill Energy was Richard Simmons. The infamous Glasses of Urza were some X-ray glasses we found in a catalog. Ruthy Kantorovitz constructed a darling flame-belching baby for Firebreathing. I myself had the honor of being the Goblins. The pictures and additional players greatly added to the game atmosphere. It became clear that while the duels were for two players, the more players playing, the better the game was. In some sense, the individual duels were a part of a single, larger game.

Striking the Balance

Each playtest set saw the expulsion of certain cards. One type of card that was common in alpha and beta was rare in gamma and is now nonexistent: the type that made one of your rival's cards yours. Yes, Control Magic used to permanently steal a creature from your opponent. Similarly, Steal Artifact really took an artifact. Copper Tablet no longer even remotely resembles its original purpose, which was to swap two creatures in play. ("Yes, I'll swap my Merfolk for your Dragon. On second thought, make that my Goblins—they're uglier.") There was a spell, Planeshift, that stole a land, and Ecoshift, which collected all the lands, shuffled them and

redealt them—really nice for the user of four or five colors of magic. Pixies used to be a real pain—if they hit you, you swapped a random card from your hand with your opponent. These cards added something to the game, often in the form of players trying to destroy their own creatures before their opponents took them for good or even trying to take their own lives to preserve the last shreds of their decks. However, in the end it was pretty clear that the nastiness this added to the game environment wasn't worth the trouble, and no card should ever be at risk unless players choose to play for ante.

It was around this time that I began to realize that almost any decision made about the game would be opposed, often vehemently, by some players. The huge amount of dissent about what should and should not be part of the card mix has led players to make their own versions for playtesting—a significant task that involves designing, constructing, shuffling, and distributing about 4000 cards. Each of these games had its merits, and the playtesters enjoyed discovering the quirks and secrets of each new environment. The results of these efforts will form the basis of future Deckmaster games that use the structure of The Gathering while containing mostly new cards.

To Build a Better Deck

Playtesting a Deckmaster game is difficult. Probably the only games harder to playtest are elaborate, multiplayer computer games. After developing a basic framework for Magic that seemed fairly robust, we had to decide which of the huge selection of cards to include, and with what relative frequencies. Common cards had to be simple, but not necessarily less powerful, than rare cards—if only rare cards were powerful, players would either have to be rich or lucky to get a decent deck. Sometimes a card was made rare because it was too powerful or imbalancing in large quantities, but more often, rare cards were cards that were intricate or specialized—spells you wouldn't want many of anyway. But these design guidelines only got us so far. The whole game's flavor could change if a handful of seemingly innocent cards were eliminated or even made less or more common. When it came down to actually deciding what to include and what to do without, I began to feel like a chef obliged to cook a dish for 10,000 people using 300 ingredients.

One thing I knew I wanted to see in the game was players using multicolor decks. It was clear that a player could avoid a lot of problems by stripping down to a single color. For this reason, many spells were included that paralyzed entire colors, like Karma, Elemental Blast, and the Circles of Protection. The original plan was to include cards that thwarted every obvious simple strategy, and, in time, to add new cards that would defeat the most current ploys and keep the strategic environment dynamic. For example, it was obvious that relying on too many big creatures made a player particularly vulnerable to the Meekstone, and a deck laden with Fireballs and requiring lots of mana could be brought down with Manabarbs. Unfortunately, this strategy and counter-strategy design led to players developing narrow decks and refusing to play people who used cards that could defeat them flat out. If players weren't compelled to play a variety of players and could choose their opponent every time, a narrow deck was pretty powerful.

Therefore, another, less heavy-handed way to encourage variety was developed. We made it more difficult to get all the features a player needs in a deck by playing a single color. Gamma, for example, suffered from the fact that blue magic could stand alone. It was easily the most powerful magic, having two extremely insidious common spells (Ancestral Memory and Time Walk), both of which have been made rare. It had awesome counterspell capabilities. It had amazing creatures, two of the best of which are now uncommon.

Blue magic now retains its counterspell capability, but it is very creature poor and lacks a good way to do direct damage. Red magic has little defense, particularly in the air, but it has amazing direct damage and destruction capability. Green magic has an abundance of creatures and mana but not much more. Black is the master of anticreature magic and has some flexibility, but it is poorly suited to stopping noncreature threats. White magic is the magic of protection, and it is the only magic with common banding, but it has little damage-dealing capability.

Sometimes seemingly innocuous cards would combine into something truly frightening. A good part of playtest effort was devoted to routing out the cards that contributed to so-called "degenerate" decks—the narrow, powerful decks that are difficult to beat and often boring to play with or against. Without a doubt, the most striking was Tom Fontaine's "Deck of Sooner-Than-Instant Death," which was renowned for being able to field upward of eight large creatures on the second or third turn. In the first Magic tournament, Dave "Hurricane" Pettey walked to victory with his "Land Destruction Deck." (Dave also designed a deck of Spectres, Mindtwists, and Disrupting Sceptres that was so gruesome I don't think anyone was ever really willing to play it.) Skaff's deck, "The Great White Death," could outlive just about anything put up against it. Charlie Catin's "Weenie Madness" was fairly effective at swamping the opponent with little creatures. Though this deck was probably not in the high-win bracket of the previous decks, it was recognized that, playing for ante, Charlie could hardly lose. Even winning only one in four of his games—and he could usually do better than that—the card he won could be traded back for the island and the two Merfolk he lost, with something extra thrown in.

In the end I decided that the degenerate decks were actually part of the fun. People would assemble them, play with them until they got bored or their regular opponents refused to play against them, and then retire the deck or trade off its components for something new—a Magic version of putting the champion out to stud. Most players ended up treating their degenerate decks much like role players treat their most successful characters: They were relegated to the background to be occasionally dusted off for a new encounter.

After the pursuit of sheer power died down, another type of deck developed: the Weird Theme deck. These decks were usually made to be as formidable as possible within the constraints of their theme. When Bit grew bored of his "Serpent Deck" (he had a predilection for flopping a rubber snake on the playing surface and going "SsssSssSs" whenever he summoned a Serpent), he developed his "Artifact Deck," which consisted of artifacts only—no land. It was fun to see the "Artifact Deck" go up against someone who used Nevinyrral's Disk. But the king of weird decks was, without a doubt, Charlie Catin. In one league, he put together a deck that I call "The Infinite Recursion Deck." The idea was to set up a situation where his opponent couldn't attack him until Charlie could play Swords to Plowshares on a creature. Then he would play Timetwister, causing the cards in play to be shuffled with the graveyard, hand, and library to form a fresh library. Swords to Plowshares actually removes a creature from the game, so his rival has one less creature. Repeat. After enough iterations, his rival was bloated with life given by the Swords to Plowshares, having maybe 60 life points, but there were no creatures left in his deck. So Charlie's Elves started in—59 life, 58 life, 57 life—and the curtain closes on this sad game. I still can't think about this deck without moist emotional snorts. The coup de grace is that this league required players to compete their decks ten times. And, because his games often lasted over an hour and a half, he received at least one concession.

Words, Words, Words

It was not just determining the right card mix that players and designers found challenging. This becomes increasingly clear to me as I participate in the never-ending process of editing the rules and the cards. As my earliest playtesters have pointed out (in their more malicious moods), the original concept for Magic was the simplest game in the world because you had all the rules on the cards. That notion is long gone.

To those who didn't have to endure it, our struggle for precision was actually rather amusing. My own rules discussions about card wordings were mostly with Jim Lin, who is the closest thing you will ever encounter to a combination rules lawyer and fire hose. A typical rule-problem session would go:

Jim: Hmm—there seems to be a problem with this card. Here is my seven-page rules addition to solve the problem.

Richard: I would sooner recall all the cards than use that. Let's try this solution instead.

Jim: Hmm—we have another problem.

[Repeat until …]

Richard: This is silly—only incredibly stupid and terminally anal people could possibly misinterpret this card.

Jim: Yes, maybe we have been thinking about this too long. If you're playing with that kind of person, you should find some new friends.

A specific example of something we actually worried about is whether Consecrate Land would really protect your land from Stone Rain. After all, the first says it prevents land from being destroyed and the second says it destroys the land. Isn't that a contradiction? It still hurts my head getting into a frame of mind where that is confusing. It is perhaps a little like wondering why anyone would give you anything for money, which is, after all, just paper.

But, then again, I could never tell what was going to confuse people. One of the playtesters, Mikhail Chkhenkeli, approached me and said, "I like my deck. I have the most powerful card in the game. When I play it, I win on the next turn." I tried to figure out what this could be; I couldn't think of anything that would win the game with any assurance the turn after casting. I asked him about it, and he showed me a card that would make his opponent skip a turn. I was confused until I read exactly what was written: "Opponent loses next turn." It was my first real lesson in how difficult it was going to be to word the cards so that no two people would interpret the same card in a different way.

The Magic Marketplace

Another thing I realized in the second year of playtesting really surprised me. Magic turned out to be one of the best economic simulations I had ever seen. We had a free-market economy and all of the ingredients for interesting dynamics. People valued different cards in different ways—sometimes because they simply weren't evaluating accurately but much more often because the cards really have different value to different players. For example, the value of a powerful green spell was lower for a person who specializes in black and red magic than for one who was building a deck that was primarily green. This gives a lot of opportunity

for arbitrage. I would frequently find cards that one group of players weren't using but another group were treating like chunks of gold. If I was fast enough, I could altruistically benefit both parties and only have to suffer a little profit in the process.

Sometimes the value of a card would fluctuate based on a new use (or even a suspected new use). For example, when Charlie was collecting all the available spells that produced black mana, we began to get concerned—those cards were demanding higher and higher prices, and people began to fear what he could need all that black mana for. And, prior to Dave's "Land Destruction Deck," land destruction spells like Stone Rain and Ice Storm were not high-demand spells. This of course allowed him to assemble the deck cheaply, and after winning the first Magic tournament, sell off the pieces for a mint.

Trade embargoes appeared. At one point a powerful faction of players would not trade with Skaff, or anyone who traded with Skaff. I actually heard conversations such as:

Player 1 to Player 2: I'll trade you card A for card B.

Skaff, watching: That's a moronic trade. I'll give you card B and cards C, D, E, and F for card A.

Players 1 and 2 together: We are not trading with you, Skaff.

Needless to say, Skaff was perhaps a bit too successful in his early duels and trades.

Another interesting economic event would occur when people would snatch up cards they had no intention of using. They would take them to remove them from the card pool, either because the card annoyed them (Chaos Orb, for example) or because it was too deadly against their particular decks.

I think my favorite profit was turned during an encounter with Ethan Lewis and Bit. Ethan had just received a pack of cards and Bit was interested in trading with Ethan. Bit noticed that Ethan had the Jayemdae Tome, began to drool, and made an offer for it. I looked at the offer and thought it was far too low, so I put the same thing on the table.

Bit looked at me and said, "You can't offer that! If you want the Tome you have to bid higher than my bid."

I said, "This isn't an offer for the Tome. This is a gift for Ethan deigning to even discuss trading the Tome with me."

Bit looked at me in disbelief and then took me aside. He whispered, "Look, I'll give you this wad of cards if you just leave the room for 10 minutes." I took his bribe, and he bought the Tome. It was just as well—he had a lot more buying power than I did. In retrospect, it was probably a dangerous ploy to use against Bit—after all, he was the person who was responsible for gluing poor Charlie's deck together once, washing a different deck of Charlie's in soap and water, and putting more cards of Charlie's in the blender and hitting frappé.

Probably the most constant card-evaluation difference I had with anyone was over Lord of the Pit. I received it in just about every playtest release we had, and it was certainly hard to use. I didn't agree with Skaff, though, that the only value of the card was that you might get your opponent to play with it. He maintained that blank cards would be better to play with because blank cards probably wouldn't hurt you. I argued that if you knew what you were doing, you could profit from it.

Skaff asked me to cite a single case where it had saved me. I thought a bit and recalled the most flamboyant victory I had with it. My opponent knew he had me where he wanted me—he had something doing damage to me, and a Clone in hand, so even if I cast something to turn the tide, he would be able to match me. Well, of course, the next cast spell was a Lord of the Pit; he could Clone it or die from it, so he Cloned it.

Then each time he attacked, I would heal both of the Lords, or cast Fog and nullify the assault, and refuse to attack. Eventually, he ran out of creatures to keep his Lord of the Pit sated and died a horrible death.

Skaff was highly amused by this story. He said, "So, when asked about a time the Lord of the Pit saved you, you can only think of a case where you were playing somebody stupid enough to clone it!"

Dominia and the Role of Role Playing

Selecting a card mix that accommodated different evaluations of the cards wasn't enough; we also had to develop an environment in which the cards could reasonably interact. Establishing the right setting for Magic proved to be a central design challenge. In fact, many of our design problems stemmed from an attempt to define the physics of a magical world in which duels take place and from building the cards around that, rather than letting the game define the physics. I was worried about the cards' relationship to each other—I wanted them to seem part of a unified setting, but I didn't want to restrict the creativity of the designers or to create all the cards myself. Everyone trying to jointly build a single fantasy world seemed difficult because it would inevitably lack cohesion. I preferred the idea of a multiverse, a system of worlds that was incredibly large and permitted strange interactions between the universes in it. In this way, we could capture the otherworldly aspects of fantasy that add such flavor to the game while preserving a coherent, playable game structure. Almost any card or concept would fit into a multiverse. Also, it would not be difficult to accommodate an ever-growing and diverse card pool—expansion sets with very different flavors could be used in the same game, for they could be seen as a creative mingling of elements from different universes. So I developed the idea of Dominia, an infinite system of planes through which wizards travel in search of resources to fuel their magic.

In its structured flexibility, this game environment is much like a role-playing world. I don't mean to suggest that this setting makes Magic a role-playing game—far from it—but Magic is closer to role playing than any other card or board game I know of. I have always been singularly unimpressed by games that presumed to call themselves a cross between the two because role playing has too many characteristics that can't be captured in a different format. In fact, in its restricted forms—as a tournament game or league game, for example—Magic has little in common with role playing. In those cases, it is a game in the traditional sense, with each player striving to achieve victory according to some finite set of rules. However, the more free-form game dueling with friends using decks constructed at whim embodies some interesting elements of role playing.

Each player's deck is like a character. It has its own personality and quirks. These decks often even get their own names: "The Bruise," "The Reanimator," "Weenie Madness," "Sooner-Than-Instant Death," "Walk Into This Deck," "The Great White Leftovers," "Backyard Barbeque," and "Gilligan's Island," to name a few. In one deck I maintained, each of the creatures had a name—one small advantage to crummy photocopied cardstock is the ease of writing on cards. The deck was called "Snow White and the Seven Dwarves," containing a Wurm named Snow White and seven Mammoths: Doc, Grumpy, Sneezy, Dopey, Happy, Bashful, and Sleepy. After a while I got a few additional Mammoths, which I named Cheesy and Hungry. There was even a Prince Charming: my Veteran Bodyguard.

As in role playing, the object of the game in the unstructured mode of play is determined largely by the players. The object of the duel is usually to win, but the means to that end can vary tremendously. Most players find that the duel itself quickly becomes a fairly minor part of the game compared to trading and assembling decks.

Another characteristic of Magic that is reminiscent of role playing is the way players are exploring a world rather than knowing all the details to start. I view Magic as a vast game played among all the people who buy decks, rather than just a series of little duels. It is a game for tens of thousands in which the designer acts as a gamemaster. The gamemaster decides what the environment will be, and the players explore that environment. This is why there are no marketed lists of cards when the cards are first sold: Discovering the cards and what they do is an integral part of the game.

And like a role-playing game, the players contribute as much to an exciting adventure as the gamemaster. To all the supporters of Magic, and especially to my playtesters, I am extraordinarily grateful. Without them, if this product existed at all, it would certainly be inferior. Every one of them left a mark, if not on the game itself, then in the game's lore. Any players today that have even a tenth of the fun I had playing the test versions with them will be amply pleased with Magic.

MAGIC DESIGN: A DECADE LATER

by Richard Garfield (written in 2003)

Magic and the trading card game industry have undergone a lot of changes since the time I wrote those design notes. In the meantime Magic has grown stronger with each successive year—as the game itself is improved and as more people are brought into trading card games from products such as Pokémon and Yu-Gi-Oh!

It is difficult for people these days to appreciate how little we knew about the game design space we were entering in the early nineties. My design notes failed to mention what, in my mind, is the strongest sign of that—after describing the concept of a trading card game to Peter Adkison I concluded with the cautious statement, "Of course, such a game may not be possible to design." It is hard for me to imagine that state of mind today, in a world where trading card games have reached every corner and are a part of almost every major entertainment property. This is a world where trading card games have left their mark on all areas of game design, from computer games to board games, and where trading card games have directly inspired games ranging from trading miniature games to trading tops games. This is a world where Jason Fox, from the comic strip *Foxtrot*, complained that a deck of cards coming with only four aces was some sort of ploy to get people to buy expansion kits.

That could be left as the end of the story; Magic was designed—as the design notes of a decade ago portray—and 10 years later it was still going strong. But this leaves out a large part of the story because Magic was anything but a static game since then. The changes and improvements to Magic warrant design notes of their own.

First and Foremost—A Game

One thing that might look arcane in my notes to people who know something about the game market is my reference to the form of game that Magic launched as a "trading card game," rather than a "collectable card game." I still use TCG rather than CCG, which became the industry standard despite my efforts from its earliest days. I prefer "trading" rather than "collectable" because I feel it emphasizes the playing aspect rather than the speculation aspect of the game. The mindset of making collectables runs against that of

making games—if you succeed in the collectable department then there is a tendency to keep new players out and to drive old ones away because of escalating prices. One of the major battles that Magic fought was to make it perceived principally as a game and secondarily as a collectable. Good games last forever—collectables come and go.

This was not merely theoretical speculation—Magic's immense success as a collectable was severely threatening the entire game. Booster packs intended to be sold at a few bucks were marked up to 20 dollars in some places as soon as they hit the shelves. While many people view this time as the golden age of Magic, the designers knew that it was the death of the game in the long run. Who is going to get into the game when it was immediately inflated in price so much? How many people would play the game if doing so was wearing holes in some of their most valuable assets? We might be able to keep a speculation bubble going for a while, but the only way Magic was going to be a long-term success—a classic game—was for it to stand on its game play merits, not on its worthiness as an investment.

During "Fallen Empires," the fifth Magic expansion, we finally produced enough cards that the speculative market collapsed. The long-term value of Magic could perhaps thrive, but it wouldn't immediately price itself out of the reach of new players before they got a chance to try it. There was an inevitable negative patina that Magic got for a while, and Fallen Empires still has, but from this point on Magic was sinking or swimming on its game merits. Fortunately, Magic turned out to be a strong swimmer.

Binding the Unbounded

The part of my notes, which, I believe, reveals my biggest change in thinking over the last decade is the statement that in the future we would publish other games with mechanics similar to Magic. What I was referring to is what became Ice Age and Mirage, two expansions for Magic. Why did I think these would be entirely new games, rather than what they ended up being—expansions for the main game?

We all realized from the start that we couldn't just keep adding cards to Magic and expect it to stay popular. One reason for that is that each successive set of cards were a smaller and smaller percentage of the entire pool of cards, and so they would necessarily have less and less impact on the whole of the game. This was illustrated vividly by players of Ice Age talking about how the entire set introduced two relevant cards to the game. One can imagine how the designers felt—working for years to make Ice Age a compelling game to have it boil down to a mere two cards. Another, perhaps more important reason, is that new players wouldn't want to enter a game where they were thousands of cards behind, so our audience would inevitably erode.

Initially we saw two solutions to this problem:

1. Make cards ever more powerful. This is a route many trading card game makers followed, and one I greatly dislike. It feels like strong-arming the players to buy more and more rather than really providing them more game value. But it would bring new players in because they wouldn't need the obsolete old cards.

2. Eventually conclude Magic: The Gathering and start a new game—Magic: Ice Age, for example. I advocated this approach because I believed we could make exciting new game environments indefinitely. When one set was finished, players wouldn't be forced to buy into the new game to keep

competitive, they could move on if they wanted a change, and new players could begin on equal footing.

When it actually came time to do Ice Age, it was absolutely clear that players would not stand for a new version of Magic, so we had to think of something else. Additionally, we were also worried that fragmenting the player audience was a bad idea; if we made a lot of different games, people would have a harder and harder time finding players.

The solution we found was to promote different formats of game play, many of which involved only more recent sets of cards. Today there are popular formats of play that involve only the most recently published cards, cards published in the last two years, and cards published in the last five years, in addition to many others. While this does fragment the player base—because you might not be able to find players who play your format—it is less draconian than different games because you can apply your cards to many different formats over time. This was a far more flexible approach than the first because it didn't command players to start fresh; it allowed them to, and it allowed new players to join the game without being overwhelmed.

Trading Card Games Are Not Board Games

I used to believe that trading card games were far more like board games than they are. This is not surprising because I had no trading card games before Magic to draw examples from, and so I was forced to use the existing world of games to guide my thinking on TCGs. A lot of my design attitudes grew from this misconception. For example, my second trading card game was designed to be best with four or more people, and it took several hours to play. These are not bad parameters for a board game, but trading card games really want to be much shorter because so much of the game is about replaying with a modified, or entirely new, deck.

In a similar vein, I used what I saw board game standards to be when it came to rules clarifications. It was common in board games to find that a different group played a slightly different way or had house rules to suit their tastes. With board games different interpretations of the rules and ways of play were not a major problem because players tended to play with fairly isolated groups. This led me to be quite antiauthoritarian when it came to the "correct" way to play. It turned out that a universal standard for a trading card game was far more necessary than a board game because the nature of the game form made the interconnectivity of the game audience far greater.

This meant that we had to take more and more responsibility for defining the rules and standards of play. In some ways this is analogous to being forced to construct the tournament rules for a game. The rules to bridge are not that complex, but when you write out the official tournament rules—really try to cross the *t*s and dot the *i*s—you have a compendium.

I had also hoped that players could moderate their own deck restrictions. We knew that certain card combinations were fun to discover and surprise someone with, but they were not fun to play with on an ongoing basis. So we figured players would make house rules to cover those decks and the responsible cards. The highly interconnected nature of Magic made it unreasonable to expect that, however, because every playgroup came up with a vast number of restrictions and rules, and they all played with each other. This meant we had to take more responsibility in designing the cards and, when necessary, banning cards that were making the game worse.

The Pro Tour

All this precision invested in the design of the rules and cards made Magic a surprisingly good game to play seriously. We began to entertain ideas of really supporting a tournament structure with big money behind it—big enough that players could, if good enough, make a living off of playing Magic. This was a controversial subject at Wizards of the Coast for a while, the worry being that making the game too serious would make it less fun. I subscribed fully to the concept of a Pro Tour, thinking of how the NBA helped make basketball popular and didn't keep the game from being played casually as well.

The Pro Tour had an almost immediate effect. Our players rapidly became much better as the top level ones devoted time to really analyzing the game and as that game tech filtered down through the ranks. Before the Pro Tour, I am confident that I was one of the best players in the world, now I am mediocre at best.

Now there are thousands of tournaments each week, and many players have earned a lot of money playing Magic, some in the hundreds of thousands of dollars. At the last World Championship there were 56 countries competing. There is a never-ending buzz of Magic analysis and play as players attempt to master the ever-changing strategic ground of Magic. I believe this is a major part of Magic's ongoing popularity—if even a small group of people take a good game very seriously, there can be far reaching effects.

Magic Online

Online Magic didn't come into its own until last year. For a long time I have wanted to see an online version of Magic that duplicated real life Magic as closely as possible. That is, the online game would connect people, run the games and the tournaments, and adjudicate rules, but little else. At first we tried to form partnerships with computer game companies to do this, but our partners always had other ideas about how to do computer Magic. Eventually we hired a programming studio to do it our way and now we have Magic Online.

2. Structure

After the foundation is in place and seems to function, it is time to move on to structure. The best technique for doing this is to prioritize what is most essential to the game. In our FPS prototype, some structural elements we added were our three action options: (1) number of spaces a unit could move; (2) procedures for turning; and (3) hit and miss rules for shooting. Our army men were moved and turned on the table as mock units using the rules.

These experiments solidified some ideas about moving and shooting and caused other ideas to be dismissed, which resulted in a very crude system for simultaneous movement and the basics of shooting. We also considered adding rules about movement

and starting points, as well as assigning a turn order to the players.

Think of it this way: You have built the foundation, and now you need to build the framework for your game. It is not a matter of what you think is coolest or most saleable; it is about constructing a skeletal structure that can support the rich and varied feature set that will be your finished game. What you need to do first is decide which rules are essential and which are features that those structural elements have to support. Your gameplay visualization should help you make these decisions.

At this point in the construction of the FPS prototype, the movement and shooting foundation begged for the structure of a scoring system and

One of the striking things about Magic Online is that we use the same revenue model as in real life. Despite exhortations to use a subscription model, we chose to sell virtual cards, which you could trade with other players online. This allows players to buy some cards and then play them indefinitely with no further fee—as in real life.

It was important to us that we not make it a better deal playing online than off—we wanted it to be the same. That is because we feel the paper game contributes a lot to Magic's ongoing popularity, and it could be threatened if many of its players go to the online game.

For this reason one of the prime targets for the online game was going to be lapsed players. Many studies had been done on how long people play Magic and why they leave the game, and for the most part they didn't leave because they were bored with the game; they left because they had life changes that made it more difficult to play; for example, getting jobs or having kids. These players would potentially rejoin the game if they could play; from their own home on their own hours.

Magic Online is still a bit too young to be sure about, but it appears to have acquired a dedicated sizeable audience of players without hurting the paper game. Many of the players are formerly lapsed players, as we had hoped.

The Next 10 Years

Who knows what the next decade will bring? Ten years ago I had no clue at all; it was an exciting time, and we were riding a roller coaster. Now I am more confident. I believe that Magic is fairly stable and that there is every reason to believe that it will be around and as strong in another 10 years. At this point it is clear that Magic is not a fad, and as many new players are coming in each year as are leaving the game.

Certainly Magic has stayed fresh for me. I get into the game every few months—joining a league, constructing a deck, or perhaps preparing for and participating in a tournament. Every time I return I find the game fresh and exciting, with enough different from the previous time to keep me on my toes but enough the same that I can still exploit my modest skills at the game. I look forward to my next 10 years of the game.

unit hit points. As we added these elements, our crude movement and shooting system was retested with them in place. The tests illuminated problems that could only be seen with the system in motion. The whole system was revised to address the problems. At this point the system was still messy and ill defined. Nothing had been written down. There were open questions everywhere. However, the system was basically functional.

When working through this, keep in mind the distinction between what are features and what are rules. Features are attributes that make a game richer, like adding more weapons or new vehicles or a nifty way to navigate the space. Rules are modifications to the game mechanics that change how the game functions, such as winning conditions, conflict resolution, turn order, etc.

You can add rules without adding features, but you can never add a feature without changing or adding rules. For example, if you added a new type of laser gun to your game, the rules would dictate how this gun could be used, what damage it would do, and how it would relate to all aspects of the game. One new feature might introduce several new rules to support it. As you modify your game, you will be constantly tweaking the rules to enhance gameplay and accommodate a growing feature set.

Your best strategy for adding structure is to focus on rules first and features later. Rules, by their very nature, tend to be inextricably linked to the core gameplay, while features tend to be peripheral. That is a generalization, but if you keep it in mind, it will help you to structure the development of your game.

3. Formal details

The next step is to add the necessary rules and procedures to the system to make it into a fully functional game. Focus on what you know about formal elements to decide what your game needs. Is the objective interesting and achievable? Is the player interaction structure the best choice? Are there rules or procedures that you wanted to add, but they were not part of the core mechanic? The trick is to find an appropriate level of detail to add. Beginning game designers typically add too much. The art of game design often involves paring a bunch of feature ideas down to a small, important set.

At this point in the development of the FPS prototype, we added the hit percentage, health, and scoring. Many other ideas were discussed, including: mines, shields, vehicles, mechanisms for hiding, and more. However, we scrapped all of them and focused on rules affecting the central gameplay, rather than a set of new features that we believed would create the most interesting game. How did we decide on some elements and not others? It was a creative judgment backed by input from our playtesters.

One way to add formal details efficiently is to isolate each new rule and test it individually. If you feel the game cannot function without this rule, then leave it in the game and add another rule. But do not overuse this privilege. Not every rule is critical, and the less you add, the cleaner your skeleton. A lot of what you consider to be rules are probably features. Try to draw a clear distinction, and keep your core rule set as clean as possible.

Test each rule, then remove it, and add another rule, and test it. It will be clear that some of the rules are optional and others must be included in the game if you are to continue to expand the gameplay. This is a litmus test. If you can continue to build out the game without a specific rule, no matter how amazing that rule seems, you should leave it out. You can always add it later, but it should not be included at this early stage.

4. Refinement

At this point in the process, the prototype is a playable system, although it might still be somewhat rough. By experimenting and tweaking, the play system will become more refined. The play experience created by the game will flow. Instead of questioning the fundamentals of the game (and possibly thinking it will never work), you will switch to questioning the smaller details, and, of course, the big question: Is your game compelling? If not, what will make it so? This process of refinement can continue for a number of iterations.

7.13 Physical prototype with procedures outlined

Refinement is also the time to add all those great ideas for features that have come up while testing but were not really essential. We went back to those ideas about mines and teleport pads for our FPS at this point. Again, be careful not to get ahead of yourself. It is tempting to add five new features, create a bunch of rules to support those features, and then start playing, but this blurs your view of the game. It becomes difficult to tell which features are making the game more fun to play and which are causing problems.

To avoid this, rank your features in terms of necessity. Then introduce and test each one. Test how it affects overall gameplay, and then remove it. This might seem cumbersome, but it will keep your game structure from getting convoluted. If you add too many features too early, you will find yourself losing your grasp on what the game is about. We have seen this happen over and over again with beginning designers, and this is why we caution you to postpone the pleasure of creating the ideal game from the outset, and instead we recommend that you focus on what is needed step-by-step.

As you do this, you will discover that some rules and features that seemed like great ideas actually diminish the playability, while others that appeared dull add a whole new dimension to the player experience. You can only know this by testing each one in a controlled environment without the interference of other features. After testing each new twist, write down an analysis. Be sure to use your playtesters, and incorporate their feedback into your analysis. They are your eyes and ears. You might love a rule or feature so much that you are blind to its flaws. Trust your testers.

Exercise 7.9: Prototype Your Own Game

Use what you have learned to create a paper prototype of the game idea you described in Exercise 6.8 on page 163. This is a hard task. Break it down into the iterative steps described on pages 189–190 and 202–205 (i.e., foundation, structure, formal details, refinement). If you get stuck on a step, just take your best guess and move on. With prototyping you always have room to iterate.

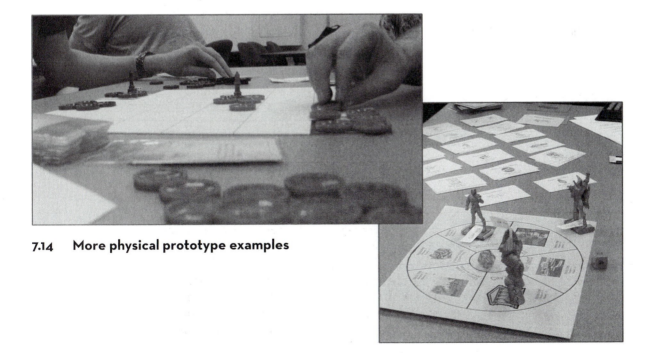

7.14 More physical prototype examples

Refining Your Visualization

As you prototype, you will probably wind up changing the relationships of the various activities in your game. We recommend refining your gameplay visualization as you go along so that you can see how your changes affect the overall flow of the system. As you analyze and refine the structure, you will be able to see if there are activities that have little or no payoff for the player or other activities that are overvalued. You will want to make sure that the core actions have significant impact for the player and that each is there for an appropriate reason. We will talk more about balance and tuning of your game in Chapters 10 and 11.

MAKING THE PHYSICAL PROTOTYPE BETTER

The prototype you have created may or may not be very playable. Parts might be out of balance, and rules might conflict. Your game might also feel slow or disjointed. Some beginning designers become discouraged at this point and walk away. They feel that their game is hopeless, and the only solution is to start from scratch with a new game idea.

This might be true, but before you take such drastic measures, it is good to go back to your core game mechanics. Strip away all the additional rules and then reintroduce them one-by-one in an attempt to isolate the problem. In doing this, you will come to understand how each rule and feature actually fits into the system. Some features and rules might seem innocuous at first, but as you add and remove them, it will become apparent how they can throw the whole system out of balance.

Your game is a complex system, and specific elements might interact with others to produce a result that is unexpected. Your job is to systematically determine the problems and experiment with solutions until you solve them. Sometimes this can be a painstaking process, as you rip apart rules and rebuild them over and over again, but it is the only way to truly figure out what part of your game is actually broken.

When you get to the point where you are absolutely certain that your prototype is both playable and fun, then you are ready to start all over again. Yes, that's right. Just because your game is good does not mean it is brilliant. Before you move on to the next stage, you want a great game. And even if it is great, there might be a way to make it better.

BEYOND THE PHYSICAL PROTOTYPE

Now that you have experimented with physical prototyping and iterated several designs, you are probably beginning to get a good sense of what it means to be a game designer. The physical prototype of your original game concept is working, though perhaps not perfectly. At this point you will want to do some playtesting of your prototype, as discussed in Chapter 9.

But physical prototyping is only the first in a long set of steps to completing a functional digital game. You and your team should use the physical prototype as the blueprint for a software prototype. Because you have spent a lot of time thinking through the core mechanics and most important features of your game by building a physical prototype, articulating those mechanics will be much simpler.

Obviously, taking your physical prototype from a physical to a digital design will change the nature of how players access the game, but the core mechanics of the system are still valid. For example, in the FPS prototype you could lay out the arena, spawning points, ammo, first aid, etc., in the software prototype exactly as you had them in the physical prototype. The programmers would implement a real time system for movement and shooting, making your card system obsolete, but the basic gameplay would

remain intact, and the map you created would provide a good design guide.

The main differences you will find in translating your physical prototype to a digital design are in the controls and interface for the target system. Rather than players moving their army men on the grid, now you have to provide a control map for a keyboard and mouse, a proprietary controller, or for whatever other input device you are designing for. Also, you have to design a visual display of the game environment for a PC screen or television. Chapter 8 goes into more detail on this process.

CONCLUSION

Creating a physical prototype is a critical step in the design of your original game concept. It will save your team tremendous amounts of time because everyone will have a clear understanding of the game you are making. In addition, a physical prototype will enable you to focus your creative energy on the game mechanics without becoming distracted by the production and programming process. And most importantly, making a prototype gives you the freedom to experiment—and through experimentation comes innovation.

DESIGNER PERSPECTIVE: JAMES ERNEST

President, Cheapass Games

James Ernest is a prolific designer of board, dice, and card games including Kill Doctor Lucky, Gloria Mundi, Button Men, Diceland, Give Me the Brain/ Lord of the Fries, Falling, Brawl, and Fightball. He has also done freelance design work for several major game companies, including Hasbro and Microsoft.

On getting into the game industry:

I met some of the people at Wizards of the Coast in 1993, shortly before they released Magic: The Gathering. I worked with Wizards on support material for that game, and I designed new games to submit to them for publication, with limited success. Eventually, with a backlog of unpublished designs, I started my own game company in 1996.

On favorite games:

I like simple games, whether they have deep strategy or not. For example, I'm a sucker for casino games of all types. Judging by the time I spend playing them, my five favorite games would have to be poker (by a wide margin), Diceland, blackjack, Dungeons & Dragons, and my family's unique version of cutthroat pitch. I also play plenty of computer games, mostly of the casual, puzzle, and arcade variety. Poker tops the list because of several factors: I can make money at it, so I'm pretty fascinated by that. The rules are incredibly simple, but the strategy is deep. Hands are only a couple of minutes long, so in a sense you're always getting a fresh start. And it has strong components of both mathematical and psychological strategy, so I can focus on whichever one I'm most interested in at the time.

On game influences:

Magic: The Gathering inspired me both to imitate the things it did right and to learn from its mistakes. Before Magic came out, I'd given very little thought to formal game design (though I'd written a few games, including a chess variant). Being closely associated with Magic in its early stages, I became aware that games were something you could design for a living. One of the most inspiring things about Magic was its original format: To imitate that success I continue to experiment with new formats. I haven't made a hit yet, but at least I deserve a little credit for trying. I'm also a fan of popular European games like Settlers of Catan and Puerto Rico, which I like for their structure and balance, and traditional and casino games, which prove that it doesn't take many rules to create a compelling game.

On design process:

Many designers seem to invent game mechanics first, then theme, or at least they give preferential treatment to mechanics. In my experience, if a game is going to have a theme or a story, you need to settle on that part first because it's so much harder to do it last. I have been in too many design meetings (for my own games and others) where we have a perfectly functional game but now need to come up with a name or theme. Those sessions are awful, and it's often impossible to come up with the right answer. Conversely, if I know the theme of a game, I have absolutely no trouble coming up with mechanics that deliver on it. In fact, a good theme usually suggests new mechanics that I would otherwise never have considered.

On prototypes:

Even when designing computer games, I try to build a paper prototype if it's at all possible. I need to put the game in front of real players for several rounds of quick, iterative testing, and paper prototypes are much quicker to modify. On the paper side, I try to prototype every meaningful element of the game as soon as I can. For example, when creating Pirates of the Spanish Main, a miniatures game for Wizkids, I built modular, miniature pirate ships exactly the size of the final models, using Lego bricks. The result gave us a very good idea of what would and wouldn't work. Having real models, rather than generic pieces, made testing and refining the game much easier.

On balancing Diceland:

Diceland is one of the most challenging games I've ever designed, and it took about six years between the original concept and the final product. It's basically a miniatures game that uses paper dice, and it deals with damage, range, and distance in very abstract ways. Each character is an eight-sided die, and each face of the die represents the character in a different state, such as wounded, healthy, blinded, in command, etc. A core design challenge was to balance light, nimble fighters against large, bulky ones in a way that made sense. The solution involved mapping the surface of the die, controlling the damage path, and understanding all the relationships between sides. When a character moves, he tips from one side to an adjacent side. A similar thing happens when he takes damage, though not always in the same direction. Understanding and mapping the "recovery" moves—that is, those that move a character from a weaker to a stronger face—gave me the control necessary to give smaller fighters a real sense of agility.

Advice to designers:

When you're new to a discipline, everything will feel like a lot of work; and something that was a lot of work can be hard to let go. Don't get so attached to your work that you can't be honest about it. Change everything if it needs changing, even down to the roots. Also, become addicted to simplicity. It's always tempting to fix a game by adding rules, but it's better (and much harder) to take bad rules away.

A lot of game designers will tell you to borrow liberally from existing games, and you can, but only when you understand what you're doing. Don't decide that your game uses seven cards just because your favorite game also uses seven cards. Decide because seven cards is the right number for your game.

It's easy to copy what you see in the market, but it's more productive to look for what isn't there. You can try to write a game for a player you don't know, but your best target will always be yourself. That's why the sign in my office says, "Write the game you want to play."

Designer Perspective: Katie Salen

Associate Professor, Parsons the New School for Design; Executive Director, Gamelab Institute of Play

Katie Salen is a game designer, writer, and educator whose games include Squidball (2003), Big Urban Game (2004), Drome Racing Challenge, The Last Fax (2006), Forget Me (2006), Skew (2006), Cross Currents (2006), and Gamestar Mechanic (in production).

On getting into the game industry:

I fell into working with games via a project I ran with some students on the Texas Lottery. At the time I was interested in thinking about how lottery tickets effectively functioned as formal, social, and cultural interfaces and quickly realized that games were an incredible platform for creating compelling, interactive experiences. I started making games as part of this work, met a bunch of interesting game designers in Austin and New York, and starting digging into a myriad of gaming subcultures, including machinima. My career as a game designer and writer on games grew from there.

On favorite games:

This is always a challenging question to answer because there are so many games I love. But if I were to name the games that have most influenced my thinking and work, Rez, Mafia, Guitar Hero, Four Square, and DDR would top that list. Each of these games totally transformed the way I think about designing play to transform how a player relates to their social and physical surroundings, and each has a particular interactive aesthetic to which I am drawn. I also am deeply affected by the cultures of production that have emerged around some of the games on the list and the way each of these games creates performative spaces as part of their play.

On inspiration:

I tend to find design inspiration in particular moments of a game, rather than in a game as a whole. Sometimes the inspiration comes from a particular moment of play of a game that was unexpected but traceable to the game's design or from an especially elegant core mechanic. The exquisite feeling of the handholding mechanic in Ico, for example, or the egalitarian structure of a race game like the New York Marathon gets me thinking about the kinds of experiences games can provide. Katamari Damacy inspired me on the level of a core mechanic that led to the invention of strange stories and worlds. SuperMario for the DS inspired

me on the value of game balancing and the pure pleasure of failure. Because I was a high level athlete into my postcollege years (volleyball), I find that I also look for inspiration in that experience, which was intensely competitive and wholly collaborative. As a player I learned to respect what the game demanded from me; as a designer I work to translate this feeling of respect into a kind of social contract binding player to player and player to game. I really feel like it is this state of mutual respect that makes game design so interesting.

On the design process:

I see game design as requiring a balance between a systematic analysis of constraints, and understanding of precedent, and sheer imagination. Most often I begin by trying to define exactly what it is I want a player to experience—how I want them to feel, what physical movements or actions I want them to enact, in what ways they might interact with other players or contexts. I also think a lot about what kinds of meanings I want the game to express and where and by whom the game will be played. I explore core mechanics that fit with answers to these questions, doing physical or paper prototyping to gauge the effects of the mechanics, and then work with a team to embed those mechanics into a larger design system. Game ideas also sometimes start with an image—the Big Urban Game, for example, started with the image of giant bowling pins wandering through a city; the slow game Skew with an image of players running through stores scanning game pieces. I also rely heavily on brainstorming ideas with other designers and making lists and lists of kinds of experiences I'd like to create.

On the prototypes:

Prototyping is a key part of my design process because it is the very best way to understand what your player will experience and to begin to see the kind of possibility space the game provides. I use many different prototyping methods: paper prototyping, physical prototyping, scenario writing, interactive prototyping, etc. Prototypes become the basis for playtesting, which I use throughout the entire design process. Sometimes the prototypes are incredibly simple—a few chits and cards used to model a core mechanic or balancing scheme; later in the process, especially with digital games, the prototypes can become quite complex and require a number of people to produce. In all cases, I use prototyping and playtesting to help me see what is and isn't working about the game, to explore unexpected outcomes, and to constantly assess the quality of experience the player is having.

On solving a difficult design problem:

I remember with the Big Urban Game Frank Lantz and Nick Fortugno and I were struggling with the overall balance of the game. As a race game that took place between three teams over the course of five days, we needed to figure out how to make sure that the race felt dramatic throughout and that each team, each day, would have a chance to win, even if one of the teams took an early lead. We chose to add a "power-up" feature where anyone could show up to one of the race checkpoints and roll a pair of giant dice to help power-up their team's game piece. Formally this feature did what we needed it to do—a team could come from behind if they received enough dice rolls, but the feature also did something else: It invited a whole other kind of player into the game. These were the super-casual players whose entire engagement with the

game was a single role of the dice. Surprisingly, because the mechanic of the dice roll was embedded in a social context (the checkpoint where lots of players were hanging out), those players felt as much a part of the game as the hardcore players did. Designing a game where a single move was felt to be equally valid as days of play by players was pretty incredible, and it was an experience that continues to inform my work. If we were to redesign the game, we would have built on this feature even more.

Advice to designers:

Be open to the possibilities of history, diversity, and ideas that you feel matter. Prototype ideas rather than talk about them. Practice. Practice. Practice.

FURTHER READING

Buxton, Bill. *Sketching User Experiences: Getting the Design Right and the Right Design.* San Francisco: Morgan Kaufmann, 2007.

Henderson, John. "The Paper Chase: Saving Money via Paper Prototyping," Gamasutra.com, May 8, 2006. http://www.gamasutra.com/features/20060508/henderson_01.shtml.

Nielsen Norman Group. *Paper Prototyping: A How-to Training Video.* DVD available at http://www.nngroup.com/reports/prototyping/.

Sigman, Tyler. "The Siren Song of the Paper Cutter: Tips and Tricks from the Trenches of Paper Prototyping," Gamasutra.com, September 13, 2005. http://www.gamasutra.com/features/20050913/sigman_01.shtml.

Snyder, Carolyn. *Paper Prototyping: The Fast and Easy Way to Design and Refine User Interfaces.* San Francisco: Morgan Kaufmann, 2003.

Chapter 8
Digital Prototyping

Now that you have some experience creating physical prototypes, you can see their usefulness in thinking through your design and getting early feedback from players. However, physical prototypes have their limitations; if your final game will be released on a digital platform, at some point in the development process you will need to create a digital prototype of your concept. This does not mean starting from scratch—your physical prototype helped you to formalize and test the foundation of your game mechanics. The digital prototype extends that design work into a digital form and allows you to test the essence of your game in its intended format. The understanding of your formal system gained from the physical prototyping experience will breathe life into the designs for your digital game. It will inform the decisions you make and give you ideas you would otherwise have never thought of.

As part of your digital prototyping process, you will want to build models of core systems that you have questions about: game logic, special physics, environments, levels, etc. Additionally, two of the core tasks of digital prototyping will be envisioning your gameplay using the input and output devices of your digital platform. This means prototyping your control systems, such as keyboards, mice, proprietary controllers, etc. It also means visualizing your gameplay in the form of an intuitive, responsive digital interface.

An important thing to keep in mind when you are doing digital prototyping is to consider your reasons for each prototype that you make. Are you trying to answer game design or technical questions? Are you trying to establish an effective production pipeline? Or are you trying to communicate your vision to your team or to a publisher? The following section will help you to craft your digital prototype for these very different situations.

Types of Digital Prototypes

Like physical prototypes, digital prototypes are made using only the elements needed to make them functional. They are not finished games, and if you spend too much time making them like finished games, you will defeat the purpose of prototyping at all. Generally, digital prototypes are made with minimal art or sound; even their gameplay is incomplete, focusing only on unanswered questions and parts of the design that need clarity. Eric Todd, development director for Spore, divides the prototyping process into four distinct areas of investigation, which can be seen in Figure 8.1.[1] These are: game mechanics, aesthetics, kinesthetics, and technology.

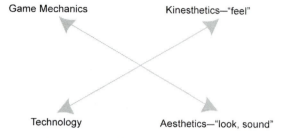

Game Mechanics Kinesthetics—"feel"

Technology Aesthetics—"look, sound"

8.1 **Four areas of investigation for digital prototyping**

Prototyping Game Mechanics

Game mechanics are, as we have already discussed, discrete features of the formal aspects of the game. If you have already created a physical prototype, you have a head start in this area of your design. Sometimes, however, a gameplay question you pose to yourself is not easily modeled in a physical prototype. In this case, you can actually begin with a digital gameplay prototype. The important thing to remember when you do this is to make it simple and focused on a particular question—do not try to integrate all of your questions about the game into a single prototype, at least not at first. Later you can prototype the integration of features, but when you are first starting out, you will want to start with your core mechanic, just like we did when we built the FPS prototype.

An example of using digital prototyping for gameplay questions can be seen in the work of independent game designer Jonathan Blow, who regularly leads the Experimental Gameplay Workshop at the Game Developers Conference. Blow talked in 2007 about his work on experimental gameplay related to time. His game Braid is an innovative action platformer that allows the player to "rewind" time in unusual ways, making that feature an integral part of the gameplay. Before deciding on the current mechanic, Blow actually prototyped a number of other potential mechanics related to time. One question that resulted in an interesting prototype

was something he called Oracle Billiards. Blow asked himself how the game of billiards would change if the player could see the future. In addition to seeing the balls on the table, the game showed the final positions of the balls after being struck. When he tested the prototype, he realized that it was not fun, but it was informative. "It didn't do what I wanted," he says, "but I got a feeling out of it that I never got out of any game I ever played before."[2] The learning from this prototype and others eventually led to the design of Braid.

Another example comes from the Spore prototyping process described by Eric Todd in his Game Developers Conference presentation on the topic. One big question for the design team revolved around the creature editing portion of the gameplay. The question was how to make it simple and intuitive to use but still complex enough to give a wide variety of results so that players without any 3D design experience could make truly unique creatures. One team member had an idea for the feature, but when he tried to explain it to the rest of the team, they did not understand how it would work. So, to prove his point, the team member put together a rough 2D prototype (left side of Figure 8.3,) to demo his idea. This prototype helped the rest of the team understand exactly what he was talking about. The successful communication of the rough idea made the team decide to go a little further with the prototype and refine it in 3D (right side of Figure 8.3,). And eventually, the 3D prototype helped to define a large portion of the gameplay.

This type of digital gameplay prototype is not just something done by professional developers; it is also extremely useful and practical for students and beginning designers. During the development of the student research game Cloud at the USC Game Innovation Lab, a number of prototypes were created to answer the team's many questions about how to use the gameplay mechanics to evoke a feeling of relaxation and freedom in the player. You can read more about the prototyping process for Cloud in the sidebar on page 228.

8.2 Oracle Billiards and Braid

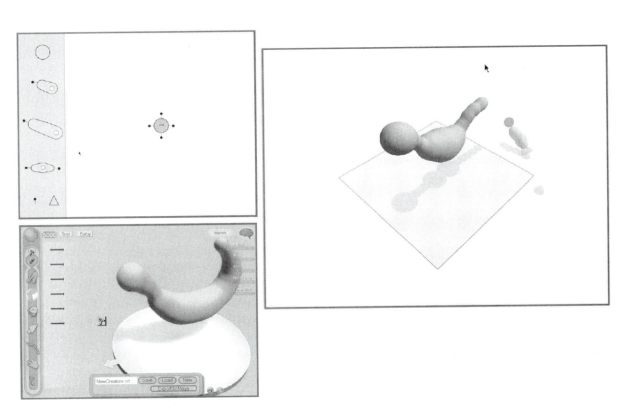

8.3 2D and 3D creature editor prototypes for Spore

8.4 Student research game Cloud

Gameplay prototypes need not be stand-alone programs. Often the questions you will have about your mechanics will involve the kind of number crunching that can be tested using a customized Excel spreadsheet or Google spreadsheets. These tools allow for embedding fairly complex game logic into a spreadsheet that allows you to test permutations of your game mechanics in a stripped-down fashion. See Nikita Mikros' sidebar "Using Software Prototypes in Game Design" on page 220 for an example of this approach to gameplay prototyping.

Prototyping Aesthetics

Aesthetics are the visual and aural dramatic elements of your game, which we have told you repeatedly not to worry about for your physical prototype. The same holds true for most of the digital prototyping work you will do. However, sometimes you will want to break this rule. Adding just a little bit of visual design and sound to a prototype can often help articulate the game mechanics. The trick is to know when you are adding just enough and when you are wasting valuable time.

Additionally, sometimes you have questions about aesthetic issues in your game that you need to test early on. For example, how will the character animation work with the combat system? Or how will a new interface solution work with the environments?

Some simple ways to do this are with storyboards, concept art, animatics, interface prototypes, and audio sketches.

- Storyboards are a series of drawings that show a rough sketch of a visual sequence. These are often used in filmmaking to determine how scenes will be shot, but they are also useful for cut scenes in games and mapping out potential play within a level.

- Concept art consists of paintings or sketches of characters and environments, exploring potential looks, palettes, and styles for the visual aesthetics.

- An animatic is an animated mock-up of the game in action. An animatic does not use the real game technology, and it does not give a sense of the kinesthetics, but it can help communicate both the aesthetics of the game and some portions of the gameplay.

- An interface prototype is a mock-up of the visual interface. This can be done in a static board or using an animatic. This can even be done first as a paper prototype and playtested before moving on to a digital format.

- Audio sketches are early drafts of the music and sound effects that can really help to set the tone of the game and are useful for bringing life to animatics and other prototypes.

8.5 Animation prototypes for Ratchet & Clank

The team at Insomniac Games described their animation prototyping process for Ratchet & Clank as saving time not only for the animators but for the design and programming staff as well. "As a rule," says animation technical director John Lally, "our prototypes emphasized function over style. . . . For the animators, this meant that prototype characters needed to jump to their correct heights, attack to their design specifications, and run at their proper speeds." The "protocharacters" were constructed with primitive objects and only roughly resembled their future incarnations, as can be seen in Figure 8.5. These animation prototypes allowed the artists to test attributes such as timing, measurement, and interaction with other characters, all of which have a direct impact on gameplay.[3]

Similarly, the team at Naughty Dog, creators of the Jak series of games, when faced with the complicated challenge of designing a customization interface for Jak X: Combat Racing, used a number of aesthetic prototypes to prove out their design ideas. Game director Richard Lemarchand says:

> The interface system for Jak X: Combat Racing was more complicated than the interface for any game that Naughty Dog had created before, since the player had to be able to customize their cars and select online multiplayer missions, as well as move through a single player game.

> We designed the interface first in a flowchart accompanied by rough pencil sketches of the screens and then prototyped it in Macromedia Flash to quickly give us a sense of how the flow between the different components would feel and whether or not some of the interface gimmicks we had in mind would come off. When we implemented the final interface, we were able to save a lot of time because of the discoveries we'd made by working out problems with the original design in the Flash prototype.

Figure 8.6 shows two stages of the prototype in progress.

Prototyping Kinesthetics

The kinesthetics are the "feel" of the game, how the controls feel, how responsive the interface is, etc. Unlike gameplay and aesthetics, each of which can be tested using physical or analog methods before moving to a digital prototype, kinesthetics for a digital game are something that must be prototyped digitally. As we will discuss in the controls section on page 227, the feel of a digital game has a great deal to do with the type of controls you have available to use. A game designed for a keyboard and mouse will have a very different feel from a game designed for a Wii. It is important, when you are conceiving your gameplay,

8.6 Interface prototypes for Jak X: Combat Racing

to keep in mind the controls that will be available on the final platform so that you can design with them in mind.

An example of the usefulness of a kinesthetic prototype is in the story behind the development of Katamari Damacy. Keita Takahashi, the game designer of Katamari, had an idea about a game in which you could roll a sticky ball around and pick things up with it. He was a student at a Namco-sponsored university at the time, and the prototype for Katamari was made as an exercise for his thesis. The game, explained verbally or even with storyboards, sounds strange and does not fit into any particular genre of gameplay. Nevertheless, when the executives at Namco played the prototype, they, like all the players since, were convinced by the simplicity and charm of the game, which uses only the two analog sticks on the PS2 controller for its simple, compelling control scheme.[4]

Another example of a successful kinesthetic prototype was actually an animatic with a clever setup. Game designer Keiichi Yano was inspired to create the beat-matching game Osu! Tatakae! Ouendan (remade for Western audiences as Elite Beat Agents) when he first saw a demo of the (then) new Nintendo DS. The core mechanic of the game involves tapping the DS screen in time with the music and visual markers to "cheer on" the game characters. According to Yano, the development team put together a Flash pitch for the new idea that mimicked the feel of the interface and controls. "When we presented this to Nintendo, I played it on my notebook. I had them use a regular pen. They were touching my PC screen to get an idea for how the game would play. . . . I got a lot of scratches."[5] The gameplay of this animatic/kinesthetic prototype looked and felt fairly close to the final version, and it sold the executives at Nintendo on the concept quickly.

8.7 Elite Beat Agents

Prototyping Technology

Technology prototypes are just what they sound like: models of all of the software that it will take to make the game work technically. This could include prototypes of the graphics capabilities for the game, the AI systems, the physics, or any number of problems specific to your game. It can also include a prototype of the production pipeline. Prototyping in this area is about testing and debugging the tools and the workflow for getting content into the game.

Prototyping is not about software engineering, however. It is an opportunity to try out ideas in a quick and dirty fashion. It is not the "real" code. In their Game Developers Conference presentation on the topic,[6] Chris Hecker and Chaim Gingold of Maxis advise "stealing it, faking it, or rehashing it" when you are building your prototype. After you have learned what you have to learn, you can go back later and write the real code much cleaner and faster. The key here is to actually do so—not to take the prototype code and try to make it into the final game code. The takeaways from a prototype should be abstract ideas, like algorithms or gameplay concepts.

One good way to keep yourself from the trap of turning your prototype into the final product is to prototype in another language—something like Java or Flash. If your final game will be written in C++, you won't be able to use the prototype code directly. However, there are exceptions to this technique. Many smaller game productions actually do evolve their prototypes directly into their final game code. While not optimal, it is a practical production process for a small team working in a single language.

Up until now, we have concentrated on a single prototype for your game—the physical prototype. But digital prototyping is often more effective when it is done in small, fast, throwaway projects. This is called "rapid prototyping," and it means that you pose a question about some aspect of your gameplay, come up with a potential solution, and then build a quick and dirty model of that solution so that you can see if your idea will work. As Hecker and Gingold point out, prototypes do not generate ideas; they simply validate good ideas or refute bad ideas. A good rapid prototype makes a testable claim and provides actionable learning about that claim. See Chaim Gingold's sidebar on page 182 for more on his prototyping techniques.

Exercise 8.1: What Do You Need to Prototype?

What concerns do you have about the gameplay, aesthetics, kinesthetics, or technology in your original concept? Of these concerns, which is the highest priority? Which will kill the game if they do not work? Depending on your answer, decide where to focus your efforts for your first digital prototype.

Using Software Prototypes in Game Design

by Nikita Mikros, CEO and Lead Game Designer, Tiny Mantis Entertainment

In a successful game, the rules of the game interact with each other and give rise to interesting but controlled emergent subsystems and compelling play patterns. Having a solid understanding of how one system interacts with another is essential in writing a comprehensive design document, answering questions from the team about the project, resolving unforeseen problems, and ultimately creating a compelling, balanced game. As games become increasingly complex, it becomes more and more difficult for the game designer to keep a complete image of all the elements or systems of gameplay in his or her mind.

Scientists use simulations and visualizations to gain understanding of complex data. Similarly game designers can employ their own set of tools to gain insight into their own creations. These tools include daily logs, design documents, paper prototypes, and software prototypes. Software prototypes should be one of many tools at the game designer's disposal, and although they can be extremely useful, without clear goals they can easily escalate into monsters more complex to build than the problem the designer is trying to solve. The goal in building a software prototype should always be to create a tool to help in your game design efforts, not to show off fancy graphics or elegant software architecture.

When Do You Need Software Prototypes?

Many games lend themselves very easily to paper prototypes, and even if the whole game cannot be modeled this way, isolated parts can often be playtested and designed using this process. However, there are times where one cannot really get a feel for a game without a software prototype. Additionally some game prototypes are just simpler to implement with software. A simple example would be the game of Tetris. Tetris was inspired by pentominoes, a puzzle/toy based on building shapes out of pieces that are constructed from five basic blocks. In Tetris, the pieces are simplified from five to four blocks (tetrominoes) and are dropped at a constant rate, allowing the player to spin and move the pieces trying to construct solid horizontal rows on the bottom of the board. When a horizontal row is created, that row of building blocks is eliminated from the game. The pieces stack up, and eventually the game is lost when the player can no longer fit pieces onto the board. Although they share many similarities, constructing shapes with tetrominoes is very different from playing Tetris. How would one model the game of Tetris in a physical/paper prototype? Although the game has its origins in a physical puzzle, it is very tightly bound to a type of interaction that can only be modeled on the computer. In this case a physical/paper prototype would be more difficult to construct than a software prototype.

Supremacy: Four Paths to Power

The creation of any software prototyping tools should be carefully considered due to the costly and time consuming nature of writing software. The questions that the designer should ask before diving into such a project are as follows:

- *Is the tool/prototype really needed?*
- *What are the requirements of the tool/prototype?*
- *What is the quickest way to build the tool?*
- *Will the tool be flexible enough?*

In the following section I will address how I attempted to resolve these questions for a particular problem in a project we completed a few years ago.

Supremacy: Four Paths To Power is an open-ended strategy war game that is waged on two fronts: the metagame, which is a battle in space, and the ground battles that determine the individual capture of planets. Each type of planet has different natural resources that the player can exploit to build unique military units and ultimately try to defeat his or her enemies. Overzealous players can destroy their own planets due to overproduction.

Is the Tool/Prototype Really Needed?

My first task was to build a paper/physical prototype and test my ideas by getting feedback from the rest of our team, whom I volunteered to be playtesters. Two separate paper prototypes were created: one simulating battles on the ground and one simulating the larger battles in space. The ground battle prototype worked fine; the math was straightforward, and keeping track of all the stats was relatively simple. Excited by the first prototype, we set out to play the space battle prototype, and disaster struck. After much groaning and moaning, we somehow slogged through seven or eight turns in what seemed like as many hours before calling it quits. The accounting of resources that was required was daunting. We were so caught up doing math that we could not see the forest for the trees. When one of the playtesters declared, "This game is hurting my head," I decided it was time to create a software prototype.

What Are the Requirements of the Tool/Prototype?

My first impulse was to build a full visual prototype, but upon further consideration I decided to ignore the "programmer within" and opted for a simpler solution. What I decided upon was a nonvisual representation of the game in software and the old paper prototype for visual representation. It was easy for us mere mortals to move pieces, count squares, calculate line of sight, and do all the things that take many person-hours to express in code. Alternatively, it was very easy to program the software to do all the accounting calculations as well as some other tedious tasks like keeping track of turns. The "prototype" looked nothing like a game; it looked like an ugly Excel spreadsheet with lots and lots of buttons. It took me about a day and a half to write it.

What Is the Quickest Way to Build the Tool/Prototype?

My first attempt was to build the tool in a spreadsheet program, but I quickly realized that it was not feasible due to the nature of some of the calculations. I decided to build it using Java and the Metrowerks RAD (rapid application development) toolset. This was a good option because I could quickly and easily lay out my tables, buttons, and other widgets and doodads. I was already familiar with the language and the development environment, so it was a natural choice. For me, writing this type of software is somewhat liberating because the end product is more or less a throwaway. I am far less concerned with software design, architecture, optimization, coding standards, and all the other things that go into building solid software. Remember, the goal is to create a tool to help your game design efforts, not to create elegant, airtight software. Ultimately, I believe that you should write your prototypes in whatever language or authoring system you feel comfortable in and that allows you to experiment and change things quickly and easily. If you are not a programmer or are unfamiliar with any type of authoring software, then you must rely on your programming team. This can be difficult because ultimately programmers want to write good code, and their first impulse is always to build well-engineered reusable code that they can then use in the final product. This is not a bad idea when you have a clear idea of all the elements of your game, but this approach to rapid game design prototyping is like building a tractor to make a sand castle. It is overkill, and it prematurely locks you into something that you might not be trying to build.

Will the Tool Be Flexible Enough?

Ultimately, you want to be able to change rules and values easily and have the ability to experiment as quickly as you would be able to in a paper prototype. Although this is somewhat of a holy grail, there are things you can do to make your software prototyping tool more flexible. Here are some simple suggestions:

1. Everything is a variable.
2. Try to avoid using any literal constants in your code; in other words a code snippet that looks like this:

   ```
   totalOutput = 15 × 2
   ```

 should look like this:

   ```
   totalOutput = rateOfProduction × numFactories
   ```

3. Expose as many variables in the interface as possible.
4. Litter your prototyping tool with editable text fields; any value that has a remote possibility of changing should be editable through these fields. Your tool will be as ugly to look at as your high school yearbook picture, but you'll be happy when you don't need to recompile or go rifling through your code looking for a variable in the middle of a playtesting session.

5. Don't even think of reusing this code. When I was an undergrad studying fine art, I had a drawing professor by the name of Marvin Bileck, and everybody called him Buddy. One day Buddy made us all go buy some sheets of very expensive drawing paper. We all came to class the next week with our beautiful drawing paper, ready to draw. At this point Buddy instructed us to throw the paper on the ground and stomp on it. If we weren't doing a good enough job he came over and joined in on the destruction of our precious paper. At the end of this exercise he declared that we were ready to start drawing. The point of the exercise was clear to me: If you want to be creative, don't hold on to anything too tightly, don't make anything so precious that you can't see beyond it. This is the way you should think about your prototyping code. In the end you may wind up reusing parts of the code, but this should not be a goal as you create it. You should be fully prepared to throw it away.

Conclusion

Software prototyping is a tool that can be used to understand and ultimately control the elements of your game. You gain nothing by writing software that prototypes a part of your game that you already thoroughly understand or that you can playtest via cheaper methods like paper prototypes. Every game is different, with its own special characteristics and requirements. If we had been working on a first person shooter, or a fighting game, a totally different type of prototype would have been needed. I believe in this particular case that the software prototype was successful. It allowed me to visualize emergent behaviors in the game that I would not have been able to see with just a paper prototype. This prototype worked because it addressed the specific problems I was trying to solve and because I could build it quickly and easily.

About the Author

Nikita Mikros is CEO and Lead Game Designer for Tiny Mantis Entertainment. Tiny Mantis creates offbeat games primarily for the Web, including The Mosquito Project, where you suck blood to save the world; Kong Fu Monkey, an adventure game in episodes; and THUGS!, a tabletop and electronic card game. Prior to Tiny Mantis, he was Cofounder and Lead Game Designer at Black Hammer Game. He served as Technical Director and Lead Programmer for the award winning Game Boy Advance title I-Spy Challenger. Prior to Black Hammer, he joined with John Mikros in 1997 to found Flying Mikros Interactive, a creator of electronic entertainment for the Internet and of graphics and entertainment software for the Macintosh and PC. Their PC game, The Egg Files, was selected as one of ten finalists in the 2002 Independent Games Festival. In addition, Mr. Mikros has taught various programming and game design classes in the MFA Computer Art Department at the School of Visual Arts for the past 12 years.

http://www.tinymantis.com/
http://www.supremacygame.com/

PROTOTYPING FOR GAME FEEL

by Steve Swink

Steve Swink is a game designer, teacher, and unicycle enthusiast. Having done stints at Neversoft and the now defunct Tremor Entertainment, he now designs for Flashbang Studios, a small development studio in Tempe, Arizona. He is also an instructor in Game and Level Design at the Art Institute of Phoenix, and he is currently writing a book entitled Game Feel: a Game Design Guide to Virtual Sensation *to be published by Morgan Kaufmann in summer 2008.*

What is good game feel? Among other things, it might mean that the feel of controlling the game is intrinsically pleasurable. The feel of Super Mario 64 fills me with thoughtless joy, enhancing every aspect of the game. From the first few seconds, I'm hooked, sold, ready to spend endless hours discovering the endless challenges and permutations implied by this tantalizing motion. Every interaction I have with the game will have this base, tactile, kinesthetic pleasure. How was this sensation designed? What's behind the curtain? Wherein does the "magic" of game feel lie?

The problems of game feel quickly become intertwined with the problems of the design as a whole, but it is possible to separate out the relevant components of game feel to make them a bit more manageable:

- *Input*: How the player can express their intent to the system
- *Response*: How the system processes, modifies, and responds to player input in real time
- *Context*: How constraints give spatial meaning to motion
- *Polish*: The impression of physicality created by layering of reactive motion, proactive motion, sounds, and effects, and the synergy between those layers
- *Metaphor*: The ingredient that lends emotional meaning to motion and that provides familiarity to mitigate learning frustration
- *Rules*: Application and tweaking of arbitrary variables that give additional challenge and higher-level meaning to constrained motions

Note: In the interest of brevity, the following discussion focuses on input, response, and context. The concepts of polish, metaphor, and rules are equally important.

Input

Input is the player's organ of expression in the game world, and the potential for expression is deeply affected by the physical properties of the input device. Consider the difference between a button and a computer mouse. A typical button has two states: on or off. It can be in one of two positions, which is about the minimum you can get sensitivity-wise. A mouse, on the other hand, has complete freedom of movement along two axes. It is unbounded; you can move it as far as the surface underneath allows. So an input device can have an inherent amount of sensitivity, what I call "input sensitivity."

An input device can also provide opportunities for natural mappings. That is, what kinds of motion are implied by the constraints, motions, and sensitivity of the input device? My favorite example is Geometry Wars for Xbox 360. Look at Geometry Wars, and then look at the Xbox 360 controller. Notice the way that the joystick is formed and how that transposes almost exactly to the motion in Geometry Wars. It's

almost one for one: The joystick sits in a circular plastic housing that constrains its motion in a circular way. That means that pushing the control stick against the edge of the plastic rim that contains it and rolling it back and forth creates these little circles, which is almost exactly the motion that gets produced on-screen by Geometry Wars. This is what Donald Norman would refer to as a "natural mapping." There's no explanation or instruction needed because the position and motion of the input device correlates exactly to the position and motion of the thing being controlled in the game.

The controls of Mario 64 have this property; the rotation of the thumbstick correlates very closely to the rotation of Mario as he turns, twists, and abruptly changes direction.

Figure 1 Natural mapping

The overall implication for game feel prototyping is to consider the overall sensitivity of your system and add or remove sensitivity to get a feel that is sufficiently, but not overly, expressive. The sweet spot is difficult to pin down, but it can be achieved with a high or low sensitivity input device, depending on how the system responds to a given input.

Response

A very simple input device with very little sensitivity can, by virtue of a nuanced reaction from the game, be part of a very sensitive control system. I call this "reaction sensitivity": sensitivity created by mapping user input to game reaction.

The NES controller was just a collection of buttons, but Mario had great sensitivity across time, across combinations of buttons, and across states. Across time, Mario sped up gradually from rest to his maximum speed and slowed gradually back down again, more commonly known as dampening. In addition, holding down the jump button longer meant a higher jump, another kind of sensitivity across time. Holding down the jump and left directional pad buttons simultaneously resulted in a jump that flowed to the left, providing greater sensitivity by allowing combinations of buttons to have different meanings from pressing those buttons individually. Finally, Mario had different states. That is, pressing left while "on the ground" has a different meaning than pressing left while "in the air." These are contrived distinctions that are designed into the game but that lend greater sensitivity to the system as a whole so long as the player can correctly interpret when the state switch has occurred and respond accordingly.

The result of all these kinds of nuanced reactions to input was a highly fluid motion, especially as compared to a game such as Donkey Kong, in which there was no such sensitivity.

The comparison in Figure 2, between Super Mario Brothers and Donkey Kong, shows very clearly just how much more expressive and fluid Mario's controls are. The interesting thing to note is that Donkey Kong used a joystick, a much more sensitive input than the NES controller. No matter how simple the input, the reaction from a system can always be highly sensitive.

Context

Returning to Mario 64, imagine Mario standing in a field of blank whiteness, with no objects around him. With nothing but a field of blankness, does it matter that Mario can do a long jump, a triple jump, or a wall kick?

If Mario has nothing to interact with, the fact that he has these acrobatic abilities is meaningless. Without a wall, there can be no wall kick. At the most pragmatic level, the placement of objects in the world is just

Figure 2 **Comparison of character motion in Donkey Kong and Super Mario Bros.**

another set of variables against which to balance movement speed, jump height, and the other parameters that define motion. In game feel terms, constraints define sensation. If objects are packed in, spaced tightly relative to the avatar's motion, the game will feel clumsy and oppressive, causing anxiety and frustration. As objects get spaced farther apart, the feel becomes increasingly trivialized, making tuning unimportant and numbing thoughtless joy into thoughtless boredom.

Concurrently to the implementation of your system, you should be developing some kind of spatial context for your motion. You should put in some kind of platforms, enemies, some kind of topology that will give the motion meaning. If Mario is running along with an endless field of blank whiteness beneath him, it will be very difficult to judge how high he should be able to jump. So you need to start putting platforms in there to get a sense of what it will be like to traverse a populated level.

Constraint is also the mother of skill and challenge. Think of a football field: There are these arbitrary constraints around the sides of the football field that limit it to a certain size. If those constraints weren't there, the game of football would have a very different skill set and would arguably be a lot less interesting because you could run as far as you want in one direction before bringing the football back. The skills of football are defined by the constraints that bound it.

Conclusion

There is an aesthetic beauty possible with game feel. That is, something beautiful is created at the intersection of player and game. The act of play can create something aesthetically beautiful, aurally, visually, and/or tactilely.

Before you dive in and start coding, consider the overall sensitivity of the system, the affordances of the input device, and the sensitivity of the response from the game. Concurrently, develop some kind of spatial context for your motion. The idea is to create a "possibility space" that will, through tweaking the variables you've exposed, give rise to the game feel you want, the thoughtless joy that will hook players, engage them, and keep them playing.

DESIGNING CONTROL SCHEMES

One of the key tasks in designing any digital game is developing good, intuitive controls. In a technical sense, digital games are about three things: input, output, and AI. Controls are the input part of this equation.

When video games were first invented, they were limited in terms of controls. Steve Russell and several other students at MIT programmed Spacewar in 1962, which is often credited as the first digital game, and in doing so, they found the toggle switches built into the front of their DEC PDP-1 to be too cumbersome, so they built their own special controller to go along with the game. Spacewar had only four controls: rotate left, rotate right, thrust, and fire.

Controls have come along way since the 1960s. Today's controls include the keyboard, mouse, game pad, joystick, steering wheels, plastic guns, guitars, bongo drums, touch screens, motion sensors, data gloves, virtual reality headsets, and more. Not all of these are practical, and the most widely used controllers today are simply more elaborate variations on the same directional arrow/selection button design that marked the very first consoles.

There have been a number of interesting developments into new types of controllers in recent years, however, including the footpad stage of Dance Dance Revolution, the touch screen for Nintendo DS and, of course, the "Wiimote" control for the Wii. These advances in control technology are opening up a brand new audience for games: Players who are interested in the active, social play of the Wii, or the simple, intuitive play available on the DS.

8.8 Spacewar on the DEC PDP-1 and custom controller

8.9 Clockwise from top left, controls for: Nintendo DS, Xbox, Wii, and PlayStation 3

Prototyping Cloud

by Tracy Fullerton

Cloud is a student research project from the USC Game Innovation Lab with an unusual design goal: Create a tranquil, relaxing, and joyful emotional experience similar to the archetypal childhood daydream of flying in the sky and creating shapes in the clouds. As faculty advisor for the project, Tracy Fullerton worked with the team at each stage of the process to define and iterate the design. This award winning game has been downloaded more than 1.5 million times from www.thatcloudgame.com.

When we began working on Cloud, we had only an innovative design goal: to somehow evoke the feeling of relaxation and joy that you get when you lie back on the grass on a clear summer day and look up at the clouds, wandering across the sky. Everyone does this. And at some time or another, we've dreamed of flying up in the clouds and moving them, shaping them into funny creatures or smiley faces or lollipops, or whatever comes to mind. It seemed like entirely new territory for a game. It seemed risky and interesting. So we decided to give it a try.

But how to do it? The first step was to create a series of prototypes based on the core mechanic of flying and gathering clouds. These prototypes were implemented in using the Processing development environment and were iterated on over several generations, starting in 2D and moving into crude 3D to test control, camera, and gameplay integration.

This core gameplay was tested by the team and a number of playtesters, and several conclusions were reached. The first was that the 2D perspective, while simple and practical, was not emotional enough. Although the final project had always been planned as a 3D game, there had been an open question of how to achieve a useable player viewpoint, and whether or not it made sense to use a 3D environment, but to lock the play within that environment to a two-dimensional plane within the 3D world.

At this point, the team began to sense that there was a conflict between

Figure 1 **2D gathering clouds prototype for Cloud, left, and control, camera, and rudimentary gameplay prototype, right**

Figure 2 **Camera simulation prototype; left shows camera zoomed out for view of entire sky, right shows camera zoomed in to fly close to the character**

the desired clarity for gameplay (which called for a 2D playing field) and the equal desire for an emotional sense of freedom in flight (which called for freedom of movement within a 3D space). So we created a camera prototype in Maya that simply tested the idea of allowing the player to zoom the camera in and out at will. For example, we knew we wanted the player to be able to zoom far out to see what they had written in the sky, but we also wanted to be able to fly close up with the character, to feel the emotion of flight. As it turned out, this concept, especially when combined with another feature—"free flight" within the 3D space—solved both the practical interface issue and the emotional issue of flying close-up with the child.

In addition to experimenting with the core mechanic and viewpoint, at this point, the team began to envision a game without the traditional goals and conflict that drives most games. It would be a simple game that would encourage creativity and playfulness. To achieve this, we began designing the features that would allow players to draw and erase clouds in the sky as easy as chalk. Also, we began to realize that every aspect of the game needed to reinforce these positive emotions. The game needed to be relaxing and refreshing in its play as well as in its look and feel. So to eliminate all the psychic stress, there is no time pressure in the game, and failure is almost impossible. There are no elements that will trap players, and they can pick up and leave at any time with no repercussions.

While our gameplay prototyping was going on, focused on mechanics and camera controls, the programming team had several other hurdles they knew they had to face. The most important, obviously, was the simulation of believable, malleable, and computationally practical clouds. The team came up with an interesting solution: the use of a Lennard-Jones particle simulation underlying the clouds that would give them a dynamic underlying structure that would feel like playing with globs of mercury.

The first implementation of this concept was most useful in the fact that it proved we could create "clouds" out of clumps of dynamic particles—and that we would be able to support a lot of them. The images below of the particle simulation prototypes show the result of several thousand particles in a prototype environment that are (thankfully) not overtaxing the machine. These particles can be grabbed and shaped, much as the team had envisioned the cloud drawing feature.

The next stage of prototypes focused on making that underlying particle simulation feel more puffy. The previous figure shows such a test. In this version, tests revolved around using the

Figure 3 Particle simulations prototypes

clumps of clouds to draw faces, pictures, and an overall excitement about how the clouds would ultimately feel to play with started to permeate the team.

In addition to creating this underlying simulation, the team also implemented a billboarding method for rendering the cloud art onto the simulation. The following cloud simulation layer screenshots show

images from the final game with rendering turned on and off to demonstrate how the method mapped to the final simulation.

Throughout the prototyping process and into production, extensive playtesting, both by the team and by outside players, led to a number of changes and decisions. In the end, a number of technical features were cut to concentrate on the cloud simulation and the free flight controls. Concepts like wind, a day

Figure 4 Cloud simulation layer (left) and with rendered clouds overlying simulation (right)

and night cycle, terrain features linked to cloud state, etc., were all prioritized under the response from playtesters for the need for a satisfyingly dynamic sky and intuitive flight controls.

These decisions are examples of the importance of playcentric design on the design and development process. While a traditional design team might have tried to implement all features, but with less depth in each, the iterative testing and reevaluation of the design based on overall experience made it clear that players were focused on the feel of the clouds and flight, not necessarily interactive terrain, day and night cycles, wind, or other missing elements.

In the end, Cloud proves that even a student research project can provide a strong model for gameplay innovation. Overall, though the design process had fits and starts throughout, and though we were not always certain of success, the methodology of playcentric design, and a clear design goal of finding new areas of emotional experience for games, brought this project safely to conclusion. So while risk was high, we had confidence in both the type of innovation we were exploring and the method by which we were doing our exploration.

As a designer, you need to make sure that you understand the capabilities of the controller for the platform you are designing to. This means creating a kinesthetic prototype and testing the controls until they are perfectly integrated with your gameplay. The article by designer Eric Zimmerman of Gamelab on page 330 describes how his team's desire to create an interesting new control idea scheme led to the idea for their game Loop. In this case, they created a digital prototype of the core mechanic—the "looping" control—and tested that thoroughly to make sure it was intuitive and fun before progressing further with the idea.

After you understand the input device, you need to think about how your game can best utilize it. You need to decide this in conjunction with your interface design, which we discuss on page 235. A good way to begin is to look at the list of procedures for your physical prototype. These procedures need to be translated into a set of digital controls. For example, in our first person shooter prototype, we had procedures for moving forward, backward, turning left, turning right, etc. We also had procedures for firing weapons, changing weapons, etc. Each of these will need to be mapped to a control. If you have a highly detailed set of controls, you will probably wind up grouping them under a menu system or other visual device that can be accessed using a single control or set of controls.

When you have decided how the controls will work, create a control table to make sure you have thought of everything. In one column, list the

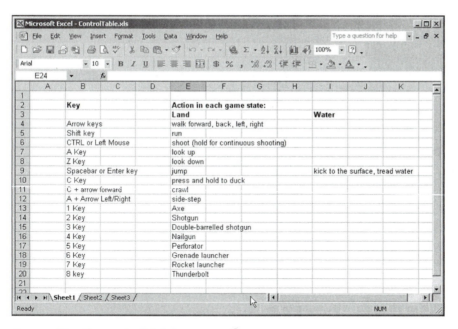

8.10 **Simple control table**

Exercise 8.2: Original Game Controls

Define a control scheme for your original game. For example, if your game is intended for a game console such as the Wii, make sure to label every button on the controller. If a button has no function, then label it as nonfunctional. If the control involves the motion sensors, describe the controller movement for each game action in the button column.

Designing controls, like designing gameplay, is an iterative process. Your first attempt might not be as intuitive as you believed. The only way you will truly know if the controls work is to test them.

Your goal should be to make the controls as effortless as possible. Gamers do not want to think when they are playing. They want the controls to feel intuitive. In this case, less is more. You will find that adding too many control options frustrates the average user. For expert players, these detailed controls might be desirable, as will custom control schemes, but you will need to do a lot of playtesting to make sure you do not alienate less experienced players.

controls, and in next column, list the game procedure taken when that control is activated. If your game is complex, you might have to make several tables, each representing a specific game state. For the purposes of controls, a new game state exists each time the controls change.

For example, if it is a game where you can drive a car, fly a plane, or ride a bike, there will be three game states. In this case, the designer should try to keep the controls as similar as possible between the three states to avoid confusing the player.

SELECTING VIEWPOINTS

The interface for a digital game is a combination of the camera viewpoint of the game environment and the visual display of the game status and controls that allow the user to interact with the system. The controls, viewpoint, and interface all work together symbiotically to create the game experience and allow the player to understand and have agency within the system.

As with control systems, the viewpoints for the first video games were limited, and they were mainly limited to text descriptions of the environment. This does not mean that they were ineffective—just the opposite— anyone who remembers playing an Infocom text adventure probably also remembers the sense of immersion that can come from a well-written story line.

However, when computer displays were able to move beyond the display of text, several major graphic viewpoints for interfaces were developed fairly early on. These viewpoints have evolved in complexity as

technology has advanced, but they remain essentially the same today as they were the first time we looked down on the classic Pong tennis court.

Overhead View

Looking directly down at an object is a somewhat unnatural angle, and today, this viewpoint is primarily used for level maps and digital versions of board games, but early games used this viewpoint quite a bit, in everything from sports and adventure games to action puzzles like Pac-Man.

Side View

The side view is popular with arcade and puzzle games like Donkey Kong, Tetris, and The Incredible Machine, but it probably has had the most influence in the form of the side-scroller. This type of interface is largely out of favor now, but that does not mean that we should ignore the power and simplicity afforded by this viewpoint. The fact that the player only has to control units in two planes leaves a significant amount of cognitive effort for solving complex puzzles and other forms of play.

8.11 Overhead views: Atari Adventure and Football, MSN Game Zone Backgammon
MSN Game Zone trademark Microsoft Corporation

8.12 Side views: Earthworm Jim and Castle Infinity

Isometric View

Popular in strategy games, construction simulations, and role-playing games, this viewpoint is a 3D space with no linear perspective. It is very good at allowing a "god's eye" view. The distinctive feature of this point of view is the amount of information the player can easily have access to. Recently, games like Myth and WarCraft III have used the isometric view in a fully 3D environment, allowing the player to move her perspective closer to or farther away from the action.

First Person View

This is the current favorite among many gamers and designers. It creates immediacy and empathy with the main character, literally putting the player in the character's shoes. This view also limits the player's

overall knowledge, allowing for dramatic moments of tension and surprise as enemies might lurk around any corner or even approach from the rear.

Third Person View

A direct descendant of the side view, this view generally follows a character closely, but it does not put the player directly inside the character's view. Adventure games, sports games, and other games that depend on a more detailed control of character actions tend to use this viewpoint.

Summary

These views have become so ingrained in how we think of games that often a designer will choose without stopping to consider several important questions that lie behind all interface design: What is the

8.13 Isometric views: Myth and Dungeon Siege

Dungeon Siege trademark Microsoft Corporation

purpose of the interface? What is the state of the game, and how much information should the player know about it?

In Chapter 5 we discussed the information structure of games—how much and what type of information about the game state was given to each player. The viewpoints we have just discussed provide degrees of access to the state of the world, as well as placing the player in a varying relationship to the character or other game objects that they must deal with. This makes the choice of interface view both a formal and a dramatic design element.

Should the player feel extremely close to the game character, sharing their sense of movement in addition to their lack of knowledge at times? Or should the player remain close but somewhat outside of the character and be able to see more of the environment, perhaps pick up on clues or tools that might not be in the character's direct vision? Perhaps there is no character in your game, or maybe there is no world; in this case, what is the view of the game state that makes the most sense for your design?

Exercise 8.3: Viewpoint

What viewpoint is the best choice for your original game? Why? Describe how this choice affects both the formal and dramatic elements of your game.

8.14 First person view: Unreal 2

8.15 Third person view: Ratchet & Clank

EFFECTIVE INTERFACE DESIGN

In addition to the game's viewpoint, there is also the consideration of other information the player will need to know and the actions they will need to take. This might include points or progress in the game, status of other units, communication with other players, choices that are always open to them, or special opportunities to take action. How will you incorporate this information in or around your main view? This interface to the game, as mentioned previously, works together with the controls and viewpoint to create the game experience, and it needs to be extremely understandable.

Just as with designing controls, your goal should be to make the interface as easy to understand as possible. The ideal interface is fresh and innovative, but it feels like something you have used a thousand times before—a very difficult design problem indeed. The following design techniques are ways of approaching your process that can help your game reflect both original thinking and sensitivity to user expectations.

Form Follows Function

You might have heard the phrase "form follows function." Louis Henri Sullivan, the architect who introduced this comment to popular culture, was making the statement that the design of an object must come from its purpose. If you are going to build a building, ask yourself about the purpose of the building before you design the doors. If you are going to build a game, ask yourself what the formal elements of the game are before you design its interface or controls. If you do not, you will wind up with a game that looks and acts like every other game.

Today many designers simply revert to saying things like, "My game is Gears of War but it is set in a maximum security prison, where you have to escape." In most cases, the designer will borrow the interface and control scheme from Gears of War and then design the content to fit within these parameters, with perhaps a new feature or two thrown in. That is fine, and it might be a fun game, but it is never going to be innovative. The key to avoiding producing nothing but clones of existing games is to go back to your original concept and ask yourself, "What is special about this idea?"

In the prison example, the concept was to escape from prison. The conflict is clear: The prisoner must outsmart the security. Now how can you do this in a new way? What does a prisoner need to do to break out of prison? What types of tools and weapons and obstacles are there? As the designer, you should play with how to represent the tension of this particular situation, the excitement of it in both the controls and the interface. Experiment with new ways of visualizing these elements, assign them properties, and allow them to interact with one another. As you can see, the interface is coming from the gameplay, not vice versa.

The best approach is not necessarily to design the interface first, but to let it evolve from the necessities mandated by the function of the game. In other words, form follows function.

Metaphors

Visual interfaces are, at their roots, metaphorical. They are graphical symbols that help us to navigate the arcane universe that is the computer. You are probably most familiar with the desktop metaphor that both the Microsoft Windows and the Macintosh operating systems share. File folders, documents, in-boxes, and trash cans are all clever metaphors for various system features and objects. This metaphor is successful because it helps users contextualize the experience of working with various objects on the computer in a way that is familiar.

When you design your game interface, you need to consider its basic metaphor. What visual metaphor would best communicate all the possible procedures, rules, boundaries, etc., that your game contains? Many games use physical metaphors linked to their overall themes. So, for example, the objects a character can carry in a role-playing game are placed in a backpack. Just like in our discussion of premise in Chapter 4 on page 93, interface metaphors take the dry, statistical facts linked in the computer's memory and display them in a way that fits with the experience of the game.

When creating a metaphor, it is important to keep in mind the "mental model" that players will bring with them to the game. This mental model can either help players to understand your game, or it can cause them to misunderstand it. Mental models include all of the range of ideas and concepts that we associate with a particular context. For example, if I were to make of list of concepts that come to mind when I think about a circus, I might come up with something like this: the ringmaster, the rings, clowns, high

wire, barkers, sideshows, animals, popcorn, cotton candy, master of ceremonies, etc.

If I were making a game that used the metaphor of a circus for its interface, I might decide to have the ringmaster be the host or help system. The rings might be different game areas, and popcorn and candy might be power-ups. Using this metaphor helps to visualize this information in an entertaining way.

However, if you are not careful, your metaphor can also obscure navigation. Each of the concepts we listed has its own range of associations as well, and sometimes the mental models we bring to a metaphor can cause more confusion than clarity.

Exercise 8.4: Metaphors

Generate a list of potential metaphors for your original game interface. They can be anything: a farm, a road map, a shopping mall, a railroad—you choose. Now free associate on each metaphor for five minutes. List any concepts that come to mind.

Visualization

In the midst of a game, players often need to process many types of quantitative information very quickly. A good way to help them do this is to visualize the information so that a glance will suffice to let them know their general status. We are all familiar with visualization techniques: the gas gauge in your car sweeps in an arc from full to empty, the thermometer bar rises as the temperature goes up. These examples both use cultural expectations to cue us as to what they mean—the arc sweeping left or down means the amount of gas is declining; a rising bar means that something is going up. This is called "natural mapping," and game interfaces can make good use of them as discussed in Steve Swink's sidebar on page 224.

The Quake interface we have looked at before is actually a great example of using natural mapping to visualize an aspect of the game state. The face in the center represents our health—when we start the game, the face is angry and snarling

8.16 Quake health meter in three states

but healthy. As our character takes hits, the face becomes bruised and bloody, letting us know our status in a glance.

Exercise 8.5: Natural Mapping

Are there any opportunities to use natural mapping in your original game interface? If so, sketch out these ideas to clarify how the designs might function. You can use these ideas later when you lay out your full interface designs.

Grouping Features

When you organize your desk, you probably sort things into similar groups—all the bills go together, all the business cards together, all the pens and pencils together, etc. Designing an interface requires the same kind of thinking. It is often best to group similar features together visually so that the player always knows where look for them.

If you have several types of health meters, for example, do not put them in different corners of the screen—group them together. If you have several combat features, you can make them more convenient to access by putting them on a single control panel. Or if you have communication features in your game, it will make sense to group these as well.

Exercise 8.6: Grouping

Take a stack of index cards and list one control from your interface on each card. Sort the cards into groups that make sense to you. Try the same exercise with three or four other people. Notice the similarities and differences between each person's decisions. Does this exercise give you any ideas on how best to group your game's controls?

Consistency

Do not move your features from one area to another when changing screens or areas of the game. As Noah Falstein counters in his *Game Developer* magazine column "Better By Design," consistency might be the hobgoblin of small minds, but it is also important in establishing a usable interface.[7] Have you ever played a game in which the exit button moved from the upper right on one screen to the lower right on another? If so, you have experienced the frustration of inconsistency.

Feedback

Letting the player know, through visual or aural feedback, that their action has been accepted is critical. A good designer always provides some sort of feedback for each action the player makes.

Aural feedback is very good for letting the player know that input has been received or that something new is about to happen. Audio designer Michael Sweet discusses aural feedback in his sidebar on page 338. Aural feedback, while very useful for creating a responsive interface, is not extremely effective for giving precise data like the exact status of a player's resources or letting the player know where their units are. In this case, you will need to come up with a method of visual feedback.

Exercise 8.7: Feedback in Your Game

Determine what types of feedback your game needs to communicate effectively to the player. Decide how best to present this feedback: aurally, visually, tactilely, etc.

PROTOTYPING TOOLS

You might have noticed that this is the first chapter of this book to deal directly with programming your game. That is because we feel that games should be approached first in terms of their experience design, and their technology should provide solutions for that overall experience, rather than driving the design process. It is beyond the scope of this book to teach you how to program, but we highly encourage you to learn at least one programming language—even if you do not plan to be a programmer. Game designers need to be literate in programming concepts so that they can create feasible designs and also so that they can communicate effectively with their technical team members. (Programmers should also be literate in the design process for the same reasons.) Being literate in programming concepts is what we

call "procedural literacy." In our case, it means having a good grasp on how computers work, how code is structured, and the general principles behind game programming.

Programming Languages

If you do not have programming skills, we recommend that you take a class in beginning programming; you can usually find classes like this at local community colleges, universities, or even at many high schools. If you cannot find a class, there are many books on the subject. Make sure your use a book that is exercise driven—the best way to learn to code is to do it. Which programming language you learn is up to you. The de facto standard language for today's

PC and console games has been C++ for a number of years; however, newer languages such as C# have the potential to displace C++. One of the benefits of both C++ and C# is that they are object-oriented languages, which means sections of code can be reused. This leads to efficiencies during production and is good for creating large-scale applications where dozens of programmers are working on the same project. Other popular languages include Java, ActionScript (used in Flash), Visual Basic, Python, and Processing.

Game Engines

Using a game engine to prototype can save you a lot of time and resources. However, it can also push you into design decisions based on what the engine can do, so using a game engine is a trade-off. Some game engines are open source, meaning that if you have the ability, you can go into the engine code and modify it to support your original gameplay ideas. Others only allow you to script game action using the existing features of the engine.

GarageGames offers a range of game engines, from 2D to 3D, and tools for developing on these engines. The GarageGames engines have good beginner tutorials that can get you up and running making simple game prototypes even if you do not have a background in programming. They also have low pricing for students and independent developers so that you can get started on your game without a big budget for purchasing tools. Other easy-to-learn game engines include Game Maker, RPG Maker XP, Adventure Game Studio, and The Games Factory. Each of these has their limitations, but they can offer the beginning game designer/programmer a chance to prototype ideas quickly and effectively. Development tools that are not full game engines but are nevertheless very useful for prototyping are Flash and Shockwave.

Probably the most powerful and widely used commercial game engine is the Unreal Engine. This engine has been used for many high-end games including Gears of War, Tom Clancy's Rainbow 6: Vegas, and, of course, the Unreal games. If you look carefully at the screenshot of the editor for the Unreal Engine in Figure 8.17, you will notice that they include the same formal elements found in our first person shooter prototype—a map grid, rooms, units, objects, etc. In fact, spending time using an editor such as this is a good way to get a feel for a specific genre of game.

Level Editors

Another useful and fun way to learn about programming even if you do not have a background in computer science is to experiment with level editors. Level editors are programs that are used to create custom levels of PC and console games. They are typically drag-and-drop tools, so you do not have to be a programmer to use them. Creating a custom level will expose you to the formal system guts of a game and help you learn how to prototype your own games. Some level editors come with the games, and some are created by third parties. Many can be downloaded from the Internet for free once you have purchased the game.

Figure 8.18 shows a third-party editor for the The Sims 2. This editor allows you to edit neighborhoods, objects, and behaviors to create new content for the game. WarCraft III, on the other hand, ships with a

8.17 Unreal Engine editor (game type: first person shooter)

8.18 SimPE third-party editor (game type: simulation)

8.19 WarCraft III world editor (game type: real time strategy)

very sophisticated level editor. The game developer Blizzard Entertainment calls it the "world editor." It allows you to create your own WarCraft III maps and manipulate nearly every facet of the game. It is the same editor that the level designers at Blizzard used

to make the tutorial on the game CD. Becoming familiar with this level editor is a good way to understand basic RTS game design.

The screenshot in Figure 8.20 shows how you can set the board size for a WarCraft III map. Like in most games, a bigger, more complex grid often lengthens the game time, while a smaller, simpler grid makes for a shorter and often more intense experience.

The unit editor in Figure 8.21 allows you to define properties for units in a game session. The default numbers are numbers set by the game designers at Blizzard. As you start to play around with the numbers, you might wonder how the designers came to choose certain values for each unit. The answer is through prototyping and playtesting. More powerful units have higher costs in terms of resources and build time. For example, the knight unit comes with 800 hit points and a ground attack strength of 25. It is almost two times more powerful than the footman unit, which comes with 420 hit points and a ground attack strength of 12.5. The knight has a commensurate cost of 245 gold plus 60 wood compared to the footman's cost of 135 gold and 0 wood. Also the knight

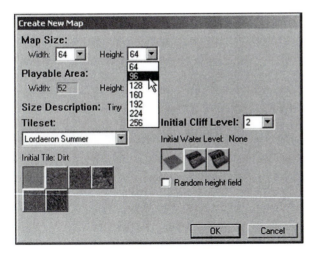

8.20 WarCraft III world editor: choose map size

8.21 WarCraft III world editor: unit properties

has a long build time, 45, compared to the footman's short build time of 20. So there is always a trade-off balanced into the game.

Every unit property in WarCraft III had to be meticulously playtested and tweaked based on benefit versus cost until the game system balanced. If any number were out of proportion, experienced players might mass produce that unit, making all other units irrelevant.

The Aurora Toolset for Neverwinter Nights is also an example of a game editor made available by the developer to allow gamers to build their own worlds, quests, and story lines. It puts complete control of

the world into the user's hands and can be used as a creative toolset for making new kinds of gameplay in a 3D space.

Exercise 8.8: Creating a Digital Prototype

Take the question or concern about your original game concept that you generated in Exercise 8.1 and come up with a potential solution for that concern. We advise starting simply, with a question about your controls or interface, for example. Then develop a digital prototype of your solution. Test your idea using the playtesting techniques described in Chapter 9.

CONCLUSION

Now you have worked through your game concept as both a physical prototype and started working through your digital prototyping process. As you continue, you are sure to discover more questions about your design that will lead to new and different ideas that will need

prototyping. Playtesting and iterating on these concepts is an exciting and creative process. The next several chapters deal with how you take your initial ideas and, through a rigorous playtesting process, develop them into working gameplay that is ready for production.

Designer Perspective: David Perry

CEO, GameConsultants.com

David Perry is a game designer, producer, and entrepreneur whose long list of credits includes Teenage Mutant Ninja Turtles (1990), The Terminator (1992), Cool Spot (1993), Global Gladiators (1993), Disney's Aladdin (1993), Earthworm Jim (1994), Earthworm Jim 2 (1995), MDK (1997), Sacrifice (2000), Enter the Matrix (2003), The Matrix: Path of Neo (2005), and 2Moons (2007).

On getting into the game industry:

I started getting paid to make games before you could buy games in stores. Back in those days, you bought special magazines or books filled with games written in a programming language called "BASIC." The reader would have to type the entire game that they wanted to play into their computer by hand. Sometimes it would take them hours, then when they tried to actually play the game, if they had made one single typo, the game would likely break and they could spend another hour just looking for their mistake. Interestingly, by getting to see the code, you quickly learn how it works. So that's what I did; I wrote tons of games to be printed in magazines and, finally, books. When games were sold in stores, I was offered a job to start making a "real" professional game (in a box), so I left school at 17 (without a degree) and never looked back.

On favorite games:

I like Battlefield: 1942 and Grand Theft Auto III because you feel you can do anything. The world is your oyster. You can choose to play the way the game wants you to or choose to just have fun and entertain yourself. I think that's a great option for gamers because some of them want to be entertained *right now*, and some of them are very creative and are quite happy to entertain themselves. I like Halo and Max Payne for their action sequences as you feel immersed in their world and can really get into the action. I like the Command & Conquer series for the strategy balance it offers because you will find yourself managing lots of things at once; it's really up to you exactly how many things you *try* to manage at once. The more you can handle, the more it can give you to handle. When you think you are good, go ahead and challenge others. Very rewarding.

On inspiration:

I like designers who think big, so I'm always interested to see what people like Rob Pardo, Peter Molyneux, or Warren Spector do. Basically they think big right out of the box. You can take it to the bank that whatever they do next will be interesting and challenging. I like that, and I wish more people did it.

On the design process:

I tend to find that I get most of my ideas in my car when driving. It usually starts with a hook, meaning something I want to experience in the game I've not experienced before. Some programmers love this, some hate it, because you can be sure I won't propose anything that's easy.

On prototyping:

Prototyping is important. I tend to try to do it visually first on a whiteboard; what would this look like? Brainstorming is essential at this phase. Then we move to code. Then we refine that code until we decide either to give up and try another direction or to lock it down and move on.

On solving a difficult design problem:

The one I've been struggling with is in-game advertising. My new games at www.acclaim.com are all free-to-play, which means they are free to play but funded by advertising and virtual item sales. The problem is I wanted everyone to be happy, and that's tough as some gamers *loathe* advertising. The obvious answer is to charge the gamer if they want a version of the game without advertising, and indeed people are working on that concept. I decided I wanted to experiment with rewarding the activity, meaning that we give you an experience boost in our MMORPG game 2Moons if you're willing to leave the adverts running. If you *really* don't want them, then simply turn them off, no problem. We then did a survey, and 96% of gamers chose to keep the adverts running. (Phew!) The point here is that they have been given a choice. So problem solved.

On taking risks:

Over the last 21 years, I have taken a lot of risks, and luckily enough of them have paid off. As a result, I've had my share of number one hits, but I've also had games that, well, cough cough, kinda sucked. Making games is all about learning, and I can assure you that 25 years later, I'm still learning new things every day. I think I am most proud of the fact that I ran a development studio for 12 years and some of that was through pretty difficult times. We had a lot of fun, paid millions in royalties to the team, and many team members had pretty fantastic career boosts. On the development side, the last game I personally programmed was Earthworm Jim, and I still remember that time very fondly. (I wish I still had time for programming!)

Advice to designers:

I have a free Web site called www.dperry.com to help new talent get started in this industry. All I can say is please help me make it better by making sure your questions are answered, or share your experiences with people who you know are going through the same things. I've also started a site called www.gameindustry-map.com to help you find companies in your area, or you can join me on a project at www.videogameteam.com. Overall? Passion is key. If you feel interested in getting into the industry, that's not enough. You need to be willing to put everything else aside (including sleep) if you plan to compete in this industry. Those with the passion will go far; those without will end up frustrated. Is it worth it? Heck yes!

DESIGNER PERSPECTIVE:
BRENDA BRATHWAITE

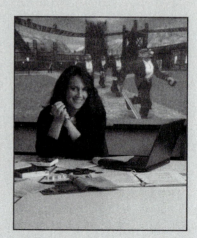

Game Designer and Professor, Savannah College of Art and Design

Brenda Brathwaite is a 25-year veteran of the game industry whose credits include Wizardry (1981), Wizardry II (1985), Wizardry III (1986), Wizardry IV (1988), Wizardry VI (1990), Jagged Alliance (1994), Jagged Alliance: Deadly Games (1995), Jagged Alliance 2 (1999), Jagged Alliance 2: Unfinished Business (2000), Wizardry 8 (2001), Dungeons & Dragons: Heroes (2003), and Playboy: The Mansion (2005).

On getting into the game industry:

I should just say "networking" and shut up, but I won't, because the story's not nearly as funny that way. While "networking" is true, it's a stretch. You see, I was only 15 at the time, and smoking a cigarette in the high school restroom (which was, of course, against school policy). Another girl walked in and asked several people for a cigarette. Because she turned each offer down, I figured she was looking for a nonmenthol and so offered her one. She struck up a conversation to be polite. At some point, she asked, "You ever hear of Sir-tech Software?" No. "You ever hear of Wizardry?" No. "You ever hear of Dungeons & Dragons?" Yes. "Are you interested in a job?" Sure. I swear, that was my actual interview into the games industry. The following day, October 3, 1982, I started working at Sir-tech Software as the resident game player and QA person. It was my job to memorize games in the Wizardry series and answer people's questions when they called the "Wizardry hotline." I still remember the answers, believe it or not.

So, that was back in high school. I worked for Sir-tech right through college and into the next century. Eighteen years, all told. I grew up in the game industry going from a gamer to a game designer during the course of those years.

On favorite games:

- *Wizardry*: Proving Grounds of the Mad Overlord: I created my party of adventurers and headed off into the dungeon—and it was *magical*. I mean that. I'd never experienced anything like that before. My work hours were 4–8, but I'd come in at 3 and leave at 9 . . . then 2 and leave at 10. I was so completely immersed in that world. It was also on Wizardry that I had my first mod experience. There was an in-house tool that we used to make levels for the game, and I'd tinker with that thing for hours just building whatever the hell amused me. I still remember that experience with the fondness many remember their first kiss, and believe it or not, I still have that original Wizardry 5.25" disk with my characters on it. I feel for today's designers who grew up with digital games and can't solidly remember their first gaming experience like I do.

- *Civilization*: This was the game that made me look behind the curtain. Though I was already in the game industry at the time, there was so much about it that I took for granted. Keep in mind that

I'd worked almost exclusively on the Wizardry series, so I knew everything about it like the back of my hand. So when I played Civ, I became fascinated with how it did that. I said that over and over and over again. "How did it do that?" I recognized the wizard behind the curtain, and I wanted to know how he did what he did. Fortunately for me, I was in the industry, so this led me to look at the games that we were working on at Sir-tech in a completely new way. I became fascinated with game design, and so I started to mentor under and work with the many talented designers that Sir-tech had in their bullpen at the time trying to learn how they did that.

- *Ratchet & Clank*: They make me laugh out loud and enjoy games like I used to when I was a little kid. There are so many things I love about them. Because they're not RPGs, I can just escape and play them without my mind wandering and wondering about the mechanics of combat or how the character is advancing in levels. Along with Guitar Hero, the R&C games are the ones that I play just for my own personal enjoyment.

- *Guitar Hero*: I get into GH like I get into R&C. I can just go in and jam for 10 minutes and have a great play experience. I'm also incredibly impressed with how well GH involves all the player's senses, way more than most games do. Everything's in the foreground—audio feedback, visual feedback, tactile input—and cognitively, you're working your recollection of the notes to your best. The result is that the world goes away for players. Completely away. Rhythm games are excellent at this sort of thing. With the exception of Rez, the play experience is generally pretty short, too, which fits my lifestyle really well.

- *Risk*: The danger in even saying this is that it will make me want to play it. Now. Risk is such a phenomenally brilliant game. As a player, I love the challenge and the emerging strategies that form throughout the game. It's incredibly satisfying. As a designer, I'm fascinated with how the mechanics play out, the dynamics of play, and the incredible meaning behind every move in the game. I don't think I'll ever get tired of this game.

On the design process:

I spend a lot of time studying the IP or the topic, as the case may be. In that sense, I'm a method designer, I guess. I really, really get into whatever topic it is that I'm working on. I submerge myself in it around the clock—movies, books, people, general free-form research on the 'net or in libraries. For example, I was once working on a proposal for a Mob game. Fortunately (or unfortunately for me), La Cosa Nostra was actually the number one gang where I lived at the time. So I had access to those who studied and reported on the mob regularly. It was fascinating. While I was working on that game, the local boss got whacked. It ended up being a potential starting point for the game itself.

During the research process, I'll come up with the core of the game—the one thing the game is about and that the rest of the design can hook itself upon. Defining a core is such a critically important task for game designers. It ends up being the arbiter of so many decisions. When the core is defined, I'll come up with five or six features of the game and expand on those. At this point—and this is another critical part of my design process—I'll ask my fellow designers and team members to go over it with me. We'll beat it into the ground and challenge every part of it until we're satisfied there's a strong core there. This is something we'll continue to evaluate during the design process.

On prototypes:

Prototypes are critical for me. I've had absolutely great ideas that turned out to be marginal (at best) when they were actually put into play. I've also had what seemed to be moderately interesting ideas that turned out to be incredibly fun. Prototyping and playing is the only way to see ideas in motion and test their validity.

My process differs depending on what type of game I'm making. For RPGs, I generally create an actual pencil and paper version of the game to test on friends or other people on the team. Just like good ol' Dungeons & Dragons, I guess. If we're getting attached to the characters we create, that's a good sign. I tweak lots of stuff, usually, from stats that seem useless to those that are utterly missing. It also gives me an excellent chance to explore player expectations. While a pencil and paper game might seem archaic compared to the processing power of today's computers, it's not at all the case. The "computers" in this game are the player and game master's imagination, and both are far more incredible than any computer or console we've created. I get a lot out of the process.

When I create systems, I often start very early prototyping in Microsoft Excel. I just want to see if the system or simulation works the way *I* think it will. At this point, I'm often just pulling stuff out of the sky, experimenting with various abstractions and having fun with it. When it starts to gel for me, it's critical to get it into code in as loose a form as possible and tweak it continuously until it feels right for me and for other players. I really try to get a lot of input into any prototype or system I design. I often tell my students or junior designers that one of the key differences between a junior and senior designer is this: The junior designer completes his work on a system and is shocked to hear that there's a major flaw in it. The senior designer completes his work on a system and is desperate for someone to help him find out the flaw as soon as humanly possible. To do that, people need to play the game.

Advice to designers:

Learn to program in C++ so that you can mess with your own designs and prototype your own concepts early on.

Study the masters.

Don't smoke.

FURTHER READING

Arnowitz, Jonathan, Arent, Michael, and Berger, Nevin. *Effective Prototyping for Software Makers.* San Francisco: Morgan Kaufmann, 2006.

Dawson, Michael. *Beginning C++ Game Programming.* Boston: Thomson Course Technology, 2004.

Maurina, Edward. *The Game Programmer's Guide to Torque.* Wellesley, MA; A K Peters, 2006.

Norman, Donald. *Design of Everyday Things.* New York: Doubleday, 1990.

Overmars, Mark, and Habgood, Jacob. *The Gamemaker's Apprentice: Game Development for Beginners.* Berkeley: Apress, 2006.

Tufte, Edward. *Envisioning Information.* Cheshire: Graphics Press, 1990.

End Notes

1. Todd, Eric. "Spore Preproduction through Prototyping" presentation at Game Developers Conference, March 23, 2006.

2. Carless, Simon. "GDC: Prototyping for Indie Developers," Gamasutra.com, March 6, 2007.

3. Lally, John. "Giving Life to Ratchet & Clank: Enabling Complex Character Animations by Streamlining Processes," Gamasutra.com, February 11, 2003.

4. Takahashi, Keita. "The Singular Design of Katamari Damacy." *Game Developer*. December 2004.

5. Stern, Zach. "Creating Osu! Tatakae! Ouendan and Its Recreation As Elite Beat Agents," Joystiq.com, March 8, 2007.

6. Hecker, Chris, and Gingold, Chaim. "Advanced Prototyping" presentation at Game Developers Conference, March 23, 2006.

7. Falstein, Noah. "Better By Design: The Hobgoblin of Small Minds." *Game Developer*. June 2003.

Chapter 9

Playtesting

Playtesting is the single most important activity a designer engages in, and ironically, it is often the one designers understand the least about. The common misconception is that playtesting is simple—just play the game and gather feedback. In reality, playing the game is only one part of a process that involves selection, recruiting, preparation, controls, and analysis.

Another reason that designers often fail to playtest properly is that there is confusion over its role within the game development process. Playtesting is not when the designer and her team play the game and talk about the features. That is called an internal design review. And playtesting is not having the quality assurance team go through and rigorously test each element of the software for flaws. That is quality assurance testing. And it is not when you have marketing execs sitting behind a two-way mirror watching a representative sample group play and discuss the game while a moderator asks them how much they would pay for this product. That is focus group testing. And it is not when you analyze how users interact with your interface by tracking their mouse movements, eye movements, navigation patterns, etc. That is usability testing.

So what is playtesting? Playtesting is something that the designer performs throughout the entire design process to gain an insight into whether or not the game is achieving your player experience goals.

There are numerous ways you can conduct playtesting, some of which are informal and qualitative, and others that tend to be more structured and quantitative. For Halo 3, Microsoft Games User Research conducted over 3000 hours of playtesting with more than 600 players in one of the most sophisticated playtesting facilities in the world.[1] Most professional games go through some level of playtesting, if not this extensive, either at their publisher's facilities or with an outside testing group. Your game might have 10 or 20 playtesters, possibly playing in your garage. All of these are valuable and important tests that are performed at the level of facility available. But the one thing all of these forms of playtesting have in common is the end goal: gaining useful feedback from players to improve the overall experience of the game.

As you develop the game, other groups will perform other types of tests. The marketing people will try to determine who is going to buy the game and how many units can be sold. The engineering team will utilize the QA department to test for bugs and compatibility problems. The interface designers will employ a variety of tests to see if people can operate the game in the most efficient and user friendly way. But as a designer, your foremost goal is to make sure the game is functioning the way you intended, that it is internally complete, balanced, and fun to play. And this is where playtesting comes in.

PLAYTESTING AND ITERATIVE DESIGN

Recall that we said the primary role of the designer is as an advocate for the player. This does not just mean in the early stages of design; the game designer must keep that relationship with the players' needs and perspective throughout the design and production process. Often, as teams work at a project long days and nights for months at a time, they forget the player in their own quest to make the game live up to their vision.

A continual iterative process of playtesting, evaluating, and revising is the way to keep the game from straying during that long arduous process of development. Of course, you cannot keep changing the basic game design—after all, the goal is to release a product eventually. Figure 9.1 shows how the testing cycle gets tighter and tighter as production moves forward, signifying smaller and smaller design issues to solve and changes to make, so that you are not making fundamental or dramatic changes to the game as the process draws to a close. This method of continually testing your assumptions with players will keep your game on track throughout the production.

You might be thinking, But testing is an expensive process, isn't it? Wouldn't it be better to wait until we have a fully working game—say about the time we have a beta product—and test it then? That way, players will get the best experience. We cannot argue against this way of thinking strongly enough. By that time in the process, it is really too late to make any fundamental changes to your game. If the core gameplay is not fun or interesting at this point, you are stuck with it. You might be able to change some top-level features, but that is it.

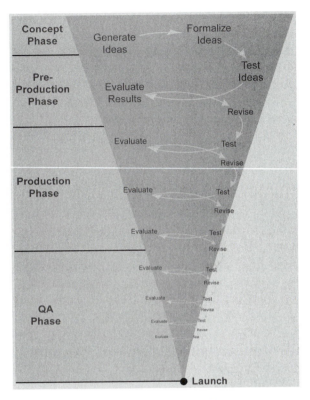

9.1 Model for iterative game design: playtest, evaluate, and revise

We advise playtesting and iterating your design from the very moment you begin. And we can show you how to do it without much expense—just your own time and some volunteers. The expense you will save is the cost of changing your game at the very end of production or releasing a game that does not live up to its full potential.

RECRUITING PLAYTESTERS

Before you can playtest, you must have playtesters. But how do you begin and who should you trust? In the earliest stage, when you are creating your first prototype, the single best tester you have is yourself.

Self-Testing

As you build a working version of your game, you will naturally try it out repeatedly to understand how it functions. If you are collaborating with other designers on the prototype, you will self-test both

as a group and as individuals. Self-testing is most valuable in the foundation stage of a prototype when you are experimenting with fundamental concepts. It is a large part of the process that enables you to come up with the core mechanics for the system. It is also where you create solutions to glaring problems with the play experience. Your goal at this stage is to make the game work, even if it is only a rough approximation of the final product. You will continue to self-test throughout the life of the project; however, as you progress and your game evolves, you will have to rely more and more on outside testers to gain an accurate understanding of what it is you have created.

9.2 Friends and family playtest for a new game prototype at thatgamecompany. Game designer Jenova Chen explains minimal information to get the game started.

Exercise 9.1: Test It Yourself

Take either the digital game prototype that you developed in Exercise 8.8 or the physical prototype you created in Exercise 7.9 and playtest it yourself. Describe in detail what goes through your head as you play the game. Start a playtesting notebook in which you record all of the feedback you get from yourself and other testers.

Playtesting with Confidants

When you move past the foundation stage and the prototype is playable, test it with people you know well, such as friends and colleagues outside the design team. These people will bring fresh eyes to the project and will uncover things you have not considered. You might need to be present to explain the game to them when you begin. This is because the prototype will likely be incomplete in the structure stage. The goal is to get to a version that people can play without much intervention from you. You should be able to give playtesters the prototype, and they should have enough information to begin playing. With a physical prototype, this will require that you write a full set of rules. With a software prototype, the user interface will need to be in place, or you might need to provide some written rules.

When your game is playable and you have a clearly defined set of rules, you must wean yourself from your confidants. Testing with friends and family might feel like it works, and it does in the early stages, but it won't suffice when the game matures. The reason is that your friends and family have a personal relationship with you, and this obscures their objectivity. You will find that most of them are either too harsh or too forgiving. It all depends on how they are used to interacting with you. Even if you believe that your confidants are providing balanced feedback, it is best not to rely too heavily on a small group of individuals. They will never give you the objective, broad criticism that you require to take your design to the next level.

Exercise 9.2: Test with Confidants

Now take your original prototype and give it to some confidants. Have them test it. Write down your observations as they play. Do your best to determine what they think of the game without asking them any leading questions.

Playtesting with People You Do Not Know

It is often hard to show your incomplete game to strangers. It means taking criticism from people you have just met. But it is only through the process of inviting total strangers into your office or home and allowing them to play your game and criticize it that you will gain the fresh perspective and insight you require to improve your design. This is because outsiders have nothing to lose or gain by telling you honestly how they feel. They are also untainted by any knowledge of the game or personal ties. If you choose them carefully and provide the right environment, you will see that they can be as articulate and dedicated as your coworkers and confidants. There is no substitute for finding good playtesters. Make them an extension of your design process, and the results will become apparent immediately.

Finding the Ideal Playtesters

So how do you find these perfect playtesters who have never heard of you or your game? The solution is to tap into your community. You can recruit playtesters from your local high school, college, sports clubs, social organizations, churches, and computer users groups. The possibilities are endless. You can also find a broad demographic of recruits by posting online or putting an ad in a local paper. The more sources you try, the better your candidate pool will become. It is as simple as putting up a notice in a local game store, college dorm, library, or recreation center. You will find that people want to be part of the process of creating a game, and if your invitation sounds attractive, you should not have trouble lining up testers.

The next step in recruiting is actually screening out and turning down applicants. You can only do this after you get enough applicants. What you should be looking for is a group of testers who are articulate enough to convey their opinions to you. If they cannot hold a decent conversation on the phone, they probably won't be of much use. We do not expect you to be an expert in demographics or sampling, but

it does not hurt to ask a few questions to help sort out which applicants are going to be useful and which are a waste of time. Questions can include: What are your hobbies? Why did you respond to my bulletin? How often do you buy this type of game? If the tester is not a consumer of the type of game you are making, his feedback will be less useful.

Playtesting with Your Target Audience

The ideal playtester is someone who represents your target audience. You want testers who actually go out and spend their hard-earned money to buy games like yours. These people will give you far more relevant feedback than someone who would not be attracted to your game in the first place. They will also be able to compare your game to others they have played and provide you with additional market research. And most importantly, they know what they like and what they dislike, and they will be able to tell you this in excessive detail. When you tap into your audience, you will uncover a wealth of information and gain an insight into your game that no one else can provide.

Exercise 9.3: Recruiting Playtesters

Now it is time for you to recruit several total strangers to playtest your game prototype. Make sure that they are in your target audience. Set up a time with these playtesters to conduct the test. Exercise 9.4 will help you prepare to get the most from the session.

The more diverse a group you can recruit, the better. By diverse, we mean a broad range of people within your target audience. You want to tap people who play your games, but you do not want to focus on too narrow a section of your total audience. Your pool of testers should represent the entire spectrum of consumers of your product. Posting notices on gaming Web sites is a great way to recruit testers in your area.

If you are worried about people stealing your ideas, have them sign a nondisclosure agreement (NDA).

This is a simple agreement where a person promises not to tell anyone about your product until it is released. In game companies, playtesters are typically paid in cash or free games. With independent games and personal projects, the testers are typically not paid, but they gain the satisfaction of contributing their thoughts.

The level of caution you take is up to you, but remember this: Do not be paranoid. The fact is that 99.99% of the people out there have no intention of stealing your ideas, and even if they did, the vast majority would not know what to do with your game after they stole it. The benefits of using playtesters far outweigh the perils. In fact, the risk of using testers is negligible when compared to what else can go wrong during a production.

For most tests, you will need to recruit new playtesters so that you get fresh input, but later in the design process, you might want to bring some of your most articulate testers back in to gauge how they feel the game has progressed. You might even find that features that you removed or changed do not work

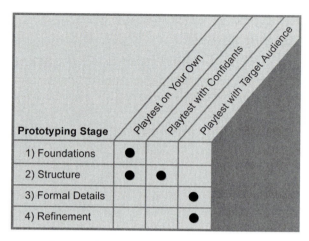

Prototyping Stage	Playtest on Your Own	Playtest with Confidants	Playtest with Target Audience
1) Foundations	●		
2) Structure	●	●	
3) Formal Details			●
4) Refinement			●

9.3 Types of playtesters appropriate for each stage of prototyping

as well, and these testers will be able to point that out. Figure 9.3 shows the various stages of prototyping and the types of playtesters you should involve at each stage.

Conducting a Playtesting Session

So now that you have all these strangers in your office or living room, what do you do with them? At this point, many game designers make a common mistake—they begin to tell players about their game, how it works, their plans for future developments, their hopes and dreams for the game. But this defeats much of the purpose of getting a fresh perspective on the game. Once you have told a playtester how the game is supposed to work, you can never go back and see their natural first impression. We tell our game design students to always keep in mind that "you don't come in the box," meaning that when the game goes out to the public, you won't be there to explain it to each and every player.

Your role at this point is not that of the game designer but that of an investigator and observer who must give these playtesters access to the game, lead them through a useful playtest, record what they say and do and, later, analyze their responses. Rather than telling players what to think about your game, or explaining how it works, let them play it with no or minimal explanation. Allow them to make mistakes. See how each person approaches the game. Maybe your rules are confusing. Provide answers if they get really stuck, but for the most part, let your testers figure it out. You will learn much more from the mistakes players make than you will if they play the game flawlessly based on your explanations.

The best way to run a playtest is to have an objective person run the test while you watch from behind a one-way glass or on a video feed. If you are doing this at home by yourself, you might not have that option. The next best solution to help control your impulse to talk too much is to create a test script. This script will keep you on track and remind you of your role as an observer. Your script should include at least the following sections and perhaps several others depending on the type of test you are doing.

Introduction (2–3 Minutes)

First, welcome the playtesters and thank them for participating. Introduce yourself—your name, occupation, a bit about what you are doing. Then give a brief explanation of the playtesting process and explain how this will help you improve your game. If you are audio- or videotaping the session, let the players know and ask if they have any problems with this. Assure them that this is for your reference only and won't be shown outside the design team. Also, if you are using a special usability room (i.e., with one-way glass, let them know if there are other people watching the test from behind the glass).

Warm-up Discussion (5 Minutes)

Develop several questions to find out about the games they play that are similar to your game, what they like about them, what are their favorites, etc. Some suggested questions are as follows:

- Tell me about some of the games you play.
- What do you like most about these games?
- Where do you go to play/find out about new games? Why there?
- What was the last game you purchased?

Play Session (15–20 Minutes)

Explain to the playtesters that they will be trying out a game that is still in development. The purpose of the session is to get their feedback on the experience. Make sure they understand that you are testing the game, not their skill. There are no wrong answers, and any difficulties they have in playing the game will help you improve your design.

There are two ways to proceed at this point. One is to leave the playtesters alone in the room and watch them play from behind one-way glass or on a video feed if you have set up a camera. The other is to stay in the room and watch quietly from behind the playtesters. In either case, it is important to ask the playtesters to "think out loud" when they are playing. By this, we mean that you want to hear what choices they are making and what uncertainties

they have when playing. For example, "I think this is the inventory button, so I'll click it. Oh, I guess it's not. Well then this one must be . . . hmmmm. Where is it?" You can see that by having a running monologue of what is going on in the players' minds, you will learn a lot more about their expectations than if they were simply sitting quietly and clicking on buttons. If playtesters forget to think out loud—and they often do—you can gently remind them by asking them a question about what they are thinking.

You should let your playtesters play for at least 15–20 minutes while you observe them. If they play longer than this, they tend to get tired. If the testers have a tremendous amount of difficulty, you can give them help to move the session forward, but be sure to put in your notes where and why the problem occurred.

Discussion of Game Experience (15–20 Minutes)

After about 20 minutes, hopefully at the end of one or more levels, you will want to wrap up the play session and have a one-on-one discussion with the testers. You will want to develop a set of questions for this discussion that probe for overall appeal, interest level, challenge level, and that check for understanding of game features. Some example questions are as follows:

- Overall, what were your thoughts about the game?
- What were your thoughts about the game play?
- Were you able to learn how to play quickly?
- What is the objective of the game?
- How would you describe this game to someone who has never played it before? What would you tell them?
- Now that you have had a chance to play the game, is there any information that would have been useful to you before starting?
- Is there anything that you did not like about the game? If so, what?
- Was anything confusing? Please take me through what you found to be confusing.

As your design process goes on, you will have more specific questions in this section regarding difficulty, progression of levels, look and feel, sound effects, music, tone, characters, etc. This discussion should focus on the most important design questions you have at this point in the process.

Wrap-up

Thank the playtesters for coming in. Make sure you keep their contact information so you can let them know when the game is finished. If you have a token gift, like a T-shirt for your game, you can give it to them now.

Exercise 9.4: Writing a Playtest Script

Write a script for the playtest session you set up in Exercise 9.3. Be sure to address areas of your game design that you have questions about. Do not lead or suggest ideas to the playtesters.

The most difficult part about this process will be learning to listen to the playtesters' feedback without responding to every point. You, as the designer, invariably feel a strong attachment to whatever it is you have created. You have spent a lot of time and effort on your game and it is only natural to become defensive. We advise you to try and ignore your ego. If you are going to gain anything from a playtesting session, you have to learn to take feedback without emotional response. Do not answer criticisms, just write them down. Learn to listen carefully to what players are saying. Keep in mind that your goal is not to have these people tell you that they love the game but to discover what they do not like about it or do not understand. Far too many designers fail to learn to listen to criticism. Either they try to answer any negative comments or make excuses for their game because taking the criticism is too painful.

If you refuse to take feedback, or if you lead your testers into saying what you want to hear, you will find that they will gladly fall in line. You invited them to your office or home, and they do not want to upset you. They want to please you. And if you let them, they will tell you whatever it is that you want to hear. If you are determined to hear only good news,

9.4 Leading a playtest session; view from behind one-way glass

then that is what you will get. It might make you feel like a genius, but it won't make your game any better. Instead try to embrace the criticism you receive from your playtesters. Even if you feel awful inside, remind yourself that you need to hear the problems because you cannot fix the problems if you do not know what they are. And it is better to hear the bad news now than later from a game critic. Do not let this chance slip past.

There are times when the criticism can get a bit heavy. If you are testing in a group, one tester might be particularly vocal and begin to sway the others. Many professional usability facilities isolate playtesters for this very reason. However, you might not have that luxury. It helps to make it clear at the beginning of the session that you are open to feedback and want everyone to be honest, but at the same time there is a certain etiquette you would like the testers to follow. Everyone should respect each other's opinions

and allow each other a chance to speak. There is no right or wrong answer, and no tester should ever criticize another tester's ideas. If you lay down some good rules for the discussion at the outset, you should avoid most problems.

Most people want to be helpful; after all, that's why they volunteered. Before you take offense at the comments of a playtester, be sure to look inside yourself for the answer. Are you being too sensitive? Is the criticism truly harmful or is this person unaccustomed to giving feedback? How are the other testers reacting to this person? It's true that one bad seed can skew results, casting a negative spin on everything, but do not jump to conclusions. Your ultimate goal is to take what you are given and learn from it, not silence anyone who says something that you do not like.

You will make mistakes at first, but leading an effective playtest is a skill you should practice over

9.5 **Playtesting sessions for physical prototypes: Matt Kassan of Atari and Richard Wyckoff of Pandemic Studios give student designers feedback on their designs**

9.6 Playtesting sessions for digital prototypes

and over. Becoming a good listener and maintaining objectivity when taking criticism is something that will help you throughout your career. The same skills can be applied to your production environment. In addition to playtesters, you need your team's input and constructive criticism, and the best way to elicit this is to make your entire production a safe environment where everyone is encouraged to speak their mind while being careful not to personally criticize each other. If you apply the same rules described earlier to all of your group meetings, you will wind up with a far more productive and motivated team that feels invested in the product you are creating together.

Exercise 9.5: Playtesting Your Game

Conduct the playtesting you set up in Exercise 9.3. Use the playtesting script you wrote in Exercise 9.4 to keep the session on track. Take notes in your playtesting notebook from Exercise 9.1 recording feedback and problems.

METHODS OF PLAYTESTING

Most professional usability testing takes place individually. It is a generally accepted rule that group dynamics are good for generating ideas but very bad for evaluating ideas. On the other hand, you might have no choice, depending on the nature of your prototype and environment, so do not feel like you cannot playtest just because you do not have the perfect setup.

Here are a number of different ways you can structure your tests, each with their own positives and negatives, but one or more should work for the environment you have available.

- *One-on-one testing:* As described in the previous test script, you sit down with individuals and watch over their shoulders or from behind

9.7 More playtesting sessions for physical prototypes: Steve Ackrich of Activision and Neal Robison of Vivendi-Universal give student designers feedback on their designs

one-way glass as they play the game. You take notes and ask them questions both before and after the session.

- *Group testing:* You get a group of people and allow them to play your game together. This works best for physical prototypes, but it is also useful for digital prototypes if you have access to a lab with several computers. You observe the group and ask questions as they play.

- *Feedback forms:* You give each person who tests your game a standard list of questions to answer after playing and then compare the results. This is a very good method for getting quantitative feedback. Professional testing facilities, like Microsoft Games User Research, use digital forms that feed into a database of user responses and allow them to generate reports for analyzing the data. You can do this too, if you like, using online

tools such as SurveyMonkey.com or even an Excel spreadsheet.

- *Interview:* You sit down face-to-face with the play-testers and give them an in-depth oral interview after the playtesting session. This is not a discussion; it is more of a verbal quiz.

- *Open discussion:* You conduct either a one-on-one discussion or a group discussion after a round of playtesting and take notes. You can either promote a free-form discussion or have a more structured approach where you guide the conversation and introduce specific questions.

- *Data hooks:* As playtesting becomes a more accepted process in the game industry, new tools and techniques are being developed for gathering data. At Microsoft Games User Research, for example, they integrate data hooks into the game engine that collect data on player movement and actions in the game. This data is then analyzed to show where players are progressing as expected and where they are taking too much time or getting stuck. Dealing with data hooks might be beyond your level of expertise, but it is good to know about such techniques because they will undoubtedly be an important part of the next generation of testing methods for games.

You can combine the previous approaches to fit your game and your space. For example, you can have players play a game together and have a group discussion afterward, but then ask each person to fill out a feedback form individually. You will be surprised how differently people respond when there is no group dynamic.

Over time, you will find out which methods work best for you at each stage of testing. Our goal is to encourage you to test no matter what your limitations are. If none of the structures on our list works for you, then think creatively and come up with your own methods. Try some of these different processes if you can. You will see how each method produces different results, and you will broaden your testing techniques and experience.

Why We Play Games

by Nicole Lazzaro, President, XEODesign,® Inc.

To take games to the next level of emotional engagement, we at XEODesign wanted to know more about the role that emotions play in games. Since opening our labs in 1992, we have seen gamers get excited, angry, amazed, and even cry. We were curious as to what could be said of all computer games. How many emotions come from gameplay? Are emotions what makes games fun? To find out we conducted research by watching people's faces as they play.

People play games in four ways. They enjoy the opportunity to master a challenge and to fire their imaginations. Games also offer a ticket to relaxation and an excuse to hang out with friends. Based on our research, each of these playstyles offers the player a distinct set of emotions that come from different ways of interacting with a game. Best-selling games such as Bejeweled, World of Warcraft (WOW), Halo, and Diner Dash tend to offer three out of the four types of fun, and players tend to rotate between these playstyles during a single play session.

We call these playstyles the "4 Fun Keys" (Hard Fun, Easy Fun, Serious Fun, and People Fun) because each is a collection of game mechanics that unlocks a different set of player emotions. Game designers cannot create the experience of play directly; instead they design rules that create the emotional response in the player. Like tasting chocolate or wine, each game has a unique emotion profile. The character of a fine wine comes from the way its flavor profile creates a variety of sensations over time, such as a nose, a head, and a nice long finish. Games are similar, only the emotion profile of games has more dimensions than beverages because the game offers opportunities for a distinct array of emotions based on player choice. In XEODesign's research, players do not want next generation graphics. What creates next generation player experiences (PX) is a range of emotions coming from four types of play.

"Games are a series of interesting choices." —Sid Meier

Game designers forget that emotions are more than the prize at the end of a stimulus–response–reward loop. Emotions involve goals and things that people care about and that happen before, during, and after choices. Emotions are not just for entertainment. Emotions around decisions shape the player experience before, during, and after a move in a game.

Emotions play five roles in games. Players **enjoy the sensations** that emotions create. Emotions **focus attention**; a boiling lava pit gets players' attention more than a city sidewalk. They **aid in decision making**; without the aid of emotional systems, people can logically compare the consequences of two options but cannot make the choice itself. For example, in Splinter Cell the choice between certain death and escape via a narrow window ledge is easier to make than selecting a door in an empty office corridor. Emotions **affect performance**. The negative emotions in Battlefield 2 facilitate the type of repetitive behavior the game rewards: shoot the sniper and move on. The positive emotions from Katamari Damacy inspire creativity and problem solving, helping the player figure out how to roll their little sticky ball from the floor to up on a table. Finally, emotions **reward and motivate learning** because all games teach.

To learn about the most important emotions from play experiences, we observed the emotions that appeared on players' faces as they played their favorite games. Based on the work of psychologist Paul Ekman and others, there are seven emotions you can measure in the face: anger, fear, disgust, happiness,

sadness, surprise, and curiosity. There is a reason why games feature boiling lava monsters, dark hallways, spewing blood, and narrow paths along cliffs. Fighting and survival horror games use these techniques to create the first three emotions. The other three facial emotions, including those we have identified that come from gameplay, involve player decisions from other aspects of gameplay.

"I always know how my husband feels about a game. If he screams, 'I hate it! I hate it! I hate it!' then I know two things. A) He's going to finish it. B) He's going to buy version two. If he doesn't say these things, he will put it down after a couple of hours."

Games provide players with the opportunity for challenge and mastery. One of the most important emotions from games is fiero, an Italian word for the feeling of personal triumph over adversity. Overcoming obstacles, puzzles, levels, and boss monsters helps players feel like they won the Grand Prix. It is a big emotion and ironically requires the player to feel frustrated first. To feel fiero, games get the player so frustrated that they are almost ready to quit and then they succeed. Then there is a huge phase shift in the body. The players go from feeling very frustrated to feeling very good. Unlike films, games provide fiero directly from choices that players make themselves. A film will never hand the audience a Jet Ski to save the world from nuclear doom, but a game has to because in games, player choice matters. For a game to continue to offer fiero from Hard Fun, the difficulty must increase to match player skill. The best games offer options for new strategies rather than simply adding more obstacles in less time. For example, in Diner Dash the trophy from winning level 4, such as a coffeemaker, changes the strategy for level 5.

"In real life if a cop pulled me over I'd stop and hand over my driver's license. Here I can run away and see what happens."

Beyond challenge, players also enjoy games for exploration, fooling around, and the sheer joy of interaction. Great games engage the imagination as well as the desire to achieve a goal from Hard Fun. Easy Fun is the bubble wrap of game design. Curiosity drives players to drive the track backward in Gotham Racing, put their Sims in the pool and pull out the ladders, and role play. Like improv theater, games offer players opportunities for emotions. In basketball, in addition to the score and making baskets, players enjoy dribbling or doing tricks like a Harlem Globetrotter. In Grand Theft Auto 3 players can drive any car they want, and the game offers other things such as plate glass store windows. The game leaves it to the player to see how the two interact. Games that respond to player choices off the path to a high score offer Easy Fun. For example, in Halo, when the Hard Fun is finished and all the aliens are gone, players enjoy the novelty of running around blowing things up or exploring a surrealistic ring world where the horizon curves up overhead. Players move between the Hard Fun and the Easy Fun of the game to prevent themselves from becoming too frustrated. The designers of Myst believe that the journey is the reward.

"I play after work to blow off frustration at my boss."

In Serious Fun, players play with a purpose. They use the fun of games to change how they think, feel, and behave or to accomplish real work. Through gameplay players express or create value. People play Dance Dance Revolution to lose weight and Brain Age to make themselves smarter or ward off Alzheimer's. Players blow off workplace frustration, relieve boredom standing in line, and laugh themselves silly. Some choose to play games such as Wii Sports over violent games because it reflects their values. The repetition and collection mechanics in games like Bejeweled create emotions and increase engagement in a visceral

way. If, instead of rubies and diamonds, the player matched dirty broken glass and animal droppings, the game would feel very different to play. With Serious Fun players feel good about the value that the game creates before, during, and after play.

"People are addictive, not the game."

Games offer an excuse for social interaction and forming social bonds. Games that provide opportunities for players to cooperate, compete, and communicate offer People Fun with emotions that come from relationships such as amusement, schadenfreude (German for happiness at the misfortune of others), and naches (Yiddish for the pride and pleasure experienced when someone you helped succeeds). Massively multiplayer online games (MMOGs) such as WOW connect people to compete, cooperate, and to share. People playing in the same room express more emotions than those playing in separate rooms. In collocated group play, the game shrinks to the corner, and the whole room becomes the stage for play. Emotions feed off each other as players jostle each other, add content to the game, and outdo each other with witty put-downs. The most common emotion when people play together is amusement. Players laugh even at negative events. The most important emotion between people is love or the feeling of closeness and friendship between players. These social emotions also relate to computer characters, such as virtual pets in Nintendogs and WOW. Diner Dash combines Hard Fun and People Fun because to win the player must keep restaurant customers happy. Emotions from playing with others are so strong that people play games they don't like, or they play games when they don't like playing games, just for the opportunity to spend time with their friends. In subscription MMOs, as with all games strong in People Fun, players come for the content, but they stay for the connection they feel with other players.

THE PLAY MATRIX

One valuable playtesting tool you can use is the play matrix. We developed the play matrix to help playtesters and students give context to their discussions about game systems.

The horizontal axis of the play matrix is a continuum between skill and chance. The vertical axis is a continuum between mental calculation and physical dexterity. We chose these two continua because they are core aspects of interactive experiences, and all games can be plotted along them. Think about the game of chess. It is a game of pure strategy, a type of skill. There is absolutely no chance involved. So on the skill versus chance continuum, it would be plotted to the far left. It is also a game of pure mental calculation. There is no physical dexterity required to play the game. So on the mental calculation versus physical dexterity continuum, it is plotted at the very top. When chess is plotted on both of these dimensions at the same time, it appears in the top left corner.

Now let's think about the game of blackjack. It involves chance, but the outcome is not determined purely by chance. It therefore falls somewhere to the right of center on the continuum. No dexterity is required to play, so it plots at the top of the mental calculation versus physical dexterity line.

9.8 The play matrix

To innovate and create more emotion we must first develop both the language and the tools to design specific emotions around gameplay. A game's core value proposition involves player choice, and choices are impossible without emotion. This makes the design of emotion central to game design. Without emotion, players lack the motivation to play. By planning an emotion profile at the start of game design, a game designer can target specific emotions with different game mechanics. Prototyping and testing these mechanics with players can gauge the success of these decisions. Offering emotions from all four types of fun broadens the opportunity for player emotion in the game, not just in response to a game event, but it is equally important to design the flow of emotions before, during, and after play. Games create emotions. By intentionally crafting and heightening emotions in player experiences in the future, games will evoke more emotions than movies.

About the Author

Nicole Lazzaro is an award-winning interface designer and the leading authority on emotion and the fun of games. Her 17 years of research defined the mechanisms of emotion that drive play and reshaped the fun of over 40 million player experiences including Myst, The Sims, Diner Dash, and smart pens. She has helped clients such as EA, DICE, Ubisoft, Monolith, Sony, PlayFirst, and Maxis explore new game mechanics and audiences. A frequent speaker, she enjoys sharing her research on why people play. Prior to founding XEODesign in 1992, Nicole earned a degree in cognitive psychology from Stanford University and worked in film.

Exercise 9.6: The Play Matrix

Now it is your turn to use the play matrix. Plot a popular type of video game, such as WarCraft, Quake, or Atomic Bomberman, on the play matrix. Compare this to a game like Twister or Pin the Tail on the Donkey. Now try plotting a board game like Monopoly, Risk, or Clue. Describe the differences and similarities between the three types of games. What does the play matrix show you?

The play matrix is not an absolute system that produces the same results every time. Different people might have different opinions on where games plot, which is okay. Everyone's opinion has value. It is best to use the play matrix as a tool for stimulating discussion and analyzing gameplay. The goal is to get your playtesters to think about the game and verbalize their feelings.

Figure 9.9 shows the play matrix with several games plotted in each quadrant. Can you see patterns in the types of games that fall in different quadrants? Many popular video games fall in the lower left (physical + skill). Many popular board games and turn-based video games fall in the upper left (mental + skill), many gambling games fall in the upper right (mental + chance), and many games for very young children fall in the lower right (physical + chance).

9.9 The play matrix including games

Exercise 9.7: Plotting Your Favorite Games

Take five of your favorite games and plot them on the play matrix. Describe what pattern you see. What does this tell you about yourself?

When conducting a playtesting session, it is sometimes helpful to ask your testers to plot your game on the matrix. Then follow by asking them these questions: (1) Is the outcome of the game determined more by chance or by the skills of the players? (2) Is the outcome determined more by mental skill or physical dexterity? Ask playtesters if they would move the game more toward one quadrant or another; what would they prefer? Different audiences often gravitate toward one quadrant of gameplay even if they enjoy different genres. For example, players who enjoy strategy games from the upper left corner might also gravitate toward other mental + skill based play, such as trivia or puzzles. Young children often gravitate toward games in the lower right, focusing on physical + chance, but as they get older, they choose games requiring mental + chance.

If players are dissatisfied with your game, they might be able to verbalize it by placing games they do enjoy in other quadrants. Ask yourself what game variables you could change to move the play experience toward a quadrant with games your target audience enjoys. For example, you might want to move from the upper right (mental + chance) to upper left (mental + skill).

The solution might be to change a variable determined by chance into a variable determined by player choice. In a physical prototype, this might be accomplished by removing dice from the system and replacing them with cards that a player can choose to play. In an electronic game, this might be accomplished by giving the player a choice of where to start or what weapons to use instead of randomly generating them.

TAKING NOTES

As mentioned, it is imperative to keep notes of your playtests. You think you will remember all of the comments later on, but what you will really remember is those comments you expected to hear or wanted to hear. If you do not keep notes, you will lose all the really important details of the playtesters' reactions. These notes should be filed chronologically in a notebook or folder or entered into a database. Each time you conduct a test, write down the date of the test, all feedback gathered from your testers, and any of your own observations.

Figure 9.10 is a form you can use to capture observations and playtester comments. It is broken into three parts: (1) in-game observations, which are thoughts that you write down while the testers are playing the game; (2) postgame questions, which are questions that are designed to help elicit opinions about the key aspects of a game system; and (3) revision ideas, which is a space for you to articulate ideas for making the game better.

This form is not intended to be used instead of a test script but rather in addition to it. The script keeps the session on track; the form is a place to take notes. If you like, you can merge these two lists so that your script has room to take notes and a list of all your questions.

You might be asking yourself right now, "What should I be testing for?" Don't worry—that is the subject of the next two chapters. For now, here are some general questions you might ask of your playtesters. After you have gone through Chapters 10 and 11, you can create your own questions that are specifically geared for your own game.

You will find that sometimes not all of the questions on the form will be relevant. For example, if you are testing for interface flaws, then data about the overall play experience might be less important to capture. We encourage you to tailor this form to your specific needs. Many of the questions will be unique to a game, so it is important for you not to rely on our questions but to create your own. Questions designed to get at issues that you have with your particular game will be the most valuable to you.

9.10 Observations and Playtester Comments

In-Game Observations

[Your thoughts as you watch the testers play]

In-Game Questions

[Questions you ask the testers as they play]

1. Why did you make that choice?
2. Does that rule seem confusing?
3. What did you think that would do?
4. What is confusing you?

Postgame Questions

[Questions you ask the testers after they have played]

General questions

1. What was your first impression?
2. How did that impression change as you played?
3. Was there anything you found frustrating?
4. Did the game drag at any point?
5. Were there particular aspects that you found satisfying?
6. What was the most exciting moment in the game?
7. Did the game feel too long, too short, or just about right?

Formal elements

1. Describe the objective of the game.
2. Was the objective clear at all times?
3. What types of choices did you make during the game?
4. What was the most important decision you made?
5. What was your strategy for winning?
6. Did you find any loopholes in the system?
7. How would you describe the conflict?
8. In what way did you interact with other players?
9. Do you prefer to play alone or with human opponents?
10. What elements do you think could be improved?

Dramatic elements

1. Was the game's premise appealing to you?
2. Did the story enhance or detract from the game?
3. As you played, did the story evolve with the game?
4. Is this game appropriate for the target audience?
5. On a piece of paper, graph your emotional involvement over the course of the game.
6. Did you feel a sense of dramatic climax as the game progressed?
7. How would you make the story and game work better as a whole?

Procedures, rules, interface, and controls

1. Were the procedures and rules easy to understand?
2. How did the controls feel? Did they make sense?
3. Could you find the information you needed on the interface?
4. Was there anything about the interface you would change?
5. Did anything feel clunky, awkward, or confusing?
6. Are there any controls or interface features you would like to see added?

End of session

1. Overall, how would you describe this game's appeal?
2. Would you purchase this game?
3. What elements of the game attracted you?
4. What was missing from the game?
5. If you could change just one thing, what would it be?
6. Who do you think is the target audience for this game?
7. If you were to give this game as a gift, who would you give it to?

Revision Ideas

[Ideas you have for improving the game]

A good way to begin is to identify key areas of your game you need input on and create questions geared to get feedback on those areas. Write down more questions than you plan to use and then rank them in order of importance. Then group the top questions by type as we did in Figure 9.10. You can develop your own categories of questions and structure. It really comes down to the type of information you wish to gather and how your playtesting sessions are structured.

One thing to avoid is getting carried away and overwhelming your playtesters. If you ask someone 20 or more questions in a row, they will become exhausted and might stop answering accurately. Remember, it is not the number of questions you ask but the quality of the responses.

Basic Usability Techniques

Asking questions is a vital part of conducting a play-testing session, but there are other methods for eliciting good responses. Some of these include techniques commonly employed in usability labs. Usability research involves getting real feedback on how people use products before those products go to market so their designs can be improved. In the next sections we have listed three techniques that you can apply to game testing.

Do Not Lead

You will learn the most from your testers by quietly observing them play. If playtesters ask a question, respond by asking them to describe what they think they should do. If they reach an impasse while playing, then you have identified something important that needs to be fixed.

Remind Testers to Think out Loud

As previously discussed, you should ask your testers to explain to you what is going on inside their heads as they play. Their commentaries will provide a window into their expectations and choices as they play your game. Most people are not used to thinking out loud, so you might have to help them get started.

Quantitative Data

In addition to taking notes on what players like and do not like, and on what they pick up quickly and have difficulty grasping, use feedback forms to generate data that shows trends. After a playtest session, you can use this quantitative data to prioritize the severity of issues.

Some game companies work with professional usability experts who might employ more sophisticated methods and use special facilities for playtesting. If you have the budget, this can be extremely beneficial. Not only do professional labs tend to produce superior results, but you can learn from the process and apply some of their methodology to your in-house playtesting sessions.

Data Gathering

So far we have mostly discussed how to obtain qualitative feedback, but you might also want to go after quantitative feedback, such as recording the time it takes someone to read the rules, counting the number of clicks its takes to perform a certain function, or tracking the speed at which a player advances in level. You might also ask testers to rank the ease of use of certain features on a scale of 1 to 10, or ask them to choose between several options to see what features are most important to them.

The type of data you gather depends upon the problems you wish to solve. If the game feels clunky and people are taking too long to get started, then measuring the time they spend on each procedure to

determine where the trouble spot is might be a good approach. However, if the problem is that the game does not feel dramatic enough, a series of qualitative questions might produce superior results.

Exercise 9.8: Gathering Data

Go back to your original prototype and think of three pieces of quantitative data you can measure that will answer three clearly defined questions you have about the gameplay.

If you are successful at gathering quantitative data, you might suddenly find yourself buried in statistics. It is nice to have stats on every conceivable aspect of your game, but if you do not know how to interpret the numbers, they are not much use. We recommend that you conduct your data gathering with clearly defined objectives in mind. Before you set out to measure something, write down your assumptions and purpose. What is it you want to prove or disprove? Then structure your test to either affirm or deny the hypothesis. For example, you might feel that a certain feature in the game is causing a problem, so you design an experiment that measures the time it takes people to reach a specific point in the game with and without that feature. You might also combine this with a qualitative approach where you ask the testers how they feel about the new feature. The combination of the qualitative and quantitative should give you the answers you are looking for.

As we mentioned above, game researchers such as those at Microsoft Games User Research have created software tools to record game data during playtesting sessions. This is a sophisticated form of keeping version notes. The developers then use specialized tools and visualization software to help analyze this data and determine the effectiveness of different game elements and features.

For example, the software might analyze the effectiveness of all units in an RTS prototype using the statistics gathered from actual playtests. If the data shows that one unit is dominating the others, the developer can then tweak that unit's variables accordingly and retest. They might make the dominating unit more expensive to build or less powerful. Or they might tweak the variables of other units to balance the game.

Although statistical analysis techniques like this are powerful tools, it is not a replacement for the designer's creative judgment on how to tweak game variables. This is because statistics can be misleading. If playtesters are new to the game, they might not be using certain units as efficiently as they could because they have not learned the subtleties of play yet. Or, at the other end of the spectrum, if the testers are experienced with the game, they might have set opinions about how to use the units and not see some innovative new way of playing. The bottom line with all data analysis is that it is a good tool that should be used in combination with other playtesting methods to have the best overall results.

TEST CONTROL SITUATIONS

A tool for improving the efficiency of your playtesting sessions is to utilize controlled game situations. A controlled game situation is when you lay down parameters that force players to test a specific portion of the game mechanics, such as:

- The end of the game
- A random event that rarely takes place
- A special situation within a game

- A particular level of a game
- New features

You can set up to test different aspects of your game independently of one another during different prototyping stages. In the foundation stage, you can test basic functionality without worrying about balancing or fairness. In later stages, you might want to test for loopholes and dead ends. Or you can focus sessions on the accessibility of the interface or navigation system.

How Feedback from Typical Gamers Can Help Avoid Disappointing Outcomes

by Bill Fulton, formerly of the Games User Research Group, Microsoft Game Studios

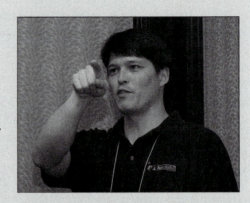

The Problem

Compared to the giddy expectations of the developers at the kickoff of a project, most games are disappointing: commercially, critically, or both. After all, few people set out to spend that much time and money to produce a game resulting in ambivalent reviews and low sales. Solving this problem is one of the holy grails of game development because it would remove substantial risk from making games.

The Traditional Analysis of This Problem and the Solution

Why does this disappointment happen? The traditional analysis of the problem is that teams are too close to their game to see it objectively, much the way that many parents seem to believe their child is above average. Because of this analysis, myriad ways to get feedback from fellow game development professionals (coworkers, publishers, journalists, playtest teams, etc.) has sprung up. While the traditional analysis has some merit, and the solution to combat the problem is quite useful, it doesn't seem to explain (or fix) the whole problem. Most games still fail to find critical or commercial success.

An Alternative Analysis and Solution

An alternative analysis for why games don't live up to the expectations of the developer is that professional game developers aren't like the people for whom they are designing the game: typical gamers. Game developers are so knowledgeable about games and game development that they have a hard time designing for the typical gamer, who knows comparatively little about games (see Figure 1 for an illustration).

This situation of game developers being very unlike typical gamers suggests that when the game is fun for the developers, it might not (yet) be fun for typical gamers, who might find it too hard or might not find the fun that is in the game. This is similar to the way that modern art is often unappreciated by anyone without a degree in art history. But to make games for the masses, it is the responsibility of the game developer to show typical gamers how to have fun with the game.

Many publishers and developers have come to see the problem this way, and they have engaged marketing research firms to do focus tests on the game to combat this problem. But often the goal of the focus test is to learn how to sell the game, not how to make the game more fun and accessible for more players. Furthermore, focus tests are often done too late in development to make many changes to the game. Because of the constraint of schedule and emphasis on selling as opposed to improving the game and time, many game developers are mixed about focus testing.

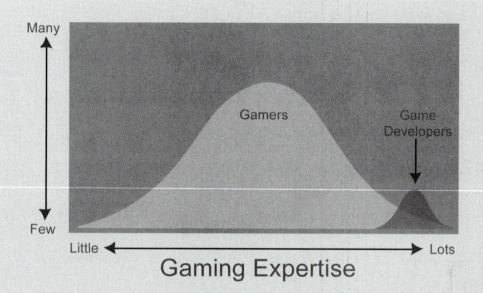

Figure 1

Gaming expertise: a comparison of hypothetical distributions of gaming expertise for typical gamers and typical game developers. This figure illustrates how all game developers know more about games than all but the most dedicated gamers. The point of this figure is to show how game developers can't simply make games that are only accessible to people like themselves if they want to make a game that the majority of gamers can understand and enjoy.

User Testing from an HCI Perspective

Getting feedback from consumers for the purpose of improving products is a major goal of the field of usability, a subset of the human–computer interaction (HCI) field. Most major software companies have usability departments staffed with HCI professionals. The games industry has been slow to adopt this practice.

This is changing; the use of HCI professionals in game development is gaining greater acceptance. One major game publisher has been doing some form of usability work on games since 1998, but other game publishers and developers are beginning to employ usability professionals as a way to make their games more fun. As more game developers and publishers do usability testing on their games in development, the typical quality of games from those developers and publishers will only get better.

An Example of User Testing from Age of Empires 2: Age of Kings

Age of Empires 2 (AoE2) is an excellent example of how user testing from an HCI perspective can improve games. The first AoE game was both a critical and commercial hit. In fact, it sold so well that the only way the sequel (AoE2) could sell any better would be if it expanded beyond the kinds of gamers who played the first AoE.

The developers and publisher decided to aim for the stars and make the game accessible to nongamers. AoE2 would be a game that someone who had never played a computer game would be able to pick up and play. This was a lofty goal because AoE2 is a complicated game, and nongamers lack the background to learn

the game on their own. We also knew from testing that the first AoE was a difficult game to learn for some experienced gamers.

To achieve this level of accessibility, it would be necessary to provide a robust tutorial and do a great deal of user testing. The details of the testing are better described in a different article, but the following anecdote from the final test of the tutorial gives a bit of flavor.

The final test of the tutorial was done on a Saturday at 10 a.m. At 9 a.m., I noticed an elderly lady (maybe in her 70s or 80s) waiting outside the building. I thought she was lost or looking for someone, but it turned out that she had been scheduled for the test. I was surprised, but she technically fit the kind of people we were looking for (never played a retail computer game, could operate a computer, was older than 40), so I let her in. I apologized for her being given the wrong time for the test, but she told me that she was told 10 a.m. was the time, "but always showed up an hour early for appointments."

I was a little concerned that she might be put off by the nature of the game (build a nation, raise an army, destroy your neighbors) and offered that she could leave if she wanted to. But she thought the idea of testing a game was "interesting" because her grandkids played them, and she wanted to be helpful. So we let her go through the test like all the other middle-aged folks. It was a bizarre sight to see dozens of parent and grandparent types playing Age of Empires 2 in the lab.

After they had completed the tutorial, they were instructed to play a random map game against the computer. Toward the end of the test, I went by the elderly lady and saw that she had the semblance of a nation going—she had several villagers collecting all four resources, and she had many of the right buildings built (barracks, granary, mining, etc.). When the Mongol hordes came over the hill and invaded her nation, she did

This type of controlled test situation is vital because it allows your testers to repeatedly experience an event under a variety of conditions. For example, let's say you were designing Monopoly, and you wanted to test the "going to jail" feature. Instead of waiting for it to happen by chance, you could force this event to occur and see the results under various conditions. How does going to jail affect a player who owns very little property versus another player who owns a vast amount of property? You might choose to start the game in the middle with the player already in jail, then play for 30 minutes and observe what takes place. Then repeat the experiment with a change in the player's financial position.

Exercise 9.9: Test Control Situations

Create three test control situations for the original prototype that you created. Describe the purpose of each control and how it functions. Then try it out and make note of your observations.

You do not have to have your testers start from the beginning and play the game all the way through. You can start at any point: beginning, middle, or end. You can make one of your players grossly more powerful than the others and see what happens. Testing control situations is not about being fair to your testers or making sure that they enjoy the game. It is about seeing what happens under every possible condition. Many of these are rare cases and need to be forced so that they materialize at key moments in the game. This way you can see how it affects the gameplay. Does it ruin the experitence? Or is it a nice surprise?

Also, when testing, your time is limited, and some games take days to play. If you do not have the time, you will find yourself relying on test control situations almost every session. One of the most common control situations is starting a game near the end. To do this, you set up the prototype to simulate where players would be in the final conflict. You define the parameters to create the type of ending that you want to test, and then you start the session from this

several things right—she hid her villagers and started to build a (woefully inadequate) army. Unfortunately, she was too slow and got overrun; Age of Empires 2 had just crushed grandmother's nation. When I escorted her from the lab, I asked her what she thought. She said she could see how her grandkids would like it, but the game wasn't her "cup of tea."

While the grandmother didn't enjoy the game, after completing the tutorial she was able to understand the basics of the game and responded reasonably to being attacked. This was a dramatic improvement over the original AoE, where sometimes even experienced gamers got stuck and couldn't figure out the game without going to the manual. The reliance on testing AoE2's tutorial with real people, not just paid game industry professionals, resulted in a game that almost anyone can pick up and play.

In the end, AoE2 sold dramatically more units than did the first version, in large part due to improvements to the game that stemmed from doing user testing throughout the development of the game.

About the Author

Bill Fulton is one of the founders of the Games User-Research Group at Microsoft Game Studios and worked there between 1997 and 2004. The group's mission is to get feedback from typical gamers for the purposes of improving games in development, such as the Age of Empires series, the Halo series, Project Gotham Racing series, and Forza series, throughout the development process. In 2004, Bill moved to game design and worked on the PC and Xbox 360 game Shadowrun. To read more about user research and games, see http://www.mgsUserResearch.com/publications/.

control point and study how the end game plays out. Because it is a controlled situation, you might be able to test the end game four times in one hour.

This is one of the reasons that cheat codes exist for electronic games. They are tools that the game developers use so that the team can test control situations. For example, the designers of a real time strategy game might find it helpful to have a cheat code for turning off the fog of war. This would allow them to better monitor the AI for the computer-controlled units, while a cheat code for infinite resources would allow them to test how the game plays with the maximum number of units. It has become a tradition among game developers to leave the cheat codes in the final releases of game titles. One reason is so that players can have fun experimenting with different game situations that would otherwise be impossible.

PLAYTESTING PRACTICE

We have found that it is easier for designers to learn the process of playtesting by using a game that they have no emotional connection with—it is easier to be objective when your design skills are not on the line. For the next few exercises, we will take a simple, familiar game and use it to learn the essence of playtesting. As we do this, much of what we discussed earlier will become apparent, and some new concepts will be introduced.

Connect Four

Many of us grew up playing the game Connect Four. It is where two players take turns dropping red and black checkers into a vertical grid. The first player to get four of their units in a row (horizontally, vertically, or diagonally) wins the game.

1. Create the prototype

First, you need to create a simple prototype for Connect Four. To do this with pen and paper, draw a grid, seven squares wide by six squares tall, on a piece of paper. One player will use a black pen to represent black units on the grid and a second player will use a red pen to represent red units. Make sure to have a stopwatch handy to time your playtest sessions. Next, decide who goes first. Each player, on his turn, chooses a column in which to place a unit. He then draws units at the bottom of the chosen column as if gravity dropped them from the top. Units stack on top of one another when they "land" in the grid.

2. Prepare your questions and script

Write down the questions you plan to ask in advance and prepare a script for the session.

3. Recruit testers

Go out and find two playtesters.

4. Playtesting

Introduce your testers to the game and let them begin playtesting.

5. Alternate the grid size

Play according to the previous description a few times. Use your stopwatch and mark how long each game takes to resolve next to the game grid. Next, draw the game grid at 9 × 8 instead of 7 × 6. Play this a few times using the same rules. What happens to the play experience in the 9 × 8 version? What happens to the time it takes to resolve? Which version is more interesting? Why? Does changing the grid size give you ideas for changing other variables?

6. Alternate the objective

Go back to a 7 × 6 grid, and this time change the objective, so that winning requires connecting five in a row. Play this a few times. What happens? Does changing the objective give you ideas for changing other variables as well? For example, you might find that a 7 × 6 grid is too small. If so, try the "connect five" version on the 9 × 8 grid.

7. Alternate turn procedure

Now go back to the original rules (i.e., Connect Four on a 7 × 6 grid). This time change the turn procedure. Players can now place two units on each turn; the second unit must be placed in a different column than the first unit. Play the new version of the game. What happens? How does this change affect the players' strategies? Is the game still balanced?

8. Alternate number of players

Go back to the original rules (i.e., Connect Four on a 7 × 6 grid). This time, change the number of players to three—you can act as the third player yourself if you do not have another playtester. Use a third color for the new player. Take turns as usual and play the new version of the game. What happens? How does this change affect the players' strategies? How does it affect the social dynamics of the game?

Final Analysis

Clearly changing system variables has a direct effect on the play experience, and the only way to determine this effect is through playtesting. How do these alternate versions compare with the original? How did each change affect the player experience?

Compile your notes and analyze your results. What changes would you make to the game of Connect Four as a result of this playtesting session? Do your notes point to any conclusions?

The previous exercise exposes you to the basics of playtesting and iterating on the fly. This works great if you are testing a physical prototype like the Connect Four game we created. However, the same process can also take place over a series of tests as you change and iterate your digital prototype. We used the Connect Four example so that you could quickly and easily see the change in the game experience over several iterations. Understanding and practicing this iterative process of playtesting and revising over and over is fundamental to the creation of good games. In the next two chapters, we will test your own original game in the same way—though it might take longer than the Connect Four example—as you iterate and improve your design over a number of playtests.

CONCLUSION

As you can see, playtesting is an involved task, but it is a critical part of game design that cannot be rushed through or sidelined. Your job as a designer is to make sure playtesting remains at the heart of the game design and development process. As soon as you let it slip into the background, then you give up your chance to see your game as the players will see it when they open the box for the first time.

Playtesters are your eyes and your ears. They allow you, as the designer, to keep your finger on the pulse of the game, even after you have played it hundreds of times. If you learn to listen to your playtesters and analyze what they are saying, you will be able to see the game mechanics for what they are, not what you want them to be or imagine they should be. And that is the key to good design. It is understanding what it is you have created and being able make it even better, not in one flash of brilliance, but step-by-step over months and even years. If you can master this process, then you have mastered one of the key skills to being a great game designer.

Designer Perspective: Rob Daviau

Senior Game Designer, Hasbro Games

Rob Daviau is a prolific designer of board and card games who works on staff at Hasbro Games. His credits include Risk 2210 AD, Axis & Allies Pacific, Heroscape, Star Wars: Epic Duels, The Game of Life: A Jedi's Path, Battleship Card Game, Risk: Star Wars (both editions), Clue DVD, and Nemesis Factor.

On getting into the game industry:

I played games all my life and spent a lot of time fading in and out of role-playing campaigns. After five years as an advertising copywriter, I was looking for a change. I applied as a copywriter for Parker Brothers (mostly writing rules and box bottom copy) at the exact time they were looking for a game designer with a writing background. I ended up getting the designer job, and the bulk of my work still involves copy-heavy projects. In my interview, I named two of my favorite games from childhood. It turned out that the guy interviewing me had designed both of those games. It was luck on my part, but I advise that as a good tactic when interviewing somewhere. Just don't make it look like you planned it.

On favorite games:

I admire games that create a whole new way to think about games—games that create a new type of game. So my top five (in no order) are: Dungeons & Dragons, Diplomacy, Magic: The Gathering, bridge, and Monopoly. I go through all sorts of favorite games during the months and years, but it really depends on who I'm playing with and what experience I'm looking for. There are big differences between picking up an Xbox RPG to play solo versus playing a game with my young kids versus playing a game with my hardcore gamer buddies. I just like the act of playing.

On inspiration:

Every game—okay, most games—have something in them that is clever or new or cool. I keep a mental list of the cool mechanic, the cool piece, the new storage tray, or different artwork in the games I play. I think of it as creating a palette to paint my own pictures. I am also inspired by the narrative potential of a game, even the nondigital games that I create. I want my games to tell a story or evoke a mood or create a moment of narrative tension. Trying to do that with a deck of cards can sometimes be a tall order.

On the design process:

I usually think of the feel first and then put in mechanics to evoke that feel. Do I want the game to be tense? Exciting? Dramatic? Full of twists and turns? Relentless? Do I want the players to be casually involved or intensely focused? From there I start creating a game that tries to fit the mood I am going for. This is probably backward from how a lot of people design games.

On prototypes:

I'm a nonvideo game designer, so I use prototypes all the time (even when I designed games with DVDs I had some sort of prototype). Because my games live in the physical world and are made of plastics, paper, and (sometimes) electronics, it is necessary to get to a physical representation very early. My line of work has a lot of questions about board size and plastic design and piece storage issues that are unique to the board and card game world. My office has a full model shop and engineering lab that can pretty much create anything I can dream up.

On designing Risk Star Wars: Clone Wars:

Instituting Order 66 into the Risk: Star Wars: Clone Wars edition was tough. We had read the script, but the movie wasn't out yet. The issue was: How do you have one person's armies suddenly be controlled by the other player in such a way that it is still a game? Why doesn't the person issue Order 66 at the start of the game? How can the other player win after it is called? Eventually we came up with a system where Order 66 became (statistically) more successful the longer you waited, so you always had that feeling of waiting one more turn to better your odds. Then we put in a shoot-the-moon win condition for the Republic player where he could, with a ragged bunch of troops, still have a chance of snatching victory from the jaws of defeat.

Advice to designers:

It's very easy to hide behind a gimmick—graphics, sound, a license, nice video segments—but game players are smart. They'll figure out if it's all smoke and mirrors with no real game. What makes your game different? If it's just more of the same as that game or just this game mashed with that other game then it's just a rehash. When starting a game, remember to question everything. Even if all those crazy ideas eventually are rejected or don't pan out, at least you started someplace new. The business people in the company will always try to direct a game toward the familiar and safe. It's your job to push back against that . . . because you might be the only one.

DESIGNER PERSPECTIVE: GRAEME BAYLESS

President, Kush Games

Graeme Bayless has been directing computer game development for 20 years. His long list of credits includes Battles of Napoleon (1991), Kid Chameleon (1992), MissionForce: CyberStorm (1996), Madden NFL (2001, 2002, 2003), NFL Street (2004), NHL 2K7 (2006), and Major League Baseball 2K7 (2007).

On getting into the game industry:

Well, I got in a long time ago (1987) when the industry was still trying to find its identity. I had always been a gamer (I've played games as my primary form of recreation since I was 8, and I submitted my first paper game design when I was 14) and thus I spent my weekends at the local game store, playing various paper games or miniatures games. One day I noticed a posting on the bulletin board of the store I frequented. The posting was an advertisement for a part-time weekend playtester. I figured, "Hey, I can do that," especially because the company was Strategic Simulations Inc., a company that made computer war games that I played heavily.

I applied and got an interview with their manager of testing (who was also their manager of customer service). As the interview went on, she became more and more impressed with my game knowledge, so she asked me if I'd like to interview for their customer support position. I agreed and came back for another interview. The second interview round included a programmer who was temporarily helping customer support until they could hire someone. This programmer was impressed with my design sensibilities, and suggested I return for a third interview for a game developer position (effectively an associate producer). I agreed, and the next thing I knew I was at lunch with the company president (Joel Billings) and vice president (Chuck Kroegel). The interview went well, and I was hired. I spent the next 30 months shipping about 30 SKUs, operating as the testing department, writing manuals, and participating in design on numerous war game and RPG titles.

On favorite games:

- *M.U.L.E.:* This was a superb title published by Electronic Arts in 1983. It was simple yet one of the most elegant game designs ever. The fun factor was undeniable, and it had replay value because the game was randomly generated every time you played. The most memorable part of this game is the trading interface, a truly brilliant game design. Players needed resources of varying types and would

have to bid on them through an interface where players literally scrambled for resources with the seller, able to dance higher and higher on price as folks raced to buy. Brilliant and fun.

- *Advanced Strategic Confrontation:* This was the rough translation from the Japanese name. The game was a Sega Genesis title released around 1990 that became the inspiration for the entire series of Panzer General games that kept Strategic Simulations going for years. This game was incredibly original, with a simple war game style that made war games accessible for the rest of us. All units had "10 hit points" and could heal by sitting on friendly cities. Infantry captured cities, and tanks were for killing other units. They had artillery and air units, allowing the full rock, paper, scissors strategy matrix. Though it wasn't released in the United States, it was extremely successful in Japan, and it still resides in my collection.

- *Star Control II:* This is the only sequel on my top list. It took all of the arcade fun of the first game and combined it with a single player RPG story that was both fun and, at times, hilarious. The replay value was mostly in the arcade mode, but the RPG side was deep enough that it was worth playing more than once to see what you might have missed. The only action RPG of its type, Star Control II has never been successfully imitated since. Note that the sequel, Star Control III, did not live up to its predecessors and effectively terminated the franchise.

- *EverQuest:* I'd be remiss to leave this off my list, given how much of my life it has sucked out of me. The first true 3D MUD, EverQuest, is undeniably addictive (more so than alcohol or tobacco, some might argue) and plain old fun. It is the perfect operating example of how powerful the concept of "toy factor" is in a game—the base concept being that the more toys players have to play with and sort through, the better. Of particular note regarding EverQuest is the incredible change the game has undergone, literally evolving to mimic the desires of the player base. EverQuest is perhaps the best example of a living game we've ever seen.

- *Fallout:* The original post-apocalyptic RPG, this masterwork helped maintain the vitality of the single player RPG. Fallout had a deep storyline, yet it didn't overwhelm the player with so many options that they got lost. It was long, but not so long that players couldn't finish it in a reasonable time frame (unlike the sequel). Add in a nice mixture of dark humor, and you have a game that is still top of the heap for single player RPGs. Fallout spawned two sequels, and neither has lived up to the original, unfortunately.

Advice to designers:

I would urge any prospective designer to become a complete package. It is not adequate to merely learn how to generate good designs; a skilled designer must also know how to communicate those ideas to others both in written and verbal form. A good designer must also be able to communicate concepts through visual tools, allowing the viewer to see what is in the designer's head. Likewise, interpersonal skills are also key, as a designer must sometimes negotiate for resources and/or for the ability to take a product in new directions when that designer isn't also the company CEO.

I will note that the theme of this book—and how it approaches game design—very much mirrors my own beliefs. I strongly support the idea of paper design prior to electronic implementation. Playtest your ideas thoroughly long before a coder codes. Use prototyping whenever possible to avoid inefficiencies that might end up costing you features later when time and money limit the scope of your project.

FURTHER READING

Dumas, Joseph, and Redish, Janice. *A Practical Guide to Usability Testing*. Bristol, UK: Intellect Books, 1999.

Kuniavsky, Mike. *Observing the User Experience: A Practitioner's Guide to User Research*. San Francisco: Morgan Kaufmann, 2003.

Rubin, Jeffrey. *Handbook of Usability Testing: How to Plan, Design, and Conduct Effective Tests.* New York: John Wiley & Sons, 1994.

Nielsen, Jakob. *Usability Engineering.* San Francisco: Morgan Kaufmann, 2004.

END NOTE

1. Thompson, Clive. "The Science of Play." *Wired.* September 2007.

Chapter 10

Functionality, Completeness, and Balance

Now that you have tried your hand at the playtesting process, you are probably wondering what to do with all the comments your testers are giving you. How can you prioritize all these ideas and comments into a helpful list of changes to your game? You need a way to focus your thinking about the next steps and take your game step-by-step from a prototype of the core gameplay to a fully functioning model of your game concept. This chapter provides some tangible steps you can take to make sure your gameplay is functional, complete, and balanced.

The process we suggest here is based on years of watching student and professional game designers work through this very problem. What we have found in this experience is that it is important to break the playtesting process down into several discrete phases, with each phase focusing on specific aspects of the design, perfecting these aspects, and only then moving on to the next phase.

Of course, as we have discussed, games are dynamic, interrelated systems. A change to one part of the system can completely change the player's perception of another. We realize this, and the process we are about to walk through is a vast simplification of what you will actually experience when you try this yourself. What is important to take away from this process is the need to focus your mind on the distinct goals of each phase, not try to fix everything in your game all at once. We want you to feel in control of this process, and giving you these goal-based phases and a method to move your game through them is a good way to do that.

WHAT ARE YOU TESTING FOR?

When you built your original prototype, we discussed the four basic steps of design: foundations, structure, formal details, and refinement. These four steps allowed you to visualize first the core gameplay or foundation, then carefully add structure to the system, one rule or procedure at a time. Only then did we go on to the formal details and refinement.

When we talked briefly about these steps in Chapter 7 on page 189, we spoke mostly in terms of prototyping—getting your ideas into physical form. We did not talk much about playtesting, revision, or your goals at each of these stages. At that point, we just wanted you to get some experience building out a design of a game from scratch. Now that you have a handle on the art of prototyping and playtesting, we can go back to these basic steps and discuss the design goals you should keep in mind as you work your way through each of these phases of development,

using the iterative process and playtesting at each step along the way.

Foundation

During this stage, your main concern is that the basic idea for your game is fun. Your prototype might only consist of a core mechanic with which to engage, and there might not be much else. You might have infinite loopholes, dead ends, etc., but do not worry about all of that right now. At this point, you just need to get a sense of the core of the system you have thought of, so that you can judge whether or not it is a compelling base for a game. As we mentioned in Chapter 9, at this stage, you will probably be playtesting the system on your own. The game is really only valid as an exercise in confirming your intuition that the idea makes a good foundation for a game.

Structure

When you have a solid foundation, your next goal is to add enough structure to make the prototype functional for playtesters other than yourself—probably your close friends or coworkers, but still, someone other than yourself. We will discuss the essence of "functionality" in detail, but intuitively, you already know what it means: Your prototype works at a basic, albeit clunky, level. You need to build out the rules and procedures to the extent that the system can be played by people who don't have a full vision of the end experience in mind.

What you want to know when you get to this stage is: Was your intuition right? Does the foundation hold up under the rigors of a real playtest with real players? Your focus here is on both functionality and fun. Are the formal elements working together even in this basic state? Is there a beginning, middle, and an end to the experience? Can the players reach the objective? Are they engaging in the conflict you have designed? Are they enjoying that engagement? Is there a spark to your game? Should you even continue with this idea, or is it time to head back to the drawing board?

Formal Details

Let's say the spark is there—you are on to something. Now you've got the problem of having to build out a fully functional version of the game system you envisioned. What should you do first? You know there are problems—they have already come up in the first few playtests—but where to start? The answer to that question is the basis of this chapter. During the formal details stage, your focus should be on making sure the game is (1) functional, (2) internally complete, and (3) balanced.

These three tasks might seem deceptively simple at first, but they require skills that you can only learn through practicing the craft of game design. Every game is intrinsically different, so the answers you found during one playtesting process are not the right answers next time. Experience will help you judge what decisions to make, what choices will make your game a clean, well-balanced system. But this process is really an art. A game can sink or swim during the formal details stage.

What about fun, you say? Why don't we test for fun during this stage? Of course, you are always keeping your eye out to make sure your game stays "fun" as it develops, but remember, we are trying to focus here, to break down the process so that you do not have to worry about everything all at once. Making sure your game is functional, complete, and balanced is a huge undertaking.

Refinement

During the refinement stage, we are going to assume your game is functional, complete, and balanced. You tested primarily for fun in the first two stages of design, by yourself and with confidants, and if your core gameplay was fun to begin with, completing and balancing the game should not have detracted from that; on the contrary, it probably added to it. But perhaps something of that original spark got lost in the process. Now is the time to focus all your energy on making sure the fun you envisioned from the start is there in spades.

You probably noticed the quotes we use around the word "fun." This is because fun is such a broad term that it is almost impossible to define what it is and how you make sure your game has it. And yet, if you ask a player what they want in a game, nine times

out of ten, they say it should be fun. We all know when we are having fun, even if we cannot define it. Chapter 11 is all about how you can make your game more fun for players, with strategies and ideas for adding that elusive emotional pull to a game system that keeps players coming back for more.

Last, but not least, during the refinement stage, you will be testing for accessibility. Remember, your game has to stand on its own without you there to explain it. You might have the most functional, complete, balanced, fun game in the world, but if it is not accessible, players won't ever know this. And so this final aspect is as critical as any of the others that come before.

When you feel overwhelmed by the process of playtesting and revision, review Figure 10.1 to remind yourself of the stage of design you are in and where your design focus should be. If you do not try to solve

Prototyping Stage	Functional?	Internally Complete?	Balanced?	Fun?	Accessible?
1) Foundations				●	
2) Structure	●			●	
3) Formal Details	●	●	●		
4) Refinement				●	●

10.1 **What are you testing for?**

every issue in your game at once, your tasks will suddenly become simpler, and your next steps much clearer. With these steps in mind, let's look at functionality, completeness, and balance in detail.

Is Your Game Functional?

Before you can even think about completeness, you must have a functional game. By functional we mean that the system is established to the point where someone who knows nothing about the game can sit down and play it. It does not mean the tester won't run into trouble or that the experience will be thoroughly satisfying, but it does mean that they can interact with the game unaided by you. In a paper prototype, this means the players can play the game—following the rules and procedures properly—and not reach an impasse. In software prototypes, it means players can use the controls and make the game progress. In both types of prototypes, it means that the components of the system interact properly and a resolution can be achieved.

Beyond this, deciding your game is "functional" is really a matter of judgment. If your players can make

it through a session without help from the designer, let's call the game functional and move on to more demanding questions.

Exercise 10.1: Testing for Functionality

Take the physical game prototype you developed in Exercise 7.9 or a digital gameplay prototype and test it for functionality. Give the game to a group of people who have not played the game before, and give them no verbal instructions—only the challenge to "play the game." See if they can play your game from start to finish without any input or assistance from you. If they can, your game is functional. If they cannot, figure out what was missing, and revise the game to make it functional.

Is Your Game Internally Complete?

As you playtest, you will invariably notice places where your game is functional but incomplete. For example, early in the first person shooter prototyping process, we established movement and shooting rules so the

system could function, but we had no rules about hit percentages or winning conditions, so it was still incomplete. Some of these missing elements are obvious, but others are much more difficult to discern. Only by

testing every possible permutation under all conditions can you be certain that there are no sections of the game that are left unfinished. Your job as the game designer is to identify and resolve these issues.

This sounds simple, but it is not. Most games are quite complex systems that can act in unexpected ways under different conditions. The more you test, the more you will discover how malleable your game is. Players will do things that you could have never anticipated. There might be gaps in the rules that made sense on paper, but when they are actually implemented in the game, they lead to irresolvable situations or gray areas. In board games, this often leads to arguments between players, with each side interpreting the rules in their own way. In software, it leads to a loophole that players can exploit, a dead end in the player experience, or a complete breakdown of the system. You might hear your testers making comments like, "The rules don't say either way," "I'm completely stuck," or "You can't do that!" These types of reactions are red flags that something within the game is not complete and needs attention.

After identifying an incomplete portion of your game, the first thing to do is go back to the rules. Whether you are working on a digital game or a board game, you should have a design document or a rule sheet that clearly describes how your game is to be played. What you will discover is that what you thought was a clear set of rules actually has holes in it. You now have to plug the hole (or complete the rules) so that it makes sense. Doing this can often affect other parts of your game, so it is a delicate task and might require several testing sessions and revisions before you get it right.

Exercise 10.2: Testing for Completeness

Take the physical or digital game prototype you have been working with and test it for completeness. This time look specifically for moments in which players reach an impasse, question the rules, or have to make a judgment call about what happens next. If players argue about the rules or reach a dead end, your game is not complete. Revise your game to deal with the issues you find and test again.

You will find that sometimes playtesters uncover problems in a system despite the fact that the rules are unambiguous. For an example, let's go back to the first person shooter prototype from Chapter 7 on page 181. Is it internally complete?

Here is a potential problem that plagues many first person shooters, including our prototype: When more than two people play this game, it is possible for players to camp near both of the spawning points on the arena map. When a recently killed opponent appears at either spawning point, the campers can promptly shoot the opponent. Players stuck in the position of being shot are furious at this seemingly unfair tactic.

The problem is that the rules are comprehensive, and the players are behaving within the bounds of the rules, but certain players have figured out a way to gain an advantage that the designer did not expect. Thinking as the designer, how would you alleviate this spawn camping problem? For a challenge, stop reading now and think through your own solution. Then compare yours with the following four possible solutions.

Solution 1

The number of spawning points on a map should be equal to the number of players in the game.

- *Pro:* Players will always have at least one safe point on which to spawn.
- *Con:* You have to design arena maps specific to the number of players that will play on it. Maps cannot facilitate a fluctuating number of players as most online FPS games allow.

Solution 2

A force field shield surrounds each spawning point hex. A spawning player can fire and move outward through the force field. However, no one can shoot or move back in. The force field incinerates a spawning player if he remains on the spawning point hex for more than one turn.

- *Pro:* Players are safe when they first spawn, and they can fire upon a single camper.
- *Con:* Multiple campers can still wait nearby, making the turn after spawning difficult for players.

Solution 3

Players can choose to spawn on a randomly generated hex. If the hex is occupied by a wall or another player, then a different hex must be randomly generated.

- *Pro:* This solution reduces player interest in camping by spawning points.
- *Con:* This solution adds an element of luck to the system.

Solution 4

Do not fix this because it is a feature, not a problem.

- *Pro:* Some players think spawn camping is just part of the game. Leaving the system as is will force players to fight for choice camping spots, which will create a game in itself.
- *Con:* Other players are extremely frustrated by spawn camping.

Discussion

The options listed illustrate that there are many creative ways to tweak this system during the process of making a game internally complete. As we noted, the spawn camping problem is not unique to our first person shooter prototype. If you do an Internet search on the phrase "spawn camping," you will see dozens of Web sites discussing the pros and cons. You will also notice that many fans have created numerous work-around mods to alleviate the spawn camping problem. Some of the mod solutions are similar to the options we listed previously. Some are different. One solution makes a player invisible for two to three seconds after spawning. This lets a player run around and shoot without being seen, giving them a fighting chance.

Exercise 10.3: Spawn Camping

Write down three original solutions not mentioned previously to the spawn camping problem. Describe the pros and cons of each solution.

Loopholes

Finding loopholes is an essential part of testing for completeness. A loophole can be defined as a flaw in the system that users can exploit to gain an unfair or unintended advantage. There are always some ways in which players can gain advantage in a system—otherwise no one would win—but a true loophole allows for a type of play that ruins the experience for all players. As long as unintended loopholes exist, your game cannot be considered complete. Your goal as a designer is to eliminate loopholes without closing down all potential for emergent play.

This is no simple task, especially with digital games. The very nature of a computer program makes it easy for loopholes to go undetected. In most digital games, there are so many possibilities that no designer can test them all, and some gamers actually make a point of ferreting them out. To these gamers, the challenge of finding loopholes is irresistible. They love to tout their discoveries and use them to their full advantage when competing against other players. Finding loopholes has become a form of play in itself for these players, who make a sport out of finding flaws in game systems and posting them for others to find.

Consider an example from the PC game Deus Ex. Deus Ex, released in 2000, was a pioneering piece of work due to its genre-mixing design and its open and flexible game environment. One of the weapons available in the game is called a "LAM." LAMs can be attached to walls and used like proximity mines, meaning that they explode a few seconds after someone stands in close proximity to them. They are great for blowing up doors and for killing unsuspecting opponents. Apparently, however, they were also good for something the designers never anticipated.

Creative players learned that they could attach multiple LAMs to a wall and then quickly run up them like a ladder before they detonated. Doing this allowed players to climb into places on game maps in ways that the designers had not anticipated. This meant that some levels were less challenging than originally planned. If this can happen to world-class game designers, it can happen to you. Players are much more creative and resourceful than you would ever imagine.

10.2 Deus Ex: gameplay screens, inventory, and LAM (smallest image)

A classic example comes from the Atari game Asteroids. This game was a smash hit in the arcades when it was released in 1979. In this game you control a spaceship and must blast your way out of a field of floating asteroids, and you also gun down flying saucers that come on screen to shoot you.

Engineers at Atari played the game incessantly for six months before it was released and had recorded a company high score of 90,000 points. No one believed that a normal player—someone not familiar with how the game was programmed—could ever achieve a score like that. However, shortly after the game's release, Atari began receiving reports that players all over the country were scoring three and four times that many points. In fact, the players were beating the machine because the Asteroids scoreboard maxed out at 99,990 points and, when surpassed, the score started over at 0.

The engineers at Atari were stunned. They drove out to an arcade to investigate firsthand. Eugene

Lipkin, then-President of Atari's coin operated game division, was quoted in *Esquire* magazine in 1981 as saying, "What had happened, was that a player had been smart enough to understand the movement and the programming on the product and had then come up with an idea of how to work around it. It took about three months for that to happen. Then, all of a sudden, we began hearing the same thing from all over. People had figured out that there was a safe place on the screen."[1]

The safe place on the screen occurred because the player's bullets can "wrap around" the screen—meaning that when bullets are fired off the right side of the screen, they reappear from the left on the same trajectory, whereas the flying saucer bullets cannot wrap around. Players learned that if they destroyed all but one asteroid floating on the screen they could lurk near an edge and pick off the flying saucers as they appeared.

The small flying saucer is normally very formidable and is worth 1000 points. With the lurking

strategy, however, a player could shoot a flying saucer with wraparound bullets and get it from behind, or if the saucer appeared on the same side of the screen as the player, they could quickly blast it before it could get off a shot. It still took a lot of skill to do it effectively, but when mastered, this lurking practice allowed players to rack up huge scores. Asteroids purists regarded the practice derisively. However, this did not keep players from exploiting it to the fullest. Atari had to wait until the next version of the game, Asteroids Deluxe, to fully fix the problem.

Loopholes versus Features

Sometimes it is debatable whether a system issue enables a loophole or whether it is actually a benefit to the game. You will see heated arguments online, where gamers take both sides of the issue. The first person shooter spawn camping loophole discussed on page 280 is one example of this. When you identify one of these subjective issues, you must make a creative choice on how to handle it. Sometimes it is possible to make variants on the game to satisfy different types of players.

As an example, let's look at how massively multiplayer online role-playing games (MMORPGs) have dealt with one specific type of loophole. Ever since MMORPGs were introduced, players have debated the pros and cons of being able to kill other players. MMORPGs are persistent online worlds where players role play and interact as virtual characters. Most people dislike players who maliciously kill other players. These people are called "player killers." The remaining players would prefer that the game designers, for a given MMORPG, tweak the system to prevent player killing from happening. However, some people think that player killing adds to the richness of the game because evil characters are free to play evil roles, and it creates a more intriguing and challenging environment.

Which side is correct? Does the presence of player killing mean that an MMORPG has a loophole and that the game is not internally complete? The solution that MMORPG designers developed over time—through playtesting with real players—was to

provide spaces for both types of players. In essence, many MMORPGs have two variants: one where players cannot hurt one another and another where they can. Each variant is internally complete in its own way. The following are examples of how several well-known MMORPGs have evolved through play and revision to deal with player killing.

Ultima Online was one of the first MMORPGs. Early in the game's history, new players complained about being bullied and killed for no reason by more powerful players. Newbies had no protection. The problem was spoiling the fun for many players and deterring others from joining. People generally loved the game but hated the player killers—whom they called cowards. They filled online message boards with complaints. Articles appeared in magazines about the problem. The designers at Ultima Online needed to tweak their game system to alleviate the tension.

In response, Ultima Online's designers created a reputation system for characters in the game. Players who murdered other players were given red name banners and designated as "dishonorable." When law-abiding characters saw a red character, they would likely not trust or cooperate with them. This made it harder and less fun to be a player killer. In addition, and perhaps more dissuasive, was the fact that experienced law-abiding characters would (and do) band together to hunt down red characters. This created

10.3 Ultima Online: EvilIndeed makes a kill

a system of vigilante law in the game, which greatly alleviated the tension, but it also developed its own set of problems.

Over time, the game designers continued to tweak their system to make it less and less appealing to be a player killer. For example, they placed invincible computer-controlled guards at the entrances to all but one city in the game world. The guards killed red characters on sight. This meant that the cities were safe for law-abiding characters, and player killers were relegated to an outlaw's existence, either out in the wilderness or in the one town that accepted them—a dangerous place called Buccaneer's Den. This solution accommodates both law-abiding players and player killers. It also meant that player killers could camp outside of towns, ready to pounce on any hapless players who might wander outside the city limits.

Today the world of Ultima, and many other MMORPGs that have followed since the release of Ultima, is divided into two separate spheres: one in which player killers run free and one in which player killing is disabled by the system.

Asheron's Call, another early MMORPG that had to deal with the same problem, came up with a very different solution. In the first version of Asheron's Call, the designers created an allegiance and fellowship system. When a new player came into the world, he had the option of swearing allegiance to another player character. In return, the new player might receive protection or even money and weapons from the experienced player, who was designated as his "leader." From that point onward, a share of the new player's experience points would go to his leader. Likewise, a share of the leader's experience points would go on to that character's follower (if she had one) and so on. This created a mutually beneficial pyramid structure that helped protect players.

In addition, Asheron's Call players had the option of joining fellowships. Fellowships were temporary agreements with other players, usually formed to go on a quest or pursue a goal. Experience points generated while the players were a fellowship were distributed across the group. Individuals in the group received a share of the points based on their experience level. For example, a third-level character received a bigger share of the points generated by the fellowship than a second-level character, etc. The designers at Turbine Entertainment developed these systems as an elegant way of rewarding players for working together. They made it more fun to cooperate and less fun to be a spoiler.

Even with these systems in place, law-abiding players of Asheron's Call still complained about player killers. Turbine responded by tweaking the game so that, by default, players could not be attacked by other players. The story of the game was tweaked to say that the powerful magic of the world of Dereth protected them from one another. This made all players completely safe from one another, but it was disappointing to players that wanted the thrill of battling other live players. In response, Turbine created a way for players to voluntarily convert to player killer status. The interested player had to find a special altar in the game world to do it. After conversion, the player could kill and be killed by other player killers. In this approach, all players could inhabit the same game space, but only players designated as player killers could battle one another. This approach continues to be utilized today.

EverQuest, released after Ultima and Asheron's Call, learned from their solutions. The developers at Sony Online Entertainment created a system in which players who choose to convert to player killer status can kill or be killed by other players. To further appease player killers, EverQuest offers player-killer-only game servers. On these servers, all players are susceptible to attack from one another. These servers are popular with hard-core fans. By responding to player feedback—a form of playtesting—the Sony designers succeeded in closing a disruptive problem and made their game internally complete in regard to the player killer issue.

In most cases, you will never find all the loopholes before the release date, and this is why many game developers opt for a public beta test. Especially with massively multiplayer online games, it is a valuable tool for finding and solving loopholes before final delivery.

10.4 EverQuest

Whether you initiate a public beta or not, it is your responsibility to make sure that there are no loopholes that will ruin the player experience. Whenever a loophole is discovered, your job is to tweak the system and perform another playtest to see if the disruptive technique works. Eventually, you will find a solution that eradicates the loophole. It is an iterative process, and each loophole can take days or even weeks to solve. By the time a game is released, most designers manage to do a pretty good job at eliminating the obvious flaws, but even with the most sophisticated testing schemes, some loopholes seem to find their way into the final products. This is because the number of people who play a released title is so much larger than the number of dedicated testers any company could manage to recruit, and all it takes is one player to uncover the flaw that everyone else missed. Here are some tips for finding and weeding out loopholes:

- Use control situations, as described in Chapter 9 on page 265, to test aspects of the system in isolation. This will force testers into situations they might otherwise avoid, exposing flaws that otherwise would not be apparent.
- Do a series of playtests where you instruct testers to attempt to disrupt the system. Challenge them to see who can come up with the most creative way to get ahead.
- If possible, find testers who enjoy figuring out alternative or subversive solutions. Hard-core gamers are good at finding loopholes in games.

Exercise 10.4: Loopholes

A loophole is an unintended system flaw that a player can exploit to her advantage; take the game prototype you have been developing and test it for loopholes. In this exercise, use seasoned playtesters who know your game inside and out. As advised previously, instruct testers to disrupt the system. Challenge them to see who can come up with the most creative way to subvert the rules.

Dead Ends

A dead end is another type of common flaw that disrupts the gameplay experience. Dead ends are not loopholes, in that they do not allow a player to exploit a game, but like loopholes, they must be fixed before a game can be considered internally complete.

A dead end occurs when a player gets stranded in the game and cannot continue toward the game objective no matter what they do. Adventure games, where players have to collect objects in the world and then use these objects later to solve the puzzle, are susceptible to this. If the player cannot solve the puzzle because they are missing a piece, they have reached a dead end.

Dead ends can also occur in other types of games. For example, in a strategy game, a dead end can be a situation where the players cannot resolve the conflict because their forces wind up without resources. In an FPS, a dead end can be a virtual space that a player stumbles into and cannot get out of. Most titles have ironed out dead ends before they are released, but now and then, one slips through the playtesting cracks.

Wrapping Up Completeness

The idea of completeness can be summed up by the following statement: An internally complete game

is one in which the players can operate the game without reaching any point at which either the gameplay or the functionality is compromised.

This is both an objective and subjective decision. You can say your game is complete at almost any point, and that will hold true until someone uncovers a flaw. In reality, no game is ever complete. There is always room for improvement, and in most cases, there are unknown or irresolvable issues lurking within the game system.

Schedule and budget constraints often preclude designers from ever fully completing this stage of the process. But your job as designer, and specifically your focus during the formal details stage of design, is to enforce a high enough standard and to lay out rigorous enough tests so that you can be certain beyond a reasonable doubt that there are no critical deficiencies lurking within your game. Only when you have accomplished this can your game be considered internally complete.

Is Your Game Balanced?

As with fun, the concept of balance is often used to describe the process of making a game better. We offer a specific definition of balance here. Your game might require specific balancing techniques not addressed in this definition. But hopefully this will help you get started and help you focus your thoughts as you step through this sophisticated process.

Balancing a game is the process of making sure the game meets the goals you have set for the player experience: that the system is of the scope and complexity you envisioned and that the elements of that system are working together without undesired results. In multiplayer games, it means that the starting positions and play are fair (i.e., no player has an inherent advantage), and no single strategy dominates all others. In single player games, it means that the skill level is properly adjusted to the target audience. For short, we call these four balancing areas variables, dynamics, starting conditions, and skill.

Resolving issues of balance is one of the most difficult parts of designing a game. This is because the notion of balance encompasses so many different elements, all of which are dependent on one another. Many of the concepts involved in balancing also involve complex mathematics and statistics, which you may or may not be skilled at computing. Do not let that deter you from the process, however. Balancing is as much about gut instinct as it is about numbers; with enough experience, you will be able to tweak the variables in your physical prototype, or give detailed feedback to the programmers for your digital game, without a degree in calculus.

Balancing Variables

The variables of your system are a set of numbers that define the properties of your game objects, whatever those might be. These variables can define how many players the game is designed for, how large the playing area is, how many resources are available, the properties of those resources, etc. In the game Connect Four, used in the playtesting example from Chapter 9 on page 269, the properties included two players, a 7 × 6 game grid, 21 red units, and 21 black units. Indirectly, these variables also determine important aspects of how your game will work when it is set in action.

For example, in Connect Four, when you changed the grid size from 7 × 6 to 9 × 8, you would have had to increase the maximum number of units from 21 of each color to 24 of each color. If you didn't, your players might have run out of units before the game was over. This is because we need enough units to fill every cell on the grid: 9 × 8 = 48, 48 ÷ 2 = 24. Hence, the change in one game variable necessitated a change in another.

Changing the grid size changed some other aspects of Connect Four, which you undoubtedly discovered during your playtest as well: (1) the playing time was increased and (2) the game became less exciting. The reason for the first discovery is somewhat obvious. With more area to fill, players had more options to explore and less contention for the space.

The second discovery is an interesting and perhaps unexpected one. With nine columns, rather than seven, the game is less exciting. Why is this? In the

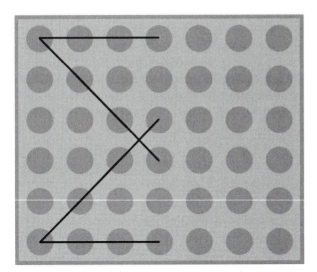

10.5 **Connect Four: The center column is flanked by three columns on either side**

game with seven columns, the center column is flanked by three columns on each side. This means any horizontal or diagonal row of four units must include a unit in the center column. This places great importance on that center column. The battle for control of it draws the players into conflict with each other quickly and makes the overall experience more exciting.

Thus, the original size of the grid is more successful than the 9 × 8 grid. We can only learn what scope will be most effective for a system through repeated testing with alterations in the game variables.

Digital games operate under the same principles. In Super Mario Bros. you start with three lives. If you started with one life, the game would be too hard. If you started with ten lives, the game would be too easy. Changing lives changes how the game plays. Playtesters act differently when they have ten lives versus one, so the experience and balance of the game shifts.

Many variables in video games are hidden in the computer code. This makes them more difficult for us to analyze, but we can conceptualize them. We have already looked at several examples of game variables: the unit properties in the WarCraft II editor (Figure 8.19 on page 240) as well as the map size for the WarCraft III editor (Figure 8.20 on page 241).

Although it is not as easy to visualize, the number of resources available at any given time in the environment of World of Warcraft, as well as the running speed and jumping height of a game character like Mario, are also variables that can be adjusted to control the experience of the game.

Can you imagine playing Mario if he moved like a slug? It would be boring. Likewise, can you imagine if Mario moved really, really fast? It might be frustrating because he would be too hard to control. Game designers at Nintendo tweaked the numbers for these variables up and down to arrive at a comfortable speed that would appeal to the majority of players.

The purpose of manipulating variables all comes back to your basic goals for the game: the player experience you are trying to create. You can only effectively judge the viability of your system variables if you have a clear picture of that experience.

Exercise 10.5: Game Variables

List out the game variables in the game prototype you have been working on. Make a change in one variable and observe how it affects other variables. This is an opportunity to test how your system plays under different conditions. Can you make easy, medium, and hard levels simply by tweaking the variables?

Balancing the Dynamics

When we talk about balancing the dynamics, we mean the forces at work when your game is in action. As we discussed in Chapter 5, when systems are set in motion, sometimes there are unexpected results. Sometimes a combination of rules creates an imbalance. Sometimes it is a combination of objects, or even a "super" object that unbalances play. Other times it can be a combination of actions that provide an optimal strategy for players who know the trick. Whatever it is, these types of imbalances can ruin gameplay. You will need to identify them and either fix the rules that create the problem, change the values of the objects, or create new rules that mitigate the optimal strategies.

Reinforcing Relationships

As we saw in Chapter 5 on page 133, a reinforcing relationship occurs when a change in one part of a system causes a change in the same direction to another part of the system. For example, if a player earns a point, she would be rewarded with an extra turn, thereby strengthening her advantage. This starts a cycle that rewards the stronger player over and over until the game concludes, probably prematurely, with that player the winner.

This type of problem might be solved by changing the reinforcing relationship you have set up into one that balances the power more fairly; for example, when a player earns a point, the turn is passed to the other player, thereby balancing the effect of the point advantage.

Basically you want to keep the strong player from accumulating too much power from a single success. Instead they might receive a small, temporary bonus, but nothing that throws the game out of balance. In many cases, designers make the winner pay a price for taking a strategically important position. This tends to balance out the gains, ratchet up the tension, and provide the loser with a chance to come back.

Other techniques include adding an element of randomness, which can come into play and alter the balance of power. This can take the form of external events, like shifting alliances, natural disasters, and unfortunate circumstances. You might also want to enable the weaker players to group together to battle the dominant one or have a third party intervene.

The goal is to keep the scales balanced without causing the game to stagnate. After all, this is a competition and someone has to be able to win eventually. Naturally, in the last stages of a game, the scales will tip, and when this happens, let the scales tip dramatically. There is nothing as satisfying as a sweeping victory. This makes the winner feel good and provides for a swift, merciful defeat for the loser. You never want to drag out the ending. Think of your game in terms of its dramatic arc; when you have passed the climax, wrap it up fast.

A game that deals creatively with this type of problem is the strategic multiplayer shooter Battlefield 1942. In assault matches, one team starts with a single spawning point and the other team controls every other spawning point and area of the map. The attacking team must fight to take ground. An example of a map that works like this is Omaha Beach, which simulates the D-Day invasion. The Allies start on board a ship and must take spawning points on land from the Germans. Battlefield 1942 incorporates a tickets system. Each side begins with a certain number of tickets that are reduced whenever a player is killed in action and subsequently respawns. When the number hits zero, the game is over. However, fulfilling certain victory conditions will cause the opposing team's tickets to slowly deplete until they manage to reverse the situation by reclaiming a required control point. This gives teams a chance to come back from the brink of disaster, or at least it gives players the resolve to stay in a losing game and manage a minor, rather than a total, defeat based on the percentage of tickets by which they lost.

Exercise 10.6: Reinforcing Relationships

Analyze your original game prototype for reinforcing relationships. Is it common for the player who gets an early lead to win the game? If so, you might have a reinforcing relationship that is creating an imbalance in the system. Identify the issue and change the relationship to balance the play.

Dominant Objects

A good rule of thumb is to keep similar game objects within a game proportional in terms of strength. For example, in a fighting game, no single unit should be significantly more powerful than the others. "Super units," as they are sometimes called, ruin the gameplay by becoming so valuable that none of the other units matter. One of the best ways to keep every element in proportion but still provide a range of choices is to think in terms of strengths and weaknesses. Every unit can be balanced by giving it a special advantage and a corresponding drawback.

Think of the classic rock, paper, scissors game. This game works because each element has a clearly defined power and failing. In this game, two players simultaneously choose one of three items: rock, paper, or scissors. Each item wins, loses, or ties depending on what is played by the opponent. Rock beats scissors, scissors beats paper, and paper beats rock. When illustrated in a payoff matrix, it looks like Figure 10.6.

On the matrix, 0 equals a tie, +1 equals a win, and −1 equals a loss. It shows that the three options balance each other out. This concept, sometimes called "rotational symmetry," is often used to balance digital games as well. For example, as Ernest Adams points out in his article "A Symmetry Lesson" on Gamasutra.com, The Ancient Art of War by Brøderbund was designed so that knights had an advantage over barbarians, barbarians had an advantage over archers, and archers had an advantage over knights.[2]

Many games use this technique in one form or another. In fighting games, each unit or character has his killer moves and Achilles' heel. In racing games, some cars are good at going up hills but handle poorly on corners. In economic simulations, some products are more durable but cost more, while others have a limited shelf life but higher profit margins. Assigning strengths and weakness is one of the fundamental aspects of game design and should be kept in mind whenever balancing gameplay.

Let's take WarCraft II, in which players can play a human or an orc civilization. The two sides are symmetrical in many respects but have minor differences. Both civilizations have the same types of units and buildings that yield the same types of abilities. For example, the humans have a peasant unit that has the exact same hit points, cost, build time, and abilities as the orcs' peon unit. The name and the artwork associated with human peasants and orc peons are different, but from a formal perspective, they are identical.

An example of a difference is the orcs' bloodlust ability versus the humans' reciprocal healing ability. Taken only at face value, bloodlust is more powerful than healing. It enables orcs to deal triple damage in battle. A gang of bloodlusted orcs can easily slay a same-sized gang of humans in direct combat. To balance out this discrepancy, the designers at Blizzard gave the humans other abilities and strengths. However, the player must choose an appropriate strategy to benefit from them. Healing is not very useful in direct combat with orcs, but it can be effective when utilized as part of a hit and run strategy. To do this, the humans must attack the orcs, then retreat quickly, heal their units, and attack again. This works particularly well as a strategy for gryphons because they can fly away.

Humans also have slightly more powerful magic spells than the orcs. However, they also require both skill and strategy to employ. The human mage unit can make other units invisible so they can sneak into an orc camp for a surprise attack. Or the mage can cast a polymorph spell that will change an orc unit into a harmless sheep. Both of these spells are expensive in terms of mana and require the player to execute

	Rock	Paper	Scissors
Rock	0	+1	−1
Paper	−1	0	+1
Scissors	+1	−1	0

10.6 "Rock, paper, scissors" payoff matrix: rotational symmetry

10.7 WarCraft II—bloodlusted orcs attack a human stronghold

complex maneuvers, but the payoff is there. Overall, the orcs are more powerful in direct ground combat, but humans can compete through crafty choices and acquired skills. The point is that there are discrepancies between orc and human units, but overall, the game does a good job of balancing the strengths and the weaknesses, which is no easy task.

Dominant Strategies

Sometimes players can discover one or two strategies in a game that effectively dominate all others. This has the effect of narrowing the number of overall choices in the game because no one will choose the weaker strategies when the dominant ones are known.

For example, if one way of attacking is far superior, the players will gravitate toward this method. Even a minor imbalance in this regard can have a significant effect upon a game's playability. When balancing a game, make sure there is ample choice in all areas and that as the game progresses, nothing limits the players' options. When players focus on only a limited set of options in pursuit of a win, games often become dull.

Can you imagine trying to play a game in which your opponent has already calculated the dominant strategy and simply executed it? The game would be frustrating for you and boring for them. If you both knew the dominant strategy, it would be a rote entry of choices on each of your part, resulting in an experience that you could have predicted from the outset. Tic-tac-toe is a game in which there is a dominant way of playing, and thus it is not an exciting game.

What makes games interesting and challenging is the fact that their systems do not offer a dominant strategy—at least, not at first glance, or even upon repeated play. As a designer, you should always be on the lookout for dominant strategies. When you see one, find a way to get rid of it or obscure it so that players do not simply latch onto that method at the expense of everything else.

One word of caution: A dominant strategy is not the same as a favorite strategy. If hard-core players discover a way of playing your game that they like to employ over and over, but it is not always effective,

this is not a dominant strategy. If the game is balanced properly, then other players might have ample choice of opposing strategies to counter with.

Exercise 10.7: Dominant Strategy

In your original game, can you identify a dominant strategy that limits player choice? If you cannot find one, list out some strategies that do work. What are the opposing strategies that players can utilize?

Balancing Positions

In balancing the starting positions for your game, the goal is to make the system fair so that all players have an equal opportunity to win. This does not always mean giving each player the exact same resources and setup. Although many games are symmetrical in this way, just as many others are not. As we saw in our discussion of player interaction patterns in Chapter 3 on page 51, there are various and interesting ways to design the competition in your game—a symmetrical competition is only one.

Additionally, the challenge of balancing multi-player games is different from that of single player games. This is because single player games often involve a computer "player" or AI that competes against the human player. To understand how this affects balancing, let's look at two basic models for multiplayer games: symmetrical and asymmetrical.

Symmetrical Games

If you give each player the exact same starting conditions and access to the same resources and information, your system will be symmetrical. In chess, black has the same 16 units as white, opponents start in a mirror image configuration of each other on the board, and opponents have the same amount of space on the board to maneuver. Connect Four, Battleship, Othello, checkers, Go, and backgammon are likewise symmetrical systems.

In turn-based games like the ones just mentioned, there is one asymmetrical aspect that must

be dealt with. It is the issue of who moves first. This issue could throw off the fairness of the game if not balanced correctly. In his article on symmetry mentioned previously, game designer Ernest Adams points out that you can reduce the effects of one player going first by establishing a system where the first move provides little strategic advantage.[3] Chess is set up so that only the pawn or the knight can move at the opening. These are two of the weakest pieces in the game. Additionally, four rows separate the opponents at the opening, which means neither side can threaten the other with the first move. The game of Go has the komi system, which compensates the player who moves second with a predetermined number of points. (This number varies depending on what part of the world you are playing in, under which rule set, and the comparative ranks of the players.) The game of Hex, a connection game invented separately by mathematicians Piet Hein and John Nash, uses the "pie rule" (or swap rule) in which player 1 moves, then player 2 chooses whether to switch positions (or colors) with the first player, thereby negating the advantage of the first move.

Another option is to balance the system so that a game takes many moves to resolve. This renders the first move of little strategic significance. Chess is a fairly long game, so going first has little effect over the course of a whole game. Contrast chess with a very short game such as tic-tac-toe. In tic-tac-toe, moving first is an enormous advantage, so much so that it enables a rational player to always win or tie.

Adams also points out that you could incorporate chance elements to reduce the effect of one player going first. Symmetrical board games like Monopoly and backgammon require players to throw dice to move. The dice are chance elements. Because the first player could have a bad roll and the second player could have a good roll, the first mover's advantage is mitigated.

Asymmetrical Games

If you give opponents different abilities, resources, rules, or objectives, your game will invariably be asymmetrical. An asymmetrical game, however, must still be fair. As a designer, your goal is to tweak the variables so that the system balances out. If played properly, each opponent will have roughly the same chance of winning, regardless of the other factors.

This type of asymmetry is powerful in games because it can be used to model conflicts and competitions from the real world. Historical events, nature, sports, and other aspects of life are full of situations where opponents compete with differing positions, resources, strengths, and weaknesses. Imagine trying to recreate a World War II battle where the players had to begin with the same units on a symmetrical board. It wouldn't make sense. For this reason, the vast majority of digital games tend to be asymmetrical. Let's look at a few games and see how they deal with the issues of asymmetrical abilities and resources.

In the fighting game SoulCalibur II there are twelve different characters, each with its own set of ability statistics. A typical character has about a hundred fighting moves and a distinct fighting style. As in many fighters, a move can inflict a variable amount of damage—from none all the way up to a kill—depending on the counter move played by the opponent. Each time one character attacks another, a damage payoff is determined for one or the other or both of the characters. Mastering the game requires an understanding of how and when to play fighting moves in different situations against different characters. In this example of asymmetry, designers at Namco balanced a system where opponents have the same objective and basic movement resources but different abilities.

In the RTS game Command & Conquer: Generals, players choose one of three different armies: America, China, or an underground terror organization called the Global Liberation Army. Players adopt a playing style that matches the strength of their chosen army. The Americans utilize high tech weaponry, the Chinese swarm opponents with sheer numbers, and the Global Liberation Army relies on cunning and sneakiness. The key to this game is that the armies

10.8 Command & Conquer: Generals

have different resources that are balanced, so that, if played skillfully, any one of them has ample choices to beat the other two.

Another game with asymmetrical resources is NetRunner, a collectible card game designed by Magic: The Gathering creator Richard Garfield. In this game, one player plays a corporation using one deck of cards, and another player plays a runner (kind of like a cyber hacker) using another deck of cards. The cards in the two decks are completely different. The corporation uses cards to build and protect data forts, with the ultimate goal to complete corporate agendas. The runner uses cards to hack corporate security and steal agendas before the corporation can complete them. The competing sides in this asymmetrical game utilize completely different resources and abilities, but they share the same overall objective: to score seven agenda points.

Exercise 10.8: Symmetrical versus Asymmetrical Games

Is your original game prototype symmetrical or asymmetrical? Describe how and why.

Asymmetrical Objectives

Another type of asymmetry involves offering each player different objectives. This can add variety and intrigue to a game. You can offer asymmetrical victory conditions when opponents are otherwise equal, or you can combine asymmetrical objectives with asymmetrical starting positions for a real balancing challenge. In this case, your motive might be to add variety or evoke a real-life situation. Following are several models for offering asymmetrical objectives. Notice that in each case the differing objectives are still balanced against each other to keep the game fair.

10.9 NetRunner—corporation cards versus runner cards

Ticking Clock

Many electronic games allow maps to be set up where a weak defender must fend off a strong attacker. The defender's objective is to hold out for a set amount of time. The attacker's objective is to kill all defenders before time runs out. The second mission in the StarCraft tutorial works this way. In it you must build a small human base and hold out for 30 minutes before being overrun by a horde of attacking Zerg.

The ticking clock is a staple in mission-based games including Homeworld, WarCraft, and Command & Conquer. The model is also used in turn-based military board games such as Panzer General. Here the ticking clock victory condition is measured in a set number of turns versus a set amount of time. The weaker defender must hold out for 30 turns.

The multiplayer mode in the RTS game Age of Empires lets players choose to start the ticking clock as a victory condition on their own. They start it if they choose to build an expensive building called a "wonder of the world." When one player builds a wonder, all opponents see the ticking clock start on their screen. The player must now defend his wonder from being destroyed by all other players. If he can hold out until time runs out, then he wins the game. In this case the ticking clock is a victory condition chosen strategically by a player. It is balanced into the game to enable richer methods of play.

Protection

This is a variant on the ticking clock, and it can be equally dramatic. In this model one side tries to protect something (such as a princess, magic orb, secret document, etc.) and the other side tries to capture it. If the defenders protect or sneak the thing to safety, they win. If the attackers capture the thing, they win. Many games include missions that work like this. One example is the beach invasion map in the World War II-based game, Return to Castle Wolfenstein. On this map, the Allies' objective is to storm a beach held by the Axis. Then they must penetrate a seawall, infiltrate the base, and steal several top-secret documents. The Axis objective is to protect these things and keep the Allies from completing their goals.

Combination

It is also possible to combine ticking clock and protection devices. Take, for example, multiplayer assault maps in the FPS game Unreal Tournament. These maps have a ticking clock (usually 4 to 7 minutes long), as well as objectives that need to be protected. The attackers' goal is to reach the headquarters, steal the code, or blow up the bridge. They try to do this as quickly as possible, while the defenders protect the objectives for as long as possible or until the ticking clock runs out. When the goal has been met, the time to beat is displayed. The two teams then switch roles. They play the same map, but the team who was just attacking is now defending. The new attackers

try to beat the time set by their opponents in the previous round. This type of game can be extremely exciting because of its clear objectives and dramatic use of time.

Exercise 10.9: Asymmetrical Objectives

Take the original game prototype you have developed and create a variant with asymmetrical objectives. If your game is a single player game, add a choice of objectives. Describe what happens to the gameplay when you test the game with these changes.

Individual Objectives

In the classic board game Illuminati, the designers use asymmetrical objectives in a novel way. It is a game of politics, diplomacy, and sabotage in which opponents vie for control of societal groups such as the Mafia, the CIA, the "Boy Sprouts," Trekkies, and convenience stores. Each player can play for a shared objective: to control a specific number of groups, between 8 and 13 depending on the number of players in the game. Or players can go for their own individual objective. For example, the individual objective for the "Servants of Cthulhu" is to destroy any eight groups. The individual objective for "Discordian Society" is to control five "weird" groups. Players must watch to ensure that no one gets the shared objective while also battling and negotiating to ensure that other players cannot

10.10 Illuminati Deluxe

achieve their individual objectives. The differing objectives create an environment of shaky alliances and mutual distrust. The game is balanced so that, to win, players must cooperate with one another in some instances and betray one another in others.

The previous models are only a few ways to think about asymmetrical objectives in games. Like many concepts in game design, there are other ways to go about it, some of which can be found in existing games and some of which have yet to be invented.

Complete Asymmetry

Scotland Yard is a popular board game in which just about everything is asymmetrical. In this game, one player takes on a group of opposing players who work as a team. This player is the fugitive, Mr. X, and the other players are a team of Scotland Yard detectives trying to track him down. To make this contest fair, the designers at Ravensburger balanced the system so that Mr. X has the ability to hide. He also has unlimited subway, bus, and taxi tickets (i.e., resources) from which to choose. Mr. X moves around London invisibly but must surface every four or five turns according to a turn schedule. The detectives use information about where Mr. X was last sighted and work in coordination to try to surround him and cut off potential lines of escape. The detectives have a set number of movement tickets. If one of them runs out of a type of ticket, he cannot use that mode of transportation anymore. Mr. X's objective is to evade capture for 24 turns. The detectives' objective is simply to catch Mr. X at any time. Essentially, the following are balanced against one another: Mr. X with unlimited resources and the ability to hide versus four or more detectives with limited resources and the ability to work in coordination. The game variables are tuned so that over the course of a whole game each side has an equal chance of winning.

In the symmetrical and asymmetrical multiplayer models we have just looked at, the most important balance to work out is between the various players. Because most models of multiplayer interaction employ other players as the basis of the game conflict, the question of balance often comes down to a question of how resources and powers are distributed to each party at the start of the game.

In single player games, however, conflict is usually provided by the game system either in the form of obstacles, puzzles, or AI opponents, which we discuss on page 297. As with the multiplayer models, single player games can also employ symmetrical or asymmetrical forms of play.

Balancing for Skill

Balancing for skill involves matching the level of challenge provided by the game system to the skill level of the user. The challenge with this is that every user has a different skill level.

For some games, it is practical to simply offer multiple skill levels. For example, the original Civilization offers five skill levels: chieftain, warlord, prince, king, and emperor. Each of these levels is progressively more challenging to play. The difference between the skill levels in this system is simply a different balance of numbers in the system variables.

When you play Civilization at the easy level, chieftain, you start with cash reserves of 50, and when you

Feature	Chieftain	Warlord	Prince	King	Emperor
Endgame Year	2100 AD	2080 AD	2060 AD	2040 AD	2020 AD
Starting Cash	50	0	0	0	0
Content Citizens Number of citizens per city born content.	6	5	4	3	2
CP Rows of Food Number of rows in computer player's food storage box.	16	14	12	10	8
CP Resource Cost Multiplier Computer players have cost to build units and improvements multiplied by this amount.	1.6	1.4	1.2	1.0	0.8
CP Lightbulb Increment per Advance Each time an advance is discovered, the cost of the next advances by this amount.	14	13	12	11	10
Human Player Lightbulb Increment per Advance Each time an advance is discovered, the cost of the next advances by this amount.	6	8	10	12	14
Barbarian Unit Attack Strength Multiplier Barbarian's attack strengths are multiplied by this number.	0.25	0.50	0.75	1.00	1.25
Parley Coin Demand Multiplier Peace payment demands are multiplied by this number.	0.25	0.50	0.75	1.00	1.25
Civilization Score Multiplier Used to convert final score to percent for High Score ranking.	0.02%	0.04%	0.06%	0.08%	0.10%

10.11 Civilization difficulty levels

play at the emperor level, you start with cash reserves of 0. At chieftain, the computer opponents attack at 0.25 strength, whereas at emperor their strength is multiplied by 1.25. Figure 10.11 shows a chart of the system variables for each Civilization skill level.

Exercise 10.10: Skill Levels

Does your game prototype have skill levels? If so, describe how they work and the method you used to balance them. If not, why not? Can you add skill levels, and how would they affect the gameplay?

What if it is not practical to offer multiple skill levels for your game? Perhaps your design is not as dependent on starting variables as the Civilization example. In this case, your best bet is to balance the system variables against the median skill level of your target players.

Balancing for the Median Skill Level

Balancing for the median skill level requires extensive playtesting with players from your target audience across the range of ability levels—from novice to hard-core gamers. Designer Tim Ryan suggests a good way to find the proper ability levels in his article on Gamasutra.com.[4] First, set the high water mark of difficulty by testing with hard-core gamers. Next,

set the low water mark by testing with novices and progressively adjusting the difficulty level downward.

When you have these boundaries established, you can balance the system variables to be in the median between these two marks. In games that are structured in progressive levels of play, which is most single player video games, you can incrementally increase the difficulty level for the player as you move from level to level in the game. Of course, each level will have to be balanced individually.

Balancing Dynamically

In some types of games it is possible to program the system to adjust to the ability level of the players as they play. Take Tetris, for example. In this famous game, different shaped blocks fall downward from the top of the screen. The player rotates the blocks and moves them left or right as they fall to attempt to fit them together at the bottom. If the player fits pieces together to fill a row completely across, that row disappears and points are scored. When the game starts, the blocks fall slowly, so it is fairly easy for the player to fit them together at the bottom. But as the score increases, so does the speed at which the blocks fall. The system is balanced so that the difficulty increases automatically as the player's ability increases. In this case, difficulty is directly related to the variable of speed.

10.12 Balancing for the median skill level

10.13 Tetris for Game Boy

10.14 MotoGP and Road Rash

*MotoGP © 1998, 2000 Namco Ltd.,
All Rights Reserved. Courtesy of Namco
Holding Corp.*

Single player racing games such as Gran Turismo 3, Project Gotham Racing, and Mario Kart 64 have a self-balancing mechanism. In these games, when a race starts, the computer opponents (i.e., the other cars) accelerate up to their maximum speed. This speed is slightly slower than the maximum speed achievable by a human player if she drives perfectly. The computer opponents remain at maximum speed as long as the human is close or leading the race, meaning the pack will be tight. When the human crashes her car, the rules for the computer opponents change. They slow down to a reduced speed so that the human can catch up.

When the human player closes in on the computer opponents, they accelerate back to their maximum speed. The human players can be unaware that this is going on. The ideal is for the human players to feel that they are successful because of their own abilities, but at the same time keep the game balanced so that novice players are not shut out from the possibility of winning.

Balancing Computer-Controlled Characters

A problem with designing computer characters is that they must seem to be human and make mistakes. Otherwise a computer-controlled race car could whiz through a track at maximum speed without crashing; a computer-controlled rifleman could hit an opponent between the eyes with every shot. This would clearly be no fun for a human player. Designers solve this problem by designing a character to act within a range of possibilities. Here's how the flying saucers work in Asteroids, as explained by the programmer, Ed Logg:

> *Sluggo [the big saucer] fires at random. Mr. Bill [the little saucer] aims. Mr. Bill knows where you are, and he knows what direction you're moving in. He takes this information and picks a window bounded a few degrees on each side of you, and then shoots randomly inside of that. For this reason, you should never move straight at him. It makes you bigger relative to him. [Also] the higher your score the more accurate Mr. Bill becomes. When your score reaches 35,000, he narrows down his firing window and increases his chances of hitting you.*[5]

In this example the saucer aims randomly within a few degrees of the player. This provides a variable that can be tuned to balance the game. If the number of degrees is increased, then the saucer is more likely to miss, and the game is easier. If the number is decreased, then the saucer is less likely to miss, and the game is harder. The result is a balanced, challenging, but not impossible, computer opponent.

A Conversation with Rob Pardo

Rob Pardo is the vice president of game design at Blizzard Entertainment in Irvine, California. Blizzard makes some of the most respected and best selling games in the industry, including the WarCraft, Diablo, and StarCraft series, among other games. In this conversation, Rob shares some details about the game balancing process he's developed with the team at Blizzard and also some of his views on being a professional game designer today.

On his role at Blizzard:

Game Design Workshop: *Can you tell us about your role at Blizzard?*

Rob Pardo: My title here is Vice President of Game Design. I am responsible for all game design done at Blizzard. I have also acted as the lead game designer on several Blizzard products including Warcraft III and World of Warcraft.

GDW: *One of the things we're interested in for this conversation is the process that goes into balancing a Blizzard game. Is a lot of what you do involved with game balancing?*

RP: Well, I do that, but game design includes lots of things. For example, on World of WarCraft I've done a fair amount of balancing on the different classes for the game. So I'm trying to hone the skills for each class and put in the right balance numbers and work with the designers to make each class stand on its own.

On WarCraft III, as lead designer, I had broader responsibilities. It went to unit design; it involved working with Chris Metzen, our storywriter; it went to working with our level designers and determining the gimmicks and play features for each level and how they all fit together. It went to, you know, "how does the mini-map work?" spec'ing out the design documentation and giving it to programmers and artists where appropriate. It's basically all areas of the game that the player sees and interacts with.

Game balance is just one small, but important, part of what we do.

On the process of designing WarCraft III:

GDW: *Can you tell us about the process of designing WarCraft III?*

RP: Sure. WarCraft III was interesting because it went in a couple of different directions. First of all, it was our first 3D game. So that presented some challenges. Also we wanted to do something different from StarCraft. We had just rolled off StarCraft and we felt that we'd nailed that form of gameplay—you know: macromanagement, action, RTS—whatever you want to call it. When we rolled onto War III we thought about the fantasy elements of the game, and we wanted to take a new tack. So we decided to add a lot of RPG elements.

With 3D we decided to bring the camera down quite a bit and try out some things. The problem was with the camera pulled all the way down it became a pseudo-third-person experience. It was

disorienting when you went around the map, and it was difficult to select units in battle because your camera frustum was pointed in one direction so you didn't have a good view of the battlefield. It was a challenge because we still wanted a fun strategy game. Eventually we pulled the camera into a more traditional isometric view, and that's when we really started making progress.

GDW: *That's great. What were the first things that you built for WarCraft III? Did you make a prototype?*

RP: Yes. Since it was our first 3D game it was really important to get the 3D engine up and running. And we had to get the art path ready so the artists could start testing art files with the new engine. Something we did for the first time on War III (and now we've been doing on all our projects) is we committed to making a build that ran every day. So when we finally got the engine running we could immediately put art in it. From that point forward every day the team could come in and boot up the newest version of WarCraft III and it would work. Obviously not every day did the new build work—there would be bugs sometimes—but that was a commitment and it really helped us see where we were. On StarCraft it wasn't until right before beta that we started getting stable builds on a regular basis. So that was a big step for us. So we spent a lot of time prototyping the look of the world and what we wanted to do with the camera and what elements we wanted to go with.

GDW: *It sounds like figuring out where to put the camera was a part of the prototyping process.*

RP: Yes, for sure. Something we believe in strongly here at Blizzard is iterative design. You know, prototype can mean a lot of different things. We didn't really have a prototype that was made of blocks that we could test gameplay on like are often made at other companies. In this case we did more of a technology and art prototype rather than a gameplay prototype. So once we had the art and the actual 3D engine in there, that's when we actually started messing with the camera; messing with the units; trying to figure out exactly what kind of game we wanted to make for War III.

On developing the WarCraft III races and units:

GDW: *Can you tell us about the process for developing the races and units?*

RP: We knew we didn't want to do StarCraft. We knew we wanted to add role-playing elements to the game, and we knew we were going the 3D route. Some people on the team wanted a lot of units. Some people wanted to do a few units. That was a contentious topic in the early days.

One of the first things we came up was the concept of "heroes." In the old days we called them "legends." We actually referred to the game itself as "Legends." We didn't want to refer to it as WarCraft III because we felt we might end up making just a sequel to WarCraft II. So we referred to the game entirely as "Legends" with the thought that we might release it with that name.

Early on we designed a lot of legend/hero units. We designed many heroes including the Archmage and Warlord. We built them in prototype form and started playing around with different spell kits and tried to figure out how they should work. We asked: "Should they work like Diablo heroes?" We tried to figure out what a hero was; what that meant in a strategy game versus a pure role-playing game. We experimented with stuff like, "Well maybe you can only have units when they are following their heroes."

Those concepts formed a lot of the core gameplay early on. But it was a baseless sort of gameplay at that point. Then on the art side we were trying to figure out what we could do with 3D: what was possible, what wasn't. At the same time we were also experimenting with different network models and technological concepts that were going to dictate certain gameplay elements. So there was interlinking between gameplay, art, and technology.

GDW: *So the idea of hero units was an early concept that you built on. What about the four races in the game? How were they developed?*

RP: Early on we had lots of discussions about races. We talked about different cool abilities and play styles they might have and quickly decided that Undead should be a race. It was interesting: In the early days we sketched ideas for nine totally different races. That was never really reasonable though—it was more like nine core concepts from which we could draw the coolest ideas. Nine races went down to six and then that later went down to five. We really thought we were going to release with five for a long time. So in the beginning we had lots of races and units designed on paper.

We started implementing Humans and Orcs first and then the Undead. The fourth race, the Night Elves, was next. They were a compromise between early race concepts we had for Dark Elves and High Elves. We wanted to get elves in the game in a way that hadn't been done before. The fifth race was Demons. We didn't cut them until probably right before alpha. The problem was: We wanted Demons to be the ultimate bad guys in the story line, but we also wanted to be able to balance them into multiplayer play. We were having a lot of kit issues with how they should work and how they should interact with the other races. Ultimately we decided to keep them as bad guys in the story but drop them as a full-blown playable race.

GDW: *Interesting. You said you had "kit" issues?*

RP: Yes. When we look at a race we think: "What's this race about? Is it a sneaky race? Is it a micromanagement race? Is it a heavy ground race? Is this race supposed to be really versatile? Is it magic?" When we looked at Demons we said, you know: "Really powerful. Good at Fire Magic. Lots of incredibly tough units." It seemed weird to come up with say a Peon or Footman unit for the Demons. They just didn't lend themselves to that. We decided we'd make Demons less cool by filling out all the roles that races need to fight each other on Battle.net.

On "concentrating the coolness":

GDW: *Game balancing always seems to involve tuning system variables numbers up and down. Sounds like with WarCraft III you guys thought really big early in the project and then tuned some numbers downward as you went along.*

RP: That's right. Early on we brainstormed tons of cool ideas. We have lots of sharp, creative people here so we come up with way more ideas than we could ever put in a game. Then the designer's job over the next year or two years (however long the dev cycle is before the beta) is to hone all those ideas. Some we have to get rid of, some we have to modify, and some become a cornerstone of the gameplay.

One of our mantras—we have lots of mantras around here—is "concentrating the coolness." With War III, for example, we could've blown out to 20 or 30 units per race if we wanted to, but we

wanted each unit to be meaningful. And we wanted to make sure each race had a unique feel. So even though every race has flying units and worker units they still all do things in different ways.

We wanted that idea to carry through to heroes too. Each race should have a little set of heroes that made it unique. When we started detailing out the heroes' spell kits we originally had four heroes per race. But the spell kits were muddled with overlap, so we cut down to three heroes. That decision created a big controversy with our fan base because it led to us cutting the Human's Ranger hero. The Ranger ended up on the cutting room floor and there were petitions and all kinds of stuff like that online. So it was quite a contentious cut.

GDW: *Wow. Talk about a rabid fan base. They were petitioning the loss of a character before they'd even played the game.*

RP: Yeah. Crazy isn't it (laughs)? We like to have a big fan community going even before we go beta. It's great to have fans that are really into it. The downside is you can't just blackbox a game and bring it to market. Lots of people are watching.

The day the Ranger was cut was big. People knew about her because we'd shown her on our Web site. When she disappeared one day it caused quite a ruckus. Again it was that kit argument I was talking about. Humans already had a ranged magic hero with the Archmage, and they had a cool tanklike hero with the Mountain King, and they had the Paladin hero as well. I was a little heartbroken to see the Ranger go too. But I looked at the Night Elves and they had lots of archer units. Even looks-wise the Ranger looked like an Elven archer. We had to differentiate the races so she got cut. It was still really tough.

On the effect of balancing heroes in WarCraft III:

GDW: *That's interesting. The heroes have really affected the gameplay dramatically. One thing I notice in WarCraft III is that I end up playing with smallish parties of units and not the huge armies that I play with in StarCraft.*

RP: That's right. When we started developing War III, a lot people wanted another game with StarCraft-style gameplay. You know macromanagement and that. But we wanted to branch out a bit. We wanted a game with units that were tougher and more meaningful. In StarCraft you can just throw lots of units into the battlefield and not care whether they live or die. You can get an army of 50 to 100 units going and it's no big deal.

For War III we wanted to get rid of what we call the "fodder" unit. We want you to care about every grunt and every footman. Part of the reasoning for that was the increased focus on heroes. We wanted a hero to be a dominant force in the battlefield because, well, that's what you think of as a hero. So if we know there's going to be 50 units on the battlefield, then we'd have to make the hero ridiculously powerful for him to have a meaningful impact. If you have a battlefield with say 10 or 20 units, then the hero could be more realistically balanced. For War III to work the way we'd envisioned, the hero had to be balanced proportionally to the number of units that could be in a battle. Right? If the game was designed for 50 unit battles and then a hero gets into a fight with say only 10 units around then he'd just mop them up. In War III it's normal to see people running around with maybe 12 to 15 units. That's like an army in War III. Twenty-four units is almost the max.

Trying to enforce that mechanic, though, was a challenge. It was like, "How do we do that?" We had the mechanic in the game, "food," which kind of limited the number of units you have. We also had gold and lumber intakes for resources. But what was happening early on was that with just those mechanics in place players would build up to the cap in the game and just play there. Then if they lost their units they'd have this big gold and lumber surplus that they'd just spend to rebuild their army and max out again. It just didn't play very fun.

GDW: *This sounds like how you came up with the system for "upkeep."*

RP: Right, that's where upkeep came from. Upkeep was a concept that was pretty controversial and we tried a bunch of different ideas beforehand. But that's what we eventually settled on.

The concept of upkeep is: The bigger your army is, the more it saps your gold income. If you build up a big army then upkeep siphons off your excess gold income so you can't get these huge gold surpluses. The idea was to encourage you to fight more when you have fewer units.

Originally we tried to encourage small armies just through tweaking unit numbers and costs. But as we watched people play around here—with giant armies—we realized we'd have to go back to the drawing board. We sat down and said, "We want a game that plays with fewer units where heroes feel important. How do we make that happen?"

Everyone brainstormed up a bunch of ideas and we talked through each one. We just kept picking at it and testing ideas for a couple of weeks until we had a system that worked. Actually lots of people hated upkeep at first so getting it implemented was controversial. Part of the problem was we origi-nally called it "Tax." I guess it gave people, I don't know, like April 15 flashbacks or something (laughs). They couldn't accept the game dynamic just because of the name. Once we came up with the name "upkeep," though, the last people opposing it said, "Okay, let's try it."

Upkeep was a game mechanic that got developed to encourage the hero-based gameplay we had set as a goal. As a game designer, figuring stuff like that out is series of big conversations to little ones to minibattles to see which elements work, which don't, which need to be changed, and which need to be yanked. You know, it's an ongoing process every day.

On iterative design and balancing a game after it has been released:

GDW: *So it sounds like iterative design is a key component for how this gets done.*

RP: Absolutely. We hone system variables over and over as we play and test a game. We're not afraid to pull a unit, pull a major design system, or put in a new one all the way up until beta. In fact with War III, we actually introduced a couple of spells postbeta. We had designed them ahead of time knowing we might need them. I figured we should go into beta with about 90% of the racial units and spells in the game. I'd learned from previous betas that, no matter how great we think the units play, once pro gamer-types—who're going to play much more than we'll ever play and at a much higher skill level—get a hold of it that we're going to have to change things. So I went ahead and left some holes in each race so we could fill them with different things if we needed to. And sure enough we did that.

GDW: *Interesting, so you were still balancing things after beta. Is it still being balanced?*

RP: Yep. We did patches to the StarCraft balance for two years after we released it. It definitely evolves. You could probably do a sociology class on the evolution of a game community.

There are two things that I see that happen once a game's been released. First of all, imbalances are discovered that just were never discovered before. This is because a million people playing a game is a lot different than a thousand people playing from the beta. Somebody out there will come up with a creative play technique that no one else has thought of. Then once he starts using it on Battle.net, every person he plays sees the imbalance and it spreads across the community like a virus. That forces our hand into doing something.

The other thing that happens is just evolution of gameplay. Sometimes I see things that I want to patch slowly. Like, suddenly one race might be winning a larger proportion of games on Battle.net for a couple of weeks and it seems like a dominant strategy has emerged. And we could certainly go in and "fix" it. But usually what's happening is just an evolution of how people play. You see spikes and valleys. What happens is—let's say the Humans become dominant for a couple of weeks. Well, you've got to give the community a chance to see the new strategy and develop a counter strategy. You see the same thing happen in professional sports sometimes. You know in NFL football the 3-4 defense dominated for a few years. It wasn't an imbalance that they had to go to the rules committee and say, "We need to outlaw the 3-4 defense because it's too badass." The offensive coordinators just had to scheme and develop their playbooks to attack it. I see the same thing sometimes in our game community. It can be really challenging sometimes postrelease to decide what to patch and what not to patch. So it's a process.

GDW: *Tell me a about the software tools you use to do this. You can track what players are doing pretty closely via Battle.net?*

RP: Yes. For War III we hired a Web programmer to make a system that could track all kinds of data. We found someone who had created a really amazing fan site that tracked statistics from our other games and gave him a job. Like we'll say, "We want to see how races play against each other on a map by map basis." And he can make a report of that. We do that pretty often. So there'll be times when my game balance designer wants to make an adjustment to the Orcs or something. And I'll say, "Okay, that sounds reasonable, but let's look at the stats too." And we'll look at the stats and we'll go, "Hey, actually Orcs aren't really having that problem, so let's hold off for a while."

GDW: *So you use the data to determine whether the imbalances are perceived or real.*

RP: Yeah. We're not slaves to it though. It's just one of many tools we use. You have to have an intuitive sense of it also. Luckily the game balance guy on War III is a really good player.

We also have a group of top-level players that send us feedback directly. Like if we see something like the Undead hammering the Humans in a peculiar way then we might gather replays from top-level players and look at exactly what they're doing.

GDW: *Sounds like there's a symbiotic thing going on between the fan community and the development team. For example, you hired the Web programmer from the fan base.*

RP: Yes, our webmaster had one of the top WarCraft II Web sites back in the day. He got hired as a QA tester and then moved himself up on the Web side. Even if you're the best programmer in the world, we're not going to hire you unless you're a game enthusiast. If someone's a fan of our games and they have development skills too, then that's perfect.

GDW: *It must be a dream job for them.*

RP: Yeah. They tend to be pretty happy employees (laughs).

On playtesting at Blizzard:

GDW: *Okay, this is a good segue to the next point: I'm curious about your process for playtesting early versions internally.*

RP: Sure. Before we go beta we're—as a development team—playing on a fairly regular basis. We don't have structured play sessions like where we say, "Friday is playtest day" or something because, like I said, we're all a bunch of gamers. Everyone here loves to play these games. So once the game gets playable everyone on the team is playing it. There'll be lunchtime sessions where all the artists play together. They work in a bullpen so they're really close. And the designers will be playing together and the programmers will be mixing and matching. One way we know when a game is fun is when we have to say to some people, "Hey you're playing too much of the game. Start working some more." (laughs)

Programmers have created many clever ways of coding their computer-controlled characters. In fact, there are many books just about programming game AI. What is important for you as a designer is not how the characters are coded but that they can be tuned to provide a balanced and satisfying experience.

TECHNIQUES FOR BALANCING YOUR GAME

As you work through these aspects of balancing your game, you might be tempted to dive right in and change everything at once. The playtesters say they want more of X and less of Y, they want to change procedure A and make a new rule B. Before you know it, you have a real mess on your hands—your balancing process is out of control.

On the following pages are some techniques for keeping a calm head and making changes that truly improve your game. Obviously these apply at all stages of revision, but right about now is probably when you need them most. If you master these techniques, you will be able to take a game that works marginally well and fine tune it without making changes that lose your previous work.

Think Modular

Most games are not comprised of a single system but a set of interrelated subsystems. A good way to simplify a game is to think in terms of modularity. Breaking your game up into discrete functional units allows you to see how the mechanics of each unit interrelate. If you think of a game like WarCraft, it has a combat subsystem, a magic subsystem, and a resource management subsystem. Each of these subsystems is a part of the greater game system. The more interconnected the various pieces, the harder it can be to make alterations because one change can throw off the balance of seemingly unrelated parts of the game.

On being a game designer:

GDW: *Tell us something you've learned about the craft of being a game designer.*

RP: One thing I've learned from starting young to where I am now is: Yes you need to have all the game design skills, and you need to know about different development disciplines so you can design smart. A designer needs to wear a lot of different hats. But the other side of it that I don't see talked about much is the skill of working with your team.

The game designer, at least here, is not the primary idea generation guy. He's the primary vision holder for the game. I struggled early on when I used to really fight for my ideas versus other people's ideas. What I learned was, "Hey, I'm in a position where I can put in a lot of the game design elements, and it's really important for me to be a conduit for everyone else's ideas." When I made that mental shift it was a pretty big day.

Now I look at my job and see that it's really important to listen to everyone else on the team and try to get their ideas in when they are good for the game. Sometimes a team member will have great idea but not know how to package it within the overall framework of the game. So that's where I come in. I might work with them and try to get it into the game in a way that works from a game system perspective. Once you do that then your job becomes a lot easier. Everyone trusts you more. And it's just this domino process: You're not fighting your ideas versus their ideas; you're not explaining to them why their ideas suck. You're working with them, and you're their tool for getting good ideas into the game. Then everything just flows better.

The key to dealing with this problem is to isolate the subsystems and abstract them from one another. This type of functional independence is a critical part of large-scale game design. It is similar to object-oriented programming, where each object is clearly defined with a set of input and output parameters, so when you make a change somewhere else in the code, you can track how it affects every other object. The same holds true for game design. If you keep your subsystems modular, when you tweak one element of your game, you know exactly what impact it will have on the other parts.

Purity of Purpose

Along the same lines, try to design your game with a purity of purpose, meaning every component of your game has a single, clearly defined mission. Nothing is fuzzy, nothing exists for no reason, and nothing has more than one function. To accomplish this, visualize your game mechanics using a flowchart as shown on page 188 and define the relationship and purpose of each mechanic. This will help you to avoid creating a morass of rules and subsystems, which will grow increasingly convoluted as your game evolves. When this principle is adhered to, tweaking an element only changes one aspect of the gameplay, rather than several aspects, and the job of balancing your game will become methodical, rather than a haphazard guessing game.

Exercise 10.11: Purity of Purpose

Think about your original game prototype. Are there any extraneous elements—elements that have no purpose? Remove the least important element of your game and test the system without it. Does the game still function? Is it complete? Balanced? Remove another element. Continue stripping elements from your game and retesting until you reach a point where your game no longer functions. Now again answer the question: Are there any extraneous elements in your design?

One Change at a Time

Train yourself to make only one change at a time. Limiting yourself to just a single change often feels cumbersome because after each change, you have to test the entire system again and gauge the effects. However, if you change two or more variables at once, it becomes difficult to tell what effect each of those changes has on the overall system.

Spreadsheets

When balancing a game, nothing is more valuable than a good set of spreadsheets. As you design, you should track of all your data in a spreadsheet program like Excel. This will make the job of balancing your game much smoother.

If possible, your spreadsheets should mirror your game's structure. This will allow you to better communicate with your programmers. We strongly recommend sitting down with your technical team and laying out the spreadsheets together. Each subsystem within your game, whether it is combat, economic, or social, should have its own set of interconnecting tables. Apply the same principles of purity of purpose and modularity to your spreadsheets. Look at the spreadsheets as both your starting point—a great tool for laying out the game design—and your ending point—a tool used in refining and perfecting the gameplay.

Exercise 10.12: Spreadsheets

Take the game variables you listed in Exercise 10.5 and put them into a spreadsheet program like Excel. Make sure that the structure of the spreadsheet parallels that of the game system. Now you can use this tool in balancing your game.

CONCLUSION

Congratulations, by now your original game should be functional, internally complete, and balanced. That means you are ready to begin refining your game, the final stage of the design process. But before we move on, one word about how you "know" your game is really balanced. We have filled you up with rules, tools, and methods, but when it comes to balancing a game, much of what you do will depend on your gut.

We mentioned this briefly early on. There is no way to teach you how to use your instincts in a book.

Intuition is both a gift and a learned skill. The more you design, the finer your gut instincts will become. You will know when a game is out of balance without a tester raising an eyebrow, and you will be able to spot a loophole or dead end immediately and implement the proper fix. Our goal in this chapter has been to give you a head start, and hopefully, when you combine this with your natural sense for game design, you will be able to master the process quickly and see your game reach its full potential.

DESIGNER PERSPECTIVE: BRIAN HERSCH

General Partner, Hersch and Company

Brian Hersch has designed all types of games, including CD-ROM games, DVD games, and games for television game shows. He is best known for his blockbuster board games, including Taboo, SongBurst, Outburst, Trivial Pursuit DVD Pop Culture, Oodles, Hilarium, ScrutinEyes, and Out of Context.

On getting into the game industry:

Trivial Pursuit unlocked my creative curiosity, and my business background led me to conduct a market research study of games in general, and the then-burgeoning adult game category. The interpretation of that research resulted in a recognition that a number of sociological imperatives were all coalescing at that time. A recession was impacting entertainment budgets. The baby boom was strapped with bills, had demonstrated a willingness to entertain at home, and had a predisposition to play board games. So the opportunity presented itself, and I jumped in. Happily, our interpretations were correct, and our creative efforts resonated with the public, and our games sold.

On favorite games:

- *Taboo*: Because it is one of my babies, and it really demonstrated how the simplest concept can be translated into fun.
- *Carducci*: Though it never licensed, this was the game that I am proudest of. It has so many creative and fun elements, and people seem to really enjoy it when we play (even though no company can figure out a marketing strategy for it).
- *Poker*: Because I enjoy taking money from my friends.
- *Trivial Pursuit*: Because it was perfectly suited for my brain full of garbage, and it was the catalyst for my entry into this business.
- *My most recent game*: Because I really get enthused by my work and I never send a game out unless I really enjoy it and am proud to have my name on it.

On inspiration:

I am not sure that my design instincts are inspired as much by games as by outside influences. I happen to design games. And obviously I have an understanding of play patterns and compelling entertainments. But I think purely from a design standpoint, I am often more stimulated and inspired by nongame products: art,

photography, architecture, edgy commercial products, and innovations. I think I fear being over-influenced by other game designers' works, and I worry about the impact on my own desire for originality.

On the design process:

I subscribe to the theory that creativity is 90% inspiration and 10% perspiration. On occasion I test the theory by trying to force the creative process as the lead element in design, but generally I like to take my inspiration and channel it toward crafted entertainment. That may sound complex, but in the end it is all about the search for "fun." I always start with the desire to find a new combination. There are always physical components and interactive requirements between players. But the combinations are endless. Is it dice with cards? Is it teams or individuals? Do players demonstrate skills or instincts? Should players be creative or just use basic skills? The right combination can be the difference between a classic game and a forgettable one. That's the art.

On prototypes:

I am a big believer in prototypes. Like the game itself, they start off simplistic and a bit rough, and eventually they refine into parts that support and heighten the game experience. Judging the gameplay really requires that test players are not distracted by the "idea" of components rather than having examples of the component to work with. Cards can be hand drawn, but they need to be cards (as opposed to a list of material on a sheet of paper, for example). Often the specialness of the game is found in a single unique component. My best example would be the buzzer in Taboo. The original prototype was made from my garage door opener. But players at least had the chance to push a button and react to that *bzzzzzz*. That single component supported the game play, added fun, had a tactile feel, and allowed people to be free of structure.

On solving a design problem in NameBurst:

In NameBurst we wanted to create a way for each player to team up with each other player at least once per round. But there was also a requirement that on some turns one player would give, and other times with the same "partner" they would receive. We really struggled trying to create some rule that would be easy to understand. And we never did find it. Instead, we created a series of cards appropriate for different numbers of players. We snapped it into a recess on the score pad and added a slider. The game began with the slider pointing to the first pairing of players, and then each round pointed to another pairing. It also designated who gave and who received. It was a nifty physical demonstration of that which we could never succinctly put into words.

Advice to designers:

Gamble. Try and do new things. Be original in your thinking. Remember that you are attempting to put entertainment in a box. If you can engage people, make them laugh, spend a compelling hour, then you have succeeded. But it will always feel more satisfying if it is not derivative. Be original—the only thing you have to fear is rejection. And you're going to get plenty of that anyhow.

Designer Perspective: Heather Kelley

Game Designer

Heather Kelley is a game designer whose credits include Redbeard's Pirate Quest (1999), Thief: Deadly Shadows (2004), Tom Clancy's Splinter Cell: Chaos Theory (2005), Star Wars: Lethal Alliance (2006), GLEE (2006), and High School Musical: Makin' the Cut! (2007).

On getting into the game industry:

I was in grad school in Austin, studying gender and technology. Right before I graduated, a company called Girl Games opened in Austin with the goal to make PC games for preteen girls. I got on board as a researcher for their first game, Let's Talk About Me!, and then became the producer and content manager of the Web site, which included games, entertainment, and community features for 'tween girls. Over the next ten years at various companies I moved on to smart toys, PC, console, and handheld games. Basically, like many game designers, I was very lucky to be at the right place at the right time, with the right skills and experience!

On game influences:

I generally like games that present a complete aesthetic package and that exist outside the mainstream.

- *Raaka-Tu for TRS-80*: Probably the first computer game I ever played—a text adventure. I never finished it! In retrospect the design was not too great (extremely unforgiving), but I was captivated by the exotic locale and mysterious events.
- *Dragon's Lair in the arcade*: This one showed me that games could captivate the imagination in a completely different way. The gameplay was of course terribly unforgiving, and it doesn't look so special now, so it's hard to understand the complete deviation that game was from the others that surrounded it in the arcade. It was like night and day in both visual treatment and gameplay concept.
- *Vib Ribbon for PS one*: An early beat-matching game from famed music game designer Masaya Matsuura. What inspires me is the completely unique vector graphics, the warm but creepy soundtrack, the zen-out rhythm combo gameplay, and especially the ability to use your own CDs to generate levels. The game allowed you to take the game out (with the entire game running in memory on a PS one), put your own CDs in, and let the game generate the game level from the songs from your own collection. This was user-generated content way ahead of the curve, and it was a big inspiration for Kokoromi's event GAMMA 01 : Audio Feed.

- *Seaman for Dreamcast*: This game amazes me on a couple of levels—the absolutely bizarre under-lying concept (a talking pet fish with a human face that you grow in a virtual tank, and which eventually starts to psychoanalyze you), the well-honed vocal recognition system (it shipped with a microphone, and the software's ability to understand relevant conversational keywords was just eerie), and of course the voice-over intros by Leonard Nimoy.

On the design process:

Sometimes I'm given constraints to work within, and my process for those might differ from situations in which I'm starting from scratch. For my own personal work, I usually have an idea or emotion I want to convey and then think about what interaction and goals could put the player in a position to experience those feelings or ideas firsthand.

On the prototypes:

I use them as much as I can. I'm not a coder, so I usually work with a programmer to get them done. First I'll have a very "high level" design document on paper—maybe just one or two pages long. Then I will meet with the programmer and we'll talk about the idea, sketch it out more, and decide if anything specific needs to be documented. Then from these documents and the conversations, the programmer creates a piece of interaction. We review that and talk about it some more, and continue the process like that. Of course that sometimes means throw-ing out stuff that you thought was a good idea on paper but which turns out not to work when you get it in your hands. That's what prototyping is all about! If you would like to see an example of the prototyping process for one game I designed, you can visit this Web site, which documents (from the coder's perspective) the development of my game design collective Kokoromi's first game, GLEE. (GLEE was code named KISH during the development process.) http://code.compartmental.net/kish/

Advice to designers:

A lot of game design training focuses on the creation of documents. But don't lose sight of the big picture. Documents are part of the process, not an end in themselves. Do what you need to communicate ideas and structures, but don't document more than you really need. Keep your communication lean by picking the best medium for each bit of information. Draw sketches, make a flow chart, pull reference images and videos from the net, or heck, roll around on the floor if you have to! And whenever you can, build things with inter-activity to represent your concepts. If you know or can learn a bit of programming, you can use development environments like Processing, Flash, or Virtools. Hone all these communication skills now so you can use them flexibly throughout your career.

FURTHER READING

Conway, John. *On Numbers and Games*. Natick, MA: A K Peters, 2001.

Knizia, Reiner. *Dice Games Properly Explained*. Surrey, UK: Elliot Right Way Books, 2000.

Lecky-Thompson, Guy W. *Infinite Game Universe: Mathematical Techniques*. Boston: Charles River, 2001.

Nowakowski, Richard J., ed. *Games of No Chance*. Cambridge, MA: Cambridge University Press, 1998.

Tweet, Jonathan, Williams, Skip, and Cook, Monty. *Dungeons & Dragons Core Rulebook Set*. Renton, WA: Wizards of the Coast, 2003.

Weinberg, Gerald M. *An Introduction to General Systems Thinking, Silver Anniversary Edition*. New York: Dorset House Publishing, 2001.

END NOTES

1. Owen, David. Invasion of the Asteroids. *Esquire*. February 1981.

2. Adams, Ernest. "A Symmetry Lesson," Gamasutra.com, October 16, 1998.

3. Ibid.

4. Ryan, Tim. "Beginning Level Design Part 2: Rules to Design by and Parting Advice," Gamasutra.com, April 13, 1999.

5. Owen, Invasion of the Asteroids.

Chapter 11

Fun and Accessibility

Remember when you first started testing your core idea, when you had just built out the foundations and structure of your game? All we were worried about at that point was making sure the idea was fun; that is, was it a good idea for a game? Now that we have gone on and created a functional, complete, and balanced game, it is time to go back and really make sure the essence of what you thought was fun and appealing is still there. Of course, you have been paying attention to whether or not your game was fun throughout the process, but now is the time to make fun and accessibility your primary focus.

Before we can test for fun, we need to think about what we mean by "fun." Unfortunately, fun is one of the most elusive concepts you will ever try to pin down. As with many aspects of art and entertainment, fun is subjective, contextual, and entirely up to personal taste. You might think washing dishes is fun (we do not), or you might think shooting bad guys is fun. Your favorite game might be entirely based on

strategy, while a friend's game requires physical skill and dexterity.

To have a useful guideline for our testing process, we can at least determine why we want our games to be fun. Games are voluntary activities; they require player participation—a high level of participation. Unlike movies or television, the show does not go on if players cease to play. So if your game has no emotional appeal, players are apt to stop playing or never pick it up in the first place. So fun appeals to the emotions. All of the emotional and dramatic elements that drive a player to pick up your game, to try it out, and to continue to play it, are usually what players cite when asked about what makes a game fun. Nicole Lazzaro discusses four very different types of fun in her sidebar, "Why We Play Games," on page 258. They are Easy Fun, Hard Fun, Serious Fun, and People Fun. Qualities such as these are what we will look for when testing your games during this next stage.

IS YOUR GAME FUN?

How can you tell if your game is fun? By this time, you know the answer: Ask the playtesters. But playtesters are not often able to articulate exactly where the fun is lacking, so you will need some tools to help identify the fun factor yourself.

When we discussed the dramatic elements of games, we talked about the fact that these elements are what engage players with the formal system—what gets them and keeps them emotionally involved in the

game. Challenge, play, and story can all provide emotional hooks that captivate players and invest them in the outcome so that they will keep playing.

Challenge

In Chapter 4 on page 86, we talked in detail about some of the element of challenge, including the state of "flow" that players can reach when the challenge

the game offers is perfectly tuned to the participants' skill levels. The following list of thoughts and questions addresses several of the most import aspects of challenge to consider when testing your game for fun. Ask yourself and your testers these questions to measure where the challenges in your game are working and where they can be improved.

Reaching and Exceeding Goals

The desire to achieve goals is a fundamental part of being human. How can your games tap into this desire? Does your game have one goal at the end or are there subgoals along the way? Reaching subgoals can charge your players up emotionally and get them ready for the long haul to the end of the game.

Are your goals too hard to reach? Too easy? Are they clearly defined? Or are they hidden from view? Ask your playtesters to talk out loud about their goals as they play the game; this will help give you a sense if they are engaged in the goals you have planned or if they are moving off on tangents.

Competing against Opponents

Many of us are competitive by nature, and competition provides a natural challenge in a game, whether it is directly multiplayer or indirect in the form of rankings or other criteria. We like to see how we compare to others, whether it is in terms of skill, intelligence, strength, or just dumb luck.

Are you missing a chance to create competition in your game? Listen to your players talk to each other if your test is face-to-face. If your testers are in different places, make sure they have a way to communicate with each other. Trash talking, ribbing, and the kind of chest thumping that happens naturally during playtests might give you a great idea for what is driving the competition in your game.

Stretching Personal Limits

The goals we set for ourselves often carry a power that the goals set by others do not. We know our own limits better than any game designer can. When we set our own goals and surpass those personal limits, there is a sense of accomplishment beyond any in-game payoff system.

Some of the most popular games of all time allow players to set their own goals—challenge themselves, so to speak. Of course, not all players enjoy this type of system; they find it too open-ended. Can your game incorporate this phenomenon? You need to know your potential audience and judge whether or not you should strive to offer this type of freedom.

Ask your playtesters to talk out loud about their personal goals in the game as they play. Are they setting their own goals; would they like to be able to set goals for themselves? You will be surprised to find out how often players create their own subgoals within a system, especially if they know they cannot win, but they want to feel a sense of accomplishment anyway.

Exercising Difficult Skills

Learning a skill is hard, but the process has its rewards when you finally master it—even more so when you get to show it off. Presenting your players with the opportunity to learn difficult skills is a challenge, but it is a hollow one unless you provide ample opportunity for them to master and display that skill. And remember, people do not master skills after five minutes of a tutorial. Learning a new skill often takes time and trials. Rewarding the player for sticking with it will make the process enjoyable.

Making Interesting Choices

Game designer Sid Meier once said, "Games are a series of interesting choices." These choices can range from where to place your blocks in Tetris to how many peons to produce in WarCraft II. If the choices have consequences, then they are interesting. If not, they are merely a distraction. Is your game providing choices with consequence? Or are your players simply micromanaging? Are players aware of the consequences as they make those choices? Creating dilemmas, where players must weigh their choices carefully, is a powerful way to challenge your players.

Ask your playtesters to explain what they think the consequences of their choices will be as they play. What factors are weighing into their decisions? Are they correct? Or are they making arbitrary

**11.1 Setting personal goals:
SimCity**

decisions? Arbitrary decisions can kill a player's sense of responsibility for an action. How can you improve the choices, macro and micro, that players are making in your game?

Play

Along with presenting challenges, games are an arena for play. As we discussed in Chapter 4, there are as many different types of play as there are players. What forms of play does your game employ? Are you making the most of that opportunity? Can you offer other areas of play for different types of players, or do you want to deepen the play for a single type of player? Think about your game in terms of these natural types of play.

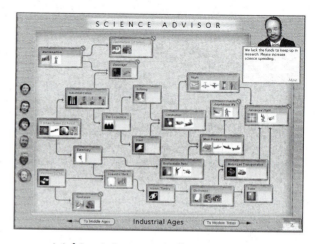

**11.2 Making interesting choices:
Civilization III**

Living out Fantasies

The desires for pleasure, romance, freedom, adventure, etc. are all powerful forces. Most people dream of being something they are not—an astronaut, snowboarder, general, rap star, etc. Let your players live their fantasies, even for a moment, and you will have a captive audience. Role-playing games have their basis in this kind of fantasy play, but all games can gain from tapping into people's dreams for themselves. What aspirations does your game put within reach for its players? What fantasies does it fulfill?

This concept can be extended to imaginative play scenarios that are not necessarily fantasies that a player wants to fulfill but rather scenarios that are intriguing to explore even though they go against a player's personal ethics. Grand Theft Auto III, for example, fits this description. Players may be compelled by the game even though they don't fantasize about robbing and killing.

Social Interaction

People love interacting with one another. Games offer an amazing forum for social interaction, one that is equally about the game and the relationships people bring to the game. Adding this element to your game creates an unpredictable, emergent layer that is often enough for many players to stay hooked on a game long after its release. Some online games with strong social interaction have such loyal players that they have found ways to keep playing even after the official servers and support for the game have ended. Is your game making the most of any potential social interaction? Have you provided time and opportunity for people to get to know one another?

Exploration and Discovery

Nothing is so thrilling as venturing into uncharted waters and seeing what you find. If your game makes

11.3 Living out fantasies: Star Wars Galaxies

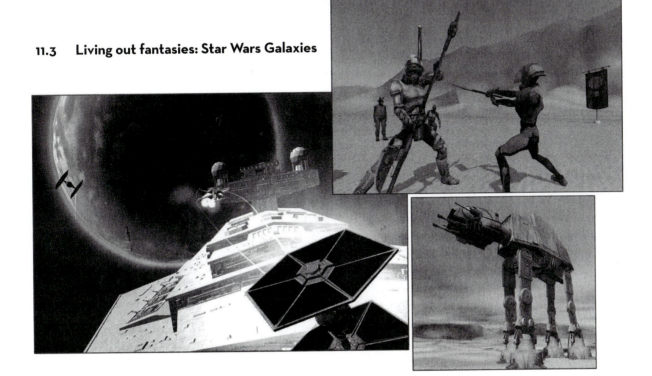

this promise to the player and then fulfills it, you will create an enchanting experience. Most great adventure, RPG, and FPS games include an element of exploration. The act of discovering something is magical. But creating that sense of trepidation when turning a new corner, anticipation when you think you might have found something, fear of getting lost, and exhilaration of discovery is a difficult task. Are you telegraphing the right direction to the secret treasure? You want to help your players, but you do not want the process of exploration to become rote. Try going on adventure yourself. Go for a hike on a new trail, or take a walk through a part of town you do not know. Think about the emotions you feel as you make your way—how can you recreate these feelings in your players?

Collection

Some remnant of our hunter-gatherer ancestors must drive this need, but there is nothing like letting players create collections for engaging them in a game. Whether it is a collection that only lasts a single hand of a card game or a collection of Magic: The Gathering or Yu-Gi-Oh trading cards that spans years of play and hundreds, perhaps thousands, of dollars of spending, collection is fun for many different types of players.

Stimulation

A game that stimulates the senses and imagination is a treat. Whether it is immersive 3D graphics, surround sound, or a Wii controller that gets you up on your feet acting out the part of an adventurer or a tennis player, sensory stimulation adds to the fun factor. Designers have more opportunity than ever to design innovative new gameplay using today's new control systems that include motion sensors, cameras, footpads, guitars, bongos, biofeedback devices, and other inventive attachments.

Self-Expression and Performance

As human beings, we have a desire to express ourselves, whether it is in the form of artwork, poetry, or building a character in a game world. Giving people the chance to show off who they are and be creative makes for an engaging experience and will add a new dimension to your game.

Construction/Destruction

Construction is a great tool for making players feel invested in a game. Whether it is constructing cities, armies, space colonies, or characters, building things is fun. On the other hand, as much as we humans enjoy construction, we also like tearing things down.

11.4 Magic: The Gathering Online: card collection screens
Illustrations used with permission of Wizards of the Coast, Inc.

11.5 Destruction: The Hulk

*Hulk: TM & © 2003 Marvel Characters, Inc. Used
with Permission. Image courtesy of Universal
Interactive, Inc. and is used under license.*

Anyone who has built a sand castle only to stomp it down again can tell you that. Giving players the opportunities to both build and destroy provide different types of fun, both of which can make your game successful.

Story

A game does not have to have a story to be fun, but story can be a powerful mechanism for engaging people's emotions. As one of the earliest forms of entertainment as well as communication, we have a natural urge to tell and listen to tales about one another. By incorporating dramatic elements into your game, you can tap into this fascination with narrative and storytelling.

As we discussed in Chapter 4, however, drama in a game has a different source than that in a traditional story. In a movie or novel, drama comes from our investment in characters who struggle to overcome obstacles, both internal and external; it is what we call empathy. In games, drama arises from our own

struggle to overcome those obstacles ourselves, or agency. The difference between creating drama using empathy and agency presents a very difficult problem to the game designer. Ask yourself some questions about the drama in your game, such as:

- Do you have a compelling, imaginative premise?
- Do you have unique characters?
- Does your story line drive the gameplay or emerge from it?
- Are your players playing your game because of its story or in spite of it?
- What is it about the story, the characters, etc. that is working or not working for them?

Analyzing Appeal

The preceding list encompasses some of the elements that can, if executed well, improve your game's appeal. Do not try to cram all of them into your game design, though. It is more important to analyze the core pleasures of your game concept

and make sure they are complimentary and clearly apparent to players. Let's take a look at a couple of popular games and see how they have incorporated these elements.

World of Warcraft

- Overarching goal of growing your character combined with the smaller goals inherent in quests, adventures, and tasks
- Competition among players to become more powerful, popular, and/or famous than others
- Fantasy of being in a world of magic and adventure
- Social interaction with other players online
- Exploration of huge, unusual fantasy world
- Stimulation of beautiful 3D graphics and sound
- Self-expression through role playing
- Huge back story and legends of the world and characters
- Construction of character, building wealth, accumulating possessions, etc., and destruction of monsters and other players (if you choose)
- Collection of inventory items

Monopoly

- Goal of owning all the property on the board
- Competition among players
- Fantasy of being a real estate tycoon
- Social interaction with other players, trading properties, etc.

- Construction/destruction of houses, hotels, and monopolies
- Collection of property sets

Tetris

- Goal of clearing all your lines of blocks
- Stimulation of catchy music, colorful blocks
- Collection of all the blocks in a single row
- Construction/destruction of rows of blocks

As you can see, we identified ten distinct types of pleasure, all elements of challenge and play discussed above, in World of Warcraft, just six in Monopoly, and four in Tetris. And yet each of these games has been wildly successful in its own way. Clearly there is no relationship between the number of elements and the amount of fun a player can derive from a game. Tetris might be one of the most universally addictive games ever, and it is quite simple. Making games fun is not about including every possible type of challenge or play but in finding the right combination. If you can do that, you will delight your players and keep them interested in your game.

Exercise 11.1: Challenge and Play

As we did with World of Warcraft, Monopoly, and Tetris, analyze the opportunities for challenge and play that are present in your original game prototype. List the types of challenges that players must face and the ways they can express themselves through fantasy or play. Describe how these elements interact to make your game fun, or identify how they might be improved.

IMPROVING PLAYER CHOICES

Because it is simply one of the most powerful aspects of fun in gameplay, we need to look more closely at choice as an aspect of fun. What makes a choice interesting versus uninteresting? How can you design choices that are more interesting than not?

One of the most important aspects of choice is consequence. For a game to engage a player's mind, each choice must alter the course of the game. This means the decision has to have both a potential

upside and a downside; the upside being that it might advance the player one step closer to victory, and the downside being that it might hurt the player's chances of winning. This concept is often called "risk versus reward," and it is something we face every day in our own lives, not just in games. When Sid Meier says "interesting choices," what he means is that the game must present a stream of decisions that directly or indirectly impact the player's ability to win. This is

because, in addition to story elements, drama and suspense in games can arise naturally from asking players to make decisions that have weight and consequence.

As a designer, this is what you must strive for. But how do you make the choices in your game have significance? To start with, let's step back and analyze your game. Look at the gameplay diagram you created in Exercise 7.8. What type of decisions are your players making? Are those decisions truly meaningful or are they tangential to the main objective? To help analyze this, we use a concept we call the decision scale, which is shown in Figure 11.6.

If there are many decisions in your game that seem inconsequential or minor, you have a problem. Go back and rethink the choices you are giving your players. Is there a way to make those choices matter? And if there is not, most of those choices need to be eliminated because they are not adding anything to the game and are probably hurting the experience. Now take a look at the decisions higher up on the diagram. Is there a way to make some of your players' decisions fall into these categories? These are the types of decisions your players want to make.

The decisions you ask your players to make should not all be life and death, however. Nonstop action can get boring too; it is in the breather between waves of enemies that we can appreciate our accomplishments, anticipate the next wave, and steel ourselves for the battle ahead.

To create a truly engaging game, you want some peaks and valleys. Let the decisions rise and fall, and as the game progresses, ratchet up the tension by making the decisions gradually more important until, by the climax of the game, everything hangs in the balance. This structure mirrors the same dramatic arc that we looked at in Chapter 4 on page 104.

Types of Decisions

It is easy to say that games should have interesting choices, but why is one choice more interesting than another? The answer lies in the type of decision you ask to the player to make. If the player has to choose between two weapons, and one weapon is only slightly superior to the other, even though the player might be faced with a life-and-death encounter, the decision itself does not reflect this. To make this decision interesting,

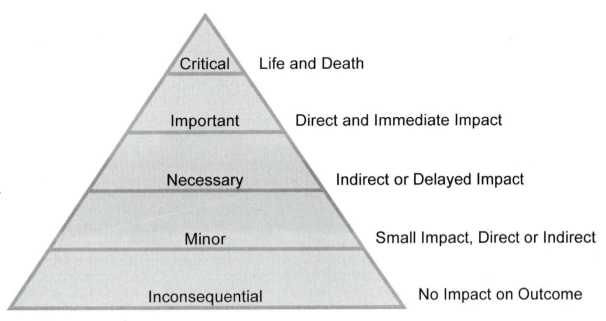

11.6 Decision scale

each weapon must have a dramatically different impact on the player's chance of winning.

But if the decision itself is too easy, then it is not a decision at all. If it is obvious that the player should use the golden arrow to slay the dragon, there is no real choice. Why would the player risk using anything else? This decision, although it appears to be life and death, is meaningless. The player will invariably choose the golden arrow unless he does not know about its powers, and in that case, it is an arbitrary choice, not a decision.

The key to making this decision interesting is for the player to know that the golden arrow is the right choice but also to know that if he uses the golden arrow now, he won't be able to use it later when he has to fight the evil mage. To make this decision truly dramatic, the player must be put in a position where both paths have consequences. If the player does not use the arrow now, his faithful companion, who is not immune to dragon fire, might die during the battle. However, if the player uses the arrow, it will be much harder to destroy the evil mage later on. Suddenly the decision has become more complex, with consequences on both sides of the equation.

Some decision types are as follows:

- *Hollow decision:* no real consequences
- *Obvious decision:* no real decision
- *Uninformed decision:* an arbitrary choice
- *Informed decision:* where the player has ample information
- *Dramatic decision:* taps into a player's emotional state
- *Weighted decision:* a balanced decision with consequences on both sides
- *Immediate decision:* has an immediate impact
- *Long-term decision:* whose impact will be felt down the road

In the example of the golden arrow, the decision is a combination of the previous decision types. It is an informed decision because the player knows a lot about situation he is in, it is a dramatic decision because the player has an emotional attachment to his faithful companion, it is a weighted decision because there are consequences balanced on both sides, it is an immediate

decision because it impacts the battle that is taking place with the dragon, and it is a long-term decision because it impacts the future battle with the evil mage. All of these combine to make the decision of whether or not to use the golden arrow a critical choice in the game, and this makes the game interesting.

Exercise 11.2: Decision Types

Take your original game and categorize the types of decisions you ask your players to make. Are there any hollow, obvious, or uninformed decisions? If so, try to redesign these choices.

Not all decisions in a game need to be as complex as the one with the golden arrow. Simple decisions are fine, just so long as they are not hollow, obvious, or uninformed. As a rule, you do not want to waste the player's time with nondecisions, though there is often a place in games for decisions that are purely creative, expressive, or exploratory. Finding a balance between the types of decisions that players find interesting and engaging throughout the flow of your game is more important than relying on one type of decision making.

Dilemmas

Dilemmas are situations where players must weigh the consequences of their choices carefully, and in many cases, where there is no optimal answer. No matter what the player chooses, something will be gained and something will be lost. Dilemmas are often paradoxical or recursive. A well-placed dilemma and trade-off can resonate emotionally with a player when encountered during the struggle to win your game.

Mathematician John von Neumann used dilemmas as a framework for studying how players in gamelike situations make choices and how conflicts are resolved in both game-based and real-world dilemmas. The branch of mathematics and economics that he cocreated was called "game theory," and though the games that this discipline studies are not the type of games that we are discussing here, you might find parts of this methodology useful to study player choices in your own and other designers' games.

To understand dilemmas, von Neumann broke them down into very simple structures called moves. Each move was diagrammed on a matrix, showing the potential outcomes of each strategy as they pertain to each player. To understand this concept more clearly, let's next look at a classic scenario with a simple move structure and payoff matrix.

Cake Cutting Scenario

A mother wants to divide a piece of cake between her two children. To avoid arguments about how large a piece each child should get, she makes one child the "cutter" and one child the "chooser." The cutter gets to cut the cake, and the chooser gets to choose which piece. If we assume that each child wants the bigger piece (i.e., wants to "win" the game), we can diagram this conflict to show the potential strategies for each player, the dilemma they face, and the payoffs for each potential outcome.

As we can see, each child has two possible strategies. We know that it is impossible to cut the cake exactly in half—there will always be one crumb more or less on either side—but the cutter can choose to cut the cake as evenly as possible, or she can choose to cut one piece bigger than the other in an attempt to get the larger slice. Since we have determined that one piece will always be larger than the other, even if just by a crumb, the chooser also has two strategies. He can choose the smaller piece or the larger piece.

By looking at the payoff matrix created by combining these two possible strategies for each player, we can see that in this simple scenario, there is an optimal strategy for each player. Because we have said that each child will try to get the bigger piece, the chooser's optimal strategy is obvious: He will choose the larger piece. Because the cutter is also trying to get the largest piece possible, she will try to cut the pieces as evenly as possible. The optimal strategies for each player meet in payoff #1: The chooser gets a slightly bigger piece.

The cake cutting scenario is an example of a zero-sum game. By this we mean that the total amount won at the end of the game is exactly equal to the amount lost. In this case, the chooser gains the crumb lost by the cutter. Because of the nature of zero-sum games, the interests of the players are diametrically opposed. What one player loses is gained by the other.

Chooser's Strategies:

	Choose Bigger Piece	Choose Smaller Piece
Cut as Evenly as Possible	**Chooser gets a *slightly* bigger piece.**	Chooser gets a *slightly* smaller piece.
Cut One Piece Bigger	Chooser gets a bigger piece.	Chooser gets a smaller piece.

Cutter's Strategies:

11.7 Cake cutting scenario payoff matrix

What von Neumann discovered in his study is that there is an optimal strategy for each player in games of this nature that will produce the best possible results in a given situation. He called this concept "minimax theory."

Minimax theory states that there is a rational way for players to make choices in a game, if we are talking about a two-player, zero-sum game. The optimal strategy for all players is to "maximize their minimum potential result." In the case of the cake cutting example, while the cutter cannot win the game, her optimal strategy will still maximize the amount of cake she gets to eat.

Games that fall easily into optimal strategies might be interesting for mathematicians, but for game designers, they are something to be avoided. If you present your players with a game as simple as the cake cutting scenario, they will always make the optimal choice, and the game will play out the same way every time. How can we create scenarios that are more complex, where the players must weigh the potential outcomes of each move in terms of risks and rewards—scenarios that truly are dilemmas?

A scenario that has a more complex payoff structure was created by two RAND scientists in the 1950s. Called the "Prisoner's Dilemma," it is a simple, baffling game that shows how games that are not zero-sum can create situations where the optimal strategy for each player can result in suboptimal results for both.

The Prisoner's Dilemma

Two criminals commit a crime together and are caught by the police. For the purposes of our example, we will call the two unlucky criminals Mario and Luigi. Mario and Luigi are held in separate cells with no means of communication. The DA offers each of them a deal and discloses that the same deal was made to his partner in crime. The deal works like this: If you rat on your partner, and he denies it, you can go free and he gets five years. If neither of you rat on each other, the DA has enough circumstantial evidence to put you both away for one year. If you both rat, you will each get three years. Figure 11.8 shows the payoff matrix for each potential strategy.

Mario's Strategies:

	Rat on Luigi	Don't Rat
Rat on Mario	Mario = 3 years Luigi = 3 years	Mario = 5 years Luigi = 0 years
Don't Rat	Mario = 0 years Luigi = 5 years	Mario = 1 year Luigi = 1 year

Luigi's Strategies:

11.8 Prisoner's Dilemma payoff matrix

Using the same process we used to determine the optimal strategy for the cake cutting dilemma, we can see that the optimal strategy for Mario is to rat on Luigi. If he rats, he gets either three or zero years. If he does not rat, he gets one or five years. The optimal strategy for Luigi is also to rat on Mario for the same reasons. This is completely rational decision making; there is no question that the optimal strategy for both of these prisoners is to rat out their partner. Simple, right? But wait: If both players choose the optimal strategy, they will both serve three years! More years total will be served in jail than in any other resolution, and in fact they will both do much worse overall than if they had used a more naïve, intuitive strategy of keeping their mouths shut.

To be clear, the hierarchy of payoffs in the Prisoner's Dilemma is as follows:

- *Temptation for defection:* zero years
- *Reward for mutual cooperation:* one year each
- *Punishment for mutual defection:* three years each
- *Sucker's payoff for unreciprocated cooperation:* five years

The actual numbers in this hierarchy are not important. What is important is that they ascend in this order: Temptation > Reward > Punishment > Sucker. If this hierarchy exists, the optimal strategy for each player will always result in a payoff that is less than if they had acted cooperatively. As opposed to the cake cutting scenario, the question put before these two prisoners does not have an obvious or optimal solution. If the prisoners use rational thinking to make their decision, they will be punished more than if they rely on mutual trust. But trust is a risky business. Now we are talking about a true dilemma. What will Mario and Luigi do?

Exercise 11.3: Dilemmas

Does your original game contain any dilemmas? If so, describe these choices and how they function.

In a presentation at the Game Developers Conference, designer Steve Bocska of Radical Entertainment applied the hierarchy of payoffs in the Prisoner's Dilemma to a hypothetical game design to show the usefulness of game theory concepts to designing compelling dilemmas.[1] Bocska imagines an online game in which two players are building and customizing spacecraft with a budget of $10,000. The game requires bartering and trading of raw materials but at a high transaction cost: $8000 of "shipping and handling" in a typical game round. A technology can be purchased that allows materials to be "transported" with no transaction cost, but for it to work, both players must purchase it. The cost of the technology is $5000. Bocska asks:

> Under these conditions, what is a player likely to do? If both players purchase the transporter equipment, they will reduce their transaction costs for the game from the usual $8000 to a one-time cost of $5000 for the transporter—a savings of $3000. If, on the other hand, neither player purchases a transporter, the transaction costs throughout the game for each player will amount to the usual $8000. What if only one player purchases the machine? With nobody else to connect the transporter to, their machine becomes effectively useless, resulting in them receiving the "sucker's payoff"—the cost of the equipment plus the added cost of continuing to barter using the traditional costly method ($5000 + $8000 = $13,000).

The payoff matrix in Figure 11.9 shows the results of the potential strategies.

Unlike the Prisoner's Dilemma, Bocska envisions a game in which the players can communicate, negotiating with each other when and if to purchase the technology. This complex payoff structure creates a dilemma for the players that can make for compelling strategic moments and potentially deceitful or cooperative decisions play after play.

This is exactly the type of situation you should strive to create in your games. If possible, give the players dilemmas as part of the core gameplay. Make sure to tie the dilemma into the overall objective of the game. If you can accomplish this, it will make the choices much more interesting.

Player 1's Strategies:

	Buy a Transporter	Keep the Status Quo
Buy a Transporter	Player 1 = $5000 Player 2 = $5000	Player 1 = $0 Player 2 = $13,000 (Player 2 goes Bankrupt)
Keep the Status Quo	Player 1 = $13,000 Player 2 = $0 (Player 1 goes Bankrupt)	Player 1 = $8000 Player 2 = $8000

Player 2's Strategies:

11.9 Transporter game payoff matrix

Puzzles

Another format for structuring interesting choices in your games is by incorporating puzzles. As puzzle designer Scott Kim describes in his sidebar, "What is a Puzzle?" on page 35, puzzles are defined by the fact that they have a right answer. While there are many variations of form and genre that a puzzle can take (abstract, word, action, story, simulation, etc.), the underlying similarity is that they are solvable or have a right answer, as Kim suggests.

Puzzles are also a key element in creating conflict in almost all single player games. There is an innate tension in solving a puzzle. They can contextualize the choices that players make by valuing them as moving toward or away from the solution. Suddenly, the act of rifling through a treasure chest takes on new meaning if you are searching for the key to open the door to a maze rather than just looting the castle.

If you tie this into a system of rewards for solving the puzzle and punishments for failure, the puzzle

transforms into a dramatic element. For example, take Myst, a best-selling adventure game. This game is essentially comprised of puzzles. It incorporates story and exploration as well, but at its core, the mechanics of the game are a collection of interlocking puzzles integrated into the environment. Similarly, Ico, a more recent adventure game, also incorporates puzzles into its environments, balancing its action mechanics with puzzle solving.

The popular genre of first person shooters is also puzzle based, especially in single player mode. Take Medal of Honor. You have to plant bombs, unlock doors, find medical kits in a labyrinth of rooms, and figure out how to use weapons and explosives in just the right way. As with Ico, the action elements of the game are enhanced and balanced by the puzzle-solving elements. The same holds true for many other single player games.

You will notice that we keep using the qualification "single player." This is because in multiplayer

11.10 Puzzle Pirates

mode you do not necessarily need puzzles to provide conflict. The conflict can come from the competition with other players, whether they are human or computer controlled. But in single player mode, especially when you are sent on a quest or mission, puzzles play an increasingly important role. That is why every game designer should also consider herself to be a puzzle designer. The better your puzzle design skills, the better your game will be.

An example of a multiplayer game that does include puzzle elements, however, is Puzzle Pirates. In this online multiplayer game, players must play single player "duty" puzzle games such as "bilging" and "carpentry" onboard virtual pirate ships. However, they must also play multiplayer puzzle games such as "drinking," "brawling," or "swordfighting." Puzzle Pirates combines puzzle games with role-playing elements such as a persistent world to create its unique, and successful, play experience.

One consideration when designing puzzles in your games is to make sure that the elements of the puzzle are woven into the fabric of the game. By this we mean that it advances the player toward his overall goal. If a puzzle does not enable progress, it is a mere distraction and should be redone or removed. A puzzle can also advance the story line. You can use the puzzle to tell the player something about the unfolding plot. If you can integrate your puzzles into the gameplay and the story, they won't feel at all like puzzles but rather

like integral, interesting choices a player must make to progress in the game as a whole.

Rewards and Punishments

The most direct consequences for player choices are rewards and punishments. Obviously, players enjoy being rewarded and dread punishments. Nothing is more natural. So when designing a game, a designer often emphasizes the rewards while limiting the punishments. This makes sense; players are not playing games to suffer the hardships of life. And in reality, you do not want to punish players so much that they stop playing your game. But often, the threat of punishment, if not the actual punishment itself, carries a dramatic tension that can add layers of meaning to even the most trivial choices a player makes.

Think of a game that forces the player to be stealthy, like Thief or Deus Ex. The tension, when you are trying to accomplish a task without being caught, is tremendous. Getting caught and attacked—and let's face it: killed—is not fun. But that moment when you oh-so-quietly pick a lock and sneak past security without incurring any harm is made much more effective by the threat that the anvil of punishment was hanging over your head all the time (see Figure 11.11).

Coming up with a balanced system of rewards and punishments is a way of making the choices in your games much more interesting for players. The type

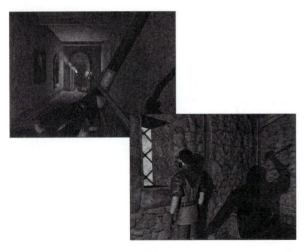

11.11 Being stealthy: Thief

of rewards you offer can vary, but the best rewards are those that have utility or value in the game. When you develop your rewards system, use the following guidelines:

1. Rewards that are useful in obtaining victory carry greater weight.
2. Rewards that have a romantic association, like magic weapons or gold, appear to be more valuable.
3. Rewards that are tied into the story line of the game have an added impact.

Make each reward count, and if it can both push the player closer to victory and advance the story line, that's even better.

The timing and quantity of rewards is also critical. If you give a steady stream of small rewards, it can become meaningless. Players know the rewards are coming, no matter what they do, and they stop caring.

Psychologist Nick Yee has studied the reward/punishment structure of an extremely addictive game system, EverQuest, and he believes its addictive power lies in a behavior theory advanced by B.F. Skinner called "operant conditioning." Operant conditioning claims that the frequency of performing a given behavior is directly linked to whether it is rewarded or punished. If a behavior is rewarded, it is more likely to be repeated. If it is punished, it

becomes suppressed. It is usually explained by using the example of a Skinner Box, a glass cage equipped with levers, food pellets, and drinking tubes. Rats are placed in the cage and rewarded with a food pellet for pressing the lever, using reinforcement to shape their behavior.

Yee writes:

There are several schedules of reinforcement that can be used in Operant Conditioning. The most basic is a fixed interval schedule, and the rat in the Skinner Box is rewarded every five minutes regardless of whether it presses the lever. Unsurprisingly, this method is not particularly effective. Another kind of reinforcement schedule is the fixed ratio schedule, and the rat is rewarded every time it presses the lever five times. This schedule is more effective than the fixed interval schedule. The most effective method is a random ratio schedule, and the rat is rewarded after it presses the lever a random number of times. Because the rat cannot predict precisely when it will be rewarded even though it knows it has to press the lever to get food, the rat presses the lever more consistently than in the other schedules. A random ratio is also the one that EverQuest uses.[2]

While this might seem surprising, if you relate it to your own actions in games and in the real world, it begins to make more sense. Have you ever sat down to play five minutes at a slot machine and looked up to realize you had been there, determinedly pulling that lever, for several hours? In many ways, Las Vegas is simply a giant Skinner Box.

We might all be just rats in a cage, but there is one type of reward that is very powerful and that cannot be delivered like a pellet, and that is peer recognition. We crave acknowledgment for our achievements, especially in multiplayer games. If there is a way for you to make the players, even the ones who are not winning, feel recognized for their efforts when they do achieve a goal, then you will have a much stronger game.

Many games do this through the Internet, tracking scores or providing tournaments and ladders. There are more immediate ways to provide recognition in

the moment as well. One is to track and broadcast the players' achievements during the game, highlighting and dramatizing each success for everyone to see. If it is an online strategy game where one team is pitted against another, make it clear when a player pulls off a brilliant maneuver. Let his comrades know exactly what happened and how it impacts the victory conditions. If it is an online RPG, allow the players to show off their conquests to the world, either in the form of legends, artifacts, or admirers who follow them about.

Exercise 11.4: Rewards

Analyze the rewards system in your original game prototype. Look at each reward and determine if it is useful, romantic, and/or tied to the story line. How are rewards timed? Does the timing reinforce the player's desire to continue playing?

Anticipation

The Skinner Box example works well for game mechanics that are repetitive and apt to become rote. For larger, more complex choices, however, the more clearly you allow players to see, and antici-

pate, the consequences of their actions, the more meaningful their choices will be.

In chess, and other games with open information structures, the entire state of the game is visible to both players for evaluation. Nothing is hidden. If players are experienced, they can calculate out moves many turns in advance and see exactly what will and will not happen. The anticipation that players feel in a situation like this is heightened by the knowledge of when they will be able to capture a piece or get in a particular position.

Can games with closed or mixed information structures create anticipation? Definitely. Real time strategy games often use limited visibility to offer the player a glimpse of the opposition, but only while her units are posted in enemy territory. Because the game state is always changing, the view quickly becomes outdated, and the player winds up making decisions based on only partially accurate information (see Figure 11.12).

In this example, players accept the lack of information as one of the conditions of the game and understand that their job is to maximize their position given the limited information they have available. In fact, the lack of visibility can increase a player's sense of tension. With the knowledge that the game state is in

11.12 **WarCraft III: fog of war (on mini-map at bottom left of screens) turned off (left) and on (right)**

flux, players feel compelled to act swiftly to counter anticipated enemy moves. In this case, the hiding of knowledge has added a new dramatic twist that is lacking in the completely open strategy games.

Surprise

Surprise is one of the most electrifying tools at a designer's disposal. People love to be surprised, especially when they feel they should have anticipated the event. Too many surprises will alienate players, however, so how do you know when to use surprise and when to telegraph an event?

A surprise outcome to a player's choice can reinvest them in the game; perhaps they thought they were going to find 20 gold pieces behind door number three, but it turns out to be a trusted friend ready to join their journey instead—a much greater reward.

Surprises might feel random to players, but in a good way. The trick is to find the right balance between the randomness of surprise and the importance of making player choices meaningful. Take the example of a real time strategy game, where you might send a simple foot soldier up against an ogre because he is all you've got. The foot soldier has strength of 1 to 5, while the ogre has strength of 1 to 20. Odds are that the ogre will win. But there's always that chance, no matter how small, that the foot soldier will prevail.

Randomness, and surprise, in this case adds a level of drama—the tension of not knowing exactly how a highly probable event will play out. Will this be a David and Goliath story or just another dead foot soldier? In most well-designed games, the element of choice remains dominant. If every choice a player makes results in random effects, they will feel like their choices have no meaning. But keep surprise in mind; used judiciously, it can create a wealth of fun and excitement.

Exercise 11.5: Surprise

Are there any surprises in your game? Try taking one type of choice and adding an element of surprise to the outcome. How does this affect the gameplay?

Progress

Nothing is quite as satisfying as seeing the choices you make result in progress. It is part of human nature to derive joy from the act of advancing toward a goal. The small payoffs along the way are often sweeter than the final victory. The same is true in a game. Allowing players to feel that they are moving forward is the best way to draw someone into a game and keep them engaged.

One approach for structuring progress is to design milestones for the players. These are small goals along the way to the grand goal of winning. Advertise these milestones to the players so that they know what they are striving for, and reward them after each accomplishment.

Many games do this well. In games like Medal of Honor, the milestones come in the form of missions. They give you a map and let you see where you are headed and what you have to achieve to get there. This helps the player feel like they are making progress throughout a long campaign. The same is true for games that use story to block out their single player levels, preparing the player at each step and setting out clear and obtainable objectives, and then rewarding the player at the end of each sequence with graphics, praise, and another chapter of the narrative.

No matter what the game, whether it is an arcade shooter or a simulation, providing a path for the player to follow gives a sense of achievement. Be creative in finding new ways to represent progress for your players. Do not limit yourself to just one system. There is no reason you cannot measure progress in several ways at once.

When you consider the pacing of progress that players can make in the game, you might also consider the typical amount of time a player spends with a game. Veteran game designer Rich Hilleman with Electronic Arts says that their designers plan "mini-arcs" of about one hour into the overall game progress. This is because they have found that this is the length of time an average gamer plays in a single sitting.

At the end of each mini-arc, the designers try to make sure the player encounters a "memorable moment" of gameplay, which makes sure they will

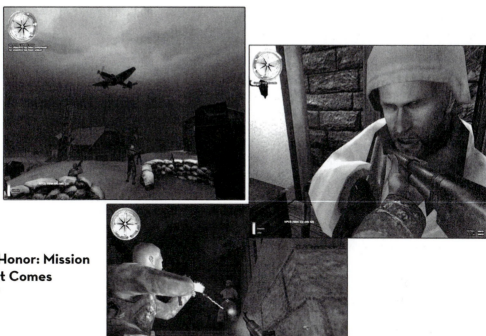

11.13 **Medal of Honor: Mission 2_4, "What Comes Around?"**

return for another play session. These mini-arcs, when aggregated, form the overall dramatic arc of the game.

Exercise 11.6: Progress

Take your original game prototype. Is the ultimate goal clear? Is the player always moving toward this goal? Make sure that you have milestones established along the way. Does your system help motivate the player to reach the final goal? Describe how.

The End

By "the end," we are not talking about when a player dies; we are talking about the moment when the play completely resolves. After investing hours, days, weeks, or even months, this is the instant when your most loyal players deserve a reward for all their effort.

Multiplayer games have their own reward built in: the satisfaction of beating the other players, or, if you have created a cooperative, unilateral, or team interaction structure, the satisfaction of having worked together to beat the game or the other side.

But what of your single player game? After all the conflict, struggle, and time invested, make sure to give the player a satisfying reward. Too often, the end of all that work is a fluffy animation, where the hero is showered with praise and adulation. If you are going for an ending like this, why not build the reward into the story? Make that animation a moving moment in your hero's quest for whatever he lacks.

Exercise 11.7: Endings

Is the ending or resolution of your original game prototype satisfying? If not, how could you make it even better?

The Core Mechanic: Game Design as Activity Design

by Eric Zimmerman, Cofounder and CEO, Gamelab

The following is adapted from a longer essay entitled "Play as Research" that appears in the book Design Research, *edited by Brenda Laurel (MIT Press, 2004). It appears here with permission from the author.*

Too often, game designers focus on the content, narrative, or aesthetics of their game design rather than asking more fundamental questions. As participatory, dynamic systems, it is crucial that games be understood not just as content but as action. As you begin working on a game design, ask yourself, What is the actual activity of the game? What is the player actually doing from moment to moment as he or she plays your game?

Virtually all games have a core mechanic, an action or set of actions that players will repeat over and over as they move through the designed system of the game. A game prototype should help you understand what this core mechanic is and how the activity becomes meaningful over time. Asking questions about your game's core mechanic can guide the creation of your first prototype, as well as successive iterations. Ideally, initial prototypes model this core mechanic and begin to test it through play.

Case study: LOOP

LOOP is a single player game in which the player uses the mouse to catch flittering, colored butterflies. The player draws loops around groups of butterflies of the same color or groups in which each butterfly is a different color (the more butterflies in a loop, the more points). To finish a level, the player must capture a certain number of butterflies before the sun sets. The game includes three species of butterflies and a variety of hazardous bugs, all with different behaviors. LOOP was created by Gamelab and is available for play at www.shockwave.com.

LOOP grew out of a desire at Gamelab to invent a new core mechanic. There are ultimately not very many ways to interact with a computer game: The player can express herself through the mouse and keyboard, and the game can express itself through the screen and speakers. Deciding to intervene on the level of player input, we had a notion to cast aside point-and-click or click-and-drag mouse interaction in favor of sweeping, fluid gestures.

The first prototype tested only this core interaction, allowing the player to draw lines but nothing else. Our next step was to have the program detect a closed loop and add objects that would shrink and disappear when caught in a loop.

As you can see in the screenshots, each of these prototypes had parameters that were adjustable as the game was actually running. The length of line and detail on the curve could be tweaked, as well as the number of objects, their speed and behavior, and several other variables. As we played the game, we could try out different parameters and immediately see how they affected the experience, adjusting the rules to arrive at a different sort of play. This programming approach, building accessible game design tools into a game prototype, is a technical strategy that incorporates and facilitates iterative design.

As the butterfly content of the game emerged, so did debate about the game's overall structure and victory and loss conditions. Did the entire screen need to be cleared of butterflies, or did the player just have to catch a certain number of them? Did the butterflies gradually fill up the screen or did their number remain constant? Was there some kind of time pressure element? Were there discreet levels or did the

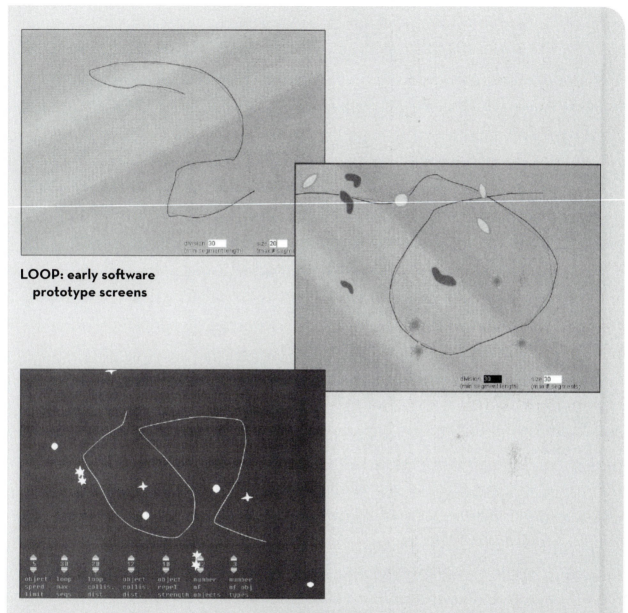

LOOP: early software prototype screens

game just go on until the loss conditions were met? These fundamental questions, which grew out of our core mechanic prototyping, were only answered by actually trying out possibilities and coming to conclusions through play.

As the game code solidified, the many adjustable parameters of the game were placed in a text file that was read into the application when it ran. These parameters controlled everything from the behavior of game creatures to points scored for different numbers of butterflies in a loop to the progression of the game's escalating difficulty. Thus the game designers could focus on refining game variables and designing

levels, while the rest of the program—screen transitions and help functionality, the high score system, and integration with the host site—was under construction. A sample of this game editor code follows:

```
-- LOOP SCORES
score_same=0,5,10,20,40,80,150,250,350,500,700,1000,1400,1900,2500,3100,3800,
4600,5500,7000
score_different=0,0,30,75,200,500
score_badloop=-20

-- # of caught butterflies for each level of loop sound effect
loop_sound_num=1,4,6,8,10

-- BONUSES
-- butterfly-borne bonus (x2):
bonus_lifetime=60
-- leaf-blown bonus (longer, moretime, freeze, flock):
freebonus_speedlimit=15
bonus_freeze_duration=4
bonus_flock_duration=12

-- HAZARDS
snail_speedlimit=1.2
killerbee_speedlimit=12,
killerbee_attackrate=3,killerbee_stingduration=6
beetle_speedlimit=3, beetle_fighttime=4, beetle_aborttime=10,
beetle_effectradius=300
stinkbug_speedlimit=2, stinkbug_tag_radius=40,
stinkbug_effect_duration=10, stinkbug_effect_radius=300
spider_speedlimit=9,spider_climblimit=22,spider_stingduration=6,
spider_loop_length=5
```

LOOP followed an iterative design pattern of testing, analysis, and refinement, moving outward from the game creators to include a larger circle of players. During the development of LOOP, Gamelab created the Gamelab Rats, our official playtesting "club," to facilitate the process of testing and feedback.

The concept for LOOP began as the design team questioned the conventions of mouse and keyboard interaction. In the end, LOOP managed to achieve the fluid gameplay we had first envisioned, a fresh and original game evolving from a simple idea about a new kind of core mechanic.

LOOP was developed by Ranjit Bhatnagar, Peter Lee, Frank Lantz, Eric Zimmerman, and Michael Sweet and his team at AudioBrain.

LOOP: Game Interfaces

About the Author

Eric Zimmerman is a game designer who is exploring the practice and theory of gaming. Eric has been making games in the game industry for more than 13 years, and he presently runs Gamelab, a company he cofounded with Peter Lee in 2000. Gamelab creates experimental online single player and multiplayer games. Before Gamelab, Eric collaborated with Word.com on the underground online hit, SiSSYFiGHT 2000 (www.sissyfight.com). Other titles include the PC CD-ROM games Gearheads (Philips Media, 1996) and The Robot Club (Southpeak Interactive, 1998). Eric has taught game design at MIT, NYU, Parsons School of Design, and School of Visual Arts. He is the coauthor with Katie Salen of Rules of Play (MIT Press, 2004) and The Game Design Reader (MIT Press, 2006) as well as the coeditor with Amy Schoulder of RE:PLAY (Peter Lang Press,2004). See also his article on iterative design on page 16.

Fun Killers

For all your efforts, you may have implemented some features that killed the fun in your original concept. Here are just a few we have seen come up in first-time games over and over.

Micromanagement

Micromanagement is a common problem with games that give players a lot of control over minute details. For hard-core strategy gamers, like those addicted to games like StarCraft, this control is critical. They want to tweak everything and dissect each element of the game. But there is a fine line between granting your hard-core players control and burdening your average players with unwanted chores.

As a designer, how do you know when you have given players enough control and not too much? Start with the basics. Is the task necessary? Make sure the decision the players are given is not obvious, hollow, or uninformed. If it passes these tests, it still might fall into the micromanagement trap. Micromanagement takes place when a task becomes repetitive or tedious to a player. The best way to know this for certain is to bring in fresh playtesters. If they complain that certain mechanics are too much work or too tiresome, this is a red flag.

One solution to this issue is to simplify your game system. Micromanagement usually comes from breaking up a task into too many small pieces. The overall impact of the combined decisions might be important on a strategic level, but each individual decision is too burdensome to be worth the effort. You might look at combining the microdecisions into one macrodecision. For example, if deploying an army requires choosing what weapons each unit will use, what supplies they are going to carry, what form of transportation they will utilize, and what route they will travel, you might be asking too much of your players. You can solve this by making some of these choices for them. Set default values that make sense and leave only the most important decisions, like what route to travel, up the players.

In addition to eliminating lesser decisions, you can give the players the choice of automating certain tasks, like resource management, troop deployment, and logistics. Allowing this choice provides hard-core players with the degree of control they desire and lets other players avoid dealing with the details. Micromanagement in itself is not an issue; it is only a problem when it affects the player experience. You will often find that different people want different experiences from your game, and the more flexible a system you can provide while still keeping the game relatively simple, the better.

Exercise 11.8: Micromanagement

Are there any elements of micromanagement in your game? If so, how can you streamline the choices players make so that they are not bogged down by unimportant details?

Stagnation

Some games fall into a pit of stagnation, where nothing new seems to be happening for a long period of time and choices stay at the same level of importance and impact.

A common source of stagnation is repetition, where players are caught doing the same task over and over. For example, if the players are forced to fight the same type of battle repeatedly, the game can feel like it is at a standstill. The players might actually be advancing in levels or moving closer to their ultimate goal, but the actions they are performing are so repetitive that they mask any progress being made. In this case the solution is twofold. First, you should vary the type of action being performed. Next, you need to communicate how each action is bringing the player closer to victory.

Another type of stagnation is a balance of power. For example, you have three players competing to conquer the world, and whenever one player gets ahead, the others gang up and smash the leader down, thus creating an endless cycle where no one is able to achieve victory. The solution here is to create a condition that tips the balance of power so far in favor of the winner that she can defeat the combined strength of the opposition.

A third type of stagnation is a reinforcing or balancing loop, as discussed in Chapter 5 on page 132. This type of stagnation occurs when a game device traps the players in a cycle that balances rewards with penalties. For example, in a business simulation game, a player might get caught in a trap where all his profits are being eaten up by debt payments. No matter how long he plays, he cannot get over this hump. One solution is to shake things up with an unexpected event, like a windfall or natural disaster that will either push the player over the hump or knock him into bankruptcy. Of course, you could also tweak the game so that players never get stuck in this type of situation. Give the player debt relief or jack up interest rates—whatever it takes to move the game in one direction or the other.

The last type of stagnation is where it feels like nothing is happening because nothing is actually happening. In other words, no progress is being made, either because the game is poorly designed or because there is no clear goal. An example of this might be an adventure game with a poorly defined objective. The players roam around but have no idea where they are supposed to go or what they are supposed to do. In this case, the solution is to go back and design the game so the objective is clear.

Exercise 11.9: Stagnation

Is there any point in your original prototype at which the gameplay stagnates? If so, determine what is causing this problem. Do you have a balancing loop? A balance of power? How can you break the cycle and improve the progression of the gameplay?

Insurmountable Obstacles

Another problem area to avoid when designing a game is insurmountable obstacles. Despite the name, these might not actually be impossible situations, they just seem that way to a certain percentage of players.

Whether this occurs because of a dearth of information, a missed opportunity, or lack of experience or intuition, the result is always the same: Your players wind up banging their heads against the same obstacle over and over and over. Look at your watch—how long is it before they shut the game off in frustration, never to return again?

Most of us have been trapped by insurmountable obstacles at one time or another and wound up going in circles looking for that hidden doorway or secret panel. As a designer, make sure that the game has some way of recognizing when a player is stuck, and provide them with just enough assistance to make it past the obstacle without diluting its challenge completely. Of course, this is easier said than done. Nintendo adventure games, such as those in the Zelda series, are typically good at providing information when players are stuck. Game characters are placed in strategic spots to provide clues and other information that will help you overcome the obstacles. As with other variables, clues have to be balanced to provide an appropriate level of difficulty for the players.

Building this kind of intelligence into the game is costly and time consuming. Sometimes it does not need to be that sophisticated. In a presentation at the Game Developers Conference on making games more fun through user testing, Microsoft User Testing Manager Bill Fulton (see his sidebar on user testing in Chapter 9 on page 266) used an example from the opening moments of the original Halo to illustrate how a task that seems obvious to the designer might seem like an insurmountable obstacle to the player.

Immediately after the introductory tutorial of this first person shooter game, your character is asked to follow a guide character to the bridge of the spaceship you are on. Of course, you do, but seconds later, the guide character is killed in an explosion right before your eyes, leaving you trapped behind a partially open doorway with no guide and no clue how to open the door.

As part of his presentation, Fulton showed a videotape of just one of many user tests in which a playtester stumbled around the corridor, pressing every button on the controller, trying everything he could think of to open the door, all the while talking out loud about how he did not know what to do. This went on for several minutes until it became clear from his tone of voice that if this player were at home, he

would have given up only five minutes into the game. As Fulton pointed out humorously, "I hope you all recognize this as 'not fun.'"[3]

The goal of the Halo designers, in leaving you guideless and trapped behind the door, was to create a sense of confusion and vulnerability that lasted only a few seconds for dramatic purposes. They assumed the player would immediately realize the door was not going to open, see the alternate exit to the corridor they had planned, and be on their way. User testing proved that most players needed a little help past this obstacle.

In the final product, a second explosion, timed a few seconds later, drives the player instinctively away from the half-opened door that will, in fact, never open. A text prompt pops up showing the player how to jump over objects, and a carefully designed floor mat points toward another opening in the corridor. The opening is blocked by a set of pipes, but if you know how to jump, that is no problem at all. With just a few modifications, the opening moments of the game were changed from an exercise in frustration to an exciting scene filled with drama and tension.

11.14 Tape from Halo user test: stuck at a broken doorway—note video insert of player's hands trying different control combinations, lower left

Arbitrary Events

As much as random events can be used for good effects in certain circumstances, like fortuitous surprises and unforeseen dangers, badly designed randomness can be the downfall of a game. Many games involve some form of randomness. We have seen how randomness can affect combat algorithms in real time strategy games and how it can stop movement mechanics from becoming predictable in board games. These types of randomness add to gameplay.

But there is a big difference between utilizing randomness to change up gameplay and allowing for totally arbitrary events to disrupt the player experience. For example, imagine that you have spent weeks building a sophisticated character in a role-playing game, and then suddenly a plague, for which there is no cure, kills your character. You had no chance to defend yourself, and all your hard work has gone down the drain. It is hard not to feel cheated. We all know that life is full of unexpected events, some of which are devastating. So why shouldn't games include them?

The problem is that, as in life, good surprises are welcomed by players, but bad surprises are not. So how can you include random events that are negative in nature without alienating the player? Whether it is a meteor storm that levels a city, an economic fluctuation that bankrupts a company, or a surprise attack that wipes out an army, you have to make sure it fits into the players' expectations of the game. Prepare your players in advance for the possibility of such an event and give them options to mitigate the damage. Just do not tell them when it is coming or how bad it is going to be.

If we take the example with the plague, you should warn the player about the possibility of diseases and allow them to purchase an antidote in advance. If they choose to ignore the warning signs and take no action, then when the event does come, it is their fault, and they will know it.

A good rule of thumb is to caution your players at least three times before hitting them with anything catastrophic. Random events that have a lesser impact require smaller warnings or even no warning at all. It is fine for a player to learn through experience to expect events of smaller consequence. But the bigger the impact, the more of a heads-up

you should provide. If you follow this rule, the events won't appear to be arbitrary, and your players will feel like they are in control of their destiny.

Predictable Paths

Games with only one path to victory can become predictable. As we discussed in Chapter 5, linear or simple branching structures often lead to this type of predictability. If you want to add a greater sense of possibility to your design, consider treating the structure in a more object-oriented approach. Giving each type of object in the world a simple set of behaviors and rules for interaction, rather than scripting each encounter separately, often leads to creative and unusual results.

An example of this type of thinking is Grand Theft Auto III, which has a level structure and story line that the player can follow, or he is free to wander the world, stealing cars, committing crimes, or running a taxi service if that is what he wants to do. While wandering the world does not advance the player very far in terms of the overall game objectives, it

does give the sense that the world of the game is responsive and unpredictable. At any moment, you might attract the attention of the police and wind up in an unscripted high-speed chase. Simulation games are other examples of this type of design. Games like the SimCity series can evolve in many directions, all based on the choices of the players.

Another way to keep game paths from becoming predictable is to allow players to choose from several objectives. For example, in Civilization III, the player can choose between six paths to victory: conquest, space travel, cultural advance, diplomacy, domination, and overall score. Each choice takes careful planning and will cause the player to weigh each choice anew, making the game not only interesting the first time around but also extremely replayable. Simply choose another path to victory and the game takes on an entirely new twist.

Not every game has to have the scope of a Civilization or a Grand Theft Auto, but when finding the balance between too much possibility and too much predictability, it is usually best to err on the side of greater possibility.

BEYOND FUN

As games develop into a more mature medium, they are finding other venues beyond entertainment. For example, games are now being used in education, political activism, and news coverage. There are games that are more experiential than competitive, and there are those that might be considered to be fine art rather than popular culture. For these, and other new forms that games might take, fun might not be the most useful measuring stick for the appeal they have to players. As a part of the

playcentric process of design, however, you will have to set other, more appropriate goals for your gameplay. In this case, these are the goals you need to be testing for. It is beyond the scope of this book to discuss how your game can achieve such important goals as teaching an academic subject or raising players to activism, but we have suggested some further reading at the end of the chapter for those of you who are interested in taking your gameplay beyond the realm of fun.

IS YOUR GAME ACCESSIBLE?

The final aspect to refining your game is making sure that it is accessible for the intended players. Can players pick up your game and understand it without any help from you and, realistically, without much help from the directions?

Accessibility is a strange paradox for the designer because the better you understand your own game, the

less able you are to anticipate problems that players might have in encountering it for the first time. Testing for accessibility is related to testing for usability. The difference is really who is doing the testing. Usability tests are generally done by specialists in usability labs. We highly encourage you to utilize such a group if you or your publisher has access to them.

Using Audio as a Game Feedback Device

by Michael Sweet, Creative Director, AudioBrain, LLC

Sound can have a profound impact on the game. Not only is it important in setting the overall mood for play, it can dictate emotional responses to the player. Whether you're struggling to make it to the end of a level or waiting for the next monster to appear from around the corner, the music and sound can make the player's heart race or stomach drop. In this article we'll be exploring two titles that I composed the music and sound design for and how we utilized audio to solve design challenges and give a rich aural experience to the player.

Diner Dash

Diner Dash broke boundaries with its simple one-click gameplay and distinctive style. In the game you play Flo, a struggling waitress that wants to ditch her desk job to open her own restaurant. The player helps Flo grow her fledgling diner into a five-star restaurant by managing different tasks as a waitress, such as seating customers, taking orders, bringing them coffee, etc. As the game progresses, the restaurant grows, and the player purchases upgrades for the restaurant, which poses new challenges.

When shaping the music for the game, we wanted to keep it away from the more traditional puzzle music that you heard in casual games at the time. We worked to create a unique musical style that used fun, unusual instruments and palettes. We wanted to make it as unmidi as possible. We did this by using interesting sampled percussion and horn hits along with fun melodic elements (guiros, handclaps, vibraslaps, congas) and lots of good room reverbs. We wanted to keep it super friendly and have some toe tappin goin' on.

From the initial design stages we were involved in shaping how the sound effects in the game would create the atmosphere, and at the same time complement the music. We needed to have a rich background of sound effects and give good feedback to the player. The sound of the restaurant, people entering and leaving, plates being dropped off, orders being taken, all added to the basic ambience of the restaurant. In addition the other effects included player feedback, like scoring events and level start and end. In all there were about 30 different effects that shaped the game.

On the music front there are four gameplay themes that were written for Diner Dash, and each of these is split into smaller pieces (two, four, or eight bars) that all work together no matter what order you place them in. These smaller loops then get played end-to-end randomly during the gameplay to best utilize our assets and give the player as much variation as possible. In addition there was a main menu theme that was split up in the same way. We used a combination of ProTools, Reason, and Digital Performer to compose and create the sound effects and music. We then mastered the individual elements in Peak and Goldwave.

BLiX

Another title that takes a completely different approach to sound is a innovative puzzle game called BLiX. The game brought me several nominations for best audio in a game and the Independent Game Festival Award for Best Audio in 2000. The object of BLiX is incredibly simple: Get the balls into the cup. The

game itself was designed to be played by anyone; the interface was iconic, the scoring system didn't use numbers, there was also no real language in the game design itself.

This title takes a completely different approach to music. When designing the sound, I wanted the player to create the music through gameplay without actually realizing they were participating in it. All the sound effects are musical phrases that get added to an underlying loop of ambient background techno music. In addition the game space is divided into a grid of nine spaces that have rollovers, so as the player moves around the screen placing bumpers and playing the game, these musical rollovers trigger simple drum hits and synth notes. In essence the musical score is self-generated by the user.

At the time, with limited toolsets, we introduced some fairly unique concepts to an Internet puzzle game: the creation of music centered around gameplay. Today there are many newer technologies that allow the composer to really shape narrative in real time through seamless branching of the musical score and dynamic created sound effects. At the time BLiX was done, we had to be creative about the use of the limited technology, trying to break the rules of the system.

BLiX interfaces

There were a total of about 30 different sound assets for the game, including 14 background music loops and many sound effects. The sounds themselves were created using software packages Rebirth and Protools. I wanted to integrate lots of delays and effects into the individual sounds. I wanted to also recognize a retro arcade feel to the game, taking beeps and blips to a whole new level. The other developers were all old arcade heads and we wanted to recognize our heritage, so to speak.

Adding delays on sounds add a lot of file size to the game. The codesigners of the game let me have full reign over file size, which really allowed me to be creative first instead of being led by the technology or inherent difficulties of the limitations of an Internet game. Although we took out assets to maintain file size when Shockwave.com acquired BLiX, it really allowed me to open up creatively and experiment in ways I really hadn't before. I was lucky to be working with designers who let me experiment and try new things.

Audio feedback is incredibly important. When I talk to people who play BLiX, they always mention the *game over* sound and how they hate hearing it. I was in the process of taking it out during the creation of the game because I felt it was too harsh, when the other designers (Peter Lee and Eric Zimmerman) told me how much they liked it. Players of BLiX hate getting to the game over sound, and they immediately start a new game as a result.

The one sound in the game I didn't create was the timer running out sound. Peter Lee found this sound and we ended up not changing because it's another sound that jolts you back to reality. After playing the game for a while you get that sort of numb Tetris-like feeling where the game is a machine and you're part of it. All of a sudden the timer is running out, and it jolts you back to the reality that the game is about to end.

It was really important to me that the audio feedback during the game was a single audio-rich experience. The sound effects in BLiX needed to be tightly integrated into the music. Even though we didn't have the ability to sync sounds to the beats, the sounds are so well designed (ultimately to my initial disbelief) and synergistic with the background loops that everyone just considers it music instead of two separate elements.

Something frequently overlooked is that audio feedback can also establish the rhythm of interaction for the player. Digital gameplay has a player interaction that has a specific speed of movement, mouse clicks, and keystrokes. These interactions have rhythm all on their own that the music and sound effects can support or detract from.

Similar to film, the game sound designer can use motifs and themes to create metaphors for characters, help transitions, and give direct or indirect feedback to the user about how they're doing in the game. The power of sound design can also create emotions that are hard to achieve strictly by the visual representation of the game; things like empathy, hatred, and love can all be represented through music and sound.

Usability specialists are generally trained psychologists or researchers whose focus is on testing and evaluating how users interact with various products. The general software industry has incorporated usability testing into its product cycle for years. The game industry lags somewhat behind, although several large publishers, such as Microsoft, now have impressive internal groups dedicated to usability testing for games.

Professional usability labs are often set up with sophisticated recording equipment, allowing the researchers to insert a close-up view of the participant's hands on the controls—keyboard and mouse or console controller—within a shot of the main interface. Sometimes another camera shows the participant's facial responses, and her voice is recorded over the sound of the product as she talks out loud about what she is thinking. The researchers usually sit behind one-way glass with the designers and producers of the product and communicate with the participant via intercom.

The researchers prepare a test script for the session—similar to but more detailed than the one you created in Exercise 9.4—that asks the participant

11.15 Microsoft playtesting lab

Multiple participants are playing games, each at their own station. Stations have partitions between them and headphones to minimize distractions. This is done so that one participant's experience does not affect another's. Each participant's opinions and preferences are collected via a Web-based questionnaire on the monitors at each station. (Photo by Kyle Drexel)

Each game designer should recognize the power that audio has to increase every aspect of his game. Studies have shown that higher quality audio often gives the game player a perceived increase in the overall visual look of the game and heightened awareness during gameplay.

About the Author

Michael Sweet is the creative director for AudioBrain. As a composer and sound designer, he has won numerous awards for his work, including the prestigious BDA Promax Award 2000 for Best Sound for a Network Package (HBO Zone) and the Best Audio Award at the GDC Independent Games Festival in 2000. You can find Michael's sonic imprints on many award-winning games and Web sites. Award-winning work includes: Xbox 360 startup and interface sounds, PlayFirst's DinerDash, iWin's Shopmania, Sesame Workshop's MusicWorks, Shockwave's BLiX and LOOP, RealArcade's WordUp, and many games for the Cartoon Network. In broadcast, Michael's work can be heard in many commercials and network identities, including HBO Zone, Comedy Central, CNN, General Motors, Kodak, AT&T/ TCI, and The X-Files. In addition Michael's sound sculptures have traveled around the world, including the Millennium Dome in London and galleries in New York, Los Angeles, Florence, Berlin, Hong Kong, and Amsterdam.

to walk through a number of areas in the product or complete a set of tasks. Data on how successful participants are in completing these tasks and an evaluation of how critically any findings will impact the product are compiled in a report.

When we ask you to test for accessibility in your game, we are basically asking you to do a layman's usability test. By now, you have probably playtested your game with quite a few different people. Unfortunately, these people are now disqualified for your accessibility testing. The right people to test for accessibility are:

- Part of your target market
- Objective (not friends or relatives)
- Those who have never played your game

You will need a fair sized group: three to five people in each segment of your market (if there is more than one) are sufficient. Eight is preferred.

To make things go smoothly and to get the most out of the session, you need to identify the most critical areas of your game. Your list will probably include starting a game and some of the more critical choices or features. Now create a script you can use to get the

11.16 Microsoft usability lab

A participant (background, on the right) is playing a game. In the foreground, a user-testing specialist is observing the participant play the game in an adjacent room, separated by one-way glass. The one-way glass allows the user-testing specialist and development team members to discuss the game and participant behaviors without being overheard by the participant. (Photo by Kyle Drexel)

participants to these critical areas and present them with tasks that will give you insight as to how they are working. The script does not have to be elaborate; its purpose is to help you keep the session on track with as little fumbling and forgetting as possible. You want the participants to concentrate on your game, not on you.

Unless your game demands a multiplayer environment, it is best to do this type of testing one-on-one. You want to see where people are stumbling or guessing, and people sometimes try to hide that, or they copy from a neighbor in a group. If you have to have participants in the same room during a test, explain to them that they should not help each other with the tasks.

You might want to have a friend help you out, if you cannot record the session, by taking notes while you walk through the script with the participant. Have the note-taker sit out of the participant's peripheral view to lessen distractions. When you have run several tests, you will undoubtedly begin to see a pattern. You might be surprised to learn that your game is not as accessible as you believed. The example of the first few minutes of Halo shows how easy it is for game designers to miss potential areas of confusion simply because they are so familiar with the game. Just remember that participants in a test like this are never wrong.

As tempting as it might be to believe that a feature is obvious, your opinions do not count in this type of testing. If your players cannot play, there is no game.

Identify the areas that are causing problems, make revisions, and do another series of tests. Continue this process until you are satisfied that a majority of your target players can access the most critical areas of your game. In a perfect world, you could test every aspect of your game for accessibility, but you probably won't have the time or resources to do it. What you can do is make the game easy to get into, easy to understand, and accessible to play.

Exercise 11.10: Usability Testing

Conduct a set of usability tests for your original game prototype as described previously.

1. Write a script for a usability test in which you focus on critical tasks like starting a game, understanding objectives, making key choices, etc.

2. Recruit a group of new testers who have not played your game before.

3. Conduct the tests and analyze the results. Come up with three ideas to improve your game's usability.

CONCLUSION

You now should have a game that is functional, complete, balanced, fun, and accessible. That is a major accomplishment. Whether you have gone through this process alone, working with a paper prototype, or whether you have managed to get a team together and create a digital prototype of your game, the fact that you have gone through all the phases of design and testing means that you had an idea that was worth the effort. This certainty will be what you need to carry you through the full production and release of this game.

Before moving on, take a look back at the process you have just been through:

* You not only came up with an idea for an original game, you learned skills and techniques that will make you a valuable member of any design team.

* You have translated your ideas into a physical prototype and possibly a digital prototype of a working game.

* You have playtested your prototypes and revised them until your gameplay delighted your testers and achieved your gameplay experience goals.

At this point, you should feel empowered by your control of the playcentric design process. No longer a mystery, the process of game design is one you should feel confident with practicing on your own, with friends, or as a member of a professional design team. You can use your skills to create games in your garage, or you can try to get a job with an established developer or publisher. Whatever you decide to do, you will have the experience and the critical skills to approach the task of game design as both a personal art and a social, collaborative dialogue between the designers and the players of games.

Designer Perspective: Richard Hilleman

Father to Rachel and Christopher

Richard Hilleman is a Creative Fellow at Electronic Arts. He has been a game producer and designer for more than 20 years, and his credits include Racing Destruction Set (1985), Ferrari Formula One (1988), Indianapolis 500 (1989), Chuck Yeager's Flight Trainer (1990), John Madden Football (1990), NHL Hockey (1991), Kasparov's Gambit (1993), The Lost World: Jurassic Park II (1997), Tiger Woods 99 (1998), Tiger Woods PGA Tour 2000 (2000), and American McGee's Alice (2000).

On getting into the game industry:

I had a friend, David Gardner, who used to work at the computer store I haunted. He told me about going to EA and the fact that Tim Mott worked there. I knew about Tim from his Xerox Parc/Bravo days and knew it beat business applications in Fortran, which is what I was learning in school. I started out copying discs, making cables, and making Apple IIs and IBM PCs work. Then EA figured out I could do some other things.

On favorite games:

- *Chess:* Just the most perfect game ever invented, true mental warfare.
- *Hold 'em poker:* The best game of chance ever invented.
- *Quake III:* For what it became after the public got a hold of it.
- *Quake:* For the work that American and John did to redefine what a shooter could be.
- *M.U.L.E.:* The best multiplayer game for computers. As close as computers have to a classic like Monopoly.
- *Indianapolis 500:* The first real driving simulation that was also fun.

On game influences:

- *F15 Strike Fighter:* Sid Meier shaped more of my views as a designer than anyone else.
- *TV Sports Football:* Got half of the idea right. Madden, the game series, put the rest of the game with the presentation.
- *Nintendo Golf:* This might actually be Miyamoto's greatest game. Look at how much fun it still is today on 8-bit hardware. Then you try and make a game that is still fun after almost 20 years.
- *Pole Position:* The first great racing game.

On what makes you proud:

- That sports and simulations are no longer the backwaters of interactive entertainment. When I started producing and designing, D&D games were about half the market.

Advice to designers:

- Get as broad a background in the liberal arts as you can. The technology will change enormously in your lifetime, but people won't.

Designer Perspective: Bruce C. Shelley

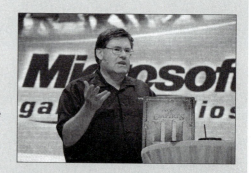

Senior Designer, Ensemble Studios

Bruce C. Shelley is a veteran game designer whose credits include Covert Action (1990), Railroad Tycoon (1990), Civilization (1991), Age of Empires (1997), and Age of Empires II: The Age of Kings.

On getting into the game industry:

I played games of one sort or another all of my life. I began testing board war games by mail for free and eventually landed a job with the company. I was developing board games in 1987 when my company asked me to move over to computer games, which I did. In 1988 I landed a job with Micro Prose and got a chance to work with Sid Meier. In 1995 an old friend asked me to join Ensemble Studios, and I have been here since.

On favorite games:

I generally dislike this question because tastes change and games that were very important at one time are no longer even available for current operating systems or platforms. Here are five that I particularly enjoyed:

- *Railroad Tycoon:* Working on this game was something I would have done for free if I could have made a living somehow; it was great to see Sid Meier figure out how to make a good game out of something as cool as railroading—not an easy task. The game had a fun economic model, cool trains running, multiple paths to victory, and was endlessly replayable.

- *Civilization:* Great fun to work on; we knew we were making something very special. It had a great hidden map, 4X game, multiple paths to victory, endlessly replayable, levels of difficulty, great topic, deep and rich, and presented a very interesting stream of decisions for the player to make.

- *Age of Empires II: The Age of Kings:* An excellent RTS in a great period, fantastic graphics, tremendous value to customers, lots of different game experiences within the same box, endlessly replayable, and a deep and rich game experience.

- *Empire Deluxe:* A very old game but a classic that is an early and excellent example of many good design principles for strategy games: hidden maps, inverted pyramid of decision making, a great first 15 minutes, adjustable levels of difficulty, not beautiful but clean, great opportunities for strategy and tactics, simple but interesting economic system, and a great stream of interesting decisions, but the one negative for me is the end game, which can drag on.

- *World of Warcraft:* A very rich and deep online role-playing game that keeps me coming back for more. It appeals to both hard-core and casual gamers and can be enjoyed in a variety of ways. There is an amazing variety and quantity of content to explore. It is perhaps the finest achievement in interactive games to date.

On inspiration:

The single greatest resource for any game developer is all the existing games that can be played and learned from. Empire Deluxe and SimCity were great inspirations for later games that I helped design. Populous offered a lot of ideas about god games and strategy games. At Ensemble Studios we were greatly influenced by WarCraft I and II, and Command & Conquer.

On the design process:

Our games have been primarily derivative; that is, derived from existing games. We often took parts of several games and brought them together with a leavening of new ideas. The original Age of Empires, for example, was inspired by the content of Civilization and the gameplay of Warcraft and Command & Conquer. Borrowing is fine, but be careful not to imitate. Your game must be easily differentiated at a high level (AoE was about history with realistic bright graphics) and innovative at the gameplay level (AoE included randomly generated maps, multiple paths to victory, a noncheating AI, etc.). People want games similar to ones they already like, but they won't buy the same game twice.

On prototypes:

We prototype as quickly as we can. When the game is playable we test, fix, retest, and so on in a process we call design by playing. We rely on our instincts as players to tell us when something new is working or not. Features that are fun are enhanced and polished; those that are troublesome are dropped. We plan up front for sure based on our best ideas, but the design by playing process ensures that the game is fun when finished. I believe that extensive testing for gameplay is crucial to making fun games.

Advice to designers:

Play a lot of games and analyze them. Understand why some games succeed and why others do not. Understand what is actually happening within a player's mind when he or she is being entertained by a game. Think in terms of entertaining a large audience, not a small one. It is okay, even encouraged, to borrow from great games, but be different at the vision level (topic, look, and feel) and innovative at the gameplay level. Don't imitate great games—people have had that experience and probably won't pay to repeat it.

FURTHER READING

Bogost, Ian. *Persuasive Games: The Expressive Power of Videogames.* Cambridge, MA: MIT Press, 2007.

Cooper, Alan and Reimann, Robert. *About Face 2.0: The Essentials of Interaction Design.* Indianapolis: Wiley Publishing, 2003.

Gee, James Paul. *Good Video Games and Good Learning: Collected Essays on Video Games, Learning and Literacy.* Bern: Peter Lang Publishing, 2007.

Koster, Raph. *A Theory of Fun for Game Design.* Scottsdale, AZ: Paraglyph Press, 2004.

Maeda, John. *The Laws of Simplicity: Design, Technology, Business, Life.* Cambridge, MA: MIT Press, 2006.

Norman, Donald. *Emotional Design: Why We Love (Or Hate) Everyday Things.* New York: Basic Books, 2004.

END NOTES

1. Bocska, Steve. "Temptation and Consequences: Dilemmas in Video Games," Game Developers Conference, 2003.
2. Yee, Nick. "EQ: The Virtual Skinner Box." http://www.nickyee.com/hub/home.html.
3. Fulton, Bill. "Making Games More Fun: Tips for Playtesting Games," Game Developers Conference, 2003.

Part 3
Working As a Game Designer

The first two sections of this book were designed to help you become literate in the structural elements of games and to learn the art of prototyping and play-testing your own game concepts. In this third section we will turn to focus on practical information that will help you to become a working game designer. To succeed as a game designer, you will need to be able to work effectively on a team, communicate with diverse types of people, and understand how the structure of the game industry can affect your project.

We start out this section with a discussion of how development teams are structured in the industry. We provide insight about the types of people who work on game projects, from the executives at the publishing company to the QA testers who assure that the game is ready to release. Then we look the various stages of development that digital games go through from concept to completion.

In addition to having a clear grasp of team structure and the stages of development, you will need to be able to communicate game concepts effectively with the entire team in a design document. In recent years, design documents are often created using collabora-tive tools such as a wiki. Whether you use a design document or a wiki, we will show you how to describe your design so that it reflects the gameplay you have designed, prototyped, and playtested. We will also discuss how to make your design document or wiki a useful tool for team communication.

The final two chapters are a brief discussion of the game industry and how to get a job or sell an original concept. In Chapter 15, we explain the various par-ties that make up the game business, the platforms and genres that drive the industry, and the nature of publishing deals. The final chapter discusses practical strategies you can follow for getting a job in the indus-try or pitching your own original game ideas.

Chapter 12

Team Structures

When digital games were first commercialized in the 1970s, one person, with a decent knowledge of programming, could create the entire product. That person would act as game designer, producer, programmer, and even graphic artist and sound designer. A finished game averaged only eight kilobytes or less in size; on-screen characters were represented by jagged blocks of pixels, and sound effects consisted of generic "beeps" or "bonks" generated from the sound card. To give you a sense of the state of the art, the arcade classic Space Invaders, from 1978, was four kilobytes in size, including all art and sound. Asteroids, released in 1979, was eight kilobytes in total, and Pac-Man, released in 1982, was 28 kilobytes.

As PCs and game console hardware have become more powerful, the size and complexity of the games on these platforms have grown exponentially. The amount of art and audio that can be incorporated into games has surpassed and now dwarfs the computer code. Today's titles take up hundreds of megabytes of storage, with their overall production values fast approaching that of television and movies. Elaborate visual effects, sound effects, music, voice acting, and animation are all standard fare in today's games. Some, such as CSI: Crime Scene Investigation or Pirates of the Caribbean, rely on the voices and 3D models of well-known television and film actors to give life to game characters, while others, like Medal of Honor, set their epic cinematic game scenes with music performed by live orchestras.

Along with this rise in production values has come the need for much larger teams composed of people from many different backgrounds. From database programmers to interface designers and 3D graphic artists, game teams are becoming increasingly composed of a wide range of specialized talent. In this chapter, we will look at the roles of each of these types of individuals and how the game designer fits into the team structure.

TEAM STRUCTURE

Figure 12.1 illustrates the basic job categories that make up most development and publishing teams in the game industry today. Note that this diagram only shows the types of individuals who are involved in the production at some level. We purposely did not include human resources, accounting, public relations, sales, and support, because they do not typically become involved in the actual production and are outside the scope of this discussion.

Publisher versus Developer

To understand team structure, we must first examine the relationship between the publisher and the developer. As any game developer can tell you, this relationship is critical. It determines how everything else will be structured. The types of relationships vary. Sometimes the developer will do almost everything but sell and market the game. Other times the

12.1 Team structure

Publisher	Developer
- Chooses which titles to produce - Finances titles - Provides QA testing - Markets titles - Distributes titles	- Pitches creative ideas and demos to publishers - Uses money from publishers to produce titles, including game design, programming, art, audio, etc.

12.2 Publisher/developer responsibilities

publisher will do its own internal development. But in most cases, the arrangement will break down according to the chart in Figure 12.2.

Typically the publisher gives the developer an advance against royalties, and the developer uses this money to pay the team members, cover overhead, and subcontract certain portions of the work. The developer's main task is to deliver the product, while the publisher's is to finance and distribute it.

Figure 12.3 shows examples of some typical publishers and developers in the industry today. One confusing aspect of this relationship is that many game publishers also develop games internally. Electronic Arts is one example of a publisher that develops a number of its titles in-house. Additionally, some game developers are owned by publishers. For example, Blizzard Entertainment is wholly owned by Vivendi Games.

Even in these cases, however, there is a basic publisher/developer relationship between the internal development group and the rest of the company. In many respects, in-house development teams, as they are called, are forced to act like small companies that are responsible for their own cash flow, profit and loss, schedules, and staffing. This helps the publisher to gauge the success of each developer and analyze whether it is more cost effective to work with internal or external groups.

We will look at the typical individuals involved in a game production from the publisher's side on page 362, but first, let's focus on the production team from the developer's perspective.

Publishers	Developers
Electronic Arts	Blizzard Entertainment
Nintendo	Rockstar Games
Activision	Ensemble Studios
Sony Computer Entertainment	Naughty Dog Entertainment
Take-Two	Bioware
Microsoft Game Studios	Firaxis Games
THQ	Gas Powered Games
Ubisoft	Epic Games
Konami	Lionhead Studios
Sega Sammy Holdings	Relic Entertainment
Namco Bandai	Insomniac Games
Vivendi Games	Ready at Dawn
Square Enix	Pandemic
Capcom	id Software
NCSoft	Infinity Ward
SCi/Eidos	Valve
Lucasarts	Vicarious Visions
Buena Vista Games	Bethesda Softworks
Atari	Treyarch
Midway	Crytek
	Harmonix
	Bungie

12.3 Example publishers and developers

DEVELOPER'S TEAM

Game development companies often begin life as small groups of people, usually friends, who enjoy working together. Many times, especially in the beginning of a company's existence, the exact job descriptions might not be clear. "Everybody does everything" is a common comment at small start-up game companies. But as the team grows larger, budgets grow bigger, and projects grow more and more complex, even the best of friends have to determine who is responsible for what—and when.

Most established game developers clearly delineate job descriptions for every member of their team. This does not mean that individuals do not work together closely, they just sometimes ignore the exact lines of their formal job descriptions. It does mean that each individual has a specific focus, however, and a set of skills that makes him the best person to be ultimately responsible for certain aspects of the project.

Let's look at each of these types of individuals closely, beginning with the game designer, because our primary goal is to understand how the game designer fits into the structure of the team and interacts with all of these other individuals.

Game Designer

As we have already discussed, the game designer is responsible for the play experience. From conception through completion, it is the designer's job to ensure that the gameplay works at all levels. Because gameplay is so intricately linked with how that play is programmed, visualized, and supported by music, voice-over, etc., the game designer must collaborate closely with just about every other team member.

Because you have had experience designing your own games by now, you know the designer's primary responsibilities. To review, they are as follows:

- Brainstorm concepts
- Create prototypes
- Playtest and revise prototypes
- Write concept and design documents and update throughout production
- Communicate vision for the game to the team
- Create levels for the game (or works with level designers; see page 361)
- Act as advocate for the player

Not all companies have dedicated game designers. This role is sometimes undertaken by programmers, artists, executives, or producers. Depending on the scope of the project and the skill of the individual taking on multiple roles, this practice can sometimes have a detrimental effect on the design process.

For example, a game designer who is also the programmer of a game might not be objective about the success of a crucial feature of gameplay simply because the feature took them several weeks, or even months, to code. If the roles are divided, the game designer can approach playtests and feedback with a more objective mindset.

This conflict of interest is true of game designers who also play the part of producers, artists, or executives. It is seen most clearly when the role of game designer is combined with that of the producer. Because the producer is ultimately responsible for the schedule and budget of the project, there is a natural conflict with the designer's role. How can a single person advocate expenditures of time and money to ensure the best gameplay possible, while on the other hand making sure the team sticks to a strict bottom line?

As a solution to this problem, at some companies, like Electronic Arts Canada, the producer does act as the game designer, but many of the producer's traditional responsibilities are handled by another individual who is called the development director.

In the end, exact titles are not as important as job descriptions. What matters most is that on every game there is someone who is able to focus specifically on the workings of the gameplay without the distraction of too many other responsibilities. We call this person the game designer.

To take on this responsibility, especially on games as complex as those being made today, is a full-time job, and the industry has begun to move toward a system where dedicated game designers can concentrate on the gameplay and the player experience without being burdened by budgeting, scheduling, resource allocation, and other production duties.

Producer

The simplest definition of a producer for the developer's team is that she is the project leader. The producer is the person who is responsible for the delivery of the game to the publisher as promised. To make this delivery, the producer must create a plan for that delivery, including a schedule, budget, and resource allocation.

In most productions, there is a producer on the publisher's team as well as one on the developer's team. These two producers, in a good working structure, serve collectively as the single point of contact for important decisions regarding the production that have to pass between the publisher and developer. By making this single point of contact the main conduit of information between the two teams, the producers can work together to make sure that both teams are acting on the same assumptions and that important decisions are communicated to the right people on each team as they are made.

In brief, the responsibilities of the producer for the developer are as follows:

- Team leader for developer's team
- Main communication link between developer and publisher
- Schedule and budget for the production from the developer side
- Track and allocate resources as well as forecast
- Manage developer team to make sure deliverables are completed on time
- Motivate team and solve production related problems

Meeting the delivery schedule usually involves making some tough decisions during the course of the production; some of the producer's many responsibilities might include hiring or firing employees as well as saying no to excessive resource or spending requests. Ultimately, being a producer can be an extremely rewarding role. Producers interact with the contacts on the publisher's team more than the other team members. They might also be asked to represent the team in public, at conferences, or in the press. The office of the producer often serves as a "United Nations" for the production team—the place where everyone comes to air their grievances and concerns and, hopefully, to resolve them.

Applying for a Job in Game Design

by Tom Sloper, President, Sloperama Productions

First off, it's important to understand that everybody wants the title of "game designer." It's the "sexy" job title in the game industry, akin to "director" in the movie/TV world. So even with a game design degree and a great design portfolio, it's tough to break into the industry in game design. You'll have to study what interests you, and apply for any game industry job you can get.

The key is getting in in the first place. Your first goal must be simply to get inside the industry. We're talking about a career—a way of life—not a sinecure.

When you are inside, you have to work hard, volunteer to help out in any way you can, learn everything you can, and prove yourself before you can gain the title of game designer.

After proving yourself as a game designer once, you will have to prove yourself time and time again. Know that ahead of time, steel yourself, and be willing. And you'll be fine. Okay, the necessary basic info is out of the way now. Here's how to apply for that game industry job.

First, you must be prepared for the job.

Presumably, you have completed the exercises in this book. Presumably, you are a high school graduate and have a college degree. Presumably, you are an avid game player. Presumably, you have already been participating in the online game forums, to wit:

- http://www.igda.org/Forums/
- http://www.gamedev.net/community/forums/
- http://www.gamecareerguide.com/forums/

Next, you need to have a well-written résumé.

I'm not going to tell you how to write a résumé. There are lots of books and Web sites about that. One way to sweeten your résumé, though, is to mention your personal design projects. You will differentiate yourself a lot if you list prototypes you've made, treatments you've written, mods you've created, game groups you've organized, newsgroups you participate in, etc.

Next, prepare your portfolio.

What's a portfolio, you ask? According to Merriam-Webster, a portfolio is:

- A hinged cover or flexible case for carrying loose papers, pictures, or pamphlets
- A set of pictures (as drawings or photographs) either bound in book form or loose in a folder

If you're an aspiring game designer, you can create a portfolio with samples of your writings and drawings, photographs of your paper prototypes, flyers, newspaper clippings, or photos from game events you

organized—anything that shows off your creativity and desirability as a job candidate. Just the best stuff, though. A portfolio should fit into a half-inch flexible three-ring binder. (It shouldn't be too thick; you'll only have a few minutes to show it off.) Protect the paper by encasing it in sheet protectors (available at office supply stores). And make copies of your portfolio so you have the option of leaving them permanently with numerous hiring managers.

Organize your portfolio with your most striking stuff in the front. In an interview, the interviewer might open the binder, look at the first few things, then close it. So you need to make the best possible impression with the first things right up front.

Don't put complete designs into your design portfolio—game companies almost always have prohibitions against receiving game concept submissions without signed agreements in place, and they might perceive your portfolio as a stealth submission. There shouldn't be more than about 20 sheets in a portfolio.

If you've created animations, audio pieces, or programs, collect those on a CD. Don't bring demos on Zip disks, 8-tracks, Syquests, or reel-to-reel tapes! But, as with the paper portfolio, make a copy.

So that's what a portfolio is and how it's used. If you can't make a spectacular portfolio, don't make a portfolio at all. It's okay to show up for an interview without a portfolio. However, having one is important if you want to set yourself apart from the competition.

Next, you have to have a target list of game companies.

I can't give you a target list; each aspirant has to make this for himself. Any game company worth working for has a Web site. And there are lots of game industry job Web sites. Assuming you're familiar with Gamasutra and Google, you will find them. Ideally, your list contains companies in your local area or in an area you are willing to move to on your own dime.

Next, you need to educate yourself about your target companies.

Read their Web sites. Learn their product lines. Find out about their stock, if they're publicly owned. It looks bad if an applicant comes in and says, "Well, I don't know anything about your company, but I'd like to work here."

Now you're ready to contact the target companies.

Don't pin all your hopes on one specific company. Have multiple companies to contact. You never know what's going to happen. Find out the name of a person to contact at each company. If you know someone who knows someone at a company, get in touch with that person and find out whom you should send your resume to. You need a name to put at the top of each cover letter. If you don't know anybody who knows somebody, call the company and ask for the name of the studio head (the VP in charge of the game production department) or for the name of the human resources head.

Write a good cover letter.

As with résumés, you can find information about how to craft a good cover letter on the Internet. Being a game designer means being a creative writer. Your cover letter should showcase your creativity and your communication skills. Mention the games you've created on your own. The cover letter (especially if there's basically nothing on your résumé) is arguably even more important than the résumé.

It's unrealistic to say, "I'm seeking a job as a game designer," and it's not helpful to say, "I'll take any job you have open." Find out what job openings are available. Figure out which opening is suited to your skills and interests. That's the job you should be applying for.

Mail the résumé and cover letter or deliver them in person.

If you do not live in the local area of the target company, mail your package to the person previously identified. But if you do live in the local area of the target company, call the person and request an interview. If you mailed your package, follow up with a phone call a week or so later. Ask the person if she's received your package. Your goal is to come in and meet with the person. A game company will not pay your airfare to fly out for an interview for an entry-level position, so don't ask.

When speaking with the person on the phone, be your normal, personable self. Don't say you want to come in for a job interview; just ask if you could come in to introduce yourself. You're interested in learning about the game industry, you're a college graduate, you've done some stuff on your own, and you'd appreciate a short chat.

Eight times out of ten, that straightforward approach will get you in the door. And that's exactly where you want to get—in the door.

Attend the interview.

Don't put on a three-piece suit. Nobody in a game studio (aside from some top executives) wears a suit. Wear clean, presentable clothes. Long pants. Shoes and socks. Bring two or three copies of your resume and cover letter, and bring your portfolio along with extra copies of that as well.

The main goody, the best thing you bring to the interview, is you. Be eager, attentive, charming. Your goal is to get a job, any job, so that you can eventually be a game designer. Find out what job openings are available. Figure out which opening is suited to your skills and interests. That's the job you should be angling for.

What the company is looking for is hard-working, smart, capable communicators first and foremost. That's the impression you want to convey through your appearance, your eye contact, and what you say during the interview.

Show your portfolio, if possible.

In an in-person interview, you could, at a logical point in the conversation, show samples of your work. If you're a game designer, sample game concepts might be construed as an unsolicited submission, making the game company liable to a lawsuit from you if they ever did anything similar. It would be wise to put your designs on your own Web site (like a free GeoCities Web page, for example), which would make them public knowledge (taking your portfolio out of the realm of "submission" and into the realm of "portfolio"). Letting the interviewer know this in advance could prevent what might otherwise turn into an awkward moment if someone perceives your portfolio as an unsolicited submission. And it shows that you are both savvy and sensitive to the company's needs.

Be prepared with your portfolio, in paper form, CD form, and/or Web form, but realize that the interviewer might not have the time to look at it during the interview. Do not expect the interviewer to navigate through whatever labyrinthine path you have on the Web or on a CD during the interview. It doesn't work like that. If you have the opportunity to show it, that's great. If not, don't be upset.

An important point about game concepts you developed on your own (oft stated on the game design Web sites): It's unlikely that anybody is going to steal your idea and make your game idea without you. It's

also unlikely that they'll take your idea and make the game with you. Game companies are teeming with more ideas than they can ever make. What game companies need is people, not game ideas. Your purpose in showing them your portfolio is purely to show them that you're a creative individual whom they should hire.

What to do after the interview:

It's unlikely that the interview will end with you walking out the door with a job offer in hand. That's possible, and that's desirable, but it's more likely that the interviewer will discuss you and your resume with others before any decision is made about offering you a job. When you leave the interview, you will probably have a sense of how well the interview went. If it didn't go very well, then just spend a few minutes thinking of what you could have done to make it go better. Then use that thinking on the next interview. When a stumbling block is in your way, use it as a stepping stone.

Send thank-you notes to the people who interviewed you. I know it sounds old-fashioned, but we're not talking about robots, we're talking about human beings with whom you want to build human relationships. Some folks send thank-yous electronically; some will tell you a paper letter is best. Here are some tips on thank-you letters from CareerBuilder (www.careerbuilder.com):

- Send the thank-you letter within 24 hours of the interview. The idea is to show them that you have follow-up skills.
- The letter should be one page max.
- Each one you send must be written specifically for the individual. If you met multiple individuals, get their business cards so you have proper spellings and job titles, and take notes immediately after the interview so you can recall details for personalizing the letters.
- An important purpose of the letter is to restate why you are a good candidate and also to answer any potential objections, especially those you might have heard the individual mention during your interview.
- Just like with a cover letter or résumé, the smallest writing error can spoil any good impression they may have gotten of you.

It can take weeks or even months to get called back to a company after your first interview. Keep in touch, but again, don't pin all your hopes on one company. Go for other interviews. The worst thing that can happen is that you don't get any offers. The second worst thing that can happen is that you get one offer. The third worst thing (the same thing as the best thing that can happen) is that you get more than one job offer to choose from.

About the Author

Tom Sloper's game biz career began at Western Technologies, where he designed LCD watch and calculator games and the Vectrex games Spike and Bedlam. Subsequently, he worked in designer, producer, and director roles at Sega Enterprises, Rudell Design, Atari Corporation, and Activision. Sloper participated in the completion of 127 game products—85 in the role of project leader, and 27 in the role of designer—winning six awards along the way. Sloper has produced games with developers in the United States, Japan, the United Kingdom, Australia, Russia, Europe, and Southeast Asia, and he lived for several months in Tokyo while working for Activision's Japan operation. Doing business as Sloperama Productions, Sloper is currently consulting, writing, speaking, and teaching at USC.

There might also be an executive producer on each team whose job it is to oversee multiple productions or sometimes an entire development group. Additionally, there might be assistant producers and associate producers on each team whose job it is to support the producers. Most producers start out as assistant producers and associate producers then work their way up the ladder to producer, senior producer, and eventually executive producer.

As a game designer, you must work hand-in-hand with the producer. This means sitting down together at the start of any production and going over the design in detail. It is your job to make certain that the producer crafts a realistic schedule and budget, and the producer cannot do this without a clear understanding of the game you plan to make. If you do not clearly explain the entire scope and vision of the project, the producer will wind up using canned numbers or rough estimates, and both the schedule and budget for your game will be inaccurate, potentially insufficient, and the cause of a lot of unnecessary anxiety.

This means that to be a really efficient game designer, you need to understand the ins and outs of scheduling and budgeting almost as well as the producer. You do not have to create these documents, or be responsible for tracking them, but you should review them carefully and understand each line item. Make sure they match your vision of the project, and articulate any issues you see as early as possible in the process.

Programmers

We use the term "programmers" as a catchall to refer to everyone involved in technically implementing the game. This includes high- and low-level coders, network and systems engineers, database programmers, computer hardware support, etc. Programmers are also referred to as engineers and software developers at some companies. Advanced positions in this track are senior programmer, lead programmer, and technical director, all the way up to CTO. Some companies break down the titles according to specific areas of specialization, such as tools programmer, engine programmer, graphics programmer, database programmer, etc.

In general the programming team's responsibilities include the following:

- Drafting technical specifications
- Implementing technical aspects, of the game, including:
 ◊ Software prototypes
 ◊ Software tools
 ◊ Game modules and engines
 ◊ Data structures
 ◊ Management of communications
- Documenting code
- Coordinating with QA engineers to fix or resolve bugs

As a game designer, if you do not have a technical background, you might find it difficult to communicate your ideas to the programming team. While you do not need to become a programmer, if you are going to design digital games, you do have to learn the basic concepts of programming to have a common language with which to speak to the engineers. There is no right way to do this. If you learn best by reading, then buy a book on programming for beginners. If you need a structured environment in which to learn, then take a class. If you have a good relationship with a programmer, then ask him questions about his work. Everyone likes to talk about things they are good at. If you express genuine interest, most programmers will talk your ear off about how games are programmed.

After you have a strong understanding of how games are implemented technically, you can use this knowledge to write better design specifications and to describe your game concepts more clearly to the technical team. This, in turn, will make programmers more open and accessible to talk to about tweaks and changes to the gameplay as they are required.

Throughout the production cycle, you will find that almost every change you need to make to the gameplay requires alterations in the code. If you have designed your game modularly, as we discussed in Chapter 10 on page 304, this won't mean drastic repercussions to the entire system, but it will still

mean additional work for the programming team. To achieve the kind of relationship with the programming team that will allow you to suggest these changes without an uproar, you will need to use all your communication skills and your knowledge of programming.

Whether your team is large or small, there is likely a hierarchy you will need to respect to get things done. No matter how much you would like to circumvent the technical director, for example, and go straight to the database engineer to ask for a quick change, try to avoid such an action. This undercuts the technical director's authority, and there is no better way to create an adversary out of this person.

You need to partner with the technical director, lead programmer, or whoever is in charge of your programming team. It is this person's job to communicate your ideas to the other team members, and you want to establish a relationship where they will respect your ideas in the same way that you respect their expertise and contribution.

The goal is to have your programming team become active participants in the iterative improvement of the game. They will soon look for validation of their work by asking you when the next playtest session is, and you will have a solid partnership with one of the most important groups who will work on your game.

Visual Artists

As with the term "programmers," we use the term "visual artist" as a catchall to refer to those team members who are tasked with designing all of the visual aspects of the game. This includes the character designers, illustrators, animators, interface designers, and 3D artists. Advanced positions in this track include art director, senior art director, and lead animator. In some companies there are even positions like creative director and chief creative officer, whose responsibilities include making sure there is a consistent look and feel across a company's entire product line.

Visual artists come from many different backgrounds. The best artists may or may not have a degree in the field. Some artists have always worked on computers, others might have come to computers after gaining a background in traditional tools. Before hiring your artists, you need to think about what skills your team will need. Will the game require predominantly 3D art? Will you need someone who can animate? Does your interface need to appeal to a specific market segment?

As you look at various portfolios, you will find that some artists are brilliant at creating intricate cityscapes and imagining 3D worlds, but when it comes to animating a character, they simply cannot do it. For this reason, teams tend to be structured around the key tasks required in the production, and artists will be hired for specialized tasks like 3D modeling, animation, texture mapping, interface design, etc.

Overall, the responsibilities of the visual artists are to design and produce all visuals for the game, including the following:

- Characters
- Worlds and world objects
- Interfaces
- Animations
- Cut scenes

Game designers and artists can also have trouble communicating even if there is no technical barrier of understanding, as with the programming team. It is the job of the artists to make the game as visually appealing as possible. Sometimes the needs of the game design can get in the way of a beautiful screen. You might find yourself in a situation where the wireframes you created, showing each important feature and detail of the design, have been only loosely followed. Artists might take it upon themselves to condense features to make the layout look better.

In a situation like this, your first reaction might be to insist that your designs be followed to the letter. This is one way to get things done. Another way might be to evaluate the work of the artists more objectively. After all, if they thought your design was convoluted, perhaps players will as well. You might be able to compromise and find that your designs become better and more intuitive as they are rethought by someone with a skilled artistic eye. Of course, you

need to make sure that features are not hidden or lost for the sake of beautiful artwork. Remember, it is your job to think about how a player will respond to these screens. They won't care about the beauty if they cannot find the feature they need to continue on in the game.

Another issue that might come up between artists and game designers is in the overall style of the game. As you work with different artists, you will find that they all have their own unique styles and techniques. While most artists are trained to work outside their personal style, they will always respond more enthusiastically to a project that mirrors their own interests more closely. To use an analogy, if you were starting a rock-and-roll band, you might think twice about hiring a percussionist from a philharmonic orchestra to play drums for you. In the same way, try to assemble an art team that is passionate about the look and feel you are striving for.

It might not be possible to choose the specific artists who will work on your project. If you are at a larger company, you might be simply assigned a team of artists. In this case, you will have to make a decision: Either change your vision to utilize the skills of the people you have, or find a way to communicate your ideas clearly enough so that the team can implement them.

Artists are visual people, and a great way to communicate with them is through visual reference material. Most art departments have a great deal of reference material—other games, magazines, art books, etc. For example, game artist Steve Theodore uses video to capture reference, as well as textbooks on human and animal motion to create visuals.[1] If needed, bring in your own reference material to get the conversation going. When Tracy and Chris, two of the authors of this book, were working on a game for Microsoft that had a retro space-age style, the art team collected samples of brightly designed 1950s fabrics from flea markets and scanned their patterns and colors to create the visual palette for the game.

As with the programming team, you will get the best results if you partner with the lead artist or art director in the process of design. Explain your vision, but listen to his or her responses. Chances are,

your artists have seen and studied far more visual references than you have, and they might have some fantastic ideas that take your initial concepts much further than you could have yourself. Look at these references together, and be specific about what you like and do not like about them.

When you have decided on an approach, the artists will begin creating concept art, and you will need to start giving criticism. Keep in mind that the purpose of criticism is to move the project forward. Even if a sketch or design is not exactly what you want, there might still be some elements in it that are useful. Search for those elements before you start speaking. Try to see what the artist was going for. And when you do start speaking, it is always nice to begin on a positive note.

Giving and taking feedback is probably one of the hardest things to do in life. As you saw when players were critiquing your gameplay, it is often a complete surprise to find that people do not respond to a part of the design that is very close to your heart. Your most important ally in the process of giving feedback to the artists is the art director. You must work together with this individual to set the tone of the project. Listen carefully to your art director and try to come up with solutions that appeal to both of you. Remember, there is more than one answer to each design problem, and by creating an open dialogue, you might find another approach that neither of you has considered.

Ultimately, unless you have the skills to create the art yourself, you need to allow the artists some freedom to move beyond your initial concepts and bring their own ideas and passion to the project. If you have created a good working relationship with the art director, chances are that you will feel a strong sense of authorship in the final artwork, even if it is not what you initially imagined, just as the rest of the team will feel that they have contributed to the overall game design.

QA Engineers

Quality assurance (QA) engineers are also referred to as testers or bug testers. Many game professionals start their careers as QA engineers, and then they

move to other tracks, such as producer, programmer, or designer. Advanced positions on this track are QA lead and QA manager. As noted on the team structure diagram, there are QA engineers on both the publisher side and the developer side. Publishers typically QA projects themselves before they accept delivery of the code.

The responsibilities of the QA team are as follows:

- Create a test plan for the project based on the design and technical specifications
- Execute the test plan
- Record all unexpected or undesirable behavior
- Categorize, prioritize, and report all issues found during testing
- Retest and resolve issues after they have been fixed

As the designer, you should take it upon yourself to make sure the QA staff has everything they need to create a comprehensive test plan. Do not assume that they have a complete understanding of the game just because you have distributed a design document. Offer any assistance they might need to create the best test plan possible. But do not be surprised if they want to experience the game first without your input; as with playtesters, it is often best if QA testers have some objectivity about the game when they begin the testing process.

QA testers can be the designer's best friends. Other than your playtesters, they are the last line of defense you have before your game ships out to the masses. Do not be upset if some of your design features come back listed as bugs. This is not a criticism of your design—this is QA's way of helping you make sure your design is working properly. Their job is to make sure your game is functioning both technically and aesthetically. If you get a bug back that says the font you have chosen for the character screen is illegible under certain circumstances, do not bristle defensively. Be grateful that you have the chance to fix it before the game goes to the players.

It might help for you to sit down with the QA team and observe their process. You can learn a lot by consulting with your QA engineers and going through the game element by element. Because they are seasoned testers, they might be able to provide you with insights no one else can.

Another consideration is to let your QA manager review your wireframes early in the process. They might find problems with your design before you even start to implement it. Starting the QA process early and making the QA team part of the design process will mean they are more invested in your game. This means that in crunch time, they will make your game a priority and put in the extra hours it takes to find every last glitch.

Specialized Media

As we have seen, games have grown to include many specialized types of media—too many to address each possible role on all game productions. Your game might require the skills of writers, sound designers, musicians, or even motion capture operators, karate instructors, and dialogue coaches. We include these in a group as "specialized media" because they are too numerous to list. These types of individuals are usually hired for a short period of time on a contract basis, rather than coming on as full-time employees.

One of the most important things that you can do as a designer is to define what you need from these professionals as clearly as possible before they start working. When people are hired as contractors, they often charge by the hour or day. If you bring in contractors and waste time trying to figure out what to do with them, you can wind up wasting a lot of money that would be better spent elsewhere in the production.

Some of the most typical contractors that you will work with include writers and sound designers. In the case of a writer, the responsibilities can range from creating bits of dialogue where needed to scripting the entire story. How much writing you will need depends on what skills you have as a designer. If your strength is writing, you might not need a writer at all. If you are not a strong writer, you can bring a writer in very early and work with her throughout production.

Advice from the International Game Developers Association (IGDA) on Choosing an Academic Game Program

by Susan Gold, Chairperson of the IGDA Education Special Interest Group (SIG), and Jason Della Rocca, Executive Director of the IGDA.

The International Game Developers Association (www.igda.org) means a lot of things to a lot of people. As a professional organization, it has a mission to advance the careers and enhance the lives of those working in the game industry. And as a part of this mission, the IGDA is interested in how they can help young people who want to make game development their careers. Today many students are looking at game programs as a way to learn the skills necessary for a career in games and are confused by the variety of programs available. How do you choose the right program?

The IGDA's Education SIG has developed curriculum framework recommendations that schools all over the world are looking to for guidance, and they are good place for potential students to find guidance as well. These recommendations advise schools that are starting a program to consider offering courses in a number of topic areas that are important to game studies. These include the following:

- Critical game studies
- Games and society
- Game design
- Game programming
- Visual design
- Audio design
- Interactive storytelling
- Game production
- Business of gaming

Depending on what part of game development you want to go into, you will want to focus on different requirements. For example, if you want to be a programmer, you'll want to make sure the program offers a strong set of game programming courses. Or if you want to be a visual designer, make sure there are plenty of courses on visual design for games. You can find more information on these core topic areas at http://www.igda.org/academia/curriculum_framework.php.

In the case of a sound designer, the task might be limited to creating special effects and music for the game when it is almost completed. Or, if you are striving for a more integrated sound design, it might encompass laying out a plan for the entire audio design for the project up front and working with you to make sure the audio supports the gameplay effectively. Sound and music affect players at a very emotional level; if you involve a sound designer more deeply in the project, you might be surprised at the improvement it can make to the player experience.

As productions continue to grow more complex, they will invariably require more media professionals in a diverse range of fields. As the designer, you will have to interact with many of these media professionals and give them direction and support.

Much of your decision will depend on your own focus and talents; however, there are some qualities of game studies that you'll want to make sure your potential school offers no matter what area of emphasis you are interested in. These include the following:

- Teamwork
- Rapid prototyping and the iterative process
- Giving students serious responsibilities
- Facilitating collaborative learning, especially across disciplines
- Pedagogical model capable of handling the intrinsic complexities of multidisciplinary work

We also encourage students to make sure their program encourages internships or apprenticeships, not only to make sure that they know what they are getting into after graduation, but to see what the real pressures are of working in the game industry. There are several common qualities and skills—no matter what type of degree you get—that lead to success in not only landing a job, but keeping that job. These include being a great team player, communication, and professionalism. An internship is a good way to practice these on-the-job skills. When you are applying to a game program, be sure to ask if they have an internship program already established.

Parents of prospective students often ask us which school is the best game school. This is not a question that has a simple answer. Some schools are at well-known institutions and have great connections with the industry. Others are small and found at local community colleges. Where you get your education depends on your own focus and opportunities, and it might be constrained by money or location. The most important thing is that you learn as much as you can wherever you are. Being curious and dedicated and working hard on your game design skills are more important than where your degree is from.

Many of the game designers and developers today didn't graduate from a game school. Game design legend Will Wright never even got a university degree. Other developers graduated with a degree in a related field, but they gained their understanding of games by playing and making them. If they were interested in how people played, they watched people playing games; they took human behavior courses and applied the knowledge to their observations and to their games.

The fact that there are schools that have game-specific degrees is a great opportunity if it is available to you, but it is not a requirement to have a game degree to be a great designer or developer. Knowing what you want to do and finding an educational environment that allows you to explore and grow is the best program for the future game developer. And, if you are not able to attend a school with a game-specific degree, the curriculum framework outlines almost every type of course you would need to take to be a well-rounded member of the game industry. So if you can't go to a school with a degree program, perhaps you can craft your own game program out of the courses available to you at your own school.

For more details on the IGDA curriculum guidelines, check out www.igda.org/education.

As you deal with people who might not work exclusively on games, it is important to communicate with them in terms they are familiar with. Many of these media professionals will not be hard-core gamers, and they might get lost if you use shorthand or game jargon. To bring out the best of their talents, you will have to learn as much as you can about their specialty, and act as their guide when it comes to game production.

Level Designer

Games that are organized into levels will need someone to actually design and implement each level. If your project is very small, you might design all the levels yourself. On a larger project, however, the game designer often leads a team of level designers who implement their concepts for the various game

levels and sometimes come up with ideas for levels themselves.

Level designers use a toolkit or "level editor" to develop new missions, scenarios, or quests for the player. They lay out the components that appear on the level or map and work closely with the game designer to make these fit into the overall theme of the game.

Responsibilities of level designers include the following:

- Implementing level designs
- Coming up with level concepts
- Testing levels and working with the designer to improve overall gameplay

Level design is an art, and it is a great way to enter the industry. Good level designers often go on to become game designers; an example is American McGee, who won notoriety for several of the levels he designed while working at id Software. Other level designers might move on to become producers.

As a game designer, you will want to develop a close working relationship with your level designers. Levels are the structures within which the players will experience the gameplay you have designed. They might include story or character elements that are crucial to the development of the game. Because levels are so critical, sometimes game designers can become somewhat controlling of how they are implemented.

As with artists, however, you can usually achieve better results by fostering creativity in your level designers rather than making them toe a strict line. If you have created an amazing system of gameplay, it will inspire your designers to come up with combinations and situations that you might not have even thought of in your initial pass at the game levels. Try not to micromanage your level design team, and you will find that they will work harder and come up with better results than if they had implemented your designs to the letter.

The fact is that you are the designer of the game, and their hard work and innovations will only make you look better. So tuck any insecurity away and treat your level designers as partners with whom to experiment and take the game to places that even you did not think was possible.

Exercise 12.1: Recruit a Team

Now that you know a little bit about the roles of team members in a game production, think about enlisting some friends or recruiting some talent to work on the original game idea you prototyped in Part II. Decide which of these positions you cannot fill yourself, and go out and try to fill them. Post notices on local bulletin boards or Web sites. You are sure to get a response because many people out there are eager to work on game projects.

Publisher's Team

Publishing companies are often huge corporations, with offices in many cities and sometimes countries. They employ thousands of people whom you might never meet but who might work indirectly or directly on your game in the process of getting it to the shelves. Here we have focused on those you are most likely to interact with while working on your game.

Producer

As with the producer on the developer's team, the producer for the publisher is also a project leader. Unlike the producer on the development team, however, the producer for the publisher will spend less time interacting with the production team and more time marshalling the forces of the marketing team, and making sure that the executives at the company continue to stay behind the game concept throughout development.

The responsibilities of the producer for the publisher are as follows:

- Team leader for the publisher's team
- Main communication link between the publisher and developer
- Schedule and budget for the production from the publisher's side

- Track and allocate resources as well as forecast
- Approve work accomplished by the developer so milestone payments can be made
- Coordinate with internal executive management, marketing, and QA personnel

The producer for the publisher is one step removed from the actual production, although he is usually more involved than any other person from the publisher's team. This position means that the producer has a vested interest in the success of the game when it goes to market, but is also somewhat removed from the day-to-day struggle of production and is sometimes able to see the game and its potential more objectively than the game designer and the rest of the production team.

There is a sense in many creative industries—the game industry is no exception—that executives and producers who are removed from the process do not understand the plight of creative teams. The suggestions and direction of these people are often met with resistance and scorn. While it is true that no one understands your game design the way that you do, it is also true that these individuals are skilled at publishing and marketing successful games, and they might have some good points to make if you remain open to their feedback.

No one gets into the game industry because they want to make bad games. The producer and executives on the publisher's team are no exception. They want to make great games, games that they feel a sense of authorship in just like everyone else on the team. And if you can find ways to incorporate their suggestions into your game in ways that improve the gameplay, rather than dragging your heels, you will find when it comes time to sell the game that the publisher is behind it all the way.

Marketing Team

The goal of the marketing team is to find ways to sell your game to the buyers. In some cases, they might have direct involvement during the production process, giving feedback on game concepts and holding focus groups for various character designs. In other cases, you might never meet them until the game is almost ready to ship. The marketing team can be an asset to the open-minded game designer. This is because they are the strongest link to the demands and desires of buyers. It is their job to know the market, and if you can interpret the data they have creatively, you can address the trends and features that people are interested in without sacrificing your core gameplay.

One important factor that the marketing team has a strong influence on is the target hardware platform for PC titles. Marketing professionals study things like the projected penetration of different processors, available RAM on consumer PCs, average screen sizes, etc.

If it is important to you as a designer to have a best-selling product, it is smart to bring the marketing team in early. Tap them for information, invest them in the project, and give them credit for their insight. Sometimes having a clear concept of what those key bullet-point features will be on your box can help you stay on track with your designs when ideas are flying in from all directions. The marketing team can help you with this, and you will have a powerful ally when it comes to publicizing your game or getting a new project off the ground. Nothing speaks louder than sales, and the marketers often represent the voice of the buyers.

Exercise 12.2: Marketing

Design the box for your original game idea. Come up with a slogan or tag line that will capture buyer interest. Write call outs for the top three or four features in your game. Really try to sell your game through your box design. Think about what aspects of the game will illustrate these points. Will your box show screenshots, character designs, or original artwork? Show your box design to some of your playtesters and do an informal focus group on your design. This process will help you develop a good sales pitch for your idea, which we address in Chapter 16.

Executives

Executive management can include the CEO, president, CFO, COO, assorted VPs, and directors of the publishing company. It is beyond the scope of this discussion to detail all the responsibilities of all these individuals. Suffice to say that it is the job of the executive management to run the publishing company. This means providing leadership and direction, overseeing every department, and ultimately publishing great games.

Of course, there might be upper management on the game developer's team as well, if the company is large enough. In many cases, executives at game development companies are the founders of the company, or they have risen up from the core design team to take on more responsibilities.

At publishing companies, people in upper management can come from all types of backgrounds. Some might have business or marketing degrees or experience in other industries. Others might have extensive experience in game production but otherwise no business background. The nature of the game industry is that it grew out of a hobbyist culture, so there are many people who are very skilled in the development and publishing of games, though their academic credentials would not tell you so.

The best-case scenario for a game designer is when an executive has considerable experience with game development, a deep understanding of the market, and is willing to take a hands-on approach. Unfortunately, most game designers do not see it this way. As a rule, designers tend to resent upper management's involvement in the production process. They want management to put out the money for the game and then leave them alone to create their masterpiece.

As we said before, no one wants to make bad games, executives included. You might want to take the time to find out what games or products the executive you are dealing with has worked on, and what their expertise was before they moved up the ladder, before disregarding their input or pushing back on their suggestions.

If you do this and still find that you just cannot get along with an executive, try to learn from their mistakes.

What are they doing that you do not like? Is it the way they present their ideas or the ideas themselves? Is it their attitude or the content of their suggestions? Use this interaction as an opportunity to improve your own management skills. Write down what it is that they are doing that is ineffective, annoying, or counterproductive, then make sure that you are not doing the same thing when it comes to your own team.

If all else fails, at a certain point, you might find that the decisions coming down to you from the executives are "ruining" the game. You might be fed up and ready to walk. But before you blow a gasket, consider this: It is part of your job to communicate the vision for the game to the upper management, and you might be partly to blame if they are on the wrong track. Design documents and wikis are elaborate and detailed, and they might not have read yours. Development code is clunky and unstable, and they might not have had time to install and play with your latest build. All in all, they might not have a clear idea of the finished product from either of these sources.

Take a step back from the situation and try to educate them. Perhaps you can have a brainstorm on the area under question with the entire team and invite the executives to participate. This will allow them to give advice in an open forum and to see some of the issues you are up against in implementing their suggestions.

In most cases, everyone will walk away from such a discussion feeling that their ideas have been taken seriously, and they will be invested in the decisions that were made. No one wants to be told what to do—not you, and not the executive team. Everyone wants his or her opinion to be heard and respected. An open discussion for the purpose of solving design issues accomplishes both of these objectives. In the end, you might wind up having to make the changes anyway, but perhaps you will have formed a new channel of communication for the next project.

QA Engineers

The QA team for the publisher's team functions in much the same manner as that of the developer's

team. The two exceptions are that they probably are not as familiar with the game, because they do not work side by side with the production team, and their overall goal is to determine whether or not to accept the build as a deliverable. This acceptance generally triggers a payment to the developer, so it is important that the build passes muster with the publisher's QA team and their typically strict technical requirements.

Usability Specialists

Some game companies use the services of usability specialists as part of the development process. As we discussed in Chapter 11, usability specialists can be an important part of making sure your game is intuitive and accessible to your target market. They evaluate a user's abilities to perform important tasks in the game and understand key concepts. Usability testing generally focuses on the interface and controls, rather than the core gameplay, which distinguishes it from playtesting.

Usability specialists are almost always third-party companies that are hired by the publisher or the developer for a specific series of tests at a point fairly late in the development cycle. Some larger publishers, however, such as Microsoft Game Studios, have in-house usability labs, and they have integrated usability into the development process from start to finish.

This is the ideal situation if it is available to you. Usability testing can make an incredible difference in the player experience of your game. Like playtesting, it brings the player to the forefront of your design process and allows you to respond to playtesters' input before your game ships and it is too late to make changes.

Responsibilities of the usability specialists are as follows:

- Heuristic evaluation of interfaces (This is an application of general interface principles and reporting of potential issues.)
- Creation of user scenarios

- Identification and recruitment of test subjects from the target market
- Conduction of usability sessions
- Recording and analysis of data from sessions (This might be visual, in the form of video and audio, or quantitative, in the form of task success/failure reporting or questionnaire data.)
- Reporting of findings and recommendations

A common mistake game designers make is to push off usability testing until the end of development. Some designers associate it with focus testing and marketing. In general, usability testing has not been as widely accepted in the game industry as it has been in the rest of the software industry. For many game designers, there is a resistance to outside input on the game that makes them fear and dislike the testing process.

Unfortunately, these designers are missing out on a great opportunity to improve their game and learn more about how players interact with games. Every usability session can teach a designer something new about the craft of game design. Interacting with usability specialists can also teach designers how to break down issues with play, navigation, control, etc., to test these issues and solve them.

It seems obvious that learning how to solve issues with gameplay will make you a better designer. A smart and successful game designer will bring usability specialists into the process as early as possible and try to learn as much as possible from them during their work on the project.

Exercise 12.3: Usability Experience

Contact a third-party usability lab and find out if you can either watch one of their test sessions or participate as a user. What types of tasks were you or the subjects asked to complete? Were you able to use the software being tested successfully? Why or why not? How do you think the input from the usability tests helped the designer of the software that was tested?

Team Profile

As we touched on at the beginning of this chapter, the number of people involved in a typical game production has grown steadily since the start of the industry. Additionally, both budgets and timelines for production have increased. Because of this, the expectations for sales of each game have grown higher as well. This means that publishers are only interested in producing games that have the potential to be blockbusters.

Figures 12.4 and 12.5 show the evolution of team size and development time for an A-list title on each of the major console systems. A-list PC games have experienced a similar growth in team size and development time. These estimates were provided by Steve Ackrich, vice president of production at Activision, based on his 20-plus years in the game industry. Ackrich has extensive experience producing console games, managing internal and external developers, and overseeing product acquisitions among other responsibilities. He has worked for many publishers and developers including Sega of America, Atari, Accolade, and Sammy Studios.

You might be wondering how many people from each job category work on a typical title. Ackrich shared the estimates in Figure 12.6 with us. As you can see, not only have team sizes grown over time, but specialization in areas like programming and art have created new categories of employment.

As teams have grown and production schedules have lengthened, the stress on the team, professionally and personally, has grown as well. The following sections are designed to help you understand what factors can make a team come together, how to build a team, and how to keep that team communicating during the entire production.

All Contribute to the Design

Notice the phrase "all contribute to design" on the team structure diagram in Figure 12.1 on page 349. This does not mean that everyone will literally participate in the design process, but it does mean that in a well-run project, each and every member of the team is able to contribute their special talents to the articulation and execution of the design at whatever level they might be involved.

In some cases, this might just mean that every suggestion is always received with respect and consideration. In other cases, it might mean that the designer actively solicits input from the team when

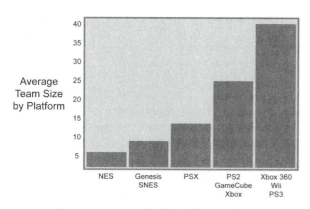

12.4 Average console development team size

12.5 Average console development time

NES	PlayStation
- 1 Producer/Game Designer - 2 Programmers - 3 Artists	- 1 Lead Game Designer - 2 Level Designers - 1 Producer - 1 Associate Producer - 1 Lead Programmer - 3 Programmers - 1 Lead Artist - 4 Artists
Genesis/SNES	
- 1 Game Designer - 1 Producer - 3 Programmers - 4 Artists	
PS2/GameCube/Xbox	**Xbox 360/Wii/PS3**
- 1 Lead Game Designer - 4 Level Designers - 1 Producer - 1 Associate Producer - 1 Lead Programmer - 2 Engine Programmers - 4 Game Programmers - 1 Lead Artist - 10 Artists	- 1 Director of Game Design - 2 Game Designers - 4 Level Designers - 1 Executive Producer - 2 Producers - 1 Associate Producer - 1 Lead Programmer (Engine) - 3 Programmers - 1 Lead Programmer (Game) - 6 Programmers - 1 Art Director - 3 Lead Artists - 14 Artists

12.6 Team profile by platform

making decisions about the design. Every designer and every team will have their own process. But the end result should be that everyone who works on the game should have a sense of authorship in the final product and be able to say with pride about some aspect of the experience, "I worked on that."

As the designer, and also as a producer, fostering this sense of authorship is a vital part of the job. You should take the time to establish good channels of communication with each of the team members we have discussed in this chapter and to structure your interaction with the team so that everyone's input is heard. There is no single way to orchestrate something like this, but there are some tips we can give you that will help.

- Set up weekly leads meetings where the heads of each group gather to discuss the current status of project.

- Start a suggestion list—an open list of ideas that may or may not be used.

- Take time for one-on-one creative talks with key members of the team.

- Have open brainstorming sessions during the design phase for anyone who wants to attend. This includes everyone from the production assistants to the QA team. Shutting people out of the design process fosters cliquishness and might deprive you of hearing some great ideas.

- If you get stuck on a design issue, ask your coworkers to help solve it. Present the issue as a creative challenge.

- Share authorship. When you speak, make sure to use "we," not "I." This is a subtle but effective way to let everyone share in the ownership of the ideas.

Team Building

In addition to having a great idea, the next most critical thing you can do to make sure you produce a great game is to build a team that can bring that idea to life. This does not just mean hiring a group of talented people, throwing them together, and expecting miracles. The structure you define for your team and the working environment you create will determine their ability to succeed.

Talent is always a key ingredient to team building, and, of course, you want the most talented individuals you can find. Microsoft is an example of a company with a corporate philosophy of hiring the smartest, most talented individuals who are available. But talent only goes so far. Finding the right mix of talent and personality is even more crucial. Some people are brilliant at what they do individually, but, when put on a team, they are unable to interact productively with their teammates and cause more trouble than their contribution is worth.

When assembling your team, you have to look at each person as an individual and as a potential team member. Examine their track record and make sure to talk with people who have worked with them before. Ask about both their individual performance and how they interact in a team.

Team Communication

Notice on the team structure diagram on page 349 that in addition to the vertical lines of hierarchy, there are also horizontal lines of communication connecting the different groups. This is to illustrate that all of the groups interact with each other laterally as well as reporting to the producer. This does not mean that the production has no hierarchy; it is the job of the producer and the leads from each department to make decisions about the big picture vision for the project and the day-to-day tasks each group should be working on.

There is also one communication line on the diagram between the producers' lines for the developer and the publisher. This line is important because it signifies that one person from each team is responsible for communication between these two groups. Veteran developers know that it is important to have a single person on the publisher side who is empowered to approve their work and authorize payments. It would be problematic if team members from each side were making decisions without having the producers involved to maintain consistency.

The same goes for communication within the development team. As we mentioned, if you need to work with the database programmer or make changes to part of the interface, go to the technical director or the art director to make your request, not to the person directly responsible for that change.

Conducting Meetings

Meetings are the best way of getting your team members to communicate. But conducting effective meetings is not as simple as gathering your coworkers together in a conference room and beginning a conversation. You need to structure the meeting so that it produces the desired results.

If you are calling the meeting, you will need to set the agenda. The best meetings are ones for which there is a definite goal, everyone knows the goal ahead of time so that they can come prepared, and by the resolution of the meeting the goal has been accomplished. If you do not have a clear agenda in mind, you are likely to waste everyone's time and accomplish very little in your meeting.

If you are asked to participate in a meeting, you will need to come prepared. Find out the agenda and goal and make sure you have all the material you will need to contribute. This might mean doing some research for a brainstorming meeting or evaluating your workload for a status meeting. If you do not come prepared to a meeting, you will also be wasting

other team members' time and have very little to contribute.

At the meeting, the person who called it will most likely function as the discussion leader. This person might designate other individuals to run certain parts of the meeting, but it is still up to the discussion leader to keep the meeting on track and moving toward the goal.

As in our rules for brainstorming, many of the rules of meetings involve personal and social skills. No one should be left out of the conversation intentionally, and those who speak should be able to do so without being criticized. No personal attacks should be permitted. If people make personal remarks, they should be warned, and if it continues, they should be asked to leave the meeting. Make it clear that differences of opinion are helpful in sorting out the problem, and allow people to approach the same topic from multiple angles.

As the meeting draws to a close, you should make sure to review the decisions that have been made and any action items that have been assigned to the team. If the discussion requires a follow-up meeting, determine when it will be and make sure that everyone will have time to prepare for that follow-up. And last, if you have called the meeting, you should always send out notes and reminders of the decisions and assignments to the participants and to any key team members who were unable to attend.

Agile Development

Agile development represents state of the art thinking for software development. It is a modular framework that strives to make the development process more adaptive and people-centric. A popular variant used by forward-thinking game developers is called "Scrum." Scrum organizes teams into small cross-functional teams. These teams prioritize their work each day and embrace iteration—especially short turnaround iterations. Short iteration and review forces strong communication and builds bonds with team members. Scrum development is especially good for game environments because the ability to change fluidly is important for solving hard game design problems. Big game productions organize Scrum teams around game features. This allows a large number of creative people to work effectively on a project without the burdens of too much top-down management.

CONCLUSION

Understanding your role in a team and having the interpersonal skills to work within a team structure are as important as any of the design skills we have discussed to this point. Game development is a collaborative art, and game teams are getting larger and more complex every day. We urge you to take the time to practice your team-building skills before you are thrown into the maelstrom of production.

Take the time to understand the roles of the other team members and to learn to communicate with them. Make sure they know who you are and what your role is on the production. Participate at the highest level possible in team discussions. Always come prepared, and focus your input toward achieving the goals of the meeting. Whether you are starting at the bottom or you are leading the team, be the best team member you possibly can, and your contribution will act as an inspiration to others.

Just as there is no one way to design a game, there is no one way to go about structuring and building the best team. The concepts we have introduced here are just a starting point. You will need to find the right way to set up your specific project and the individuals who work on it. Feel free to experiment; take the rules we have given you as a starting point and expand from there. But remember, your objective is to create an environment where all individuals are able to contribute to the very best of their abilities. Succeed at this, and your game will reflect excellence in every aspect of its development.

Designer Perspective: Matt Firor

President, Zenimax Online Studios

Matt Firor is a game developer and executive with a long history in online games. His game credits include Rolemaster: Magestorm (1996), Godzilla Online (1998), Aliens Online (1998), Starship Troopers: Battlespace (1998), Spellbinder: The Nexus Conflict (1999), Silent Death Online (1999), and Dark Age of Camelot (2001).

On getting into the game industry:

I was a big fan of dial-up BBS multiplayer role-playing games in the 1980s, and a few friends and I decided to make our own game. We worked nights and weekends over the course of about four years on the project. The game Tempest came out in 1992 and was a fantasy role-playing game that allowed up to 16 players to play simultaneously on dial-up modems in the Washington, DC, area. This was strictly a hobby, though—it was for fun, and we all had day jobs. Eventually our lawyer hooked us up with another company, we merged and became Mythic Entertainment, got some contracts, and I started full-time in the industry in January 1996. I was at Mythic for over 10 years, which is a long time to be at any one company in the game industry.

Looking back on it, we didn't really know how hard it was to make it in the game industry when we started, which probably explains why we were successful. No one was around to tell us that the odds were almost impossible.

On favorite games:

In no special order:

- *Fallout:* It had the best story and immersion of any game I've played. Even though the technology was basic (this was a 1997 game, after all), you really felt like you were exploring a vast postnuclear wasteland. Fallout, among all games, shows how important story can be to a game.

- *Half-Life:* The best shooter of all time, with a great story. Even though as a first person shooter, there wasn't much room to tell a story, Half-Life still did an excellent job of explaining why I was in the Black Mesa facility, and even though I really didn't know who the bad guys were, I knew I had to escape. It had such a great feeling.

- *Wizardry:* My favorite fantasy single player RPG, the one that got me hooked. Now it is hopelessly dated, but it was my first really exciting, immersive game experience. When I went back to try it again a few years ago, I was shocked at how hard-core it was—it was very easy, especially in the beginning, to lose your characters completely. Games have gotten a lot easier in that respect over the years. In Wizardry, though, you really cared how combat turned out because one wrong move and you had to basically restart the game. That made things exciting!

- *EverQuest:* This game proved that online role-playing games were just as good (if not more so) than single player games. This was my first MMORPG, and it is still one of my favorites.

Looking back on it (much like Wizardry), I find that EverQuest was a lot more hard-core than today's crop of MMOs, like World of Warcraft. This again explains why it was so exciting—when failure in combat meant a two-hour "corpse retrieval" run, you really, really didn't want to die.

- *World of Warcraft:* This game has changed the online landscape forever. WoW has shown what we online game developers have been saying for almost 20 years: Online games are the wave of the future. WoW is the first game to hit the public consciousness—at least here in North America and Europe—that has had massive success and spillover into mass culture. WoW, at its core, is a very simple game, with lots of content and awe-inspiring production values. It's a very simple equation, but it's one that is extremely difficult to pull off. Even though I've been making online games since 1990 or so, and I have played them all, I've spent more time playing WoW than probably all the others put together. Why? Because it's so much damn fun.

On designing MMOs:

In MMOs, you really have to think about creating a world as well as a game. Usually you start with an intellectual property (in Dark Age of Camelot's case, it was the Arthurian Legends, of course), and start creating the world from there—terrain, types of monsters one would encounter, architecture, player classes, weapons, armor, etc. It all flows from the IP of the game. On top of that, you start adding the rules for how players interact with the world—the class system, the economy, the combat system, and so on. Usually there are strict rules for the direction of the game—it is a PvP-centric game, for example, or a socialization/exploration game. It is very important to stick to these rules when completing a design for an MMO—if you stray far from the original vision, then the game will become less sharp and defined and players will become confused as to their purpose in the world.

On designing PvP in Dark Age of Camelot:

The implementation of the player versus player combat system in Dark Age of Camelot was an extremely thorny design problem. Players had to use skills, combat abilities, and spells to kill monsters in order to level, but then they had to use these same abilities when fighting other players to remain consistent. Making abilities work against AI opponents (monsters) is relatively easy, but when you try to apply those same abilities against human-controlled enemies, it gets really, really difficult to balance. Any player of Dark Age of Camelot back in the original days of the game (2001–2002) can attest to the fact that the game was balanced in some areas, but not so well balanced in others. It took a long time for the design team to come up with a system that was fun and balanced for both player versus player combat as well as player versus monster.

Advice to designers:

Don't be afraid to do whatever it takes to get into the industry. If you have to start as an artist, QA tester, programmer, whatever—just do it. When you're in the door, it's a lot easier to get your voice heard. And be patient. People won't respect your ideas until they know that you are competent and level-headed. This takes time.

Designer Perspective: Jenova Chen

Cofounder and Creative Director, thatgamecompany

Jenova Chen is a game designer and entrepreneur who recently released his first commercial game, flOw (2007), as a downloadable title for the Sony PlayStation 3. Jenova's other credits include the student research game Cloud (2006) and the online version of flOw (2006).

Photo by Vincent Diamante

On getting into the game industry:

When I was still a sophomore in college, my dad happened to know people from Ubisoft Shanghai. Because of him, I was hired as the only intern for the summer. For the most part, however, it just gave me a taste of what a video game company is like. My first opportunity to enter the game industry happened when I graduated from undergrad in China. Because of the student games we made during college, my team got lots of publicity. In a country without any systematic video game education, it was very easy for us to get special attention from the game industry. Nearly the entire team got offers from Shanda Network, biggest Chinese online game publisher and developer at the time. However, during the interview, I got a sense that the games I wanted to make and play would not be born in Shanda or even China for a long time. The only shortcut I knew at that time was to go abroad and pursue more education.

So in August 2003, I started my graduate studies focusing on interactive media in the School of Cinematic Arts at the University of Southern California. I was surprised that video game education was also new to America. The program I was in was merely one year old at that time. Though my language skills were pretty weak, my game making experiences from undergrad got me my first job as a teaching assistant in video game modeling and animation. I then worked on various video game-related jobs across campus. In 2004, Electronic Arts made a major endowment to our school, and I was informed that there were student internships available, which eventually became my first step into the commercial video game industry. Meanwhile, I worked on multiple popular student video game projects such as Dyadin, Cloud, and flOw, which helped me to step further into this field.

On learning on the job:

Designing video games is exciting and challenging. But making video games is also exhausting. It is a constant process of compromising and self-correcting. One interesting thing that occurs is when you read reviews about your own games. Knowing that your work has inspired, encouraged, or moved other people is the most rewarding thing in your life. At the same time, when you find out that others did not understand your game, you might want to laugh and cry at the same time.

On getting a degree in game design:

Though many brilliant designers did not graduate from college, I was lucky to learn about game design from my graduate education at USC. Though game design is still a new field, and its education system is still young, I was able to read and speak about game design in an academic way. This design vocabulary is going to replace "fun" and "cool," allowing you to see deeper into video games. Video games are so new that the theories and rules applied in this field usually come from elsewhere. I learned theories from film, screenwriting, and psychology, and I came up with my own rules out of them. If I hadn't gone to grad school, I probably would have never touched those areas.

On the design process:

I've found that nearly everybody I talk to in the video game industry has good ideas. Not only the people from the industry, but young gamers also have great ideas. However, I often find that people mix up the concept of a good idea with a good game design. In my opinion, everybody has good ideas. However, very few can keep refining their ideas for years and eventually realize it as something practical.

My design process is very much about refining a simple idea that has not been done before. For example, Cloud was based on the idea, "Can we make a game about the beautiful clouds in the sky?" After we digested the idea for a while, it evolved into, "Can we make a game that evokes the exciting but peaceful feeling when you look at the blue sky and white clouds?" As we started developing the game, more details were needed to guide the direction of the gameplay. We solidified this feeling and bound it with the idea of childhood daydreaming, which helped us to further shape the avatar character, the story, and the world of Cloud.

In terms of how I come up game ideas, I see video games as entertainment rather than an interactive software product. When you design products, you care a lot about features. This seems to be the common trend in the current video game industry. When you come up with ideas for entertainment, you start from a feeling, a sense of emotion. From there, unique game ideas are within inches.

On prototypes:

If you consider video games as an art form such as painting, then prototypes are the sketches of video games. Prototypes help you to shape the final gameplay experience in your mind. Literally, prototyping is a collection of all your previsualizations: art, sound, and gameplay. Video games are still a young media, and the gameplay aspects are least understood when you are working on something original. Therefore, prototypes tied to gameplay previsualization are the best tool you can have to iterate on your designs.

We make prototypes to solve difficult game design problems, namely for games that the team and I haven't seen in the past. We like to spread the net wide and prototype as many of our alternatives as possible before we dive in deep into details without knowing whether it is the best direction. Like painting, after you deal with one prototype for too long, you will become too used to it to tell the hidden problems. When that happens, we won't hesitate to abandon it and start a new one.

On solving a difficult design problem:

I focus on creating new emotional gaming experiences. Nearly all the projects I have designed were difficult because of the lack of similar game designs. Cloud, for example, was focused on the emotion of relaxing. During the design process, I often was distracted by thinking of fun and challenging mechanics from the classic games I have played. I knew those mechanics worked, and they worked well. It would be very easy to assume those mechanics would also make the game I'm making better. However, "challenging" and "relaxing" are contradictory goals. The only way to solve the problem is to constantly remind and question myself: What am I making? What kind of feeling do I want the game to evoke? Will this type of gameplay help to communicate that emotion? Because of that, Cloud ended up becoming a very unique game experience.

On the next five years:

In five years, I hope I can prove what I believe about where video games should be going. I wish to be one of those who will make that change; literally, use the games we create to move and inspire the new generations of video game makers and accelerate the video game's evolution toward a mature entertainment media for everyone.

Advice to designers:

There is no so-called "natural born talent." There is a person's passion toward something he loves to do. If he loves what he is doing, he is likely to spend more time and effort on doing it, thinking about it, and dreaming about it. As time and effort accumulate, others who spent less time are likely to call this person "talented."

Like in a video game, you need to have very clear goals to start your own "hero's journey." Like in a video game, you need to be aware of your intermediate goals and the progress and rewards they bring to you. Like in a video game, you need to adjust your challenges to match with your current abilities so that you are in the flow of achieving goals instead of giving up on them because of boredom or anxiety.

FURTHER READING

Bennis, Warren G., and Biederman, Patricia Ward. *Organizing Genius: The Secrets of Creative Collaboration.* New York: Perseus Books, 1997.

Brooks, Frederick P. *The Mythical Man-Month: Essays on Software Engineering.* Boston: Addison-Wesley, 1995.

DeMarco, Tom, and Lister, Timothy. *Peopleware: Productive Projects and Teams.* New York: Dorset House Publishing, 1999.

Schwaber, Ken, and Beedle, Mike. *Agile Software Development with Scrum.* Upper Saddle River, NJ: Prentice Hall, 2002.

END NOTE

1. Theodore, Steve. "Artist's View: And a Partridge in a Poly Tree." *Game Developer.* November 2003.

Chapter 13

Stages of Development

Producing electronic games is a complex and expensive process. A developer's goal is to produce the highest quality game within the limits of its resources and budget. The publisher's goal is to produce the best-selling game while limiting its risk by keeping costs low. There is a common interest in producing a successful product between these two parties, and there is also a conflict of interest in how much money and time that product should require.

The industry has evolved some best practices for producing games efficiently. A core aspect of the process is that a project is developed and approved in stages. Each stage is defined by milestones. Contracts between publishers and developers are typically based on these milestones, and the developer is paid a predetermined amount for each milestone it reaches. Even if you do not plan to be a game producer, as a game designer, you will need to work with a producer and understand these stages of development clearly. In this chapter, we will walk through each of the stages of development and talk about how to create a project plan that takes into account the unpredictable nature of developing games.

STAGES DEFINED

Figure 13.1 is a graphical representation of the stages of development. Notice that the five stages are drawn in a "V" shape. This is to represent that in the beginning of a project, the creative possibilities are broad, open, and changeable. Early on, changes can be made with little financial consequence. If you want to alter your idea from an ant simulator to a submarine combat game, for example, the concept stage is the time to do it. As the process moves along, ideas must become more focused, and smaller and smaller changes can be made to the design without disrupting the production.

By the time you reach the middle of a production, it is virtually impossible to alter the broad vision of a game, but you can tinker with some features or concepts within it. For example, during the production stage, you might find yourself discussing whether or not to create nine submarine models instead of five. This will change the gameplay but won't require significant restructuring of the application or starting over in terms of the existing art and animation. During later stages of production, it becomes increasingly difficult and more expensive to make any modifications to the game design beyond tweaking variables that have been set up to be flexible.

As you approach the testing stage, only the completion of details is an open area of discussion. Any major or even moderate changes are usually out of the question. At this point, you might discuss things like whether the controls for a German U-577 submarine have been implemented to spec, but you would never suggest adding another model of submarine.

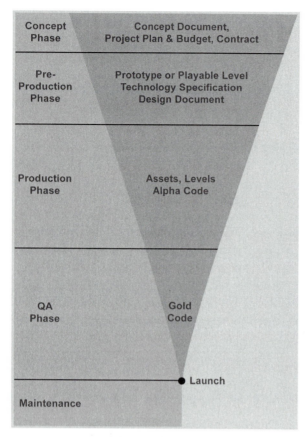

Concept Phase	Concept Document, Project Plan & Budget, Contract
Pre-Production Phase	Prototype or Playable Level Technology Specification Design Document
Production Phase	Assets, Levels Alpha Code
QA Phase	Gold Code
	● Launch
Maintenance	

13.1 Stages of development

But what about the playtesting process, you are wondering. How can we implement changes to the gameplay based on our playtesting if our decisions are dictated by the needs of the production process? The answer to this is why we insist that you prototype and playtest your gameplay early. If you do so, the major issues will be found in the concept and preproduction stages—before you have even begun to create the art or program the actual code for the game. The playtesting you do during the production and QA stages will reveal smaller problems, requiring the type of focused changes we are talking about.

The time estimates given in the following headings for each stage are based on typical schedules for today's big console titles. Naturally, estimates will be different for PC, cell phone, and online titles as well as for teams with different levels of experience.

Concept/Contract (Month 1)

Selling a game is one of the hardest tasks for a developer. Unless you are an A+ developer with at least one hit under your belt, getting a publisher to even consider funding your idea can be a challenge. The developer's goal at this stage is to get a publisher to commit to funding at least the first milestone. Unfortunately, publishers do not like to work with unproven talent because the risks are too high, so they put up a number of barriers to entry. Even getting in the door to make a pitch can be difficult.

We will talk about how you can get in the door in Chapter 16, but for now, let's assume that you found the right contacts and you have made your pitch. In this case, the publisher will base its decision on three things: the team, the project plan (which includes a schedule and budget), and the idea.

The Team

Above all, a publisher wants to see an experienced development team. This is because game production is expensive, complex, and risky, and the publisher can reduce its risk considerably by going with a proven group of individuals.

When listening to a game pitch, the publisher is going to weigh its merits against the strength of the team. In the publisher's mind, ideas are a dime a dozen. It is implementation that counts. Can you deliver a groundbreaking game on budget and on time? The best gauge of this is a proven track record, and publishers tend to fund the teams who have already published games, dismissing even brilliant ideas from lesser-known developers. Sometimes, however, a first time developer gets lucky. For an example of a young development team's experience in developing their first title for the PlayStation 3, see Kellee Santiago's sidebar on page 380.

What makes up a winning team? First, it is important that the group has worked together in the past. As we discussed in the last chapter, teamwork is critical. If you have talent from all across the industry, but they have never worked together, the risk is higher than a less talented team that has demonstrated they can deliver a product. The publisher will look closely at your team's

history and try to determine how long you have been together and how you operate. Are there clear leaders in each area of production? Who performs what functions within the company? What obstacles have you overcome and how have you dealt with them? Is there a good history with previous publishers?

Second, the publisher will want to know if your team can deliver the type of product that you are proposing. If your team is known for producing simulation games, but what you are proposing is a first person shooter, there is obviously more risk involved. The publisher will wonder if your group can really deliver a compelling game in a different genre. Do you have a handle on the technology, which is quite different from that of a simulation? What about the gameplay elements? A good first person shooter and a good simulation game are two entirely different play patterns. Because of this, publishers often pigeonhole developers, expecting them to produce the same type of games that they are known for.

Lastly, the publisher will want to know if you can deliver on the platform of choice. This varies, depending on the publisher's internal objectives. Some publishers only focus on console games, while others cover PC and handheld games as well. If it is a console game, then a developer who has produced hundreds of PC games might be deemed more of a risk than another developer who has produced one hit console game—the point being that platform matters. Publishers want a team that is experienced in exactly what has to be delivered. This is because both the schedules and budgets are so tight that there is little room for error.

If your team meets all those qualifications, then at least you are in the running. We are not saying this to discourage you. What we want is for you to focus your efforts on the areas that maximize your chances of success. The bottom line is that if you are starting out, you will have to work your way up by joining an established developer or publisher and establishing a track record before you can take on projects of your own.

The Project Plan

Next in importance is the project plan, which includes a budget and schedule. The project plan shows the publisher that you have thought through every element of the production and understand what it will take to implement it. The project plan should articulate all the goals of the project, the deliverables that will be created to meet these goals, a schedule of how long it will take your team to complete each deliverable, and a budget for the people and resources that will be needed.

The project plan is arguably the most important document in the whole production because the signed contract typically includes the project plan as an addendum. This means that after it is approved by the publisher, the developer is legally obligated to adhere to it. Our advice is to take your time thinking through the project plan, evaluate it with each group lead, and make sure that everyone is on board to execute the plan.

The Idea

In many ways, the idea is the least important thing to the publisher. This is not to say that publishers are not interested in great ideas. But the criteria by which a publisher judges an idea is very different than that of a developer. Throughout this book, we have taken the perspective of a designer and developer. We have encouraged you to seek the essence of great gameplay and to pursue it, no matter the genre or precedent. This is the way to develop great game ideas, but unfortunately, it is not necessarily the way to sell great game ideas. And publishers want to find and fund games that they can sell.

Publishers rely on market data to determine what types of games the audience wants buy. Because of this, if your game does not fit into a top-selling genre, a publisher will be hesitant to fund it. While publishers do like to see innovation, they like to see it implemented on top of a proven genre of game. For example, Deus Ex was a truly innovative game. But its gameplay has a solid basis in two proven genres: the first person shooter and the role-playing game. While Deus Ex actually has more innovation than most publishers would feel comfortable supporting, it also had an amazing team behind it, including the game designer and project director, Warren Spector, whose years of experience in the industry balanced

the risk involved in such an innovative project (see Warren's Designer Perspective on page 23).

When you present your idea to the publisher, it is called a "pitch." Pitching is an art, and we will go into more detail on this art in Chapter 16 on page 442. Briefly, your pitch materials need to communicate the strength of all three things we have talked about: the team, the plan, and the idea.

It might take a long time to get there, but at the end of the concept/contract stage, the developer should have a signed agreement with a publisher. This agreement will spell out the terms of the association, including rights, deliverables, and the payment milestones. The first milestone is signing the contract and approving the project plan. Subsequent milestones occur during each stage of development, as described next.

Preproduction (Months 2–6)

During preproduction, a small team will be put on the project to verify the feasibility of the idea. This team will typically work to create one playable level or environment of the game, focusing on proving out differentiating features and risky technology. As Steve Ackrich of Activision pointed out to us, this is the most critical period in development. If a game looks like a dog after six months of preproduction, he will kill it.

The team at this point will be small because a small team is inexpensive. Until the publisher is certain that the game concept and technology are going to work, they won't fund a full team. The job of the small team is to further refine the plan for the design, technology, and implementation of the entire production, from staffing and resource allocation through schedules and deliverables. For a great breakdown of preproduction methods, see the sidebar by Glenn Entis of Electronic Arts on page 157.

If a software prototype was not created in the concept stage, now is the time to make it and playtest it. This is also the time to write up a detailed design document and technical specification or create a project wiki with detailed design and technical pages. When the full team is hired for the production

stage, they will use and contribute to these living documents. The more clearly the design document or wiki describes the elements of the gameplay, visual design, and technology, the more efficient the production can be.

In addition to refining the game design, preproduction is the time to build prototypes of the risky technology elements and prove the feasibility of your approach. This helps to reduce the potential risk for both developer and publisher. It would be foolhardy to begin a technically ambitious project without a clear sense of the viability of the ideas or the time to complete implementation. At this point, the technology does not need to be 100% complete, but the publisher needs to see that the game is technically achievable before funding the next stage of development.

At the end of preproduction, the publisher will evaluate the prototype or completed level, the progress on the technology, the design and technical documents, and the fully developed project plan to make a decision to finance the production or kill the project. Smart publishers will not hesitate to kill projects that they think are too risky or do not seem marketable. At this point, their overall investment is fairly low, and the loss is negligible compared to the cost of releasing a product that does not sell.

If the publisher does kill the project at this point, it will pay the developer the milestone payment for the preproduction and cancel the rest of the development. Then, depending on the rights negotiated in the contract, the developer can either go to another publisher with their work or start over on a new idea. Problems can crop up if the developer has spent more money than planned during the concept and preproduction stage while counting on the next milestone payment to make up the difference. More than one developer has gone out of business at this stage.

Production (Months 7–22)

Production is the longest and most expensive stage of development. The goal in this stage is to execute the vision and plan established in the previous stage. In the process of improving and executing the design,

some changes will inevitably be necessary that must be reflected in the design document. However, in most cases, larger creative changes will not be possible to meet deadlines and stay within budget.

During this stage the programmers write the code that makes the game function. The artists build all the art files and animation. The sound designers create sound effects and music. Writers write dialogue and other in-game text. QA engineers familiarize themselves with all aspects of the project and do some light testing of early builds. The producer works to make sure everyone on the team is communicating and is aware of the overall progress, while tweaking the schedule and monitoring resources to ensure that everything remains on track.

As the production gains momentum, the levels and environments are fleshed out, art and sound files are integrated into the working builds of the code, and the game begins to take shape. One recommendation that Steve Ackrich makes to his teams is to build the first levels last. This is because the team will have worked out kinks in their production process and tools, they will know the limitations of the game system, and because of this the levels built last will likely be the best designed ones in the game. You want users to have an amazing experience with the first levels because that is what will get them hooked on the game.

The goal in this stage of development is to get to "alpha" code. This means that all features are complete and no more features will be added. Sometimes the team has to cut ambitious features to meet the alpha milestone and stay on schedule. For example, let's say the design called for a feature that allows users to import names from their e-mail address book into the game. Then, during gameplay, those names would appear on units as they come into the game. That would be fun, and it is actually a feature in the game Black & White. However, if the team is running out of time and this feature is not complete, the producer might classify it as low priority and cut it.

As the programmers work on the code, they will periodically assemble versions of the project, which are called "builds." Each build is given an incremental number so that any issues or bugs can be referenced as to what build they were found in. When the

developer achieves alpha code, it sends a build to the publisher's QA team. If approved, the publisher pays the developer for reaching the milestone, and the team moves on to the QA and polishing stage.

QA/Polish (Months 23–24)

In the last few months of production, the focus shifts from producing new code and features to making certain that what has already been built functions as expected and that the levels and artwork are complete and polished. The team shrinks down in size because the majority of production artists and outside talent such as sound designers and writers are no longer needed.

During this stage, the developer takes the alpha build and transforms it into the final product that we see on the store shelves. The user experience grows tighter and more complete. Levels are fine tuned. Game designers, programmers, and QA engineers work together to iron out timing issues, bugs, and annoying interface and control problems. As Steve Ackrich points out, 70% of the quality of a game comes during this last 10% of development. He cautions developers to leave enough time in their production schedules to truly refine the game.

It is in this last stage that the developer has a chance to truly see its game for what it is and to make sure it offers the best possible experience for the player. The difference between a game rushed off to market and one that has had the luxury of a good polishing can be enormous. It is the subtle tuning of gameplay and tweaks to timing and controls that can create an unforgettable player experience, and this is the level of quality that makes blockbuster games.

As we have mentioned before, QA testing is an art, and it is something that should not be taken for granted. In brief, the QA team creates a test plan, a document that describes all the areas and features of the product, and the various conditions under which each will be tested. This test plan is based on the design document or wiki. The QA engineers run the tests against the current build and note when the game does not behave according to spec. This is called a "bug."

Bugs are entered into a database with a description of the exact steps to be taken to recreate the

From Classroom to Console: Producing flOw for the PlayStation 3

by Kellee Santiago, President and Cofounder, thatgamecompany

thatgamecompany was founded in 2006 by fellow indies Kellee, Jenova Chen, John Edwards, and Nick Clark.

What was it like to ship our first commercial title? It was totally insane. We were a small group of recent grads and friends from game festivals, and we had all the makings of great new developers: We were naïve, optimistic, naïve, energetic, and naïve. None of us had ever shipped a commercial title before and we were ready to change the world. . . .

Jenova Chen and I founded thatgamecompany in May of 2006, just as we were graduating from the USC School of Cinematic Arts. We saw an opportunity in digital distribution to make the kinds of games we loved and earn a living doing it. Because of the surge in digital distribution, big publishers were willing to take creative chances on small games and even smaller teams because distributing games through the digital channel greatly reduced financial risk.

We knew we wanted to complete our first game relatively quickly—definitely under a year. There was a lot to learn about developing a commercial title with a publisher, from start through shipping, so we needed the project to be simple enough to allow for our inevitable mistakes. Therefore, developing Jenova's thesis project, *flOw*, for the not-yet-announced PlayStation Network, emerged as a good choice for our first game. We felt that a lot of the heavy lifting on the design had been done while creating the Flash version of game, and most of the difficult challenges had already been tackled. Also, the game itself is about simplicity—a perfect match!

We pitched a PS3 version of flOw to Sony. Additions included more creatures to play, each in their own unique world, and it would be in 3D. Nooooooo problem.

We realized a couple of months into development that these additions presented three major challenges:

1. Designing controls for one player character is hard, and we were about to tackle five.
2. Developing a game on a platform that is also in development (next-gen or not) is *always* difficult.
3. Changing the game from a completely 2D game into a game that plays in 2D but lives in a 3D environment actually creates a significant change in design.

In short, we realized we were in just a bit over our heads. These challenges culminated only two months after we had begun development when we decided to submit a demo of the game to the Tokyo Game Show. It was during that time that we realized a huge difference between academic and professional development: a deadline. You make it, or you die. The game had to be completely self-contained, and it could not crash. Oh yeah, *and* it had to stand alongside the other Sony games in development at that time. Yikes! While this was one of the most horrendously stressful periods of production, we learned an important lesson about what it takes to make a game shippable. We learned that on top of the challenges previously listed, there was also going to be this period of optimization and bug fixing that would take a long time and eat into our production schedule quite a bit. And we learned the limits of ourselves as mortals. Passion for your work takes you a long way, but there are definite limits that you have as a human being.

So, what could we do to fix this situation? We simplified. However, because our initial approach to the game was based on what we wanted the game to *feel* like, and what we wanted the player to *feel*, it was possible to simplify the game without losing any of its essence.

In flOw, the player is one of five aquatic organisms, eating, growing, and evolving their way through a surreal abyss. The Flash game was a demonstration of the application of flow theory (the theory of how and why humans have fun) into games. Therefore, there is a constant underlying zenlike, relaxing, zone experience. Each creature lives in its own abyss, and each one is meant to evoke a dif-

ferent emotion, all under the umbrella of this relaxing feeling. I think of it as an adventure down a river—the scenery might change and the water might move in different ways or at a different pace, but you are always traveling along the same river.

To address designing five unique player creatures, there was not too much we could do to change the situation we were in, other than just focus on making eating, growing, and evolving through a unique environment as fun as possible. We cut anything that didn't have to do with enhancing these core actions because if your core game isn't fun, you just don't have a game at all.

Developing the game alongside the development of the PS3 was an extremely difficult situation to be in. We didn't know much about programming for the PS3, and while we wanted to tap into the technology, we were so unfamiliar with the platform that we didn't have much time to delve into it. From the start of the project, we should have designed a game that didn't need the features of the PS3, so we wouldn't have been dependent as much on the platform.

The changes that occurred when we moved the player character from 2D to 3D were very unexpected, although looking back, they probably shouldn't have been. The possibilities for movement and camera angles of course increase greatly, so you can create these completely different experiences just by changing a couple of variables. However, we knew we had to remain true to the simplicity and the feeling of flowing through the game from the Flash version, so this acted as our guide through the design. If it wasn't simple, it wasn't flOw. Although a word of warning: a simple, elegant design solution is often the most complicated to implement.

I am still, to this day (no matter when you are reading this!), glad we chose flOw as our first title. While we had more design challenges than we initially suspected, we were right that developing the Flash game first helped a lot. The Flash game really helped to solidify the core concept and feeling of the game, which then acted as our guide throughout the development of the PS3 game. It taught me how important it is to know the core of your game from the very beginning. What do you want the player to feel? What is the fun in your game? If you have the answers to the questions, you will be much better equipped to handle all of the difficult design and production challenges of developing a video game.

problem, the severity of the issue, and the name of the tester who discovered it. There are dozens of bug databases available; some are expensive and some are free. We like the free open source systems—especially Mantis and Bugzilla.

To keep track of what has been fixed, by whom, and in what build, bugs are assigned to specific individuals. For example, a bug related to a game's database will be assigned to the database programmer. When the programmer has fixed the bug, she sends it back to the QA team for retesting. When the QA team is satisfied that the bug is fixed, they mark that issue "resolved" in the database.

When the development team gets together to assess the current state of the code and prioritize and resolve bugs, it is called a "triage" meeting. A typical console title will have several thousand bugs in the database. The programmers work through the database systematically, eliminating the highest priority bugs first. Bugs can be found in all areas of the game. There might be bugs that require the attention of the visual designers, the programmers, and even the legal staff if there are outstanding questions on things like disclaimers or registration. When all of the features are complete and there are no more "priority 1" bugs in the database, the project is considered to be at beta.

The final goal of this stage is to reach what's called "gold code." This means that all bugs have been resolved. Interestingly, nearly every game ships with some minor bugs in the code. At the very end of the project, the producer resolves remaining minor bugs as "deferred." This means that time has run out and the producer has determined that the remaining bugs are so unobtrusive that they can ship with the game. An example would be something like a slightly wrong font size on an alert message. It might be annoying to the art director, but it does not impact gameplay, so it is left in.

Maintenance (Ongoing)

Now that the Internet is so accessible to most game players, games are often updated via "patches" distributed online. This means the team monitors user feedback when the game is shipped and continues to fix bugs even though the product has shipped. These patches are reasonably small downloads that correct pervasive problems. Patches are usually not released for cosmetic or low-severity issues. Generally, they address feature problems, incompatibility issues, or other medium- and high-level bugs that managed to make it past the testing team.

How to Make a Project Plan

As we have mentioned, the project plan is the most important document that the developer creates. This set of documents is a road map for producing the game. It includes the schedule and the budget, which are generally attached to the contract for the production. Figure 13.2 provides an overview of the process for creating a realistic project plan and budget. Notice how each step directly affects its successor. The following sections describe each step of the process.

Goals

First articulate all the goals of the project. Include gameplay goals, such as features and levels, and technical goals, like enabling multiple players over the Internet. Also include the target platform and proposed launch date. An example might be to launch on the Xbox 360 and PlayStation 3 for Christmas in two years.

Exercise 13.1: Goals

Working with the team you have recruited, write down the goals for turning your original game idea into a finished product. Make sure to include both gameplay goals and technical goals.

Deliverables

The goals have a direct impact on the deliverables, which are the materials that you produce as part of the project. List out everything you envision making, and organize them under the stages of development.

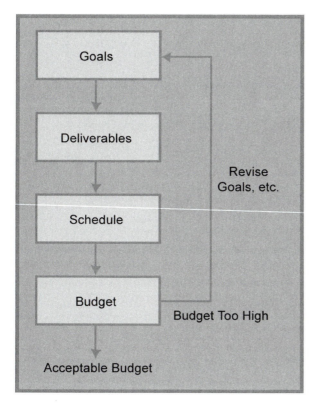

Goals

Deliverables

Schedule

Budget

Revise Goals, etc.

Budget Too High

Acceptable Budget

13.2 How to make a project plan

Schedule

A schedule is an estimate of how long it will take your team to complete each deliverable. The deliverables are made up of tasks, and these tasks are assigned to specific team members. The best way to begin creating your schedule is to break down each deliverable into a list of tasks. If you are experienced, you will know the tasks already. If you are not experienced, you might need to confer with your team members to get an idea of what tasks will need to be done and how long each task will take. Next go through the tasks and define what resources (i.e., team members) you will assign to each one and how long, in terms of days, it will take to complete.

Finally, assign start dates to each task on the list. Some tasks can be done in parallel, while others won't be able to begin until certain other tasks are completed. These are called dependencies, and they must be accounted for in the schedule. It can become quite complex when one aspect of the game requires 15 tasks to be completed by three different groups in a very specific order. You will also need to make sure you are balancing the workload for each team member. If you schedule a programmer to be coding three features at once, you will undoubtedly be disappointed when only one task actually gets accomplished.

Many game producers use a software program like Microsoft Project to create schedules. Microsoft Project and other scheduling programs allow you to drag tasks around the schedule visually and create links and dependencies between tasks. If you do not have a scheduling program, you can use a spreadsheet like Excel or even a paper calendar. The key is to organize all the tasks that will need to get done during each stage of development and to estimate how long each one will take and how many people will need to work on it. When you are done, you will have an overview of your production time line and a list of resources you will need and for how long. This list is what you need to produce the budget.

As you will see, the schedule forms the foundation of your project plan and will become an indispensable tool for managing the production. The sample schedule in Figure 13.3 is shown in Gantt chart format—a typical view for looking at schedules.

For example, you would list a design document under the design stage. If your game has levels, you should list the number of levels or environments under the production stage. Likewise, you would detail out exactly how much artwork, animation, and other media you will need to produce during the production as well, defining things like the number of 3D models, characters, sound effects, minutes of music, seconds of linear animation, seconds of voice recordings, etc. Each one of these is a deliverable, and it has to be both budgeted for and placed on the schedule.

Exercise 13.2: Deliverables

List out the deliverables for your production based on the goals you just stated. Think of every single element that goes into making up your game, from code modules to sound effects. Work with your team members to make your deliverables as accurate as possible.

13.3 Sample schedule in Gantt chart format

Exercise 13.3: Schedule

Using either scheduling software or a paper calendar, create a detailed schedule for the production of your original game. Do not leave any tasks unspecified. Also, make certain to identify any dependencies. You might need to estimate the length of time it will take to complete many of these tasks. Do not worry, the important thing is not how accurate your schedule is right now but that you think through the process and see how the pieces all fit together.

Budget

The budget is a direct function of the schedule. This is because the schedule tells you exactly how many people you will need and for how long, and salaries comprise the majority of a game budget. Other direct costs include things like software licensing and specialized services.

The sample budget in Figure 13.4 was created using Microsoft Excel and shows several important elements of a budget. The cover page on the left shows total costs for various types of production labor: project management, game design, graphic design, digital video, 2D/3D animation, and software development. It also shows the direct costs for testing, production supplies, media, licensing, and administrative costs. The right-hand page is an example of how each of the labor totals on the front page is calculated from a breakdown of line items.

Overhead expenses refer to all nonlabor expenses that are required to operate the business. For game developers it generally includes rent, utilities, supplies, insurance, and other such costs. A true overhead percentage can be calculated by an accountant as a function of the developer's real labor and nonlabor costs. This percentage is extremely important because many developers do not calculate it correctly and wind up shortchanging themselves.

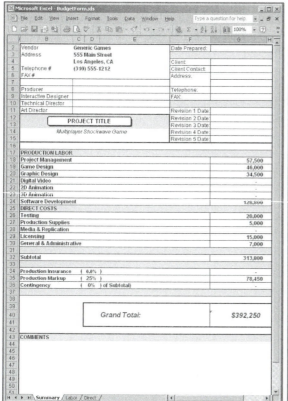

13.4 Sample budget

After the benefits and overhead are calculated for a specific line item, it is included in the total for the group of resources and carried over to the front page. All the various costs are added in a subtotal. Then several important percentages are calculated. The first is "production insurance." If you have taken any insurance out to back up your company's ability to complete the job, you will need to add that cost here. In this case, the developer has not done so.

The second percentage to be calculated is "markup." This is a percentage that the developer charges above their costs. Thus it might be possible for a developer to actually make some money on a production if they manage it closely and meet their expectations.

Exercise 13.4: Budget

Now it is time to create the budget for your original game. Use the sample budget in Figure 13.4 as a starting point. It is okay to put down your best guess for the various costs because you will revise your estimates later.

Revise

After you have gone through the first four steps, do not be surprised if you wind up with a gigantic budget number that far exceeds what you know the publisher will advance to you. Your next step is to go back to the beginning: Look at your goals and revise them.

Business Opportunities for Independents

by Chris Swain

Developers are finding opportunities for both creative freedom and financial return by publishing their games online versus with traditional retail-oriented publishers.

There are lots of ways to publish independent games, each with its own set of pros and cons. Here are the five main categories:

1. Your own Web site
2. User generated game sites
3. Indie game aggregators
4. Casual game publishers and portals
5. Downloadable console games

Here is a bit about each ranked in order of how hard they are for developers to gain entry.

Your Own Web Site

This simply means you produce a game and sell it via your own Web site. An example of this kind of game is Desktop Tower Defense. This game was self-produced by a young designer with no professional experience, Paul Preece. Preece makes Desktop Tower Defense available for free and reaps ad revenue off the Web site. The game is addictive and receives over 20 million page views per month. This translates into nearly $100,000 per year. A second example is the game Peacemaker, which is about solving the Israeli–Palestinian conflict. The game was developed by some college friends and is sold via their Web site for $20.00. Peacemaker is a success because it's a good game and because they've generated tremendous press. The press can be thought of as marketing for the game because it drives traffic and sales.

Pros: *You have complete control over the creative and the marketing.*

Cons: No production budget, no marketing budget, no help whatsoever. Very hard to get traffic to your site for one game.

User Generated Game Sites

Think YouTube for games. Established sites in this category are Newgrounds.com and Kongregate.com. Essentially, developers upload their games in Flash or Shockwave format to these sites for free. Players rate the games, and top rated games appear prominently on the site. Kongregate.com awards cash prizes for multiple top rated games each week and each month.

Other interesting examples are The Great Games Experiment from GarageGames.com, which is a full Web 2.0-style gamer community, Armorgames.com, Crazymonkeygames.com, and Addictinggames.com. These sites are a great way for developers to promote their work and network with potential business partners.

Pros: *Low barrier to entry. Complete creative freedom. Potentially lots of traffic. Anyone can build a game and upload. Go do it!*

Cons: No development budgets. Lots of competition so only a tiny fraction of games will/do make a financial return. Go do it anyway!

Indie Game Aggregators

The best known company in this category is Manifesto Games. The company founder, maverick game designer Greg Costikyan, says the "[game] industry was once the most innovative and exciting artistic field on the planet [but] has become a morass of drudgery and imitation. We plan to change that." He wants to "build a viable path to market for independently developed games." Manifesto seeks quirky, innovative, and offbeat titles that are not likely to be sold at GameStop. Manifesto takes care of distributing, marketing, and selling the games (all online). Developers keep 60% of revenues and retain all intellectual property rights. Manifesto does not publish casual games.

A second example of an aggregator is Moondance Games. Moondance publishes anthologies of indie games on CD-ROM via retailers like Amazon.com. Moondance accepts submissions from developers through their Web site.

Pros: *Strong emphasis on independent thinking and gameplay innovation. Out-of-the-box thinking is rewarded. The aggregator provides the marketing for your game. You retain control of your intellectual property.*

Cons: No funds for production budgets.

Casual Game Publishers and Portals

Casual games are big business. Casual game publishers work similarly to traditional console game publishers but focus on lighter games and distribute them online. Established publishers in this space are PopCap Games and PlayFirst. Here's how PlayFirst's business works in a nutshell:

- A developer pitches a concept to PlayFirst via their Web site. Pitches generally must include a playable demo to be taken seriously. And, like any creative business, your ability to get a deal going is greatly enhanced if you first build a relationship with people at the company.

- PlayFirst provides a production budget to games they believe will make money. The size of the budgets vary depending on many factors. Expect budgets to be in the $50,000 to $200,000 range.

- PlayFirst manages the production through completion and makes sure the quality level is to their high standards.

- When the game is complete, PlayFirst markets and sells it to casual game portals. PlayFirst sells to over 500 game sites worldwide.

- Publishers typically give a royalty rate of 10 to 15% of net sales to developers after they've received revenues from the portal. This rate is negotiable depending on the track record of the developer and how much of the project is funded by the publisher. This rate increases dramatically if you bring the product to the publisher completed and they provide distribution services only.

Casual game portals aggregate lots of games and sell them to players. Typically casual games are downloaded and allow players to play for free for one hour. If the player wishes to continue playing after an hour she can buy the game with a credit card for $20. Examples of casual game distributors are Games.yahoo.com, Games.msn.com, Realarcade.com, Pogo.com, Bigfishgames.com, Shockwave.com, and iWin.com. Distributors typically share 25 to 50% of revenues with publishers depending on the deal. Thus, in a typical arrangement, a game sells for $20 via the portal; about half (e.g., $10) goes to the portal and half goes to the publisher. The publisher gives about 15% of that $10 (e.g., $1.50) to the developer as a royalty. Publishers provide royalties to developers after they have recouped their investments.

Pros: *Production budgets are provided! Also games are marketed and sold aggressively by the publisher.*

Cons: There is less or no creative control. The developer typically does not own intellectual property.

For a more comprehensive look at the business of casual games—including an extended list of publishers—check out the Casual Games SIG on IGDA.org.

Downloadable Console Games

There are two venues here: (1) Xbox Live Arcade and (2) PlayStation 3 Downloadable. These are games that download directly to player's game consoles via their console's connection to the Internet. Games typically cost $5 to $15 to buy.

This category is listed last here because it is generally the hardest for developers to access. Xbox Live Arcade has been a big success for Microsoft partly because they keep tight control of the content on the site. For example, Microsoft prefers to not allow games that are very similar in gameplay to their popular offerings on the service. If you can get on Xbox Live Arcade or PlayStation 3 Downloadable, then chances are lots of people will play and buy your game. Getting accepted by these companies, however, is very difficult. It is akin to getting accepted by a traditional console game publisher.

After you revise your goals, you will need to revise the deliverables, which should now require a shorter schedule. When you have revised your schedule, you will need to reflect those changes in your budget.

The biggest mistake that beginning developers make during the budgeting process is to not change their goals and deliverables but instead fiddle with the numbers until they come out looking "reasonable." Always start with your goals and work down through the deliverables and schedule, item by item. If you overpromise and underbudget, you will run the risk of losing money, overworking your team, and being unable to complete the project as promised.

Exercise 13.5: Revise

Now assume the publisher has asked you to cut 20% out of your budget. Starting with your goals and working your way through the deliverables, schedule, and finally the budget, revise your plan to reduce costs.

Milestones and Approvals

Each time a stage of development has been completed and approved by the publisher, the developer receives a milestone payment. It is important that the developer keep a written record of all approvals and decisions from the publisher. Quite often the

publisher will ask for changes to the design in the middle of production, which will increase the cost of production. If the producer for the developer has been thorough about getting approval on the stages of development, she will be in a good position to discuss an increased budget for additional feature requests.

These details that seem so formal and unnatural in the rather casual environment of game production can mean the all difference in the development process. As we have said already, a lot of good producing comes down to maintaining clear lines of communication and documenting all decisions and requests for changes.

CONCLUSION

Games tend to be some of the most technically advanced software in the world, and the challenge in creating them keeps growing as the teams get larger and the player expectations increase. Knowing how to put a good process in place and understanding what to expect at each stage of development are ways that you can ensure the success of your design ideas. Although designers are not typically responsible for creating the project plan or managing it, the more you know about the process of development, the more you can contribute to your team's plan, and the better designer and team member you will become.

Designer Perspective: Stan Chow

General Manager, EA Japan

Stan Chow is a game designer, producer, and executive whose credits include 4D sports Tennis (1990), 4D Boxing (1991), Skitchin' (1994), NBA Live '95 (1994), PGA Tour Golf '98, NBA Live 2001, NBA Street (2002), Def Jam Vendetta (2003), and Theme Park DS (2007).

On getting into the game industry:

I spent most of my teenage years either playing video games at the arcade or on my Apple II computer. In 1989, my best friend, Don Mattrick, who started his own video game company in 1982, asked me if I wanted to join his company and help design games. I was in university studying computer science at the time; it was a no-brainer.

On favorite games:

- *Robotron:* Mowing down hundreds of robots with my blaster and escaping against all odds gives me a sweaty, heart-pounding, white-knuckled adrenaline rush.
- *Metal Gear Solid:* It's the first game to let me play out my fantasy of sneaking around and taking people out. The game triggered feelings of fear and anticipation as I ran and hid from the enemy or snuck around a corner. It also has a good story.
- *Pikmin:* I love this game for its fresh concept and great execution of gameplay.
- *WarCraft:* As a player, real time strategy is my favorite genre of games. The most important thing in an RTS game is balance. When you find an imbalance that you can exploit in an RTS game, it is no longer fun to play. In terms of balance, WarCraft is the best execution of an RTS game.

On inspiration:

What inspires me the most are games that feel fresh and original in concept or design. Games that have fallen into that category in their time are: Test Drive, SimCity, Goldeneye, Metal Gear Solid, The Sims, and Pikmin.

Advice to designers:

Understand the structure of games and what makes them fun. Ideas and concepts are cheap. Structure and execution are what make a game great.

DESIGNER PERSPECTIVE: STARR LONG

Producer, NCSoft

Starr Long is a game producer and project director whose credits include Ultima Online (1997), Ultima Online: The Second Age (1998), City of Heroes (2004), and Tabula Rasa (in production). While working in QA, he contributed to games such as Wing Commander: Privateer (1993), Wing Commander: Armada (1994), Bioforge (1995), Ultima Underworld 2 (1993), Ultima VII: Part 2: Serpent Isle (1993), and Ultima VIII (French, 1994).

On getting into the game industry:

I was working in live theatre in Austin (I have a degree in set/lighting/sound design) and not making very much money. I needed a steadier income, so I answered an ad in the local paper that said Origin was looking for playtesters. I have always loved games of all kinds, and I had no idea that people actually got paid to play games. I got the job and went on to project direct Ultima Online, the first large-scale success in online gaming.

On favorite games:

- *Diablo II:* I have spent more time playing Diablo II than any other game. The game is very simple but incredibly deep. The item and monster generation in this game are some of the best ever. Each time I played, I found some new combination of weapon attributes or boss monster abilities. When combined with the multiplayer aspect, there are few games that can match this one. They also provided stellar support over many years on Battle.net.

- *Grand Theft Auto: Vice City:* The immersive quality of this game was truly groundbreaking. The possibilities the designers built into the game for emergent behavior were almost limitless. Being able to solve almost every single mission in a myriad of ways (drive-by shooting versus sniper, moped versus semi, etc.) was thrilling. Just driving or flying around the game was fun. To top it all off the radio station soundtrack of 1980s tunes was a stroke of genius.

- *Guitar Hero:* Many of my friends are musicians, and I have done lighting for many of them over the years. I have always wanted to be under the lights, however. Guitar Hero made me feel like I was a rock star. This game, more than any other, fulfilled a fantasy, and in fact this game supplanted my previous fantasy fulfilling game: Tony Hawk's Pro Skater.

- *Command & Conquer:* The first real time strategy game to truly leverage multiplayer. While the game only had a few units compared to recent titles, each of those units was very differentiated so strategies from session to session could vary immensely. They also nailed the luck factor through their "crates" so it was possible to come back and win even if you fell really far behind. To this day I have yet to see another RTS that you can come back from behind like this.

- *Ultima IV: Quest of the Avatar:* The first role-playing game where what you did in the game actually mattered. You could not just go around killing and stealing to win the game. You really had to be a good guy by following the virtues or else the game would become unwinnable: a game with a conscience, if you will.

On game influences:

- *DOOM:* This game was the first to really open my eyes to the possibilities of multiplayer games. For the first time, I truly understood how human beings were infinitely more entertaining and unpredictable than any artificial intelligence. This game, more than any other, was my inspiration for Ultima Online.

- *Diablo:* Diablo showed me how an incredibly simple game mechanic in an RPG could be so captivating. The mechanics of starting up games with small groups and having that play space to yourself is what has inspired the focus on instantiated spaces in my current project.

- *Medal of Honor:* To me, this game, more than any other, showed me how you could create a feeling of actually being in the middle of a war via wonderful NPC interactions. This game was the direct inspiration for our battlefields in Tabula Rasa.

On the design process:

It is a highly collaborative process first of all. Many people working together come up with all the ideas that go into the game. For our ideas we play lots of games, read lots of books, and watch lots of media (film and TV). We then decide what kind of experience we want to create for the user. Then we try to figure out how we can make that experience happen. In the game I am currently working on, Tabula Rasa, our fundamental goals were to create an MMO where it feels like there is a war on all the time and where the pace is much closer to an action game even though the game is a role playing game at its core.

On starting in QA:

I am most proud of the fact that I worked my way up from the very bottom of the organization to leading multimillion-dollar projects. The perspective I gained from having to test broken games informed every aspect of how I make games today. My QA experience inspired my mantra: "Stable, fast, and fun: in that order."

On Ultima Online:

Ultima Online started out as the bastard child of EA/Origin. At one point they had us sitting in a hallway while they were remodeling an entire floor of the building around us. Despite the hardships, I supported my team and kept us going. The result was the first large-scale success in online subscription-based gaming.

However, what made me most proud was a letter we received from a physically challenged individual who thanked us for giving him an alternate world that he could live in where he could run.

Advice to designers:

Play every game you possibly can. Then analyze them carefully. Ask yourself what you would change if you could. Figure out what feature was best executed and which one was the worst executed. Finding inspiration from outside of games is extremely important. Read books, watch movies, see plays, look at art, listen to music, watch people interact with each other—there is inspiration everywhere. We take books and mark passages for directing level design. We show each other clips from films for art direction ideas. Finally, always make sure you are having fun. If you are not having fun making your game, then your customers will not have fun playing it.

FURTHER READING

Chandler, Heather M. *Game Production Handbook*. Boston: Charles River Media, 2006.

Hight, John, and Novak, Jeannie. *Game Project Management*. Boston: Thomson Learning, 2007.

Irish, Dan. *The Game Producer's Handbook*. Boston: Thomson Course Technology, 2005.

McCarthy, Jim. *Dynamics of Software Development*. Redmond: Microsoft Press, 2006.

Chapter 14

The Design Document

We have said throughout this book that digital game development is an inherently collaborative medium. In the last two chapters we have looked at all the various types of people who make up that collaborative environment, as well as the stages of the production process. One of the most important parts of managing this process is communicating the overall vision of the game to each and every team member. If your team is very small, or if you are working alone, this might not be a problem. But most games are complex enough, and most teams are large enough, that the most effective way to ensure communication is to write down that vision as well as a detailed plan for executing it. This plan is called the design document, and the game designer is its primary author and caretaker. In recent years, many teams have begun using online tools such as wikis to create and manage their design documents in a collaborative environment. Wikis can include text, images, and other media and changes to the design that can be tracked by users.

Whether you use a wiki or standard word processing software, the goals of the design document are the same: to describe the overall concept of the game, target audience, gameplay, interfaces, controls, characters, levels, media assets, etc. In short, everything the team needs to know about the design of the game. The artists will use it to lay out interfaces that reflect the features that you and the team have designed, the programmers will use it to define the software modules for those features, the level designers will use it to understand how their level fits into the overall story arc, the producer will use it to generate an accurate budget and schedule, and the QA department will use it to develop a comprehensive test plan.

As team sizes, schedules, budgets, and the overall complexity of game designs have grown exponentially, the need for clear, comprehensive documentation has become unmistakable. Most game developers and publishers today would never think of going into production without a detailed design document, and updating this living document throughout production is a critical responsibility of the game designer.

COMMUNICATION AND THE DESIGN DOCUMENT

A good design document is like sound blueprints for a building. Everyone on the team can refer to and add comments while they do their separate tasks and understand how their work fits into the game as a whole. The writing of the document facilitates collaboration and useful conversations between team members.

Without design documentation to direct their efforts, the individuals on a team might interpret what they know about the game in their own unique ways, working hard, but not necessarily toward the same ends. When it comes time to integrate that work, art might have been made to unusable specs, technology

394

might reflect out-of-date features, or the essence of the gameplay might have been lost in the level designs.

To create an effective design document, the game designer needs to work with every other member of the team to make sure that the areas of the document affecting their work are accurate and achievable. In this way, the writing of the document itself generates communication. By conferring on the details of the game via text, wireframes, concept art, flowcharts, etc., team members have to think through the entire game, from the highest-level vision concepts to the lowest-level art specifications, the file types, and the font sizes. Game developers tend to be visual people, so supplementing the document with lots of visuals is generally a good thing.

There is a tendency for design documents to become very large. This is especially true if you use a wiki to write your design document because the collaborative management of these online documents allows them to grow very easily. However, a good design document can (and should) be succinct. Effective design documents can communicate core information in 50 to 100 pages so that a busy executive or programmer can find the areas that affect them quickly and easily. If there are areas that need to be expanded on as production moves forward, one strategy is to create subdocuments that delve into these areas more deeply.

Always keep in mind that you are not writing the design document for the sake of writing it—your objective is communication, so do whatever it takes to accomplish that goal. Documentation is not a substitute for talking to your team. Just because you have written it down, do not assume that everyone has read and understood your vision. Writing the document provides a process for establishing communication and serves as a touchstone for the entire team in terms of creative and technical designs, but it is not a substitute for team meetings and in-person communication.

CONTENTS OF A DESIGN DOCUMENT

The game industry has no standard format for documenting designs. It would be nice if there were a set formula or style to follow, like the standards for screenplays or architectural blueprints, but this simply does not exist. Everyone does agree that a good design document needs to contain all the details required to create a game; however, what those details are will be affected by the specifics of the game itself.

In general, the contents of a design document can be broken up into the following areas:

- Overview and vision statement
- Audience, platform, and marketing
- Gameplay
- Characters (if applicable)
- Story (if applicable)
- World (if applicable)
- Media list

The design document can also include technical details, or these can be articulated in a separate document called a technical specification. The technical specification or the technical sections of the design document are generally prepared by the technical director or lead engineer.

Exercise 14.1: Researching Design Documents

To get a feeling for the various ways that designers approach the writing of design documents, go on the Web and do a search using Google for "game design documents." You will find dozens posted on the Internet. Pick two and read through them. What are their strengths and weaknesses? If you were a member of the design team, would you be able to execute the design as described? What questions do you have for the designers after reading the documents?

When you approach the writing of a design document, it is easy to get distracted by the scope of the document and forget the ultimate goal: to

communicate your game design to the production team, the publisher, the marketing team, and anyone else with a vested interest in the game. This is one reason why we advise you not to write your design document until you have built and playtested a working prototype of your idea. Having this type of concrete experience with your proposed gameplay can make all the difference in your ability to articulate that gameplay in the design document.

You should also think of your design document as a living document. You will likely have to make a dozen passes before it is complete, and then you will need to constantly update it to reflect changes that are made during the development process. Because of this, it is important to organize your document modularly. If you organize your document carefully from the beginning, it will be easier to update and manage as it grows in size and complexity. Also, as we mentioned earlier, it will be easier for each group to find and read the sections that affect their work.

Using a wiki to create your design document will naturally enforce this idea of modularity. You will want to create separate pages for the various areas of your design and subpages for areas that require deeper descriptions, images, charts, or other materials.

The following outline is an example of how you might organize your design document. We have noted under each section the types of information it should contain. Keep in mind that our goal here is not to give you a standard format that will work for every game, but rather to provide you with ideas for the types of sections you might want to include. Your game and its design should dictate the format you use for your own document, not this outline.

1. **Design History**

 A design document is a continuously changing reference tool. Most of your teammates won't have time to read the whole document over and over again every time that a new version is released, so it is good to alert them to any significant modifications or updates that you have made. As you can see, each version will have its own section where you list the major changes made in that iteration. If you use a wiki, this section will be replaced by the editing history feature of the software. This makes it simple

and effortless to track changes to the document and to backtrack changes if it becomes necessary.

1.1 Version 1.0

1.2 Version 2.0

 1.2.1 Version 2.1

 1.2.2 Version 2.2

1.3 Version 3.0

2. **Vision statement**

 This is where you state your vision for the game. It is typically about 500 words long. Try to capture the essence of your game and convey this to the reader in as compelling and accurate a way as possible.

 2.1 Game logline

 In one sentence, describe your game.

 2.2 Gameplay synopsis

 Describe how your game plays and what the user experiences. Try to keep it concise—no more than a couple of pages. You might want to reference some or all of the following topics:

 - Uniqueness:
 What makes your game unique?

 - Mechanics:
 How does the game function? What is the core play mechanic?

 - Setting:
 What is the setting for your game: the Wild West, the moon, medieval times?

 - Look and feel:
 Give a summary of the look and feel of the game.

3. **Audience, Platform, and Marketing**

 3.1 Target audience

 Who will buy your game? Describe the demographic you are targeting, including age, gender, and geographic locations.

 3.2 Platform

 What platform or platforms will your game run on? Why did you choose these platforms?

 3.3 System requirements

 System requirements might limit your audience, especially on the PC, where the hardware varies widely. Describe what is required to play the game and why those choices were made.

3.4 Top performers
List other top-selling games in the same market. Provide sales figures, release dates, information on sequels and platforms, as well as brief descriptions of each title.

3.5 Feature comparison
Compare your game to the competition. Why would a consumer purchase your game over the others?

3.6 Sales expectations
Provide an estimate of sales over the first year broken down by quarter. How many units will be sold globally, as well as within key markets, like the United States, England, Japan, etc.?

4. **Legal Analysis**
Describe all legal and financial obligations regarding copyrights, trademarks, contracts, and licensing agreements.

5. **Gameplay**
5.1 Overview
This is where you describe the core gameplay. This should tie directly into your physical or software prototype. Use your prototype as the model, and give an overview of how it functions.

5.2 Gameplay description
Provide a detailed description of how the game functions.

5.3 Controls
Map out the game procedures and controls. Use visual aids if possible, like control tables and flowcharts, along with detailed descriptions.

 5.3.1 Interfaces
Create wireframes, a type of functional visualization described on page 400, for every interface the artists will need to create. Each wireframe should include a description of how each interface feature functions. Make sure you detail out the various states for each interface.

 5.3.2 Rules
If you have created a prototype, describing the rules of your game will be much easier. You will need to define all the game objects, concepts, their behaviors, and how they relate to one another in this section.

 5.3.3 Scoring/winning conditions
Describe the scoring system and win conditions. These might be different for single player versus multiplayer or if you have several modes of competition.

5.4 Modes and other features
If your game has different modes of play, such as single and multiplayer modes, or other features that will affect the implementation of the gameplay, you will need to describe them here.

5.5 Levels
The designs for each level should be laid out here. The more detailed the better.

5.6 Flowchart
Create a flowchart showing all the areas and screens that will need to be created.

5.7 Editor
If your game will require the creation of a proprietary level editor, describe the necessary features of the editor and any details on its functionality.
 5.7.1 Features
 5.7.2 Details

6. **Game Characters**
6.1 Character design
This is where you describe any game characters and their attributes.

6.2 Types
 6.2.1 PCs (player characters)
 6.2.2 NPCs (nonplayer characters): If your game involves character types, you will need to treat each one as an object, defining its properties and functionality.
 6.2.2.1 Monsters and enemies
 6.2.2.2 Friends and allies
 6.2.2.3 Neutral
 6.2.2.4 Other types
 6.2.2.5 Guidelines
 6.2.2.6 Traits
 6.2.2.7 Behavior
 6.2.2.8 AI

7. **Story**

7.1 Synopsis

If your game includes a story, summarize it here. Keep it down to one or two paragraphs.

7.2 Complete story

This is your chance to outline the entire story. Do so in a way that mirrors the gameplay. Do not just tell your story, but structure it so that it unfolds as the game progresses.

7.3 Backstory

Describe any important elements of your story that do not tie directly into the gameplay. Much of this might not actually make it into the game, but it might be good to have it for reference.

7.4 Narrative devices

Describe the various ways in which you plan to reveal the story. What are the devices you plan to use to tell the story?

7.5 Subplots

Because games are not linear like books and movies, there might be numerous smaller stories interwoven into the main story. Describe each of these subplots and explain how they tie into the gameplay and the master plot.

7.5.1 Subplot #1

7.5.2 Subplot #2

8. **The Game World**

If your game involves the creation of a world, you need to go into detail on all aspects of that world.

8.1 Overview

8.2 Key locations

8.3 Travel

8.4 Mapping

8.5 Scale

8.6 Physical objects

8.7 Weather conditions

8.8 Day and night

8.9 Time

8.10 Physics

8.11 Society/culture

9. **Media List**

List all of the media that will need to be produced. The specifics of your game will dictate what categories you need to include. Be detailed with this list,

and create a file naming convention up front. This can avoid a lot of confusion later on.

9.1 Interface assets

9.2 Environments

9.3 Characters

9.4 Animation

9.5 Music and sound effects

10. **Technical Spec**

As mentioned, the technical spec is not always included in the design document. Often it is a separate document prepared in conjunction with the design document. This spec is prepared by the technical lead on the project.

10.1 Technical analysis

10.1.1 New technology

Is there any new technology that you plan on developing for this game? If so, describe it in detail.

10.1.2 Major software development tasks

Do you need to do a lot of software development for the game to work? Or are you simply going to license someone else's engine or use a preexisting engine that you have created?

10.1.3 Risks

What are the risks inherent in your strategy?

10.1.4 Alternatives

Are there any alternatives that can lower the risks and the cost?

10.1.5 Estimated resources required

Describe the resources you would need to develop the new technology and software needed for the game.

10.2 Development platform and tools

Describe the development platform, as well as any software tools and hardware that are required to produce the game.

10.2.1 Software

10.2.2 Hardware

10.3 Delivery

How do you plan to deliver this game? On DVD, over the Internet, on wireless devices? What is required to accomplish this?

10.3.1 Required hardware and software

10.3.2 Required materials

10.4 Game engine

10.4.1 Technical Specs

What are the specs of your game engine?

10.4.2 Design

Describe the design of your game engine.

10.4.2.1 Features

10.4.2.2 Details

10.4.3 Collision detection

If your game involves collision detection, how does it work?

10.4.3.1 Features

10.4.3.2 Details

10.5 Interface technical specs

This is where you describe how your interface is designed from a technical perspective. What tools do you plan to use, and how will it function?

10.5.1 Features

10.5.2 Details

10.6 Controls' technical specs

This is where you describe how your controls work from a technical perspective. Are you planning on supporting any unusual input devices that would require specialized programming?

10.6.1 Features

10.6.2 Details

10.7 Lighting models

Lighting can be a substantial part of a game. Describe how it works and the features that you require.

10.7.1 Modes

10.7.1.1 Features

10.7.1.2 Details

10.7.2 Models

10.7.3 Light sources

10.8 Rendering system

Rendering is a big part of games these days, and the more details you can provide, the better.

10.8.1 Technical specs

10.8.2 2D/3D rendering

10.8.3 Camera

10.8.3.1 Operation

10.8.3.2 Features

10.8.3.3 Details

10.9 Internet/network spec

If your game requires the use of the Internet, LANs, or wireless networks, you should make the specs clear.

10.10 System parameters

We won't go into detail on all the possible system parameters, but suffice to say that the design document should list them all and describe their functionality.

10.10.1 Max players

10.10.2 Servers

10.10.3 Customization

10.10.4 Connectivity

10.10.5 Web sites

10.10.6 Persistence

10.10.7 Saving games

10.10.8 Loading games

10.11 Other

This section is for any other technical specifications that should be included, such as help menus, manuals, setup and installation routines, etc.

10.11.1 Help

10.11.2 Manual

10.11.3 Setup

We want to emphasize that the previous outline is merely a list of suggested topics that might need to be addressed to communicate your design. Every game will have its own specific needs, and the organization of your design document should reflect these needs.

Under each of the sections in your design document, you need to answer all the questions that a team member might have. For example, the character designs section would include drawings and a description of each character in the game, while the levels section would include not only the intended gameplay for each level but explanations of any story elements that would be found in each level.

WRITING YOUR DESIGN DOCUMENT

Before you sit down to write your design document, you should have spent a considerable amount of time thinking through the gameplay. The best way to do this, as we already discussed, is to build a physical or software prototype of your game and playtest it, improving and expanding your design until you have a solid foundation for your full game. Only after you have gone through several iterations of prototyping can you really be ready to write your design document.

Many designers will move to an outline and start pounding out the text of the design document at this point. We recommend flowcharting your entire game and building a set of wireframe interfaces for every screen in the game first. A wireframe is a rough sketch or diagram that shows all the features that will need to be included on an interface screen. By sketching out both the flow of the game and every required screen, you will be forced to think through the entire player experience for the game, finding inconsistencies and issues before any artwork or programming has been done.

Figure 14.2 is an example of a game flowchart created using typical software, like Microsoft Visio. This is for an online multiplayer version of the Wheel of Fortune game. As you can see, it illustrates how players move through the game and interact with it.

Notice how the flowchart shows all possible paths through the game and all possible results, including how the player wins and loses and what happens if the player disconnects. You can use flowcharts to map out all sorts of processes within your game. The more detailed you are, the easier it will be to communicate your ideas to your teammates.

After you create your flowcharts, you will need to sketch out the main interfaces for the game in wireframe format. Figure 14.3 shows an interface wireframe from Wheel of Fortune, an early concept sketch for the interface, and the final interface as released. If you look closely, you will see that several changes were made during production, notably in the way that chat is handled in the game. Wireframes are not the end of the design process; they are the beginning. They give the game designer, artists, programmers, and producers a visual reference point to discuss the game in its early stages. They can also be usability tested at this point. Changes can be made to the design at this time, when they cost nothing to make, rather than months down the road when they would have much higher repercussions.

Exercise 14.2: Flowchart and Wireframes

Either on paper or using a software tool like Microsoft Visio or Flow Charting PDQ, create a full flowchart for your original game design. Next create a complete set of wireframes for every interface state in the game. Then annotate your wireframes with callouts describing every feature as described in the next paragraph.

Now that you have created a prototype, a flowchart, and a full set of wireframes, you will have a very good idea of what you need to communicate in your design document. You will also have a set of visual aids for explaining the features of your game. Most people can absorb information more clearly from visual displays like your wireframes than from long paragraphs of text explaining the features of your game. Because of this, your wireframes are not only a good tool to help you think through your game, but they are an excellent reference point for

14.1 Character sketches from Jak & Daxter and Ghost

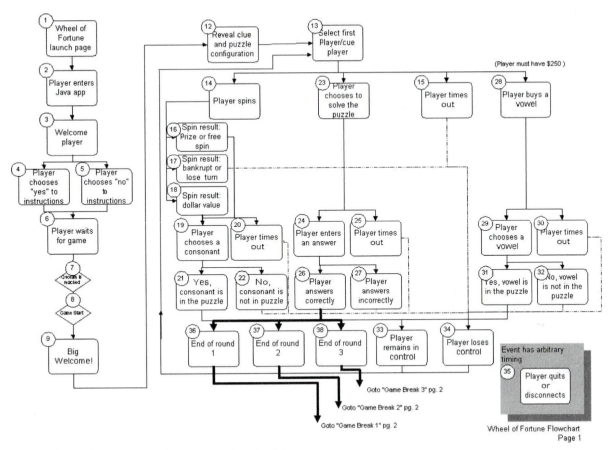

Wheel of Fortune Flowchart
Page 1

14.2 Flowchart for multiplayer Wheel of Fortune

your readers. As you outline your document, use the flowchart and wireframes to explain the areas and features of the game. You might want to create callouts on your wireframes explaining how various features will work. These callouts can be supported by bullet points that expand on the visual diagrams.

Ideally, by working through your concept from prototype to flowchart and wireframes to documentation, you will find that the document is actually quite simple to write. Instead of being faced with the mammoth task of thinking through the game while you write the document, you will have broken the tasks down into smaller stages that allow the game itself to dictate how the design document should be written.

As with the rest of your design experience, the document should be an iterative process. Do not try to complete it in a single pass. Let it grow over time. Fill out sections as they become clear, then go back to other sections and refine them.

Exercise 14.3: Table of Contents

Outline the table of contents for your original design document. Consider every aspect of your prototype, flowchart, and wireframes when you are deciding how to describe your game. Draw from the example documents you downloaded from the Web and the generic template found in this chapter.

14.3 Interface wireframes, sketch, and final interface for multiplayer Wheel of Fortune

You might realize while writing a later section that your thoughts from an earlier section need to be revised. Because each aspect of a game system is interrelated to the others, you will be continually going back and forth between the sections, modifying and updating them. Here is an example as to how the process might go for the level design section:

- *First pass:* Make outline of all levels and give them names.
- *Second pass:* Write one-paragraph descriptions of what takes place on each level.
- *Third pass:* Design maps for each level.
- *Fourth pass:* Populate maps with content.

Indie Game Jam: An Outlet for Innovation and Experimental Game Design

by Justin Hall

Austin Grossman is fleeing through a city, fervently searching through tens of thousands of shuffling, pixellated citizens for the wide sombrero of the man who wants to kill him. Austin's movements with the mouse are jerky, and he's holding his breath. Suddenly he hears a loud reverberating ping off to his left. Austin whirls to face the sound. The crowd parts, and before Austin can react, the man in the sombrero shoots him down.

Thatcher Ulrich watches over Austin's shoulder, gently nibbling his finger. Austin and his colleague, Doug Church, are playing Thatcher's game, Dueling Machine. In Dueling Machine, one player hunts another using sonar pings to find or avoid their enemy amidst tens of thousands of innocent bystanders. Few games use sound in such an integral way; this idea came from Marc LeBlanc. At the time, Marc worked for Visual Concepts, a video game development studio owned by Sega. Thatcher worked at Oddworld Inhabitants, a video game development studio owned in part by Microsoft. Given the competitive nature of the modern game industry, it doesn't make much sense that these two would be designing a video game together.

Thatcher and Marc are both working on Dueling Machine as part of the Indie Game Jam. Tired of calcification in commercial video games, a small group of game designers decided to jump-start some experimental game designs. In March 2002, they built a system for simultaneously displaying up to 100,000 moving characters on the screen at one time. Then they invited a dozen designer-programmer friends from a half a dozen game companies to join them for collective quick and dirty garage-style programming in a barn on a marina in Oakland, California.

The roots of electronic entertainment lie in these sorts of collaborations, in garages and basements and dank laboratories—places where people gathered over rudimentary machines to make virtual worlds. Thirty years ago, the people responsible for electronic entertainment were not yet game professionals, they were simply dedicated hobbyists. They tinkered with computers and code to make small simulations, establishing rules and parameters that their friends would break.

These tinkerers gave birth to a $20 billion industry. Electronic gaming has expanded rapidly; now 30 years later, most games are made by massive teams of specialized developers working for years with a marketable product in mind. Still, there are some folks who hope to encourage a generative creative spirit, to inject some creativity and vitality into a medium that's increasingly conservative.

This Indie Game Jam was organized in part by programmer Chris Hecker, who sees a games industry that is "too risk adverse." Hecker is eager to see an independent subculture for video games; a film festival or garage band ethos feeding new ideas to commercial developers.

When the Indie Game Jam started, Hecker worked out of the top floor of a red barn in a cluster of Victorian buildings surrounded by bland office parks and industrial sites. This cluttered, compact office served as a retreat for a revolving cast of independent programmers—laptops working on a futon propped up with old CPU cases between stacks of old graphics cards, books on math theory, and antique PC games.

Hecker opened up his Oakland office to serve as the site of the first few Indie Game Jams. Over a bowl of dry noodles at a nearby Vietnamese restaurant, Hecker speaks passionately about the evolution of gameplay: "Games of the future will be interactive not only at the second-to-second level, which we focus on now,

Indie Game Jam participants in action

Top left: Chris Hecker and Doug Church working on their game FireFighter. Top right: Chris Corollo and Brian Sharp of Ion Storm working on their game Wrath. Bottom: 2002 Indie Game Jammers, left to right: Austin Grossman, Robin Walker, Art Min, Brian Jacobson, Chris Hecker, Sean Barrett, Zack Simpson, Ken Demarest, Jonathan Blow, Doug Church, Brian Sharp, and Chris Corollo. Photos by Justin Hall.

but also at the minute-to-minute and hour-to-hour levels. This means that not only can you walk left or right interactively, but your decisions impact the overall flow of the game." Deeper interactions require richer simulations; Hecker gets excited about physics, the system of game rules determining interactions between physical objects in games. Do you want to stack those crates over there against the door to keep the bad guy from following you into this room to eat you alive? As Hecker points out, most games today won't allow that kind of strategy. Crates are for climbing on or smashing up only.

In March 2003, the second Indie Game Jam replaced 100,000 sprites with one main actor—the human body. The usually crowded Indie Game Jam headquarters was packed with projectors and webcams taped to the tops of halogen lamps and hanging off other hazardous supports. Building on Zack Simpson's Shadow Garden engine, 14 programmers had one weekend to design games that used the shadow of a human body cast on a wall as an interface for electronic entertainment. Casey Muratori and Michael Sweet created Owl Simulator, where a player's outstretched arms controlled their flight path. In Atman Binstock's Squisy Marshmallow Maze, two players struggle to move their colored block through a maze, using their shadow to block the progress of the other player. Squisy Marshmallow Maze games typically devolved into wrestling matches, a kind of physicality mostly unseen in video games until the advent of the Nintendo Wii, years later.

Programmer/designer Doug Church explains in an e-mail, "The game industry has always been about smoke and mirrors, and making the correct tradeoffs. So even little baby steps and experiments which seem silly now may lead to some real and unexpected successes later." Now that game development schedules have extended out beyond 18 months, it can be difficult to work through a few different game design concepts. The format of the Indie Game Jam weekend codefest is a good uninhibitor; as Doug explains, "Given a lack of research money and time, Game Jam-like 'no-time-to-think-just-type-and-see-what-happens' sort of events may help provide some of the ideas which eventually help us make progress."

IGJ co-organizer Sean Barrett is a refugee from the commercial game industry. Since leaving Looking Glass Studios in 2000, Barrett works independently to make software that goes beyond "people doing simple games and high-end graphics." Barrett has been integrating personality and conflicting priorities in a hovercraft game he's programming: "Your squadmates have personal agendas (derived from their allegiances to various political and religious groups) and become satisfied or unsatisfied with you based on whether you cooperate with those agendas in game." Choosing which objects to blow up might not seem like much of a step toward richer interaction, but any in-game motivation other than scoring and linear progress is remarkable. As Barrett points out about game making, "We do violent conflict great, but we don't do any other kind of conflict, especially interpersonal relationship sorts of conflict, at all."

In 2005, the fourth Indie Game Jam used an engine with human models from The Sims to make games about human interaction. By then, Indie Game Jam contributors included people drawn from other disciplines beyond programming: art, sound design, game theory, and education. And now Indie Game Jams were occurring elsewhere. In Lithuania in 2002, a group of young programmer/designers got together in a room, made games on a short deadline, and released them free online, using the first Indie Game Jam engine. Soon Toronto, Dallas, Boston, Ohio, and Nordic Game Jam groups launched, listing themselves on the Indie Game Jam page on Wikipedia.

Within years, schools, companies, and developer groups around the world were spending occasional weekends to hack at electronic play: professional and amateur programmers alike unleashed by a weekend of fast prototyping in a shared, supportive atmosphere. As commercial game industry budgets grow to accommodate ambitious graphics and rigid licenses, these kinds of development experiments give people a chance to poke at new ideas. Some rather mainstream developers are finding happiness in smaller, informal collaborations, some of which even evolve into commercial titles sold as PC or console downloads.

A weekend-long Indie Game Jam is usually not enough time to develop deep, engrossing games. Most of the participating programmers must leave happy fun prototyping land for their day jobs, and participating designers might not have the technical skills, tools, or time to accommodate big visions. For people who spend their days working on large, slow-moving entertainment software, an Indie Game Jam gives them a compressed freedom where personal inclination and a sense of playful experimentation direct game design more than market concerns.

On the last day of the first Indie Game Jam, most of the games had been finished and many of the programmers had headed home. Sean Barrett stood over Chris Hecker's shoulder as Hecker's dirty glasses reflected tens of thousands of tiny figures being mowed down by a single warrior on-screen. As Hecker handily killed with mouse and keyboard, the camera panned out slowly until his character was shown to be surrounded by an impossible sea of enemies. There was clearly no way he could survive. The artful futility of Barrett's Very Serious RoboDOOM put a wide grin on Hecker's face.

Each Indie Game Jam begins to explain how games can meet broader social needs: beyond athlete, gangster, and space marine power fantasies. Beyond our current vocabulary of "first person shooter" and "real time strategy." Past "attack" and "jump," where "manipulate" and "convince" are possible game verbs. Where learning to make your own rough draft games is part of being an active player.

More information about the Indie Game Jam can be found online at www.indiegamejam.com and on Wikipedia at en.wikipedia.org/wiki/Indie_Game_Jam.

About the Author

Justin Hall participates in digital culture and electronic entertainment. Present at the birth of the popular Web, Hall invested his mortal soul in the exchange of personal information online. Later consumed by machine stimulation, Hall set out to study video games to better understand his lifelong computer babysitters. He finished his MFA in interactive media at the University of Southern California in 2007. From there Hall went on to work with the team at GameLayers Corporation as CEO as they fashioned ongoing electronic play out of daily life through "Passively Multiplayer Online Games."

Exercise 14.4: Fleshing out Your Design Document

Flesh out your design document using your table of contents, flowchart, wireframes, and the documentation you created while designing your prototype, such as your concept document, rules, etc. Work with your team members to complete each section as described earlier.

Writing the design document will help you clarify the details of your design. When the document is written, it is used to manage team members from both the publisher and the developer. The core concept as detailed by the design document will be approved by the publisher before the team moves into production. Then the document will evolve as the project progresses.

CONCLUSION

In this chapter, you have learned how to take your original game concept from the prototype to a full design document or design wiki. You have created detailed flowcharts and wireframes for every area of your game. You have worked with your team, if you have one, to flesh out both the technical and creative tasks that will need to be accomplished to make your game a reality.

Writing and updating your design document is a monumental and sometimes tedious responsibility. The design document can be a useful tool or a millstone around the designer's neck. Always remember that the purpose of your design document is communication and articulation. A designer huddled in a cubicle writing in isolation for weeks on end will produce a document that is far less valuable than a designer who engages the team, includes them in the process, and works with them to build out each section.

By working with the team, a designer will not only wind up with a better design document but will also help focus the team on the project at hand. This is how living design documents are created, and when you have a living document in which everyone is an acting coauthor, it becomes a force in and of itself, which serves to unite the team and give them a common platform from which to understand the game as it evolves.

Designer Perspective: Chris Taylor

CEO and Founder, Gas Powered Games

Chris Taylor is a game designer and entrepreneur whose credits include Hardball II (1989), Test Drive II (1989), 4D Boxing (1991), Total Annihilation (1997), The Core Contingency (1998), Triple Play Baseball (2001), Dungeon Siege (2002), Total Annihilation: Dungeon Siege II (2005), and Supreme Commander (2007).

On getting into the game industry:

I started in the business by answering a small classified ad in the newspaper. I started as a programmer at a game developer in Burnaby, British Columbia, Canada, called Distinctive Software. My first assignment was to do Hardball II. It was a sequel to the hugely successful Hardball by Bob Whitehead, and it was a great learning experience. I worked almost every single day for the 18 months it took to develop the game.

On favorite games:

This list changes over time, but some of them include Populous, Duke Nukem 3D, the original Command & Conquer, Ratchet & Clank, and now Battlefield: 1942. I like these particular games because they grabbed me and gave me a fresh new experience. I really don't enjoy games that retread old ideas. I like spending my time experiencing something new!

On game influences:

The most inspirational games are the early Sid Meier and Peter Molyneux games, and then without a doubt Dune II and Command & Conquer from Westwood Studios. Without Command & Conquer, I would never have left EA to create Total Annihilation. Recently I have been inspired by games like Harvest Moon on the GameCube. These games remind me that it's not about technology, it's really about great game design.

On the design process:

I'm pretty random, and I get my inspiration from everything around me. Lately I have been playing games on handheld systems and GameCube. My latest ideas are specifically targeting story and characters as central themes because this is what makes TV, film, and books successful. I have started to really lean

away from technology and really asked myself a tougher set of questions regarding gameplay and what precisely the market wants. More than ever I aspire to make games for everyone, not just hard-core gamers.

On prototyping:

We do something we call a visual slice. A visual slice (sometimes also called a vertical slice when it includes gameplay as well as visuals) is developed to communicate the overall visual aesthetic for a game. It's what sales, marketing, and publishing executives look at to get excited about what the game will look like when it is done, and to a lesser extent, how the game might actually play.

On solving design problems:

A great example of a difficult design problem that we solved was on our upcoming game, Space Siege. We wanted to make the game playable by a large audience, but we still wanted to make the game challenging for expert players. We came up with a concept that made it more difficult to play if the player wanted to keep their "humanity" intact, but if they allowed cybernetic upgrades, they would have an easier time of it. This was a perfect way to blend story and gameplay *and* difficulty into one seamless solution. If you play through the game and win but become a horrific machine in the process, you can always play again, this time with the goal of keeping your humanity. It has the added benefit of being a scoring system as well. It was awesome the way it all came together.

On writing design documents:

Each time I have sat down to write a game design, the approach is usually evolved from the last one. When creating a new design, I describe the high level stuff at the start of the document and then cover the details later. One of the key things I do right up front is to answer the ten most difficult and jaded questions that someone who challenges my design might ask. Like I have always said, if I can't answer these questions, it's a good time to reconsider why making the game is a good idea in the first place.

Advice to designers:

My advice would be to get a job in the business at any level to get your foot in the door. When you see how games are really made, you will change your strategy and get your game made much sooner, even though it could take you 10 years to learn the business. Read every book you can find and play every game you can get your hands on. Pick your role models and look carefully at how they find success.

DESIGNER PERSPECTIVE: TROY DUNNIWAY

Creative Producer, Brash Entertainment

Oddworld: Munch's Oddysee (2001), Bruce Lee: Quest for the Dragon (2002), Command & Conquer: Generals Zero Hour (2003), Impossible Creatures (2003), Tao Feng: Fist of the Lotus (2003), Voodoo Vince (2003), Age of Empires 3 (2005), Ratchet Deadlocked (2005), Rainbow Six Vegas (2006), Star Wars: Empires at War (2006), Command & Conquer 3: Tiberium Wars (2007), Ratchet & Clank Future: Tools of Destruction (2007), and Troy Dunniway is a game designer and producer with numerous credits, including TNA Impact Wrestling (2008).

On getting into the game industry:

I started off working in the film industry doing effects work on movies. I eventually began doing art for games and eventually joined a small game developer in Northern California full time around 15 years ago. I was hired as the lead animator, but I quickly began doing design work on games. Every year I did more and more design work and less art. I eventually moved over to Microsoft as a lead designer and first party action and strategy design director. I have since worked at Westwood Studios, EA Los Angeles, UBISOFT, Insomniac Games, and Midway Los Angeles on a wide variety of very successful titles.

On game influences:

Every game I work on has a different set of games that inspire me. I grew up owning and playing practically every game that came out, so it's hard to say which of those had the most influence on me. Early on professionally, games like WarCraft, Ultima, Command & Conquer, and System Shock had a lot of influence on me. I liked games that showed me that it was possible to play a game, have a story, and be able to think through them instead of just fight or jump your way through them. I've always been more into role-playing and strategy games than anything else, even though I play most action games on the PC and consoles. I like games that push the limits, allow players to find their own paths, and have fun doing it. I get tired of games with little to no innovation or originality.

On designing Rainbow Six:

When I worked on Rainbow Six Vegas, we were tasked with innovating a very successful series and taking it to the next level. We already knew what the core game experience in general was going to be, so this let us focus on what could be new and innovative and simplified our lives tremendously during the concept phase. However, because it was a successful franchise, we also had to constantly weigh each change and addition to the series to make sure it was something that was ultimately right for the franchise. This let us start with the core mechanics of the previous Rainbow Six games and build on them instead of having to come up with everything from scratch.

On designing new concepts:

When coming up with a whole new game, you will face many possible challenges. If the game is taking place in a new world, with new characters, then you might have to spend a lot of time early on figuring out where the game is taking place because this could drastically affect everything in the game. If you're also planning on coming up with highly innovative gameplay, this can also dramatically affect the way you build the game and the prototype.

The challenge with totally new game concepts is that you have to figure almost everything out. It's also just as hard for designers to take an existing game and try to expand it. Whether you are trying to brainstorm new ideas for locations, stories, characters, or gameplay, it is tough to know where to look for inspiration. Many designers just look at and imitate the competition, but I find that this only occasionally helps because if the feature or idea is in a game that is already out, then the idea might already be old or cliché. So I tend to pull my new ideas from a lot of sources, including movies, TV, board games, books, and especially pen and paper RPGs like GURPS. I have huge collections of RPG books that help me brainstorm a wide variety of ideas when I get stuck. But, in the end, there is no substitution for just having a great team with a lively imagination.

Many games are also started to leverage a particular set of technology, which will also affect all of the early design decisions. If you have licensed Unreal 3, this will limit you in some ways but also help you stay focused. Many games have been done because a company had some great technology, which allowed them to make a game. This technology, like the water that was used in Bloodwake, drives the entire design of the game and dictates what it will ultimately become.

On prototyping in general:

Building a prototype is absolutely critical. The only time you absolutely don't have to is if you're building a sequel using the same engine, and even then I still recommend it. There are many different ways to approach building a prototype. Your goal should be to evaluate risks, prove technology, and prove what will be fun. The trouble is that every publisher has a different set of expectations of what they expect from a prototype, and it is important that you ask or understand what the expectations of the prototype are before you begin working on it.

The main thing you have to understand is if you can focus on just a gameplay prototype or if you have to build a technology prototype or an art prototype. At some publishers you are required to prove all three things at the same time, while some publishers realize that it is impossible to include all three aspects into one playable version. So, before you begin, you must clearly understand what the requirements for your prototype are going to be.

On prototyping gameplay:

Coming from a long game design background, I believe that it is critical for you to build a gameplay prototype. You must show what is fun in your game. It's not enough to just write about what is fun; you must prove that the game will be fun to play. Every game that I have worked on has had a different type of prototype that has been built to fit the need of that particular project. I believe in trying to prototype the most risky

features as well as the unique features of the game that will really set it apart. Sometimes this is by far the riskiest thing to do, but then this is exactly the point.

The gameplay prototype doesn't have to look pretty, but it has to be fun. I've built 2D overhead maps that show a bunch of different colored triangles moving around on the screen to prove how well characters will react to the environment, move together as a team, respond to stimuli, and stuff like that. When it is all said and done, the code responsible for this can still drive a 3D world.

On multiple prototypes:

Something else I like to do is build multiple smaller prototypes to prove out a variety of different gameplay issues instead of trying to always have to lump it all into one large prototype. You might have a basic prototype to prove out basic control mechanics, like running, jumping, etc., then have another to prove AI, and another to prove out other things like driving cars, fighting, etc. You must still demonstrate how all of these will work together, but having a variety of small prototypes can often allow a bunch of different team members to each focus on a different aspect of the game.

Along with the gameplay prototype, I also like to have some of the art team, along with possibly some additional design or programming help, build a visual prototype that accurately demonstrates what a portion of the game will visually look like. It is important that they utilize the correct technical limitations, even if the prototype will just ultimately be a rendered movie and not played in the game engine itself. Another reason that I like to separate the game prototype from the visual prototype is that it allows the gameplay to hopefully run at the correct frame rate early on, and it won't cause the art to be compromised.

At the beginning of Ratchet & Clank Future: Tools of Destruction for the PS3, we wanted to show how much better the world would look on the PS3 versus the PS2, so our first prototype was just an animated flythrough of the city, which was used in the first Ratchet & Clank game. Because the gameplay wasn't going to change a tremendous amount, the first video was really important to just show how much visually the world would change from the first four games. This video was also used to wow the executives at Sony and help us kick off the project officially. Other smaller prototypes were also built to show how new weapons would function and stuff like that.

On facing design challenges:

Every game has a different set of challenges. Most challenges come because of time constraints more than anything. Almost any problem can be solved with enough time and resources. The question is what you do when faced with a limited amount of time and have a fundamental problem you need to solve that will affect the entire game. When designing Munch's Oddysee we expected a lot of additional features to be completed for the final game, but then suddenly we realized that we didn't have time to finish them.

For example, the main character, Munch, was originally supposed to be able to transform into a giant creature, like the Incredible Hulk, and then be able to fight, instead of being unable to attack anyone and really just being an antihero. Munch was also a fish and was supposed to spend most of his time in the water, but we never got any additional gameplay working properly in the water, except for Munch's ability to swim in it. There were no enemies in the water, and not very much could even hurt you in the water.

As a result of these two issues, and many others, we actually had to throw out most of the levels in the game and rebuild them all to make the game fun and interesting. This was an extremely risky decision because we only had a few months remaining until we had to ship the game, but it proved to be the right choice in the end.

Advice to designers:

To be a great designer, you have to be a great student. Never stop learning, studying, thinking, or rethinking what you are doing. You have to be motivated and willing to work hard to succeed. Learn from the good and bad lessons that other designers make. Look outside of games for inspiration, learning, and help. Always ask, "Why?" Don't design games for yourself, and leave your ego at home.

FURTHER READING

Freeman, Tzvi. "Creating a Great Design Document," Gamasutra.com, September 12, 1997. http://www.gamasutra.com/features/19970912/design_doc.htm.

Ryan, Tim. "The Anatomy of a Design Document: Documentation Guidelines for the Game Concept and Proposal," Gamasutra.com, October 19, 1999. http://www.gamasutra.com/features/19991019/ryan_01.htm.

Sloper, Tom. "Sample Outline for a Game Design," Sloperama.com, August 11, 2007. http://www.sloperama.com/advice/specs.htm.

Chapter 15

Understanding the Game Industry

Unless you are a producer or an executive, you might never even see the contract or terms under which your game is produced. You might not feel the need to understand the royalty structure of the agreement or the rights assignments for the characters you create. You might want to ignore all the lengthy contract language and business mumbo jumbo and stay focused on what you love—designing games. But if you are going to be a smart, effective, and successful game designer, you might want to think again before dismissing the business side of things so quickly.

Understanding the basic structure of the game industry—the players, the market, and how business deals are structured between publishers and developers—is knowledge that can make you a better designer, especially in a commercial sense. This chapter provides a basic overview of how the game industry works and how deals are structured to produce and publish games. It is not a comprehensive explanation, but it will give you enough understanding to participate intelligently in the deal-making process for your game if you are invited to do so. Even if you are not part of that process, this information will help you to understand the concerns of, and communicate more clearly with, the executives and marketing people who are working on your game.

Our advice to all game designers is to embrace business knowledge in the same way you would embrace technical knowledge. You might not specialize in either, but understanding how the business aspects of the industry work, and how they affect your designs, will help you to be a more effective creative person and a more valuable resource on the team.

THE SIZE OF THE GAME INDUSTRY

The game industry brought in around $43 billion dollars in 2007 worldwide including hardware and software. In the United States, annual revenues are about $12.5 billion, which is bigger that the United States domestic box office revenues from the film industry. Because of this, many people refer to games as "bigger than movies" these days. This is not precisely true—movies make most of their money today on DVD sales, as well as rights for broadcast, cable, and foreign distribution. The $12.5 billion number for games revenue includes $5 billion for hardware sales. Software sales alone, which are a more equivalent comparison to box office revenues, bring in about $7.5 billion annually. This number is growing consistently and is expected to be at $10 billion by 2010. While games are large and growing, they still have a ways to go before they truly surpass the film industry in terms of domestic revenue.

It might not take long before the games industry bridges this gap, however, because the

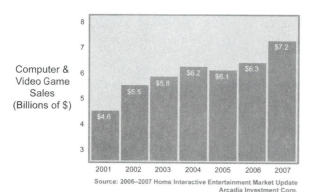

Source: 2006–2007 Home Interactive Entertainment Market Update
Arcadia Investment Corp.

15.1 Video game sales growth

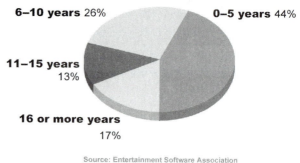

Source: Entertainment Software Association

15.2 How long have most gamers been playing games?

industry has remained strong, even in the face of recession, and has grown steadily over the past decade. Figure 15.1 shows the growth of video game sales (PC and console) in the United States since 2001.

Digital games have become a significant form of entertainment since their introduction in the 1970s. Today, more than 60% of all Americans, or about 145 million people, play games on a regular basis.[1] The split between men and women players is closing as well, with women comprising 40% of gamers. Women comprise 44% of the 45–54 demographic, and women actually outnumber men in the 25–34 demographic, mostly due to the popularity of casual and online world games. As several generations of players have grown up with digital games, most have continued to play as they grow older: 40% of PC gamers are over the age of 36, and 26% are between 18 and 35. The majority of game players have been playing

for more than six years. Figure 15.2 shows that gaming is a phenomenon that people tend to continue once they've begun.

According to Entertainment Software Association President Doug Lowenstein, "Video games have become a leading form of mass market entertainment as the core user has aged from the teens into adulthood, and millions more casual gamers join the hard-core gamers to drive market growth and expansion."[2] All of these statements point to the fact that digital games are no longer a niche market. They are making the transition from being a pastime to becoming an integral part of the entertainment industry. This phenomenon is not limited to the United States. The game industry is growing worldwide. The United States might be the single largest market, but countries like Japan, the United Kingdom, Canada, and France are also known for their game industries and high-quality products.

Platforms for Distribution

One way to define the basic segments of the game industry is by the platforms for which games are distributed. Consoles dominate the sales of the industry by far, garnering roughly two thirds of overall video game sales.

Console

Within the console market, there are multiple competitors. Historically, the console market has

always been dominated by one or two players, with cutthroat competition and technological advances meaning new platform releases every three to five years. The console machines of today have astounding processing power and graphics capabilities. This enables designers to create dramatic experiences with production values rivaling television and film. Here's a breakdown of today's top console platforms.

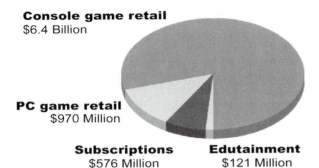

Console game retail
$6.4 Billion

PC game retail
$970 Million

Subscriptions
$576 Million

Edutainment
$121 Million

Source: 2006–2007 Home Interactive Entertainment Market Update
Arcadia Investment Corp.

15.3 Console game sales versus computer game sales

Microsoft Xbox 360

As of 2007 the Xbox 360 had the largest install base of the next generation consoles. As of August 2007, Microsoft had sold over 11.6 million Xbox 360 consoles worldwide. Microsoft projects the Xbox 360 installed base will grow to between 13 and 15 million consoles by June 2008. Its large slate of exclusive titles, such as Halo 3, and its solid developer tools make the Xbox 360 a formidable competitor for the foreseeable future.

Nintendo Wii

Nintendo surprised the world with the runaway success of its innovative Nintendo Wii console. Nintendo designed the console with the belief that to grow the game market, it needed to appeal to a broader demographic. The wireless motion-sensitive controllers stressed more player interaction and captured the world's imagination. The console was the must-have item of the Christmas 2006 season. As of August 2007, sales exceeded nine million units worldwide.

Sony PlayStation 3

The PlayStation 3 debuted in November 2006 to great fanfare. Sales of the $600 machine, however, were much lower than expected after launch due to a combination of two factors: lack of games and a high price point. The console is strategically important to Sony as a corporation because it represents a gaming platform, a Blu-ray DVD player, and a Sony Internet connected device in the living room. The company has announced both price cuts and the release of over 300 games to compete with its rivals in the console business: Microsoft and Nintendo. The PlayStation 2 deserves mention because, as the winner of the war in the previous generation of consoles, it has an install base of over 120 million worldwide. This makes the PlayStation 2 a viable release platform for years to come.

Computer (PC and Mac)

The computer game market is much smaller than the console game market, and it is divided by games created for the two dominant operating systems. Computer game players tend to be older than console game players, and they are more evenly divided between male and female.

GENRES OF GAMEPLAY

In addition to platforms, another way of looking at the game industry is in terms of game genres. You have probably noticed by now that we did not emphasize the concept of genre in any of our discussions about design. This is because we believe genres are a mixed blessing to a game designer.

On one hand, genres give designers and publishers a common language for describing styles of play. They form a shorthand for understanding what market a game is intended for, what platforms the game will be best suited to, who should be developing a particular title, etc. On the other hand, genres also tend to restrict the creative process and lead designers toward tried and true gameplay solutions. We encourage you to consider genre when thinking about your projects from a business perspective but not to allow it to stifle your imagination during the design process.

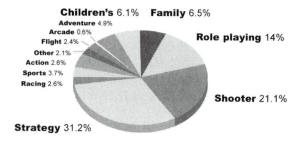

Computer Game Sales by Genre

Video Game Sales by Genre

Source: 2006–2007 Home Interactive Entertainment Market Update
Arcadia Investment Corp.

15.4 Top-selling genres in 2007

That said, genre is a big part of today's game industry, and as a designer, it is important for you to understand the role it plays. The top-selling genres differ between platforms and between market segments. When publishers look at your game, they want to know where it falls in current buying trends of the gaming audience. Without the benefit of genre, this would be a difficult task.

Although we do not want you to inhibit your design process by too great an emphasis on genre, designers can learn something from the publishers' emphasis on creating products for players who enjoy specific types of gameplay. To better understand today's top-selling genres, we have briefly listed their key differentiators.

Action Games

Action games emphasize reaction time and hand–eye coordination. Action games can include titles as disparate as Battlefield 2, Grand Theft Auto IV, and Tetris. Action as a genre often overlaps with other genres; for example, Grand Theft Auto IV is an action game, but it is also a driving/racing game and an adventure game. Tetris is an action game and a puzzle game. Super Mario Galaxy is an action adventure game, and Final Fantasy XII is considered to be a role-playing action game. Action games are, without exception, real time experiences, with an emphasis on time constraints for performing physical tasks.

Strategy Games

Strategy games focus on tactics and planning as well as the management of units and resources. The themes tend to revolve around conquest, exploration, and trade. Included in this genre are Civilization IV, Gary Grigsby's World at War, and Risk. Originally, most strategy games drew upon classic strategy board games and adopted turn-based systems, giving players ample time to make decisions; however, the popularity in the 1990s of WarCraft and Command & Conquer changed this, ushering in the subgenre of real time strategy games. Today there are action/strategy games, which combine physical dexterity with strategic decision making. Medieval II: Total War is an example that fits into this hybrid genre.

Role-Playing Games

Role-playing games revolve around creating and growing characters. They tend to include rich story lines that are tied into quests. The paper-based system of Dungeons & Dragons is the grandfather of this genre, which has inspired such digital games as Baldur's Gate, Dungeon Siege, World of Warcraft, and the pioneering NetHack. Role-playing games begin and end with the character. Players typically seek to develop their characters while managing inventory, exploring worlds, and accumulating wealth, status, and experience. As with all genre discussions, there are hybrids. For example, games like Jade Empire and Kingdom Hearts II are typically called "action role-playing games."

Massively multiplayer online role-playing games, or MMORPGs, are a major development in this genre of gameplay that have had a great influence on the business of games. The subscription market for games like World of Warcraft is over $1 billion dollars a year in North America and Europe, and it is still growing.[3] The design for this genre of games requires a deep understanding of social play and game economies in addition to classic role-playing mechanics.

Sports Games

Sports games are simulations of sports like tennis, football, baseball, soccer, etc. Since the success of Pong, simulations of sports have always made up a strong segment of the digital game market. Some of the most popular sports games today are Madden NFL, FIFA Soccer, NBA Jam, as well as Sega Bass Fishing and Tony Hawk's Pro Skater. Most sports titles rely on real-world games for their rules and aesthetics, but increasingly, there is a new breed of sports titles that take more creative liberty, like Def Jam Vendetta, which combines hip-hop celebrities, wrestling, and fighting. Many sports games involve team play, season play, tournament modes, and other modes that mimic sporting conventions.

Racing/Driving Games

Racing/driving games come in two flavors: arcade style, with game series like Mario Kart and Burnout; and racing simulators, with games like NASCAR 07, F1 Career Challenge, and Monaco Grand Prix Racing Simulation. The arcade style appeals to a broader audience overall, whereas the simulations go into more depth and tend to appeal more to enthusiasts. One thing that all of these games have in common is that you are racing and you are in control.

Simulation/Building Games

Simulation/building games tend to focus on resource management combined with building something, whether it is a company or a city. Unlike strategy games, which generally focus on conquest, these games are all about growth. Many simulation/building games mimic

real-world systems and give the player the chance to manage her own virtual business, country, or city. Examples include: The Sims 2, SimCity, RollerCoaster Tycoon, and Gazillionaire. One of the key aspects of simulation games is the focus on economy and systems of trade and commerce. Players tend to be given limited resources to build and manage the simulation. Choices must then be made carefully because an overemphasis on developing one part of the simulation results in the failure of the entire system.

Flight and Other Simulations

Simulations are action games that tend to be based on real-life activities, like flying an airplane, driving a tank, or operating a spacecraft. Flight simulators are the best example. These are complex simulators that try to approximate the real-life experience of flying an aircraft. These cannot be put squarely in the action camp because they are not focused on twitch play and hand-eye coordination, but instead they require the player to master realistic and often complex controls and instrumentation. Good examples include Microsoft Flight Simulator, X-Plane, and Jane's USAF. These types of simulations usually appeal to airplane and military buffs who want as realistic an experience as possible.

Adventure Games

Adventure games emphasize exploration, collection, and puzzle solving. The player generally plays the part of a character on a quest or mission of some kind. Early adventure games were designed using only text, their rich descriptions taking the place of today's graphics. Early examples include the text-driven Adventure and Zork, as well as graphic adventures like Myst. Today's adventure games are often combined with elements of action, such as the Jak and Daxter series. Shigeru Miyamoto, the creator of the Zelda series of adventure games, summed up the nature of the adventure game in his comment that "the state of mind of a kid when he enters a cave alone must be realized in the game. Going in, he must feel the cold air around him. He must discover a branch off to one side and decide whether to explore it or not. Sometimes he loses his way."[4] Although characters

ALTERNATIVES: GAMES FOR GIRLS AND WOMEN

by Sheri Graner Ray, Women in Games International, Senior Game Designer/Author

Today, mention the concept of "girls' games" and you find yourself in the middle of an emotionally charged debate on the value, or lack thereof, of "pink games." But how did this happen? How did an industry that is populated with such smart and creative people fall into the trap of such stereotypical thinking? And then, based on this thinking, summarily dismiss an entire market?

It all started in the early 1990s when American Laser Games' VP of Marketing, Patricia Flannigan, noticed that her daughters weren't interested in the games her company was producing. She saw how much disposable income they had and realized that if they could capture that market, it would be amazingly lucrative. So she went to the Albuquerque Independent School District and enlisted their aid in helping her research this market. Through the school district she distributed surveys, conducted interviews, and held play study groups. Then using this information she set out to design a game that girls would want to play.

The title this produced was McKenzie & Co., a full motion video (FMV) game that was dubbed a "Social Adventure" by the American Laser Games marketing department. It was a story-based game that involved getting through your junior year in high school with a group of your friends. The player "attended class," which consisted of playing themed minigames, and made social choices that pitted popularity and friends against social and personal responsibility. At the same time, the player tried to impress the boy of her choice and get him to ask her to the prom. It was one of the first games to involve commercial product placement and explored marketing opportunities outside the traditional game channels.

As the work on McKenzie & Co. progressed, the developers took it out to all the major publishers. They included their demographics, play studies, and prototypes. Every single publisher turned it down and all for the same reason, "girls don't play games."

Undaunted, the developers decided to self-publish the title. It went on to sell over 80,000 units during its lifetime. This was during a time in the industry when a product selling 100,000 units was considered a "blockbuster." Armed with this success, the developers at American Laser Games went back to the publishers with their next girls' game idea but found even a harder time getting in to talk to them. The publishers still held that girls don't play games.

Fortunately, at the same time there were three other companies just about to release games for girls as well. One year after McKenzie & Co was released, Mattel released Barbie Fashion Designer. At about that same time Purple Moon released the first of their Rockett titles, and Girl Games in Austin released Let's Talk About Me.

All of these titles had good success, but Barbie Fashion Designer sold amazingly well, moving 600,000 units in the first year. This was unheard of in the game industry and got the attention of the major publishers. They all changed their tune from "girls don't play games" to "how do we make games for girls?"

Unfortunately, rather than doing what Purple Moon, Mattel, Girl Games, and Her Interactive did, which was research what their specific market wanted, they looked at the most successful of the group, Barbie

Fashion Designer, and said, *"Get me that market!"* With that they were off and running, each trying to produce a Barbie-like game as fast as they could.

Soon the Barbie clones were flooding the market, and that niche quickly became saturated. Add to that the fact that only Barbie can be Barbie, and everything else paled in comparison. In short, the Barbie clones didn't do well. The lower-than-expected sales prompted studios to lower production costs even further, and sales continued to fail to meet the expectations set by Mattel. At one point this author was sitting in the office of a prominent publisher as he proudly talked about finalizing a million-dollar deal for a traditional title but, when he turned to the subject of making a girls' game, he said, "So, what can you do for me for under 100K?"

The continued decrease in production value, the flagrant attempt to imitate Barbie, and the ubiquitous use of pink in the packaging resulted in the derogatory name of "pink games."

Within the next three years, Purple Moon closed its doors, Girl Games moved their business strategy away from games and changed their name, and American Laser Games (Her Interactive's parent company) went through bankruptcy but spun off Her Interactive. Of these groups, only Her Interactive survives today in the same market space in which it began. All of this, combined with the lackluster sales of the Barbie clones, caused the industry to immediately declare, "See? We *told* you girls didn't play games!" and retreat from the idea of any games that targeted females of any type.

So on one hand Barbie helped the girls' game industry by opening the door to the idea that girls actually do play games. On the other hand, it also irrevocably hurt the concept because the industry redefined the entire broad and diverse female *market* into one single, small, *genre* of "fashion, shopping, and makeup for girls ages 6–10;" hence, pink poison.

Unfortunately, this definition continues to exist. The industry still flinches at the concept of girls' games. They do not see it as a potential market, rather they see it as a single genre, like "flight sims" or "god games." This is, of course, a terrible disservice to the market that not only rightly deserves its own specifically targeted entertainment, but it is lucrative and *wants* to play!

For the short term, developers who are interested in developing for the female market will have to accept that a girls' title cannot be pitched without the specter of "pink games" hanging over it. They might find it easier to target the "casual games" market because most studies report that the audience for those titles range from 60–70% female.

At this point, it is important to understand that this *does not* mean that girls and women shouldn't have computer entertainment/games developed specifically for them. In fact, this author would strongly support anyone who wants to target titles to that audience! The female market is a strong, viable market and has many facets that are prime candidates for computer entertainment development.

However, developing for that market means more than putting games into a pink box. It means make no guesses or assumptions about what the audience wants. Get out and do the research. Find out what they do in their spare time, what they are playing now, and what they like and don't like in computer entertainment. It is only when they have the answers to these and other questions that they can begin to develop a title tailor-made for their audience.

Ultimately, today's female audience is more technically savvy and discerning than the generation originally being developed for in the early 1990s. They won't settle for something that isn't exactly what they want to play.

What is important in all cases, regardless of genre, is for developers to decide *before* they begin development who *exactly* their market is and then to do the research to find out what that market wants. And if they are targeting a female market, they need to get past the idea that games for females has to be fashion, shopping, and makeup for girls ages 6–10 and wrapped in a pink box!

About the Author

Sheri Graner Ray is author of the book Gender Inclusive Game Design: Expanding the Market. *She has served as the cochair for the Women in Game Development SIG of the IGDA for 4 years and has been a spokesperson for female game players for many years. In 2004 she was the chair of the Women's Game Conference, the first game conference to specifically address the issues of women and games that was held in the United States. Sheri has served as a design consultant to Cartoon Network and as Senior Game Designer with Sony Online Entertainment. Before coming to Sony, she served as President of her own studio, Sirenia Software, and before that as Director of Product Development for Her Interactive, where she began her research into females and computer games. She has also worked for Origin Systems as a writer and designer on the Ultima PC series.*

are central in adventure games, unlike role-playing games, they are not a customizable element and do not usually grow in terms of wealth, status, and experience. Some action–adventure games, like Ratchet & Clank, do have the concept of an inventory of items for their characters, but most rely on physical or mental puzzle solving, not improvement and accumulation, for their central gameplay.

Edutainment

Edutainment combines learning with fun. The goal is to entertain while educating the user. Topics range from reading, writing, and arithmetic to problem solving and how-to games. Most edutainment titles are targeted at kids, but there are some that focus on adults, especially in the areas of acquiring skills and self-improvement. Emerging serious games, which we discussed in Chapter 4 on page 93, often include games that both teach and entertain.

Examples of kids' edutainment software include Putt-Putt Saves the Zoo, Reader Rabbit's Kindergarten, and Curious George Learns Phonics; and for adults, Sierra's Driver's Education, a simulation that teaches you how to drive safely, and Chutes and Lifts, a simple online game that helps foreign speakers to learn and read English.

Children's Games

Children's games are designed specifically for kids between the ages of 2 and 12. These games might have an educational component, but the primary focus is on entertaining. Nintendo is a master at creating these games, though its franchises such as Mario and Donkey Kong are also loved by adults. Other examples include the hit online game ClubPenguin.com and Humongous Entertainment's Freddi Fish series.

Casual Games

Casual games are typified by the fact that they are meant to be enjoyed by everyone: male and female, old and young. This means they eschew twitch play, violence, and complex gameplay in favor of attracting the broadest possible audience. Most of the time these are simple games, like those found on Pogo.com, MSN Games or Yahoo! Games, where you will see everything from Canasta to Gem Drop to Literati. A number of breakout hits in the casual game space, including Bejeweled and Diner Dash, have made it a quickly growing area for innovative game designers. (See a discussion of the sound design for Diner Dash in Michael Sweet's sidebar on audio for games on page 338 and more information on the growing market for

downloadable games in the "Business Opportunities for Independents" sidebar on page 386.)

Casual games often incorporate puzzle elements into their play mechanics. Tetris is probably the most famous casual game ever made, and it is an action puzzle game. Puzzle games might emphasize story, as in Puzzle Quest Challenge of the Warlords, or action, as in Tetris. They might also include elements of strategy, as in Scrabble or solitaire, or construction, as in the famous The Incredible Machine series. Designer

Scott Kim discusses puzzles and puzzle games on page 35.

Exercise 15.1: Your Game's Genre

What genre does your original game fit into? Why does it fit this genre? Given this information, what platform should your game be released on, and who is your target audience?

PUBLISHERS

The publishing landscape has changed dramatically over the past decade. Finding a publisher for your console game is more difficult than ever due to the explosion of developers out there. However, there are more avenues than ever for publishing if you include the opportunities afforded by online-only publishers. In a recent report by *Game Developer* magazine, the top 20 publishers were featured and analyzed as to their overall revenue, the number of titles released, the types of games released, and their relationships with developers. Much of the data included in the following list of publishers was gleaned from this survey.[5]

Nintendo

Nintendo is the oldest game publishing company in the business; the company was founded in 1889 as a publisher of "Hanafuda" playing cards in Japan. From the mid-1980s through the 1990s, Nintendo dominated the console business. With new platforms such as the Wii and DS, it has reestablished itself as a major player and one of the most innovative publishers in the business. Key Nintendo franchises include Mario, Zelda, Pokémon, Pikmin, Metroid, and many more.

Electronic Arts

EA, as it is commonly called, is the world's largest independent publisher. By independent, we mean that it is not part of a platform company, like Sony, Microsoft, or Nintendo. EA published just over

100 titles in the 2006 fiscal year. About 60% of these were developed by the company's internal development studios. EA focuses heavily on licenses and sequels, with original titles making up only about 16% of their games. Key titles include Madden NFL, FIFA Soccer, SSX Tricky, Def Jam Vendetta, The Sims, Medal of Honor, and Command & Conquer.

Activision*

Activision has been one of the top publishers in the business since its formation in 1979. The company tends to rely on licensed properties and sequels, with original ideas making up only about 14% of its titles. Like EA, Sony, and Nintendo, Activision focuses mainly on console titles—69% of its releases in the 2002 fiscal year were in that area. Handheld games made up 22% of its titles in that time period, and computer games were just 9%. Activision titles include Return to Castle Wolfenstein, the Tony Hawk series, Spider-Man, as well as Quake III: Arena and X-Men.

Sony Computer Entertainment

Sony focuses on titles for its PlayStation 3 console, for obvious reasons. Sony releases titles in all genres, but action, sports, and racing games together make up about 54% of their output. Historically, Sony has invested heavily in original ideas—about 45% of its games in the year surveyed were new intellectual properties. Franchises from Sony include God of War,

* At the time of this publishing, Activision is in the process of merging with Vivendi Games to form Activision Blizzard.

SOCOM: U.S. Navy Seals, Jak and Daxter, Motorstorm, and Eyetoy.

Take-Two

Take-Two is considered to be one of the top publishers mainly because of the amazing success of its internally produced Grand Theft Auto series. Take-Two titles tend to be in the action and sports genres. Aggressive and original, 41% of the company's titles are new concepts, with 50% being sequels and only 10% licensed properties. In addition to the Grand Theft Auto titles, Take-Two has released Max Payne, Railroad Tycoon II, and Big Bass Fishing.

The other publishers in the top 20 as ranked by *Game Developer* magazine include:

- Ubisoft
- THQ
- Sega Sammy Holdings
- Microsoft Game Studios
- SCi/Eidos
- Square Enix
- Namco Bandai
- Vivendi Games
- Capcom

- Konami
- NCSoft
- Disney Interactive
- Atlus
- Lucasarts
- Midway

As Tristan Donovan from *Game Developer* magazine points out, "Awareness of a publisher's general attitude toward external development, its treatment of other developers, and what genres it concentrates on can be highly valuable when dealing with a publisher."[6] We encourage you to research publishers before approaching them. Knowledge of their products, their business focus, and trends they seem to be a part of can help you present your own game in the context of their goals and plans.

Exercise 15.2: The Right Publisher

Do some research of your own and find a publisher you think would be right for your original game idea. Do not just choose the biggest or the most well-known publisher; find a company that is a match for your game in terms of focus, market, and other games they have published.

DEVELOPERS

There are so many game developers, large and small, that it would be unhelpful to list them all. In general, there are three types of developers: independent studios, wholly owned studios, and partially owned studios. Most developers start out small. Many times, it is a group of friends who have either worked together in the past or perhaps have gone to school together. Like starting a band, starting a development studio is a usually a labor of love.

Many start-up developers never make it past the concept stage. Perhaps they build a demo and shop it around. Only a few very lucky teams actually sign a deal to produce a game. And even fewer wind up producing a hit. Being a game developer is a very risky business.

Many small developers produce one or two games, but they do not have the financial cushion to deal with a dry spell or a spate of unexpected costs. These companies go out of business, but the talent always seems to reemerge at another company under a new name.

Some developers might make a series of successful games for a publisher who decides to invest in them or to buy them outright and make them an internal development group. Whatever the case, every game development company is filled with people who love games, and no matter what their level of success, are trying to find a way to balance managing a business and staying true to their artistic vision while staying alive and in the game.

THE BUSINESS OF GAME PUBLISHING

From a business perspective, designing a game is just one small part of the elaborate process of producing the game. Producing is also a smaller part of the lengthy process for publishing a title. Game publishing involves all the steps needed to get a game from the glimmer of a concept to a polished product that is distributed to the store shelves. This section explains the four key elements of publishing: development, licensing, marketing, and distribution. Game publishers are the primary source of funding in the game industry, so understanding these elements of how they work will help you interact with them more effectively.

Element 1: Development

The basic task of development involves financing a team to create a title and then managing that process so that a high-quality game is delivered on time and within the budget.

Industry Trends

The average cost of game development has risen steadily since the 1980s. Today, it typically costs $13 to $30 million to produce a high end console title, and that number continues to rise. The reason for the increase is simple: Customers expect games to have more media of better quality to utilize the features of newer, better hardware systems. Back in the days of the Sega Genesis, for example, a game cartridge could hold 4 MB of data. A standard DVD, such as those used by the Xbox 360 and PlayStation 2, can hold 4.7 GB. A dual layer Blu-ray disc such as those used by the PlayStation 3 can hold 50 GB. That is over a one million percent increase in capacity since the days of the Sega Genesis. Historically, more capacity equates to greater customer expectations and to more costly production of graphics, sound, music, gameplay, etc.

The range of costs for development of a console title has increased steadily since the first generation game consoles, as shown in Figure 15.5. Today, a title for the Xbox 360 or PlayStation 3 will cost from $13 million to $30 million to produce. However, the launch price for console titles over the same time period has remained steady at about $50. With the cost of development for each title going up and the price of each title remaining static, game publishers have been forced to adopt a "fewer, bigger, better" strategy.

This means that publishers produce fewer titles because the costs are so high, and each title must sell more units. To do this, the production values must be better and the audience appeal broader. This dynamic leads to an extreme hits-driven business, where the top 20 game titles generate 80% of the industry's revenues, while the other hundreds of titles make up the remaining 20%.

This is why, if you are a designer, you might find it difficult to find a publisher for a truly amazing, original design that appeals to only a niche market. While everyone, publishers included, would like to see more diversity in the industry, the economics make this difficult to accomplish. Additionally, publishers do not hesitate to cancel weaker products during the development cycle, saving their money and resources for games that promise to be stronger sellers.

15.5 **Rising cost range of console development**

ALTERNATIVES: UNDERSTANDING THE TABLETOP GAME INDUSTRY: A GUIDE FOR INVENTORS

by Brian Tinsman, Wizards of the Coast

In the board and card game industry—aka the tabletop game industry—game designers are called inventors. Brian Tinsman is a professional game inventor with over 35 published tabletop game products. As lead concept acquisitions representative for Wizards of the Coast, Brian has reviewed hundreds of games submitted for publication and helped many beginning inventors get their first games published.

The following is excerpted from his excellent book, The Game Inventor's Guidebook. It is used here with permission. More information on this subject can be found at www.briantinsman.com.

How New Games Happen

Design

Most tabletop game companies don't have a staff of inventors creating new games. It's usually more cost effective for them to buy or license game designs from independent inventors. Inventors drive the whole creative process. They take the germ of an idea and play around with it until it's a working game. They create a prototype and test it out with lots of players, collect feedback, and make numerous revisions until it's ready to pitch.

Pitching

The designer's next step is to convince a publisher to risk his money getting the game manufactured. Just like movies, books, and music, the game industry is full of people who overestimate their own talent. For that reason publishers have to screen out the hacks. You need to demonstrate you're a legitimate prospect and have some talent before your game reaches the reviewer's desk. Do this by focusing on the company's needs, instead of your needs, when you contact them. For example, instead of saying, "I want to work with you because you have the best distribution for my game," try saying, "I have several designs that I think might fit your upcoming product line. What kinds of games are you most interested in reviewing right now?"

Manufacturing

When a publisher gives the go-ahead to publish a new game, he hands it off to his art department. When the art and graphic design are finished, the rules are edited, and all the final touch-ups are complete, the game goes to production. The production people select what kind of paper and plastic are going to be used for each component and convert the artwork from computer files to films, which are fed into the printing machines at the factory. The presses churn out boxes, boards, and cards, the molds spit out the pieces, and a worker puts them all together and shrink-wraps it. When the entire print run is complete, it goes into a shipping container. Most North American publishers have their manufacturing done in China these days.

Distribution

When the game is on a truck, it needs to get to stores. The very largest publishers can call up the large chain retailers like Toys "R" Us and ask how many copies they want, but what about all the small publishers and small retailers? There are about 4000 game and hobby stores in North America that aren't part of any chain. This is where the distributors come in. Distributors buy games from publishers, store them in a warehouse, mark them up about 50%, and send retailers a catalog from which to order.

Retailing

Tabletop game retailers fall into two major categories: mass market retailers and specialty/hobby shops. Mass market retailers are mostly composed of big department stores like Target, Wal-Mart, and the 800-pound gorilla of the industry, Toys "R" Us. Toys "R" Us alone accounts for 19% of all tabletop game sales in the United States. Hobby shops, on the other hand, are usually small stores privately owned and run by dedicated people who love games (and/or comic books). Online stores are starting to emerge as a third category of game retailers, especially with hobby games, although online volumes don't match the bigger two categories.

Markets for Games

From an inventor's perspective, there are basically four markets (categories) in which to sell games to publishers. They're defined by the type of consumer who buys the games in that market, methods of distribution, and product expectations of the publishers. The categories are mass market, hobby games, American specialty games, and European games.

Mass Market

Mass market games are the most recognizable of all games to most Americans. They're the ones you see on the shelves of Wal-Mart, Toys "R" Us, and K • B Toys. They are mostly made up of family and party games like Pictionary, Taboo, Boggle, and Cranium. Alongside these newcomers are the venerable classics that many of us grew up with, such as Monopoly, Clue, Life, and Scrabble. Most young children's games fall into this category too. Any game on these shelves has some big names to compete with, but new ones do it each year, and the most successful ones become modern classics.

Hobby Games

Hobby games are mostly the domain of males in their teens and 20s who play religiously every week or more. In general these games are extremely complex, and it's not unusual for fans to spend hundreds of dollars a year buying supplements, cards, figurines, or new rulebooks for a single game. Hobby games fall into three major categories: role-playing games, miniatures games, and trading card games.

American Specialty

This is sort of a catchall category for American games that aren't mass market or hobby games. It includes products targeted at a certain segment, such as abstract strategy board games, war games, games with physical game play, and so forth. Generally you should expect small print runs from small publishers, but it's definitely the

easiest category to get started in. There are also a number of games in this category that would be appropriate for the mass market, but for one reason or another haven't gone through that distribution channel.

European

When someone talks about the European game market, they're mostly talking about games published by German companies. The German game market is a big one. In Germany, games are quite a bit more popular as a main-stream entertainment choice when compared to North American tastes. German companies put out dozens and dozens of new games each year, only a small fraction of which ever get translated and make it over to the States. German games in general tend to be much more complex, abstract, and strategic than American games. They also rely more on their gameplay as a selling point, and less on their themes, than American games.

Others

These four markets are by no means the only places you can sell games. If you have a football game and you can get sporting goods stores to carry it, or if you can find some other way to skip traditional game retail out-lets, that can work in your favor. Some companies sell directly to the consumer by mail order. Others sell on eBay or via a Web site. There's also a modest amount of sales to educational distributors and schools. There are innumerable other options for getting your game into the consumers' hands. However, as of yet, none of them have been able to generate sales figures that come close to those of the four traditional markets.

Idea to Store Shelf in Seven Steps

A quick overview of how the whole thing works is as follows:

1. Invent your game. Start with a certain type of consumer in mind. Refine it by getting people who don't know you to play it. They'll discover problems you didn't expect. Solve them.

2. Research publishers. If you already figured out what kind of consumer will play your game, find a publisher with other games aimed at that consumer. These publishers already have good distribution in those markets and will be most receptive to a game like yours. Find out what's missing from their product line by visiting their Web site.

3. Contact your targeted publishers. Ask if they're interested in seeing your game. If not, find out what they'd rather see instead. There are four recommended methods of contact.

 - *Cold call:* Call up and ask the best way to submit a game. Be professional. This works best with smaller game companies.

 - *E-mail inquiry:* E-mail their customer service department with a query letter asking if they would be interested in seeing your game.

 - *Inquire in person at an event:* If you have the chance to attend a game convention or trade show, companies will often have booths with development staff in attendance. Ask how you can submit a game concept. Some of the larger conventions include Gen Con (Indianapolis), Penny Arcade Expo (Seattle), and San Diego ComiCon.

 - *Broker or agent:* You will only need an agent to reach the largest mass market companies, but good agents can often give you valuable, objective feedback on your game. Stay away from the ones that advertise on TV or that don't specialize in games.

- *Not recommended*: Sending a game to the publisher without being asked, showing up in person at the company office, or trying to make an impression with wacky demos or puzzles.

4. If the company is interested in your game, send them a prototype, video demo, or meet with the concept acquisitions representative to give a demonstration.

5. Wait to hear the company's decision (usually about six weeks maximum).

6. If they decline your game, get feedback, continue development, and keep trying until you make a sale. It helps to have multiple games ready to show.

7. If they accept your game, negotiate a contract and help the publisher with development until it's ready to go to print.

Ten Reasons Games Get Rejected

1. Poor gameplay. Lots of submissions aren't fun to play.

2. Unoriginal mechanics. Poor inventors base their game directly on a traditional game or a competitor's game, whether intentionally or unintentionally. While it's fine to use minor elements from other games, it shouldn't feel like something we've all played before.

3. Game is not appropriate for that company. Reviewers see games all the time for categories they just don't publish. Either people don't do their research or are hoping a war game company will change their minds and publish a preschool game.

4. Too focused on theme, not gameplay. Many inventors like the idea of using a certain intellectual property or theme but don't have the time or talent to put together a compelling game. Instead, they take a traditional game like Go Fish, introduce a board, and put pictures of Barbie on it. If a publisher wanted to do a product like that, they wouldn't need an inventor to show them how.

5. Game submitted without required legal forms or with inventor's own legal forms. If the company asks you to sign a disclosure form and you don't, your submission goes right in the trash. Asking them to sign a confidentiality agreement usually has the same effect. It's like stamping "I don't understand the procedure" on the front of your submission.

6. Poor marketing potential. Some games are aimed at a consumer segment that's too narrow. How many people are going to be interested in your subject?

7. Not feasible to produce. New inventors tend to overdesign games with too many rules and too many extraneous components. If your game has lots of pieces or anything that would be complicated to manufacture, ask yourself if it's absolutely necessary.

8. Game depends on an unobtainable license. Sure it would be nice to do a Star Wars-themed board game, but Hasbro has the license locked up for the foreseeable future, and even if it were available, very few publishers could afford the licensing fees. If your game depends on a license, you need to make sure the license is available and affordable before you pitch.

9. Rules unclear or too hard. It's a little-known fact that rules are incredibly tricky to write. If you want to see for yourself, watch someone try to play your game for the first time from your rules while you say absolutely nothing. If a publisher has that much trouble, he's just going to quit. Many games also suffer from having too many rules. What's the most fun part of your game? If a rule doesn't contribute directly to that fun part, consider cutting it.

10. Competes directly with another product in the company. Some people assume that if a company has a hit product, they'll want another one just like it. In fact, the opposite is true if it's aimed at the same consumer segment. A new product is just as likely to pull customers away from their current hit as it is to bring in new players. This is called cannibalization risk.

Three Reasons Games Get Accepted

1. It has a certain magic. Publishers look for games with a "hook"—something about them that just compels you to pick them up. Games like Jenga and Bop It have fascinating parts that just beg you to touch them. Heroscape comes with 30 painted miniature figures and buildable terrain. Pass the Pigs has bouncy little rubber pigs instead of dice. In a bad game, it's called a gimmick. In a good game, it's called magic.

2. It has crossover potential. This means it could get new kinds of players to become interested in the product line. This is one reason why you see so many licensed products. For example, Blizzard and Upper Deck partnered to create the World of Warcraft Trading Card Game. Blizzard hoped that card gamers would cross over to become online gamers, and Upper Deck hoped the product could bring online gamers into card games.

3. The gameplay is extremely good. If the product development staff plays your game and immediately wants to play again, they'll probably find a way to get it on their production schedule.

For this reason, a number of truly innovative independent game designers can be found working on the Internet today. Web games, often produced in Flash or Java, can be produced for far less money, so they present less of a risk in terms of innovative gameplay. Sites such as ManifestoGames.com and Kongregate.com are a good place to see the work of some of these smaller developers and niche games.

Developer Royalties

Typically, publishers pay development costs to a developer as an advance against the royalties generated by the title. A royalty is a percentage of the overall revenue earned by a publisher that is paid to a project participant. The following is a basic explanation how a standard publisher developer deal works.

Base Deal

In most basic development deals, a publisher advances all development costs to the developer in the form of milestone payments. This means that if the budget is $10 million, the publisher pays the developer a percentage of the total after each stage of development: concept, preproduction, production, and testing.

These milestone payments are treated as an advance against future royalties. Typical royalty rates for a developer range from 10% to 18% of a publisher's net sales revenue after deductions. The publisher starts paying royalties after the development costs have been recouped via sales. In our example, this means that the publisher keeps 100% of the revenues generated by a title until the royalties reach $10 million.

After the royalties reach the amount advanced, the publisher shares the revenues with the developer according to the royalty schedule. If the agreed-upon royalty rate was 15%, from this point onward, the publisher would give the developer 15% of the net sales revenues earned and keep 85% for itself. Developers can ask for royalty rates to "step up" when certain sales goals are met. For example, the royalty rate might be 10% until 60,000 units are sold, then 15% until 120,000 units are sold, then 20% until 240,000 units are sold, etc.

First-time developers are a risk for the publisher, so their royalty rates are low. Established developers, who

have proven that they can deliver hits, can negotiate for a higher rate because they represent less risk.

Royalty Calculation

Royalties are calculated on net sales revenue or adjusted gross income, meaning the developer gets paid after the publisher makes deductions, such as: sales tax, duties, shipping, insurance, and returns. This can open the door for creative accounting. A developer is wise to ask that these deductions be narrowly defined and that the publisher not include its overhead costs.

Affiliate Label Deal

In an affiliate label deal, the developer shares in development and marketing costs. This reduces the publisher's risk, and thus the royalty percentages tend to be much higher—typically 65% to 75%.

Element 2: Licensing

There are two basic kinds of licensing in which publishers engage: content licensing and console licensing.

Content Licensing

As you saw in our list of the top publishers, many rely heavily on licensed properties for game titles. By licensing recognizable characters, personalities, music, or other entertainment properties and integrating them into a game, publishers can increase its exposure and sales, thereby decreasing their risk of investment. The following are examples of games based on licenses: Tony Hawk's Project 8, Harry Potter and the Order of the Phoenix, the Madden NFL series, The Lord of the Rings: Battle for Middle-earth II, and the NBA Jam series.

When a game uses a licensed property, the publisher pays the rights holder a fee for use of the property. In the case of the Madden NFL series, EA pays a license fee to John Madden and the NFL. With video games pulling in record profits, licensors of content are holding out for higher and higher prices. Because of this, some publishers, like Sony Computer Entertainment and Microsoft Game Studios, are actually quite aggressive about developing original game concepts, or intellectual property, as it is called.

Nevertheless, it is not uncommon for large titles to spend hundreds of thousands of dollars on a license, in addition to giving away anywhere from 1% to 10% of net revenues to the rights holder. The bottom line in terms of licensing is that it helps reduce publisher risk. Branded products have proven to be strong sellers time and time again, whether they have good gameplay elements or not.

Console Licensing Agreements

When you produce a game on a computer, you do not have to pay Microsoft, Apple, or the hardware manufacturer a royalty for distributing on their system. However, when publishers distribute a game on a console system, they must enter into a strict licensing agreement with the console maker, in which they agree to pay a licensing royalty for every unit sold. Typically this ranges from $3 to $10 per unit; that is on top of the retail markup, advertising, shipping, overhead, and development costs for the unit.

Here is how the responsibilities for a typical third party console licensing deal breaks down:

Publisher's responsibilities:

- Come up with game concept
- Develop the game
- Test the game
- Market the game
- Distribute the game

Console maker's responsibilities:

- Approve the game concept
- Test the game
- Review and approve the final game
- Manufacture the game

Console licensing agreements generally give the console maker the right of final approval, which means that if they do not approve of the game or its content, they can prevent it from being released. The testing and approval process can be quite rigorous. The console maker wants to ensure that the game works under all conditions and that it meets their quality standards. If they find flaws that they deem

significant, they can send the game back to the publisher and demand that it be fixed before release.

Changes at this stage of development, as we discussed in Chapter 13, can be very costly and can also impact the release date, potentially missing important market schedules. If and when the publisher finally gains approval to release the game, it must pay the console maker the royalty fee for every unit manufactured up front. Only after this payment are the games delivered to the publisher and then redistributed to retailers.

Element 3: Marketing

A big part of the publishing task is marketing the game. A marketer's job is to make decisions that will result in maximum sales. The marketing department is typically involved in a game's entire life cycle, from conception through the bargain bins. Only when the game is no longer saleable does the marketing team stop working. The marketing department handles everything from idea approvals and setting system specs through buying up advertising on local radio stations, as well as coordinating in-store promotions and publicity. Marketing budgets are typically double the development budgets. For our example of a $10 million game, the marketing budget would come in at around $20 million.

Element 4: Distribution

Publishers have very important relationships with the wholesalers and retailers that comprise the distribution chain. Without these relationships, a publisher would not be able to sell enough products to pay back all the costs they incurred in the production of the game. Getting the game onto the shelves of large chains like Wal-Mart, Target, and GameStop is a must, and that process costs more money. Here is a breakdown of the costs involved in distributing a typical console game:

- Retail price of $50
- Wholesale price (the amount retailers pay publishers for the title) = approximately 64% of the retail price or $32.00 per unit

- Cost of goods incurred by publisher = approximately $5.00 per unit
- Co-op advertising costs incurred by publisher = approximately 15% of wholesale price or $4.80 per unit
- Marketing costs incurred by publisher = approximately 8% of wholesale price or $2.56 per unit
- Return of goods contingency estimated by publisher = approximately 12% of wholesale price or $3.84 per unit

If you subtract the cost of goods ($5.00), the co-op advertising costs ($4.80), the marketing costs ($2.56), and the return of goods contingency ($3.84) from the wholesale price ($32.00), you'll find that the publisher reaps about $15.80 per unit sold or approximately 32% of the retail sale price. This is less than most people imagine.

Even if a title is fortunate enough to be sold on the shelves of Wal-Mart, there's no guarantee it will stay there for long. If the product doesn't sell right away or in sufficient quantity, retailers reserve the right to return product, which means that the publisher can wind up with a warehouse full of unsold games.

Even for larger publishers, who have a rich pipeline of games that the retailers desire, there are risks involved in producing games. The shelf life for most games is three to six months—not very long. And if you look at the publisher's other expenses, including production budget overruns, high return rates, approvals being withheld, schedules slipping, etc., you will understand why so many of the smaller publishers go out of business or are bought by larger companies. It is not easy to make a profit in the games industry unless you can control costs, produce the best products, and have the right relationships to make sure that your products get placed on the shelves and stay there.

These daunting numbers for retail distribution are driving publishers and developers alike to figure out ways to distribute their games digitally. The leading technology in this effort is the Steam content delivery system from Valve software. The business promise for online delivery is that publishers can keep 100% of the consumer sale price versus

32%. Imagine if the sale price remained the same $50, but the return to the publisher was tripled. This could energize the industry and lead to a less risky business environment, which in turn could lead to a more innovation-friendly environment for game creators.

CONCLUSION

To the game designer entirely focused on gameplay and production, the business aspects of publishing games might seem to be a confusing, cutthroat environment, best left to producers and executives. But as in all things, knowledge is power, and the more you know and understand about the industry you work in, the better equipped you will be to deal with the ups and downs of getting your original game ideas produced and published.

Creative people should not shy away from understanding the issues presented in this chapter. Understanding the needs and goals of all the parties involved in the publishing process, from the executives at the publishing company, to the representatives of the console makers, to the salespeople at the retail outlet, will help you make better decisions and will pay off over and over again in your career.

Think of yourself as a creative businessperson as well as a game designer, and educate yourself at every opportunity about the industry. Read marketing research, ask questions about contracts, understand the deal structure for your game, and treat each opportunity to deal with the business aspects of the industry as a chance to learn and expand your skills. The respect you show for this process will improve your relationships with the businesspeople involved in your game, and it will make you a better designer in turn.

BEGINNER PERSPECTIVE: JESSE VIGIL

Creative Partner, Psychic Bunny, M.F.A. Candidate, USC School of Cinematic Arts, Interactive Media

When we wrote the first edition of this book, Jesse Vigil was just beginning in the industry as a QA tester at Vivendi Universal Games. As a former undergraduate student of ours at USC, we asked Jesse to provide a beginner's perspective on the industry. While working at Vivendi, Jesse contributed to games including Battlestar Galactica (2003), Half-Life 2 (2004), and Middle-earth Online (2007). Now, several years later, Jesse is a graduate student at USC and a partner in a start-up company that has several game titles in production.

On getting into the game industry:

Accidentally. When I was interviewed for the previous edition of this book, I was three months into my first stint in games as quality assurance tester. A college professor advised me that this was a good path into the industry, and I had a really terrific buddy who offered me a job in QA at VU Games the very same day I about passed out from heat stroke as a much-abused production assistant on a TV show. QA jobs are cyclical. You're likely brought on in the summer during crunch, and you're lucky if you survive the thinning of the herd and kept through the winter until the ramp-up for the next Christmas starts.

On working in QA:

QA is a great way to see the game slowly evolve over time. Every few days you get a new build, and you see the changes that were implemented, and then you as a tester have as one of your jobs the task of seeing if the changes were beneficial to the game. It's like being able to peek over the designer's shoulder and watch the designer work. Depending on your situation, you might even be allowed to offer suggestions. It's a real rush when you make a suggestion and then, a few days later, you're playing the newest version and you say, "Oh wow, they actually did it."

In QA, I pulled 22-hour shifts, and during my lunch breaks I memorized the technical requirements guides that Sony, Microsoft, and Nintendo have for releasing titles on their consoles to make myself more valuable. I learned how to take a computer apart and replace graphics cards faster than a NASCAR pit crew, and I offered to come in all hours of day or night. It worked. I was kept on solid for almost two years and got moved on to some more permanent teams on some higher-profile games and was eventually promoted. Somewhere in there I got immersed in the culture and started to care really passionately about games and the state of the industry, to the point that I was no longer satisfied working in QA, so I went back to school to get a graduate degree in game design.

On designing games as a student:

I was asked as a student to collaborate on the design of a game for the Army that's intended to teach bilateral negotiation strategies with cultural sensitivity to soldiers about to be deployed overseas. Aside from being a really progressive game that's all about nonviolent conflict resolution, it was a fascinating design challenge. The people I worked with on that project remain some of the up-and-comers I respect the most, and I'm

proud to say it's functional and being tested with positive results. In the course of designing it, the Army made sure we spent 36 hours at one of their training facilities being immersed in both military and foreign cultures. Based on this experience, I have a completely different world view now, and it's one of the things I really value about the kind of jobs I get to do.

On learning from failures:

I've learned the most about game design from one of my biggest failures, which was an ambitious student game that had some pretty advanced conversation mechanics that I designed for it. I made a ton of mistakes. I didn't scope it appropriately. I had a good team, but we were plagued with bad luck, unsupported engines, bizarre disappearances, communication issues, and freak medical emergencies that added up to having a good prototype but one that was too far from what we needed it to be to call it a success.

I also didn't trust myself enough. Feedback is good, but every time we got a bad note from someone, we redesigned. I feel like game design is still design and that if you have an instinct for what good design is, you should be confident enough in your sensibilities to know its okay to sometimes stick to your guns.

On solving design problems:

Personally, solving a design problem is about playing to strengths. The game we designed for the Army had the problem that the NPCs were acting like game characters instead of emotional humans. Their responses were stiff and robotic and scripted, and this was killing the effectiveness of the game as a teaching tool. I ended up designing a glorified but very task-specific state machine to track player responses and build a very rudimentary "memory" system for the NPCs that would make it seem like they were more human. If you know much about computer science, this is akin to using a bow and arrow in a world where we're developing laser guns. But it was the best solution.

On the next five years:

When I was asked this question in the previous edition, my answer was: "Eventually, of course I want to write the actual game. I'm not really a designer, but I look forward to collaborating with designers." I was so pleased to read that four years later and realize that I have a writing credit on a game and actually consider myself to be a designer. Five years from now, I'd like to have a commercial title to my credit, and I'd like to continue to be writing for games and designing when I can. In five years it would definitely be nice to be trusted with a designer job on an IP I've pitched around.

Advice to designers:

A mentor of mine in college always said, "Be excellent at whatever you do, and you won't do it for long," and I think that's great advice for people starting out at the bottom. QA is a rough job and lacks glamour, but if you're a hard worker and your work is quality, you'll get noticed. But at the same time, have the sense to know if you're working at a place that values you. My last piece of advice is related to that. There are times when being the hardest worker or having good ideas still isn't going to get you promoted, and you need to have the courage to jump ship and find a new plan to get where you want.

Perspective from The Trenches: Jim Vessella

Associate Producer, Electronic Arts Los Angeles

When we wrote the first edition of this book, Jim Vessella was just starting his career at Electronic Arts. As a former student of ours at USC, we asked Jim to provide a beginner's perspective on the industry. Now, several years later, Jim is an accomplished associate producer with credits including Lord of the Rings: The Battle for Middle-earth II (2006) and Command & Conquer 3: Tiberium Wars (2007). We asked him to update his comments for this edition based on his experiences on these projects.

On getting into the game industry:

I always wanted to get into the industry, but like most people had trouble finding an open door. I thus spent my time reading articles and becoming versed in the business practices of the industry so that when an interview did come along I would be prepared. I would also take every opportunity to talk to industry personnel; you'd be surprised how eager some people are to simply share their experiences or give some inspirational words of wisdom. The research paid off, and my first gig came in the form of a summer internship at Vivendi Universal Games while I was a student at USC.

On experiences learned on the job:

One of the greatest development philosophies at EALA is the concept of pods and cells. A pod or cell is a group of individuals from each discipline who work together on a specific feature of the game. For example,

Further Reading

Chaplin, Heather, and Ruby, Aaron. *Smartbomb: The Quest for Art, Entertainment and Big Bucks in the Videogame Revolution.* New York: Workman Publishing, 2005.

Laramee, Francois Dominic. *Secrets of the Game Business.* Boston: Charles River Media, 2005.

Michael, David. *The Indie Game Development Survival Guide.* Boston: Charles River Media, 2003.

Vogel, Harold. *Entertainment Industry Economics: A Guide for Financial Analysis.* Cambridge, MA: Cambridge University Press, 2007.

on Command & Conquer 3, I was producing the User Interface pod, which included a designer, several engineers and artists, and a development director.

One strength of this pod structure is that it allows members from all different crafts to brainstorm and collaborate on design ideas. You'll find that engineers and artists have radically different ideas to offer, and on several occasions they were able to solve design issues that were stumping our design team. Learning to take suggestions from everyone on the team has been one the most valuable design lessons I've learned.

On the design process:

As noted above, design ideas can come from anyone, anywhere, and at anytime. We take great pride in leveraging not only ideas from our team, but also from our community and fans. We often start with a high level vision of what the game should be, and more importantly, how it should play. For example, if we decide that the game should be "fast and fluid," then everyone on the team can integrate that philosophy into their work. When getting into specific designs, we utilize the pod structure I previously described, which includes rapid brainstorming and prototyping to generate the most successful ideas.

On the next five years:

I've had the good fortune of working with a fantastic team and creating some amazingly fun strategy games. I hope to continue having the opportunity to work with talented teams and collaborate on innovative design, and perhaps even someday get the chance to lead my own team to success.

Advice to designers:

Be passionate and be persistent. Play games from all genres and platforms, read about the industry on a daily basis, and constantly search for internships or entry-level positions. Use these positions as a chance to network with employees and prove that you can handle greater responsibility.

END NOTES

1. Peter D. Hart Research, as quoted in "Essential Facts about the Computer and Game Industry," Entertainment Software Association.

2. Entertainment Software Association, "Essential Facts about the Computer and Game Industry."

3. Harding, Piers. "Western World MMOG Market: 2006 Review and Forecasts to 2011." *Screen Digest*. March 2007.

4. Sheff, David. *Game Over: How Nintendo Conquered the World*. New York: Vintage Books, 1994. p. 52.

5. Wilson, Trevor. "Game Developer Reports: Top 20 Publishers, 2007." *Game Developer*. October 2007.

6. Donovan, Tristan. "Game Developer Reports: Top 20 Publishers." *Game Developer*. September 2003.

Chapter 16

Selling Yourself and Your Ideas to the Game Industry

There is no one way to get into the game industry. If you have been reading along with the designer perspectives throughout this book, you have probably noticed that each individual designer has a unique story to tell about how he or she got a start designing games. No two took the same path, and you too will have to find your own way. But in this final chapter, we provide you with a number of strategies for selling yourself and your vision to the game industry. The three basic strategies we discuss are:

1. Getting a job at a publisher or developer
2. Pitching and selling an original idea to a publisher
3. Producing your ideas independently

Most game designers do not start out by selling original concepts; they get a job at an established company and work their way up the ladder. When they have some experience, they might break off to start their own company or pitch ideas internally to the company they work for. But how do you find your first job in the game industry? What are the qualifications? What should you bring to an interview? These are questions that do not have easy answers. Unlike many career paths, game design does not have an established route to success. The ideas we suggest are ways to maximize your chances in a very competitive arena.

GETTING A JOB AT A PUBLISHER OR DEVELOPER

Getting a job at an established company is the most practical way to start off in the game industry. You will gain knowledge and experience, meet and work with other talented people, and see the inner workings of game production firsthand. But even at the entry level, the game industry is very competitive. Aside from the obvious routes of responding to job postings and contacting the HR departments of game companies, we have several strategic recommendations that might help you get your first job.

Educate Yourself

When contacting companies and going on interviews, the most important thing you bring with you as a beginning game designer is a solid knowledge of games and the game industry. Being able to articulate concepts in gameplay and mechanics, knowing the history of games, and understanding how the companies you are speaking to fit into the business of games are all important ways to show your skills.

Academic Programs

Many colleges around the country are beginning to offer degrees in game design. This includes top-tier universities, like USC, Georgia Tech, and Carnegie Mellon, which have established curricula and game design research labs. There are also trade schools, like DigiPen and Full Sail, which specialize in placing people in the game industry.

These days major game companies like Electronic Arts, Activision, Microsoft, and others look to academic game programs first for new hires. Electronic Arts hired 100 people straight out of university in 2006. They hire mostly from top game design, computer science, and visual design schools and tend to hire applicants who are strong in both computer skills and people skills. The majority of their new hires start at the company as summer interns and are offered full-time jobs after graduation.

If you choose to attend a game design school, keep in mind that a well-rounded program might better prepare you for a career in game design than a curriculum focused only on tools and techniques. Additionally, studying subjects outside the field, such as history, psychology, economics, literature, film, or other topics you are passionate about, will stimulate your mind and imagination and give you interesting perspectives from which to design games.

That said, there is one bias that game companies do have: They are more likely to hire people with technical skills. If you take some courses in engineering or computer science, it will give you an edge over the competition. While you should not make tools your learning focus, you should become familiar with the applications used to make games. Programs like Adobe Photoshop, Illustrator, and Flash; 3D Studio Max; Maya; and Microsoft Project and Excel are all important nonprogramming tools that you might want to become familiar with, and most game programs will offer some training in these tools.

Play Games

You can teach yourself about design by playing as many games as you can, reading about their history and development, and analyzing their systems. We assume you love games, so playing them a lot is probably something you do already. But just playing is not enough. Get in the habit of analyzing the games you play. Challenge yourself to learn something new from each game you play. Be active in online game communities like GreatGamesExperiment.com, Kongregate.com, and GameDev.net. As we discussed in Chapter 1, develop a sense of game literacy, which can help you to discuss games at a deep system level and communicate your ideas about them with concrete examples.

Design Games and Levels

If you are following along with the exercises in this book, you should have designed at least one original game prototype by now. This experience is one of the most valuable tools you have in your search for a game design job.

Good solid paper game prototypes and well-written concept documents can form the basis for a great beginning portfolio. If you have the skills to turn your designs into software prototypes as well, you should do so. Even if you do not plan on pitching your ideas to a publisher at this point, polish your prototype and concept document anyway. During that crucial moment in a job interview when they ask you what experience you have, you will be able to show your work and discuss the process of design, playtesting, and revision in detail. This will differentiate you from other applicants because even though you are a beginner, you will be able to display actual experience of the development process, even though your games have not yet been published.

In addition to making physical and digital prototypes of original games, you can demonstrate your game design skills by building levels for existing games. As we discussed in Chapter 8, many games ship with level editing and mod building tools that are both powerful and flexible. There are also mod and level-making competitions that you can enter that might help give you the visibility and recognition you need to secure that first job. One strategy for getting in the door at a game company is to make levels or mods of that company's games, then submit these examples of your work along with your résumé.

Know the Industry

As we discussed in the previous chapter, it is important to stay informed about the industry you want to be a part of. Read books, magazines, and Web sites that can help you find out the latest news and trends. Having a grasp on the latest industry news when you go into an interview or meeting is a good way to show your knowledge of the space, and it will allow you to take advantage of opportunities that might arise with the latest announcements.

Networking

Networking is a powerful tool for people at all levels of the game industry. By networking, we simply mean getting out and meeting people within the industry. You can do this by going to industry-related events, attending conferences and conventions, reaching out to people in the industry via the Internet, and getting introductions via friends and relatives who know people in the industry.

Organizations

Joining organizations related to the industry is one way of meeting people. One of the best to consider joining is the International Game Developers Association, or the IGDA. The IGDA is an international organization of programmers, designers, artists, producers, and many other types of industry professionals that fosters community and action for the furthering of games as a medium. The organization has local chapters in many geographic locations; you can find out if there is one near you by going to www.igda.org/chapters.

Chapters often hold networking events, lectures, and other opportunities to meet people who are working in the industry. There are membership fees for this organization, but if you are a student, you can get a reduced rate.

Conferences

Another great opportunity for networking is at conferences. Two of the top conferences in the United States are the Game Developers Conference and South by Southwest. Developers and publishing executives attend these events en masse, and you will have the opportunity to meet people from all levels and areas of the industry. There are lectures and seminars on any number of topics, and you might be surprised at how accessible some of the top talent in the industry is at these events.

Exercise 16.1: Networking

Make it your goal to attend at least one networking event per month. This can be a conference, a party, a meeting, a lecture, or any other opportunity in which you can meet people in the game industry. Start a database of the contacts you make at these events.

Internet and E-mail

Another networking resource is the Internet. You can meet many people in the industry in online communities, such as the forums on IGDA.org, or you can find internships or positions in the jobs and projects sections of Gamasutra.com. E-mail is a very efficient tool for reaching out to people, but it is not necessarily the most powerful or persuasive way to introduce yourself. You can find lists of developers and publishers in the companies area of Gamasutra.com, and you can go to their Web sites and contact them via a "cold" (i.e., unsolicited) e-mail, but do not be surprised if you do not get a response. Game companies are flooded with e-mail from people who want to work in the game industry, and the chance of your e-mail getting to the right person without an introduction is slim. That does not mean you should not try, but do not be dismayed if the response to your carefully written e-mail is silence.

One problem is that HR departments are often not the best way to reach the decision makers for project hiring. We recommend searching for the individual addresses of people inside the company. Find out who is the producer or line producer on a particular game title, and then try to get an introduction to this person. Do you know someone in the industry, or otherwise, who knows them? If so, get a personal introduction. If not, try to find his e-mail address from press releases or postings on the Web and contact him directly.

Before sitting down to write your e-mail, research this person's background and the games he has worked on. Personalize your e-mail to him based on your research. A little knowledge and a well-written introduction of yourself and why you are contacting him can go a long way. If you are lucky, your e-mail will get a response. Even if there is no job at the moment, you will have made a contact, and you can introduce yourself in person at the next industry event or conference.

Good research and writing notwithstanding, do not expect too much from each message that you send. Professionals working in the game industry receive a lot of unsolicited inquiries. If they do not write back, do not be surprised or upset. They are probably in the midst of production and too busy to answer their mail. But if you continue to persevere, your odds will increase with every message you send.

Exercise 16.2: Follow-Up Letter

Write a follow-up letter to a person you have met via your networking efforts to talk about job opportunities in her company or to show her your original game idea. Try to make your letter both persuasive and courteous. Be sure you are prepared for the meeting should she respond. The next few exercises will help you to do that.

An important note about networking is to not expect too much from each activity you do. If you go to an event and do not meet anyone who can help you, do not consider it to be a failure. Networking is a cumulative endeavor. It is seldom that a single meeting will result in a job opportunity. Usually, you will have to meet people several times at events and follow up with them each time before opportunities open up. Even if a networking event opens up no opportunities, you will still learn a lot by simply mingling and interacting with the people there.

Starting at the Bottom

What jobs should you be trying to get in your quest to enter the industry? If you are an artist or a programmer, there are entry-levels positions in these tracks at

most companies. You will need to have a good resume/portfolio. These positions are competitive, but demand is high for this type of talent. As the size of game teams has grown, the largest percentage of new jobs has been created in the art and programming groups.

If you want to produce games, there might be production assistant or coordinator jobs (or internships) that you can apply for. But if you want to design games, the outlook is a bit more complicated. The best job you could get would be as an assistant designer or level designer. Truthfully, however, these positions are difficult to come by unless you are experienced or already working within a game company. Many people who become game designers do so by starting in another track and jumping over into design when they have gained experience in the industry. For example, many game designers first work as programmers or producers.

Exercise 16.3: Résumé

Create a résumé focusing on your game design experience. Even if you do not have much professional experience, make sure to include references to all the design work you have done in the exercises throughout this book, courses you have taken, or organizations you belong to, such as the IGDA.

Interning

A good way to get into the industry in any career track is by interning. Game companies, especially publishers, bring on summer interns from colleges regularly. These are generally not paid positions, and they are not as hard as getting a paying job. But before you take an intern position, make sure the company is serious about letting you become involved in actual projects. You do not want to spend three to six months making photocopies or acting as a receptionist. This won't advance your career much or teach you about the industry. A good internship will allow you to learn about some aspect of the business. Interns often do research, testing, or assist producers or executives. It is a great way to get to network and to increase your knowledge.

An Interview with a Game Agent

by Richard Leibowitz

Richard Leibowitz is the president of Union Entertainment, a talent management and production company specializing in video games.

Game Design Workshop: *How did you become a game agent and why?*

Richard Leibowitz: After considering careers in law, finance, and politics, I decided to combine the three in entertainment and took a position at Paramount Pictures as an attorney in the Domestic Television department. From there, I went on to head Rysher Entertainment's International Business and Legal Affairs department, and later returned to Paramount when Paramount acquired Rysher. During that period, I became fascinated by the video game industry and left Paramount in 1999 to apply my entertainment deal-making and legal experience to the video game business by cofounding the first Hollywood-style agency in the business.

GDW: *What's the role of an agent in the game industry today?*

RL: In my opinion, there are three types of agents in the game industry today: hunting agents, packaging agents, and Hollywood agents.

Hunting agents simply make phone calls to publishers on behalf of developers, whether they are clients or not, to solicit and secure work-for-hire deals. For example, a hunting agent calls a publisher and learns that the publisher is requesting proposals from developers to make a game based on a recently acquired license. The hunting agent then contacts developers, tells them of the opportunity, finds or settles on one of them, and presents that developer to the publisher. If the publisher selects that developer, then the developer will typically pay the hunting agent a modest percentage of the developer's resulting compensation.

The packaging agent is similar to the Hollywood producer in that he/she identifies and secures content, attaches the best available developer and other talent (e.g., writers and designers), and shops that content/developer package to financiers/publishers. Unlike producers, though, packaging agents do not generally engage in development activities, and instead of a producer's fee, packaging agents will receive a percentage of the license fee from the property's licensor and a percentage of the developer's compensation from the developer.

Hollywood agents include those at the established Hollywood talent agencies (e.g., CAA, William Morris, UTA). Each of the agencies has at least one person dedicated to games, although the services they provide vary greatly. For the most part, Hollywood agents represent their film clients' interests in the game world and earn a 10% fee for doing so. Often, this is what I'd describe as "passive representation." For example, if a publisher wants to secure an actor's name and likeness rights and/or hire the actor for voice recordings, then the publisher will contact the relevant Hollywood agent to secure such rights and/or services. However, some Hollywood agents are more proactive,

actually packaging developers with film projects at the agency and then selling those packages to publishers. Typically, a publisher will pay the Hollywood agent a percentage of the package budget (i.e., license fee, actor's rights and services fees, and development budget).

GDW: *How is a typical deal structured between a developer, publisher, and your company?*

RL: Union provides a wide array of specialized services and has a successful track record. As a result, there are many development companies and individual talent that utilize Union's services. The most common deal structures between Union and its clients are: (1) straight monthly retainer; (2) a success fee equal to a percentage of the client's compensation for the project; and (3) a combination of the first two—a lesser retainer plus a lesser success fee.

GDW: *What do you look for in a client?*

RL: We look for what we know publishers look for—talent. Publishers hire two types of developers: established developers with robust and proven technology or brand new developers comprised of superstar talent and capable management.

GDW: *What do you think the role of a game agent will become?*

RL: There will always be a place for game agents—even the biggest and best developers can take advantage of an agent's contacts and deal-making abilities. That being said, I believe the role of a game agent in the future will favor the packaging over the hunting variety for at least two reasons:

1. Internal business development personnel: Developers often have business development personnel on staff to secure and sell projects. Typically, the associated costs for the developer to employ such personnel and hunt by itself are equal to or less than what the developer would pay a hunting agent.

2. Publisher demand for projects: Publishers are extremely risk averse. One way publishers reduce risk is by hiring the best development companies, and another is to green light projects based on preexisting and identifiable underlying content (e.g., Harry Potter). Packaging agents add value to developers and pique publishers' interest when they attach developers to desirable content. By so doing, the packaging agent will most likely either (1) secure a deal for a developer that the developer wouldn't have otherwise secured, or (2) make it possible for the developer to demand a premium (e.g., higher development budget, better royalty rates) for its services.

GDW: *Will agents be as established in the game industry in the future as they are in the film and television industry today?*

RL: In the near future, I believe publishers will follow the movie studios' paradigm and rely upon game agents, and independent game producers, to present compelling game project packages. The present game industry parallels the film industry in its early days. However, the pull of Hollywood is evident in many areas of the game business, and as talent emerges as a power in the game business like it did in Hollywood, the game business will want the same kind of services and structure—including knowledgeable intermediaries such as agents—that have served Hollywood so well for so long.

Further, just as in Hollywood, content is king in the game industry. However, much more in the game than in the film business, "content" can mean both the underlying property (e.g., Spider-Man) and technology. Special effects extravaganzas aside, technology is not generally what distinguishes filmmakers. Consumers will pay the same $10 to see a low budget romantic comedy as they will to see a $100 million epic. By contrast, at up to $60 per next-gen game (not including console and add-on costs), applying the right tech to the right property can make a huge difference in creating a rewarding game experience worth the consumer's time and financial outlay. Therefore, good packaging agents—those who know how to identify and to combine developer (i.e., technology) and property to create a compelling package and who can bring packages to publishers beyond what the publishers might identify on their own—are most likely to add value for developers and publishers and prove most successful as the game business evolves.

Exercise 16.4: Internship

If you are a student, an internship is a good place to start. Go to the career center on campus or visit their Web site and look for postings. Another option is to approach game companies directly and ask them if there are any internship openings.

QA

The most common paid entry-level job is as a QA tester. The pay is usually low, and the hours can be long, but it is a decent way to start your career because QA testers are exposed to the whole development team. You will be writing bug reports that go directly to the programmers, artists, and producers. Managers might take note of talented QA testers because many of them started in QA themselves. When production teams are being built for new projects, some companies will give a good QA tester who has paid his dues consideration over an outsider. More importantly, QA testing gives you front row seats to the development process. You will get to see games evolve and come together from early builds to the final release.

PITCHING YOUR ORIGINAL IDEAS

When you have built up some experience by working in the industry, you might want to develop and pitch your own original ideas to publishers. As we discussed in Chapter 13, publishers are more likely to fund ideas that come to them with an experienced team, a stellar idea, and a good, solid project plan.

Let's assume that you have been able to get a meeting with a potential publisher (a trick in itself). What do they expect to see? How will the process unfold? The following section explains some industry practices for established developers seeking to sell their ideas to publishers. Even if you are not yet at that stage of your career, it is worth understanding the process so that you can anticipate what you will have to do when you do get to that point.

The information and recommendations in this section are based on the IGDA Business Committee's *Game Submission Guide*. In preparing this document, the IGDA surveyed and interviewed professionals throughout the industry to get a picture of trends and common practices for game submissions. The full report is available for download from the IGDA Web site. With the IGDA's permission, we have used the report to create the following recommendations.

Pitch Process

Game publishers receive thousands of submissions a year from developers. Many of these are immediately rejected for a variety of reasons, including inadequate submission materials. Less than 4% of submitted ideas are actually published. Of the ones that become products, only one or two become hits. Do not be discouraged by these statistics, though, because the odds of rejection are similar in all creative industries.

As a developer, you can increase your chances of getting past the first step with a publisher by making acceptable pitch materials. Good pitch materials will identify your team as experienced professionals, and they will convey your ideas in an exciting way. When you are pitching to a publisher, they are asking themselves: "Can these people be trusted with millions of my dollars?"

The first step in pitching is to get to someone who reviews third party submissions. You can sometimes find a contact address on the publisher's Web site or by calling the main switchboard and asking for someone in third party product acquisitions. Again, do not be surprised if your phone calls do not get returned. Always be courteous, but also be persistent.

When you eventually get a pitch opportunity, you should be prepared to sign a submission agreement or confidentiality agreement. This document will basically say that whatever idea you are going to present might already be in development at the company or has been presented to them by another developer. In any case, you will have no recourse if they end up producing a similar idea without you. Despite the one-sidedness of this document, you should sign it. Refusing to sign will show that you are not familiar with the process. Submission agreements are standard practice in every creative industry including books, film, and television.

It is best to pitch in person. However, sometimes publishers will request to review the materials on their own first. Either way, present yourself and your materials in as professional a manner as possible. You do not need to wear a suit, but ripped jeans and an old T-shirt are not appropriate.

Depending on how aggressive you are, getting through the pitch process can take anywhere from 4 to 16 weeks. Make a checklist or spreadsheet of every publisher you contact. It is okay to present the same pitch to multiple companies, but dealing with publishers that have multiple individuals evaluating your project can get confusing, and you do not want to lose track of your progress.

Pitch Materials

The package you present has to instill confidence in different types of people within the publishing company. They will be evaluating your team first, your creative materials second, and your project plan third. Make your materials easy to understand in a very short time frame because not everyone at the publisher is going to read them in their entirety. Here are some materials that the IGDA guidelines recommend preparing:

1. Sell sheet
2. Game demo
3. Game AVI
4. Game design overview
5. Company prospectus
6. Gameplay storyboards
7. PowerPoint presentation
8. Technical design overview
9. Competitive analysis

1. Sell sheet

This is a "short attention span" document that explains your idea as well as the target market. The sell sheet should include: game title, genre, number of players, platform, ship date, two-paragraph description, bullet point list of features, and some game art.

2. Game demo

A playable demo is one of the most important submission materials you can produce. Seventy-seven percent of the respondents to the IGDA's publisher survey said that a playable demo is essential to a pitch package. Demos can be built in differing degrees of completeness. The important thing is that the publisher can get to evaluate the final gameplay.

Selling Ideas to the Game Industry

by Kenn Hoekstra, Pi Studios, LLC

To be brutally honest, it's *very* difficult for someone outside the games industry to get their ideas past a company's front door. For that matter, it's not all that easy to get a game company to look at your ideas if you work for them. There are a number of reasons for this.

First of all, there are legal reasons that revolve around the legal possession of an idea. Let's say a company had a similar idea a year ago and they've spent a million dollars or more developing that idea up until this point. The company says, "Sure, I'd love to hear your new, innovative game idea," and it turns out the idea is the same as the one the company has been working on. When the game comes out, you have a "he said/she said" lawsuit on your hands over whose idea the game was in the first place. That is a hassle that no company wants. To combat this situation, most companies delete ideas and suggestions unread or send them back "return to sender" through postal mail.

Another reason game ideas are hard to sell is that most people outside the industry don't understand the fundamentals of game development. They don't understand technology limitations, development times, financial concerns, scheduling, or any of the multitudes of other headaches involved in developing a new product. Their idea proposals say things like, "You would recreate New York City to scale and have four million unique-looking and -sounding individuals that you can interact with, and you can have 500,000 of them on the screen at the same time when you join them in Times Square for the New Year's Eve ball drop. That's when the aliens attack and severely damage the city, so all of the buildings have to be half destroyed as the city is plunged into chaos and eternal night. Then you and your band of 10,000 resistance fighters lead the charge with 500 unique weapons and squad-based tactics, and the game would toggle between first person, third person, top down, and map views," and on and on and on and on and on. You see what I mean? A vast majority of game idea submissions suffer from this problem. I call it "newbie ambition." Game development is mostly about figuring out "what cool stuff you can do in a limited time period with limited cash."

Yet another reason for not accepting game ideas is a question of who takes the risk. The game company is spending 5 to 10 million dollars (or more) on the development cycle for the game and, in turn, they are taking all of the risk. Why, then, should they pay someone from outside the company for their game idea when they aren't taking any of the risk? Generally speaking, every game company has more ideas of their own on the back burner than they will ever have time to produce, and thus, there's no reason to accept outside ideas.

Think of it this way. Everyone at one time or another has tried to write a novel or has had a great idea for a novel. How many book publishers will take an idea for a novel if they have to pay someone else to do the writing? None. Therefore, the people with the ideas have to write their own books. How many of them start writing? How many of them actually *finish* the novel? When they're finished, how many get published at all? And of those who are published, how many are published without changes made by the publisher? See what I mean?

Think of game companies as established entities in the entertainment business. Generally speaking, game companies think they know everything there is to know about gaming because they've paid their dues and worked their way to the top. Just as you won't sell a *Star Wars* sequel to George Lucas or a Spec Ops book to Tom Clancy, odds are you won't sell your big game idea to a game developer. Sadly, it's just the nature of the business.

The only possible exception to the "outside game ideas" rule is if you are a world-famous person in the entertainment industry. If Stephen King, for example, came to a game company with an idea for a horror game, who wouldn't listen? The potential to have a famous name on the box can sometimes outweigh the "we have our own ideas" rule.

Now, if you do want to get your idea made into a game, there are a few things you can do:

- Inquire with the company first. Ask them if they want to hear your idea and offer to sign an NDA (nondisclosure agreement). If you're not interested in money or lawsuits, tell them in writing they can have your idea no strings attached if they want to use it. Don't just send the idea in unsolicited. It will be deleted unread, ignored, or mailed back to you.

- Get a job at a game company. If you're on the inside, your chances of getting your ideas noticed or accepted are much greater because most of the legalities disappear.

- Get a team together and make the game yourself. If not the whole game, make a solid, working demo. This will show publishers that you're serious and it will give them something concrete to look at. Game development is a very visual business, and it's a lot easier to judge a game idea from a demo than from a piece of paper or a wordy verbal description.

It's a great misnomer that game companies (or any companies for that matter) employ idea people or think tanks to push the company in bold new directions. Hard work and contribution to a greater goal or the greater good of a company is the only way to get anything done in the business world. That goes for your own company or any company you're working for. Unless, of course, your family owns the company. Then all bets are off on the hard work and contribution part.

About the Author

Kenn Hoekstra has a bachelor of science degree in English from the University of Wisconsin-Whitewater. He has designed 3D game levels for Raven Software's Take No Prisoners, Hexen II: Portal of Praevus, HexenWorld, and Soldier of Fortune: Gold Edition. He also served as project administrator for Heretic II, Soldier of Fortune, Star Trek: Voyager: Elite Force, the Elite Force Expansion Pack, Jedi Knight II: Jedi Outcast, Soldier of Fortune II: Double Helix, Jedi Academy, X-Men Legends and Quake IV. Kenn has written several game manuals, the official Soldier of Fortune Strategy Guide, the screenplay for Soldier of Fortune II: Double Helix, and has published several articles on the games industry. He is currently working on Mercenaries 2 for the PS2. Kenn lives in Houston, Texas and is working as an executive producer for Pi Studios, LLC.

3. **Game AVI**

If you cannot produce a playable demo, then a game AVI is the next best thing. It is a video file that shows the characters and gameplay. The most credible AVI will be one created using your game code. However, some established developers make them using just storyboards and narration.

4. **Game design overview**

This is a game design explanation written without excessive details. If a publisher is interested, they will want to see that you have thought through the whole project, but they will not want to read every last detail. Ideal contents include: game story, game mechanics, level design outline, controls, interfaces, art style, music style, feature list, preliminary milestone schedule, and a list of team members with short bios.

5. **Company prospectus**

This is a short document that talks about the managers in your company and the team members. It is like a résumé for your company. Ideal contents include: company information (including location and project history and proven abilities), company details (including technologies used, number of employees in each department, and other differentiating information), titles in development, titles shipped (including platform information), and full team bios.

6. **Storyboards**

These are still images from your game. They can be in sketch form or final art or both. They are nice to include in a paper package because an executive might want to review your documents when they are away from a computer and cannot run your demo or game AVI. Ideal contents are: visual walkthrough of gameplay with text explanations, play control diagrams, and character profiles.

7. **PowerPoint presentation**

This is a compilation of key visuals and points from your other pitch materials. It is easy to make, and it might be useful if the publisher wants to get the top points when you are not in the room. For example, one person inside the publisher might want to present the idea to another when you are not around.

8. **Technical design overview**

This is a technical design document without excessive details. It describes how your technology works as well as the intended development path. It should include complete explanations while being accessible for nonengineers. Ideal contents are: general overview, engine description, tools description, hardware used (development and target), history of code base, and middleware used, if any.

9. **Competitive analysis**

This identifies titles you are competing against. It shows that you understand the market and your relative position within it. Ideal contents are: summary of your concept's market position and reason for success and pro and con descriptions of competitive titles with sales figures, if you can get them.

Exercise 16.5: Preparing Your Submission Materials

Go over the preceding list, and with your team members, prepare as many of the submission materials as you can. Make sure to include all of the work you have done on your original game prototype, your design document, and your project plan.

Exercise 16.6: Pitching

From your networking database and the research you have done, target a list of companies to whom you can pitch your original game. Use all the methods described previously to find a contact within the company and set up a pitch. Even if this exercise does not result in the sale or funding of your idea, this is a great way to network and will help you to meet more people in the industry and possibly get a job.

What Happens after the Pitch

Before leaving your pitch meeting, you should ask when you should expect a preliminary response to your pitch. This will set both your own expectations for a response as well as the publisher's expectations that you intend to follow up.

Prompt follow-up on the developer's part is important, but over-eagerness can quickly wear on a publisher. A good guideline is to follow up with a short "thank you" e-mail immediately after your pitch, and provide any supplemental materials or copies of documents that were requested during the meeting.

If a publisher is interested, they will likely get back to you quickly, but if you do not hear from them immediately, it might just mean that your contact is traveling or busy in other meetings. If you do not receive a response after 7 to 10 days, you should contact the individual who set up your meeting with no more than one e-mail and one phone call per week to check on the status of your pitch. Contacting the person more than this will be seen as bothersome and is unlikely to help your cause.

What will likely be happening at the publisher during this time is an internal review process among multiple people. It is unlikely that one person will be empowered to make a decision. Most publishers are organized around three groups:

- Sales and marketing
- Production
- Business/legal

Within each group are decision makers who have input on external submissions. The people you pitch to will likely be from the business/legal group. If they like it, they will take it to the other internal groups and try to build consensus. These groups often have competitive relationships because of their differing roles in the company. Ideally someone will feel strongly about your idea and fight to convince the other groups that it will be successful. If these groups like it, the publisher might ask a technical executive to dig deeper into your project. It is a great sign if the publisher starts asking for technical details.

In essence, the final decision will be based on a combination of many possible risks. These risk factors can include: time to market risk, design risk, technology risk, team risk, platform risk, marketing risk, cost risk, etc. If the publisher goes through their process and decides that your project is worth the risk, they will prepare a detailed return on investment (ROI) analysis that will determine profit potential for the title.

If the publisher deems all risks and the projected ROI to be acceptable, then the publisher might send you a letter of intent for the project. This is a great day, but your submission process is still not over. As a final step, the publisher will probably want to execute a full contract. Or they might unexpectedly kill the project at this point for internal reasons. As a rule of thumb, do not believe you have a deal until you see a signature from the publisher on the final contract. And do not spend any of the money you expect to see from the publisher until it is actually in your company bank account.

If your pitch does not make it to this stage, know that you are not alone: You are in the company of 96% of all other submissions that the publisher has reviewed and passed on that year. Each time you go through this process, you will learn more about how to pitch your ideas, and you will have more and better contacts to pitch them to.

INDEPENDENT PRODUCTION

Like other large media industries, the game industry has its share of independents who choose to self-produce and distribute games. This is a hard route to take, and scraping together the money to support a team through months of production can be an arduous process. Some independent developers have other jobs, some do work for hire to support their original game development, and some use credit cards and

loans from friends and family. Like independent films and underground music, independent games are a long shot for their creators. More often than not, they are never finished or never find a distribution channel. But independence has its privileges as well—the ability to experiment with truly original concepts, the freedom to change ideas midstream, and the knowledge that you own your ideas and their implementation.

For most independent developers, the goal is to produce a game that will be picked up and distributed by a major publisher. If this happens, the developer will be able to negotiate a fairly good deal in terms of ownership and royalties, and the publisher will be taking much less risk in terms of advances. Unfortunately, most independently produced games do not get picked up, and their developers must resort to trying to sell them directly via the Internet or using them as a demo to get a publishing deal for a different game. But that is no reason not to go the independent route if you have a truly original idea and the passion to produce it. The edges of industries are where innovation often thrives, and your game might turn out to be exactly what the game-playing public did not know it was looking for. See the "Business Opportunities for Independents" sidebar on page 386 for more information on independent development.

CONCLUSION

As you can see, there are many ways to become a game designer and to get your ideas produced. Whether you get a job in the industry and you work your way up the ladder, try to get a deal to develop an original game for a publisher, or strike out on your own and produce your ideas independently, what really matters is not the path you choose but that you find a way to realize your dreams and make the type of games you truly believe in.

Whether you find yourself working at a large company, wind up producing games on a shoestring, or just wind up designing games as a hobby, never lose sight of your own personal vision, and keep in mind that the only way to fail is by not making games at all.

DESIGNER PERSPECTIVE: CHRISTOPHER RUBYOR

Lead Designer, Petroglyph

Chris Rubyor is a game designer who whose credits include Command & Conquer: Generals Zero Hour (2003), Lord of the Rings: The Battle for Middle-earth (2004), Star Wars: Empire at War (2006), and Star Wars: Empire at War—Forces of Corruption (2006). While working as a community manager and in QA, his credits included the Command & Conquer series and many other titles.

On getting into the game industry:

I was fortunate enough to know someone who worked in the industry. At the time (1994), I was working at a computer store, selling games and hardware. One day my old boss called the store and asked if I was interested in working as a QA analyst for the company that created Dune II (Westwood Studios). Being a big fan of Dune II and The Legend of Kyrandia, I couldn't refuse.

On learning about game design:

For every designer it's different. I knew from the day I started working at Westwood Studios that I wanted to be a game designer. Unlike most people, I made a conscious decision to learn more about the industry, thus my foray into marketing and community support. From 1997 through 2000 I worked as a PR manager for Westwood Studios under Laura Miele (VP of marketing) at the time. This position gave me the opportunity to learn about marketing products to our consumers and the importance of PR and how it relates to gaming. I traveled to various trade shows, worked with some of the top gaming magazines from around the world, and helped set up events to promote Westwood's games. It was great experience that I look back on with fond memories.

On working in community management:

Starting in June 2000, I made the decision to take on a new community manager (Command & Conquer) position at Westwood Studios. It was something new to the company and dealt exclusively with the fans. For the next year I worked very closely with Brett Sperry, the company's cofounder and visionary behind the Command & Conquer series, and Ted Morris, the Web development director, to carve out the role. Working with these two individuals gave me the chance to learn a great deal about Web design and the importance of an online community for a multiplayer product.

Over the next three years I did everything from helping design Web sites and managing message boards to creating six-month community plans layered with events for both pre- and postlaunch of a product. I also put on the PR hat at times and set up online chat events, contests, and fan site events at the main studio to help excite and promote growth of our community. From this I walked away with a wealth of knowledge about online gaming, community integration, and a realization that multiplayer gaming is my passion.

On getting a game design position:

In July 2003 I made the decision to begin working my way into a design position. Westwood Studios was just beginning work on a new project, and the team was limited to only a few developers. So after hours I began working with the creative director on concepts and big ideas. We also talked a lot about multiplayer gaming and what we should try for our next game. After about six months, an assistant design position became available, and I gladly took on the role.

Now I'm working as a lead game designer at Petroglyph. I credit the choices I made and people I met for my smooth transition into my dream job.

Advice to designers:

Don't be afraid to take chances; it would be a shame for gamers to miss out on the next killer game experience.

DESIGNER PERSPECTIVE: SCOTT MILLER

CEO, Apogee Software (aka 3D Realms)

Scott Miller is a long-time game producer and entrepreneur whose many credits include Duke Nukem (1991), Wolfenstein 3D (1992), Raptor (1994), Shadow Warrior (1997), Max Payne (2001), Max Payne 2 (2003), and Prey (2006).

On getting into the game industry:

I began first as a journalist in 1982, then in 1987 I started my own company, Apogee Software. Apogee is known as the pioneer of shareware gaming—we invented the method of releasing one episode as shareware and selling additional episodes of the game directly ourselves. This allowed us to self-publish our first 20 games without the need of a retail publisher or outside funding. We made millions using this method before finally signing with traditional publishers in the mid-1990s. Id Software and Epic Games mimicked our shareware method and also rose to great success. It's no coincidence that all three companies are among the strongest, most successful, entirely independent development studios in North America.

On self-publishing:

By first self-publishing our games we were able to build strong financial independence. This method allowed all three companies to make original intellectual property (IP) without the publisher getting long-term ownership and control of these IPs. In fact, a developer's only chance of long-term success is to create and own an original IP. Without doing this, a studio is constantly under the thumb of finicky and often untrustworthy publishers. An IP gives a studio the clout needed to get the best publishing deals. Plus, as 3D Realms and Remedy have shown with the sale of the Max Payne IP for over $45 million, an IP is where the real value of a studio resides. Additionally, 3D Realms has been offered $80 million for our Duke Nukem IP by a major publisher. Never doubt that making original IP that your studio owns is the best path to long-term success.

On favorite games:

As a longtime gamer, my list includes some classic oldies.

- *M.U.L.E.:* A breakthrough, addictive multiplayer game that is begging for a modern remake.
- *Diablo:* The core gameplay is a model of simplicity, the execution borders on perfection, and the game continuously rewards the player through a brilliant system of ever-improving gear.
- *Tetris:* Perhaps the most perfect computer game ever. Simple to learn, near impossible to master, and equally appealing to either gender.
- *DOOM:* A technical tour de force and the first game to truly frighten players.

- *Space Invaders:* The game that officially kicked off the arcade's golden years. The most adrenaline squirting game I've ever played.
- *Super Mario Bros.:* I can't leave this game off my list because it was the first game that introduced the idea of a world for the player to explore, an idea that still continues to be seen in many modern games, including the GTA series.

Advice to designers:

Learn from other games and designers, but do not copy them. You absolutely must invent something unique and compelling (one without the other is not enough) to be a success. For example, at the time we were working on the concept for Max Payne, Tomb Raider was just out and a huge hit. We could have easily fallen into the trap of making a male version of Lara Croft, but that would have been recreating another Indiana Jones. So, instead, we looked at what Tomb Raider did well, and purposely picked other things for Max Payne to do well. It was critical for Max to be seen as a unique character, not a copycat. If you follow in other people's footsteps, you'll never be a leader.

FURTHER READING

Gershenfeld, Alan, Loparco, Mark, and Barajas, Cecilia. *Game Plan: The Insider's Guide to Breaking in and Succeeding in the Computer and Video Game Business.* New York: St. Martin's Griffin, 2003.

Mencher, Mark. *Get in the Game: Careers in the Game Industry.* Indianapolis: New Riders Publishing, 2002.

Rush, Alice, Hodgson, David, and Stratton, Bryan. *Paid to Play: An Insider's Guide to Video Game Careers.* Roseville, CA: Prima Publishing, 2006.

Saltzman, Mark. *Game Creation and Careers: Insider Secrets from Industry Experts.* Indianapolis: New Riders Publishing, 2003.

Conclusion

If you have been following along with the exercises in this book as you read the text, you have not only broadened your understanding of games and game structures, but you have learned to conceive, prototype, playtest, and articulate your own game ideas.

You have thought through what it will take to produce at least one of your original game ideas by creating a production plan with goals, deliverables, a schedule, and a budget. You have a draft of your game's design document and presentation materials such as art boards, a PowerPoint deck, and perhaps a working demo of your game. You might even have a list of contacts in the industry to whom you can pitch your idea. In other words, you are well on your way to working as a game designer.

It has been our goal throughout this book to empower you with the knowledge and skills to go out and work as a game designer, either by getting a job at an established company, by selling your game ideas to a publisher, or by producing your ideas independently. If you feel confident in your ability to do this, then we have accomplished our goal.

Alongside this confidence, however, should exist the knowledge that "becoming" a game designer is a lifelong process that is never finished. Hopefully, you will continue growing and learning as a designer for the rest of your career, and the ideas we have presented in this book will just be the first step in a very interesting journey—the first level of your life as a game designer, so to speak.

Now you are ready to move on to tackle more challenging concepts in design, more professional responsibility, or perhaps to refine your focus to a particular field, such as visual design, programming, producing, or marketing. Wherever your future path in game design directs you, we hope you take with you a sense of the infinite possibility that exists for game design today, the potential for developing an entertainment form with the ability to move people to involvement and action far beyond traditional media.

The future of game design rests not only in the ever more immersive qualities of technological devices we read so much about today but more importantly in the ability of those technological wonders to serve some deeper sense of play and interaction. The potential is wide open to bring richer emotional qualities to the experience of games we know and to create new and unique mechanics for games we have yet to play. The game designers of the next few decades will show whether this medium will live up to that promise or not. We believe that you are up to the challenge.

Thanks for playing!

Index

Page numbers followed by "f" denote figures; those followed by "t" denote tables